CONTENTS

INTRODUCTION

Early Indian Art and decorated artifacts as such did not exist distinct or separate from other aspects of Indian culture. Unlike Euro-American societies Indian artists did not produce art for art's sake; it was inseparable from other material culture. Many Indian nations conceived the universe and everything in it as the creation of an all-controlling invisible force. The universe was a perfectly balanced physical and psychological structure and to maintain this equilibrium ceremonies and paraphernalia using parts of birds, animals, and other natural phenomena were used to keep and enforce the cosmic model. Feathers of birds of prey, certain animal hides, various woods, and particular paint colors were used often in combinations to placate the forces required for cosmic balance.

Into this basically organic world European traders added a range of manufactured metal goods and materials which supplemented the indigenous fauna and flora, developing and extending native arts. Some of the earliest collections of North American Indian material culture were gathered by Europeans in their colonies in eastern North America such as the Tradescant items now in the Ashmolean Museum, Oxford, England, and objects in the Musée du Quai Branly, Paris, (formerly the Musée de L'Homme) and the British Museum, London. From the eighteenth century contents of aristocratic cabinets of curiosities ultimately passed into public museums such as these. A number of important Eastern Woodland collections were taken to Europe by military personnel and later, in the early nineteenth century, the acquisitions of Prince Maximilian of Wied 1833-34 were dispersed in museums in Berne, Berlin and Stuttgart. The Berne Historical Museum also has the collection assembled by Lorenz Alphons Schoch, who returned to Berne from St Louis in 1838, which may contain material from William Clark's Indian Museum dispersed about that time in St Louis.

In the United States major institutions began procuring during the nineteenth century. A small collection of Indian material survives from the Lewis and Clark expedition of 1804-06 at the Peabody Museum, Harvard, but nothing can be found from either the Zebulon Pike or Stephen Long government expeditions of 1807 and 1819-20 respectively. William Clark, however, later assembled some objects in St Louis after his appointment as the first Indian agent for all tribes west of the Mississippi River, but this collection also largely disappeared. The artist George Catlin collected Indian relics which he took to Europe but was forced to sell his acquisitions to Joseph Harrison. These were placed in storage in Philadelphia where some material was lost and damaged in two fires. However, the surviving objects were presented to the U.S. National Museum and remains the largest traceable single collection made before 1850 in the United States.

Other early important collections in the United States include the Nathan Sturgis Jarvis collection, 1833-36, of mostly Eastern Sioux material, now in the Brooklyn Museum, New York, the Colonel Swords material collected at Fort Leavenworth in 1838, housed in the American Museum of Natural History, New York, the Francis Parkman collection in the Peabody Museum, Harvard University, and the Lewis Henry Morgan collection mostly assembled from the Iroquois in 1850 and now in the New York State Museum, Albany. In Canada the artist Paul Kane's collection is in the Manitoba Museum, Winnipeg.

The period 1870-1920 saw wealthy private collectors assemble huge amounts of Indian arts and crafts, some of which became the basis of important museum collections. George Heye, who established his own museum in New York, the Museum of the American Indian Heye Foundation, was probably the most important of these. The contents of his museum were absorbed into the National Museum of the American Indian, Washington D.C. and New York, in the 1990s.

The acquisition of Indian arts and crafts also appealed to amateur enthusiasts who started to analyse tribal variations in the styles of art objects which had become popular during the later part of the nineteenth century and early twentieth century. For a time these were still readily available at very moderate prices. These arts were beadwork, pottery, ribbonwork, metalwork, Navajo textiles, wood carving, and basketry. From this background developed the antique art market for American Indian ethnographic material during the 1970s, and the scholarly and academically trained museum personnel who have subsequently produced an array of technical journals and commentaries. It is from this, a need for an easily readable review of Native American arts and crafts, that the idea for this volume came into being, and as an accompanying volume for *Encyclopaedia of Native Tribes of North America*, a précis of Indian tribal history and native dress.

Readers however should be aware of the horrors visited on Native American communities through the effects of Euro-American colonialism and the resulting wars and diseases which decimated whole populations.

Dubious and illegal trafficking in Indian ethnographic antiquities and the looting of archaeological sites became common and continues today. Indian tribes and nations are demanding restitution of property confiscated or stolen during times past and await federal pronouncements to allow the repatriation of native collections beyond the funerary, religious, and patrimonial objects already allowed. However it is hoped this handbook will provide some knowledge of age and provenance of Indian objects sold legally at auctions and salerooms for collectors who recognise the beauty of such works.

The text is organized into a series of reviews of significant tribal styles of attire, or of Indian arts and crafts in specified areas, generally on an east to west basis. Exceptions include the section on the construction details of moccasins, which considers the continent as a whole.

The descriptions will tend to reflect specific native dress and Indian material which may still be available at sales, auctions, and curio shops, including art objects which were clearly made for sale and are therefore non-controversial. Where there are religious overtones we hope the text will be acceptable. The tribal attributions given in good faith may not always be correct as many objects were traded tribe to tribe, or obtained as gifts or booty taken in battle, or were even the result of out and out copying. Any misinformation and mistakes are purely those of the writer. Readers and prospective art buyers should be very aware of the existence of clever fakes made to deceive for financial gain, while other makers carefully copy items for their beauty, while making no claim that these are Indian-made.

Readers should also note the changes which have occurred to the spelling of various linguistic and tribal groups, also the adoption of alternative names recently derived from tribal dicta. A few are:

Algonkian = Algonquian
Apache = Inde
Athabascan = Athabaskan = Athapaskan
Chipewyan = Chippewyan
Eskimo = Inuit (Canada) = Yupik (Alaska)
Flathead = Salish
Heiltsuk = Bella Bella
Kingcome Inlet Kwakiutl = Tsawataineuk (Dzawada'enuxw) Kwakwaka'wakw (Southern Kwakiutl)
Malecite = Maliseet
Menomini = Menominee
Navajo = Diné
Nuu-chah-nulth (Nootka)
Nuxalk (Bella Coola)
Ojibwa = Chippewa = Ojibwe = Anishinabe
Western Sioux = Teton Sioux = Lakota
Winnebago = Ho-Chunk

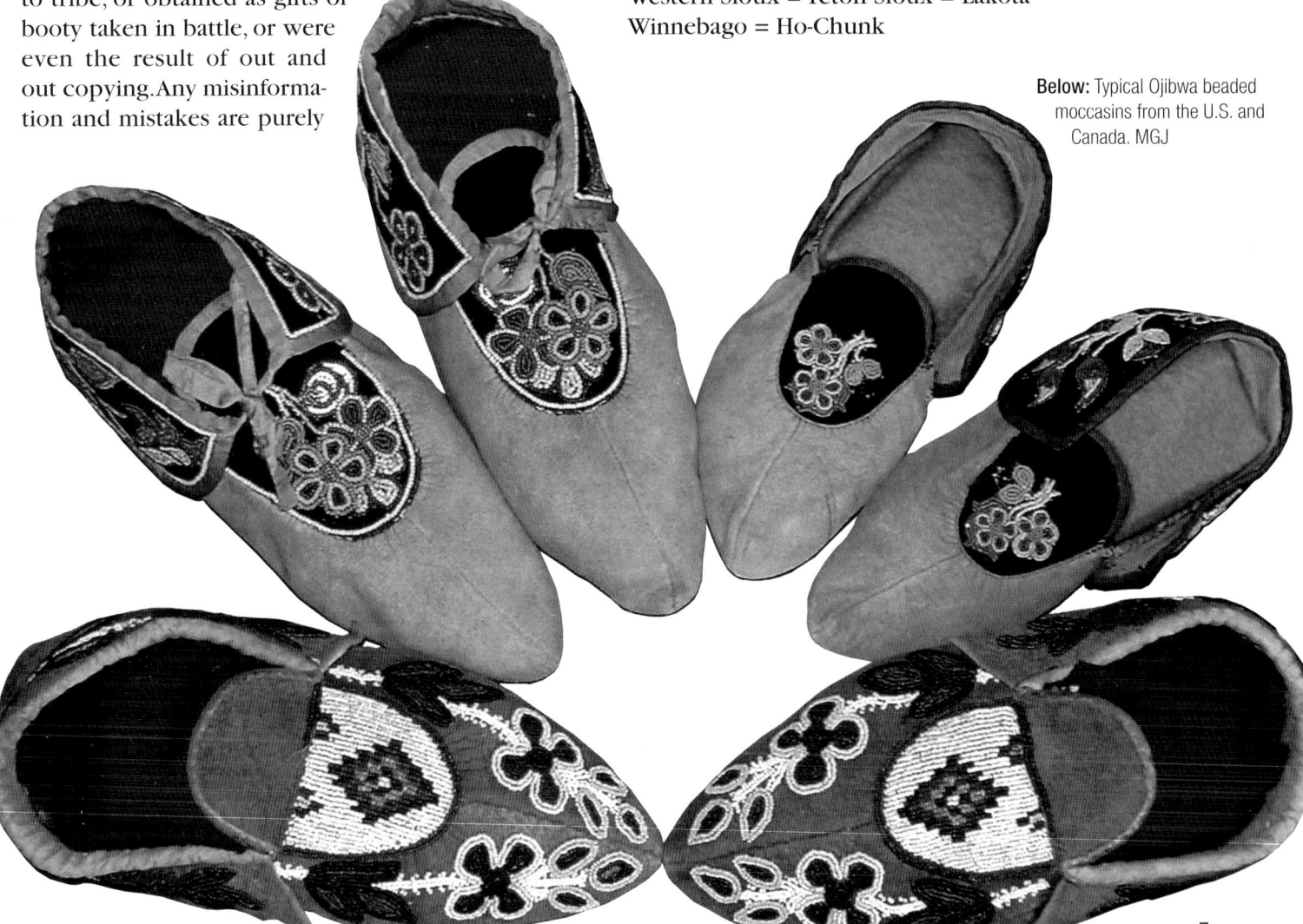

Below: Typical Ojibwa beaded moccasins from the U.S. and Canada. MGJ

Abbreviations for institutions and private collections
In order to save repeating the names of the museums and institutions where many of the images of specimens were taken or provided over the past 40 years we have adopted a system of abbreviations. In brackets are alternative names of institutions, several of which have changed over the years. Names of their staff who gave permission and helped the writer to review and photograph various items from collections are provided, with kind thanks.

American Museum in Britain, Bath, England, William McNaught (**AMB**)

American Museum of Natural History, New York (**AMNH**)

Ashburton Museum, Ashburton, Devon, England, Robert Garner, W.R. Hatch (**AMA**)

Berne Historical Museum, Berne, Switzerland (**BHM**)

Birmingham Art Gallery and Museum, Birmingham, England, Jane Pierson-Jones (**BAM**)

British Museum (Museum of Mankind), London, Jonathan King (**BM**)

Buffalo Bill Historical Center, Cody, Wyoming (**BBHC**)

Canadian Museum of Civilization, Gatineau, Quebec, Canada (National Museum of Man, Ottawa) (**CMC**)

City of Bristol Museum and Art Gallery, Bristol, England, David Dawson (**CBM**)

Denver Art Museum, Denver, Colorado, Norman Feder (**DAM**)

Field Museum of Natural History, Chicago (**FMNH**)

Glenbow Museum, Calgary, Alberta, Canada (Glenbow Foundation), Hugh Dempsey (**GMA**)

Horniman Museum, London (**HM**)

Hudson's Bay Company, Winnipeg, Manitoba (previously London), R.A. Reynolds (**HBC**)

Iroquois Indian Museum, Howes Cave, New York, Christina Johannsen (**IIM**)

John Judkyn Memorial, Freshford Manor, Bath, England, James Ayres (**JJM**)

Lady Lever Museum & Art Gallery, Port Sunlight, England (National Museums, Liverpool) (**LLM**)

Leeds City Museum, Leeds, England, Veronica Johnston (**LM**)

Linden Museum, Stuttgart, Germany (**LMS**)

Lower Fort Garry, National Historic Park, Selkirk, Manitoba, R.G. Orr (**LFG**)

Manchester Museum, University of Manchester, England, George Bankes, Kathleen Hunt (**MM**)

Marischal Museum, University of Aberdeen, Scotland, Charles Hunt (**MMA**)

McCord Museum, McGill University, Montreal, Moira McCaffrey (**McCM**)

Montclair Art Museum, Montclair, New Jersey, Twig Johnson (**MAM**)

Musée du Quai Branly (Musée de L'Homme), Paris (**MH**)

Museum Für Völkerkunde, Berlin, Germany, Horst Hartman (**MFVB**)

Museum of the American Indian, Heye Foundation, New York, New York (now incorporated with the National Museum of the American Indian (**NMAI**)

Museums Sheffield (City of Sheffield Museum, Weston Park), Pauline Beswick (**MS**)

National Museum of Natural History, Smithsonian Institution, Washington D.C., William C. Sturtevant (**NMNH**)

National Museum of the American Indian, Smithsonian Institution, Washington D.C. (**NMAI**)

National Museums of Scotland, Edinburgh (Royal Scottish Museum), Dale Idiens (**NMS**)

National Museums, Liverpool (Merseyside County Museums) (**NML**)

New Brunswick Museum, St John, New Brunswick, Gaby Pelletier (**NBM**)

Northampton Central Museum and Art Gallery, Northampton, England, Miss J.M. Swann, Ruth Thomas (**NCM**)

Nova Scotia Museum, Halifax, Nova Scotia, Ruth Whitehead (**NSM**)

Philbrook Museum of Art, Tulsa, Oklahoma, Christine Knop Kallenberger (**PMA**)

Pitt Rivers Museum, Oxford University, Oxford, Geoffrey Turner (**PRM**)

Royal Albert Memorial Museum, Exeter, England, Miss Susan M. Pearce, Jane Burkinshaw (**RAMM**)

Royal Ontario Museum, Toronto, Ontario, Arni Brownstone (**ROM**)

Saffron Walden Museum, Essex, England, Leonard M. Pole, H.J. Turner (**SWM**)

University Museum of Ethnology and Archaeology, Cambridge, England (University of Cambridge Museum of Archaeology & Anthropology), Peter Gathercole, John Osbourne (**UCMAA**)

Private collections
June Bedford (**JB**), Frank Bergevin (**FB**), Richard Green (**RG**), Richard Hook (**RH**), Michael G. Johnson (**MGJ**), Hew Kennedy (**HK**), Dennis Lyon (**DL**), Will Reid (**WR**), Ben Stone (**BS**), Mark Sykes (**MS**), Colin Taylor (**CT**), Hermann Vonbank (**HV**), Ian West (**IW**), Leo Woods (**LW**)

DECORATIVE MATERIALS

Among the oldest and most common decorative media used by the North American Indians were PORCU-PINE QUILLS. They were usually flattened and boiled soft when applied to anything other than bark, and are smooth with a high gloss. Generally they vary from 2.5 mm to 1.25 mm in width, dyed many colors and used in combinations with their natural white state, rarely split, irregular in size and form, and have characteristically crinkled edges. Most, if not all tribes of the Northeastern Woodlands, Subarctic, and Northern Plains used porcupine quills to decorate ceremonial clothing, and some tribes living beyond the range of the animal's habitat obtained quills via exchange.

BIRD QUILLS were also used often together with porcupine quills. They are smooth, translucent, and were dyed as porcupine quills. As they tend to be flat naturally, they are not flattened in preparation but often split and the edges can be noticeably frayed and uneven. The effect of bird quills is stiffer and more rigid in appearance, and slightly shinier than porcupine quills. Bird quills do not lend themselves to curved designs. They were used by Northern Athabascans, Great Lakes, and Northern Plains Indians but are much less common than porcupine quills.

MOOSEHAIR is generally similar in appearance to porcupine quills, except that it is narrower than the narrowest of quills, about 0.75 mm or less. It was never split, so the edges therefore remained smooth. However, it does have a shiny surface which has mistakenly led many casual examiners to its misidentification as quills. Some creasing may occur at the stitch position, but on the whole the effect has much fewer crinkles and irregularities than quills. Where the cellular medulla show in the cut-off bristle technique, in which the hairs stand up and are chopped off, the color is much paler, and generally has less gloss than in porcupine quills.

Below: The range of the porcupine (pink) over North America.

Right: Headband of skin and quillwork, probably Delaware, eighteenth century. MGJ

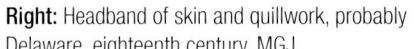

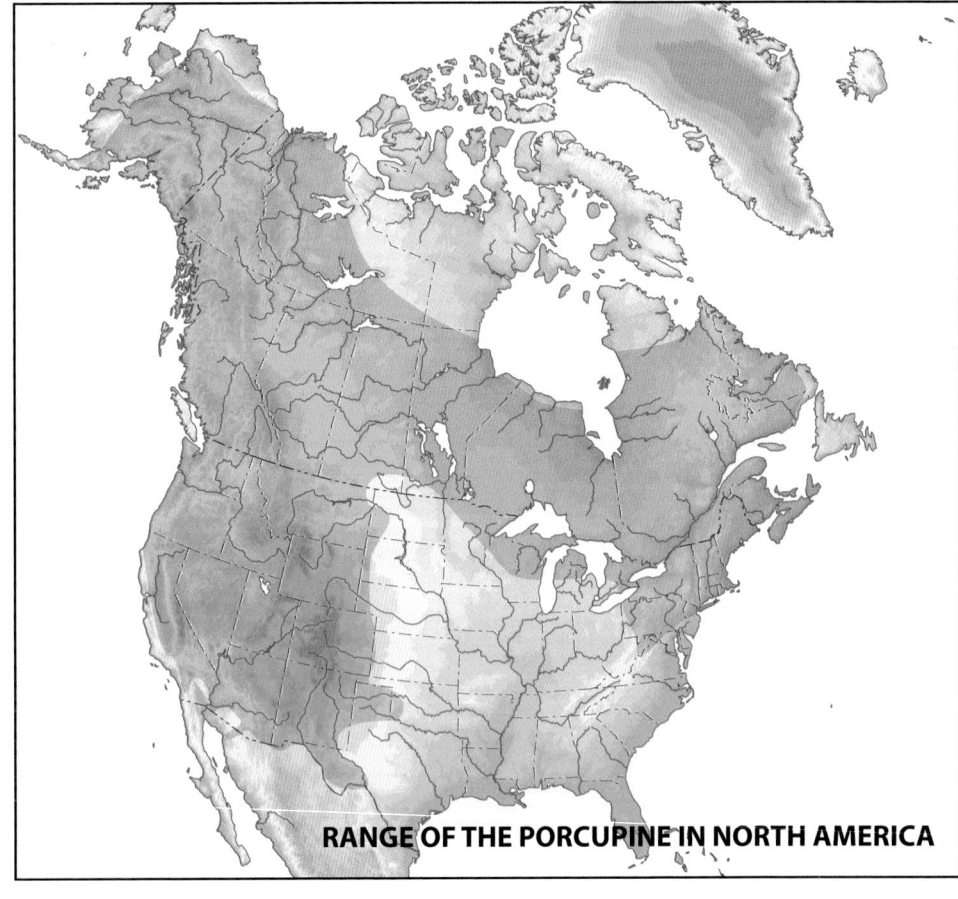

RANGE OF THE PORCUPINE IN NORTH AMERICA

CARIBOU HAIR—also used in the far north—is similar but even less glossy. Moosehair decoration was particularly common among the Huron and Iroquois but less common in surviving museum material from the various Algonkian and Northern Athabascan tribes, although a bristle form was used by some Northern Athabascan groups in fairly recent times. Moosehair was almost unknown on the Plains.

ANIMAL HAIRS generally are probably one of the oldest decorative media known to the American Indian. There were three basic techniques used in aboriginal animal hair decoration of skin objects: sewing down (appliqué), weaving on a loom often in conjunction with porcupine quills such as on Northern Athabascan work, and false embroidery executed on the surface of twined textiles such as Iroquois and Huron burden straps or prisoner ties.

A fourth technique, almost certainly introduced by Quebec nuns in the seventeenth century, which the Hurons at Lorette and French Canadians developed for the souvenir markets, involved true embroidery

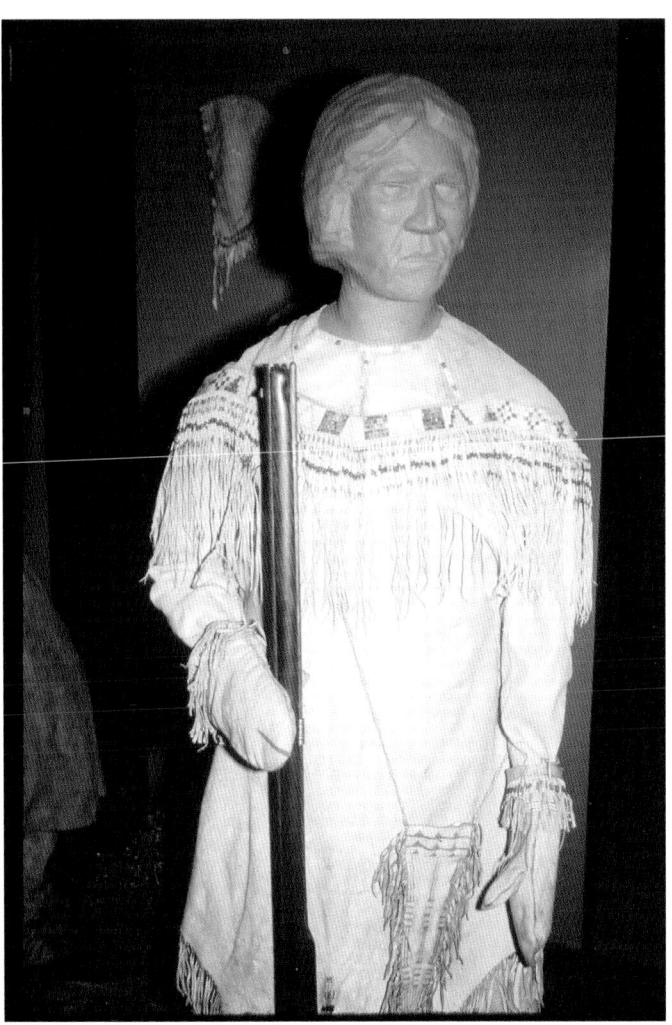

Right: Man's caribou-skin tunic decorated with multicolored porcupine quills and silverberry seeds; note mittens and knife sheath, c. 1850, probably Kutchin, Alaska. HMS

Below: Detail of moosehair embroidery or birchbark, probably a scene. Note the hoods and baby in cradle. Huron of Lorette, Quebec, c. 1850. JB

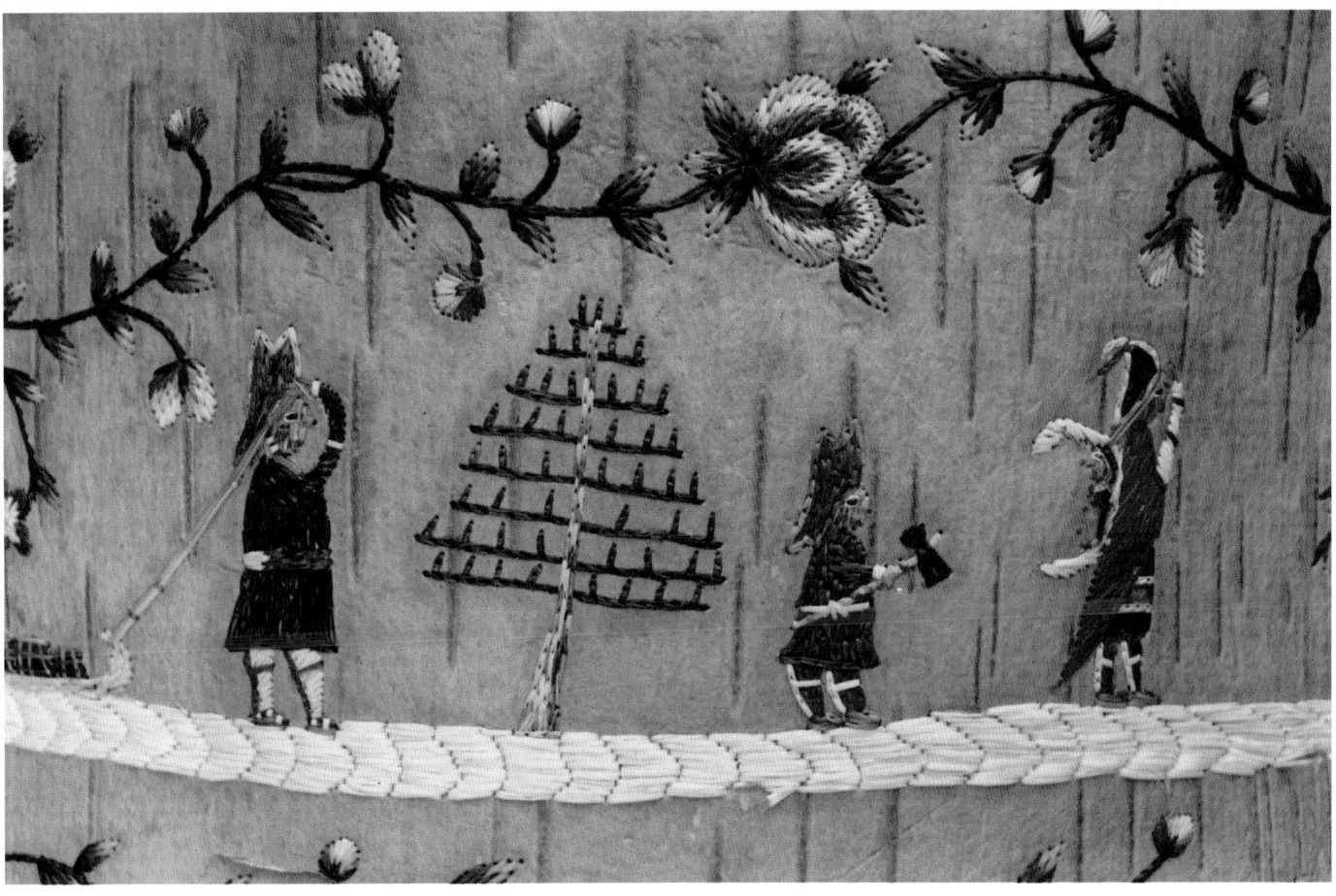

executed with steel needles through which hair was threaded and sewn in and out onto bark or cloth in the same way as European silk embroidery.

CORNHUSKS were occasionally used in a similar way to porcupine quills. The Iroquois made a form of mask and dolls from cornhusks and Plateau tribes dyed cornhusk to decorate twined fiber bags.

SWEETGRASS, commonly used to edge basketry in eastern Canada and the Great Lakes area, is characteristically flat with a matt finish. Other GRASSES, including MAIDENHAIR FERN, were occasionally used in conjunction with quills on some antique northeastern Plains specimens. They usually fade to a brown or black color.

HORSEHAIR, a circular structure element with a high gloss, was used in a coil technique to decorate the junctions of moccasin vamps (instep-tongue) and the bottom unit of Cree, Chipewyan, and other northern moccasin types, and also rarely to thread beads. Feather shafts were also decorated with horsehair-wrapped wooden sticks, usually black and white, by Prairie tribes. Many other natural fibrous materials and hairs such as bison fur were used.

PAINTING, probably the oldest of all decorative techniques, was particularly fine on Nascapi caribou-skin coats where intricate designs traced with a wooden stylus probably represented symbolic animal tracks, canoes, or toboggans, and often involved the so-called double-curve motif. These repeating sets of inward facing motifs in red, blue, yellow, and black are known throughout the Algonkian world. Cree and Northern Ojibwa coats of the late eighteenth century and early nineteenth century had less painting than Nascapi coats and by this time had been influenced in the cut, shape and treatment of the shoulders by white traders. The multi-colored designs were derived from earthen pigments, clay, and berries. Lines, bars, rectangles, circles, and curving and narrow floralistic forms followed the bottom edge, shoulders and front opening of Cree and Northern Ojibwa moosehide coats in black, red, green, light and dark blue, and yellow. The most intricate coats were likely the work of Métis (mixed bloods) and their wives, who often added bands of woven quillwork at the shoulders and disks of sewn quillwork. The Métis, one group of whom were settled in the Red River area of Manitoba, Canada, during the early nineteenth century, probably produced the most baroque forms of skin coats. Painting was also encounted on the sides and ends of Micmac and Abenaki canoes perhaps to provide protection and as hunting aids. A decadent style of dots and circles was added to split wood baskets by New England Indians.

Painting was widely used by Plains Indians for warrior and religious symbolism and used on tipi covers, liners, tribal records (winter counts), men's shirts, robes, and later drawn in sketch books (while warriors were held prisoners)—so-called ledger book art using white man's commercial drawing materials.

Early pictographs show horses conventionalized with long arching necks, small bodies, legs spread to indicate speed; men are drawn in profile view but shoulders broadside, with noses but no mouths, eyes, or hands, featuring elongated upper torsos, straight rigid posture, and costume details stylized in conventionalized patterns rather than realistic ones. Distant objects are placed above or below nearer ones.

Later examples show semi-realistic horses, fully clothed men with refined proportions, and have added details with careful application of color and a general lack of crudeness. The historically late Ghost Dance doctrine evoked a resurgence of symbolic imagery with painted butterflies, dragonflies, birds, stars, moon, and rainbows on women's dresses and men's shirts.

The four sacred Cheyenne colors—red, black, yellow, and white—were identified with the four directions home of the Sacred people Maheyuno placed there by Maheo who filled all creation with life and supernatural power.

Perhaps related to painting was the SCORING OR INCISING OF BIRCHBARK with pictographic designs. Only the outside surface of bark was used for these pictographic purposes but the inner surface when removed from a tree in early spring has a coating which can be removed by scraping, leaving a lighter surface. Among the Algonkians of Quebec bark vessels were decorated with etched or scraped designs of floral and animal images. Incised work was also popular with the Penobscot of Maine for their bark boxes and

Below: Painted spirit figures on a Plains Cree canvas tipi cover. MGJ

canoes, both full-sized and models. In these, as well as many birchbark containers, baskets, and canoes, the edges, sides, and rims were often wrapped with SPRUCE ROOT in various colors, a technique that reappears among the Carrier Indians of the Cordillera area of British Columbia. Spruce root has a very stiff texture.

BITTEN PATTERNS were produced by folding paper-thin birchbark strips several times and using the eye teeth to mark the surface so that, when opened out, these give a symmetrical pattern. Important are designs applied by the Ojibwa to memory charts recording the rituals of the Grand Medicine Society and related migration charts. Incising and carving were also frequently used to record war exploits or religious symbolism on gunstock and ball headed clubs, grave markers, Midewiwin drums, and cradle boards.

SILK floss or thread and wool were also added to the range of Indian decorative material by white traders, although their use is patchy. The Tête de Boule (Atti-kamek) of Quebec used silk thread to embroider moccasins and the Cree and Northern Athabascans produced fine work on moosehide coats, pouches, and moccasins, although the use of this material is often associated with the Métis peoples. Silk embroidery also turns up on Cherokee coats and leggings of the nineteenth century. WOOL was used for pompoms and fringing, and has been found on Plateau men's shirt strips to augment quill wrapped horsehair, and today is widely used for men's dance costumes.

RIBBONWORK was produced by two or

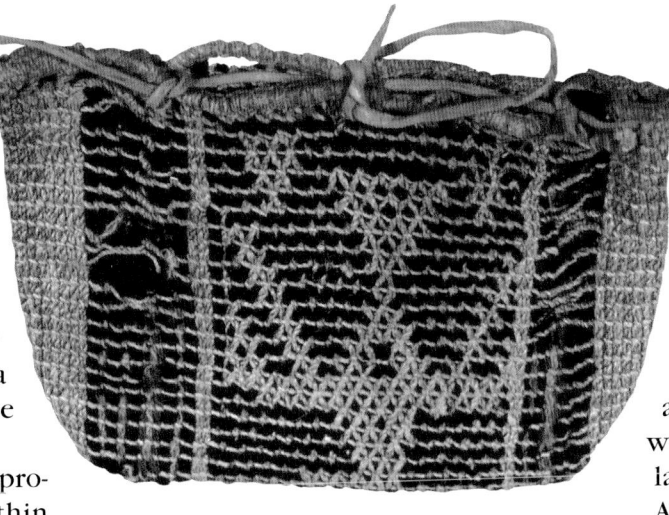

Above: Yarn and fiber bag, Sauk (Sac) and Fox, c. midnineteenth century with thunderbird designs. Collected in Oklahoma. MGJ

Below: Red trade cloth man's legging, Micmac (Mi'kmaq) c. 1825, with ribbonwork borders and beadwork. NBM

more pieces of ribbon in contrasting dark and light colors with one ribbon placed or cut in patterns and sewn over another. The craft apparently originated in Nova Scotia among the Micmac spreading to New England, Great Lakes, and the Cree, although its production was limited. It flourished later among the southern Algonkians, Prairietribes, and Oklahoma Indians during the nineteenth century, particularly Potawatomi, Kickapoo, Miami, Shawnee, Sac, Fox, Menominee, Eastern Sioux, and ultimately spread to the Omaha, Pawnee, Kaw, Oto, Ponca, Quapaw, and Osage. It was also known to the Creek Indians of the Southeast and was perhaps the genesis of the so-called PATCHWORK of the Seminole Indians of Florida in which small pieces of cloth are sewn with sewing machines (after c. 1900) in squares, blocks, and triangles to decorate women's skirts and men's coats and jackets. Originally silk ribbons were used but later rayon and today other manmade materials are used for ribbonwork on dancers' dress.

The arrival of GLASS BEADS from white traders had a huge impact on Native American art. Glass beads were probably being made in ancient Egypt at least as early as 1364 BC, and were later made by the Romans and throughout medieval Europe. We know Columbus carried beads as part of his cargo in 1492 and seed beads have been found in early historic archaeological sites as far west as the Plains. Large beads suitable for necklaces were being distributed by fur traders by the seventeenth century, replacing native beads of shell, bone, copper, and seeds. Most beads used were produced in the factories of Murano in Venice and hence called Italian beads. They were made in many sizes and shapes, and could be plain or in many colors. Bohemian, and after 1919 Czech, beads were also made for the Indian trade and are slightly larger on average and more even in color and shape than Italian beads. They became increasingly popular after about 1870. During recent years beads from many countries with brighter colors have been widely used by beadworkers.

For embroidery the small "seed" bead, particularly Italian beads, were popular with the Woodland tribes from the late seventeenth century on. However, the Plains tribes seem to have preferred the larger so-called pony or pound beads in the period 1800–50, after which they too used seed beads almost exclusively to produce mosaic surfaces for decorating men's and

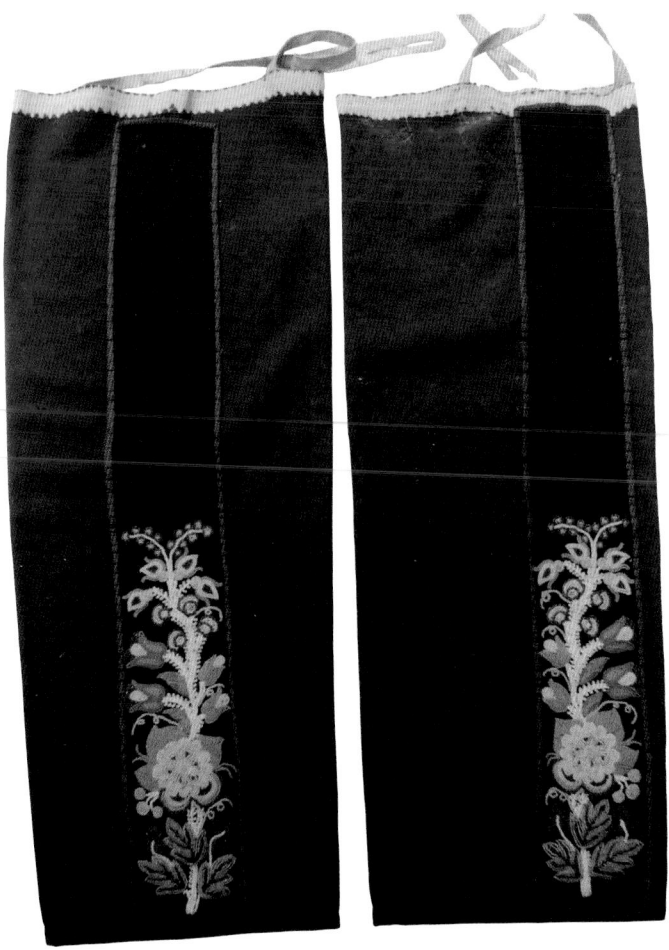

North American continent. There were many different styles and several techniques of application, but three forms stand out. The first, the so-called spot-stitch or overlay-stitch method, used two threads (sinew, cotton, or both), one to string the beads, the other to couch down on skin or cloth. The second form known as lazy-stitch or lane-stitch, consisted of lanes of eight to ten or so seed beads sewn in ridges to cover large areas of skin. The third technique is weaving, which probably descends from both woven quillwork and European weaving, and employed a wooden loom with fixed ends and weft and warp threads, originally of sinew and later cotton, sometimes on a movable heddle.

Most of the animal skins used for clothing came from members of the deer family such as the white-tailed deer and mule deer. Pronghorn antelope (strictly neither an antelope nor deer) was widely used by Plains Indians and is the true "buckskin." Elk and bighorn sheep were commonly used on the Plateau and in the Rocky Mountain areas while moose was much used by the Algonkians such as the Cree. Caribou was used in the subarctic by Nascapi and Athabascan peoples. Grizzly bear (also prized for its claws) and black and brown bear skins were used as robes. Bison (often called buffalo) hides were used for robes and tipi covers. They once had a range from almost the Atlantic to the Pacific, but were largely reduced to the Plains by the nineteenth century, when they were hunted near to extinction by

Above: Blue stroud cloth leggings, probably women's, with strips of black cloth decorated with floral beadwork, probably Cree or Cree-Métis mid-nineteenth. MGJ

Right: Plateau "flat bag," probably Nez Perce, c. 1900, made of leather and cloth with typical bold geometric-patterned beadwork. MGJ

women's ceremonial dress and for moccasins, pouches, bags, horsegear, saddle bags, and cradles.

Pony beads (0.35–0.4 cm in diameter) had a limited color range with blue particularly popular, but red, white, black, and yellow were widely used. Seed beads (0.1–0.3 cm diam.) have a huge range of colors and include faceted types popular with Southern Plains tribes. Other beads with popular identifying names are large Crow beads, faceted large tubular bugle and Russian beads, multi-patterned chevron beads, brass beads, and faceted basket beads. Metallic faceted beads (0.1 cm diam.) were used around 1880–1900.

Beadwork and quillwork was stitched and sewn with sinew to skin or cloth but increasingly among the Woodland people with cotton thread. Some Plains tribes, particularly the Sioux, continued to use sinew for beadwork until recent times.

Beadwork was produced in most regions of the

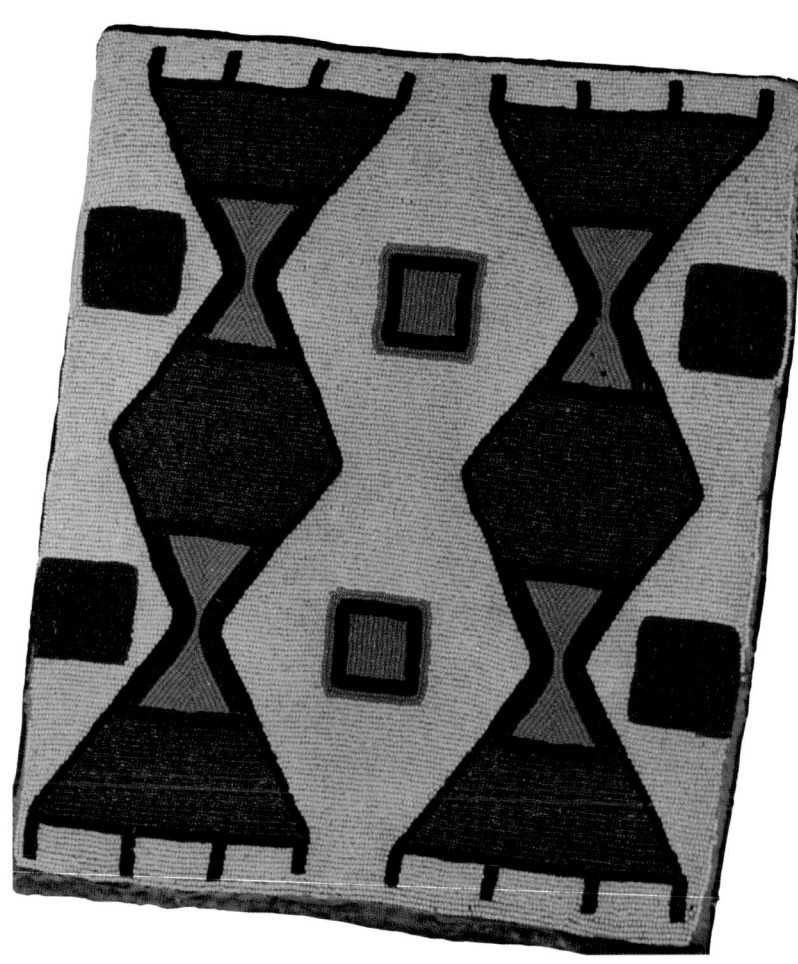

Right: Woven yarn bag, Ojibwa, c. 1900. Such bags were originally of braided or twined woven nettlestalk fiber, bark fiber, and animal hair but replaced by commercial yarns, sometimes in combination with native materials. Designs include conventionalized real or mythological animals. MGJ

Below: Dog blanket, Northern Athabascan, probably Slavey, Great Slave Lake area, c. 1900. McCM

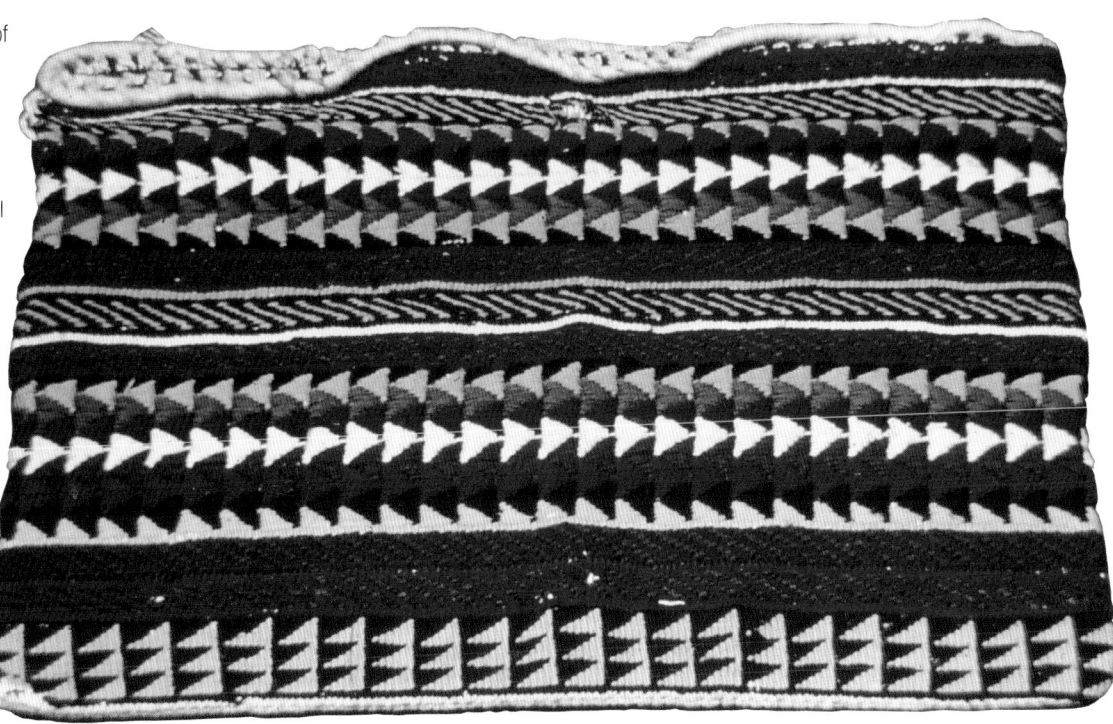

both whites and Indians. A northern sub-species, the Wood Buffalo, was found in northwestern Canada. Hides of other animals also used for decorations and robes included rabbit, hare, mountain goat, marten, mink, fox, beaver, raccoon, lynx, wolf, cougar (mountain lion), seal, otter and weasel (ermine). Feathers used for adornment and ceremony included golden and bald eagle, owl, various hawks, duck, goose, turkey, domestic chicken, magpie, parrot, jay, bluebird, hummingbird, oriole, roadrunner, and others. Various woods were used, along with the bark of the birch, elm, cherry, spruce, and red and yellow cedar, also bone of various animals, walrus ivory, numerous shells, horn, stone, basalt, argillite, and soapstone. However, it is the unique and colorful use of porcupine quills, caribou, and moosehair and their substitution with European glass beads which has been so appealing to American and European collectors.

In common with the Indians in the eastern part of the continent, the Northwest Coastal peoples were also ravaged by European diseases after contact with Russian, Spanish, British, and American traders from the sea and land during the eighteenth and nineteenth centuries. Some authorities have played down the consequences of the fur trade, claiming that Indian society was enriched materially from European contact, but the huge reduction in native population suggests otherwise. The principal material for their houses and totemic art was provided by the red cedar. Houses in the north were fashioned from timbers and planks, and huge dugout canoes were made from massive trunks. Impressive totem poles were also made from cedar. However their excessive heights and carved forms, possibly developed from earlier house posts, were facilitated through the use of imported European metal tools. Also in the north ceremonial robes, called "Chilkat" blankets, made of mountain-goat wool were widely traded by the Tlingit people. Baskets were made of twined and woven cedar splints and spruce root, and these were mixed with other grasses or goat wool for robes, capes, hats, and mats. Cedar was also used for containers, boxes,

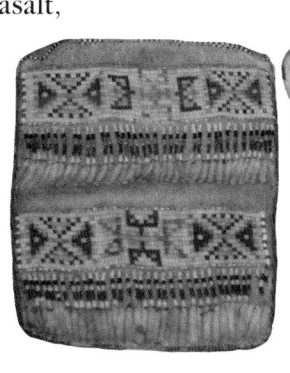

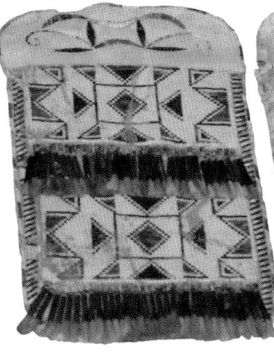

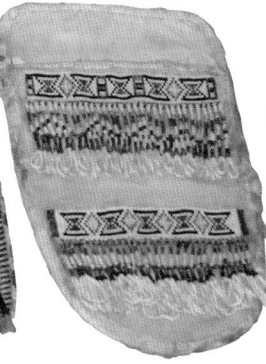

Left: Three Subarctic skin pouches, Westmain/ Swampy Cree, early nineteenth century, with horizontal bands of woven porcupine quillwork in geometric designs. BM

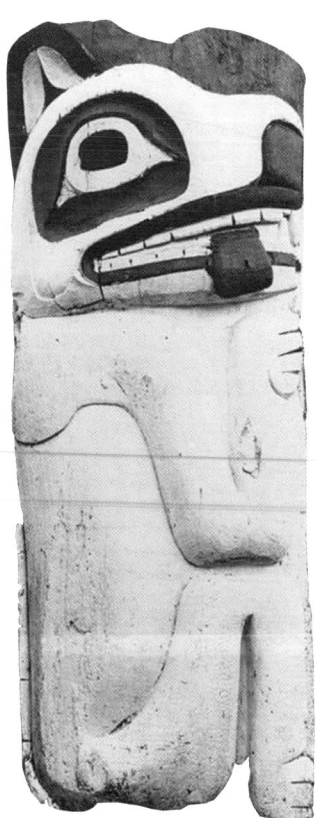

Left: A Tired Wolf house post as seen in 1915. It was estimated by the Alaska Heritage Resource Survey in 1977 that they were carved in about 1827. Originally installed at a house on Kanagunut Island, they were later moved to a new house on Tongass Island. When Tongass was deserted, the posts were taken to Pennock Island, where they marked the grave of Tongass George. They were repaired and set up in their present location in Ketchikan in 1939. LoC

Right: A Klamath basket with a polychrome design, circa late nineteenth or early twentieth century. SFSU

Below: Moose-foot wall pocket, Huron of Lorette, Quebec, c. 1860, with panels of moosehair embroidered cloth decoration. MGJ

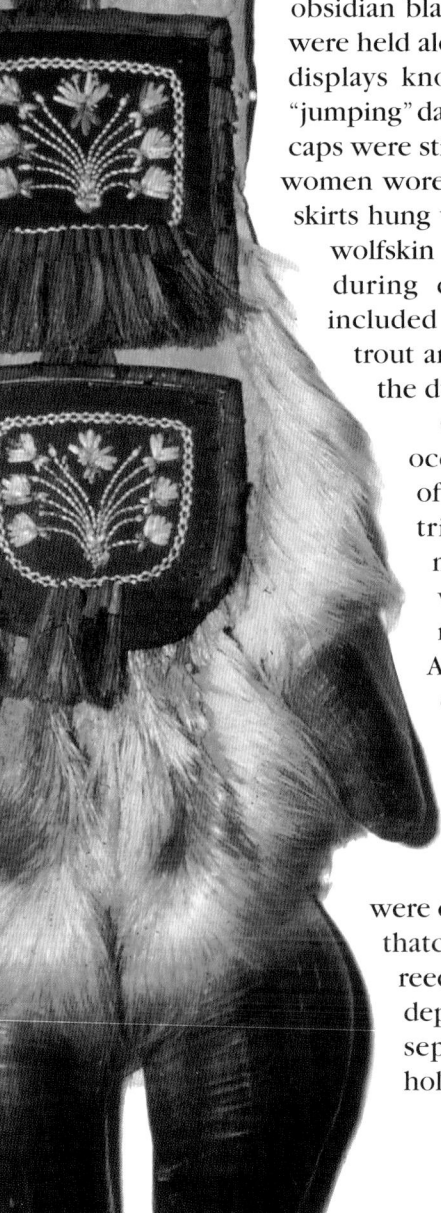

rattles and the elaborately carved masks. Totemic art can be divided into two major areas, in the north by the Tlingit, Haida, and Tsimishian and in the south by the Kwakiult and Nootka. This art includes endless expressive figures of the wolf, whale, octopus, beaver, and eagle. Subsistence was provided by the sea and rivers. Fish—halibut, salmon, and shellfish—provided the bulk of the aboriginal diet along with edible plants, berries, and roots. Their subsistence culture was wholly dependent on wild foods but their sedentary life was ruled by class privileges and complex social obligations. When food and goods were accumulated the rich would give away possessions in public during "potlatch" ceremonies.

Ceremonial dress con-sisted of cedar-bark head rings, carved headdresses with sea lion whiskers, cloaks, skin breechcloths, leggings, and tunics. Faces were often tattooed. In the south the Nootka and the various Salishan groups had a less elaborate art and subsistence resources included seal and whale hunting. Salish trade-cloth shirts were decorated with wooden pendants and beadwork, and women wore aprons of grass, tule rush or bark. Trade-cloth blankets of dark blue or red were embellished with heraldic animals outlined in pearl buttons. These were called "button blankets" and became favorites for trade or formal gifts.

This coastal culture extended through to northern California where part-subterranean houses of cedar planks with pitched roofs provided shelter. Here the Hupa, Karok, and Yurok continued the cult of wealth by massing huge amounts of dentalium shells and obsidian blades. Heads of albino deer were held aloft on poles during wealth displays known as the "deerskin" or "jumping" dances. Tattooing and basket caps were still used as in the north and women wore fringed wraparound skin skirts hung with nut shells. Men wore wolfskin crowns and buckskin kilts during ceremonies. Subsistence included acorns, venison, salmon, trout and lampreys. Canoes were the dugout type.

Central California was occupied by a large number of small linguistically diverse tribelets. In the mild climate, little clothing was worn except for robes of rabbitskin and sea otter. A wide range of foods was eaten—fruits, nuts, roots, and acorns, together with deer, fish, and other produce of the sea. Common house types for central California were conical and domed bark or thatched dwellings of grass or reed with a floor dug out to a depth of about two feet, with separate doors and smoke-holes. Pomo women stand out

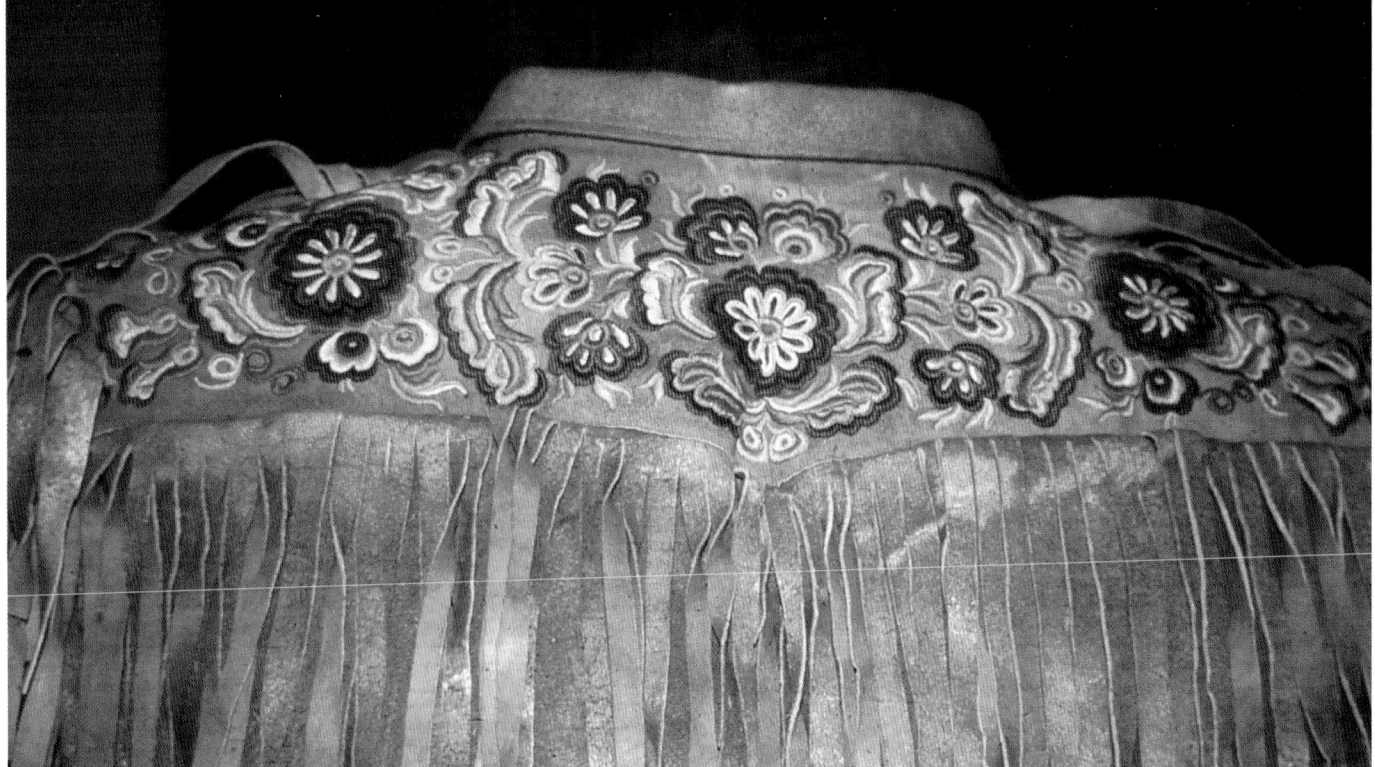

Above: Caribou and moosehide shoulder of a jacket with silk embroidery, Norway House Cree, c. 1900. MGJ

as highly skilled basket makers using both twining and coiling techniques, sometimes with shell disks or small feathers of the hummingbird or woodpecker attached. Many baskets were made expressly for cremation with the dead. Alone among all the Indians of North America the Chumash built seagoing boats of planks, caulked and sealed with asphalt; elsewhere reed balsas or rafts were the usual watercraft. Southern Californian craft objects included simple pots, bowls, pipes, and baskets.

The Indians of the Plateau were also largely dependent on wild foods, with roots such as camas taking the place of acorns as a staple plant food. Camas was boiled, roasted, or made into cakes. Transport was provided by dugouts or by a "sturgeon-nosed" spruce bark canoe among the Kutenai and some Salishan tribes. Bark utensils and fine-coiled cedar and root baskets were particularly noteworthy. These were decorated with colored grass or cherry bark imbrication. The Plateau area had already been affected by outside influences by the time of the earliest European explorers; preoccupation with wealth and social divisions had arrived from the west coast via Chinook intermediaries and in the eastern half of the area a veneer of Plains culture arrived following the spread of the horse into the Plateau area early in the eighteenth century. Skin tipis replaced brush-covered lodges, and skin shirts and dresses were decorated with beadwork with reciprocated techniques. A breed of horse, the Appaloosa, became the speciality of the Nez Perce and neighboring tribes—its genetic heritage had found its way from China to Europe, and thence to Mexico and the American Plateau.

Perhaps the simplest culture on the continent was that of the area known as the Great Basin, a huge arid region lying between the Rocky Mountains and the Sierra Nevada and home of the Paiute, Chemehuevi, Mono, and Washo. Small bands hunted rabbit and antelope while women scrabbled for edible roots, seeds, and nuts, importantly piñon (pine nut). Clothing was basic or non-existent; in winter rabbit robes, some moccasins, buckskin dresses, and simple shirts were worn. Fine basketry dominated their material culture.

Southwestern culture arose in the least fertile area of the continent south of the Subarctic and produced the only purely crop-dependent civilizations north of Mexico. The Spanish arriving from Mexico were the first white explorers of the American Southwest and used their own word "pueblo" to describe the permanent villages of adobe and stone they found along the Rio Grande in New Mexico and on the mesas of Arizona. This lifestyle probably descended from the Anasazi Culture (250 B.C.–A.D. 700) and so-called Basketmaker cultures.

The Pueblo people spoke several languages and many dialects. They made their own clothing from cotton and grew their own foods; they excelled in pottery and basketry. They had more than forty styles of pottery, including polished black ware from their northern villages, black and cream (Santo Domingo), three-colored pottery with birds and animals (Zia and Acoma), and black on mottled orange (Hopi). Vertical looms were in use by A.D. 1000, first weaving using animal and vegetal fibers then cotton. After the Spanish invasion they began to use sheep wool. Men's clothing consisted of breechcloths, kilts, and fur robes; women's consisted of a rectangular "manta" folded under the left arm and pinned under the right shoulder. Shawls were worn by unmarried girls.

The Navajo copied Pueblo weaving, first for dresses and blankets, using simple designs and somber colors from natural dyes. After 1860 they began to use commercial yarns and unraveled cloth (bayeta). After 890–1900 the Navajo made the larger rugs in various

designs encouraged by traders for the tourist markets and indentified with various parts of the huge Navajo Reservation. The Navajo began to copy Mexican silverwork techniques about 1860, using hammered or melted-down and cast Mexican silver pesos. First they made bracelets and earrings then gradually moved into more elaborate jewelry, such as squash blossom necklaces using pomegranate and Moorish crescent designs, and "ketoh" bracelets based on bow guards. The Pueblo peoples, including the Zuni, learned silverwork from the Navajo about 1870 and recently have lavishly decorated their work with turquoise. The Hopi also began the craft about 1900 and their work is noticeably more simple in design. Pueblo baskets were common in early days but only among the Hopi are they made today. Usually of flat-coiled yucca, they are dyed in bright colors. Apache baskets are willow coiled around three small rods, sometimes in bowl shapes, and large storage jars with figures of men and dogs and whirling patterns. The Havasupai, Yavapai, Walapai, Pima, and Papago all made coiled or twined baskets and still do.

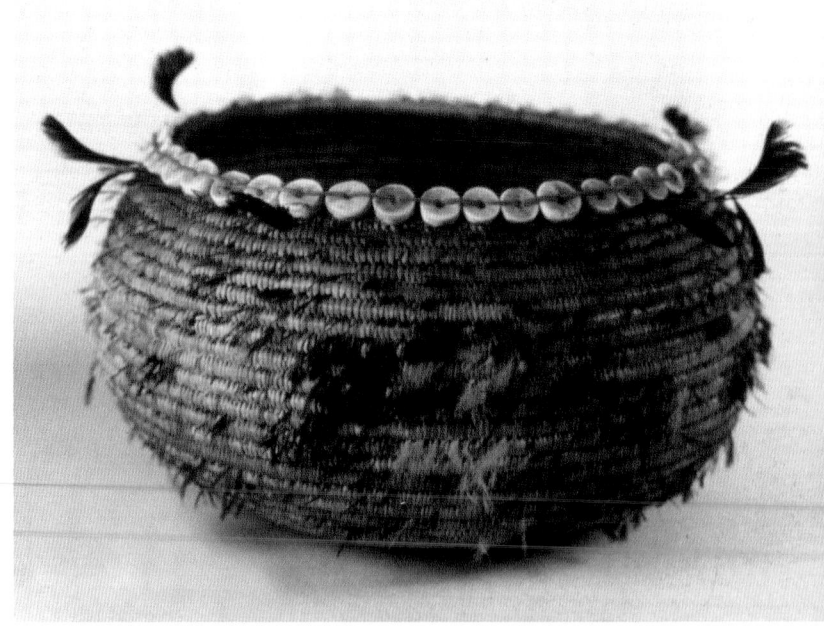

Below: Navajo woman weaving a rug or blanket, c. 1910. Made on a simple vertical loom and as a result patterns tend to be horizontal, striped, or geometric. This is part of a long tradition of southwestern textile weaving at first of cotton and later of wool (the Spanish introduced sheep). The Navajo probably learned the art from the Pueblos. A major difference between the Pueblos and the Navajo is that among the Navajo the women are the weavers. Early Navajo weaving was for clothing, blankets, and serapes. About 1890, influenced by American traders, they switched to rugs with ever-increasingly complex designs. Approximately twelve different styles of rugs are still made on the Navajo Reservation. LoC

Above: A Pomo basket decorated with feathers and dentalium shells, circa late nineteenth or early twentieth century. SFSU

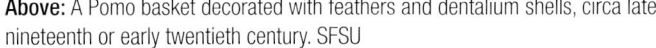

Map labels (Algonkian shaded area):
Micmac, Huron of Lorette, Malecite, Ojibwa, Abitibi, Mattagami, Timiskaming, Manouane, Nipigon, Timagami, Penobscot, Passamaquoddy, Micmac, Michipicoten, Dokis, Nipissing, Algonkin, Maniwaki, Ojibwa, Eastern Ojibwa, Golden Lake, Eastern Abenaki, Southern Ojibwa or Chippewa, Mississauga, Western Abenaki, Petun or Tobacco Nation, Mohawk, Pennacook, Pocumtuc, Massachusett, Menomini, Ottawa, Huron, Iroquois, Oneida, Onondaga, Nipmuc, Nauset, Wampanoag, Winnebago, Sauk, Wenro, Neutral, Cayuga, Tuscarora (18th C.), Mahican, Wappinger, Paugusset, Narragansett, Pokanoke, Fox, Mascouten, Seneca, Erie, Munsee, Rockaway, E. Niantic, W. Niantic, Kickapoo, Kaskaskia, Wyandot (18th C.), Mingo, Delaware, Montauk, Shinnecock, Poosepatuck, 'Metoac', Potawatomi, Miami, Wea, Piankashaw, Mosopelea, Delaware, Unami, Piscataway, Nanticoke, Moingwena, Illini, Tamaroa, Cahokia, Michigamea, Peoria, Shawnee, Powhatan, Susquehannock, Conoy, Nottoway, Meherrin, Weapemeoc, Chowanoc, Roanoke, Tuscarora, Pamlico, Secotan, Bear River, Neosiok, Machapunga, Hatteras

Chickahominy, Mattaponi, Nansemond, Pamunkey, Potomac, Rappahannock

INDIAN TRIBES OF THE NORTHEASTERN WOODLANDS
Key to linguistic families

Algonkian
Iroquoian
Siouan

NORTHERN WOODLAND TRADITIONS

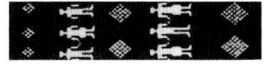

All the Algonkian people north of a line roughly joining Nemaska (James Bay) and Tadoussac of the Quebec–Labrador Peninsula have been designated as either Nascapi or Montagnais. This has been based at various periods upon the study of language (combining Nascapi, Montagnais, and East Cree) or upon a geographical or territorial distribution, Nascapi in the north and in Labrador, Montagnais along the southern coast, and Cree on the east side of James Bay, regardless of the time period concerned. Various observers have contrasted Nascapi with Montagnais based upon a dichotomy of tundra versus forest, inland versus coast, caribou hide technology versus moose and birchbark technology. More recently the divisions have also been based upon the self designations "Innu" or "Cree" by the native people themselves.

The difficulties of providing acceptable nomenclature for people scattered over immense areas without any political cohesion but clearly with some linguistic, cultural, or historical connections, is a problem found in all areas of North America. Thus the terms "tribe" or "nation" are almost impossible to define in any standard form, so we are left with the names history has provided or the new names Indian descendants are using for themselves. Some Northeastern Indians have had a long period of European contact and influence which has resulted in their nineteenth-century arts and crafts giving little indication of their earlier forms and clothing styles. The destruction of many eastern coastal people during the colonial period and their absorption by the interior tribes, and the widespread adoption of white captives from New England and New France has resulted in a very mixed gene pool. Many tribes were geographically repositioned, moving west ahead of white expansion. The result of this tribal and racial mixture has given a hybrid feel to much of the art objects and clothing which have survived in museum collections. Well before the end of the seventeenth century,

cloth, beads, silver, axes, trade tomahawks, and threads of European flax and wool had reached the Indian villages from the Atlantic coast to the Mississippi River.

In prehistoric times we know that man lived on the edge of the glacial pack 10,000 years ago in the vicinity of Chicago and since that period we have a changing land of ice, water, tundra, and forests, both evergreen and deciduous, of birch, elm, dogwood, oak, hickory, southern pine, and mountain ash through to mangrove swamp. About 2000 B.C. the first influences from Central America arrived in the Midwest. The Burial Mound period, noted for the flexed position of the dead in both natural and man-made mounds in Ohio and Kentucky, also saw the use of domesticated plants, squashes, pumpkins, and crude pottery, (Adena Culture 800 B.C.–A.D. 100). The Hopewell Culture (100 B.C.–A.D. 500) saw the culmination of burial ceremonialism, finer pottery, stone carving, and art forms of birds, animals, and humans in clay, mica, and shell. Later (A.D. 700–1600) the Mississippian Culture or Temple Mound Culture flourished, characterized by intensive corn agriculture and flat-topped pyramid mounds (Cahokia). The northern offshoot of this culture, a provincial Mississippian influence, is the Woodland pattern which had several "phases" typified by Iroquoian Culture with a northern limit of extensive agriculture in southern Ontario (Huron). Generally, however, the Woodland

people were hunters, fishers, and gatherers with less reliance on farming by the more northerly tribes.

Wood and bark were the most important materials to the northern forest Indian. Bark canoes were made in a range from the Atlantic coast to Alaska and most tribes had their own distinctive profile. Birchbark was used by various Algonkian tribes while elm bark was used by the Iroquois. Outside the areas where good quality bark was found dugout canoes were made. Wood was the basic material for both permanent and temporary dwellings, for snowshoes, toboggans, bows, arrows, clubs, baskets, cradleboards, oval or truncated containers, spoons, bowls, pestles and mortars, drums, and ball-game rackets. Similar to canoes, the snowshoe had various tribal and functional shapes with symbolic designs added to the babiche (webbing) to enlist the animal spirits for help in hunting. In the far north, Subarctic people transported goods on snow and ice by hand drawn toboggans, but after white contact improved dog breeding allowed sleds with raised runners to be pulled by large dog teams. Summer travel was usually by foot or bark covered canoes stitched to a spruce and cedar wood frame and sealed with spruce gum. The Micmac and Penobscot often painted their canoes on the prow and stern with hunting aid symbols and traditional designs. Wigwams were covered with bark sewn to a sapling frame with spruce roots. South of the birch area, woven mats of reeds replaced bark. Of the animals which provided clothing, caribou was much used by the Nascapi of Quebec and Labrador, also by the Northern Athabascan people of the Subarctic, elk was commonly used by Woodland and northwestern

Below, left and right: Sketches by Dave Sagar from native engravings at Spiro Mound, Oklahoma, showing men of the Mississippian culture.

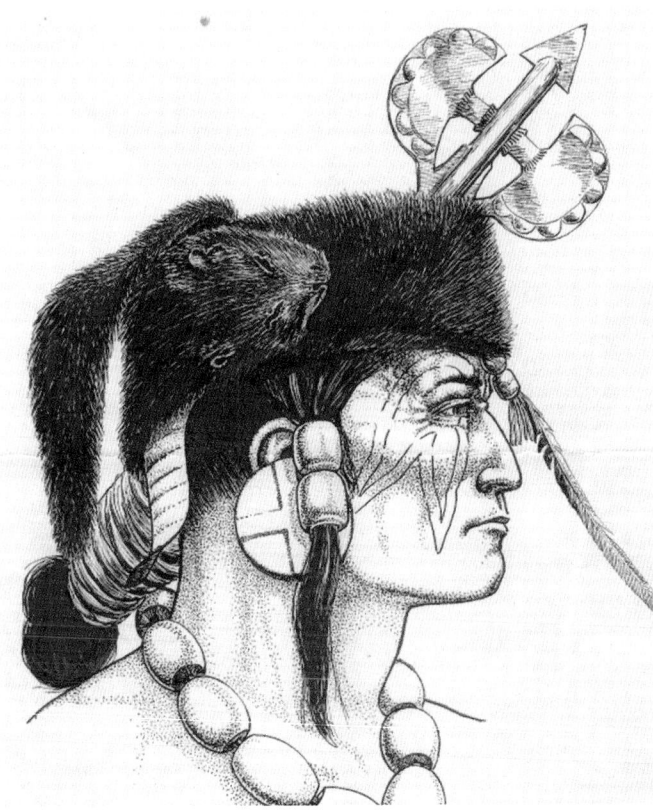

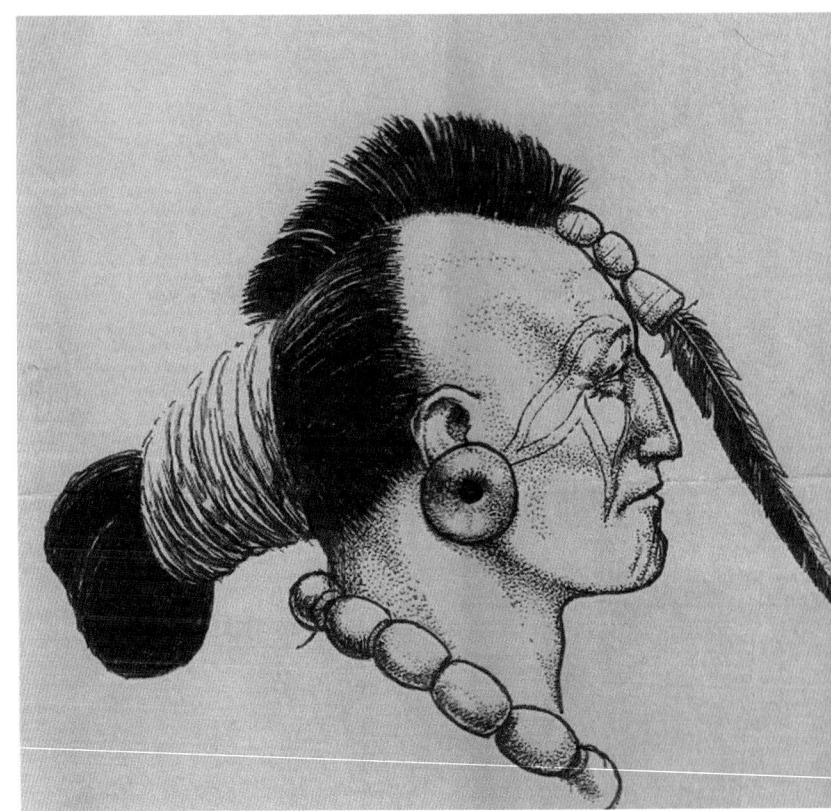

SNOW SHOES

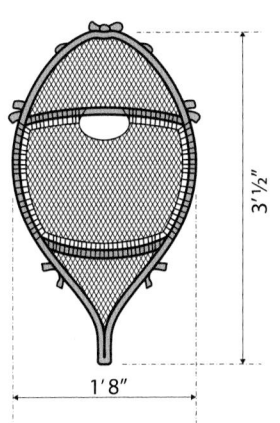

3'½"
1'8"

**MONTAGNAIS – NASCAPI
DOUBLE BAR 'SWALLOW TAIL' TYPE**

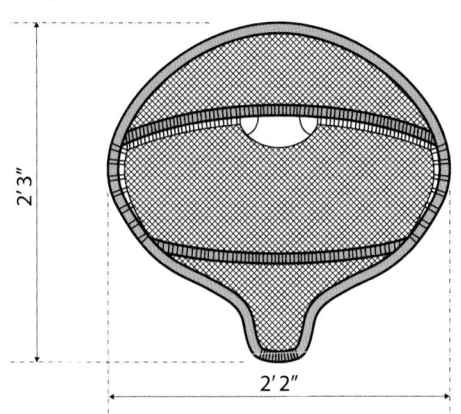

2'3"
2'2"

**MONTAGNAIS – NASCAPI DOUBLE BAR
'BEAVER TAIL' TYPE**

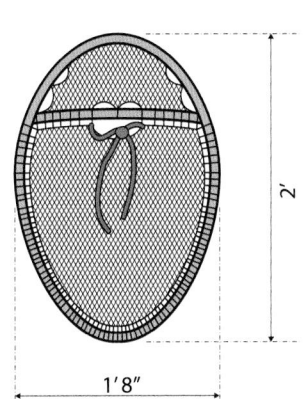

2'
1'8"

**MONTAGNAIS – NASCAPI
SINGLE BAR OVAL TYPE**

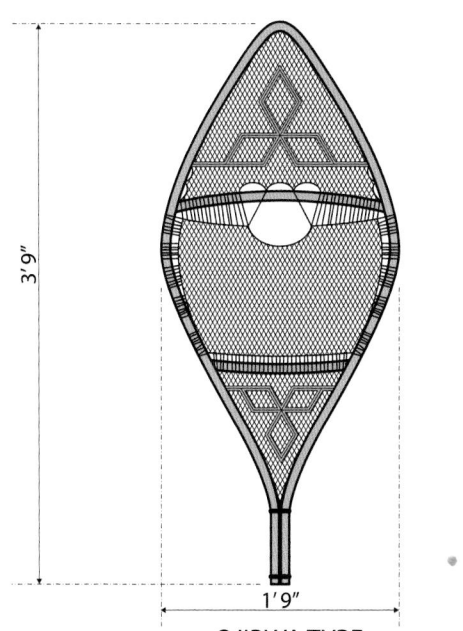

3'9"
1'9"

**OJIBWA TYPE
WITH SYMBOLIC DESIGNS
ADDED TO THE BABICHE (WEBBING)**

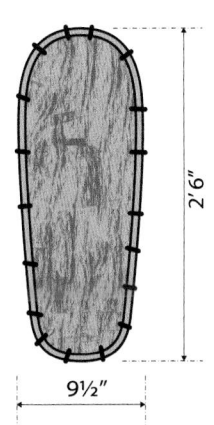

2'6"
9½"

**IROQUOIS TEMPORARY TYPE
BARK SLAB WITH WILLOW FRAME**

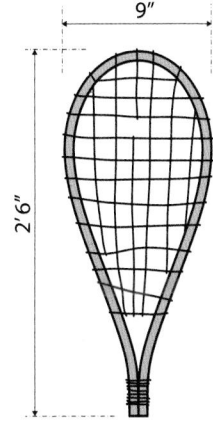

9"
2'6"

**IROQUOIS TEMPORARY TYPE
SAPLING FRAME TWIG NETTING**

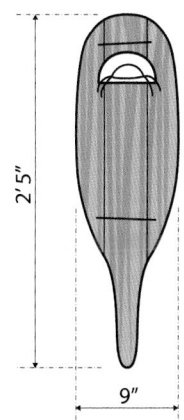

2'5"
9"

**ALGONKIN TEMPORARY TYPE
MADE FROM SPRUCE BOARD
SEWN TOGETHER WITH HIDE THONGS**

Plains tribes, moose, which had a wide range from Maine though most of Canada, was often the basic hide used for clothing by the Cree, Chipewyan, and other central Canadian Indians, and also supplied the hair from neck and belly used in the decoration of various craft objects. Bison-hide iconography and artifacts commonly associated with the Plains Indians were also used by Woodland people—a few eighteenth-century painted robes of supposed Illinois provenance are still extant. The plants and roots used to color or dye quills or animal hair for the decoration of clothing and ceremonial objects included puccoon for red, bloodroot for plum, red osier dogwood for bright red, bur oak, butternut, earth, and ochre for black, walnut also black, yellow derived from alder and sumac, bright yellow from goldthread, and blue from berries, maple and grapes.

Among the Maritime Micmac there is a tradition of a one-piece man's skin shirt or tunic and a woman's dress of moose hide or caribou large enough to encircle the human body. This type of clothing links the Micmac with their northern distant relatives, the Montagnais and Nascapi of Quebec, Subarctic peoples. Later open-fronted skin or trade-cloth coats cut in European style were worn by men, decorated with beadwork. Early reports indicate bear, walrus, seal, and other animal skins were used for clothes with representations of magical designs of animals in ritual colors of red, white, black, and yellow.

The Iroquois or Five Nations were descended from the Woodland tradition and were a political league welded together from the Mohawk, Onondaga, Oneida, Cayuga and Seneca with the Tuscarora added later as a sixth nation. The range of Iroquois agricultural produce was impressive— hominy, succotash, many varieties of beans, blackberries, blueberries, cran- berries, and others. The process of planting, cultivating, and harvesting corn was carried out by women, and the ceremonial spirits of corn, beans, and squash were the revered life-supporting "Three Sisters." Iroquois religious life centered around the cycle of the agricultural calendar. There were festivals and a series of curative medicine societies, the

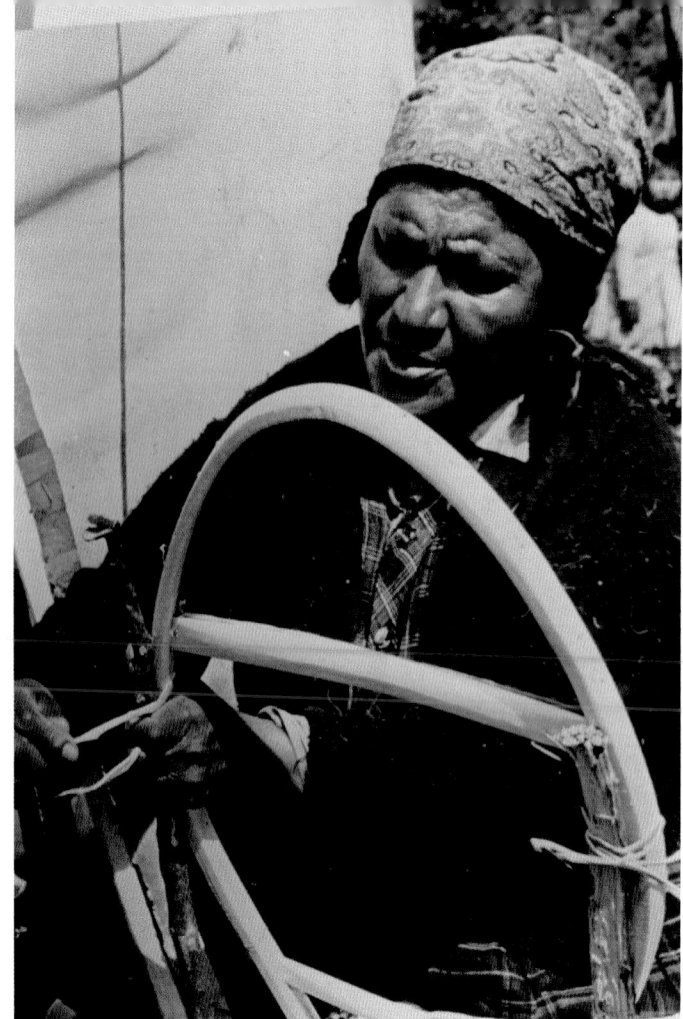

Opposite: Northeastern snowshoe types.

Left: Early bandolier form of bag of woven yarn or fiber with interspersed beads and quillwork. Note the thunderbird design. Early nineteenth century. NMS

Above: The tribes of the Subarctic and Northeastern Woodlands made use of the ample supply of wood and bark. Here a Nascapi woman prepares snowshoes, Northwest River, Labrador, midtwentieth century.

most famous of which were the mask-wearing societies of False Faces (wooden masks) and Husk Faces (cornhusk masks), who served as messengers of the Three Sisters and represented farmers from the other side of the world. The False Faces were employed to heal the sick and represented disembodied beings.

The Iroquois and related tribes lived in multi-family bark dwellings called longhouses, which were home to up to twenty families. The overcrowding and stench of these habitations were noted by French Jesuits among the Hurons in the 1640s.

Iroquois arts included quill and hair embroidery with decorative designs featuring celestial, geographical, and mystical phenomena. A number of antique pouches and so-called prisoner ties or tumplines have survived in museum collections.

Native wampum made from cylindrical clam shells from the New England shore were traded inland to the Iroquois, broken into tubular beads and woven into belts to record treaties or to carry condolence messages for deceased chiefs.

By the eighteenth century Iroquois had adopted broadcloth to replace skins for clothing; their women used calico for slit skirts, blouses, and dresses, and beadwork replaced quill and animal-hair embroidery. During the nineteenth century they produced a variety of objects for the souvenir market but these were decorated increasingly with floral designs of Victorian flavor.

Widespread in the boreal forests were tribes of the Algonkian family, holding the coastal plain as far south as North Carolina and their interior tribes heirs to Hopewell and Cahokia. The core of the Algonkian culture were the Ojibwa and their relatives the Potawatomi and Ottawa of the Great Lake region and beyond them, to the north, the Crees. The westward expansion of the Ojibwa and Cree and their involvement in the fur trade were major causes of the rearrangement of many tribes who became so-called Plains Indians.

The Ojibwa shared ceremonial customs with the Huron, such as the "Feast of the Dead," a Mississippian burial festival, but in later Ojibwa ceremonial life a curative image purveys expressed through a set of rites known as the Grand Medicine Society (Midewiwin) usually held in long open-ended bark lodges. The society had several degrees of membership requiring initiation and payment to secure health and long life for members. The world of the Ojibwa and Cree was characterized by a fear of sorcery and a pantheon of destructive spirits such as the Windigowan, giant forest cannibals of ice opposed by a supreme spirit, Manito. The Midewiwin (Mide) was also important among the Menominee, Sac and Fox, Eastern Sioux, Winnebago, and the Omaha, where it was known as the Shell Society. Medicine accoutrements were usually kept in animal skin pouches decorated with beadwork.

During the nineteenth century the Ojibwa and other Woodland peoples excelled in the production of ceremonial costume, often consisting of dark broadcloth or velveteen with beadwork in floral images, and shoulder bags which when worn appear to have reinforced their ethnic identity during native celebrations. Like the Iroquois, who finally obtained a few small reserves in New York State and Canada, the Ojibwa, Ottawa, and Potawatomi found reservations in the Great Lake states and adjacent Canada, while the southern and Prairie Algonkians were forced to Indian Territory (Oklahoma) or other locations in the west.

The Delawares, originally of the Atlantic coast, shared with the Iroquois the display of their ceremonial life in a longhouse they called the Big-house, and also a mask complex. They, and their friends the Shawnees,

Below: The wigwams of the southern New England Algonkians reflect the tribes' geographical area and were made of reeds—these were reconstructed at the American Indian Archaeological Institute, Washington, CT.

Opposite, Above: A typical Iroquois wooden False face mask.

who shared religious elements with the Southeast peoples, were pushed half-way across the continent by the advancing frontier, developing a hybrid culture en route, mixing several tribal and European traditions to survive as independent people with distinct arts of ribbonwork and beadwork.

The Algonkian tribes of New England, Long Island, and Nova Scotia were largely landless by the beginning of the nineteenth century, the waves of European arrivals beginning in the early seventeenth century (trading contacts started even earlier) having washed away their native culture leaving only fragments of Indian life. Whole families were subsisting upon wild roots and eels and their withered features told too plainly that many had suffered great ordeals. A few salvaged elements of their artistic heritage to produce delicate moosehair embroidery, multi-hued porcupine quillwork, and lavish beadwork for their European patrons and the developing souvenir market. One heart-rending tale tells of an old sad-faced Indian lady, who could hardly speak English, explaining to a customer "sister me no ate today" upon which the white woman gave her some bread and butter, which she at once gave to a boy who had accompanied her. Many tribal traditions are based upon such sharing.

Much of the fine decorative work of the Northeastern Indians was rich in colors and textures which combined European trade cloth, beads, thread, ribbons, and dyes with the native sense of design, an eye for beauty and symmetry which was bone-deep in Indian culture. Souvenir art included model canoes, quilled boxes, dolls, pouches, and purses, which often found their way to Europe. Indians also adopted from Europeans splint (ash) basketry which they pedalled door to door throughout New England and at tourist spots in the Northeast generally, for meager income. Native dress was reserved for tribal or confederacy council meetings where buckskin and paint had given way to cloth and beads, and curving designs had merged with European floralistic patterns influencing and confusing native symbolism the interpretation of which remains a matter of academic debate.

The vast area of the Northeastern Forest Indians stretched from the Atlantic to the Western Great Lakes and north towards the Arctic. The absence of major

natural barriers allowed the spread of ideas and the development of great aboriginal and later European trade routes. The transfer of material culture along these trade routes allowed the spread of appliqué and embroidery techniques of porcupine quillwork, beadwork, and ribbonwork.

Below: A canoe model of birch bark and cedar made by Ernestine Gidmark (née Caibaiosai) in Algonkian style. Collected at Red Cliff Reservation, Wisconsin. MGJ

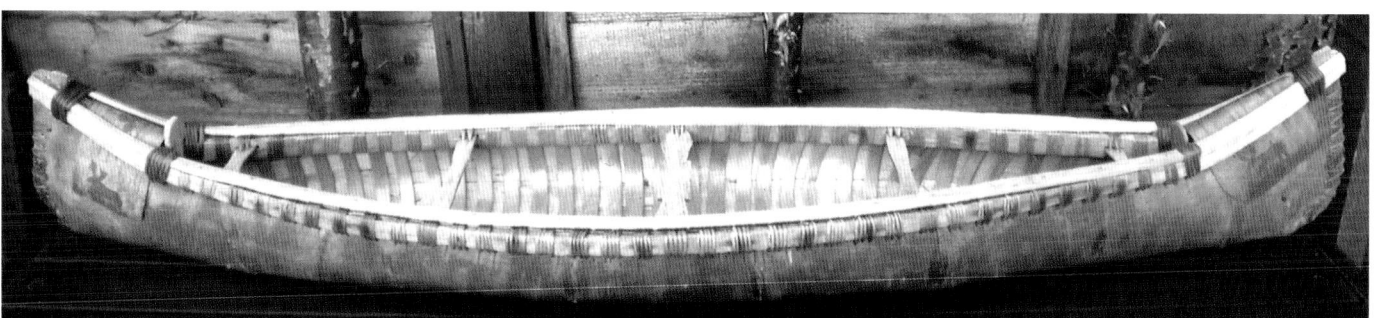

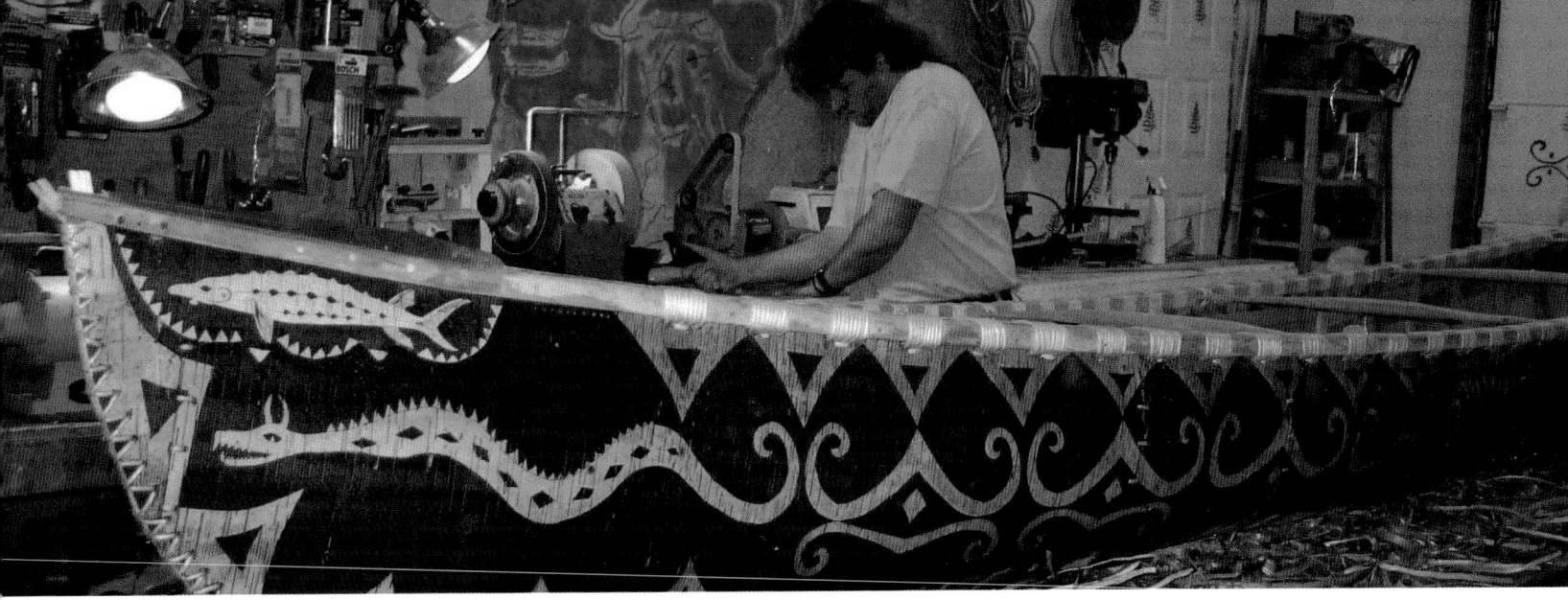

Above: Made throughout the Subarctic and much of the Eastern Woodlands, canoes allowed efficient forest travel via the vast network of lakes and rivers. They were constructed of birch (and other bark) over a frame of ribs, floor sheathing, thwarts, and gunwales of cedar. There were many variations of tribal shapes and the one shown is an Abenaki canoe, made by Aaron York, an Abenaki descendant. Aaron York

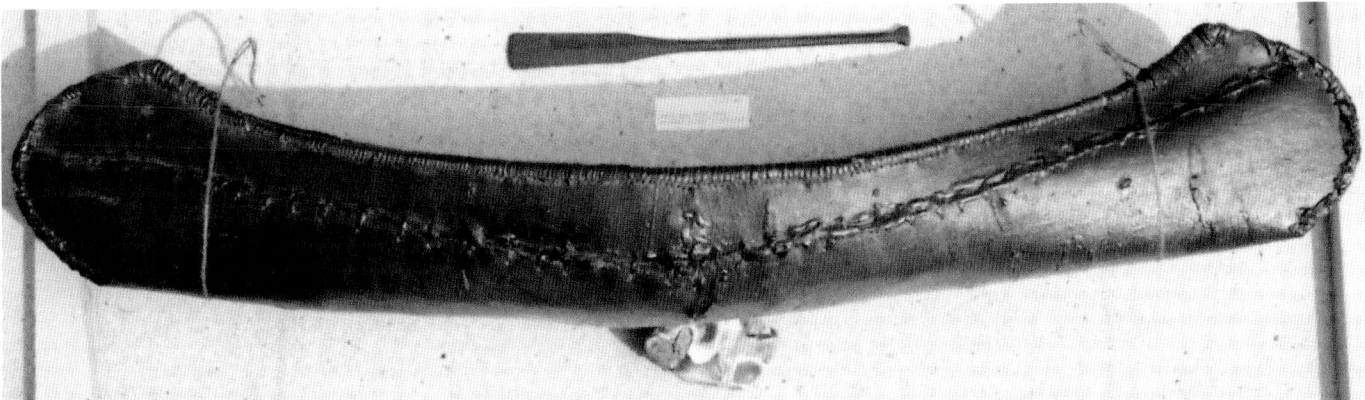

Above: A canoe model of birchbark and paddle, probably Ojibwa, nineteenth century.

Below: An Abenaki birchbark canoe made by Aaron York, c. 2000.

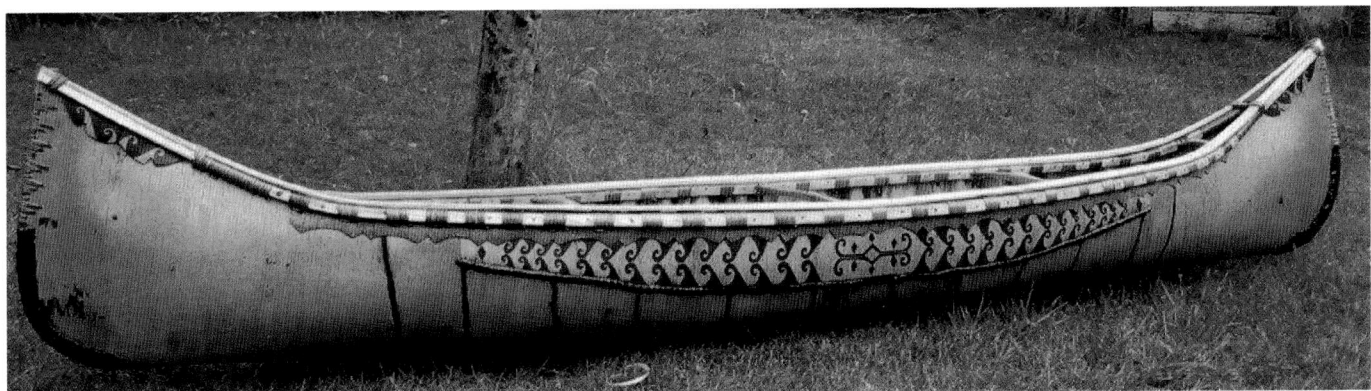

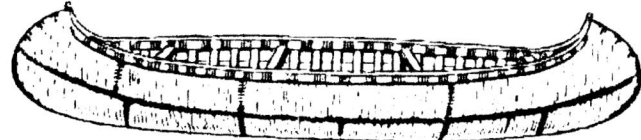

Ojibwa of Minnesota Wisconsin and Ontario. Note the recurving prow and stern.

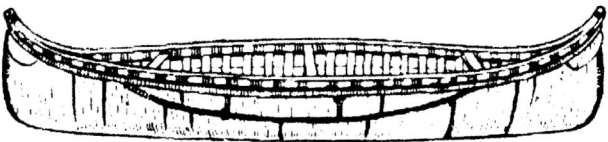

Algonkin, Quebec and Ontario. Almost straight ends. Pieces of bark set in center of sides.

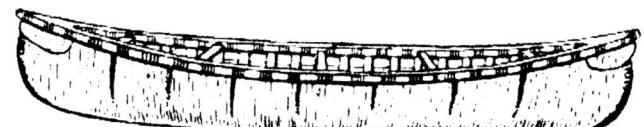

Malecite of New Brunswick, Canada. Ends slightly decked and with side flaps.

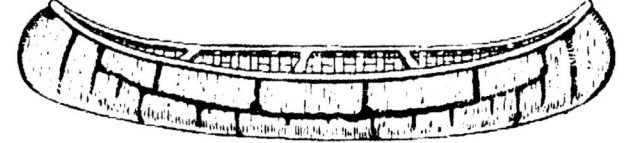

Montagnais – Nascapi, Quebec and Labrador.

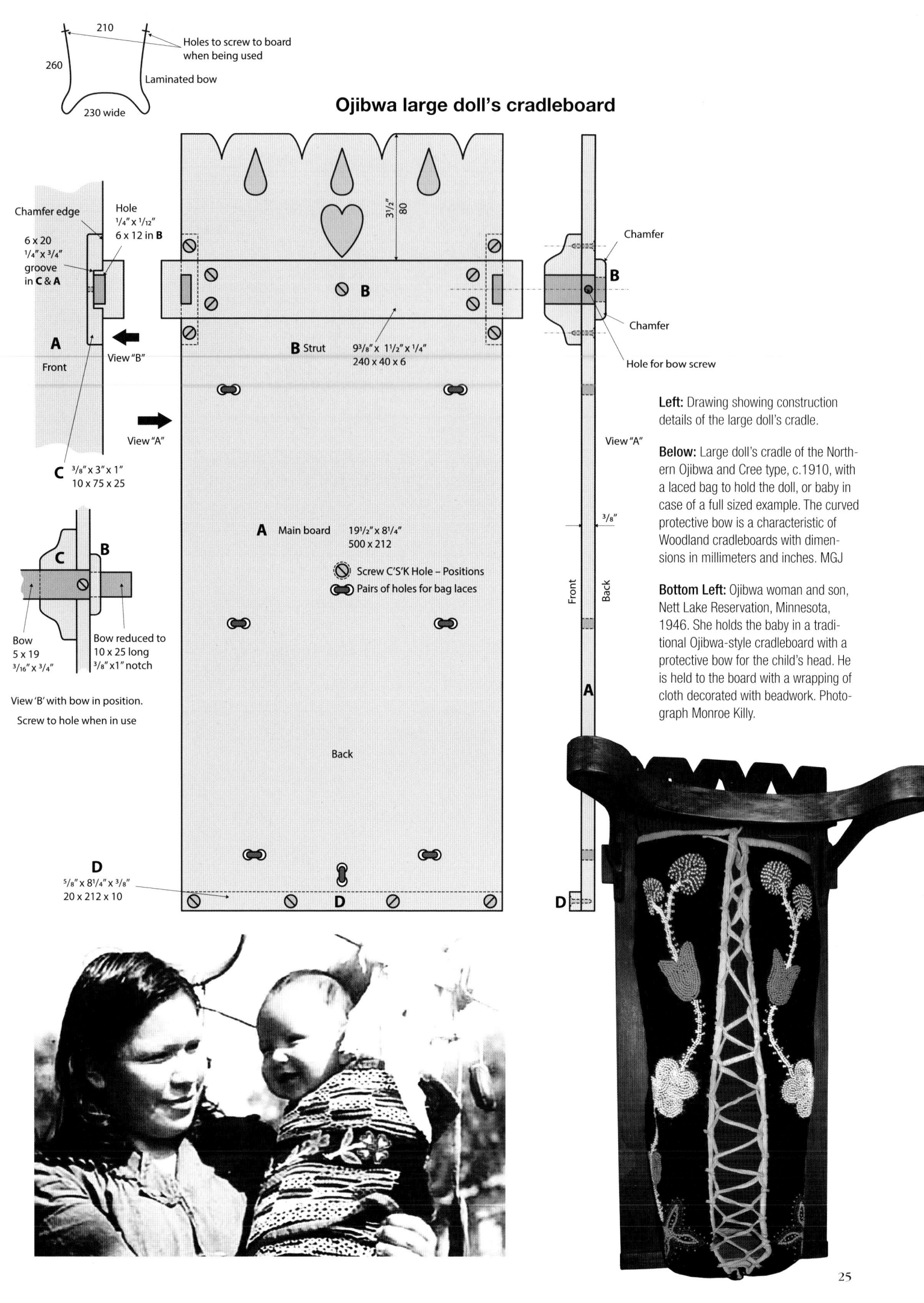

210

Holes to screw to board when being used

260

Laminated bow

230 wide

Ojibwa large doll's cradleboard

Chamfer edge

Hole
1/4″ x 1/12″
6 x 12 in **B**

6 x 20
1/4″ x 3/4″
groove
in **C** & **A**

A

Front

View "B"

3½″
80

B

B Strut 9³/8″ x 1½″ x ¼″
240 x 40 x 6

View "A"

C ³/8″ x 3″ x 1″
10 x 75 x 25

C **B**

Bow
5 x 19
³/16″ x ³/4″

Bow reduced to
10 x 25 long
³/8″ x1″ notch

View 'B' with bow in position.

Screw to hole when in use

A Main board 19½″ x 8¼″
500 x 212

Screw C'S'K Hole – Positions

Pairs of holes for bag laces

Back

D
⁵/8″ x 8¼″ x ³/8″
20 x 212 x 10

D

Chamfer

B

Chamfer

Hole for bow screw

View "A"

Front

Back

³/8″

A

D

Left: Drawing showing construction details of the large doll's cradle.

Below: Large doll's cradle of the Northern Ojibwa and Cree type, c.1910, with a laced bag to hold the doll, or baby in case of a full sized example. The curved protective bow is a characteristic of Woodland cradleboards with dimensions in millimeters and inches. MGJ

Bottom Left: Ojibwa woman and son, Nett Lake Reservation, Minnesota, 1946. She holds the baby in a traditional Ojibwa-style cradleboard with a protective bow for the child's head. He is held to the board with a wrapping of cloth decorated with beadwork. Photograph Monroe Killy.

Right: Ojibwa birch bark wigwam at the Waswagoning (The place where they spear fish by torchlight) Indian village, Lac Du Flambeau Indian Reservation, Wisconsin. MGJ

Below: Quilled bark chair seat, Micmac nineteenth century.

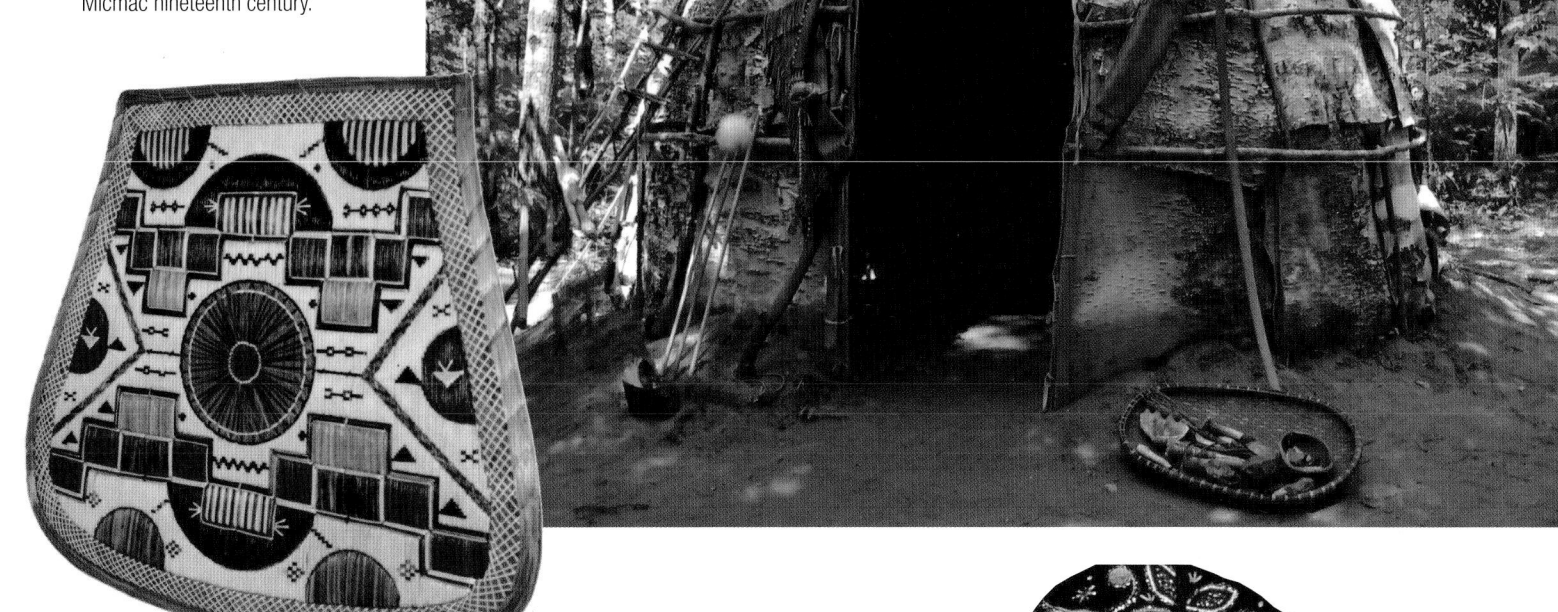

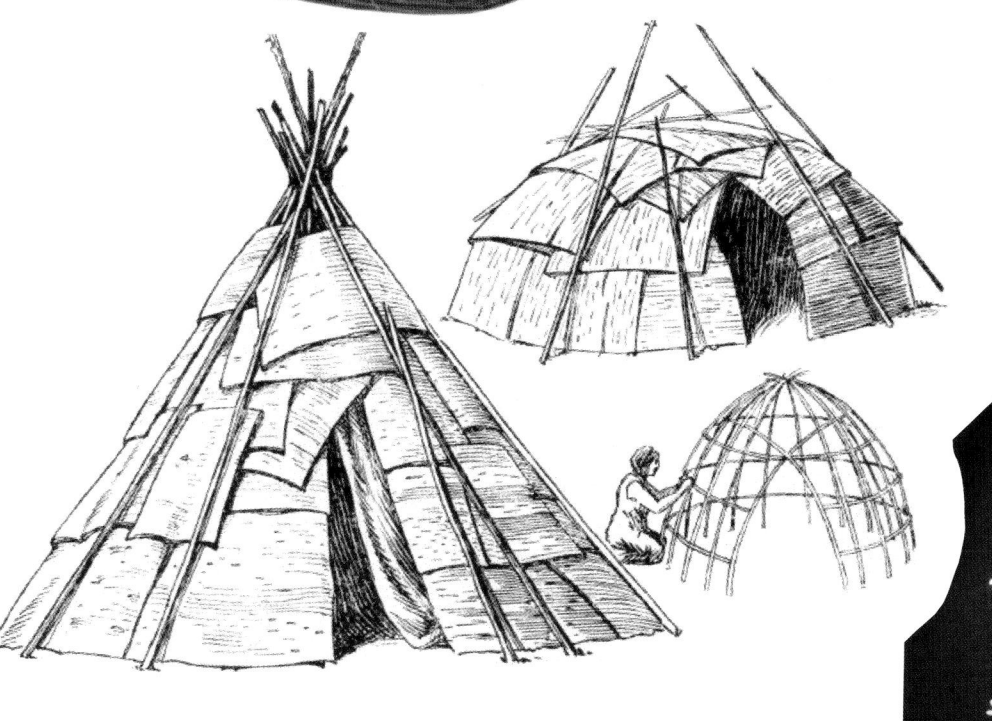

Above: Peaked or tipi-shaped bark wigwam and oval type and basic construction.

Right: The model wears a Glengarry cap—probably Micmac possibly Miramichi area, c. 1874—and a man's vest made by Mary Ann Geneace, c. 1880. NBM

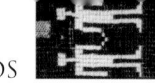

MICMAC CRAFTS

The Micmac (Mi'kmaq) Indians of present-day Nova Scotia have been known to Europeans from the early sixteenth century and began to use trade goods at an early period. However, it is very probable that they originally wore buckskin and mooseskin clothing and robes similar to those worn by other Woodland and Subarctic tribes. They used the moose for meat and also its brains for tanning hides and for strips of leather used in making the netting for snowshoes. Antlers were made into tools, and porcupine quills were dyed and used for decoration. They used animal bones, stone, claws, shells, sweetgrass, spruce root, hemp, cedar bark, feathers, and probably moosehair for further decoration. From the seventeenth century on, European trade goods of metal such as knives, guns, and hatchets were exchanged for furs and heavy coarse cloth replaced buckskin for clothing.

Left: Micmac moccasin from the mid-nineteenth century, with ribbonwork and beadwork. HV

Right: Micmac womens' cloth hoods with beadwork showing double-curve motifs, mid-nineteenth century. McCM

Below: Micmac bark box with porcupine quillwork, late nineteenth century.

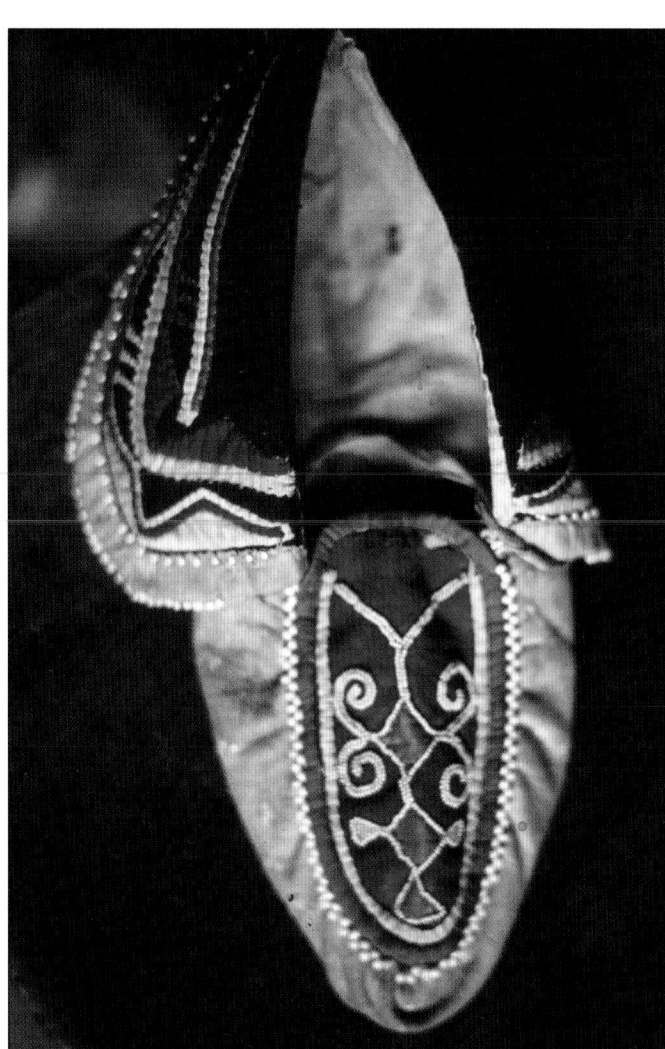

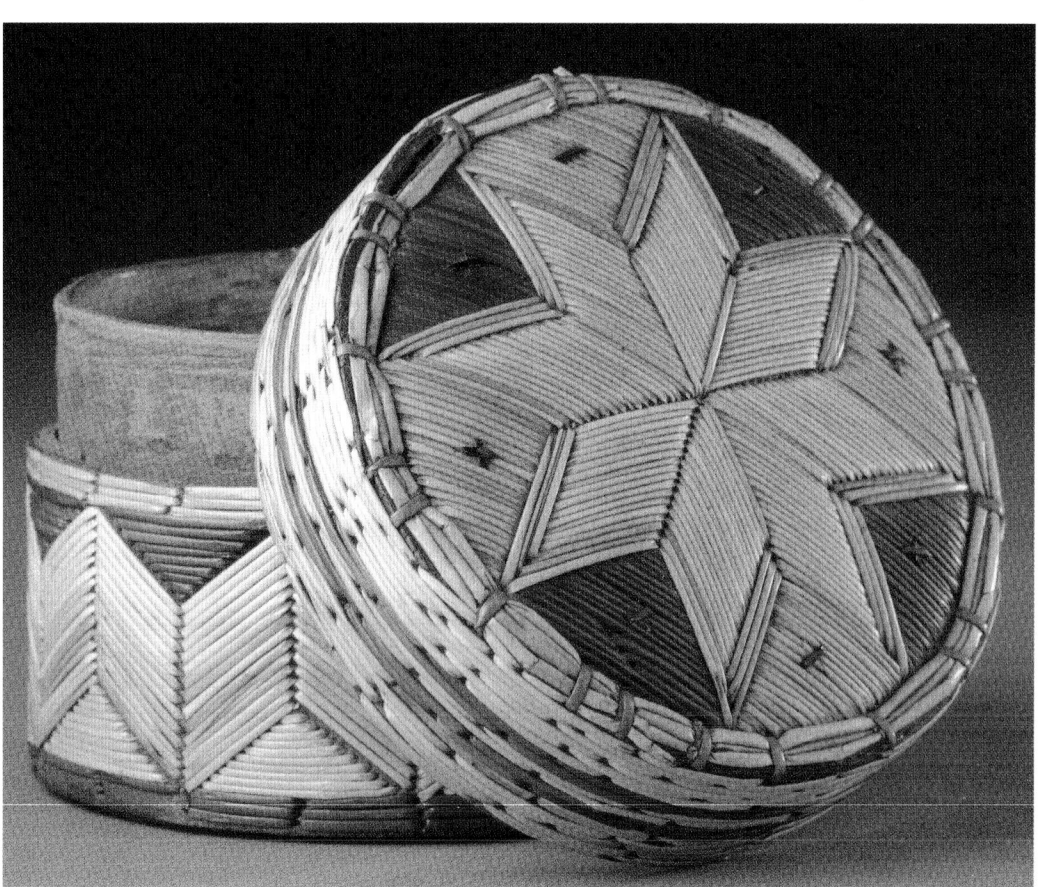

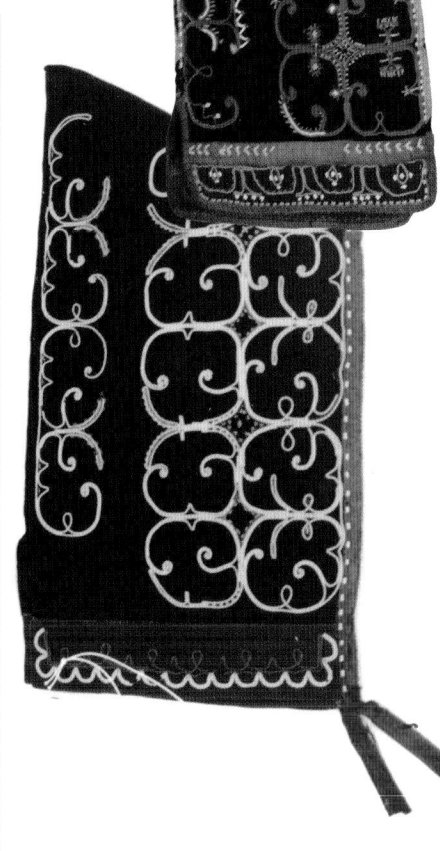

The Micmac are known for their intricate and elaborate porcupine quillwork which is likely an ancient art among them. They are particular noted for the creation of porcupine quillwork on paper-birchbark (*Betula papyrifera*) which was developed and modified in the eighteenth century by a push-through technique attributed to the influence of French convent schools. This type of quillwork was developed almost entirely for sale or trade. It usually features geometric designs with chevrons, triangles, stars, eight-legged starfish, semi-circles, and diamonds on bark boxes, model canoes, and chair seats and backs. The push-through bark technique was also pioneered by the Ursuline nuns using steel needles for the finer moosehair adapting native designs to those of French Renaissance tapestries, although most surviving material of this type is more commonly attributed to the Huron of Lorette of Quebec, and occasionally the Malecite.

During the nineteenth century the Micmac also made wood splint baskets, usually a checker-weave of ash splits, and these are still made today. They also produced beadwork to decorate both male and female cloth clothing of the late eighteenth and nineteenth centuries, such as coats, dresses, moccasins, hoods, and pouches. They often used the traditional double-curve motifs, marine forms such as shells, and floral patterns later. Beadwork was sewn with sinew, horsehair, and later thread.

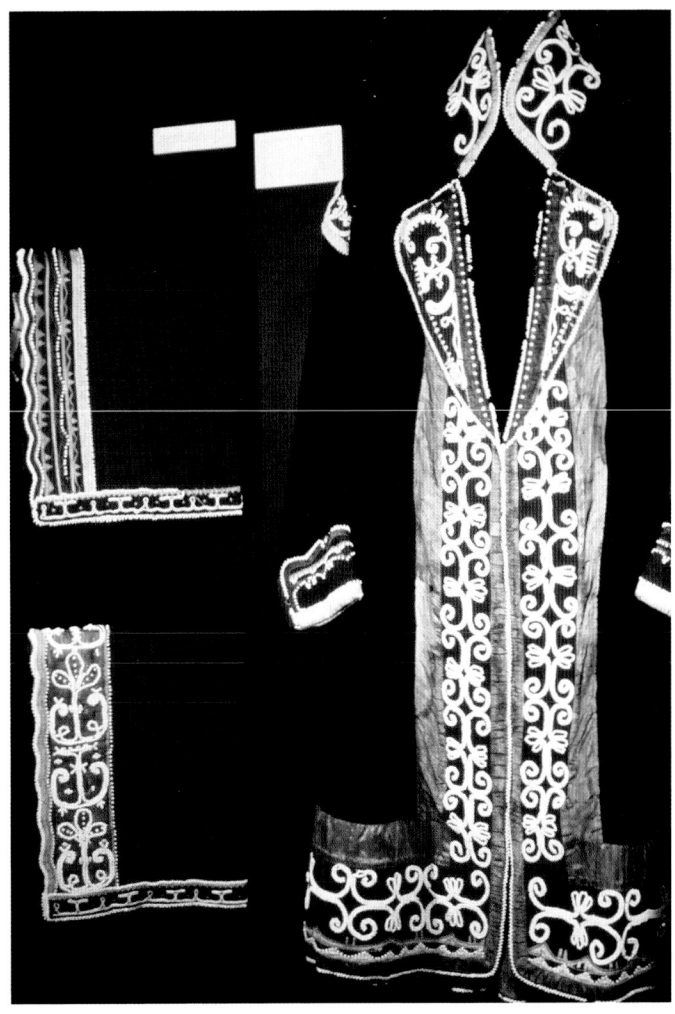

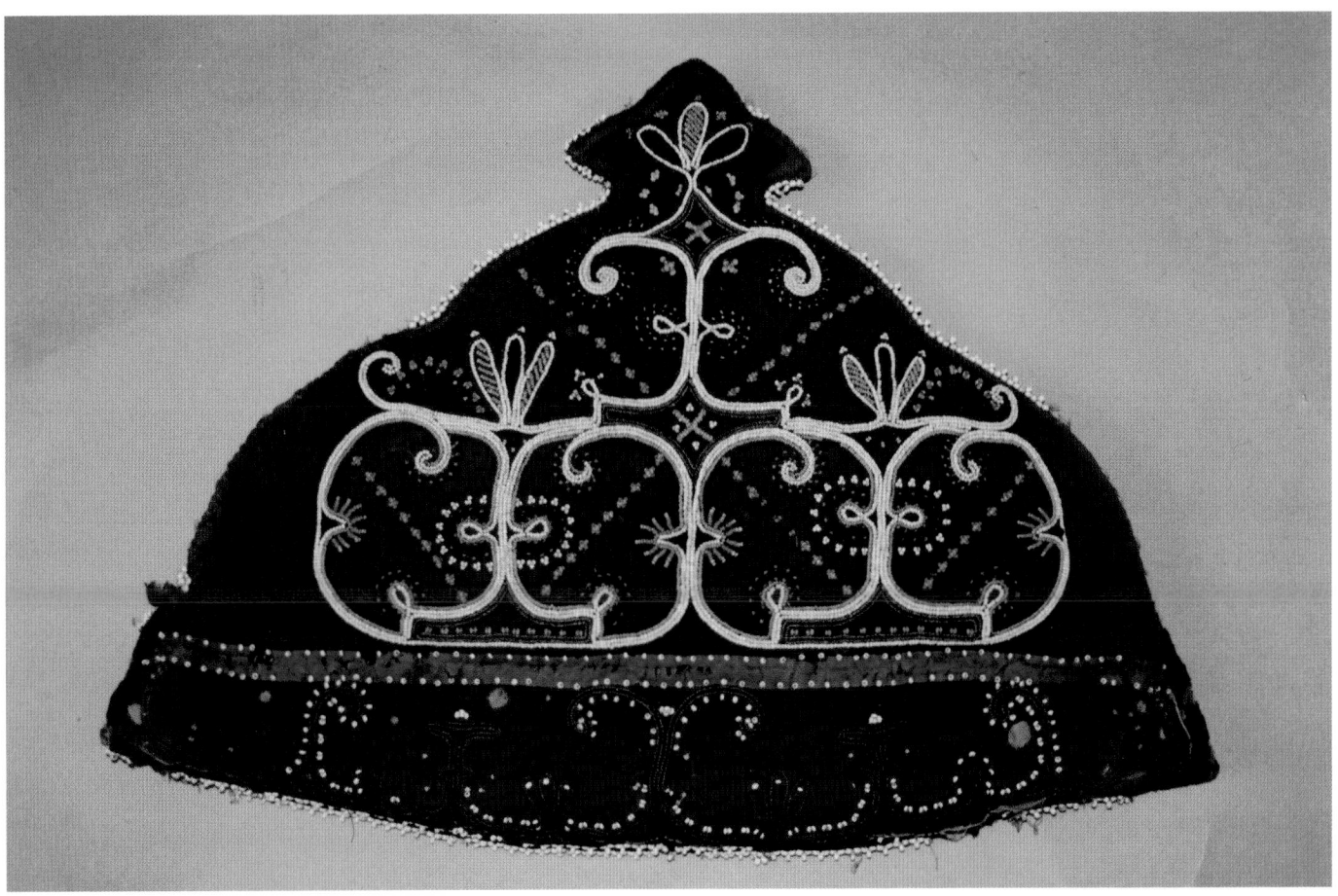

NORTHEASTERN WOODSPLINT BASKETS

It is uncertain whether woodsplint baskets have a wholly Indian heritage. In 1975, when working for the National Museums of Canada, the noted ethnologist Ted J. Brasser published an important and persuasive report suggesting that woodsplint (usually ash or oak) basketry had been introduced to the Northeastern Indians by Europeans and specifically by the Swedish colonists on the Delaware River, who settled there after 1654. There is no doubting the aboriginal origin of bark containers in the north, split-cane basketry in the Southeast, and the general use of twined woven fibers in a range and wide variety of bags and baskets throughout the Woodlands. Although Brasser argued against a native origin for woodsplint basketry, others believe the craft represents an older indigenous material culture. A century ago Speck suggested that woodsplint basketry may have been related to the cane basketry of the Southeast, but the view persists that this Indian craft is a shared tradition with northern Europeans.

In splint basketry thin strips of wood serve as warp and weft, woven in a plaiting technique in four distinct weaves: checker, twill, hexagonal, and wicker. In tracing the origin and spread of woodsplint basketry we are mainly concerned with checker and wicker techniques and the earliest shapes of baskets, which were rectangular and square-bottomed or cylindrical in form. By the late nineteenth century woodsplint basketry had spread from a relatively narrow distribution (according to Brasser) of the Delaware River and southern New England, to the Great Lakes and into Canada. A huge increase in the forms of baskets was facilitated by the development of splint gauges, which gave narrower, uniform splint widths, and solid wooden "blocks," which served as the shape around which a basket could be measured and molded. Basketry splints were frequently and characteristically hand painted or swabbed with native or later commercial dyes, or stamped with reuseable potato, cork, or bone stamps.

Following the collapse of Indian culture in New England reformed native communities were left in a desperate condition, ravaged by illness, and driven out of traditional areas by violent whites, a process which

Opposite, above: Micmac ceremonial coat, leggings and moccasins, dating from about 1825 and showing the intricacy of the elaborate beadwork. NBM

Opposite, below: Beaded tea cosy, Micmac, c. 1850. The double-curve motif beadwork designs clearly shown. IW

Above right: Iroquois splint basket with potato stamp designs from Ontario, Canada. c.1900. FB

Right: Map showing the diffusion of splint basketry in the northeast between the late seventeenth and the late nineteenth centuries.

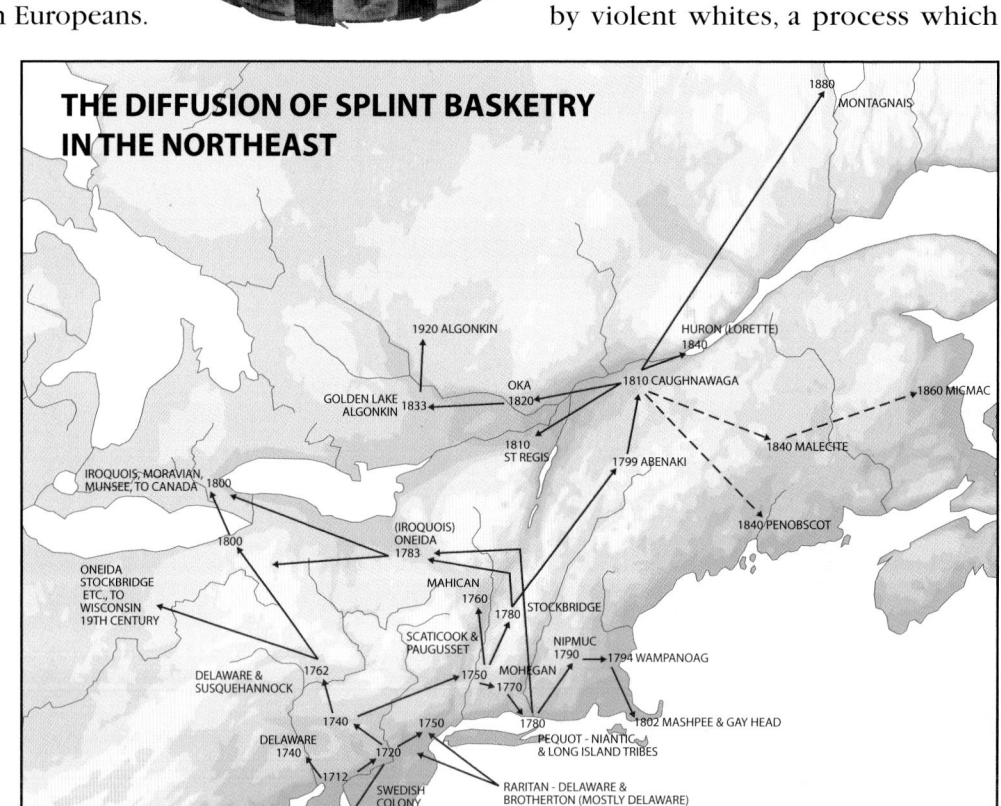

THE DIFFUSION OF SPLINT BASKETRY IN THE NORTHEAST

1880 MONTAGNAIS
1920 ALGONKIN
HURON (LORETTE) 1840
OKA 1820
GOLDEN LAKE ALGONKIN 1833
1810 CAUGHNAWAGA
1860 MICMAC
1810 ST REGIS
1799 ABENAKI
1840 MALECITE
IROQUOIS, MORAVIAN, MUNSEE, TO CANADA 1800
(IROQUOIS) ONEIDA 1783
1840 PENOBSCOT
1800
ONEIDA STOCKBRIDGE ETC., TO WISCONSIN 19TH CENTURY
MAHICAN 1760
1780 STOCKBRIDGE
SCATICOOK & PAUGUSSET
NIPMUC 1790
1794 WAMPANOAG
DELAWARE & SUSQUEHANNOCK 1762
1750 MOHEGAN 1770
1740
1750
1780
1802 MASHPEE & GAY HEAD
DELAWARE 1740
1720
PEQUOT - NIANTIC & LONG ISLAND TRIBES
1712
SWEDISH COLONY
RARITAN - DELAWARE & BROTHERTON (MOSTLY DELAWARE) BURLINGTON CO. NEW JERSEY.
TO VIRGINIAN TRIBES HENCE CATAWBA & CHEROKEE
After Brasser 1975.

ended in their social and psychological disintegration. They were therefore forced to exist on the fringes of European society, partly supporting themselves by the sale of crafts. By 1752 the Scaticook of Connecticut were reported to make a livelihood by making baskets, brooms, canoes, wooden pails and bowls. This commercial adaption of their craftwork no doubt caused the rapid spread of woodsplint basketwork to other eastern groups such as the Wabanaki, Iroquois, and Ojibwa; it was also appropriated by a number of white rural groups. The St. Regis Mohawk and St. Francis Abenaki were so heavily involved in the manufacture and sale of ash-splint baskets by the late nineteenth century that they made summer visits and semi-permanent homes in the coastal vacation resorts of Vermont, Lake George, and Maine, and they also produced catalogs of their wares.

The effects of the souvenir markets on the latter styles of ash-splint baskets and their makers saw the development of two main types of baskets: the heavy utilitarian work baskets with thick wide splints usually made by men; and smaller delicately shaped "fancy baskets," with narrow splints with "curly work" (twisted or loop projections above the surface), sometimes dyed and with intergrated sweetgrass and Hong Kong cord, primarily made by women.

Today the Penobscot, Passamaquoddy, Micmac, Maliseet (Malecite) and Mohawk are still producing splint-ash baskets in fairly large numbers, but among the southern New England groups the craft has almost gone.

Below: A group of Akwesasne Mohawk fancy strawberry baskets dating from the early and late twentieth century. Akwesasne means "where the Partridge drums." FB

PORCUPINE QUILLWORK AND OTHER DECORATION ON BIRCHBARK

The bark of the white or paper birch (*Betula papyrifera* Marsh) which grows throughout the northeastern part of the United States from the Atlantic coast to the Rockies, north to the Mackenzie River basin and east to Newfoundland, was widely used by the Algonkian and Athabascan tribes of this area. Birchbark varied in thickness, some bark being thick and strong enough for wigwams and canoes. When great sheets were required for canoes the tree was felled before the bark was removed. If smaller pieces were required for containers, thin pieces of the outer bark were removed by a vertical incision. For the most part small objects were made with the inner part of the birchbark forming the outer side of the finished article. On specimens from Algonkian tribes the grain often runs vertically and horizontally on material from Athabascan tribes, although this is by no means invariably true. Once bark was removed from the tree it could be exposed to heat (so that the bark becomes pliable), and, if flattened, it will remain flat after cooling.

The season of the year in which the bark was collected sometimes determined the type of ornamentation, particularly if engraved or scraped (*sgraffito*), a widely used form of decoration on bark containers and vessels. A thin dark substance coats the inner surface of the bark in spring which can be removed by scraping the surface away after a sharp instrument has traced the design around a template or "cutout." After scraping the design would be left standing out against a light background; alternatively the design areas could be removed leaving the background dark. Occasionally cut designs from the winter bark were stitched in the spring or summer bark with spruce root stitches to form contrasting surfaces. These designs

could be geometrical, floralistic, or zoomorphic. The geographical range of such decoration was from the Maritimes and Quebec westward to the Athabascans. Early reports note its use in New England, although surviving Penobscot work indicates their preference for line-etched work for their cylindrical boxes and miniature canoes, not the large floral or animal forms produced by using birchbark cutouts.

A wide variety of containers was made from birchbark. Simple containers for gathering maple sap were made from sheets of bark which were heated over a fire until pliable then bent into a usable shape. The form into which an item was shaped would be retained after cooling. Receptacles varied in size and shape. Common were dish-shaped vessels such as wild rice trays and "mococks"—truncated pyramid containers with rounded corners that varied in size from small trinket boxes to large storage bins. The seams and folds were pierced and laced with basswood fiber or skinned spruce root to form the different shapes. Holes, cracks, or seams were caulked or mended with balsam gum or pitch made from the resin of the bark of black spruce—"spruce gum"—when a basket was required to be watertight. Mococks were usually finished around the top with a rim of splints laced with spruce-root binding. Among the Tête de Boule of Quebec the roots were often dyed, a style of decoration which reappears again among the Athabascans of northern Canada and British Columbia. The Northern Algonkians called their truncated pyramid containers "wigwamuti"—bark receptacles.

Decorative designs on birchbark work could be geometrical, curvilinear, floralistic, realistic, and the design medium might be paint, animal hair, spruce root, or porcupine quillwork. There has always been much

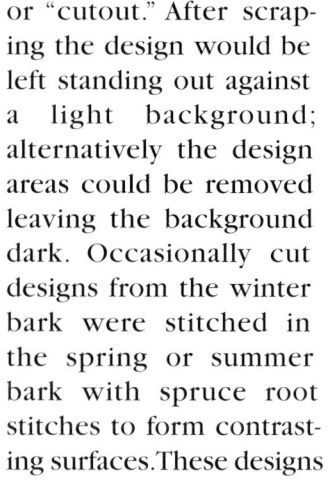

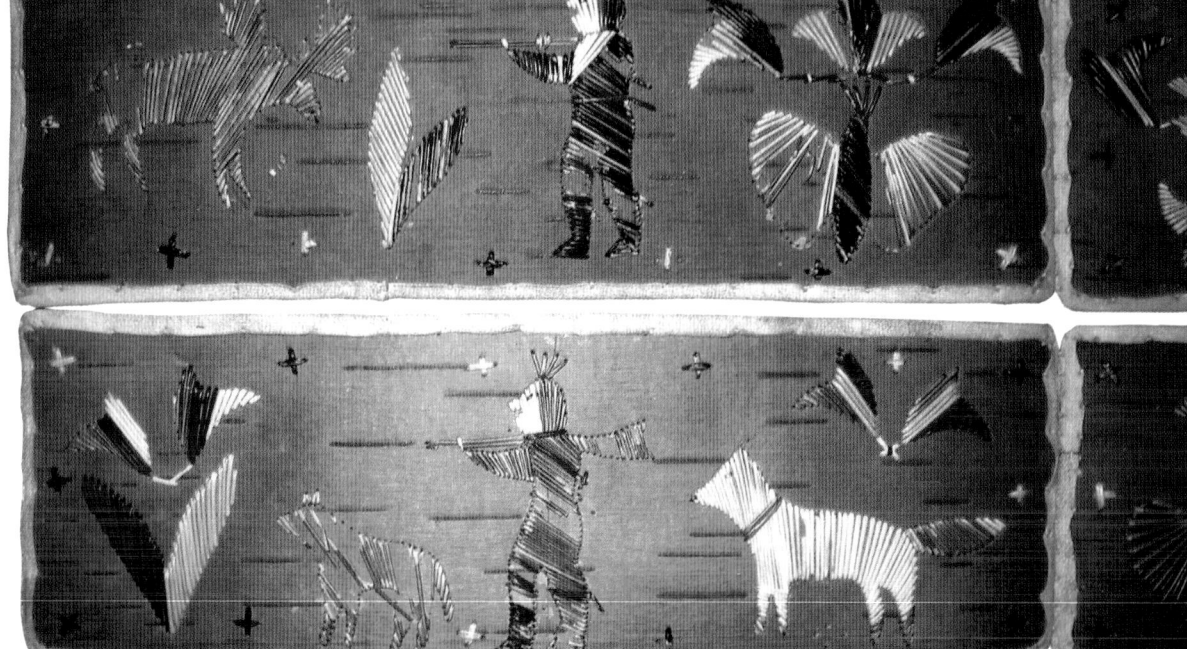

Right: Quillwork on birchbark panels. Note the realistic hunter with gun and animals including moose, wolf, dog, and butterfly. Ojibwa or Ottawa, c. 1900. MGJ

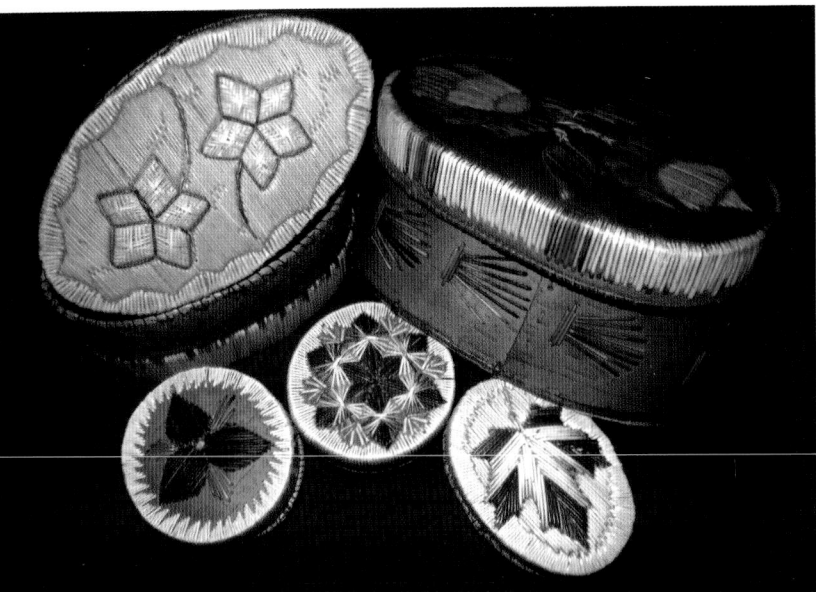

controversy as to the origin of some of the art forms and designs. Purely floral designs and embroidery with moosehair applied with needles have sometimes been given a French Canadian genesis. However, the application of colored porcupine quillwork on bark (probably aboriginal) that appealed strongly to Europeans no doubt stimulated the production of heavily decorated non-functional items of barkwork from the eighteenth century onwards.

There were two principal areas where porcupine quillwork on birchbark was produced particularly for European consumption. The first was the Micmac area of Nova Scotia and adjacent Canadian provinces. Perhaps the craft extended at some periods to the Malecite, Abenaki and New England Algonkians, but it did not extend to the Penobscot of Maine in recorded memory as their cylindrical boxes and miniature canoes were etched not quilled.

The earliest documented examples of Micmac quillwork on bark were recorded by Denys (1638–72) and during the eighteenth and nineteenth centuries quillwork was widely applied to bark boxes, baskets, model canoes, and chairs. The earliest known Micmac quilled

Above: Ojibwa or Ottawa souvenir type birch bark boxes decorated with dyed porcupine quills. c.1900-1950. MGJ

Right: Miniature Huron bark canoe with moosehair in camp fire scene. JB

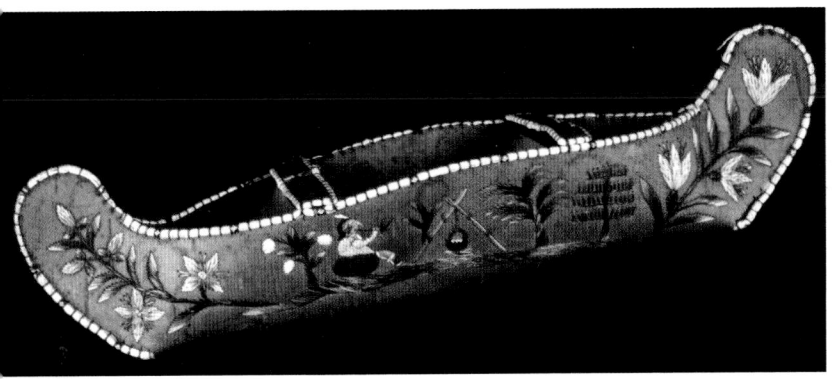

box is about 1750 and curiously most appear to be Micmac except some French Canadian ones; only a few are attributed to the Malecite.

The other great area of quilled bark production was the Manitoulin Island area of Ontario, adjacent mainland Ontario as far east as Rice Lake, parts of Michigan, northern Minnesota to least as far as Nett Lake, and in very recent times the craft appears in Saskatchewan, Alberta, and North Dakota. At the center of the area are the Ojibwa-Ottawa groups of Lake Huron. The craft persists among the women at Manitoulin Island, and two Ojibwa-Ottawa women from there demonstrated the technique of quillwork on bark at the Museum of Mankind, London in 1982 in connection with an exhibition of Woodland material culture. Floral designs stimulated the indigenous Ottawa craft of decorating birchbark containers, originally made to hold maple sugar, with colored porcupine quills. Large quantities of boxes, dishes, model canoes and other items were made for sale or exchange during the nineteenth and twentieth centuries. Among the Micmac two women were still producing the craft as late as 1955, and continued attempts are made to revive it.

Among the Ojibwa-Ottawa groups around the Great Lakes, Lyford described the technique of quilling on bark among the U.S. branches of the people. A stencil or cut-out pattern is sometimes used for making the designs with a blunt marker by tracing around the pattern. "The quills are soaked in water until soft, then the sharp ends of unflattened quills are inserted from the back through small holes made with an awl which is smaller in diameter than the quills. The quills are drawn through the hole from the back to the front, bent over carried parallel to another hole through which the sharp end is drawn to the back of the bark surface again. The ends of the quills are trimmed off, bent and pressed close to the back of the bark where they dry and thus serve as a fastening for the quill. The quills dry and stiffen and the holes in the bark seem to contract after the quill ends have been inserted, thus holding the quill securely … when the exterior of a container is decorated with quilled designs a thin lining of bark with a scalloped edge is usually provided to cover the ends of the quills that show on the inside of the container." The shaped edge was then bent over to seat on the bottom of the box. The Ojibwa-Ottawa principally produced decorated boxes, trays, baskets, miniature canoes, mococks, etc.; the Micmac extended their range to chair seats and backs, fire screens, cradles, log containers, ink blotters, and so forth, material clearly adapted to European tastes.

Many Indian groups had to survive as best they could on the periphery of Euro-American and Canadian culture as distinct tribal life collapsed. Their arts and crafts were modified where the sale of their work could add to their meager income. Souvenirs developed where a ready market was established and these remained fairly constant through the eighteenth and

nineteenth centuries for the Micmac. The Ojibwa-Ottawa (Mississauga) had a long association with Europeans and may have initiated the process of passing material cultural changes to the west. So common are these colorfully decorated "non-functional" items in museums and private collections that they cannot be overlooked by the ethnohistorian in any summary of Northeastern Indian art—although they do have the persistent breath of curio art about them. A wide variety of these items produced in the native manner were being churned out, sometimes for export, by various Indian groups from the mid-eighteenth century on. The Huron remnant at Lorette Quebec produced one type of their material. This style is decorated with moose-hair embroidery and the French Canadian influence and participation in this craftwork is undisputable. How much push-through moosehair work was done by non-Hurons or French Canadians is difficult to estimate but it has also been suggested or reported from the Micmac, Malecite and Ojibwa. Conversely we can only speculate about the amount of quilled bark work among the Huron, but clearly there was some overlapping.

The export of Northeastern Indian work was first to France and the French West Indies and later, after 1763, to Great Britain as well. Examination of specimens shows how surprisingly few changes were made in the types of material being produced. The use of commercial analine dyes on quills from 1850 onwards was one of significant development. Most eastern Indian groups were producing material for sale from the eighteenth century on—what was usable and wearable, when not used by themselves, was traded on to the western Indians, voyageurs and coureurs des bois; material not specifically hard-wearing for camp life was often produced for the European or Euro-North American market, quilled boxes, trinkets, and similar items clearly fall into this category. The mocock, however, remained a widely used vessel among the Algonkin, Cree, and Athabascans until fairly recent times, and they are now produced for the souvenir markets. All these bark specimens are part of an ancient and vast circumpolar tradition which reaches across the whole of North America.

Sweet grass and spruce roots were also widely used by the eastern Indians on their birchbark work. Coils of sweet grass, stitched over and over with a coarse black thread, frequently served as a finish around the edges and rim of containers, especially at the stress points where the lids and bodies of boxes are pushed together. Sweet grass is the ideal medium for giving the cushion effect at this points where damage would otherwise occur when the item is used. On older, shallow and Northern containers, willow or ash splints bound with spruce root served as the edge—among the Tête de Boule these lacings were often dyed. Occasionally complete baskets of sweet grass were made by simply building coils about ¼ in. in diameter sewn together

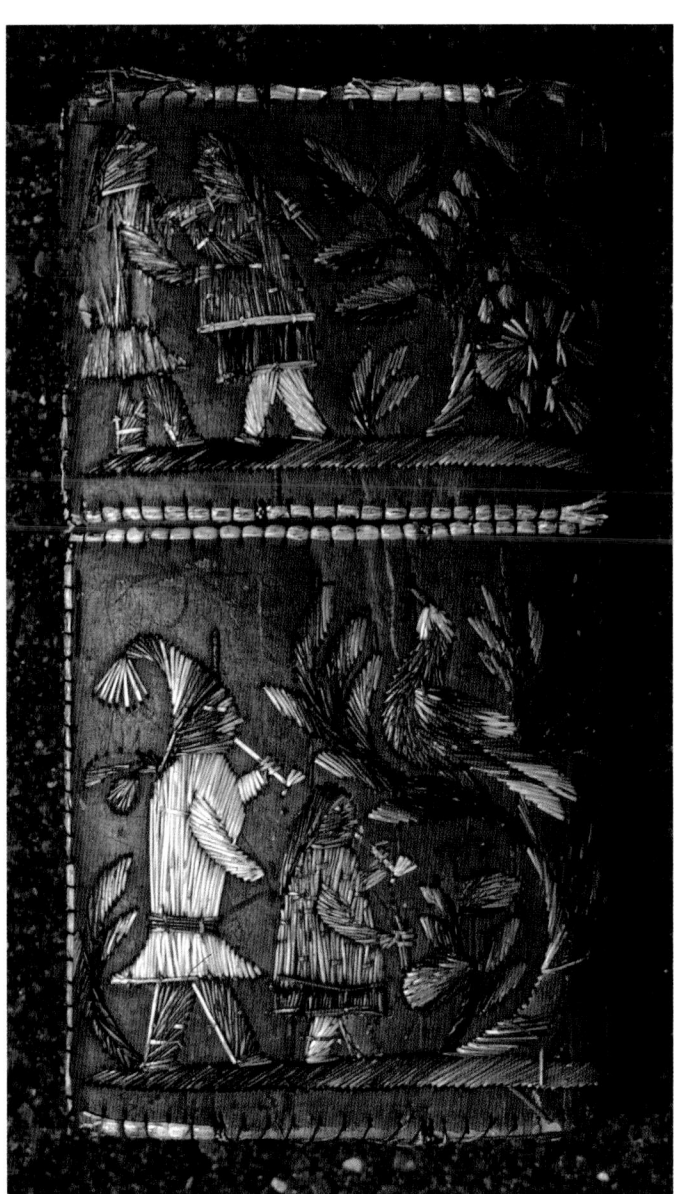

Above: Huron bark cardcase with mosehair embroidery, c. 1850. JB

with black thread. Such baskets may have a bark top and base or otherwise be entirely of sweet grass, sometimes started with a braided strip in the center. The use of a heavy coarse black thread for sweet grass stitching and coiling is very characteristic of Ojibwa–Ottawa work but not Micmac.

Two other bark decoration techniques not yet mentioned are the unique bitten bark patterns (mostly Cree) and the pictographic designs on Mide scrolls, ritual charts, and migration charts (mostly Ojibwa). To produce patterns with teeth the cork layers from the outer bark are separated into the thinnest possible sheets which are folded several times and bitten with the eye teeth. When the bark is opened out a repetitive design emerges. The line drawings on Midewewin scrolls are produced by hardwood, bone, or steel stylus on the impressionable inner or cambium side of the bark, which is also consistently more smooth than the paper or outside.

BEADWORK OF THE SOUTHERN WABANAKI (MALECITE, PENOBSCOT, AND PASSAMAQUODDY)

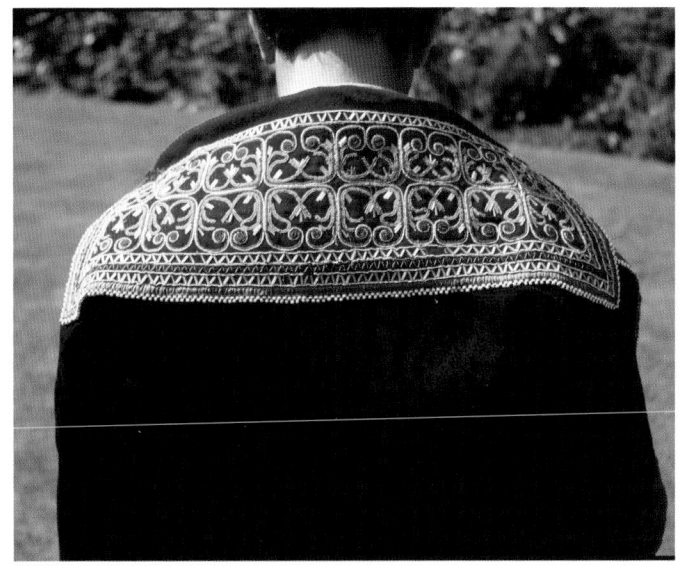

Above: Double-curve beaded motifs on the shoulder panel of a Wabanaki cloth coat, mid-nineteenth century. UCMAA

Frank Speck's fieldwork among the Northeastern (Wabanaki) Algonkian tribes during the early twentieth century, coupled with his examination of their decorated material culture surviving in museum collections, led to the publication of a number of reports in which he discussed the origins of leaf-like designs in their artistic traditions. Although he seems to have wavered at times, he claims that their nineteenth century floral and leaf-like patterns in beadwork must have had an old prototype, perhaps connected with the so-called double-curve motif and other curving designs originally using indigenous materials such as moose hair and porcupine quills. This debate still continues among academics. Some claim that floral-inspired designs developed totally from European influences, starting perhaps with the French missions on the St. Lawrence River during the first half of the seventeenth century where Indian girls were taught European embroidery techniques. Others are more cautious in attributing all nineteenth-century floral decoration to this genesis.

The Southern Wabanaki were formerly in colonial times a loose confederacy covering the combined native people called Maliseet (Malecite), Passamaquoddy, and two branches of the Abenaki who survived the massive

Below: Nineteenth century Wabanaki beadwork designs.

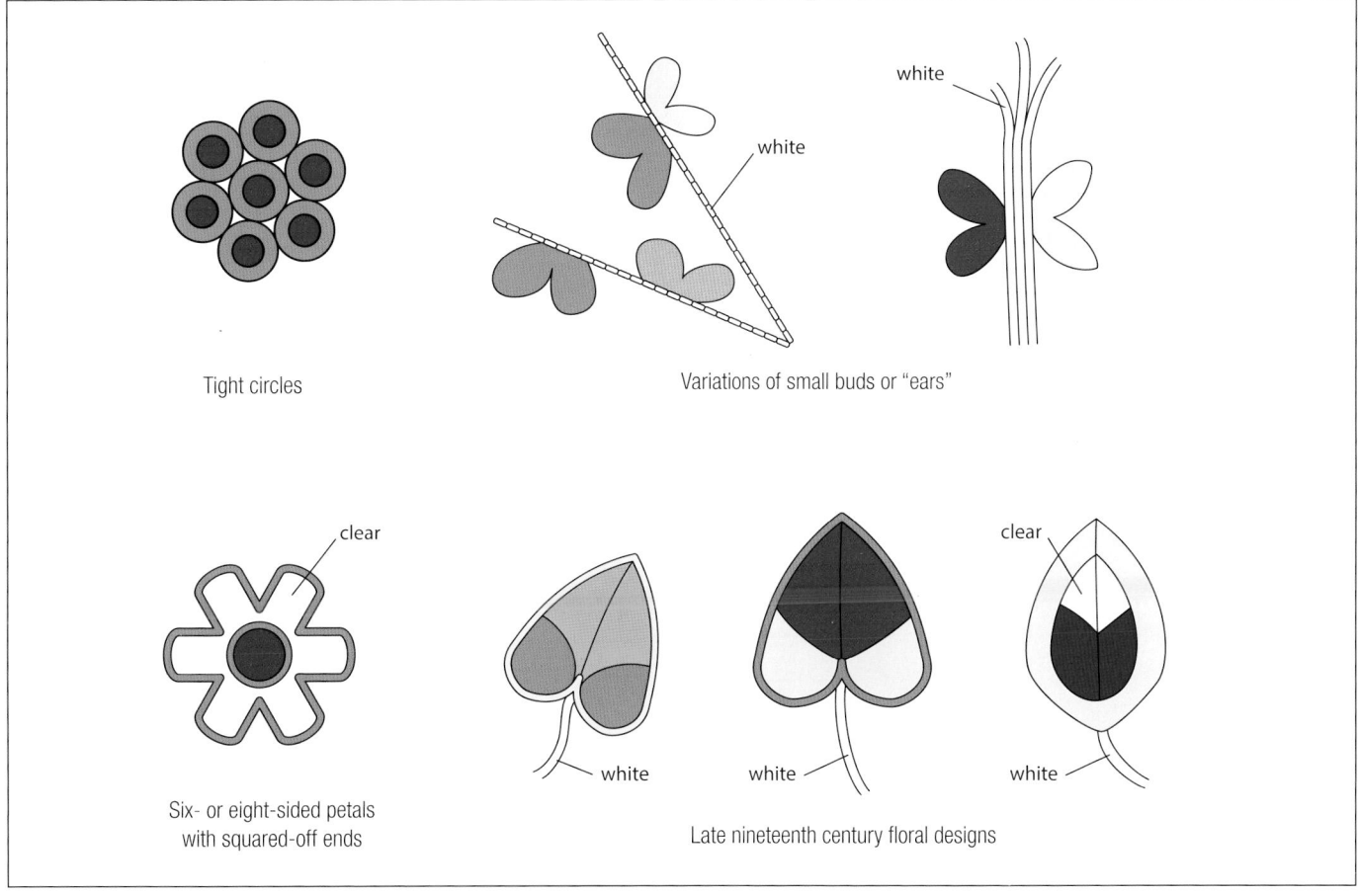

Tight circles

Variations of small buds or "ears"

white

white

white

Six- or eight-sided petals with squared-off ends

clear

white

white

Late nineteenth century floral designs

clear

white

disruption and transformation of their culture that followed the European discovery and invasion of their lands by the French and British in the late sixteenth and seventeenth centuries. At one time some of these groups were also known as "Etchemin" and together with the Micmac of Nova Scotia the whole group were one superconfederation called Wabanaki or "Easterners." The southern groups of this confederation were located, and are still found, in New Brunswick at Tobique, Woodstock, Edmundston, Fredericton (Saint Mary's), Oromocto, and Viger in Quebec (all Malecite), and in Maine the Passamaquoddy near Eastport and Princeton and the Penobscot at Indian Island, Old Town. The remaining Abenaki are mostly connected with St. Francis (Odanak) and Becancour in Quebec.

A considerable amount of souvenir material was made by these groups during the nineteenth century, perhaps reflecting the huge amount of similar material produced by the Iroquois during the same period. Such items included small cloth purses, pouches, caps, and moccasins. These were particularly popular with visitors

Below: A moose-foot wall hanging with pockets and backing of red cloth decorated with Malecite (Maliseet) style beadwork. This type of nineteenth century souvenir item was usually the work of the Huron of Lorette, Quebec. This is the only known one of likely Malecite origin. FB

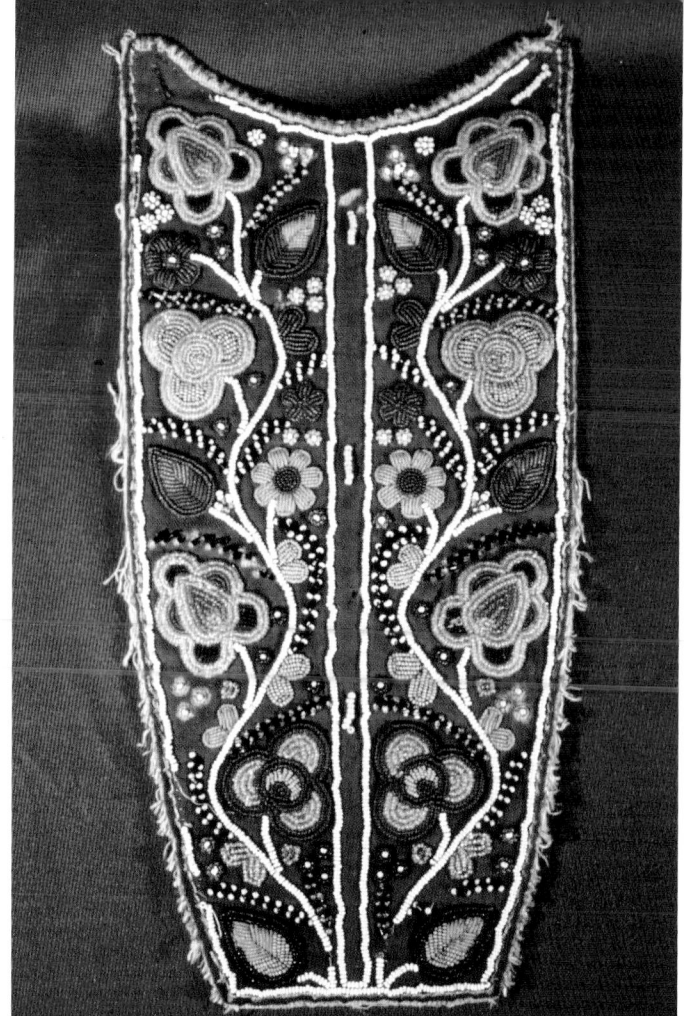

Above: Maliseet (Malecite) vest attachment, c. 1880. NBM

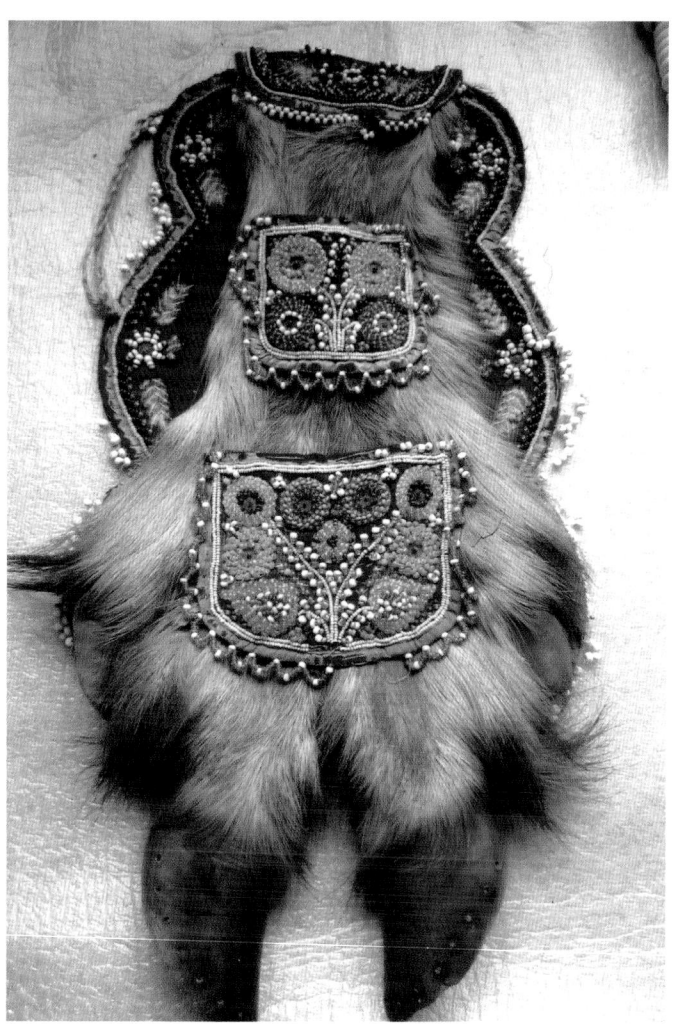

to coastal Maine and were constructed of commercial velveteen, stroud, heavy broadcloth, buckram, glazed cotton, or calico and were often edged with cotton braid tape or silk binding. The beadwork styles are usually recognizably distinct from the Iroquois forms with their tendency to embossed and massive quality, particularly on later material. Iroquois pouches, for example, are often "sporran-shaped" while the Maliseet style by comparison was often "keyhole-shaped."

Characteristic of the floral beadwork on these pouches, moccasins, hoods, chiefs' collars, and coats is the unique use of solid-color loops or buds or floralistic elements of finely worked beads. These forms are sometimes linked with bifurcated beaded stems or veins, often combined with floral and double-curve motifs and complex zigzag borders. The quality of such beadwork diminished during the later nineteenth century presumably to satisfy the demands of the tourist market. Borders became simpler and intricate designs increased in size to large leaf or heart-shaped forms.

Demographic documentation of this type of material is usually lacking but the New Brunswick Museum, Saint John, does have a number of specimens with beadwork similar to that described here apparently made on the Saint Mary's Reserve, Fredericton. Speck (1927) attributed some of the material he pictured in his *Symbolism in Penobscot Art* to the Penobscots of Old Town, Maine. So we can therefore tentatively

attribute much of this type of material to the Maliseet and Penobscot and possibly to the Miramichi Micmac and Passamaquoddy, with rare examples to the Abenaki of Odanak. Their work seems to be distinguishable from the Nova Scotia Micmac (Mi'kmaq) whose beadworkers continued to embellish their double-curve designs with loops, stars, and apparently marine-like plant and shell forms with heavily bifurcated spines and stems.

Although these Southern Wabanaki pouches survive in relatively large numbers there are few old photographs or drawings of Indian people actually holding or using them. The photographs of Mark Harrington in December 1912 of Mrs Henry Mathews (Mercy Nonsuch), a full-blood Niantic, show her holding such a beaded purse "a specimen of her handiwork" and of a type suggesting Wabanaki influence or make. This lady was apparently one of the last Western Niantic from the old reserve at East Lyme, Connecticut. However, Indian migrant workers from Maine and Canada had long been resident among the southern New England groups and may have influenced local beadwork styles. Possibly, the pouch was actually Maliseet made. A brief review of southern New England beadwork of the nineteenth century shows that the Mohegan and Montauk had a robust floralistic style using large beads somewhat resembling and perhaps copied from the Iroquois embossed or raised technique.

The few surviving nineteenth-century women's hoods in museum collections are mostly Micmac with square bottom edges but seven or eight known examples with rounded bottom edges, which were reported by Speck as a Penobscot trait, are known to the writer, with an example on permanent loan to the American Museum in Britain apparently documented as Penobscot. A drawing of a Maliseet woman wearing a hood suggests such hoods were known to all Wabanaki groups. Another example displays typical tight floral units, double-curve motifs, and multiple zigzag borders of solid colors and small loops.

The St. Francis Abenaki are the only Wabanaki group who are not so well represented by beaded material in museums, although at least one beaded slit pouch is known and in 1912 Speck photographed a Becancour man wearing a beaded cap.

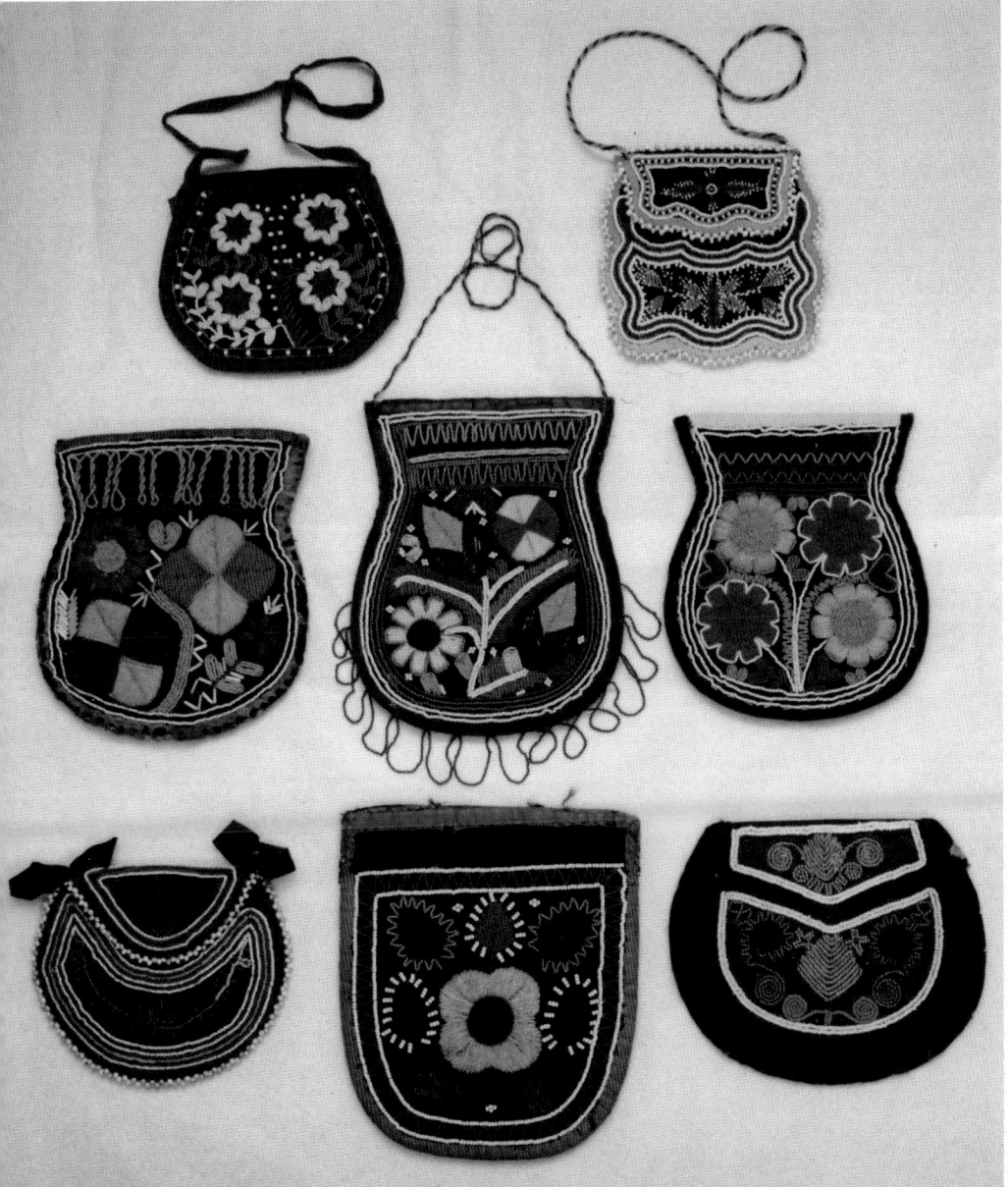

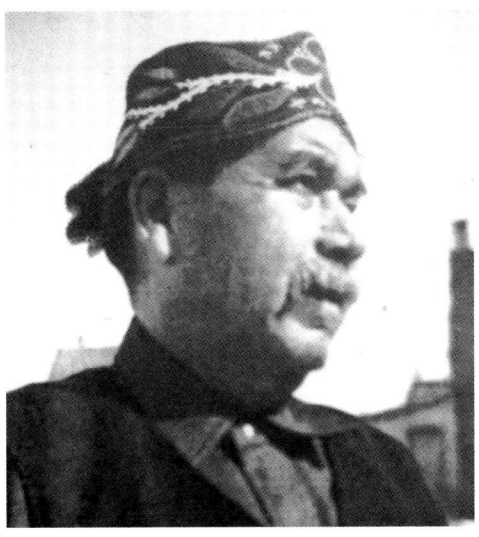

Above: Francois Neptune Becancour, man photographed by Frank Speck 1912.

Left: A selection of Wabanaki and Iroquois purses, 1840–1880. MS

Opposite, above: Iroquois man's buckskin jacket and pants with beaded belt and headdress, c. 1900.

Opposite, below: Eastern Ojibwa (Chippewa) woman photographed at Muncey Town, Thames River, Ontario, 1907. Three small groups of Chippewa, Muncey-Delaware and Oneida-Iroquois have reservations south of London, Ontario. Althought this lady is probably Chippewa, she wears a characteristically Iroquoian cloth dress, cape, skirt, and pouch. The same pouch also figures in a contemporary photograph of the Oneida Chief John Danford.

IROQUOIS DRESS

As clothing was highly perishable, no examples of early Iroquois clothing have survived. The likelihood is that clothing was originally buckskin, chiefly deerskin tanned soft with animal brains after dehairing. Gradually garments of skin were replaced by trade cloth and Iroquois women became expert with needle, thread, and scissors by mid-eighteenth century. The most sought-after cloths were English strouds which were lighter than furs and animal skins, easier to dry and therefore more suitable for mobile life in the forests. The cloth also came in bright colors—blue, red, black, and green. Typical Iroquois dress for both sexes after European contact was therefore a harmonious blend of native and European materials, design, and decoration.

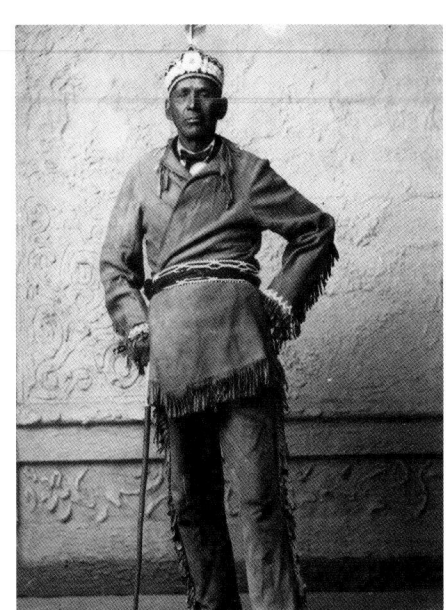

Iroquois women wore a skirt of broadcloth, patterned after the old buckskin skirt, which was left open to the knee on the right side. The border and corner of the left-hand side were decorated with beadwork or ribbonwork. Leggings of buckskin or cloth were secured with ties below the knees. Leggings were made with the seams at the front left open about 4 in. above the foot to allow the leggings to fit over the moccasins. Leggings were also decorated similarly to skirt borders. Women also wore traded shirts, gaiters, and overdresses often covered with silver brooches of various shapes. Later these garments were made by the Iroquois women themselves. Women's moccasins were of various types. The most important and no doubt the oldest form was the one-piece buckskin construction with a center seam over the instep and a heel seam. These moccasins had a collar or ankle flap, a buckskin extension to the top edge, which was folded down and often decorated with quillwork, moosehair or beadwork. Later a second form became

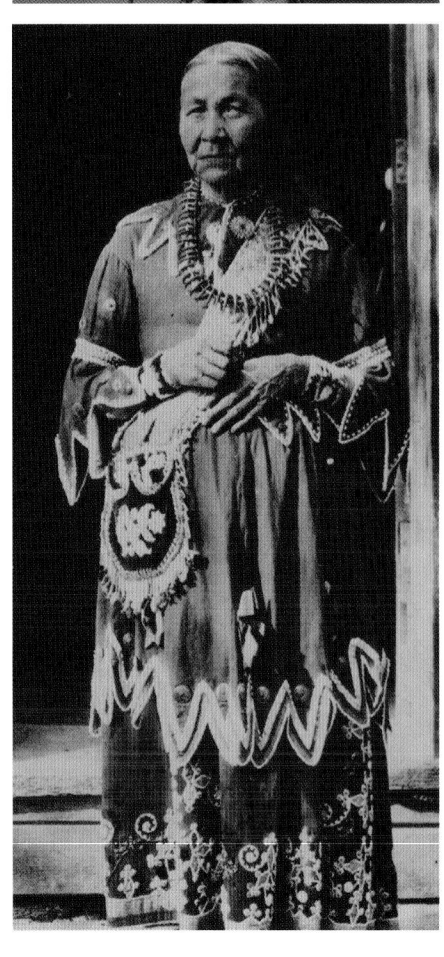

universally popular among all Woodland tribes which used a U-shaped vamp over the instep with heavy puckering to the top unit and an inverted T-shaped heel seam (and other variations). Iroquois women took pride in their long, shining black hair, well pomaded with sunflower oil. All parted their hair in the center; mothers drew their hair back into a single braid.

The dress of men originally consisted of a breechcloth, a fur robe or a deerskin shirt of two skins joined at the upper corners, deerskin kilts, leggings, and moccasins. Warrior's hair was scorched off and plucked out of the head; face, body, and limbs were tattooed; and ears slit and nose bored to be adorned with trade silver rings. Later they wore colonial hunting coats, either skin or trade cloth, tube or front-seam leggings, and moccasins similar to those of their women decorated with quillwork, moosehair, or beadwork. Later moccasins had velvet and broadcloth vamps and cuffs. Men wore woven sashes, originally of native fibers but later of woven yarn, and silver ornaments obtained in trade or made by their own silversmiths, but often in designs of European origin. Imported beads were supplied to the Iroquois as early as 1610 and gradually beadwork replaced porcupine quillwork and thread replaced sinew. Traditional designs of natural and geometric forms were replaced by floral designs, particularly in the nineteenth century. Shell wampum beads were also used for personal adornment. During the latter part of the eighteenth century Iroquois clothing was also decorated with silk ribbons. Iroquois men of importance wore a headdress called *gus-to-weh*, made on a frame of splints that arched over the head, with a silver or beaded band and a feather revolving in a tube fixed to the frame.

For many years traditional dress, both male and female, was rarely seen but it has made a significant revival in recent times. With the spread of pan-Indianism in the twentieth century both Western Indian dress and dance costumes have also been adopted for powwows.

Iroquois (Haudenosaunee) Embroidery Motifs

IROQUOIS MASKS

The Society of Faces (False Face Society) was (and still is) a curing society whose members wear wooden masks and perform appropriate rituals to eliminate sickness during visits to the homes of patients or in longhouse ceremonies. Tradition claims the forests are inhabited by strange quasi-human disembodied heads with long hair. These creatures agreed not to molest humans provided they were given offerings of tobacco and corn mush. In return they gave supernatural curing powers to dreamers, who carve their likeness in the form of wooden masks, often with tin-plate eyes. Through the mouths of these masks hot ashes are blown from the hands of the mask wearers onto the sick person without noticable burning. This removes the illness.

There are 12 types of masks based on their physical (mouth) characteristics.

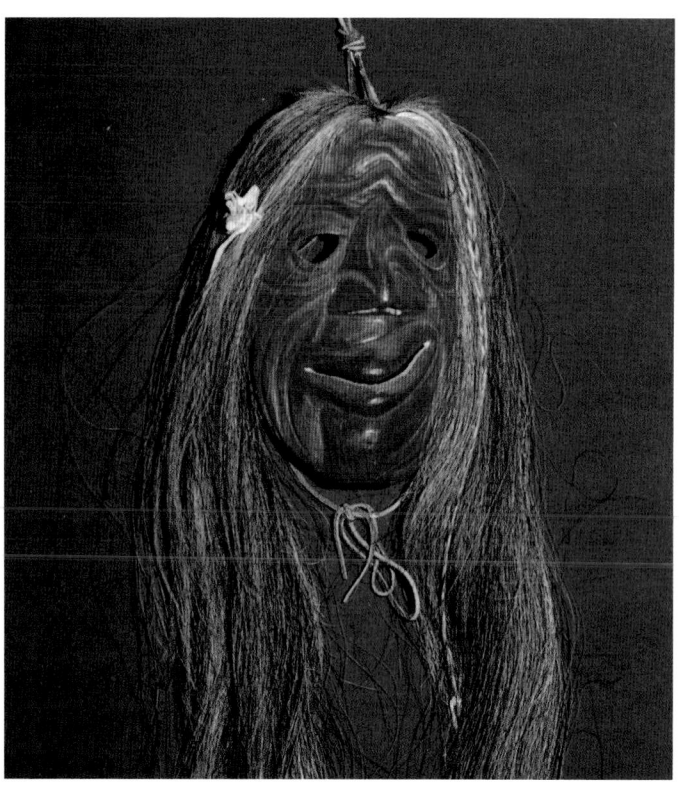

1. The crooked face mask, a form derived from the facially disfigured rim of world figure after a struggle with the Creator. Many are from Grand River Reserve, Ontario.
2. Masks with straight lips running the width of the mouth.
3. Spoon-lipped masks sometimes with a tongue notched over the nose; used in the doorkeeper's ritual. Many are Seneca from Allegany and Cattaraugus reservations, New York.
4. Hanging mouth, corners of the mouth are turned down.
5. Protruding tongue—perhaps to portray pain; many are Onondaga.
6. Smiling masks, sometimes used as beggar masks.

7. Whistling masks, with puckered mouths and wrinkles.
8. Divided masks, painted half red and half black.
9. Longnose masks, sometimes cloth or buckskin.
10. Horned or "buffalo" masks.
11. Animal masks—pigs, bears, and birds.
12. Blind masks, without eyes and metal plates.

Generally types 1, 2, and 7 are "doctors'" masks; the remainder are "common faces" and "beggars." Common faces become doctors with age, and wooden beggar masks graduate to common and doctor status also with age. Types 8–12 are forms used by the Secret Society of Medicine men.

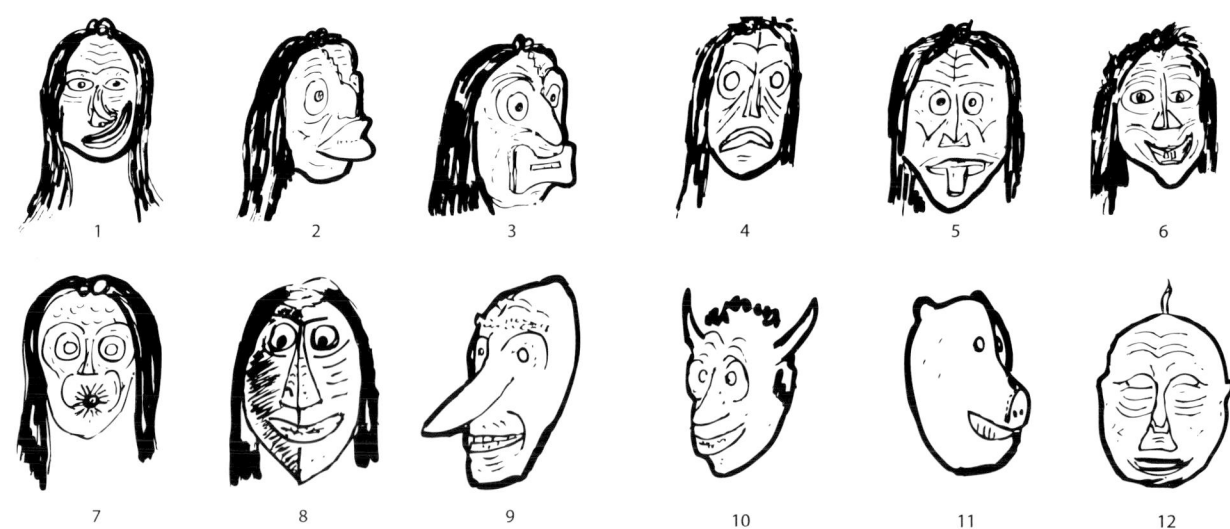

Note: The above classification is derived from *The False Faces of the Iroquois* by William N. Fenton, University of Oklahoma Press, 1987.

IROQUOIS BEADWORK

The earliest known Iroquois decorative media were various vegetable fibers, porcupine quillwork, and moosehair embroidery, including a technique known as false embroidery used for pouch shoulder straps, prisoner ties, and tumplines (burden straps). Bags and pouches were also created of buckskin decorated with quillwork. However, by the late eighteenth century, the next generation of pouches were made of buckskin and broadcloth substitute decorated with trade beads but using old traditional designs such as sun and star motifs, hearts, equal-armed crosses, and organic and double-curve motifs. A lively market for Iroquois souvenirs had been established in the eighteenth century by selling decorated objects to the British servicemen and by the early nineteenth century to white visitors to western New York and the environs of Montreal substantially increasing the number of Iroquois art objects made specifically for sale. Many of the earlier specimens are beaded with designs in very small beads in zigzag patterns, but by the 1840s beadwork was becoming more floralistic.

These new Iroquois decorative art forms were made possible through the availability of a wide range of bead colors and trade cloths, allowing the production of objects for sale. This played a crucial role in the subsistence of many families on several reservations being established in upstate New York and adjacent Canada. Building on a strong sense of design, they began to use glass beads on a wide range of delicately made hats, caps, purses, and other objects, not specifically for their own use but to sell to white visitors at such places as Niagara Falls, Saratoga Springs, Lake George, and even New York City. Changing styles in women's clothes gave rise to the use of handbags as a fashion accessory and the Iroquois fashioned bags and purses garnished at first with small seed beads in now half-forgotten symbols and motifs for the ladies of the period.

A relatively early reference to this type of handicraft is in a memorandum written by a "progressive" Allegany-Seneca, Maris Bryant Pierce, dated March 10, 1840. In it Pierce mentions wampum, moccasins, wallets, and work bags he displayed at a lecture about the Six Nations (Iroquois) which he gave to whites at Parsippany, New Jersey.

From the 1840s the Iroquois began to develop a style of floral beadwork which gradually satisfied the prevailing tastes of Victorian ladies, being

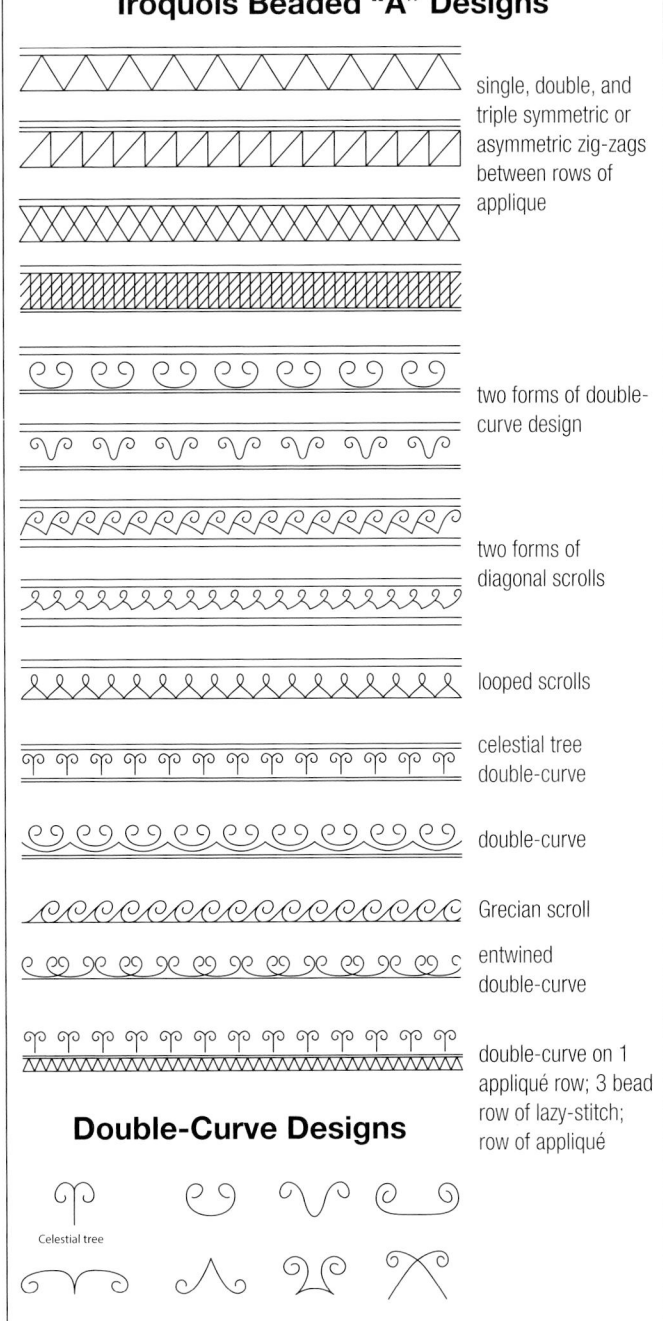

more reflective of European and white American tastes. This turned away from indigenous designs and the older floralistic designs fostered by the Ursulines two centuries before. A flourishing cottage industry developed, particularly on the Tuscarora reservation close to Niagara, and by the Mohawk of Caughnawaga (Kahnawake) close to Montreal.

The beading involves the so-called embossed or raised technique obtained by threading on more beads than required to span the design element so that when stitched the beads arch similar to the

Iroquois Beaded "B" Designs

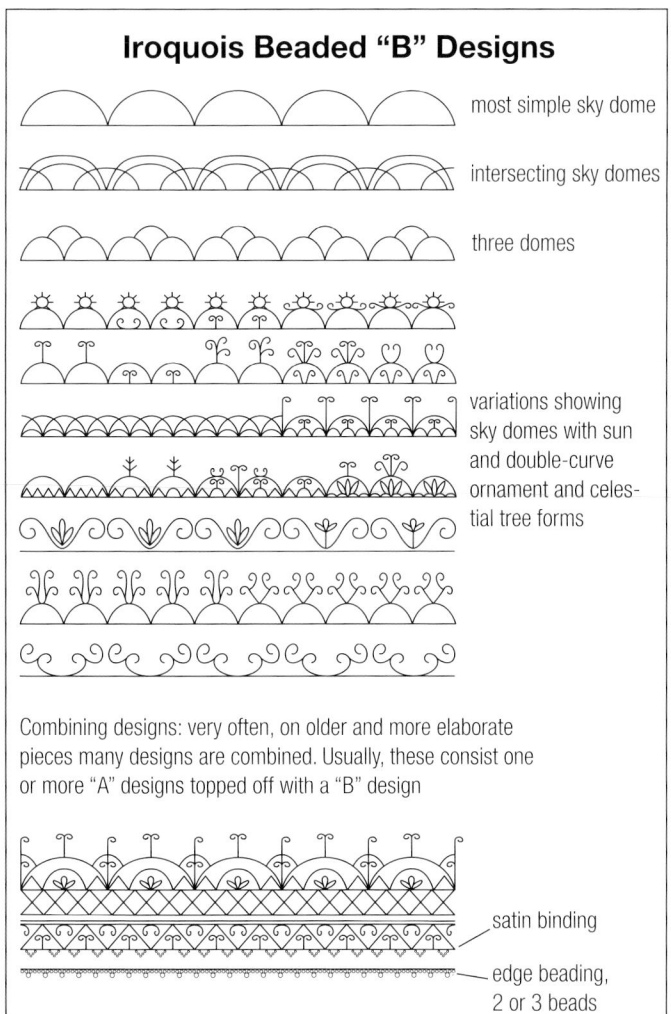

most simple sky dome

intersecting sky domes

three domes

variations showing sky domes with sun and double-curve ornament and celestial tree forms

Combining designs: very often, on older and more elaborate pieces many designs are combined. Usually, these consist one or more "A" designs topped off with a "B" design

satin binding

edge beading, 2 or 3 beads

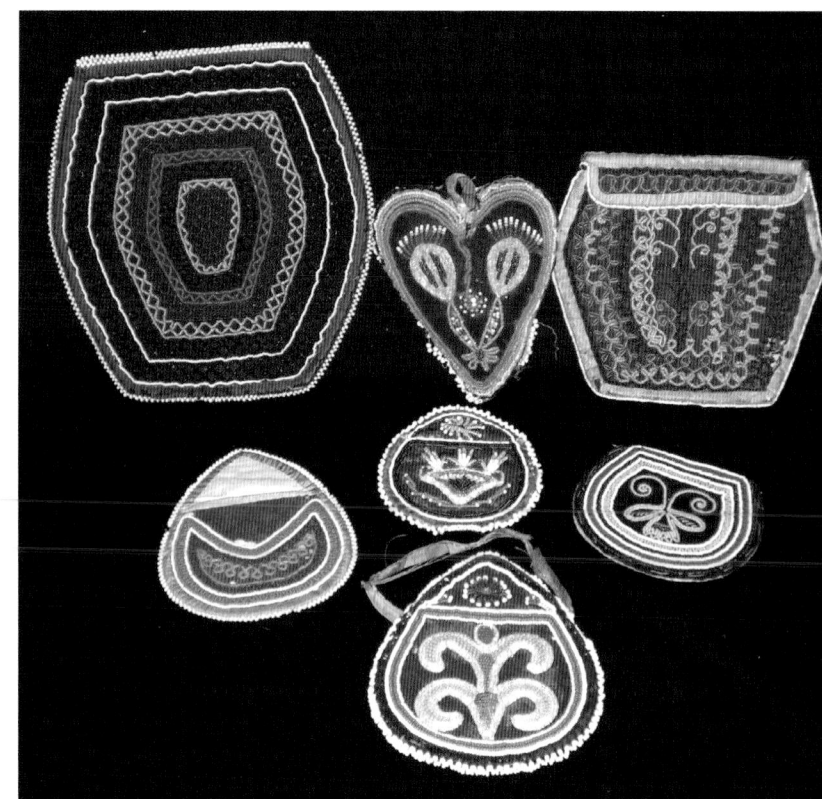

Plains Indians'"lazy stitch" but more pronounced. Often the beadwork follows a paper template positioned before the beads are fixed to the surface of the object. This is usually made of heavy wool or flannel, often red or blue, or later in velvet, in black or purple, and backed by a loosely woven cotton cambric or taffeta with edges finished with a cotton or silk tape. These embossed, bas-relief beaded objects were moccasins, pouches, caps, and glengarries (copied from the headgear of Scottish soldiers stationed in Canada).

Many pouches of the mid-nineteenth century also suggest the influence of the Scottish regiments by their

sporran shape, though this shows numerous variations. A number of needle cases and pincushions clearly exhibit the pre-1850 beading style and a number of stylistically similar pouches have been attributed to the Tonawanda Seneca around the same period.

However, toward the end of the nineteenth century through to the early decades of the twentieth, a new range of objects became popular with souvenir hunters usually called "Whimseys." These objects are usually beaded with larger beads, making raised flowers, buds, words, and dates, and are found in many forms including bags, pincushions, wall hangings, boots, shoes, and matchbox holders. Many objects are attributed to the Mohawk of Kahnawake, although exampes of this form of tourist ornament were sold throughout Iroquoia. Characteristic of these later objects are the long beaded loops hanging along the bottom edges. Specialist beadworkers continue these arts today.

Opposite, above: Iroquois beaded "A" designs used for simple borders on leggings, breechclouts, and moccasin cuffs.

Opposite, below: Iroquois glengarry cap, c. 1860. FB

Above left: A group of Iroquois beaded cloth purses with traditional geometric and double-curve motif designs. c.1830–1840 period. FB

Above right: Iroquois beaded "B" designs. "B" designs are almost always used to finish off "A" designs. Unlike "A" designs they are never used alone. The most common "B" design is the sky dome, and combinations and variations thereof. The sky dome may be ornamented in many different ways. Like "A" designs, "B" designs almost always sit on foundations of appliqué.

Below: Iroquois floral designs.

WOMEN'S AND MEN'S HOODS

The ethnologist Frank Speck reported in the early twentieth century that women's cloth-peaked hoods with a rounded lower front edge were a distinctive trait of the Penobscot tribe of Old Town, Maine. Photographic evidence also suggests that the Malecite (Maliseet) to the north in New Brunswick, Canada also wore hoods with a rounded edge, and early images of Abenaki women of Odanak, Quebec, and Passamaquoddy of Maine also suggest their women too followed this pattern. All of these groups are closely related and inter-married so it is not surprising to find similarities in their dress and material culture generally.

For several years the writer had a particularly fine example of a rounded bottom edge woman's hood in his collection (now in the Maine State Museum, Augusta). Seven others are known in various museums. This form is much rarer than the Micmac type with a squared off bottom edge. However, it is a matter of some debate if the hoods of these Maritime Algonkians are descended from some aboriginal prototype or from European influence because of a long association with French, Breton, and Basque fishermen whose own women also wore hoods. In addition the hoods which survive are made of cloth and velvet and heavily decorated with beadwork; they are clearly intended as showpieces of ceremonial wear and not intended for hard camp life.

Hoods were known throughout the Arctic, Subarctic, Parklands, Plains, and Woodlands and likely have aboriginal origins as protection against severe weather. Many were worn by women but others by men. Early artists such as Peter Rindisbacher in the 1820s drew Parkland Ojibwa and Cree hunters wearing peaked hoods with feathers attached. One curious form known in the Canada Parklands had two "ears" or double peaks and other similar hoods with exaggerated peaks are known from the Maniwaki Algonkin, Huron, and Ojibwa. About thirty women's hoods surviving in museums are attributed to the James Bay Cree and date from the early-to-mid nineteenth century. These are of trade-cloth construction with a square-cut bottom edge and are heavily decorated with floralistic beadwork and bead fringing.

The eight known Penobscot-Malecite women's hoods with rounded bottom edge are in the following museums:

• Cambridge University Museum of Archaeology and Anthropology, Cambridge, U.K.
• Saffron Walden Museum U.K.
• American Museum in Britain, Bath, U.K.
• Canadian Museum of Civilization, Quebec, Canada, (Speck's hood).
• New Brunswick Museum, St. John, New Brunswick, Canada.
• Maine State Museum, Augusta, Maine.
• Manchester University Museum, Manchester, U.K.
• University of Pennsylvania Museum, Philadelphia, PA.

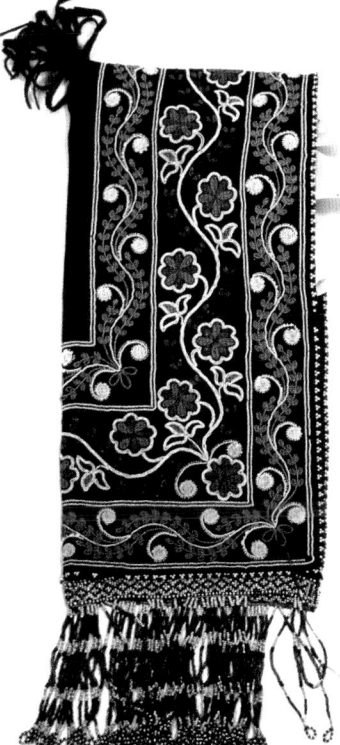

Above: Malecite (Maliseet) or Penobscot hood, c. 1860. Formerly MGJ

Far left: Malecite (Maliseet) child's hood, mid-nineteenth century. NBM

Left: James Bay Cree mid-nineteenth hood. BAM

SILVERWORK

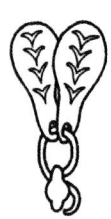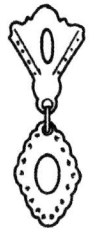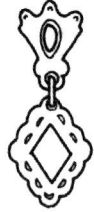

Silver crosses, beavers, rings, gorgets, ear wheels, hair plates, earrings, and brooches were very popular. A limited use of other metals such as tin, brass, iron, lead, and pewter can be found and of course, trade axes, adzes, hatchets, tomahawks, knives etc. There had also been some limited use of native mined metals, including lead, copper, and silver in prehistorical periods. Silversmiths became common among many eastern tribes and an incising art developed. The real silver remained available until about 1830 but later was almost totally replaced by German silver, also known as nickel silver, a non-ferrous alloy of copper, nickel and zinc developed in

incorporated Scottish and Masonic emblems into their brooches. Great Lakes peoples made circular hair plates and combs. Plains Indians made crosses, pectorals, and armbands, and women wore graduated circular plates hung from their hair or a belt. Later, German silver jewelry became associated with the Peyote religion, its members wearing brooches and earrings often showing an aquatic bird design. It is likely that early Plains metalwork influenced the popularity of the craft among the Navajo.

Above and Left: Examples of Iroquois German silver designs—brooches (left); pendants (below left); and earrings (above).

Below: Siota A Nonsuch, Niantic, c. 1915. At this time the Niantics were a few people living among the Mohegans in Connecticut. He wears a large silver brooch, gorget, and silver headband.

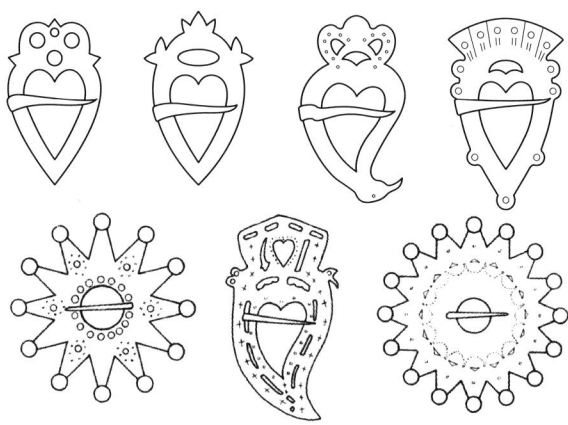

Germany as a cheap silver substitute. Sold or traded to Indians in flat metal form and characteristically hard, tough, and malleable, it became the vehicle of metalwork art of the Prairie and Plains Indians. Among the Prairie tribes such as the Sac and Fox circular brooches, combs, armbands, earrings, rings, etc. were manufactured, stamped, incised, or engraved.

The American Revolution greatly reduced the amount of trade silver arriving from Canada, after which the Indians made their own silverwork from coins and ingots, hammered, stamped, and engraved. After real silver was replaced by German silver the Iroquois often

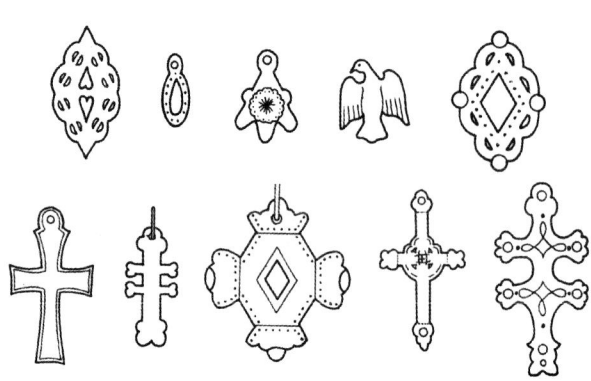

TWO EIGHTEENTH-CENTURY COLLECTIONS FROM MILITARY SOURCES

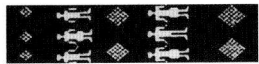

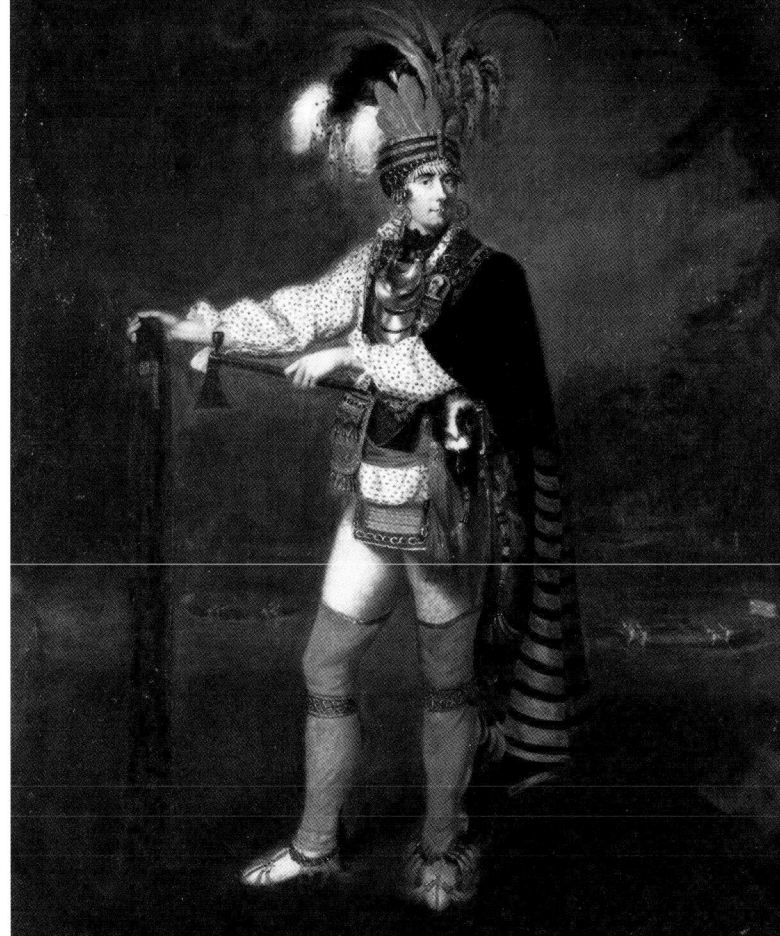

Above: Portrait of Lt. John Caldwell, dressed in Indian costume for an international council meeting at Wakatomica, Ohio on January 17, 1780. At the council with Delaware and other chiefs, a Cherokee from Chota produced a wampum belt he had received from the Americans urging their support (in the Revolutionary War), which was refused. This belt is likely the one shown in the portrait. Caldwell became Sir John Caldwell, Irish Peer, fifth baronet of Castle Caldwell, County Fermanagh, Ireland. He served in the 8th King's Regiment of Foot in the American War of Independence. Caldwell's portrait shows him holding a purple wampum war belt on which an axe or tomahawk is woven in white beads (likely the belt was provided by the Cherokee). His moccasins are typical Eastern Great Lakes type with fringes of hair and tin-cones. The leggings are red cloth and garters with beads woven in. He has a pouch of black color buckskin decorated with quillwork and beadwork. Across his shoulder hangs a knife sheath decorated with quills and beads. He has several silver gorgets and brooches. He holds an English trade tomahawk. Artist unknown, painted c. 1785. NML

Left: Wampum Belt of the Grand Alliance, De Peyster Collection, National Museums Liverpool. The imitation glass wampum design shows human figures holding hands meaning alliance, friendship or peace. Belt collected by Arent De Peyster a British military commandant at Michilimackinac from 1774 to 1779 and later Detroit. NML

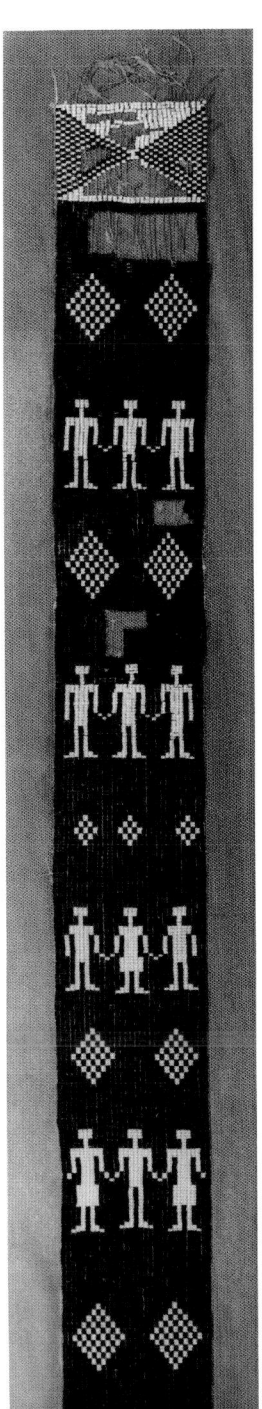

Two important collections of Indian material culture which survive from the Great Lakes region were collected by two British army officers, Arent Schuyler De Peyster (1736–1822) and Sir John Caldwell (1756–1830). De Peyster was of Dutch-American descent and served as deputy governor at Michilimackinac 1774–79 and later as governor of Detroit 1779–85. Sir John Caldwell later 5th baronet of Castle Caldwell, County Fermanagh, Ireland, served with the King's or 8th Regiment of Foot as an ensign at Fort Niagara from either 1774 or 1776 and then moved as adjutant to Fort Detroit. During 1776–80 he was mainly employed in contacting various Indian groups and counselling them to remain loyal to the British cause during the War of Independence. In this regard he visited the villages of Upper Sandusky, Chillicothe, and Piqua in late 1779. On January 17, 1780, he took part in a council at "Wakitomiky," probably the Shawnee village of Wakatomika then on the Mad River in Ohio. The Ojibwa named Caldwell "Apatto" or Runner.

After his return to Britain an unknown artist painted Caldwell in Indian dress with items he had brought back from North America. The wampum belt in his hands in the painting is likely the one the Americans had presented to the Cherokee to win over Indian support in the struggle but, affirming their loyalty to George III, they passed the belt to Caldwell. Through marriage connections his Indian collection and one portrait (apparently two copies were made) were acquired by a family in Derbyshire, England, whose descendants sold them to the German collector Arthur Speyer. Ultimately much was purchased by the National Museum of Man, Ottawa (now the Canadian Museum of Civilization, Gatineau, Quebec). The National Museum's excellent publication *Bo'jou, Neejee* pictured various items from the Caldwell relics.

During De Peyster's time at Michilimackinac, renamed simply Mackinac by the British, Caldwell was employed "delivering the King's presents to the Indians," so the two men were probably well acquainted. In 1780 De Peyster,

Caldwell, and Alexander McKee (a trader married into the Shawnee) were in council with the Potawatomi and in 1785 De Peyster was at Fort Niagara with chiefs of the Iroquois. At various times he met Delaware, Munsee, Mingo, Wyandot, and Shawnee representatives. De Peyster settled in Dumfries, Scotland, after the Revolution, his wife's home. It is believed his papers and Indian relics passed to the Dumfries Museum and Public Library, from them to the Museum of the King's Regiment, Seaforth Barracks, Liverpool, and thence on loan to the Merseyside County Museum in Liverpool (now National Museums, Liverpool, U.K.). Among the De Peyster material are approximately 20 ethnographical items and one of the remaining Caldwell portraits.

BEADWORK OF THE GREAT LAKES INDIANS AND SOUTHERN ALGONKIANS

The beadwork of the Great Lakes Indians, the Ojibwa, Menominee, and their southern relatives the Potawatomi, Sac, Fox, and Kickapoo, including sometimes the work of the unrelated Winnebago, has provided us with some outstanding artistry in beads. This is even more remarkable if we recognize that most of the complex nineteenth and early twentieth century beadwork of these peoples was executed without any recourse to reusable "patterns" except for some floral cutouts used for fairly late appliqué embroidery. In general the bead-work falls into two major stylistic categories, the north-ern (Ojibwa) and the southern (Potawatomi, Kickapoo, Sac, and Fox) with the Menominee and one band of Potawatomi forming a marginal division between the two.

The techniques used in the beadwork of the second half of the nineteenth century were undoubtedly derived from old (probably aboriginal) methods of producing sewn and woven porcupine quillwork and weaving vegetable fibers, animal hair, and later unrav-elled trade wool blankets. The first of the two major beadwork techniques was woven beadwork which can "stand by itself" (without backing) usually executed on a wooden loom comprising two fixed ends onto which threads (warps) are run lengthwise. The beads are strung on a separate thread (weft) to run between and over the warps and then back through the beads on the underside of the warps. This method is often called the single-warp method. A second weaving technique is sometimes called the double-warp method which involves a set of warps set up as in the single method but with a second movable set of warps attached to a wooden heddle so that a whole row of beads can be laid across one set of warps and trapped between each thread by moving the heddle up to its original position. Thus two rows of beads can be woven in one complete movement of the heddle. This method is faster than the single-warp method and lends itself to the production of wide sashes, and shoulder straps and panels for ban-dolier bags, whereas the basic single-warp method is used mainly for narrow garters and headbands. There were a number of complex variations of these tech-niques including weaving beads in an over and under fashion using the single-warp style and several methods of edging, some using extra white beads at the ends of each row to give a sash a wider appearance.

Another woven technique once popular with the Potawatomi, Sac, Fox, and Menominee was the side-stitch or diagonal weave employing double threads.

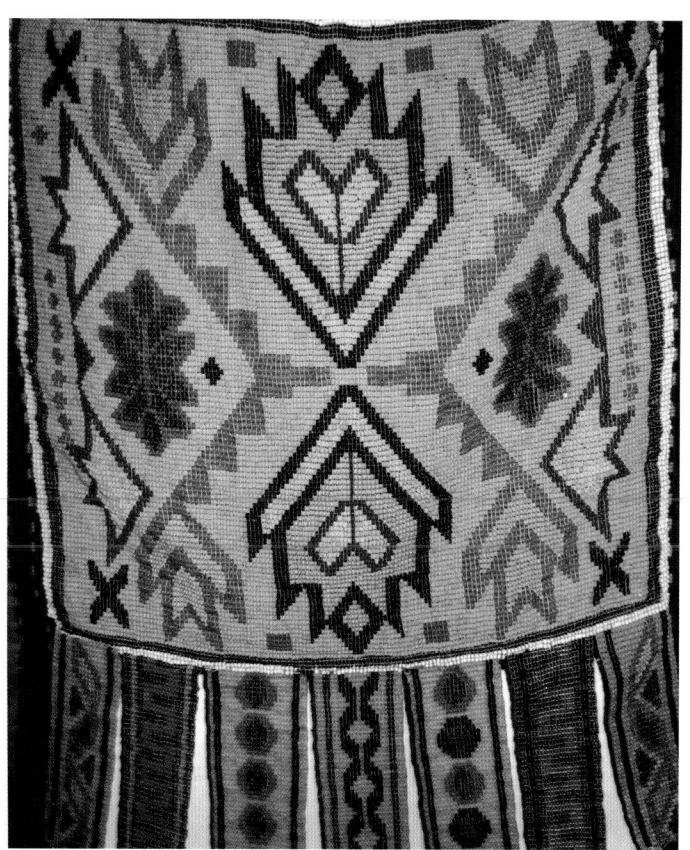

Above: Detail of a loom-woven beaded bandolier bag front panel with tab extensions. Geometric patterns perhaps derived from a thunderbird design simplified to "X" motifs. Ojibwa (Chippewa) c. 1890. MGJ

Below: Back view of an Ojibwa (Chippewa) man's shirt with panels of black velveteen decorated with floral beadwork. Photographed by Jonathan Smith at Leech Lake Powwow, Minnesota.

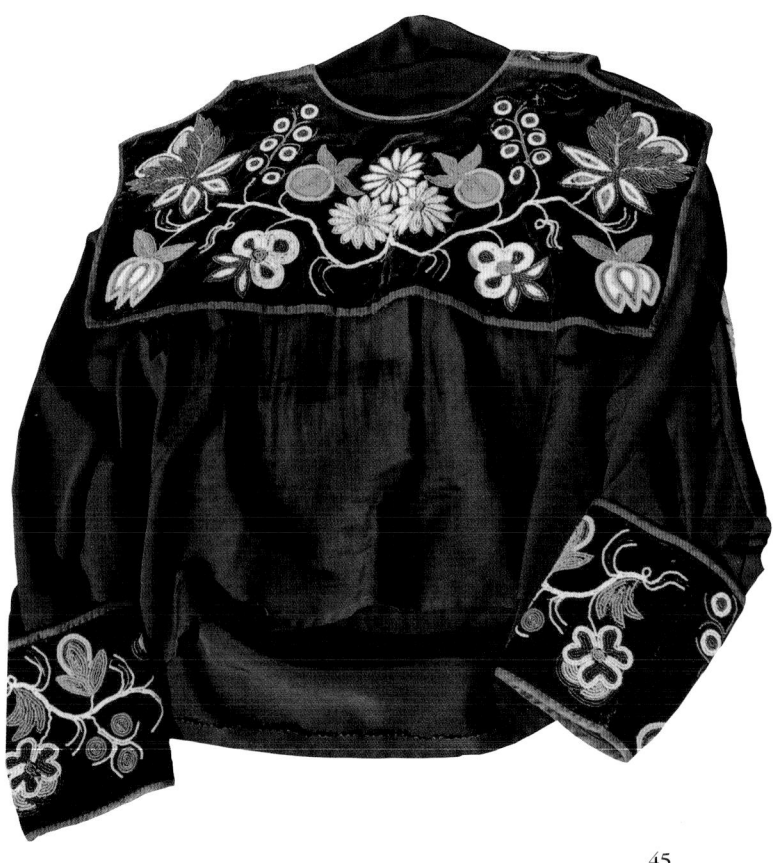

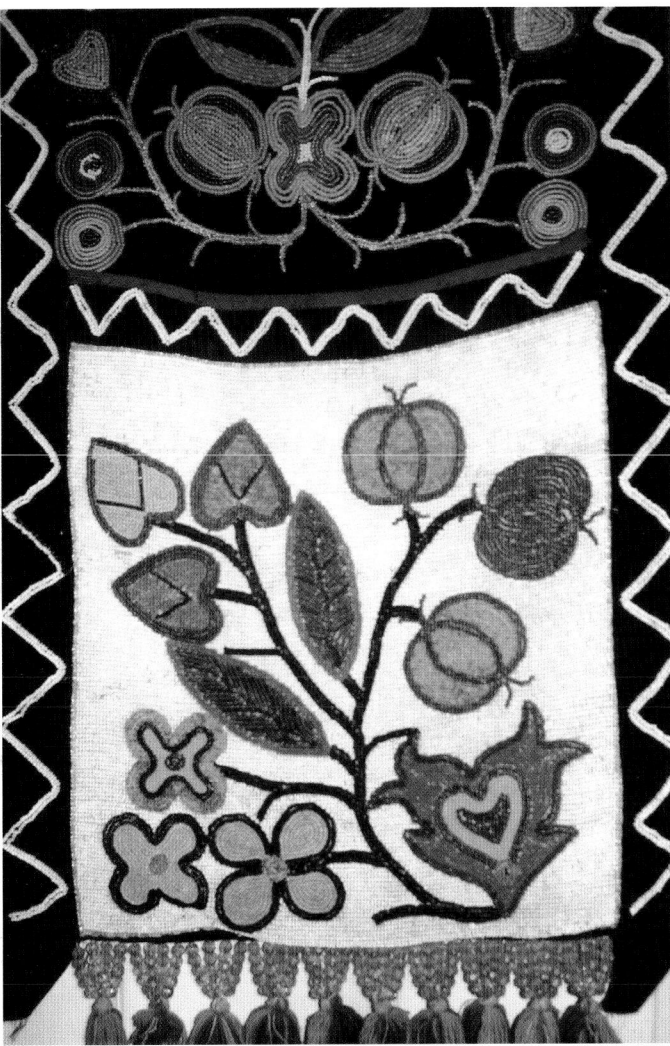

Above: The front panel of an Ojibwa beaded bandolier bag with floral patterns popular in the late nineteenth century. Note the simplified border designs indicating a fairly late example, c. 1900. MGJ

Right: Examples of loom-woven beaded sashes all probably Ojibwa (Chippewa) except the one on the extreme left which is likely Potawatomi, c. 1900. MGJ

Opposite: Mesquakie ribbonwork blanket. UCMAA

This was principally used for narrow trailers attached to women's hair-binders. A type of lace-work or net-work was also occasionally used by the Potawatomi and Menominee.

The second major beadwork technique was appliqué or spot-stitch bead embroidery applied directly to buckskin or trade cloth and more recently onto dark-colored wool cloth and velveteen. The main characteristic of this technique is that it employs two threads, one to string on the beads, the other to sew (or couch) down every second or third bead. The outlines of the designs (mostly floral)—flowers, buds and leaves—were done first, usually by a single row of beads in the case of the Ojibwa and Menominee and double rows by the southern tribes. The Ojibwa filled in the flowers by following the contours of the designs while the southern tribes preferred to fill in their designs

with rows of beads horizontal, vertical or diagonal to the contour rows of outlines. The appliqué technique gave the greatest freedom to the beadworker for her floral designs, including allowing realistic representations of oak and maple leaves, though these are frequently shown sprouting from the same stem (often black or blue). As many as thirty-six different colors and shades of beads have been noted on a single article of beadwork. The Ojibwa and Menominee often used cut, metallic, and transparent beads, which gave their dance costumes an enhanced effect.

Although the Ojibwa often translated leaves and flowers into woven beadwork, most woven work has geometric designs of lines, triangles, blocks, squares, and arrow shapes, many in highly complex patterns. By the eighteenth century, women who had originally worn skin and strap dresses now wore broadcloth garments made after the fashion of the skin dresses. During the second half of the nineteenth century velveteen dresses, with full skirts partly beaded with large floral designs, became popular, sometimes with cloth leggings and moccasins with decorated collars. Among the southern Ojibwa, black velveteen became the favored material for various garments, creating a contrasting background for glass beads. Men's ceremonial regalia of the nineteenth century had also developed from buckskin into blue and red strouds and trade blanket cloths.

The thread sewn leaf-floral beaded designs that adorned Woodland native dress in the second half of the nineteenth century may not have descended directly from those of the French Renaissance that so influenced the seventeenth-century Huron and Micmac pupils at the early Quebec convents.

Bandolier bags, both the woven geometrically beaded and the floral appliqué forms, were sewn to heavy cloth backgrounds and became important objects of personal adornment when worn during social, festive, or religious gatherings. They were worn either singly or in pairs across the shoulders by either sex and may have developed from eighteenth-century European frontiersmen's ammunition pouches or native equivalents. By the late nineteenth century wearing bandolier bags reinforced cultural vitality and Indian identity at ceremonials during a period when Indian traditions were fast disappearing in everyday life.

ARTS, CRAFTS, AND COSTUME OF THE SAC AND FOX

Among the Southern Woodland and Prairie tribes of the Midwest the Sac (Sauk) and their close relatives the Fox (Mesquakie) have some of the most colorful and finest arts and crafts.

The artist George Catlin made several paintings of Sac and Fox Indians. His painting of Keokuk of 1835, "The Watchful Fox," gives several important clues to their costume and regalia of the early nineteenth century: the roach with an eagle feather which has a shaft of quill-work along the spine; a large bear-claw necklace spaced with large trade beads; a woven assumption sash around his waist; a V-shaped fur cape which has beadwork and hair fringing; buckskin leggings, perhaps of the front-seam type, with beadwork, garters, and hair fringes; ankle-collar moccasins with a strip of decoration along the front instep; a red trade blanket; and a large shield rather like the Plains type. His arm and wrist bands seem to be metal.

Keokuk's wife and son were also drawn. Catlin describes her dress "which was of civilized stuffs" as "truly a most splendid affair; the upper part of it being almost literally covered with silver brooches." A shawl, necklace and earrings, skirt, cloth leggings, and toe-seam moccasins completed her attire. The boy wears a V-shaped cape like his father's, necklace, cloth leggings, and toe-seam moccasins; he also holds a recurved bow. The painting of Pash-ee-ph-ho (Little Stabbing Chief) is important as it shows one of the earliest representations of a "Crow belt," a warrior-society emblem among many Prairie tribes. Other drawings of Sac and Fox Indians indicate the use of bison robes, gun stock warclubs, fans, decorated calumets, the use of painted hands decoration for themselves and horses, hand drums, rattles, bow and arrow cases. A mounted drawing of Keokuk shows decorated horse gear.

Catlin's pictures of Sac and Fox Indians show their costume to be similar to the Iowa, Oto, and Pawnee, and less like that of the Great Lakes Algonkians at this time, although their origins and linguistic relatives were in that area.

The general sameness of Iowa and Sac costumes was described by Skinner in 1926: "The Sauk indeed, with their ornate and gorgeous costumes, seem to have set the fashions for a number of peoples of alien stocks with which they have been associated since Black Hawk's defeat. The writer is convinced that the majority of the grizzly bear claw and otter fur necklaces seen upon Ioway, Oto, Osage, Ponca, Kaw, and even Pawnee chiefs and warriors in early photographs, are of Sauk, or possibly Fox manufacture." Peter Rindisbacher's painting "War Dance of Sauks and Foxes" (McKenney and Hall, 1933) gives us more clues regarding their early nineteenth-century costume. Several types of headdress, some apparently representations of turban styles, are shown, as are front-seam single-piece moccasins with collars, buckskin leggings supported at the waist, and gun stock clubs. The use of a Woodland type "log" drum is a departure from Catlin's hand drum of the Plains type.

Another interesting image is that of Nesouaquoit, a Fox chieftain, by Charles Bird King painted in 1837; he too wears a V-shaped fur cape, presumably similar to that of Keokuk, also he has a woven turban with interwoven beads which was a characteristic of the Sacs and Foxes of the nineteenth century. "Kish-ke-kosh," painted by Cooke in Washington D.C. at the same time as King painted Nesouaquoit, wears a horned bonnet of bison hide and holds a feather banner reminiscent of Plains Indians. "Wa-pel-la" by King wears another fur cape and woven turban.

King's painting of Keokuk and his son Musewont, also painted in 1837, appears to show him wearing the same V-shaped fur cape that Catlin painted him wearing when visiting him at his village 60 miles above the mouth of the Des Moines River, as referred to above. His son wears moccasins which show one of the earliest representations of beaded decoration in the stylized "Prairie" floral form which became so popular later on, and would tend to suggest an earlier date for its inception than hither to indicated. One of the earliest pictures of Keokuk was a painting by J. O. Lewis made at Prairie du Chien in 1825 or 1827. He is pictured holding a feather banner, wearing a Crow belt, and has painted hands on his chest; he wears flap moccasins, and knee and arm bands.

Karl Bodmer's painting at St Louis in 1833 shows a group of Sacs and Foxes wearing robes and head roaches, and holding banners and stone-headed clubs.

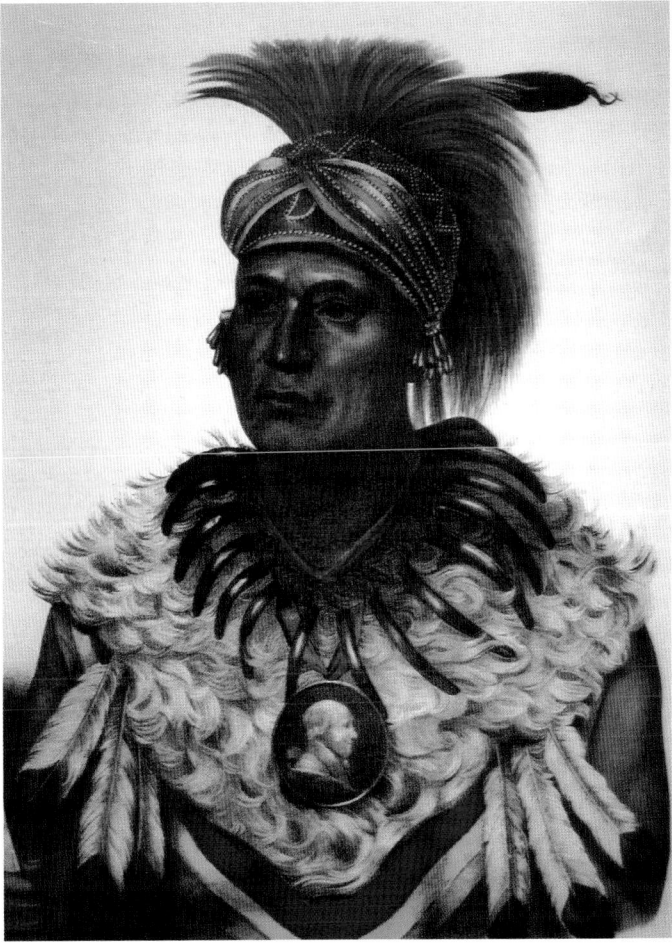

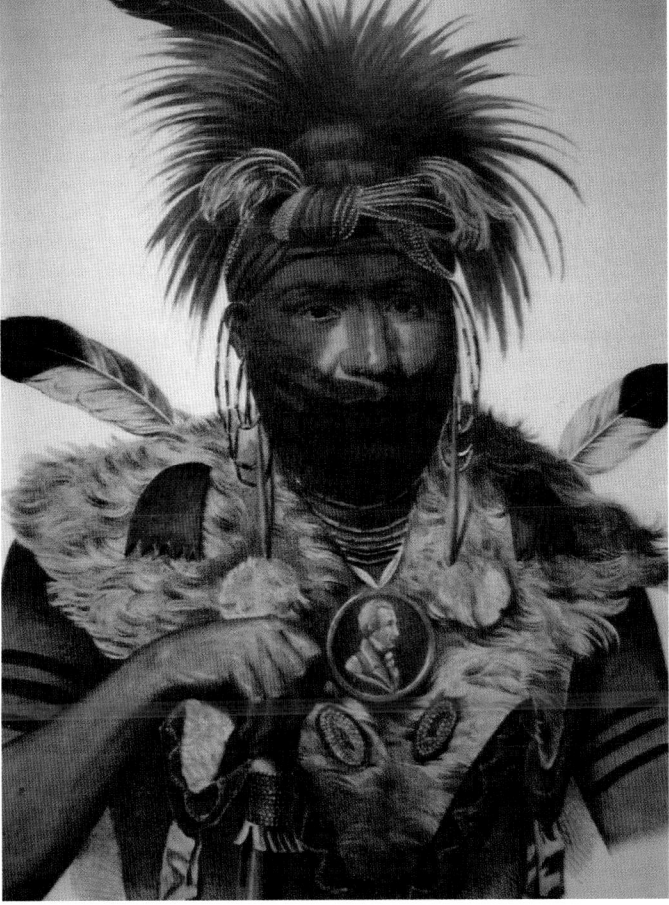

One warrior appears to be wearing a Plains Indian-type buckskin shirt. The very similar representations of the costumes of male Sac and Fox by Catlin, Bodmer, and King suggests the faithfulness of their work and hence their considerable importance in estimating early material culture.

The earliest photographs of the mid-nineteenth century indicate no real change, save the advent of cloth and calico shirts; V-shaped fur capes, metal arm bands, fur and woven sash turbans, earrings, and bear-claw necklaces were still popular and remained so, the bear-claw necklace being a mark of rank or prestige. In fact very little adoption of alien costume seems to have taken place at this period.

A mention of front-seam leggings is appropriate, as several chieftains are pictured wearing them in the 1860s, though few survive in museum collections. The man's leggings in the Owen Collection (q.v.) are a rectangular fringed deerskin form, similar to the ones described and pictured in Skinner's work on the Iowa.

A brief survey of published data in American collections with Sac and Fox costume, mostly nineteenth century material, shows a common use of broadcloth decorated with ribbonwork for skirts and blankets, a wide use of beadwork, and limited quillwork. Of rare material there survives: woven bags of Indian hemp, modern yarn, nettle fiber, woven reed mats, wooden bowls and spoons (carved and notched types), mortars and pestles, stone corn crushers, a little clay pottery, wooden cradle boards of the Central Algonkian type with a curved head bow, painted trunks (not envelopes of the Plains type), many pipes with quilled stems, medicine bags, and many small woven beaded bags, with animal, panther, human, thunderbird, and geometric designs, elkhorn scrapers, elkhorn-handled quirts, and rawhide-covered wooden saddles. In many instances their material culture is very similar to other Algonkian and Siouan peoples particularly the Potawatomi, Menominee, and Iowa.

The Sac and Fox are known to have made all the main forms of porcupine (and bird) quillwork—appliqué, plaited, wrapped, and netted—with the probable exception of woven quillwork common among the Cree. Beadwork was produced on wooden frames, or a variant side-stitch or diagonal-weave form, mostly seen on women's hair trailers. Loom beadwork was used to ornament items such as leg garters, sashes, bags, and bandoliers and was usually in geometrical designs. Floral beadwork designs varied from realistic to abstract, mostly in a form known as the "Prairie style" where beads are run across the leaf element not following the contours as in the common northern style. They share a same general style with the Iowa, Oto, Prairie-Potawatomi, Menominee, and Winnebago.

THE OWEN COLLECTION

This collection of Sac and Fox material was made by Mary Owen of St Joseph, Missouri, and presented to the London Folklore Society by her in 1901. She also produced a book, published in 1904, *Folklore of the Musquakie Indians of North America*, which is a catalog of the collection, to which she added chapters on religion. Shortly after the presentation the collection was transferred to the Cambridge [England] University Museum of Archaeology and Anthropology where it remained largely unnoticed until the early 1970s. A second collection was donated by Owen to the Missouri State Museum in 1931. Owen never married and died in St Joseph in 1935.

The Cambridge collection consists of 193 objects (109 catalog entries) including photographs; the Missouri collection contains 67 objects. The Cambridge collection is important since it concentrates on one particular tribe the Fox of Tama, Iowa, but it does lack important objects such as bear-claw necklaces and otter-fur turbans. Skinner, Harrington, and Milford Chandler

all made impressive collections from the Fox later than Owen. However, the Owen collection is an important documented collection from one group, made over a hundred years ago—despite the problems with her dubious descriptions of the shamanic paraphernalia and the supposed religious content of the largely social dance ornaments.

The Sac or Sauk (Osakiwug), "people of the outlet" or "people of yellow earth," and the Fox, a term of unknown origin, or Mesquakie, signifying "red earth people," are two closely related Algonkian tribes of Wisconsin, who successively moved south during the eighteenth century, occupying parts of Illinois, the Rock River country, and Iowa. American pressure and the Black Hawk War of 1832 forced the two tribes to unite in Iowa and after 1842 they moved to Kansas. Between 1859 and 1867 they were forced to sell their lands and as a result a number, mostly Fox, returned to Iowa, purchased land near the

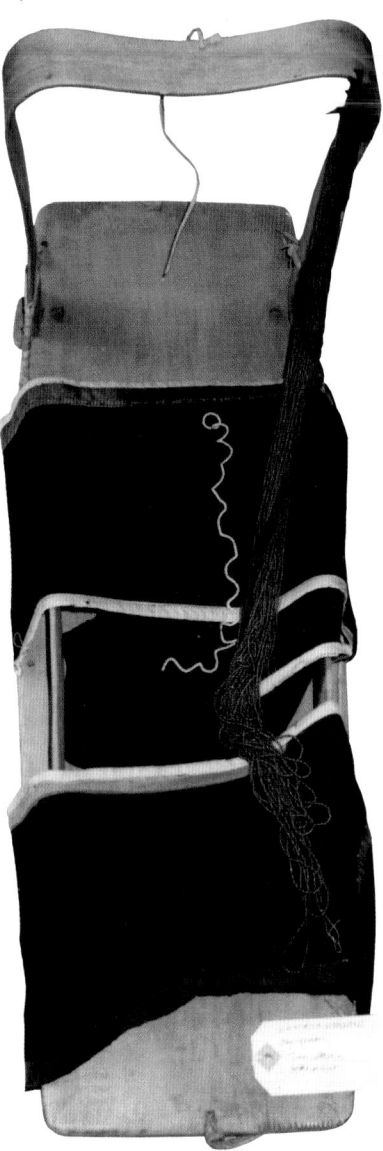

Above: Typical Mesquakie beadwork patterns.

Above right: Mesquakie cradle, late nineteenth century. Owen Collection No. 98 UCMAA

Left: Moccasins. Owen Collection No. 65 UCMAA

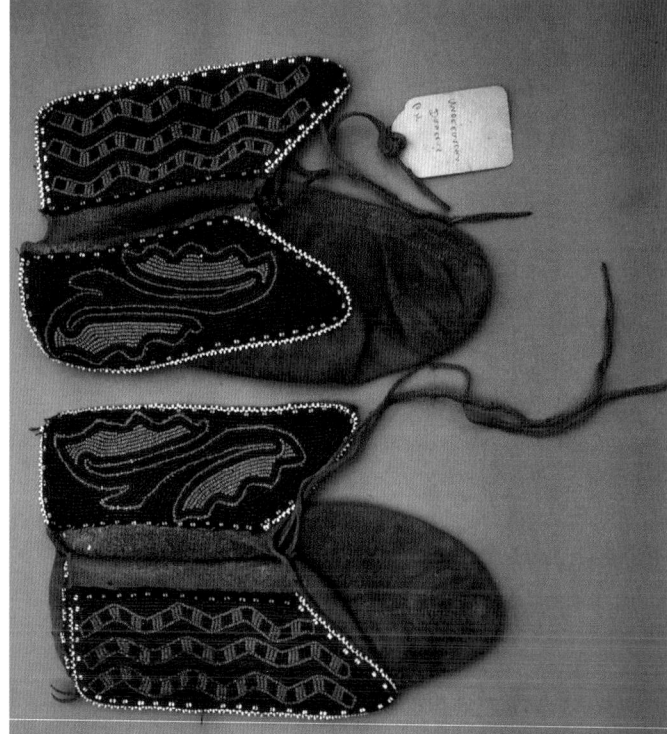

Opposite, above: "Wapella, The Prince," Fox (Mesquakie) chief, from a lithograph of a painting by Charles Bird King during a visit to Washington D.C. in 1837. He signed treaties with the U.S. at Ft. Armstrong in 1822 and 1832, also Prairie du Chien 1830. He wears a woven turban with interspaced beads and a fur cape and bear claw necklace. Published in McKenney and Hall's *The Indian Tribes of North America*, 1933–34 edition.

Opposite, below: "Nesouaquoit," a Fox (Mesquakie) chief, from a lithograph of a painting by Charles Bird King during a visit to Washington D.C. in 1837. He wears a braided or woven wool turban and a fur cape edged or lined with red wool trade cloth.

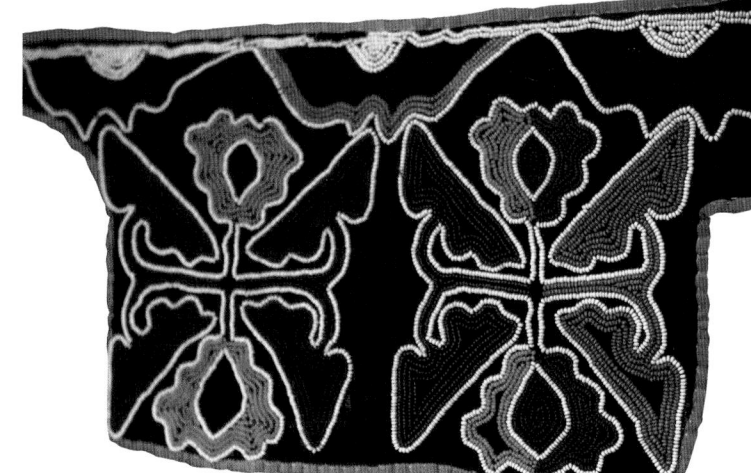

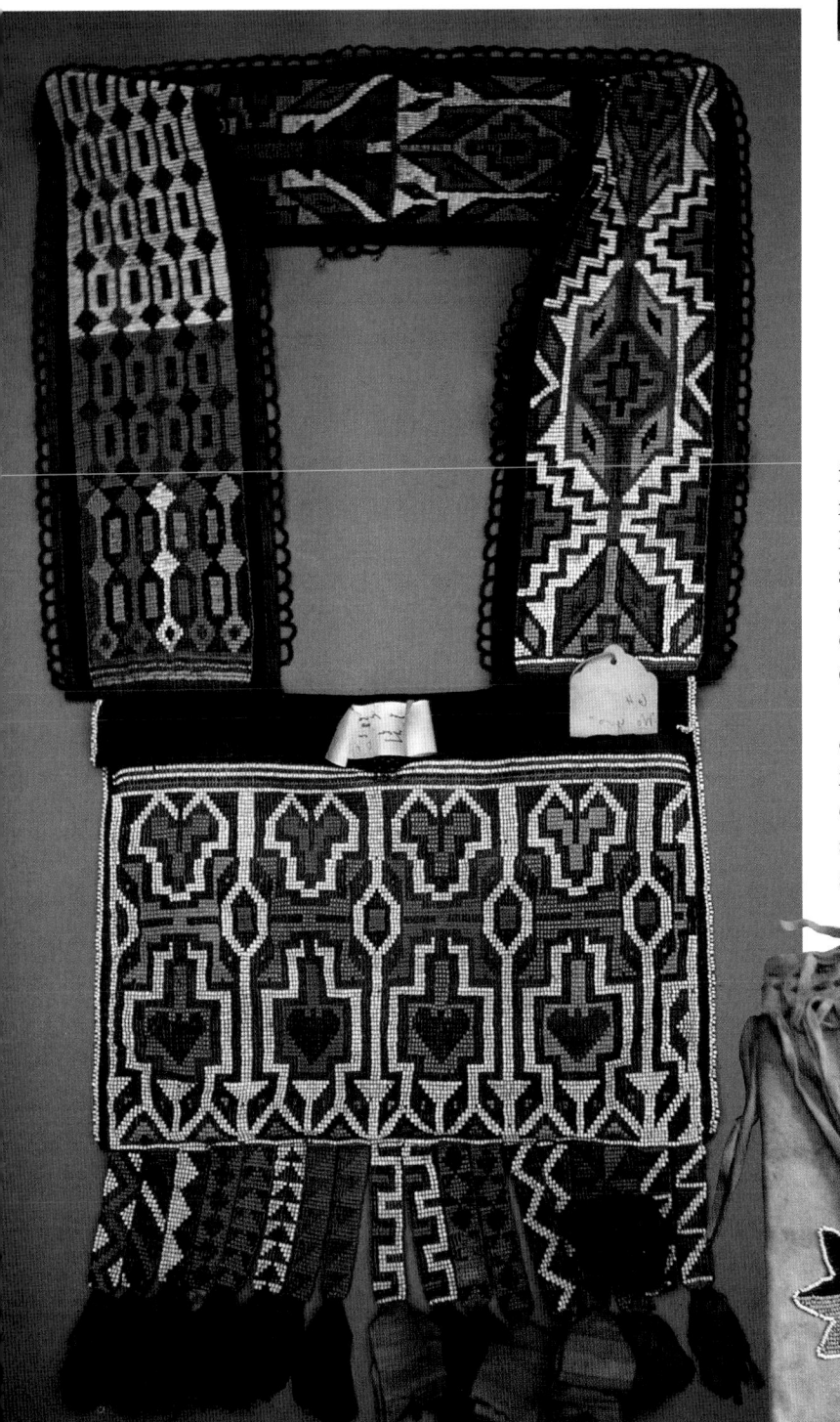

in Ritzenthaler (1956), which show the general sameness of moccasins, beadwork designs, rectangular skin leggings, cradle boards, ladles, silverwork, and feather shaft ornamentation. However, Skinner queries the use of buffalo hide shields of the Plains type as shown in a Catlin painting—these were no longer recalled by the Oklahoma Sac during his time among them.

A review of the Owen collection, which included consideration of Owen's almost unique standing as a female folklorist at the time, has recently been published (Brown, 1997). However, the non-Mesquakie material and some of Owen's unconvincing commentary on the symbolic and religious associations of various objects was not recognized.

Above right: Beadwork detail from a blanket. UCMAA

Above: Bandolier bag.

Left: Buckskin tobacco pouch, Sac and Fox, Iowa branch (Mesquakie), with stylized floral beaded designs, late nineteenth century. UCMAA

Opposite, above: Osage ribbonwork on a blanket and a woman's skirt. Probably early twentieth century. NMAI

Opposite, below: Osage, Oklahoma, ribbonwork for a blanket; Donald Drefke Collection, early twentieth century.

present town of Tama and have lived there from that time until the present. In 1867 the majority of the remaining Sac and Fox (mostly Sac) removed to Indian Territory (now Oklahoma), with a few remaining in Kansas. The Tama people, now called the "Sac and Fox tribe of the Mississippi in Iowa," had remained a highly traditional group at the time of Owen's connection with them, perhaps only the Mexican Kickapoo were a more native-orientated Woodland group at that time. Comparative material with Oklahoma Sac can be found in Skinner (1925) and with the Kickapoo

RIBBONWORK

Ribbonwork (also known as appliqué, silk appliqué, or ribbon embroidery) was made historically of silk or silk cloth, recently of rayon, satin, or taffeta, or other man-made fabrics.

Ribbons became a popular decorative medium during the fur trade period, dependent upon the proximity of European traders. The term "appliqué" here means sewing a fabric of one color on a background of another color. The earliest examples were simple strips sewn to a fabric base; the ultimate style included the use of complex positive–negative designs, often composed of mirror images. The various forms establish a relative chronology stretching back more than 200 years.

The earliest stage of the chronological sequence begins with the stitching of a straight strip of ribbon onto any item, though usually cloth-ing (skirts, moccasins, leggings, hoods, etc.). The second stage defined as the "Developmental Style," can be recognized by either the addition of a second layer of ribbon or the process of slit-ting the ribbon at ninety degrees to its length, creating flaps which are turned under and sewn down, producing a saw-tooth design. The increased complexity of designs in this "Developmental Style" was derived from repeated and mirror images or asym-metrical designs and color reversals, usually in geomet-ric or simple curve shapes, in some instances with a lane of bead embroidery included.

The third level of com-plexity, called the "Shingled Style," involves successive layers of ribbons which overlap each other like shingles on a roof. Most of the designs thus formed were composed of an odd number of ribbons with an additional ribbon form-ing the center. Sometimes the design is outlined by piping.

The fourth level of complexity is expressed as either a "Positive" or

"Negative" Style, depending which layer of ribbons creates the central design figure or element. When the figure rests on top of the layers it is termed "Positive," and when the top pairs of ribbons are cut away and the resulting bilateral figure is on the bottom, this is deemed "Negative." The key defining fea-ture of both of these styles is the central seam not present in the "Developmental Style."

This art form appears to have been developed only after the introduction and innovative use of imported trade goods, rib-bons, scissors, needles, and thread and occurred in a 3,000-mile arc embracing the Canadian Maritimes, Maine, the St. Lawrence River, James Bay, the Great Lakes, the Prairie, and Oklahoma. The his-torical connections, and conflicts between the Abenaki, Iroquois, Huron, Ojibwa, Cree, Métis, and the numerous Great Lakes tribes, and the west-ward moves and forced settlement in Oklahoma map the probable and possible routes of dif-fusion of the art.

From an histor-ical perspective the "Development Style" was typical of the Northeastern tribes (Micmac) and James Bay (Cree). One "Shingled Style" appears first in northern Indiana and Ohio (Miami) before moving west to Iowa, Kansas, and Oklahoma. Another style derived from the Métis of the Great Lakes seems to have been used by the Menominee of Wisconsin and probably others during the first half of the nineteenth century. The "Positive Style" comes from the Midwest, while the "Negative Style" appears only in Oklahoma (Osage), and probably both developed during the nineteenth cen-tury. By the mid to late nineteenth century floral and floral abstract designs had sup-planted geometrical designs among some of the resettled Oklahoma and Prairie tribes of the Midwest. Ribbonwork is still very popular for the decoration of women's cloth powwow dresses.

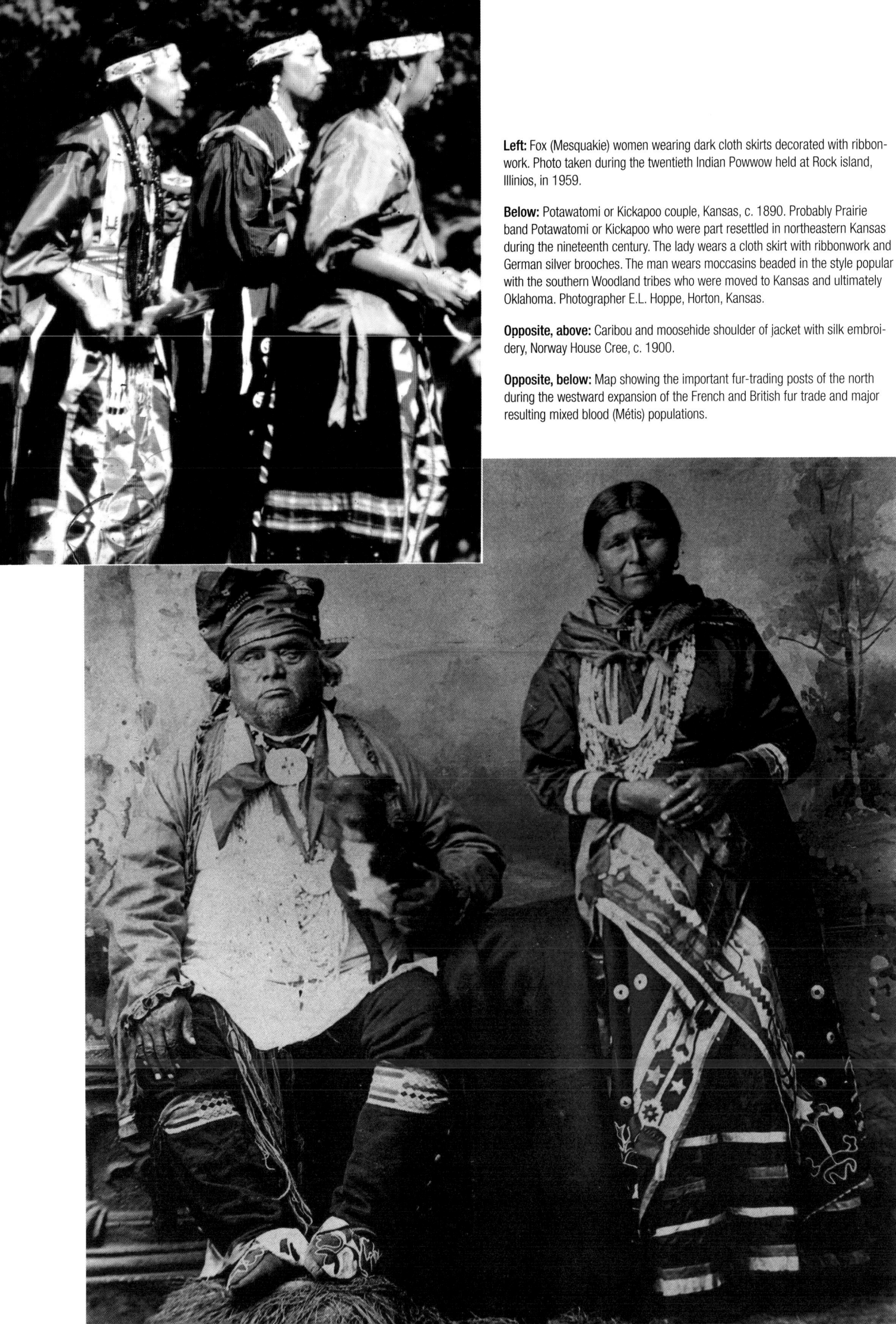

Left: Fox (Mesquakie) women wearing dark cloth skirts decorated with ribbonwork. Photo taken during the twentieth Indian Powwow held at Rock island, Illinios, in 1959.

Below: Potawatomi or Kickapoo couple, Kansas, c. 1890. Probably Prairie band Potawatomi or Kickapoo who were part resettled in northeastern Kansas during the nineteenth century. The lady wears a cloth skirt with ribbonwork and German silver brooches. The man wears moccasins beaded in the style popular with the southern Woodland tribes who were moved to Kansas and ultimately Oklahoma. Photographer E.L. Hoppe, Horton, Kansas.

Opposite, above: Caribou and moosehide shoulder of jacket with silk embroidery, Norway House Cree, c. 1900.

Opposite, below: Map showing the important fur-trading posts of the north during the westward expansion of the French and British fur trade and major resulting mixed blood (Métis) populations.

FLORAL DESIGNS IN NORTH AMERICA

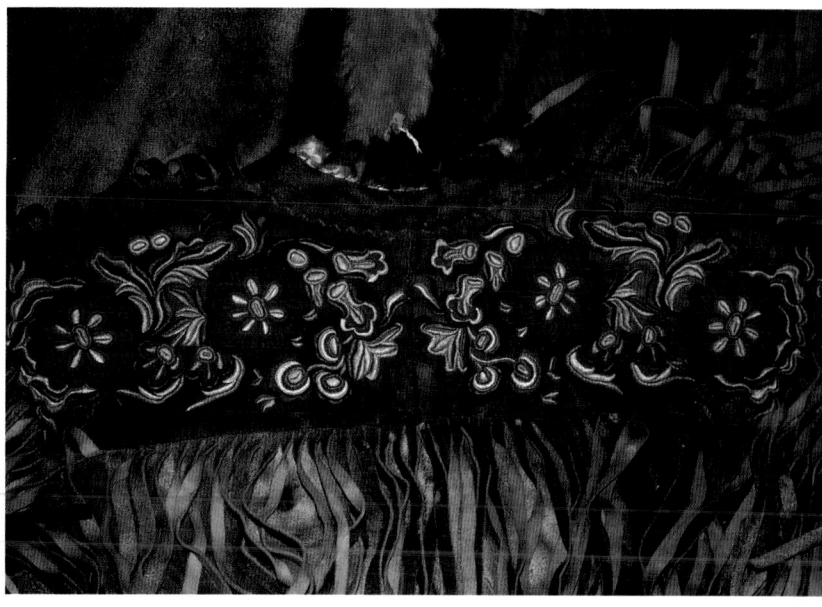

Geometric motifs were traditionally used by Woodland Indians, for quillwork, painting, and later beadwork. These geometric abstractions were often representational images of animals, birds, and humans on rock paintings, birchbark, pictographic memory scrolls, drums, pipes, quilled or woven bags, and cradleboard covers. An example is the so-called otter-tail pattern which is made up of diamond and extended hexagon shapes said to represent the action of an otter sliding on ice. Symmetrical, double-curve motifs, frequently found in the art of the Maritime Algonkians, are also found in the Great Lakes region.

Many art historians have yet to agree whether the presence of flowers and leaves in Indian art evolved from indigenous sources or came only from the result of European influences. There is some disputed evidence that incipient foliate designs existed before European contact in quillwork and also on etched and scraped bark work and subarctic painting. In 1647 Daniel Gookin reported colored flowers on baskets made by New England Indians.

It would seem likely that a people who traditionally claim to be integral to the natural environment of North America would have all manner of floral imagery represented in their religious art. However, this appears not yet proven to be the case, at least for truly realistic floral

Map: Fur-Trading Posts

Hudson Bay

James Bay

NORTHERN ATHABASCAN MÉTIS
19TH–EARLY 20TH CENTS

Ft. Edmonton 1795

Ft. Pitt 1831

MERGING PAN – MÉTIS MID – LATE 20TH CENT.

Cumberland House 1772

York Factory 1670

Nelson House 1750

HBC ROUTE

SCOTTISH & ENGLISH CREE MIXED BLOODS 18TH – EARLY 19TH CENTS.

Oxford House 1798

Ft. Severn 1685

BRITISH TRADERS 1670 ON

Great Whale River 1813

Ft. George 1800

Ft. Nascopi 1838

Ft. Nichikun 1700

Norway House 1800

Ft. Carlton 1810

Ft. a la Corne 1748

ALBERTA & SASKATCHEWAN PRAIRIE MÉTIS 19TH CENT.

Chesterfield House 1791

NON – STATUS INDIANS 19TH – EARLY 20TH CENTS.

Ft. Pelly 1791

Ft. Dauphin 1741

Ft. Qu'Appelle

Ft. Esperance 1783

Brandon House 1794

Ft. Assiniboine 1794

MERGING RED RIVER MÉTIS EARLY 19TH CENT.

Ft. Maurepas 1733

Ft. St Charles 1732

FRENCH – OJIBWA GREAT LAKES – MÉTIS 18TH CENT.

Osnaburgh House 1786

Martin Falls 1794

Ft. Albany 1683

Henley House 1741

Eastmain 1685

Rupert House 1668

Mistassini 1673

Moose Factory 1672

HBC ROUTE

Brunswick House 1744

Chicoutimi 1650

Tadoussac 1600

Ft. McKenzie 1832

Ft. Union 1828

Ft. Berthold 1845

Ft. Mandan 1804

Pembina 1797

Ft. St. Pierre 173

Ft. Nipigon 1678

Grand Portage 1688

Ft. William 1717

Michipicoten 1700

L. Superior

Sault Ste. Marie 1751

FREE NATIVE TRADERS 17TH & 18TH CENTS.

Abitibi 1686

Temiscaming 1626

FRENCH TRADERS C.1600 ON

Trois – Rivières 1634

Ft. Coulonge 1680

QUEBEC

Montreal 1642

FRENCH TRADE ROUTE

Lisa's Post 1807

Sheyenne River 1825

Fond-du-Lac 1692

OTTAWA AND HURON REFUGEES Ft. Chequamegon 1661

MISSOURI VALLEY SIOUX – MÉTIS 19TH CENT.

Ft. Beauharnois 1727

Ft. de la Baye des Puants 1670

Ft. Mackinac 1712

MACKINAC MÉTIS 18TH CENT.

L. Huron

Kingston 1673

L. Ontario

Oswego

Ft. Orange 1614

GREEN BAY MÉTIS 18TH – 19TH CENT.

Prairie du Chien 1686

L. Michigan

Ft. St. Joseph 1691

Ft. Detroit 1701

BRITISH

Ft. Niagara

L. Erie

AMHERSTBURG MÉTIS 18TH CENT.

IMPORTANT FUR-TRADING POSTS OF THE NORTH DURING THE WESTWARD EXPANSION OF THE FRENCH & BRITISH FUR TRADE AND MAJOR RESULTING MIXED BLOOD (MÉTIS) POPULATIONS.

MISSISSIPPI VALLEY MÉTIS 18TH – 19TH CENT.

OHIO VALLEY MIXED BLOODS 18TH CENT.

⊙ IMPORTANT FUR TRADE CENTRES

→ EARLY FUR TRADE ROUTES

→ SECONDARY DIFFUSION

→ MAJOR DIFFUSION

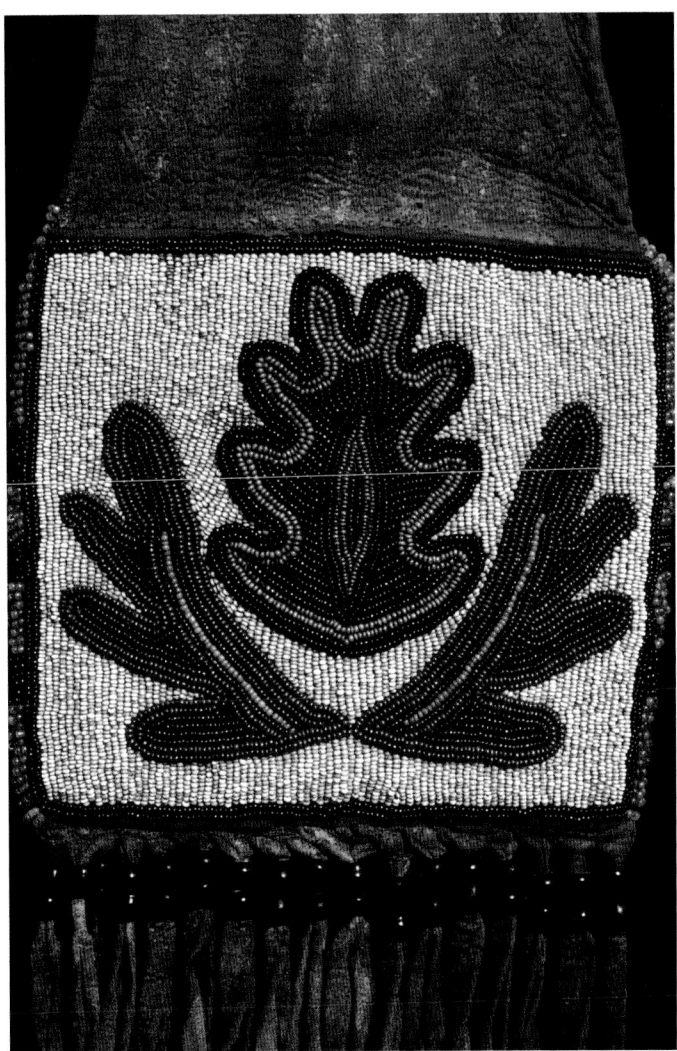

Montagnais (Innu) every summer at Tadoussac, and a network of trade routes was spreading via the rivers and lakes to the vast interior. It is not clear if the westward progression and influence of the fur trade posts on the shores of James and Hudson Bays had introduced a distinctly British influence on floral art to this area. By 1755 Anthony Henday of the Hudson's Bay Company was trading with the Blackfeet and exposing the western tribes to European materials, trade goods, and perhaps floral art. We can speculate that floral quillwork, beadwork, and silk floss embroidery likely pre-date the establishment of the Catholic mission schools at Red River and Fort Chipewyan, although these are often credited with design and technique refinements. It is certain that their classes in domestic arts included lessons in sewing and embroidery, with floral assemblages being produced in various media that had the breath of Europe about them, but balanced in volume of opposing forms and colors.

The introduction of floral embroidery to the Huron and other eastern Indian women by the Ursuline nuns of Quebec during the seventeenth century post-dated European contact by a century and is unlikely directly to have stimulated the later floral beadwork of the Great Lakes Indians 200 years later. If, as many believe, floral designs are totally European, the western spread of the fur trade, their employees, the Métis, and missionaries all combined to develop the artwork of the western tribes together with the availability of new materials such as cloth, beads, thread and needles.

The Métis were not one single ethno-cultural people, whose identity developed only at Red River, Manitoba, and which then disseminated to other areas of the western interior and subarctic Canada following the rebellions of 1870 and 1885. Other major centers of Métis people also existed in the Woodlands, Parklands,

designs, although curving, recurving, and leaf-like patterns occurred on pre-historic ceramics. We now know, from better research, that realistic floral designs have considerable age in North America, at least as far back as the 1640s when French Ursuline nuns in the St. Lawrence Valley introduced their floral designs, and probably various techniques of embroidery, to young female neophytes who were probably already versed in a native repertoire of curving forms and designs. European explorers had already made a considerable number of landfalls along the Atlantic seaboard, and Jacques Cartier had contacted at least two villages of Iroquoian peoples on the St. Lawrence over a hundred years before, taking two young male Iroquois back to France before returning them to their father.

By the second half of the sixteenth century the French were trading with the

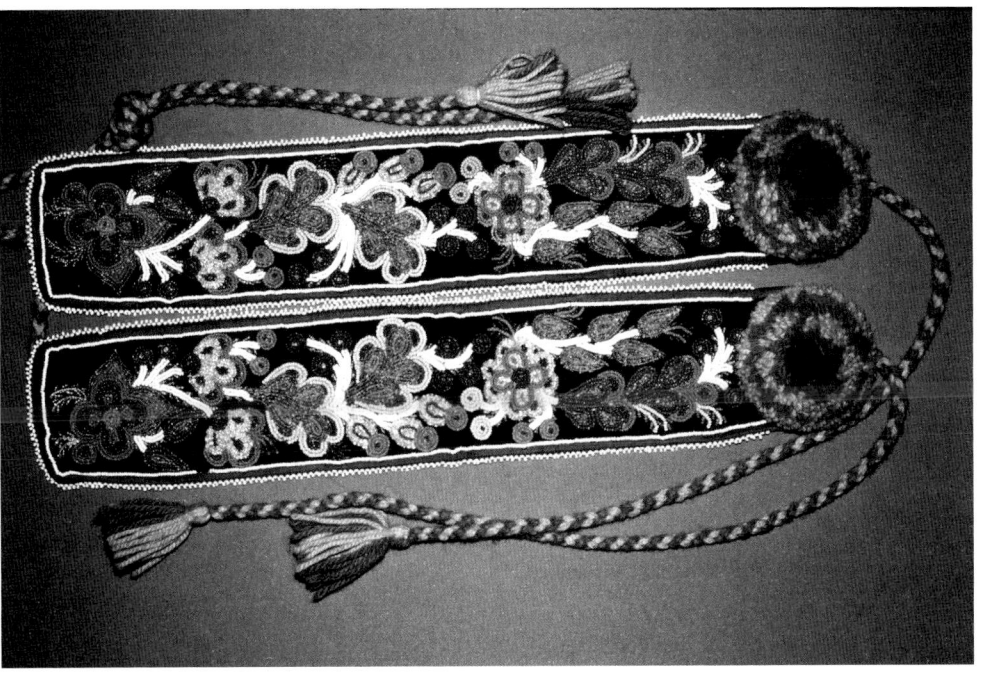

and Subarctic, and several predated Red River. Some of these communities were distinct—they were never a unified cultural people and often had different interactions with Indian tribes. The suggestion that the Métis were the only agents of distinctive Europeanized decorative patterns to Indian women artists is certainly misleading, as both Indians and Métis attended Catholic mission schools. Consideration also should be made of the impact of Protestant schooling, particularly on Scots-Métis, and their different experience and craft traditions. The Métis and other-mixed descent people have mistakenly been given credit for being the only spreaders of realistic floral art in North America.

Old double-curve designs and four-petaled flower designs gradually became more complex floral beaded compositions of flowers, leaves, and fruit with borders of white line beadwork, ribbon or braid edging, and black velvet panels that often harmonize with the beadwork. Northern European settlers in the U.S. Midwest are also now thought to have provided another source for some nineteenth-century floral designs in Indian art. Throughout the nineteenth and twentieth centuries, porcupine quillwork in floral patterns was used to decorate all manner of birchbark boxes, dishes, and trays. The quills were applied in tight push-through patterns creating a raised textured effect. Most of this type of craftwork was produced for the souvenir trade.

Floral painting appeared on Cree–Northern Ojibwa coats of the late eighteenth and early nineteenth centuries and on carved and painted Mohawk cradleboards, which appeared in the nineteenth century, but neither seem to have definite indigenous origins—there is more likely a European folk-art genesis.

However, it has been sewn beadwork which has provided the largest quantity of floral art across the North American continent. Although there was little attempt to classify such work until recently, there are some quite recognizable stylistic variations, dependent upon area and period. Museum staff and private collectors can now classify such work into area and sometimes tribal attributions.

Opposite, above: Beaded panel of a Cree tobacco pipe bag, c. 1900. HV

Opposite, below: Cloth garters with beadwork, Norway House Cree, c. 1900.

Above: Collection of cut-out designs of paper rather than birch bark. Ft. Totten Reservation, North Dakota. These were used as patterns for beadwork and other crafts. Santee Sioux, collected by Louis Garcia, 1978.

A SUMMARY OF FLORAL BEADWORK FORMS

The floral beadwork of the Nascapi and Montagnais appears quite rustic in style and angular with backgrounds filled in with white beads. There are also a number of fur-covered bags with areas of beadwork. However, the so-called East Cree on the east side of James Bay produced fine beadwork during the nineteenth century particularly on women's hoods. Much of this beadwork is sinew-sewn but couched down with thread in white, pink, green, blue, and yellow colors.

The Northeastern Algonkians (Wabanaki) executed floral beadwork on coats, leggings, capes, collars, caps, hoods, moccasins, and pouches dating from about 1800 to 1910. Their most distinctive art motif was the double-curve, a series of the inward-facing symmetrical designs common on Micmac work, used in conjunction with floral patterns, zigzag boarders, and ribbonwork edging. The Malecites near Fredericton, New Brunswick, and the Penobscot and Passamaquoddy of Maine produced a delicate floral style on objects made for sale at coastal tourist resorts in the form of moccasins, pouches, and belts. Some New England groups also made souvenir beadwork somewhat resembling the Iroquois type, probably in imitation. The Mohegan or Connecticut and Montauk of Long Island have known examples of this work.

Early nineteenth century Iroquois beadwork also used double-curve motif designs, although their form was usually outward curving, combined with a large number of old symbolic and celestial images at first on skin and later on red and dark cloth. Dating from about the 1840s huge quantities of beadwork were made for the souvenir markets at Niagara Falls, Montreal, and Saratoga Springs using an embossed technique similar to the lazy-stitch style of the Plains. The technique was achieved by a longer bead-filled thread than the area covered, resulting in a slight bulge outward from the surface of the material to which the beads are sewn. Large numbers of pouches and moccasins were made with this style, increasingly in Victorian-inspired heavy floral designs. The Mohawks of Caughnawaga and the Tuscarora living near Niagara Falls were the principal beadworkers of this style. A considerable amount of this work found its way to Europe and was once quite commonly seen at antique markets.

Floral beadwork that decorated ceremonial clothing and accessories of the Indian groups of the western Great Lakes was hugely popular from the middle of the nineteenth century on. This used European-introduced glass seed beads in eye-catching graceful curving designs in multicolors of leaves, vines, and fruits, or simple floral forms, but did not usually copy actual flowers. Bandolier bags or friendship bags (as they were often made as gifts or for exchange) gave the beadworkers large areas to show their skill in creating a variety of floralistic shapes, balanced asymmetrical designs, and beautifully controlled composition. The beadwork is tightly sewn in appliqué or couched stitching using two threads, one to string the beads and a second to tack down every two or three beads.

Floral appliqué beadwork of the Ojibwa and Menominee of the Great Lakes region is probably the finest and most distinctive of all, reaching a climax of beauty in the decoration of large bandoliers or shoulder pouches with a main panel completely filled in white or pearl beads. Floral beadwork was used for most ceremonial costuming from the mid-nineteenth century onwards. These Indians nearly always employed a dark broad cloth or black velveteen as a base on which to work when the background was not to be filled in.

A few details which may lead to the identification of the typical Ojibwa style are

a. Large spread-out flower patterns each element having two or more shades of the same color with a gradual transition.
b. The floral units have an outline row of beads.
c. The veins of the flowers are traced through the flower.
d. Except for bandolier bags and floral-decorated cloth regalia and costume, backgrounds are seldom filled in.
e. Both symmetrical and asymmetrical designs are popular.
f. The bead filled threads nearly always follow the contour of the design and in the spot-stitch (appliqué) technique.

The Southern Algonkians, the Potawatomi, Kickapoo, Sac and Fox, and the Siouan Winnebago also developed floral appliqué beadwork but filled in their designs rather than following the outline contour like the Ojibwa. The Santee Sioux of Minnesota had at least two styles of floral beadwork which had a striking resemblance to the early quilled patterns of the Canadian Red River Métis and Cree-Ojibwa and probably introduced to the Santee by Métis traders. One form involved floral work in lazy-stitch technique; the other was similar to the Prairie style of the Southern Algonkians who were moved west during the nineteenth century.

A distinctive Delaware–Shawnee style of floralistic beadwork seems to have developed with these tribes after they were forced west to Kansas, Nebraska, Texas, and ultimately Oklahoma during the nineteenth century. The design elements are often large with opposing color segments (e.g. red – blue or green) in each conventionalized motif, giving a positive – negative effect. The

style is most prominent on bandolier bags which may connect with the Southeastern tribes such as the Creek and Seminole, where the Shawnee had long standing connections, and where they, and the Delaware had acted as scouts for the U.S. military during the Seminole Wars. While many examples of Creek and Seminole beadwork pre-date their removal west in the 1830s, the surviving examples of this type of Delaware and Creek beadwork combined with the Southern Algonkian style to form the so-called "Prairie style" of the nineteenth century. After the Delaware settled in Oklahoma there appears to have been some interaction with the Kiowa, who seem to have adopted some Delaware motifs when beading their cradleboard covers.

Prairie style floral beadwork was often executed on blue trade cloth, and adorned women's skirts, men's vests, aprons, front-seam leggings, and flap moccasins (the last two items usually buckskin). Beadwork runs the whole range from realistic floral to pure abstract and the designs may also be of animals, hands, flaps, etc. Occasionally the style is encountered on Winnebago and Menominee medicine bags. As well as featuring differing design elements, this style of beadwork is quite distinct from that of the northern tribes in the method of bead application. While both styles use the appliqué or spot-stitch technique this southern style is a fill-in bead layout with an outline of one or two rows of beads of a sharply contrasting color forming the contours of each design element. In the northern areas the infill follows the contours of the flowers and occasionally some floral beadwork combines the two types. It has been suggested that this style of beadwork developed on the Old Nemaha Reservation of the "Sauk of the Missouri" with perhaps the Iowa, Oto, and Missouri tribes as alternative innovators. However there was no indication of this type of beadwork in the paintings of George Catlin in the 1830s, but by the 1860s and the time of early photographs, tribal representatives of the Sac, Fox, Kansa, Prairie Potawatomi, Winnebago, Iowa, Oto-Missouri, Omaha, Ponca, Osage, Quapaw, Pawnee, and to a lesser extent, Menominee, Forest-Potawatomi, and Wisconsin Winnebago (who also shared the Great Lakes style) were wearing clothes decorated in this style. It remains hugely popular and has continued to be made among the present day Oklahoma Indians for male dancers' aprons and some designs have been transferred for women's skirts and dresses for dance outfits using ribbonwork as a substitute or alternative to beadwork.

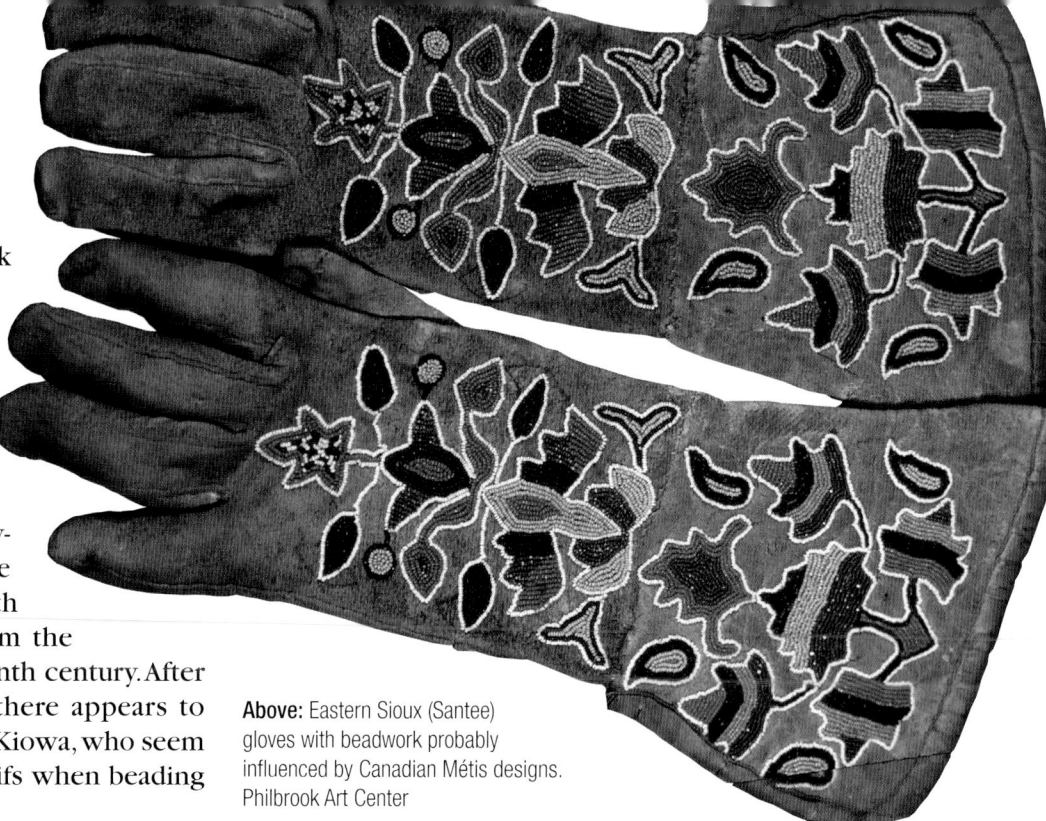

Above: Eastern Sioux (Santee) gloves with beadwork probably influenced by Canadian Métis designs. Philbrook Art Center

Below: Winnebago (Young Eagle) Chakshebneeneik wearing a bandolier bag. H.H. Bennett photo, c. 1890.

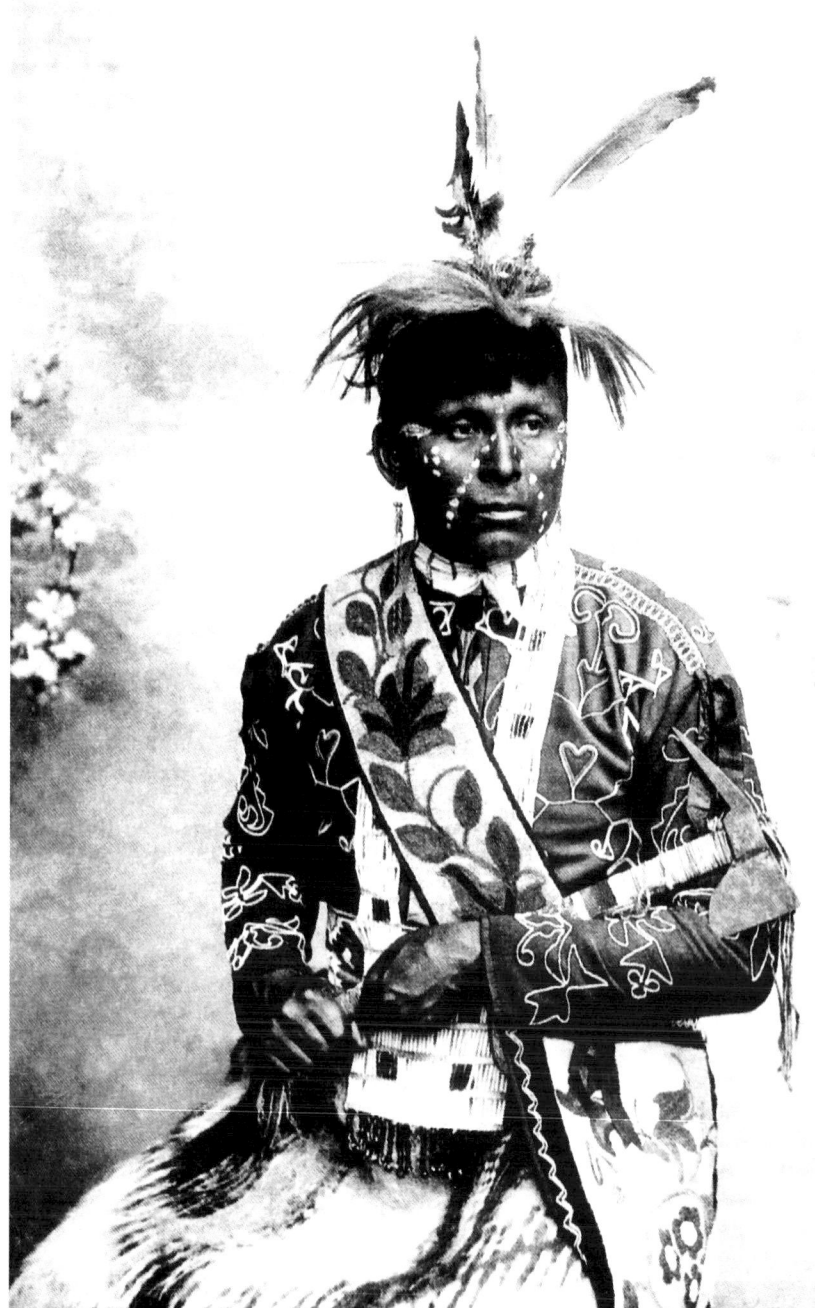

DELAWARE SHAWNEE STYLE

Some realistic floral silk embroidery was produced by the Cherokee on buckskin coats made in the nineteenth century but does not survive in abundance in museum collections. The typical beadwork designs of the Southeast were curvilinear but can be called "floral" only in the vaguest terms. However, after removal west, some of these southeastern design elements may have influenced the style which developed among the Delaware and Shawnee in Kansas, Nebraska, Texas, and later Oklahoma. This style is usually symmetrical with opposing color segments in each conventionalized element and is most prominent on cloth bandolier bags, which may also indicate southeast influence. Although some Shawnee bags have a truncated V-shaped flap, most Delaware bags appear to lack this detail. It is also probable Shawnee, Delaware, and Creek beadwork of the nineteenth century provided an input to the so-called Prairie-style or southern-style beadwork in curvilinear forms, which became popular among the Missouri Valley and Southern Great Lakes tribes resettled in the same areas during the nineteenth century.

Although the Creeks certainly produced beaded bandolier bags before removal there is little evidence that the Shawnee and Delaware did so before they too were forced west by whites after the Revolution. Typically their earlier bags were black buckskin with porcupine quillwork of the type associated with the eastern Great Lakes people. After the Delaware were settled in Oklahoma there appears to have been some interaction with the Kiowa, who in turn seem to have adopted some Delaware beadwork motifs when decorating their cradles.

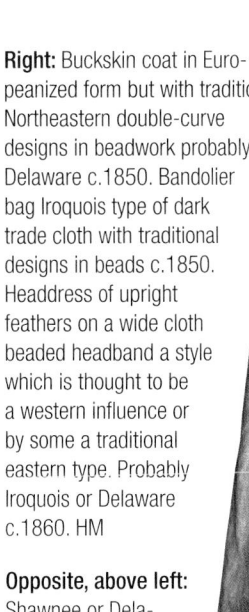

Right: Buckskin coat in Europeanized form but with traditional Northeastern double-curve designs in beadwork probably Delaware c.1850. Bandolier bag Iroquois type of dark trade cloth with traditional designs in beads c.1850. Headdress of upright feathers on a wide cloth beaded headband a style which is thought to be a western influence or by some a traditional eastern type. Probably Iroquois or Delaware c.1860. HM

Opposite, above left: Shawnee or Delaware bandolier bag. c.1850.

Opposite, above right: Oklahoma Delaware type moccasins. MM

Opposite, below right: Layout of a Delaware buckskin legging.

Opposite, below left: Buckskin man's leggings of unknown tribal origin although possibly Delaware. c. 1865. MM

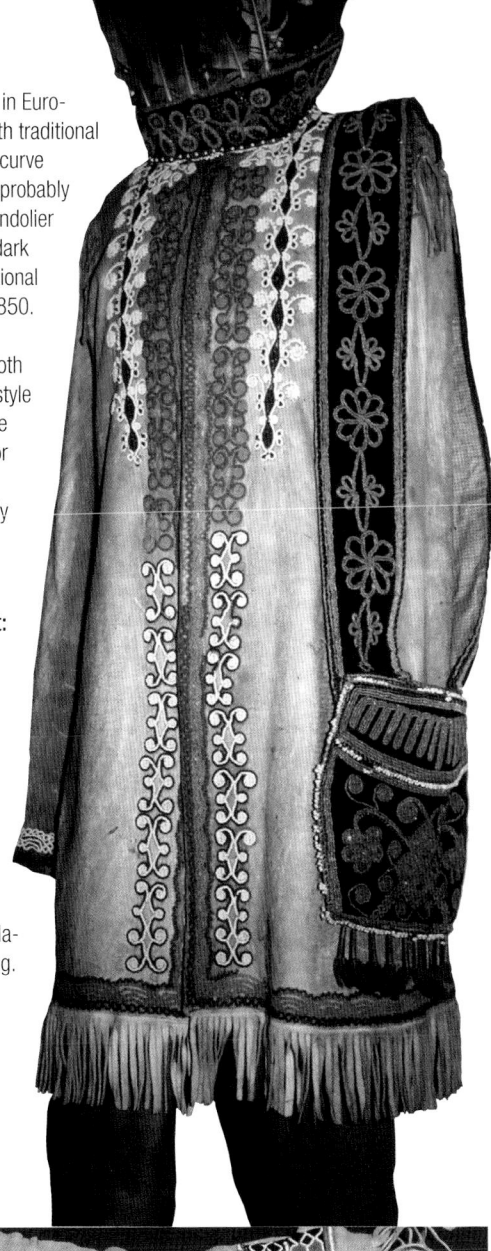

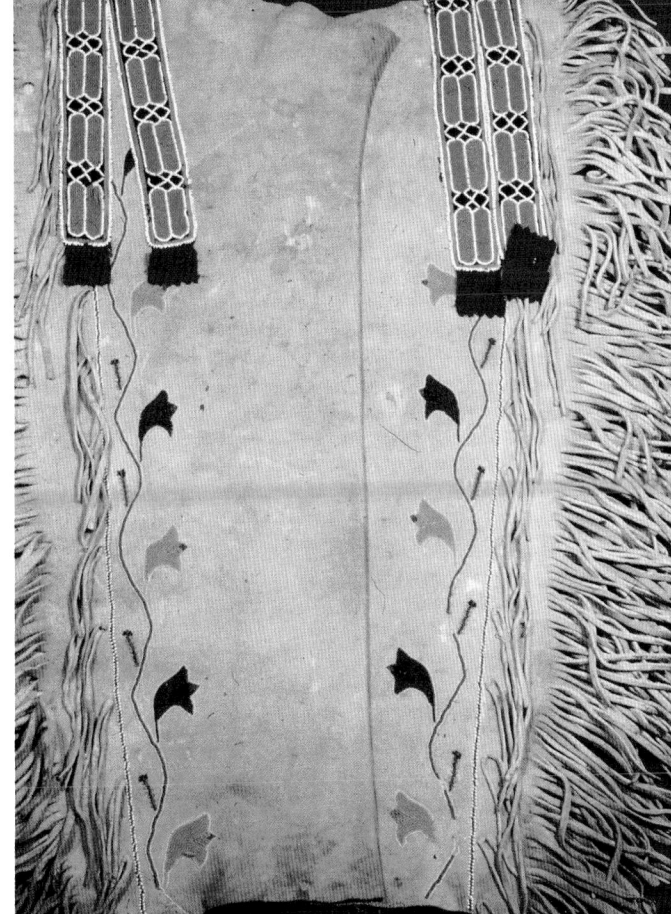

Left: Delaware purse, Oklahoma, c. 1900.

Right: Delaware man's skin leggings with beadwork, Oklahoma, c. 1900.

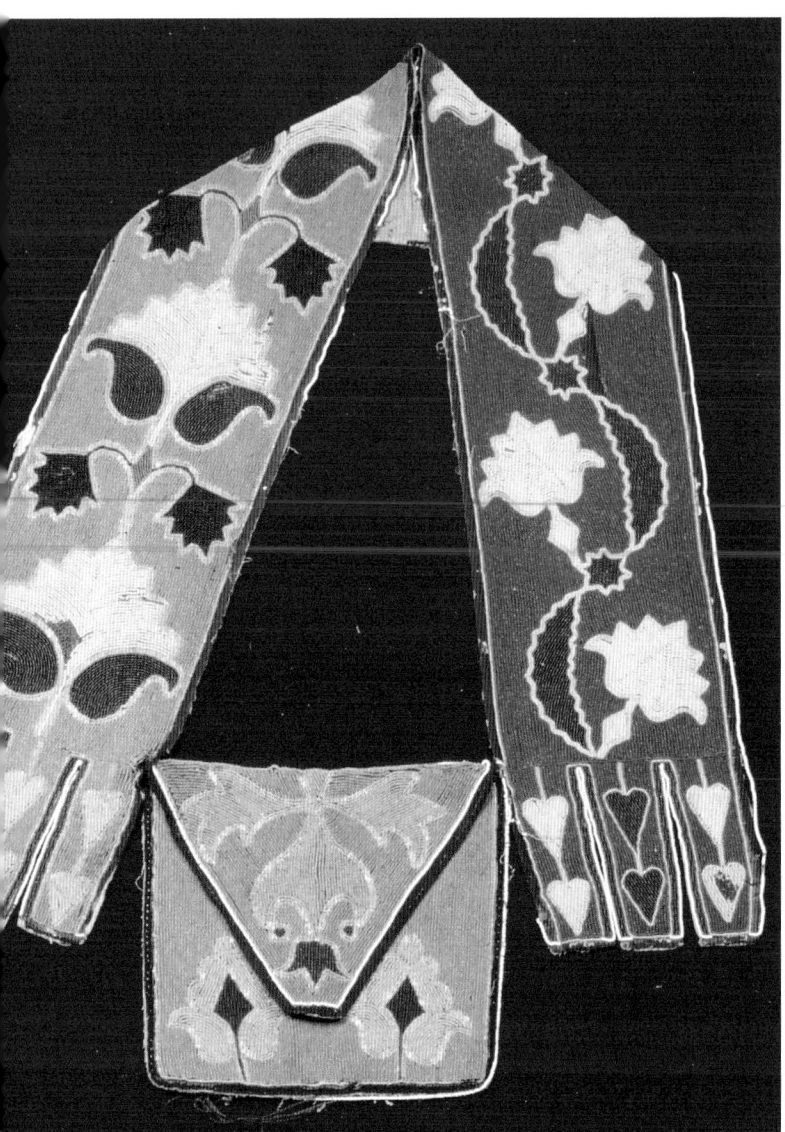

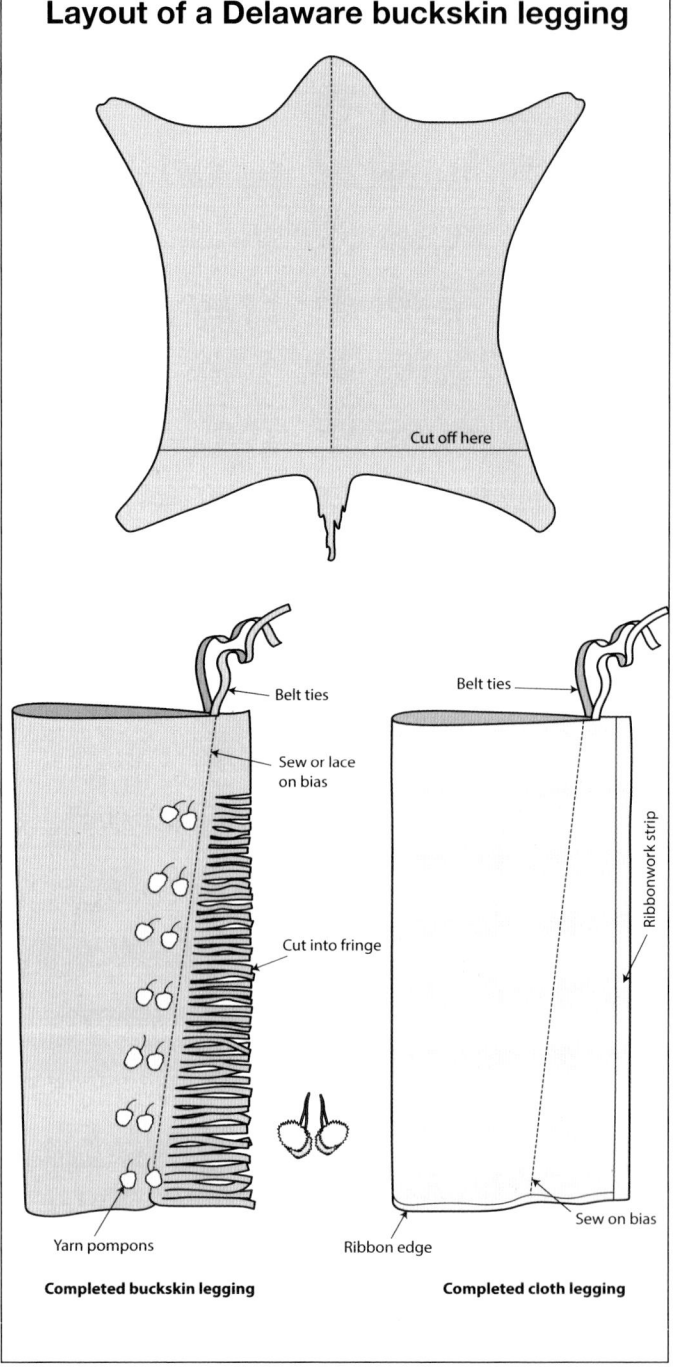

Layout of a Delaware buckskin legging

Cut off here

Belt ties

Belt ties

Sew or lace
on bias

Cut into fringe

Ribbonwork strip

Yarn pompons

Ribbon edge

Sew on bias

Completed buckskin legging

Completed cloth legging

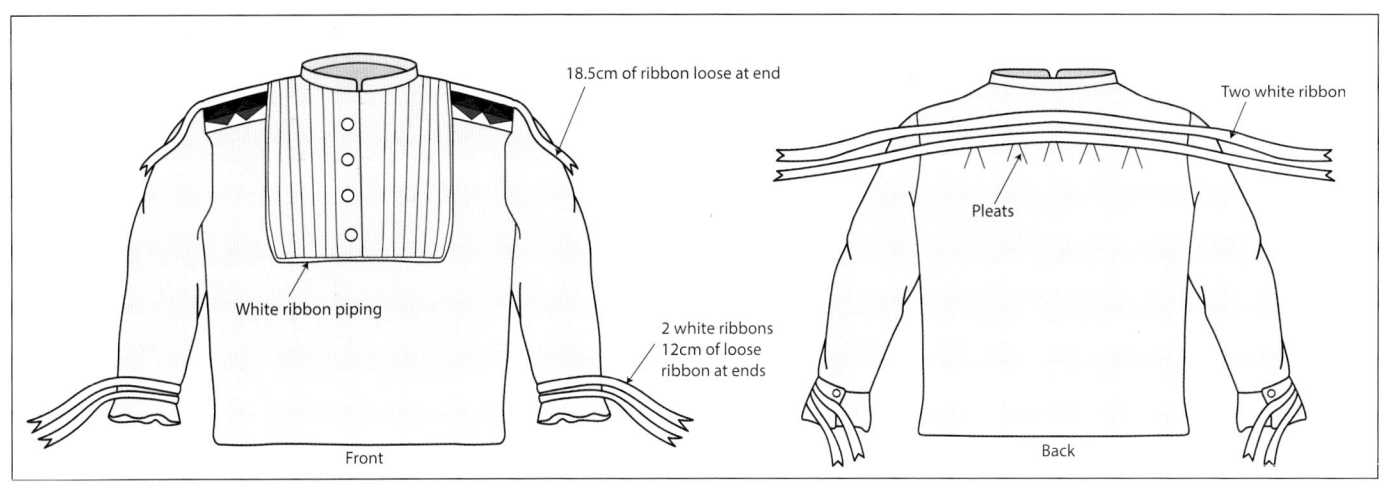

18.5cm of ribbon loose at end

Two white ribbon

Pleats

White ribbon piping

2 white ribbons
12cm of loose
ribbon at ends

Front

Back

Below: George Anderson and Charlie Webber, Oklahoma Delawares, 1937. Note the moccasins which are typical of the tribe.

Above and Below: The pattern for a Delaware man's shirt and the completed item.

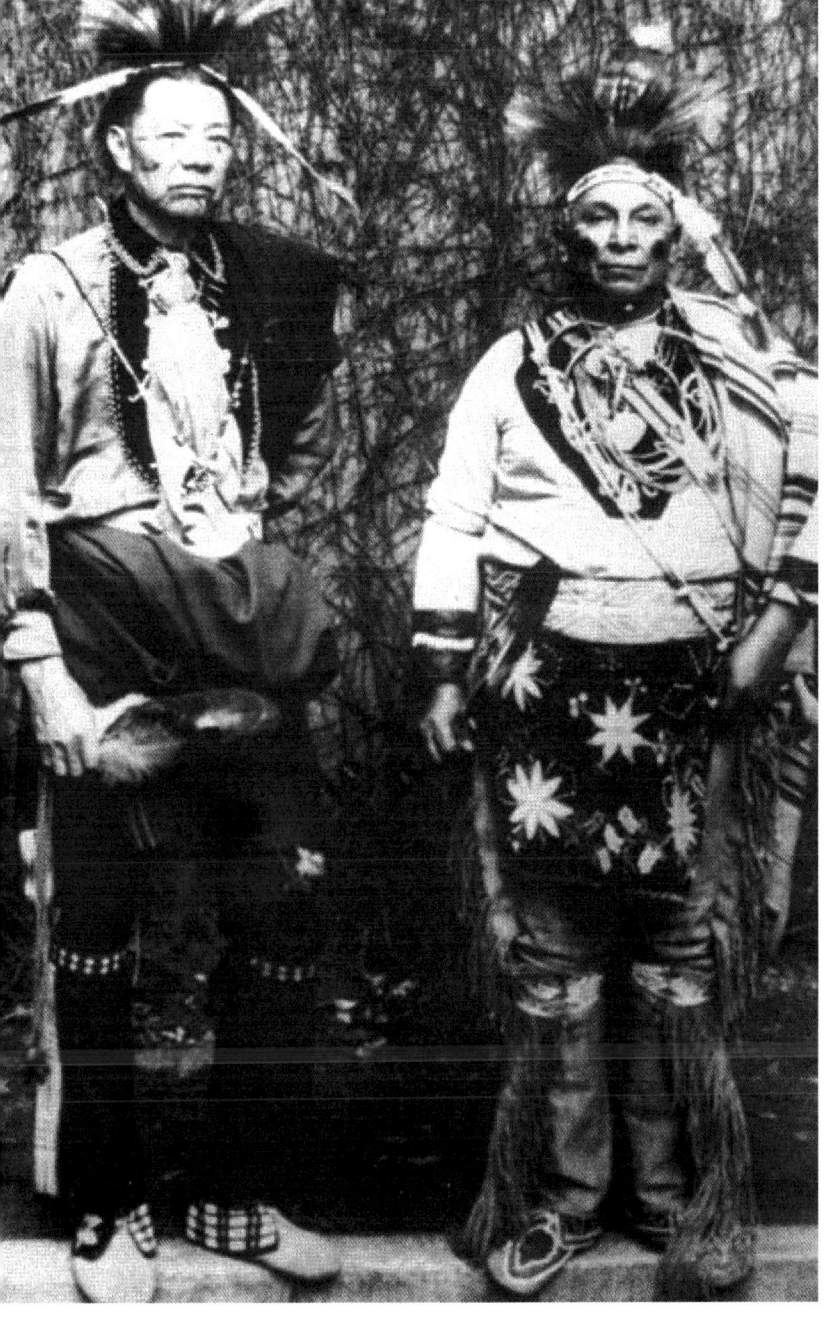

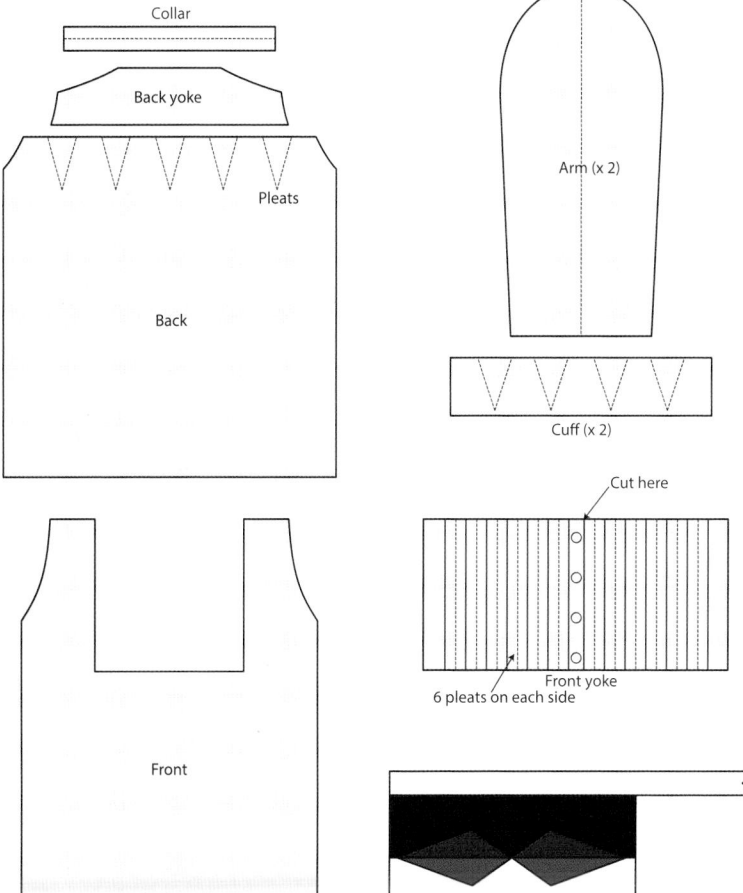

Collar

Back yoke

Pleats

Back

Arm (x 2)

Cuff (x 2)

Cut here

Front yoke
6 pleats on each side

Front

Detail of ribbonwork on shoulder of shirt

SOUTHERN OR PRAIRIE STYLE

This style of floral and curvilinear beadwork was made by several Missouri River and southern Woodland tribes, the latter mostly regrouped portions of the tribes removed west of the Missouri River during the early nineteenth century. In other words, this is typical material of Indian groups whose descendants are associated with the reservations in Nebraska, Kansas, Iowa, and northeastern Oklahoma. The tribes engaged in this style of beadwork were the Sac, Fox, Kansa, Prairie Potawatomi, Nebraska Winnebago, Iowa, Oto-Missouri, Ponca, Osage, Kickapoo, and, to a lesser extent, Menominee, Forest Potawatomi, Wisconsin Winnebago, and even Pawnee and other groups in Oklahoma.

There is no indication of this style of beadwork in the paintings of George Catlin; however, by the time of the earliest photographs of representatives of the above tribes in the 1860s, this style of beadwork was well developed, together with ribbonwork in which some designs appear to be quite similar to those used in beadwork. To some extent the costumes decorated with this form of beadwork seem to have given way to "Sioux Style" beadwork for decorated shirts, leggings, moccasins, and bags in the later decades of the nineteenth century, particularly among the Ponca, Omaha, Pawnee, etc.—no doubt a portion of the material was actually Sioux-made, as large amounts were produced.

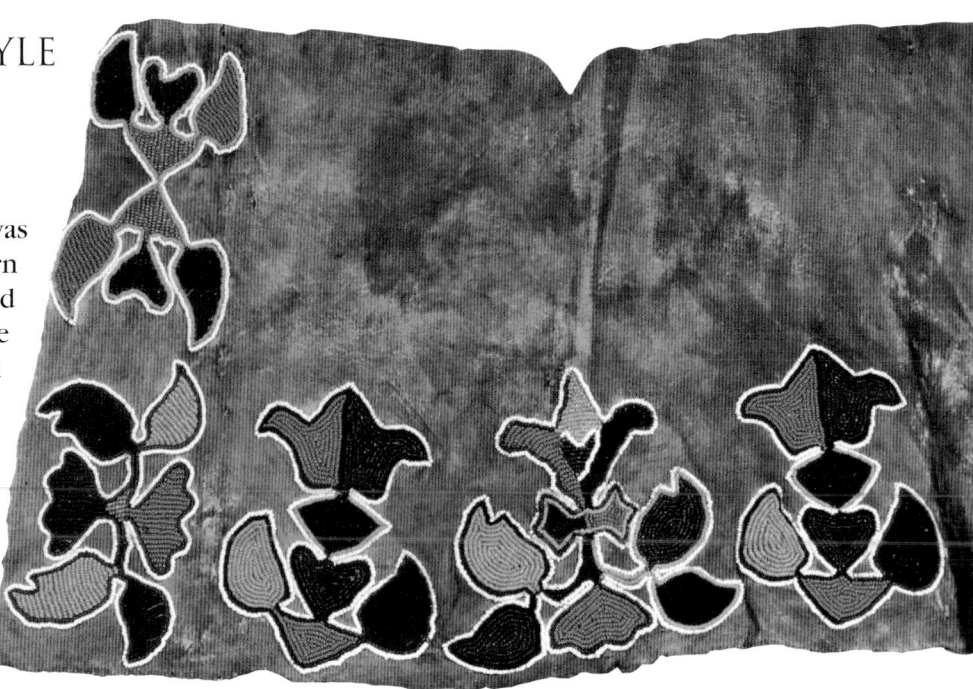

Above: Kansas Potawatomi beaded buckskin leggings, c.1880.

Below: Potawatomi family from the Forest County band, Wisconsin, c.1920.

However, both "curvilinear–floral" and "Sioux" styles have been perpetuated in the beadwork decoration of latter day Pan-Indian Oklahoma costumes, and old-type floral elements are still seen on Fox women's skirts. The distinctness of this "Southern" style floral beadwork from the Northern Algonkian and Athabaskan floral beadwork suggests independent origin, although developed during the same period.

This style was probably developed on the old Nemaha Reservation of the "Sauk of the Missouri" and

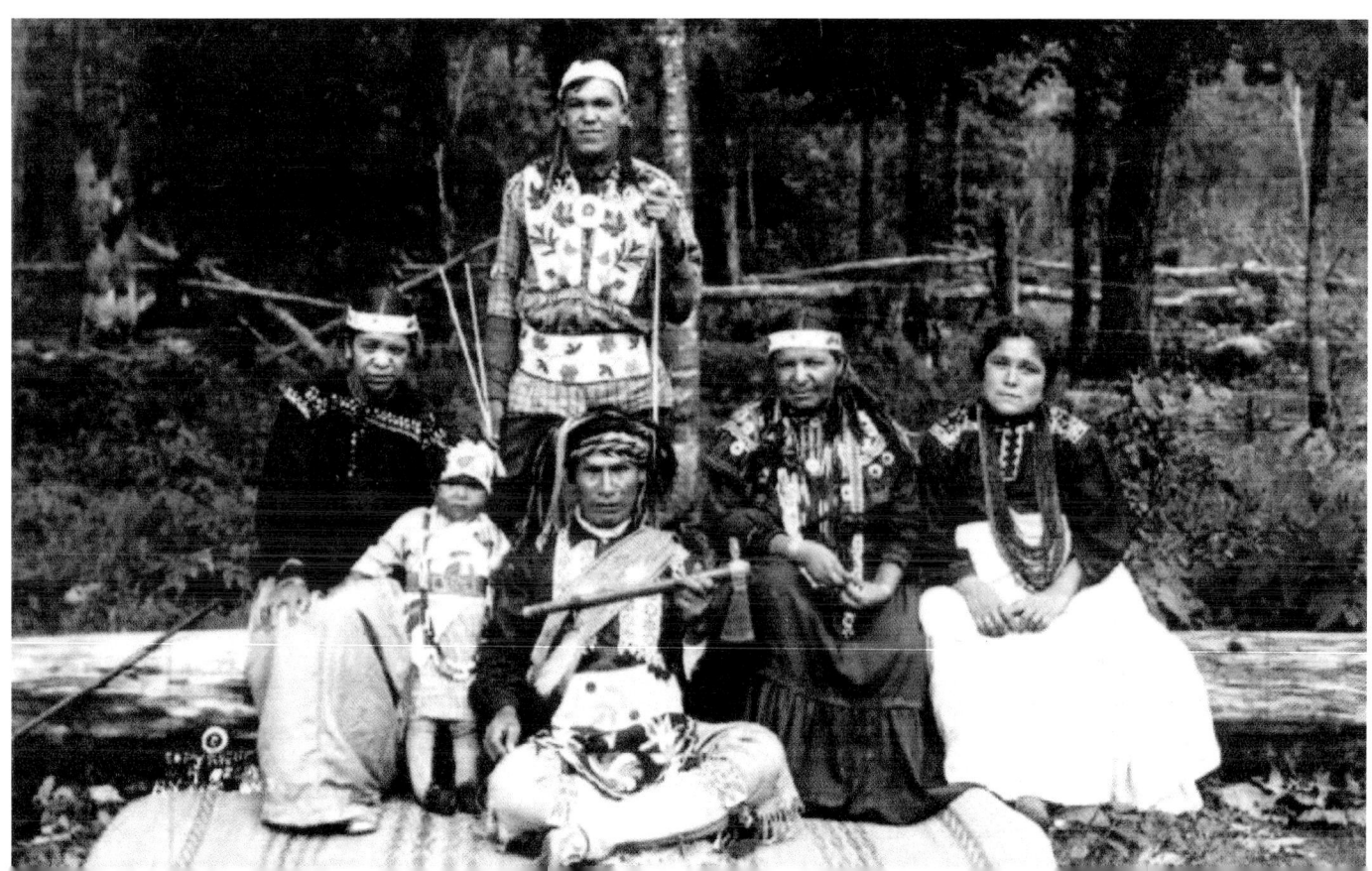

Top: Pawnee Indian men in dancing clothes, Pawnee, Oklahoma, 1928. The beadwork on their aprons and vests is typical of the floral and curvilinear style of the Prairie tribes resettled in Oklahoma in the late nineteenth century. Photographer unknown

Above: Cloth coat with beadwork Oto (Otoe), Oklahoma, c. 1900. Philbrook Art Center

Above right: Sauk and Fox beaded moccasins from Oklahoma, 1890.

Right: Sauk and Fox or Kickapoo moccasin, c. 1900. Chandler Collection

the Iowa, or perhaps the Oto-Missouri as alternative innovators and developers c. 1840–60. However, the partial Woodland orientation of the tribes in question may suggest a tradition of curvilinear art in various forms. This style adorned women's skirts, men's vests, aprons, front-seam leggings, flap moccasins, and shirts, with some of the finest beaded designs on aprons. The beadwork is nearly always on trade cloth (blue), except for leggings, and is often symmetrical and unrealistic when compared with Ojibwa beadwork. Beadwork runs the whole range from realistic floral to pure abstract and designs of animals, hands, flags, etc. are not uncommon.

As well as having differing design elements, this beadwork is quite distinct from Ojibwa and the general "Northern" style in the method of bead application. While both styles use the appliqué or overlay-stitch technique, the Southern style has a horizontal "fill-in" bead layout around an outline of one or two rows of beads of a sharply contrasting color. In typical "Northern" work the beads follow the contours of the flower or leaf.

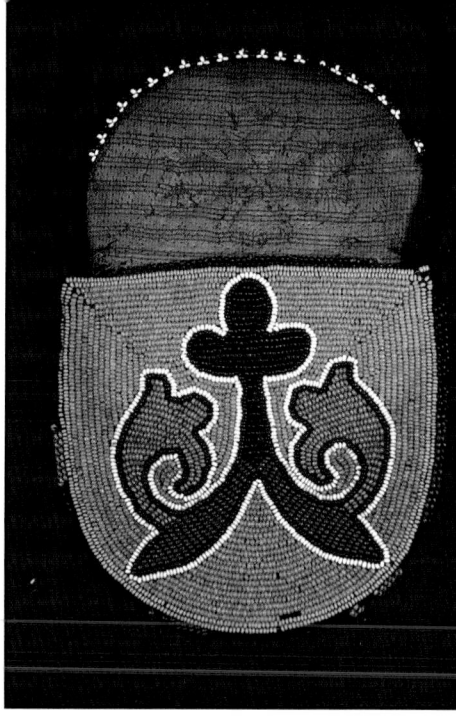

Right: Sauk and Fox purse collected in Oklahoma, 1910.

Below: John Young Bear and wife, Mesquakie, Tama in Iowa.

BANDOLIERS OR SHOULDER BAGS – TRIBAL TYPES AND FORMS

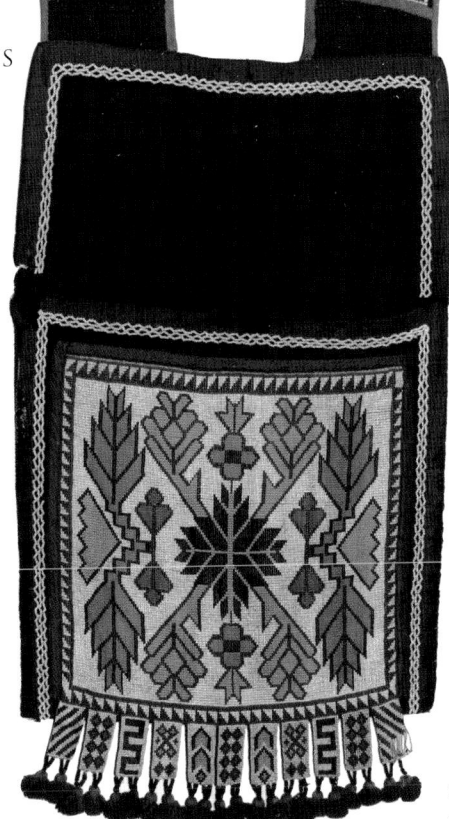

Experts seem undecided about the origins of the ubiquitous beaded bandolier bag, or shoulder pouch, so popular with the Great Lake Indians of the nineteenth century. These magnificent mosaics of beadwork, usually belonging to men, but occasionally women, were worn on gala days and for ceremonials such as the Midewiwin and Dream or Drum rites. These shoulder bags appear to have been badges of ethnic identity and highly prestigious; sold and traded widely, they were also known as "friendship" bags. Popular lore suggests that the Sioux would trade horses for them. A survey of antique museum collections, catalogs, and written essays shows a wide variety of construction forms going back to the eighteenth

Above: Bandolier bag, Ojibwa, c.1880. The bag has classical woven beaded panels on dark trade cloth with tabs along the bottom edge. The 'X' design probably derives from the old thunderbird designs. MGJ

Below: The Death of Wolf after Benjamin West—fig. 1 in the text.

century. A starting point could be the painting by Benjamin West "The Death of Wolfe" (fig. 1 below) depicting an Iroquois warrior with a woven fiber bandolier c. 1770, and the finishing point, the large pocketless appliqué floralistic beaded Ojibwa bags of around 1900–20.

The belief is commonly held that Indian shoulder bags developed, in part, from Euro-American military ammunition pouches of the eighteenth century. However, several early native receptacle forms can also be traced, suggesting a hybrid origin. Native dress usually lacked pockets, so pouches were necessary to carry equipment while on the trail—for example, to carry the accessories for a warrior's muzzleloader. However, these early shoulder bags were much smaller than the huge bandoliers of the late nineteenth century. Hail and Duncan divided the evolution of Subarctic and Woodland bags into two basic forms of construction, the panel bag and the octopus bag. Panel bags of unknown development are characterized by division into rectangular sections (usually three or four) each decorated differently with paint, quillwork, thread embroidery, or beadwork. They claim the Plains pipe bag and Woodland bandolier derive from this typographical genesis. The second form descends from animal-skin pouches which retained the original shape of the animal skin with legs and tail hanging down. Examples of indigenous skin pouches were drawn by John White at the Roanoke Colony in the 1580s, depicting Carolina Algonkians and were reproduced in Theodore de Bry's engravings. From this form several Great Lakes, Cree, and Northern Athabascan pouches demonstrate a relationship, perhaps the so-called Subarctic "octopus bag," a final development.

However, the writer feels that large shoulder bags with front pockets fit uncomfortably in either of these construction forms and probably derive from both. A number of Subarctic pouches, with woven quilled strips stitched to the buckskin or cloth in usually two horizontal bands, have survived in museum collections. These eighteenth- or early nineteenth-century pouches are invariably given Cree, Cree-Métis, or Northern Ojibwa attribution and usually display woven quilled designs in small-stepped, triangular, and eight-pointed star designs and are analogous to the woven beaded bandoliers of the Southern Ojibwa which first appeared about 1845.

However, a quite separate bandolier style was already in vogue at this period among the Southern Ojibwa which, by contrast, has a construction relationship to the old Great Lakes woven cordage bags of native fibers, yarn, or wool, with or without interspaced beads, and the black buckskin pouches with quillwork designs. Both these antique forms used symbolic thunderbird and underwater panther representations. A few trade-cloth bandoliers with a panel of plaited yarn with diagonally laced white beads to create a diamond trellis design have survived. Fig. 2 (see page 66) shows eighteenth-/early nineteenth-century shoulder bags with related Subarctic and Great Lakes derivatives. From these two forms developed the woven beaded bandoliers of the 1850–80 period. The panel and strap, now woven beadwork constructed on box, tension, and heddle looms, usually display a mixtureof the old geometrical designs with the conventionalized thunderbird design with interlocking triangles and chevrons in the "X" design. The diamond trellis design, perhaps also a thunderbird representation, is now seen on borders as the "otter tail" design. After about 1880, and quite suddenly, the Great Lakes Ojibwa adapted floral appliqué beadwork, previously used rather sparingly, to cover the front panel and shoulder strap on bags of cloth and canvas construction. Hundreds of such bandoliers were made, many survive in museum and private collections, and a few are still made. James Howard reported at least one Minnesota Ojibwa man wearing a bandolier bag at powwows in the 1950s and Ralph T. Cole collected a bag for an exhibition in 1982 made by Maude Kegg of Mille Lacs, Minnesota. Fig. 3 shows various late nineteenth-century Great Lakes bandoliers.

However, the Ojibwa and their neighbors were not the only producers of these magnificent legacies of Native American art. A divergent form is the small "shot pouch" with rounded bottom edge of the Canadian interior tribes—the Nascapi, Cree, and Northern Athabascan. The Prairie tribes, Winnebago, etc., made beaded bandoliers in the loose-warp technique, a woven form related to finger weaving of old fiber bags and charm bags. Characteristic of Prairie bandolier bags is the offset junction of the straps with the bag section

Above left: Sauk bandolier bag, c. 1885. The front beadwork on some Sauk, Fox, Potawatomi, and Winnebago examples were sometimes combined panel and strap as shown in this example. Photograph courtesy Dennis Lessard.

Above right: Ni-be-da-ah-nah-gwed, George Burnette, Ojibwa, 1907. He wears crossed bandoliers, one across each shoulder with floral beaded designs. He holds a catlinite pipe with wooden stem.

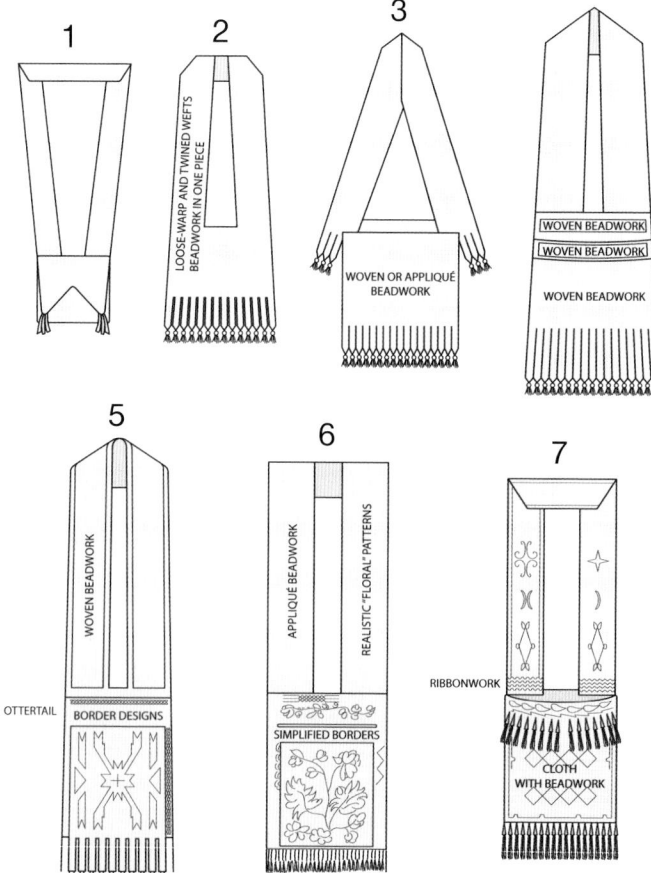

Right: Fig. 3 Late nineteenth century Great Lakes bandolier bags: 1 Canadian Potawatoni c. 1870; 2 Kansas Potawatoni c. 1890; 3 Winnebago bandolier c. 1900; 4 Wisconsin Potawatoni c. 1895; 5 Ojibwa bandolier c. 1885 with X motif in woven panel; 6 Ojibwa "Chippewa" bandolier c. 1900 with floral beadwork; 7 Miami bandolier c. 1860.

Fig. 3 Late nineteenth century Great Lakes bandoliers

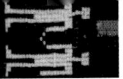

Fig. 2 Early shoulder bags with related Subarctic and Great Lakes derivatives

SHOULDER AMUNITION-POUCH DECORATED WITH GLASS TRADE WAMPUM. C.1790.

LEATHER & CLOTH

GREAT LAKES BLACK BUCKSKIN POUCH WITH QUILLWORK. C.1780.

HURON OR IROQUOIS SHOULDER BAG WITH MOOSEHAIR & QUILL DECORATION. C.1800

BUCKSKIN

GREAT LAKES FIBRE/WOOL BAG WITH INTERSPACED BEADS. C.1800

N. OJIBWA / CREE SHOT POUCH. C.1820.

QUILLWORK

QUILLWORK

HIDE

18th / early 19th century shoulder bags

CREE BULLET OR SHOT POUCH

CLOTH

MONTAGNAIS SHOT POUCH

CLOTH

BEAD WORK

SAULTEAUX PANEL BAG

CLOTH

CREE & NORTHERN ATHABASCAN OCTOPUS BAG

TAHLTAN POUCH

CLOTH

NORTHEASTERN ALGONKIAN PANEL BAG

CLOTH

WOVEN BEADWORK

Subarctic pouches nineteenth century

IROQUOIS C.1860 BEADED

CLOTH

IROQUOIS? C.1800 QUILLED

BUCKSKIN

CANADIAN IROQUOIANISED DELAWARE C.1880

OJIBWA – WOVEN WOOL WITH INTERSPACED BEADS C. 1840.

OJIBWA – WITH BANDS OF WOVEN BEADWORK C.1850.

MMSAMUEL

JULIE DENIS

Iroquois bandoliers

Southern Ojibwa bandoliers of the mid-nineteenth century

with beaded tabs. Fox bags are sometimes woven in one complete monolithic piece of beadwork.

Besides the bandoliers from the Great Lakes and Prairie tribes, the chiefs of southern tribes (Cherokee, Creek and Seminole) had been appearing in drawings and paintings wearing bandoliers as early as the 1820s. Various southern chiefs were painted by Charles Bird King and others, and the paintings used in lithographic form in McKenney and Hall's three-volume epic *The Indian Tribes of North America*. These bags probably represent a separate development from those of the north outlined above and pre-date the fully beaded Ojibwa bags by some decades. Similar to shoulder bags of the north, materials of Euro-American origin are used in their construction—cloth, silk, ribbon, military braid, and beads. At present no distinction can be made between Creek and Seminole examples, a majority of which have a pouch with a v-flap at the front. The beadwork of these southern people has a mystical quality, with ancient curvilinear, scroll, and abstract patterns, sometimes of human and animal forms, and often bilaterally symmetrical. Perhaps related to the southern form is the Shawnee bandolier, of which a few are attributed in museums. The National Museum of the American Indian, New York, has bandoliers attributed to or collected from the Shawnee, Miami, Delaware, and Mohegan. It is unknown at present if the Delaware developed their own style during their relocation to Oklahoma, where they were in contact with the Creeks, or in the Midwest, where they were in almost constant association with the Shawnee and Miami. In any case, Delaware beadwork is dissimilar to Creek–Seminole, usually featuring bilaterally symmetrical designs in beadwork of contrasting colors in stylized floral motifs. If a connection exists between the southern bandolier and the Delaware form, the Shawnee were the probable

brokers, particularly if this association took place before removal to Oklahoma.

Fig. 4 shows a range of minor construction variations of the southern style bandolier. The following tribes have documented (or attributed) bandoliers in museum collections: Iroquois, Delaware, Shawnee, Miami, Ottawa, Potawatomi, Ojibwa, Menominee, Winnebago, Sac-Fox, Creek, Cherokee, Seminole, possibly Mohegan, and Passamaquoddy. The following peoples used them and may have made them: Santee and Yankton Sioux, Omaha, Cree, Plains Cree, Plains Ojibwa, Saulteaux, Northern Ojibwa, and occasionally the Western Sioux Basin and Plateau tribes wore them.

The Southern Ojibwa women were the most prolific makers of bandoliers, particularly the late nineteenth-century floral beaded ones that were made in profusion on reservations in Minnesota and Wisconsin, such as White Earth, Leech Lake, Red Lake, Lac Courte Oreilles, and Lac du Flambeau, and are indeed silent memorials to the skill and patience of women of a bygone age.

Examples collected from or photographed being worn by members of the Passamaquoddy and Mohegan tribes were probably made in the west and later brought east by returning Indians during or after the Civil War or individuals returning to their homelands after removal.

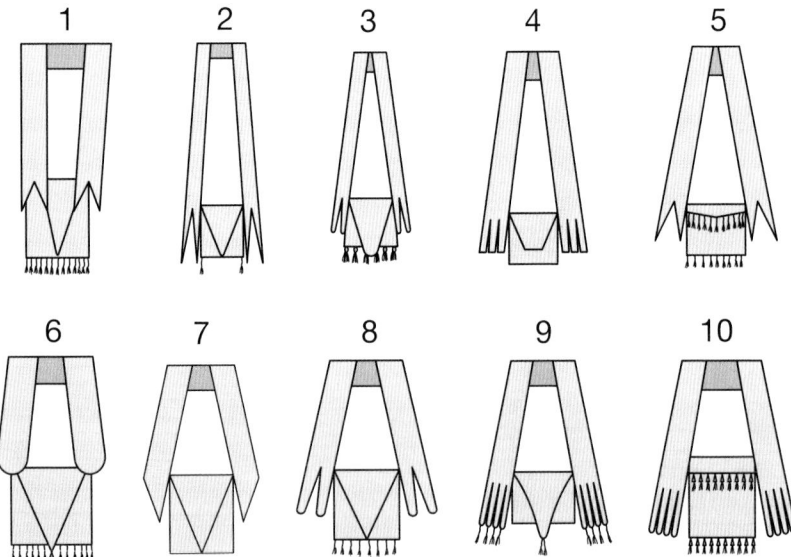

Fig. 4 Southeastern and Oklahoma bandoliers

Opposite: Fig. 2 Early shoulder bags with related Subarctic and Great Lakes derivatives.

Above: Winnebago bandolier, c. 1900. The shoulder straps on Winnebago shoulder bags are sometimes offset at the junction with the bag. At this junction are usually woven beaded tabs. The beadwork is the "Prairie" floralistic style the Winnebago shared with several Missiouri River Valley groups in the late nineteenth century.

Left: Fig. 4 Various Southeastern and Oklahoma bandoliers: 1, 3, 7, and 8 Creek; 2 and 9 Seminole; 4 Shawnee; 5 Oklahoma Delaware; 6 Cherokee and Creek; 10 Delaware.

SUMMARY

Ojibwa Produced by far the largest number of bandolier bags and many hundreds survive in museums and private collections. Earlier bags (1860–80) were usually the woven beaded type in geometrical designs, while the later ones (1880–1920) were beaded in the appliqué two thread technique in realistic to abstract floral designs. A common style depicted a winding vine with interconnecting leaves and buds. Bandolier bags were usually in three sections—the strap, a central panel sometimes partly beaded, and the bag. Occasionally the central section was missing but the other two elements were still separately made. Along the base a row of woolen fringes or woven beaded tabs or pendants were common.

Menominee Often indistinguishable from the Ojibwa examples, similarly in three sections, shoulder strap, central panel and bag. Both woven-beaded and floral-beaded examples are known.

Winnebago Usually woven-beaded in bold geometric designs including conventionalized flowers, and very occasionally appliqué-beaded specimens. Characteristically in two sections, shoulder strap and bag only. A style with a row of woven-beaded tabs or pendants at the junction of the shoulder strap and bag, usually partly offset from the bag, seems rather specific to the tribe.

Sac and Fox Shoulder strap and bag form with woven beaded patterns. Bandoliers are fairly rare from these tribes. Perhaps more common are the smaller bandolier or charm bags with woven-beaded straps and bags in a twinned technique, usually geometric designs.

Potawatomi Two forms corresponding to two branches of the tribe. The Wisconsin Potawatomi specimens were woven beaded with the designs on the bag carried through on the shoulder strap. Either one or two narrow bands of cloth separate the bag panel from the shoulder strap. The Kansas Potawatomi examples are single-piece

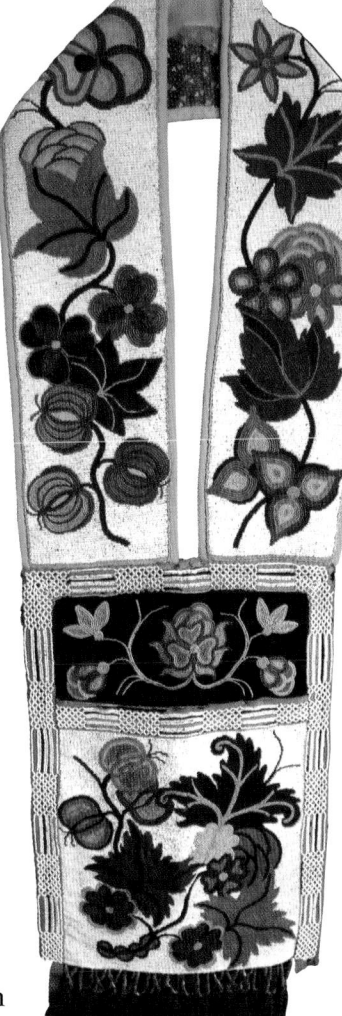

beaded construction in complex woven twinned techniques of beadwork.

Eastern Sioux Bandoliers in appliqué-beaded floral designs of the Ojibwa type were widely used by eastern branches of the Sioux and a number were probably made by them. Most, however, were obtained by trade.

Delaware and Miami Bandoliers probably developed from eighteenth-century buckskin bags with shoulder straps attached at the corners of the bag section. Delaware bags of the nineteenth century usually have shoulder straps with three squared-off tabs or lobes at the junction with the bag, sometimes offset, and in addition to the fringe along the bottom edge another fringe below the opening. These fringes are of metal cones, deer hair, or wool. Beadwork is often in large symmetrical contrasting-color designs.

Shawnee Their bandoliers shared some features with Delaware types, except that Shawnee examples are likely to have a V-shaped flap to the bag section, similar to Creek styles but truncated.

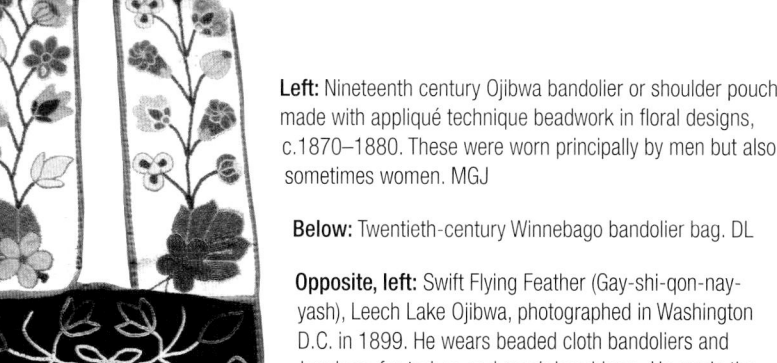

Left: Nineteenth century Ojibwa bandolier or shoulder pouch made with appliqué technique beadwork in floral designs, c.1870–1880. These were worn principally by men but also sometimes women. MGJ

Below: Twentieth-century Winnebago bandolier bag. DL

Opposite, left: Swift Flying Feather (Gay-shi-qon-nay-yash), Leech Lake Ojibwa, photographed in Washington D.C. in 1899. He wears beaded cloth bandoliers and leggings, fur turban and roach headdress. He made the first known recordings of Ojibwa songs on wax cylinders while in Washington.

Opposite, inset: Bandolier bag, Ojibwa, c. 1917 from Lake Lena, a community of the Mille Lacs Reservation, Minnesota. HK

Opposite, right: Flat Mouth (Ne-gon-e-bin-ais) Ojibwa from Leech Lake, Minnesota, son of a more famous Chief Flat Mouth. He wears a fur turban with eagle feathers and holds a pipe. Photograph Washington D.C. 1899.

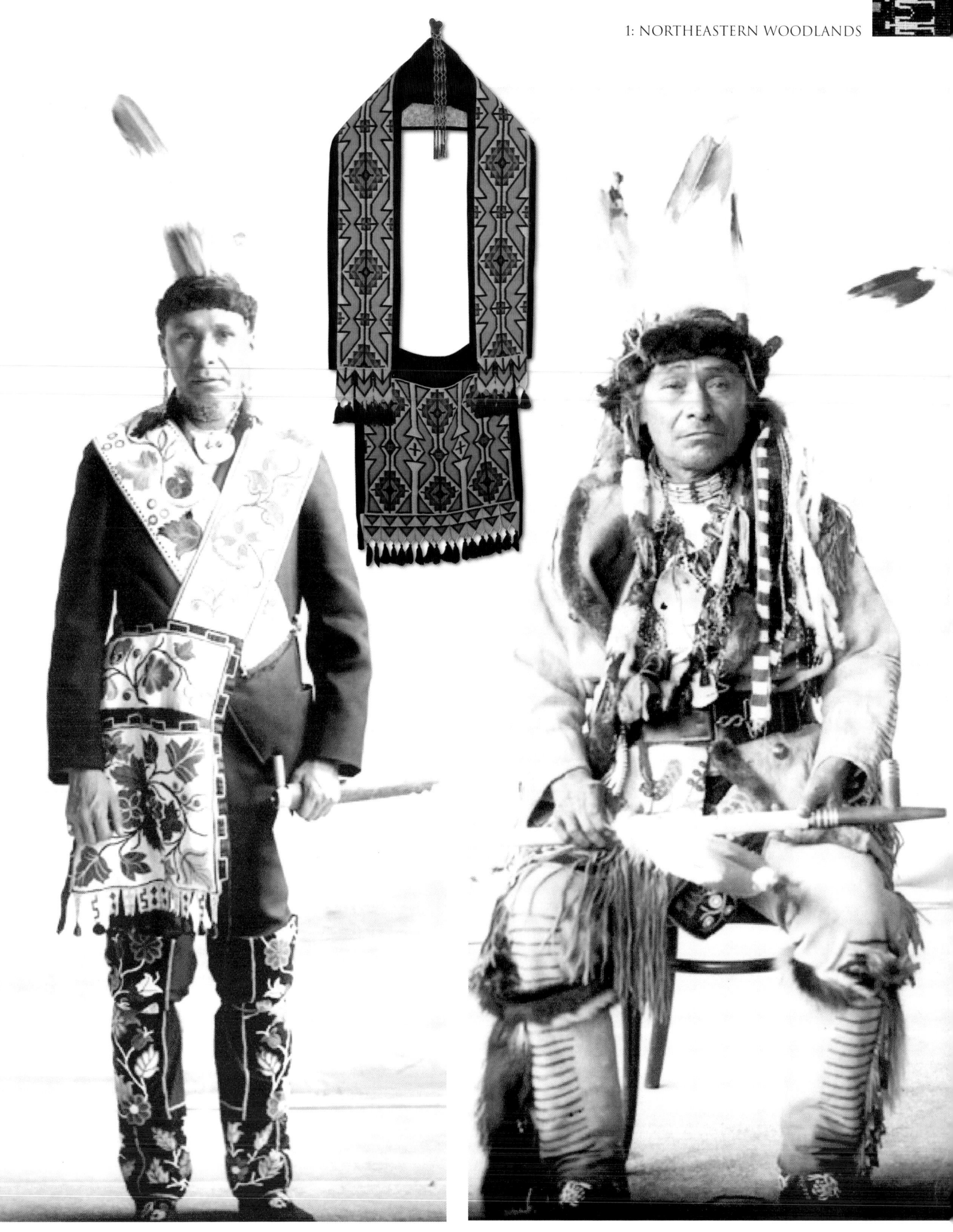

2. MOCCASINS

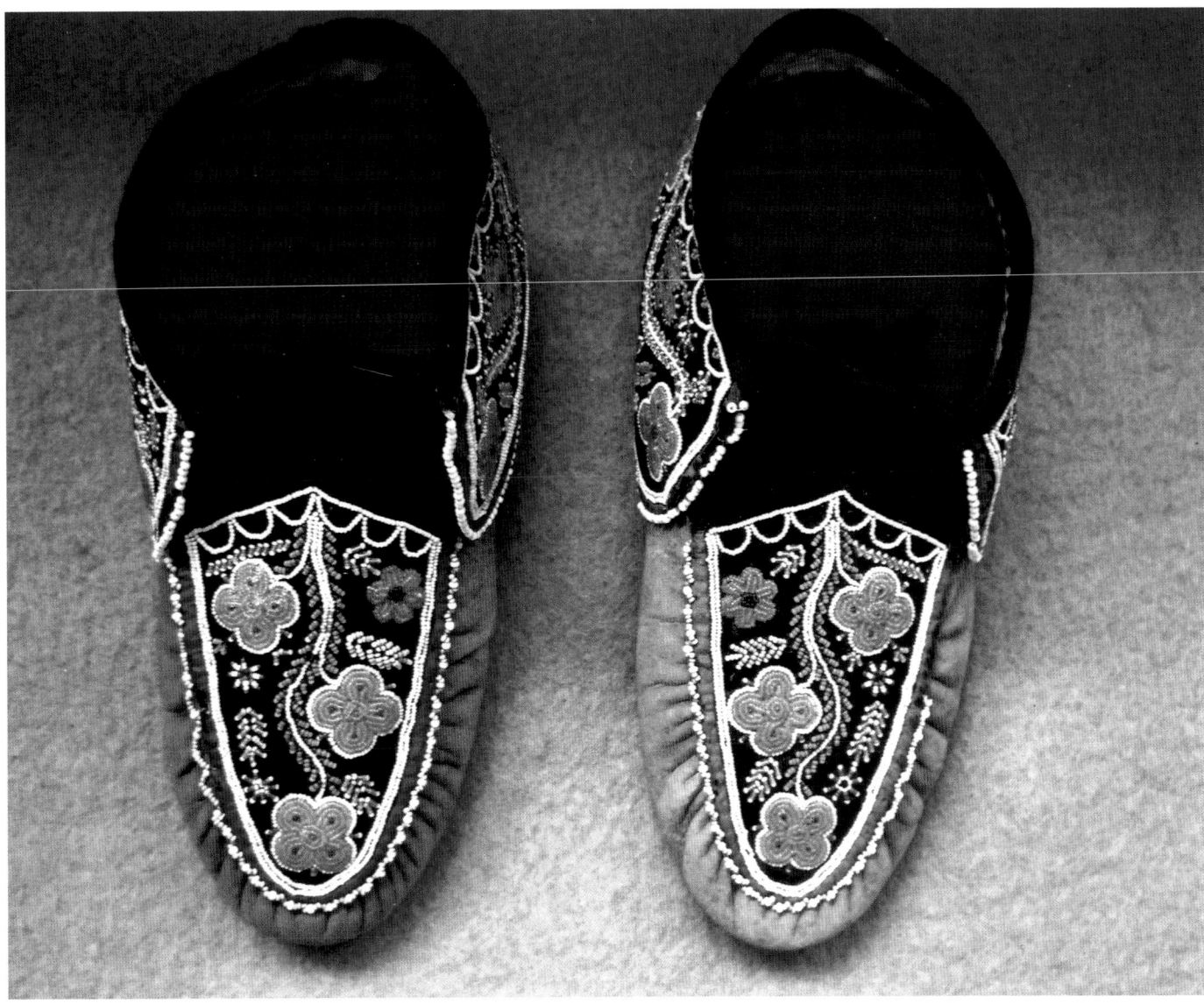

Gudmund Hatt's study of moccasin construction from 1916 remains an excellent reference work and much of his information remains valid. He arranged moccasin construction types into series, from 1 to 21. More recently there have been two important additional works, by Webber (1989) and Thompson (1990), which add to, and in some cases revise, Hatt's work. Consequently the details which follow largely reflect the information reported in all these studies.

Hatt believed that there were four main types of North American Indian footwear constructions: **True moccasins**, **Shoes**, **Sandals**, and **Boots**. Webber introduced a fifth type she called the **Modified moccasin-boot**.

Above: Moccasins probably Malecite, c. 1860. Type 9, large vamps, and collars of cloth decorated with beadwork in floral clusters, and vine and dome motifs. MGJ

TRUE MOCCASINS

These are clearly the most important and widespread form. Only in the Southwest, parts of the Plains, and Northwest Coast does it not commonly occur but even here primitive forms perhaps prototypes of Hatt's types 1–10 occasionally occur. True moccasins are made with soft hide without left or right imprints, from one or two pieces, and with a heel seam. There are two divergent subtypes, one a southern tradition of a single-piece front-seam moccasin and a northern tradition of a two-piece moccasin with a U- or V-shaped vamp or apron over the instep. Where the two traditions meet there is an array of hybrids. And as a result of the European fur trade there was a lively redistribution of native footwear, and the vamp moccasin was adopted in parts of eastern North America where once center-front-seam moccasins prevailed.

SHOES

These are generally associated with Plains Indians and comprise hard separate rawhide soles with soft uppers possibly derived from the Southwestern boot, or repaired true moccasins, or as some authorities claim Euro-American influences, perhaps a little of each. Boots derived by adding leg units above the ankles to the shoe form were popular with Southern Plains tribes and recently among the Crow, Plains Cree, and Blackfeet but are still essentially shoes. In the north among the Blackfeet and Cree separate soft-soled moccasins also occur, again a shoe.

SANDALS

These are an ancient Native American footwear type but in historic times were restricted generally to the Great Basin and Californian tribes.

BOOTS

These were used by the Eskimo (Inuit) and by Indians of the Southwest and are characterized by separate thick hard soles (bottom units) and thick or hard skin uppers in the case of the Eskimo or soft uppers in the Southwest. There is evidence linking the boot to the ancient sandal since the edges of the upturned worn sandal approximate the seam position of the sole or bottom unit and the upper about ½–1¼ in. above the foot imprint. The Southwestern boot can have asymmetrical left and right foot imprints.

MODIFIED MOCCASIN-BOOT

Webber described several forms of this type not reported by Hatt. It is similar to the boot form but has a separate soft sole, which can be either flat or an upturned bottom unit adjoining the soft uppers ½–1¼ in. above the foot imprint. Most of these specimens are from the Northern Athabascan people adjacent to the Inuit area so we can speculate that there was interaction. An old Athabascan form has the moccasin-boot attached to skin leggings to form a garment called the Moccasin-trouser. Boots generally have closed upper sections to knee height except the Southwest boot, many of which have open units bound or laced to the leg with thongs. Nineteen of Hatt's types of true moccasins, shoes and boots are noted and sketched here together with Webber's alternative codes. Only briefly noted are her code 3 forms, the modified moccasin-boot, for which there are no Hatt numbers.

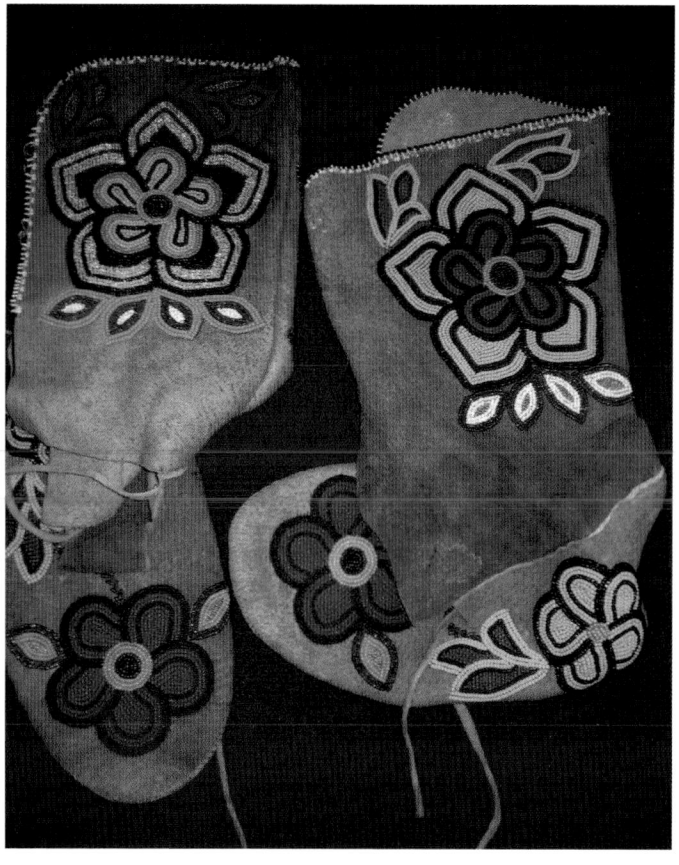

Above: Plains Cree woman's powwow moccasin-boots, c. 1990 (Alberta Cree). Heavily beaded in thread-sewn floral beadwork on moosehide with extended ankle wrap to below the knee. Basic Type 14, separate soft soles. Common style for today's powwow dances. LW

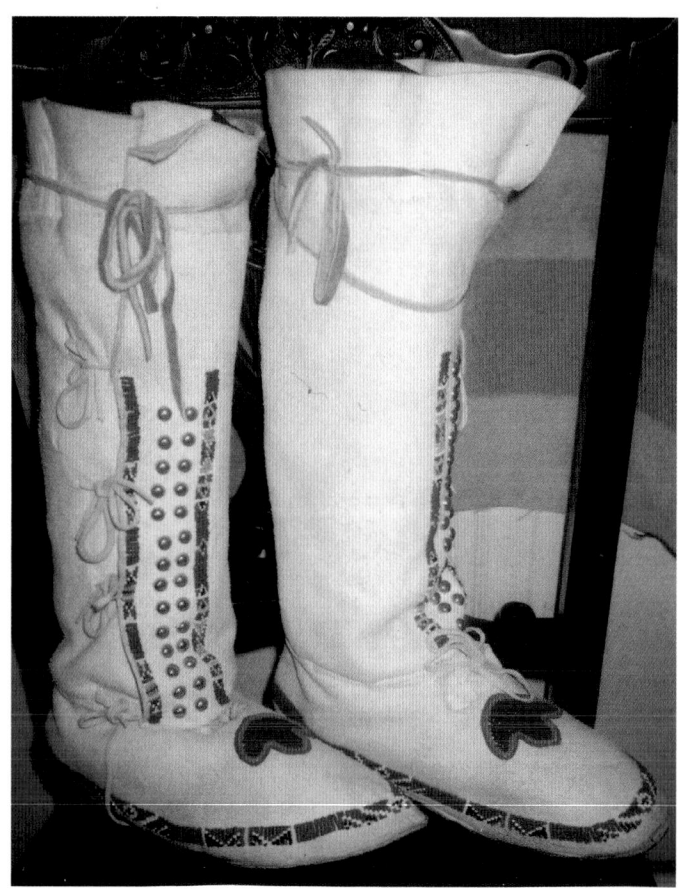

Right: Southern Plains moccasin-boots, c. 1980, Kiowa, Oklahoma made by Alice Littleman. Leg-wrap portion adjoining the shoe at the ankle on a basic Type 14 construction with rawhide soles. MGJ

Type 1 – Webber 1 (Aa)
Moccasins of one piece
• Straight heel seam
• Straight toe seam
This construction is one of the most widespread in North America, being the dominant form of the eastern United States, particularly common among the Muskogian tribes of the Southeastern area, the Prairie, and the southern Great Lakes tribes. The main differences in form are the extent of the top collar or ankle flaps, the height of the heel seam, and the length of the toe seam.

Above: A typical moccasin of Hatt's type 1 construction, the basic old and perhaps original footwear for much of eastern North America. Possibly a rare Cherokee moccasin early 19th century. BAM

Below: Webber 1Aa HATT1 Creek moccasin.

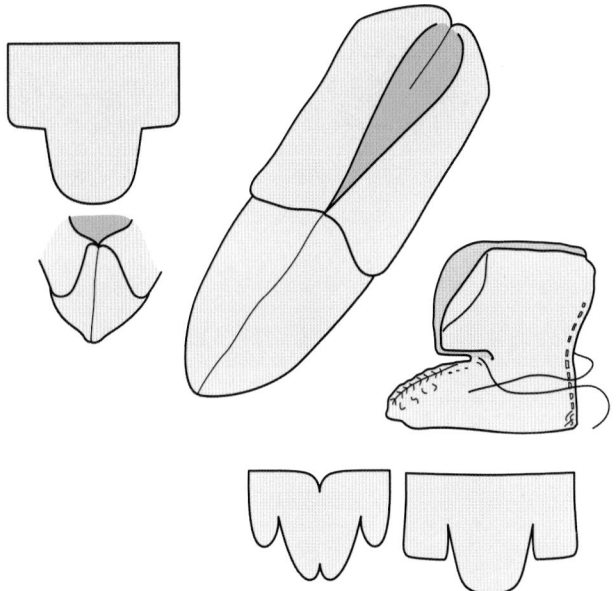

Moccasins from the Creek and Seminole are heavily "puckered" or gathered at the front of the toe seam and bottom of the heel seam, the lacing being of buckskin. The moccasins from the Prairie and southern Great lakes areas are easily distinguished from the Southeastern form by their characteristic use of side flaps which are turned down and often pointed. On most of the nineteenth-century specimens these flaps were often added separately and were highly decorated. There were also two

traits in the northern range of these forms: one in which the edges at the heel are brought together in a cone-shaped point, and the other where a narrow gore is sometimes added along the toe seam. These may be considered as intermediate with moccasins with inverted T-shaped heel seams and insteps or vamps.

Type 1 – "Winnebago Style"
This is a fairly important subtype of the single-piece moccasin. There is only one ankle flap; it is large and bent over around the dotted line in the sketch and sewn to the other side of the foot opening. Some call this form "Winnebago" as it was a common form among that tribe, but it was equally common among the Omaha, Sac, Fox, and Potawatomi.

Because of the simple construction, Type 1 moccasins occur all over the North American continent with no geographical continuity, including Lillooet, Nootka, Osage, Navajo, and possibly Apache.

Type 2 – Webber 1 (Ab)
Moccasins of one piece
• T-shaped heel seam
• Straight toe seam

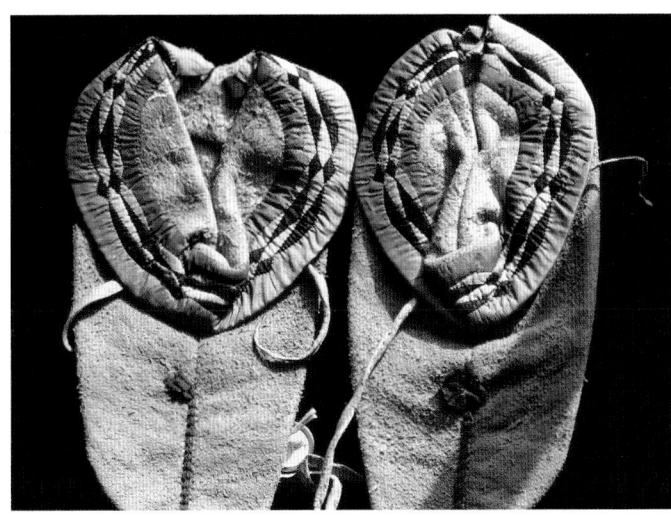

Above: Winnebago style Omaha moccasins, c. 1800 with ribbonwork decoration. Note ankle collar around the front. Hampton, VA

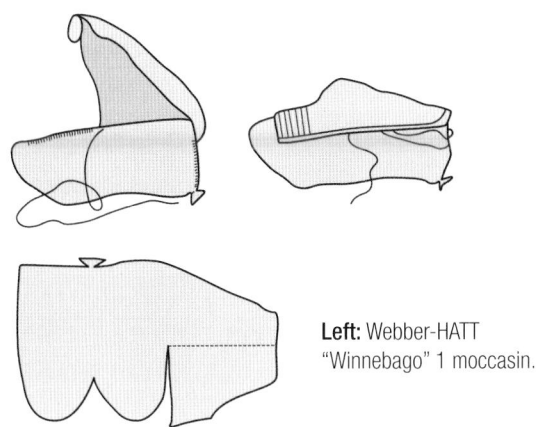

Left: Webber-HATT "Winnebago" 1 moccasin.

This form is not very common, which suggests it is merely a variation on Type 1. The important difference is that the heel seam is in the shape of an inverted T. Two parallel incisions are made in the hide at A and B, the edges D–C and C1–D1 are joined in the vertical part of the heel. One specimen sketched is a Cherokee moccasin. A few others are documented as either Ojibwa or Iroquois.

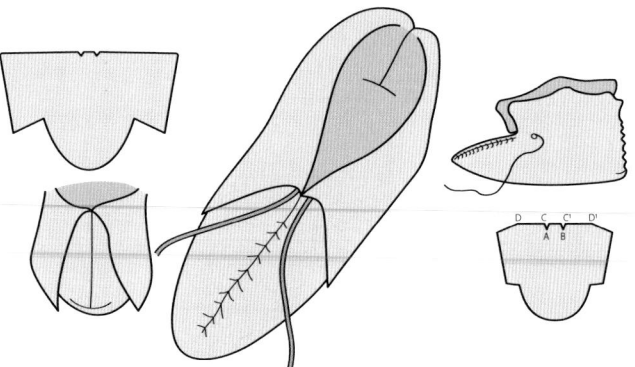

Above: Webber 1Ab HATT 2 Cherokee moccasin.

Type 3 – Webber 1 (Ac)
Moccasins of one piece
• Straight heel seam
• T-shaped toe seam

There are very few moccasins of this type. The Chitimacha moccasin sketched may have been unique to the tribe, but two other examples have been found from the Sac and Fox of Oklahoma and the Pawnee.

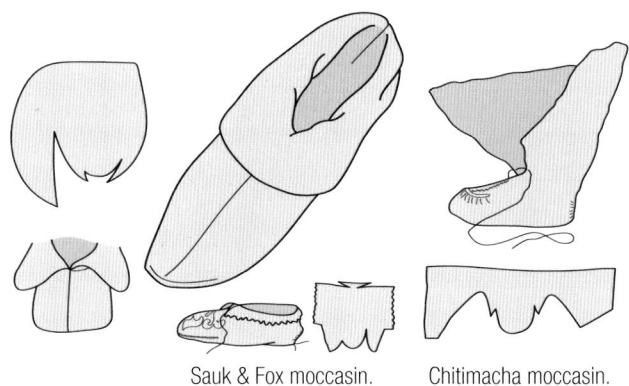

Sauk & Fox moccasin. Chitimacha moccasin.

Above: Webber 1Ac HATT moccasins.

Below: Webber 1Ac HATT 4 Kiowa moccasin.

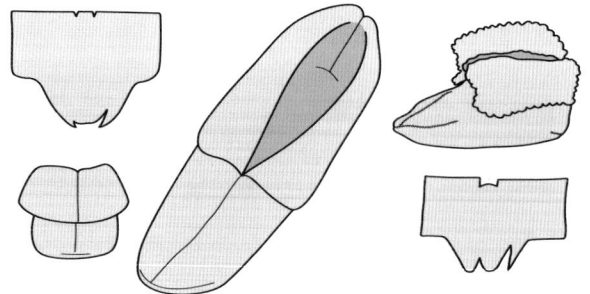

Type 4 – Webber 1 (Ad)
Moccasins of one piece
• T-shaped heel seam
• T-shaped toe seam

One moccasin of this form was collected by James Mooney and is now in the U.S. National Museum. The Kiowa called it a "medicine moccasin" which may indicate that it was old or of a rare type.

Type 5 – Webber 2 (Aa)
Moccasins of more than one piece
• Bottom piece and part top piece
• Instep vamp/tongue
• Straight heel seam
• Straight toe seam

This type is not extensive, being restricted to the northern Plateau, that is to say the Flathead, Ntlakyapmuk, and the Athabascans of Alaska. The Athabascan form sketched has the heel seam extended under the sole of the foot. The Ntlakyapmuk example has a double-piece instep with considerable numbers of "gathers" in the construction.

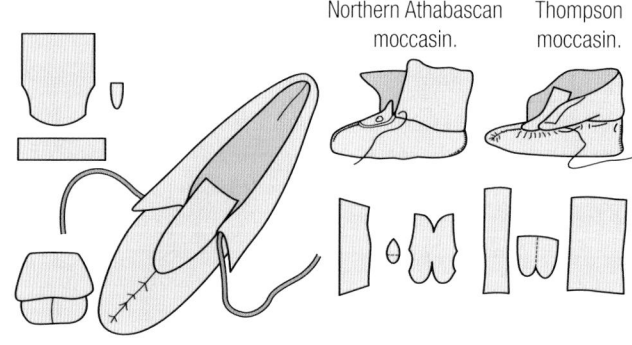

Northern Athabascan Thompson
moccasin. moccasin.

Above: Webber 2Aa HATT 5.

Type 6 – Webber 2 (Ab)
Moccasins of more than one piece
• Bottom piece and part top piece
• Instep vamp/tongue
• T-shaped heel seam
• Straight toe seam resulting in a pointed toe in many examples

The moccasins of this type are one of the most common of all, especially from the Northern Athabascan tribes— Yellowknife, Slave, Dogrib, Tahltan, Chipewyan, Kutchin, etc. Many examples survive from the Eastern Woodland tribes, although these are not so numerous as from the Athabascans. Examples of this form are known from the Ojibwa, Potawatomi, Iroquois, Huron, and Santee Sioux. Odd examples also turn up outside these areas from the Ute, Flathead, Puget Sound tribes, and Klamath. A Klamath form is sketched which has a vamp (instep)

Below: Webber 2Ab HATT 6.

Northern Athabascan moccasin.

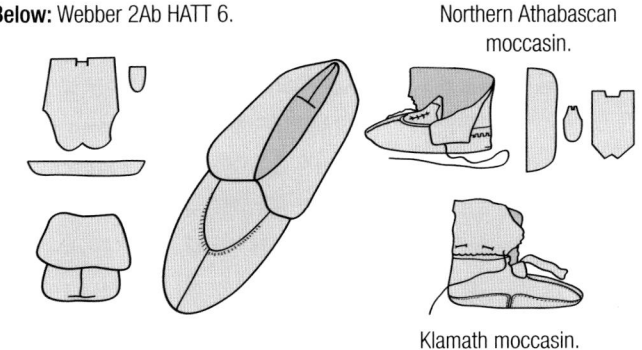

Klamath moccasin.

Below: Webber 2Ad HATT 8.

Kutenai moccasin.

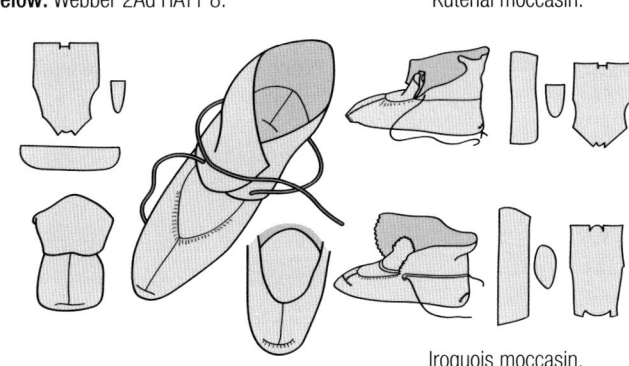

Iroquois moccasin.

which covers very little of the foot and also has patches sewn to the underside.

The Klamath example sketched has reinforced soles, a trait which has been attributed to some northern Californian Shasta groups. Type 6 is also common among the Western Woods Cree adjacent to the Athabascan area.

Type 7 – Webber 2 (Ac)
Moccasins of more than one piece
- Bottom piece and part top piece
- Instep vamp/tongue
- Straight heel seam
- T-shaped toe seam

This is a very rare type. Hatt reported only one, collected from the Warm Springs Reservation, Oregon. At least two pairs of eighteenth-century moccasins of this form attributed to the Ojibwa are known; these may be a rudimentary form of Type 8.

Below: Webber 2Ac HATT 7.

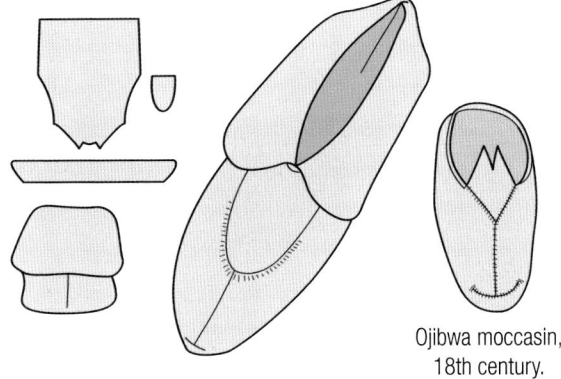

Ojibwa moccasin, 18th century.

Type 8 – Webber 2 (Ad)
Moccasins of more than one piece
- Bottom piece and part top piece
- Instep vamp/tongue
- T-shaped heel seam
- T-shaped toe seam resulting in a square toe

Like the widespread Type 6, this type is very common among the northern tribes, but in this case more prominent among the Algonkian peoples. Type 6 is a form used by the Nascapi, Têtes de Boule, branches of the Eastern Cree, and occasionally by the Iroquois, Huron, and Abenaki; in the west by the Blackfeet, Interior Salish, Puget Sound tribes, Kutenai, Ute, and Shoshoni; more northerly by the Tahltan, Kutchin, and Tlingit. An eastern moccasin in the British Museum, probably Huron, has a T-shaped toe seam and a heel seam with two small trailers which barely form a T. A similar form with a short vamp is sketched from the Kutenai tribe.

Type 9 – Webber 2 (Ba)
Moccasins of more than one piece
- Bottom piece and part top piece sewn to vamp
- No toe seam
- Straight heel seam

This is a form that descends directly from Type 1. The narrow gore referred to in Type 1 has become slightly wider and "vamp like." This type is almost totally restricted to the Iroquois groups, Penobscot, and Malecite and is therefore a modification of Type 1. The Penobscot moccasin is a subtype having an enlarged vamp like a modern commercially made moccasin and appears to be restricted to the northern Maritime tribes.

Below: Webber 2Ba HATT 9.

Cayuga moccasin.

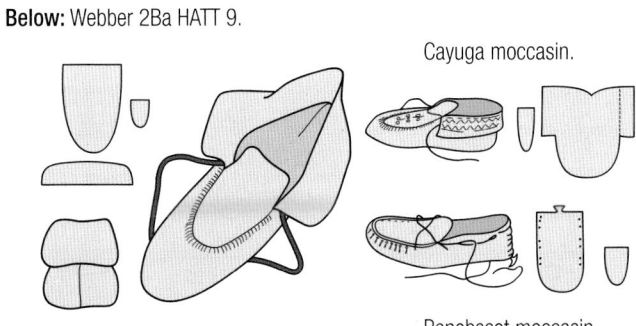

Penobscot moccasin.

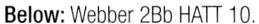

Below: Webber 2Bb HATT 10.

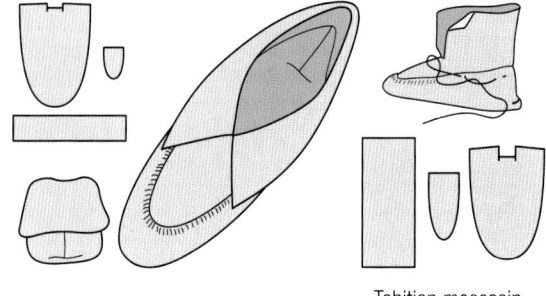

Tahitian moccasin.

Type 10 – Webber 2 (Bb)

Moccasins of more than one piece
- Bottom piece and part top sewn to vamp
- T-shaped heel seam
- No toe seam

This form and the Types 6 and 8 are the most important moccasin forms of North America. This type is a very common from the Tlingit, Tahltan, Tsimshian, and, with only slight variations, from the eastern Woodlands, and is known from the Cree, Montagnais, Nascapi, Iroquois, Huron, and Mistassini. A sub-form with a reduced ankle flap, which is turned down and often edged and decorated, is very common from the Mohegan, Iroquois, Huron, Micmac, Montagnais, Penobscot, and Ojibwa. Many of these latter types were made for tourist markets and even sold in the far west during the nineteenth century. All the forms of Types 1–10 are really all more or less descended from the basic type, the changes being relatively small.

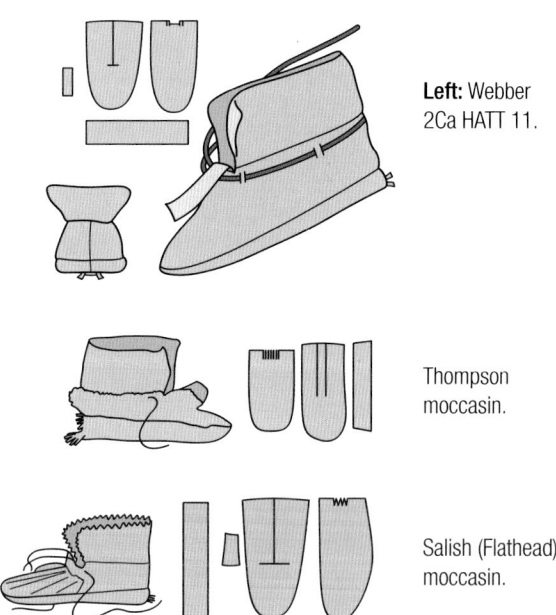

Left: Webber 2Ca HATT 11.

Thompson moccasin.

Salish (Flathead) moccasin.

Type 11 – Webber 2 (Ca-b)

Moccasins of more than one piece
- Bottom
- Upper becoming a tongue
- Top
- T-shaped heel seam

This form and Type 12 appear to be hybrids between the true moccasin Types 1–10 and the Plains shoe Type 14. The treatment of the upper and heel seam are reminders of the true moccasin form. The separate sole is the shoe form seen in Type 14. Examples are Plains Ojibwa, Blackfeet, and occasionally Sioux and Ponca. The seam between the sole and upper usually rises towards the heel in a way similar to Type 12 (the side-seam type), this detail is called a dual side seam.

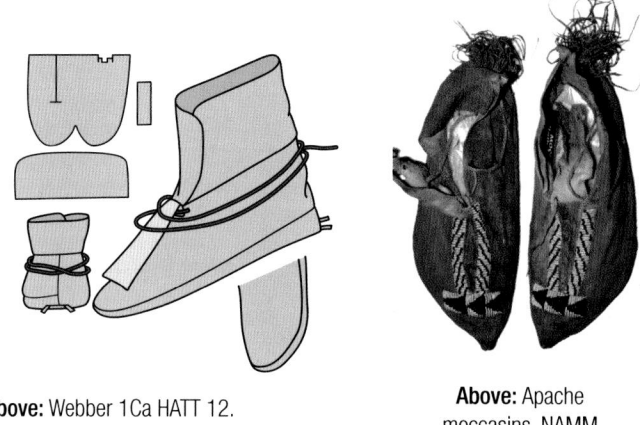

Above: Webber 1Ca HATT 12.

Above: Apache moccasins. NAMM

Below: Webber 1Cb HATT 12.

Upper Missouri moccasin.

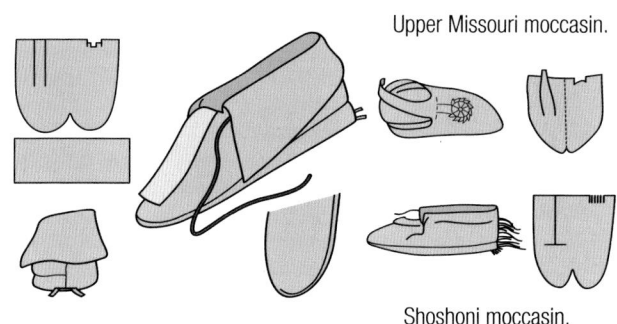

Shoshoni moccasin.

Type 12 – Webber 1 (Ca-b)

Moccasins of one piece
- Bottom/upper becoming a tongue
- Top
- Side seam running from a point near the heel along the outer side around the toe.

This form, often called side-seam construction, is characteristic of the Upper Missouri tribes before their adoption of the Type 14 during the nineteenth century. With Type 11 it is a hybrid type between the true moccasin and the Plains shoe, and was probably developed from Type 11. Many tribes used this construction: Arapaho, Cheyenne, Sarsi, Blackfeet, Plains Cree,

Below: Webber 4Aa HATT 13.

Below: Webber 4Aa HATT 13.

Mescalero Apache moccasin.

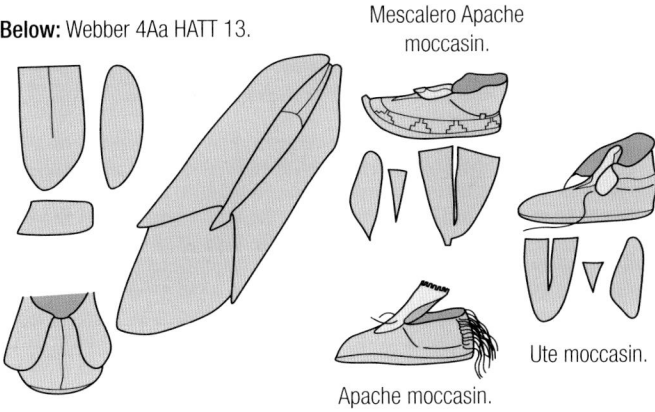

Apache moccasin.

Ute moccasin.

Sioux, Thompson, Assiniboine, Gros Ventre, Shoshoni, Nez Perce, Plains Ojibwa, and Woodland Ojibwa. The Shoshoni example sketched is interesting for the introduction of a heel fringe.

Type 13 – Webber 4 (Aa)
Shoes: flat sole (often rawhide)
• Upper
• Instep sewn into a straight slit at the foremost part
• Vertical heel seam
This and the following types of shoes and boots, usually made asymmetrical (left and right), apparently have no evolutionary connections with the true moccasin Types 1–10 unless it is via the vague associations with the hybrid Types 11 and 12. Type 13 seems to be found mainly among the eastern Apache groups and Ute; and there is a simple form from the Osage, which lacks

Below: HATT 14.

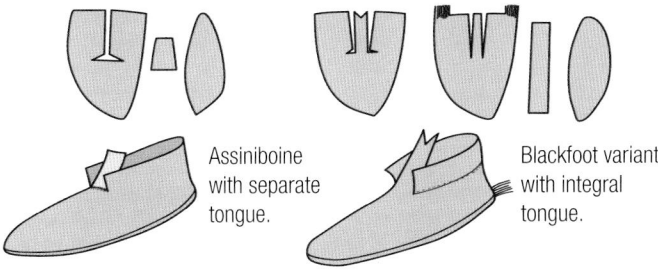

Assiniboine with separate tongue.

Blackfoot variant with integral tongue.

Below: Webber 4Ab HATT 14.

Sioux moccasin.

Crow moccasin.

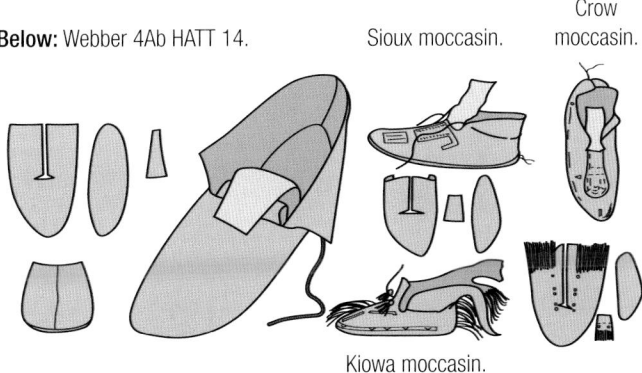

Kiowa moccasin.

Sole outline of various Plains moccasins. All right feet.

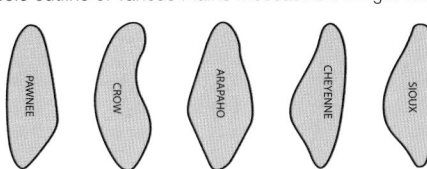

PAWNEE CROW ARAPAHO CHEYENNE SIOUX

Below: Webber 4Ac HATT 15.

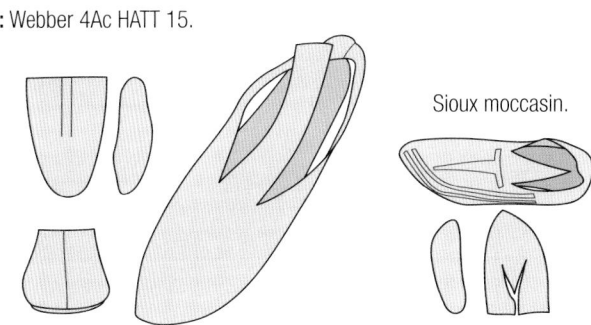

Sioux moccasin.

the instep and has two trailers cut from the uppers. A number of moccasins of this form have a fringe added at the heel.

Type 14 – Webber 4 (Ab)
Shoes: flat soles (often separate rawhide)
• Upper with a horizontal T-slit
• Instep/tongue sewn into the slit
• Vertical heel seam with or without trailers
This is the common form of the nineteenth-century Plains moccasin, with little variation except among the northern Plains tribes such as the Blackfeet, Plains Cree, etc., where soft separate soles were also common. A number of differential sole shapes have been proposed. The ones shown are from Native American sources.

The Kiowa variation has a comparatively high rear and a fringe made into the heel. Along the front part of the instep piece is sewn a fringed piece of buckskin running obliquely from the outer side of the instep down towards the toe. Another Kiowa example with a front fringe has it cut from the edge of a triangular instep as in Type 13. Interesting variations involving leggings added to this design to form boots are common from the southern Plains tribes, such as the Cheyenne and Comanche, and there are also soft-soled boots from the Crow, Blackfeet, and Plains Cree.

Type 15 – Webber 4 (Ac)
Shoes: flat sole
• Upper piece cut into a Y-shape slit as a special instep or as two parallel lines
• Vertical heel seam
• Sometimes a top
The distribution of this form is almost the same as for Type 14, although it is less common and includes the Plains Siouan and Algonkian, Basin, and Plateau tribes.

Below: Webber 1B HATT 16.

Osage moccasin.

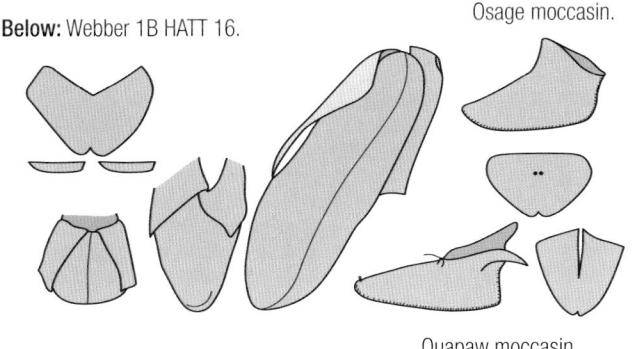

Quapaw moccasin.

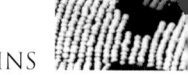

The last three forms are so different in construction from the true moccasin forms that modern experts suggest a Euro-American origin. Another suggestion is that Type 15 may have evolved from the repairing (adding soles) of true moccasin forms. Wissler was probably incorrect in suggesting that the Plains shoe was developed from the sandal as nothing in the construction of these forms indicate any connection.

Below: Webber 5Aa HATT 17.

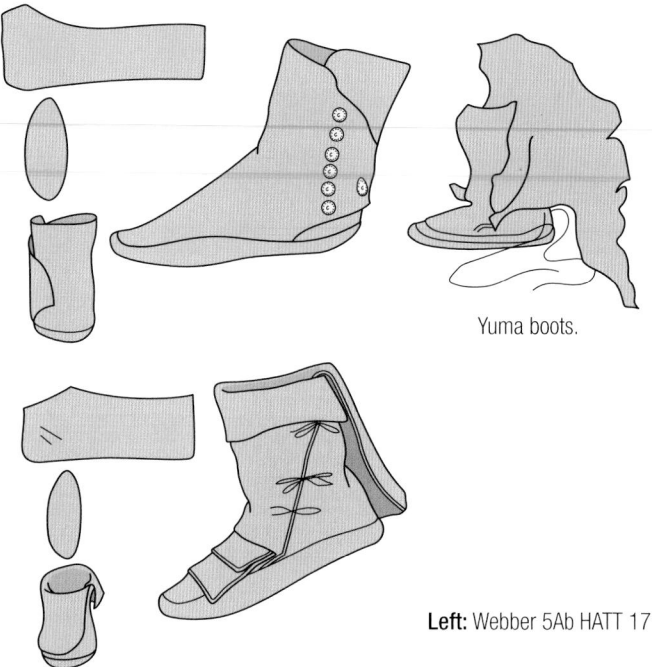

Yuma boots.

Left: Webber 5Ab HATT 17.

Type 16 – Webber 1 (B)
Moccasins of one piece
• Middle seam running on the underside from toe to heel and continued as a straight heel seam
This interesting form has only a narrow distribution from the Osage and Quapaw of Oklahoma. The sketched Quapaw example, which has fringing pushed through holes on the front, also has a repaired sole which perhaps adds weight to the idea that the shoe forms are derived from worn-out moccasins.

Type 17 – Webber 5 (Aa-b)
Boots: soles with turned up rim (often rawhide)
• Instep and top piece sewn to the sole, but otherwise unattached (bound to the legs)
This form has no evolutionary connection with any other preceeding form as it is distinctly Southwestern, being typical of the Zuni, Hopi, Navajo, Apache, Yuman groups, and Paiute. Examples vary only in the extent of their top pieces.

Type 18 – Webber 5 (Ba)
Boots: comprised of rawhide sole with turned up rim; usually one piece with vertical seam.

Below: Webber 5Ba HATT 18.

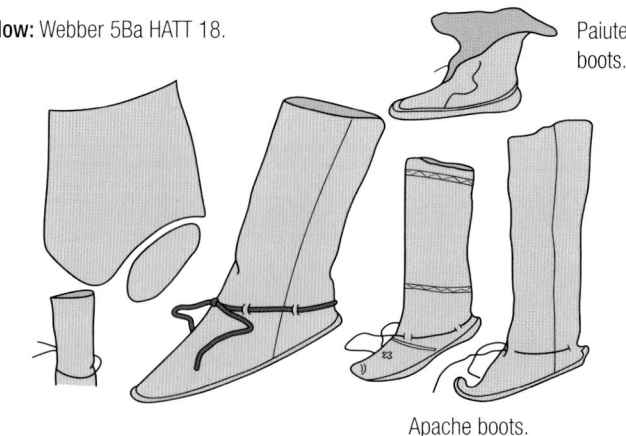

Paiute boots.

Apache boots.

Below: Webber 5Bb HATT 19.

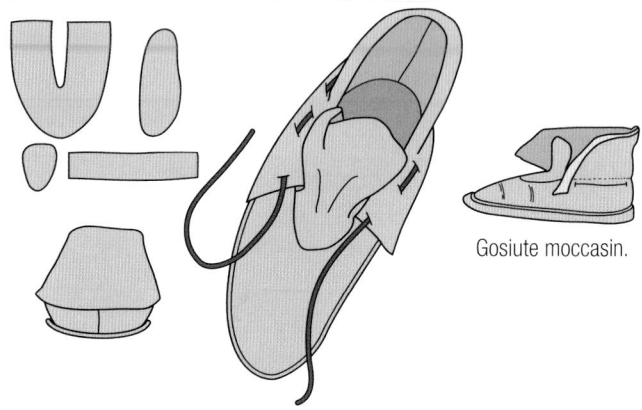

Gosiute moccasin.

It is almost certain that this form is derived from type 17 and is from the same tribes in the southwestern states: Paiute, Gosiute, Western Apache, Ute, etc. The rim and drawstring above the sole, extending around the ankle, has led to the suggestion of a relationship of types 17 and 18 to the ancient American sandal, and a similar connection is also possible for Eskimo boots.

Type 19 – Webber 5 (Bb)
Shoe: rawhide sole with turned-up rim
• Upper
• Instep/vamp
• Top
This is an interesting hybrid form from the Ute and Gosiute; it has a sole as on the Southwestern Types 17 and 18 as well as uppers reminiscent of the Type 13 soled shoe, but with the rounded insteps of the true moccasin forms.

Below: Webber 3—no HATT reference.

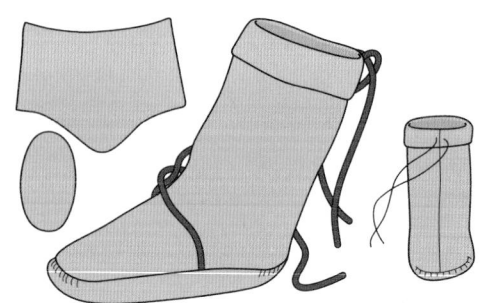

NORTHEASTERN ALGONKIAN, CANADIAN MARITIME, AND NEW ENGLAND MOCCASINS

Moccasins with Type 1 construction were probably indigenous to the whole of eastern North America including New England and adjacent Canada. Speck in 1915 illustrated an example of this attributed to the Niantic. However, almost all the New England and Maritime Canadian moccasins that have survived the decay of Indian culture are Type 9 and occasionally Type 10. Their main characteristics are: no toe seam; an ankle collar or flap, usually cloth; a vamp also of cloth gathered around the bottom unit; construction of skin, often moosehide, but sometimes, in late nineteenth-century examples, commercial leather. There is usually heavy crimping around the junction of the bottom unit and the vamp. Collars and vamps are decorated with beadwork in designs using the double-curve motif, small floral designs, or marine-like elements in the case of Micmac examples.

IROQUOIS MOCCASINS

The old Iroquois forms closely correspond to those given for the Huron. Type 1 was also particularly common and surviving examples are superbly decorated with quillwork and moosehair, sometimes with woven quillwork in strips on the instep and the collar. Early Huron, Delaware, and Iroquois moccasins are noted for the fringes of red deer hair in tin cones or tassels along the edges of the collar. During the period 1820–40 the Iroquois produced moccasins of the above type but the collars (usually cut square) were edged with blue ribbon, the collar and instep decorated in quillwork in the appliqué zigzag band and simple line techniques, later giving way to beads. Occasionally early specimens were decorated with moosehair "false embroidery." These invariably date from the eighteenth century and are very rare.

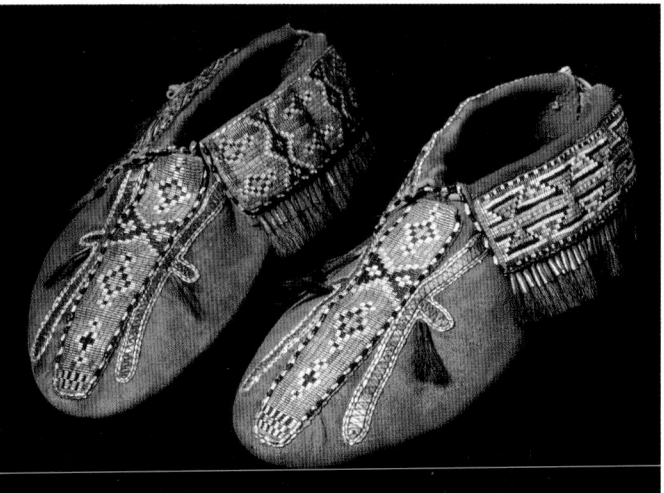

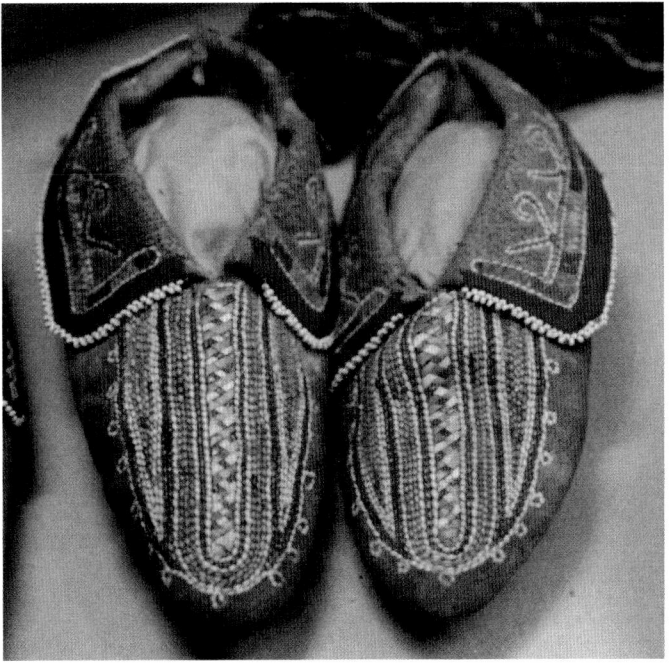

Top, right: Iroquois (probably), eighteenth century. De Peyster, NML

Above, right: Iroquois Type 1 moccasins, early nineteenth century. Buckskin with quillwork.

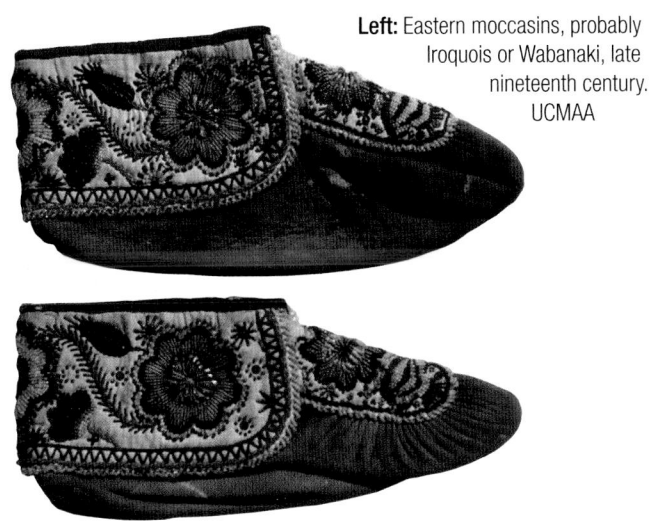

Left: Eastern moccasins, probably Iroquois or Wabanaki, late nineteenth century. UCMAA

By about 1850, the Iroquois tribes had adopted the vamp Type 10. This later Iroquois form, with distinctive embossed beadwork, often constructed of commercial hide, was produced in large numbers for the souvenir market. They usually had a deep narrow vamp of cloth or canvas, stiffened with brown paper, or any combination of these. This construction made the beadwork easier on the vamp decoration. There is evidence to suggest that these vamps were made separately from the moccasins and then put together on a near production-line basis at Tuscarora, St. Regis, and Caughnawaga in eastern Canada and New York state.

This commercial production of Indian moccasins was adopted in other places, notably among the Maritime Algonkians and later by the Athabascan and Cree groups in northern and western Canada. Moccasins became a major Indian craft item for the souvenir markets.

HURON MOCCASINS

Most of the Huron moccasins that survive in museums are attributed to the Hurons of the village of Lorette in Quebec. These are sometimes beautifully decorated with moose hair and caribou hair embroidery. The earliest forms are of Types 6 and 8, and later Type 10. The transitional Huron moccasin, c. 1840–60, had a long, narrow vamp with the collar or flap turned down. The earliest forms usually had the cuff upright to the leg, and occasionally both an upright cuff and a flap were used. Some of the early moccasins of the whole of the eastern Great Lakes area were characteristically dyed back. Huron moccasins, together with moccasins of the Têtes de Boule, were sold in large numbers by the Hudson's Bay Company and we can speculate that this was a factor in the spread and diffusion of the numerous construction variations as well as decoration techniques across Canada.

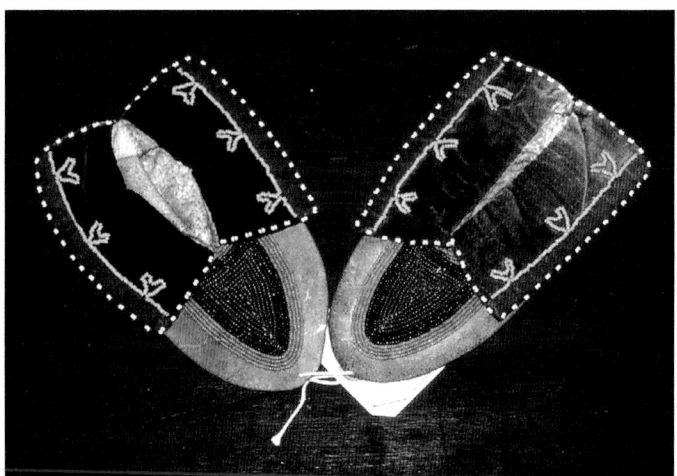

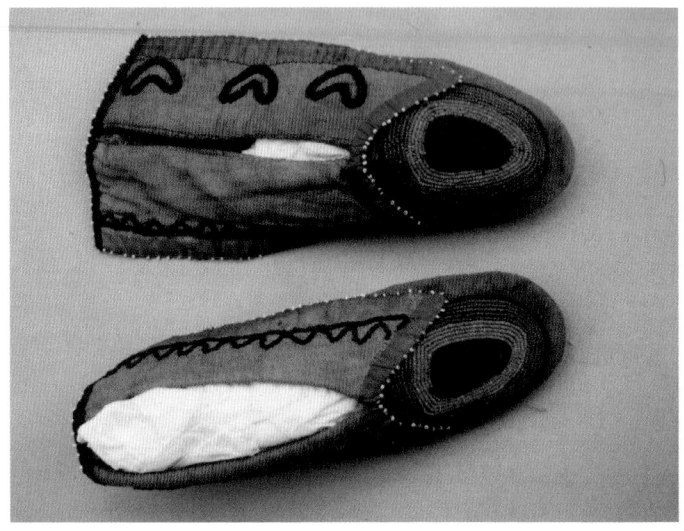

Although some early Huron moccasins had side ankle wraps or cuffs that were usually upright and are similar in shape to the more southerly one piece form, later the collars were turned down and often gusseted, presumably to save hide or to obtain a trim shape; these collars were invariably added separately. Characteristic of the Huron and many other northeastern moccasins is the heavy crimping at the junction of the vamp with the main foot unit.

Top: Moccasins, Oklahoma Delaware type construction. MM

Above: Moccasins, Oklahoma Delaware, c. 1900 Type 1 construction. MM

Left: Huron moccasins with moosehair embroidery, c. 1830.

DELAWARE MOCCASINS

Delaware moccasins from the Oklahoma branch of the tribe retained their traditional Type 1 center seam, with slightly flaring ankle flaps. These collars usually provided room for ribbonwork and beadwork. The front seam was covered with appliqué beadwork of a fairly distinctive type. This type has been well documented. However, the Munsee Delaware who were removed to Canada adopted the common Type 10 from neighboring Canadian groups, although some specimens were decorated in Delaware curvilinear and floral designs.

NASCAPI AND MONTAGNAIS MOCCASINS

A few documented examples of early Nascapi moccasins have survived which clearly show the Type 1 form—a toe seam which is straight and heavily puckered, with ankle collar which is turned down. This is reminiscent of the styles farther west and south, but has the characteristic Nascapi painting on caribou hide. However, during the nineteenth century they appear to have adopted the vamp moccasin Type 10 without the center seam in common with the Montagnais and Type 8 which they share with branches of the Eastern Cree. Characteristically eastern moccasins are more heavily puckered or crimped at the junction of the vamp and instep.

TÊTES DE BOULE MOCCASINS

These have T-shaped toe seams and T-shaped heel seams—Type 8, with various sized vamps and collars. This very common form, which extends to most of the Algonkian tribes of northeastern Canada, is usually plain in the case of the Têtes de Boule, except for a line or two of thread or silk braid which may be sewn around the margin of the vamp, or small floral threads or silkwork embroidery designs in angular form on the

vamp. The Montagnais occasionally used beadwork, the Nascapi quillwork, but on the whole the proportion of decorated examples is not great among the great volume of moccasins produced, in particular by the Weymontachingue Têtes de Boule for the Hudson's Bay Company. Many moccasins are of moose and/or caribou hide and were sold to regions where such game had become depleted.

OJIBWA MOCCASINS

They varied considerably from location to location and during different periods and run through most of the true moccasin construction forms. Most of the early examples are Type 1, the one-piece moccasin with front and heel seams, with ankle collars hanging down, and sometimes quillwork decoration. Two rare Type 7 examples, with a modest tongue and V-shaped gore, from the eighteenth century have been attributed to the Ojibwa, but the most common is Type 6 particularly during the nineteenth century. This has a straight toe seam and inverted T-shaped heel seam, usually with collars hanging down, with a characteristic U-shaped vamp or apron (sometimes multi-layered skin and cloth), and is often partially decorated with beadwork. Many southern Ojibwa moccasins are of this type; on the other hand the northern Ojibwa or Saulteaux of Canada often solidly beaded both vamp and collars. The eastern Ojibwa, the

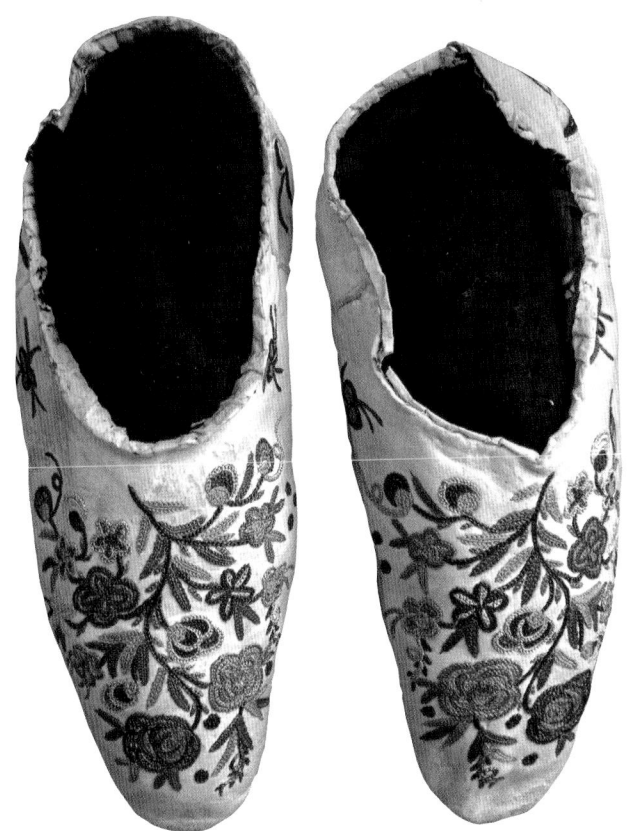

Mississauga, sometimes used Type 10, with no toe seam and a large vamp heavily puckered to the bottom unit.

One authority, Howard, gives five construction types for the Plains Ojibwa, Types 1, 6, 10, 12, and 14. Occasionally narrow gores were added to the toe and heel seams on true moccasin forms. Moccasins made by mixed Ojibwa and Cree, and Métis varied little from those of their parent tribes.

CREE MOCCASINS

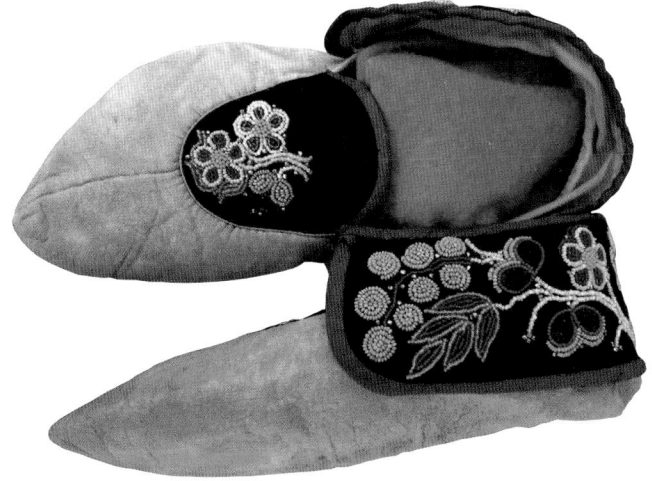

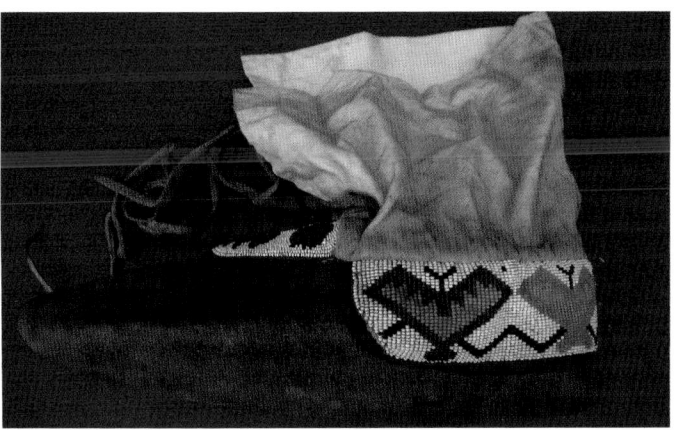

The principal construction styles of the Cree were Types 6 and 10. The Western Woods Cree favored Type 6 which they shared with some of the Northern Athabascan peoples, while their eastern branches favored Type 8 and Type 10 without front seam. A characteristic of both Cree and Northern Athabascan moccasins is the treatment of the seam at the junction of the vamp (often two layers of skin and cloth) and the bottom unit, the seam being often covered with horsehair-wrapped piping. The filler is also usually horsehair. Another feature of their moccasins was the introduction of leg wraps or cuffs attached at the ankle rim which could be bound to the leg for

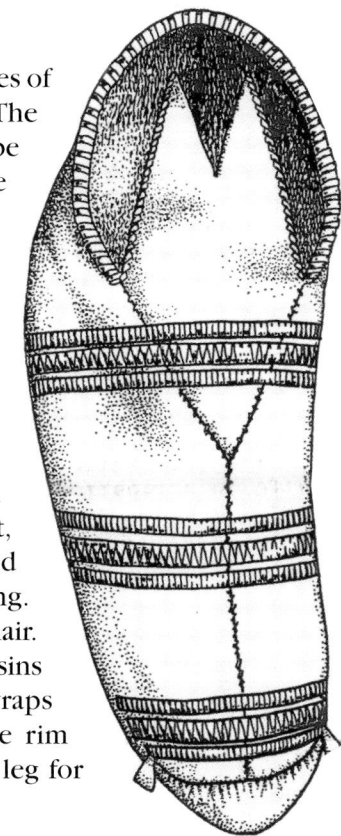

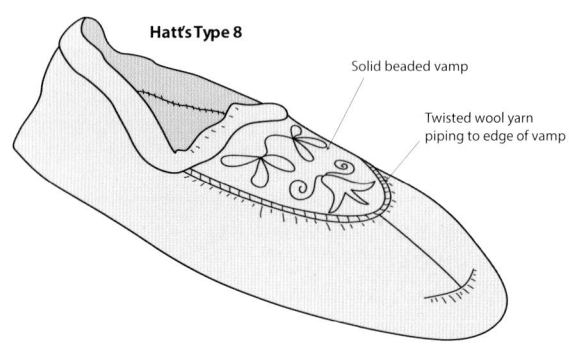

Hatt's Type 8

Solid beaded vamp

Twisted wool yarn piping to edge of vamp

Eastern Cree & Eastern Ojibwa (Ontario).
Buckskin moccasin with T-shaped heel and toe seam.

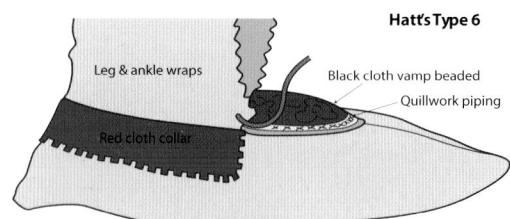

Hatt's Type 6

Leg & ankle wraps

Black cloth vamp beaded

Quillwork piping

Red cloth collar

Woods & Swampy Cree and Northern Athabascan.

protection. Some early Cree and Northern Athabascan moccasins were decorated with woven quillwork with bird-quill piping. Following the establishment of mission schools in the north during the nineteenth century, the Cree and the Cree-Métis also made a shoe-type moccasin with separate soles in the form of a European slipper with vertical side seams.

NORTHERN ATHABASCAN MOCCASINS

Most moccasins of these northern tribes were made of moose or caribou hide or sometimes of beaver skin. The most common construction was Type 6, with a straight toe seam and T-shaped heel seam. The tongue/vamp is often double hide, the outside being decorated with appliqué or woven quillwork. Beadwork, silkwork, or thread and moose-hair embroidery introduced from

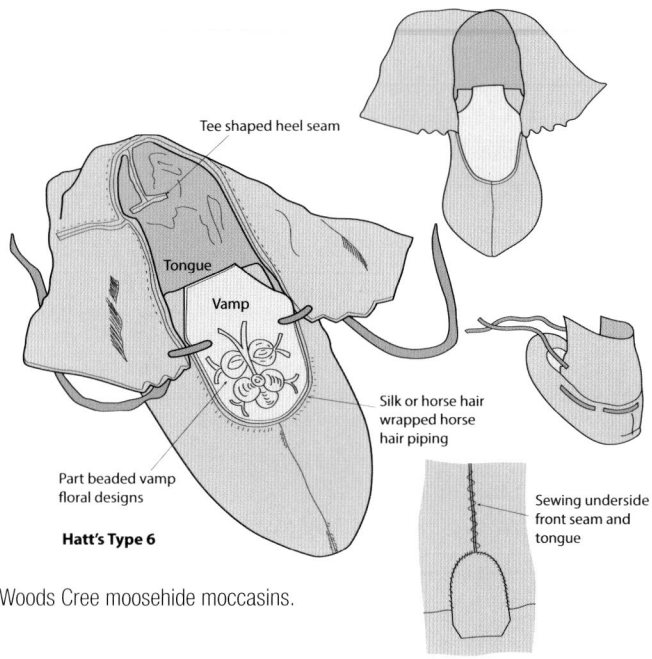

Tee shaped heel seam

Tongue

Vamp

Silk or horse hair wrapped horse hair piping

Part beaded vamp floral designs

Hatt's Type 6

Sewing underside front seam and tongue

Woods Cree moosehide moccasins.

Opposite, above left: Chippewa (Southern Ojibwa) moccasins c. 1900. Buckskin with velveteen collars and vamps with thread sewn beadwork. Classic type 6 with inverted "T"-shaped heel seam and straight toe seam. MGJ

Opposite, below left: Ojibwa (probably northern Ojibwa-Cree) moccasin c. 1890. Moose hide, cloth vamp with horsehair, wrapped horse hair piping, collar cloth with woven beadwork in thunderbird designs. Heavy seed bag or similar ankle wrap. Type 6 inverted "T"-shaped heel seam and straight toe seam. MGJ

Opposite, above right: Moccasins, Lake Winnepeg area Cree or Cree-Métis c. 1870. Shoe construction with separate soles and vertical side seams. Decorated with fine silk embroidery in floral pattern; the top edge would have been trimmed with white fur now gone. MGJ

Opposite, below right: An eighteenth-century center-seam moccasin with "T"-shaped transversal toe seam; Type 7 attributed to the Ojibwa. Sketch by Dave Sager.

Above right: Nothern Athabascan moccasins probably Kutchin c. 1910. Hatt Type 6 with moose hide bottom unit with caribou skin ankle wrap and castellated trade cloth flap. The pink beads suggest post-1900 manufacture. MGJ

Below right: Marginal Plains Ojibwa (Canadian Parklands) moccasins, c. 1900. Buckskin, cloth vamps and flaps with solid thread-sewn beadwork in floral designs. Fairly rare Type 12 side-seam construction for this area, combining with vamp-collar Types 6, 8, and 10. MGJ

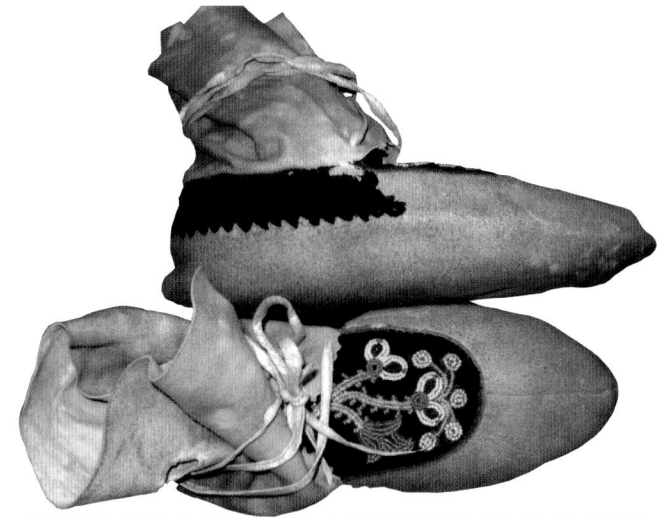

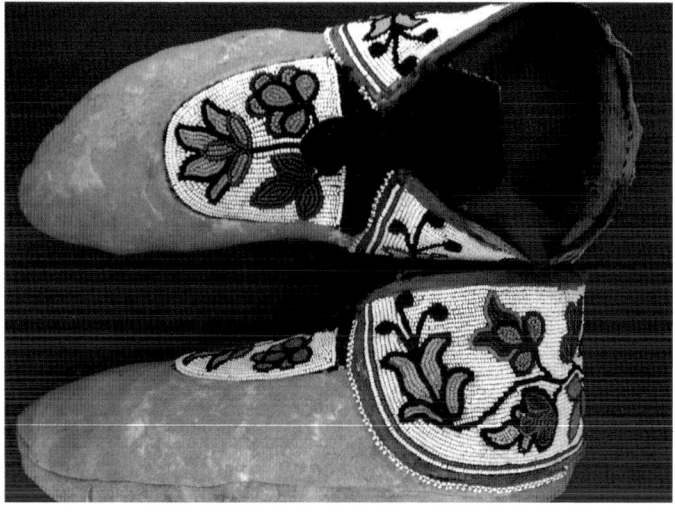

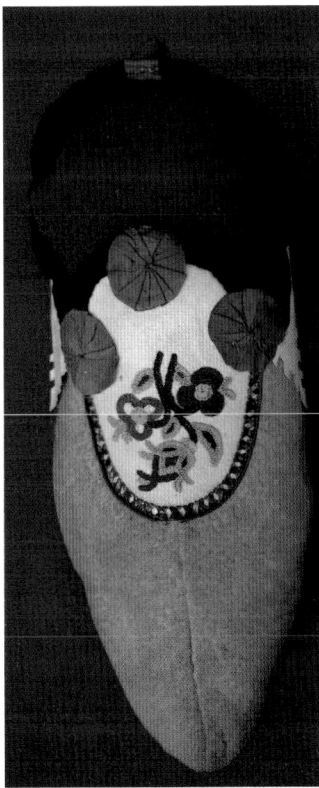
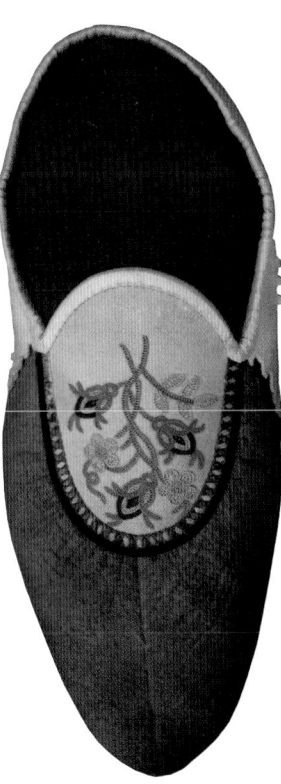

Above left and right: Northern Athabascan-Métis moccasins. Probably Chipewyan, Dogrib, or Slavey c. 1900. They are Type 6, with inverted T-shaped heel seam and straight toe seam. The bottom unit is moosehide with vamp/apron of caribou skin, all with silk thread embroidery in floral designs with horsehair piping and margins of porcupine-quill appliqué. Castellated collars or flaps appear to be a feature of moccasins from this area and period, and a number also have high ankle wraps. Boots with extended wraps to below the knee from these tribes are usually on a Type 10 moccasin, that is with no front seam.

Opposite, above left: Plains Cree moccasins. MGJ

Opposite, above right: Type 14 construction moccasins with floral beadwork, possibly Santee Sioux c. 1900. HK

Opposite, below: Eastern Sioux moccasins.

two lanes horse hair piping with band of quillwork

Margin of vamp Cree and Northern Athabascan.

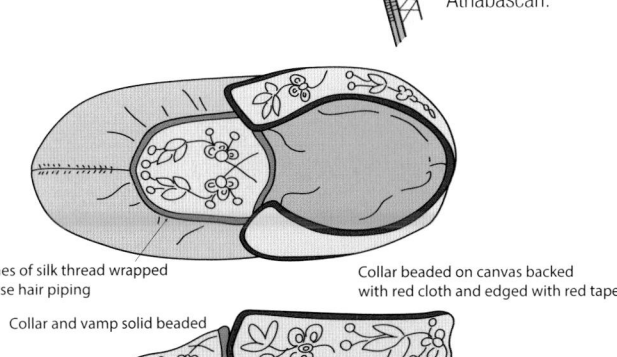

Lanes of silk thread wrapped horse hair piping

Collar beaded on canvas backed with red cloth and edged with red tape

Collar and vamp solid beaded

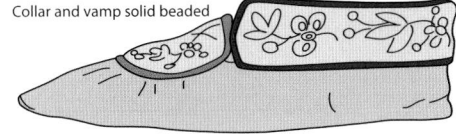

Northern Ojibwa Saulteaux (Berens River Manitoba).
Note: Ojibwa moccasins are usually without leg ankle wraps.

eastern Canada was used later. Examples of Type 8 and Type 10 are also popular, the latter form sometimes having a fully or partially beaded wide and deep vamp. This appears to be a recent form often made for sale. This form is also often edged with fur around the foot opening, a modern trait shared with the Cree, and Cree-Métis from the James Bay area. Many Northern Athabascan moccasins have horsehair coil piping at the edge of the vamp.

Duncan gives the following Hatt types for various Athabascan groups:

- Slavey, Mountain, Chipewyan, Yellowknife, Dogrib, Hare, Bear Lake, Kutchin – Type 6 and Type 10 (twentieth century).
- Kaska, Sekani, Beaver, Carrier, Chilcotin – Types 6 and 8, and Type 10 (twentieth century).
- Tutchone, Han, Ahtena, Tanana, Koyukon, Holikachuk – Types 6, 8, 10 and 11 plus moccasin-boots.
- Tahltan – Types 8 and 10 (plus 6 introduced from the Kaska).
- Tagish, Inland Tlingit – Types 8 and 10.
- Ingalik, Upper Kuskokwin, Tanaina – Boots and moccasins reported but no types indicated.

Thompson reviewed many Athabascan moccasins and confirmed Duncan's findings, that is to say Types 6 and 10 are known throughout this immense area, and Type 8 is common in the Cordillera among the Tahltan, Kaska, Sekani, and Inland Tlingit. Beadwork on vamps and flaps is common throughout the Athabascan area but silk-thread-wool floral designs occur chiefly on moccasins from Chipewyan, Dogrib, and Slavey (and adjacent Cree). Cloth vamps and flaps tend to be more common on moccasins from the Cordillera groups. While castellated flaps predominate on moccasins of the Chipewyan, Dogrib, and Slavey, most flaps of Cordillera moccasins are left uncastellated. Moosehair work occurs mainly on Slavey moccasins. Horsehair piping and to a lesser extent diamond pattern (two-quill) porcupine quillwork to vamps are more common on moccasins of the Chipewyan, Dogrib, and Slavey than the Cordillera groups.

PLAINS CREE & PLAINS OJIBWA MOCCASINS

The Plains Cree used both the side-seam and the separate-sole construction of Types 12 and 14 but their moccasins were often soft-soled. They also used an extended wrap or cuff to form a boot-like moccasin on a basic Plains shoe form, a style commonly used on recently made powwow boots from many Northern Plains groups.

In 1996 Sager commented on what he called the "the dual side seam moccasin," which is equivalent to Type 11, where the upper and lower parts of the moccasin are brought together to produce a seam all around the foot,

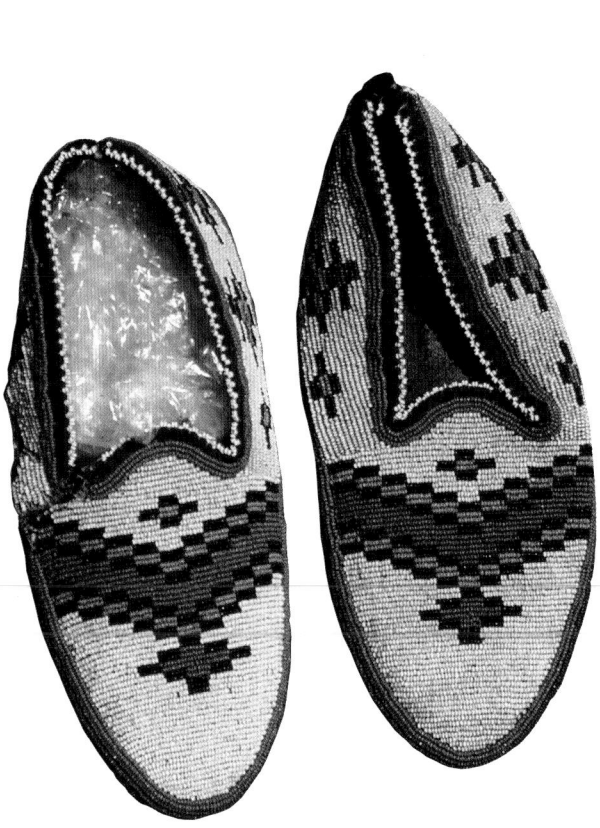

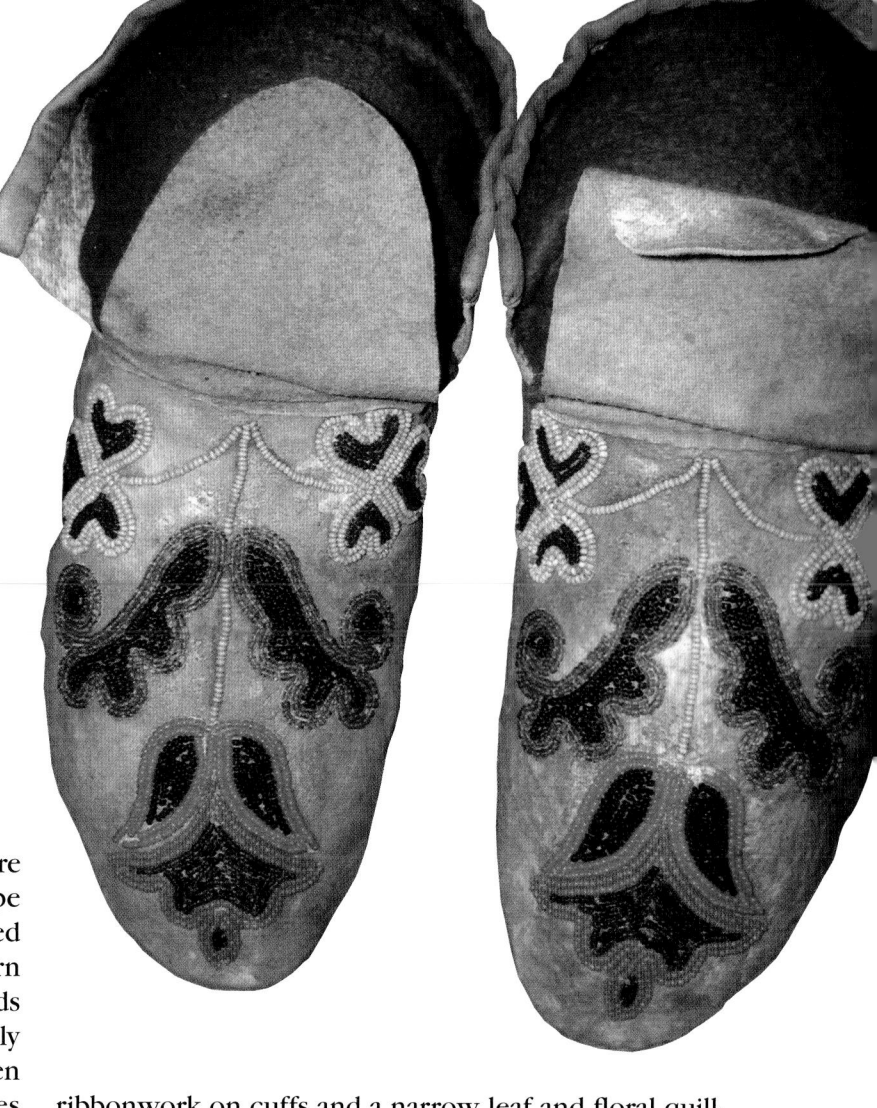

but the seam rises progressively towards the heel where it joins the inverted T-seam. Many examples of this type come from the Canadian Parklands and are attributed to the so-called Plains Cree and Plains Ojibwa (Western Saulteaux) people, although clearly most of their bands were never fully fledged Plains buffalo hunters or totally equestrian. Their marginal geographical range between the Woodlands, Parklands, and High Plains peoples gave rise to a number of hybrid construction forms, an example of which in the author's collection is a pair of Cree moccasins of side-seam Type 12 construction with an instep vamp of the style used in Types 6 and 8. Fully or partly beaded vamps or upper front surfaces, decorated in either geometric or floral beaded designs reflect their transitional culture. They were also mixed with the Assiniboine, Santee Sioux (after some moved to Canada in the 1860s), and the mixed-blood Métis making precise tribal identification of material culture from this area difficult and sometimes impossible, particularly from the later-nineteenth-century period.

SANTEE (EASTERN) SIOUX MOCCASINS

There is evidence that the earliest moccasin form of the Eastern Sioux and perhaps of all branches of the Sioux was Type 1; this is characteristically seen with a straight front seam heavily puckered and a rounded ankle collar, usually having appliqué quillwork along the front seam and around the rim of the flap. However, this style disappears about 1830 and is replaced by other construction types, particularly Types 12, 14, and 15. Evidence of Santee use comes in two examples of Type 6 (straight toe seam with T-shaped heel seam). One of these is at Cambridge University Museum, England, with

ribbonwork on cuffs and a narrow leaf and floral quillwork, and is documented as Santee Sioux. The other specimen suggested as Santee was illustrated in the Denver Art Museum Summer Quarterly in 1965. Another style with similar quillwork, but of Type 10, occurs in the Jarvis Collection in the Brooklyn Museum, New York. It is interesting to note that recently this style of quillwork has been given a Métis attribution, although such decorated moccasins could have been circulated to the Santee by trade, but in any case Type 10 does not seem to have been a common Santee type.

In 1966 Howard confirmed the use of Type 1 and Type 6, in the variant form that has the flap or wrap that extends up the leg with a cuff hanging down and usually decorated. After some Santee moved to Canada, particularly Manitoba, during the 1860s their moccasins subsequently became identical with the local Saulteaux style.

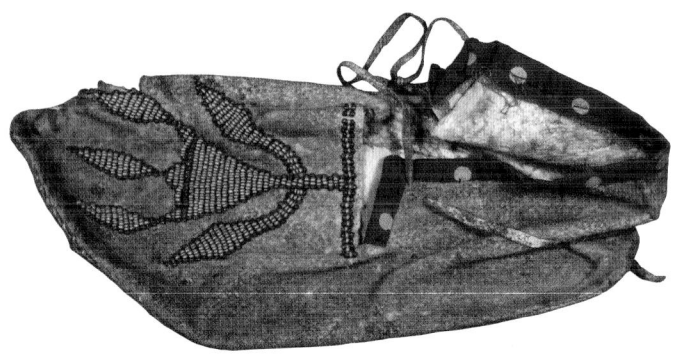

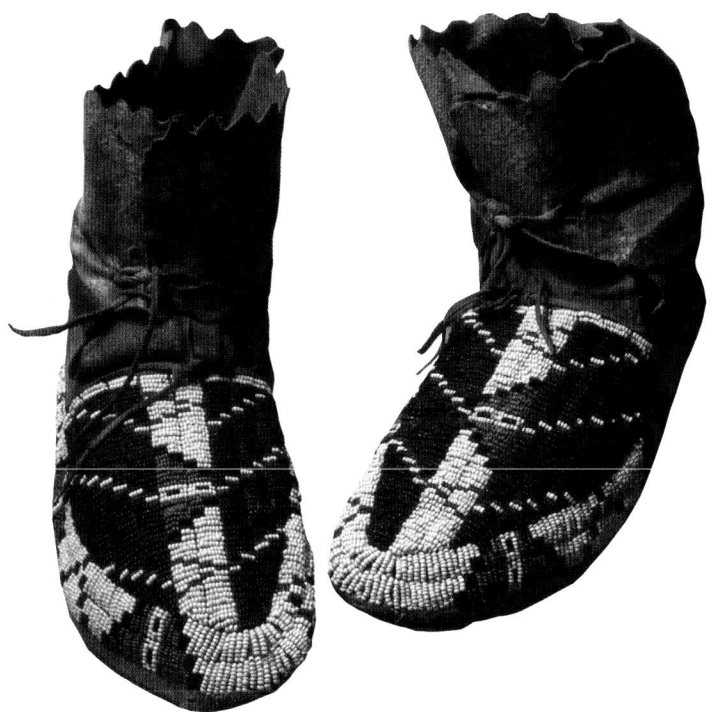

Above: Sioux woman's moccasins. Lessard Colln

PLAINS INDIAN MOCCASINS (GENERAL)

Many of the oldest moccasins from the eastern and northeastern margins of the Plains were the various forms of true moccasins, particularly Type 1. Early nineteenth-century moccasins collected from the environs of the Upper Missouri River were Type 12, the side-seam construction. A pair of unfinished moccasins in the Speyer Collection of the Canadian Museum of Civilization, Quebec, is of this type and decorated with the quill-wrapped horsehair coil technique and likely of Mandan, Hidatsa, or Crow origin.

A Comanche moccasin in the U.S. National Museum is probably the earliest documented example of the Plains shoe with a separate hard rawhide sole and is dated c. 1820. If the Comanche can be credited for introducing or evolving the separate rawhide-soled shoe, then we might look to the Basin, their original home, for the prototypes, perhaps the boot Types 17 and 18. The Comanche and Kiowa also had a knee-high boot; however, the leg-wrap portion adjoins the shoe at the ankle and not at the edge of the rim of the upturned sole. This may be some intermediate form but is a moccasin-boot not a true boot. We can assume that the hard-soled shoe form spread north and in time eliminated Type 12 and true moccasins among the relatively recently arrived central Plains tribes—Sioux, Cheyenne, and Arapaho. The Plains shoe is characterized by the rawhide sole of buffalo hide or later cow hide. Among the northern Plains tribes—Blackfeet, Assiniboine, and Plains Cree—the hard-soled moccasin never completely

eliminated the side-seam type, so by the late nineteenth century hard- and soft-soled moccasins co-existed.

The central Plains tribes solidly beaded their moccasins during the second half of the nineteenth century in sinew-sewn lane-stitch geometrical designs, varying from tribe to tribe. The Assiniboine and Plains Cree also produced solid-beaded moccasins but in appliqué-stitch technique, often using thread. Variation in the construction also occur at the tongue, heel, and welt, a reinforcement strip sewn between the upper and lower sole seen on Cheyenne moccasins. The southwestern Plains Indians—Jicarilla and Ute—made a unique form of Type 13 with an upturned toe, which may have been derived from Spanish sources. The Blackfeet usually only partly beaded their moccasins and the Plains Ojibwa, who never entirely adjusted to Plains culture, used Woodland, Plains, and hybrid forms. Variations also occurred in the cut of the uppers between Blackfeet and Assiniboine moccasins.

The Sioux also occasionally made the moccasin-boot of the Southern Plains type, while recently Crow, Blackfeet, and Cree girls have also worn this form but open-sided, not closed as the southern examples. These northern knee-high moccasin-boots are widely worn today for powwows.

Below: Western Sioux moccasins, fully beaded including soles, c. 1890. MGJ

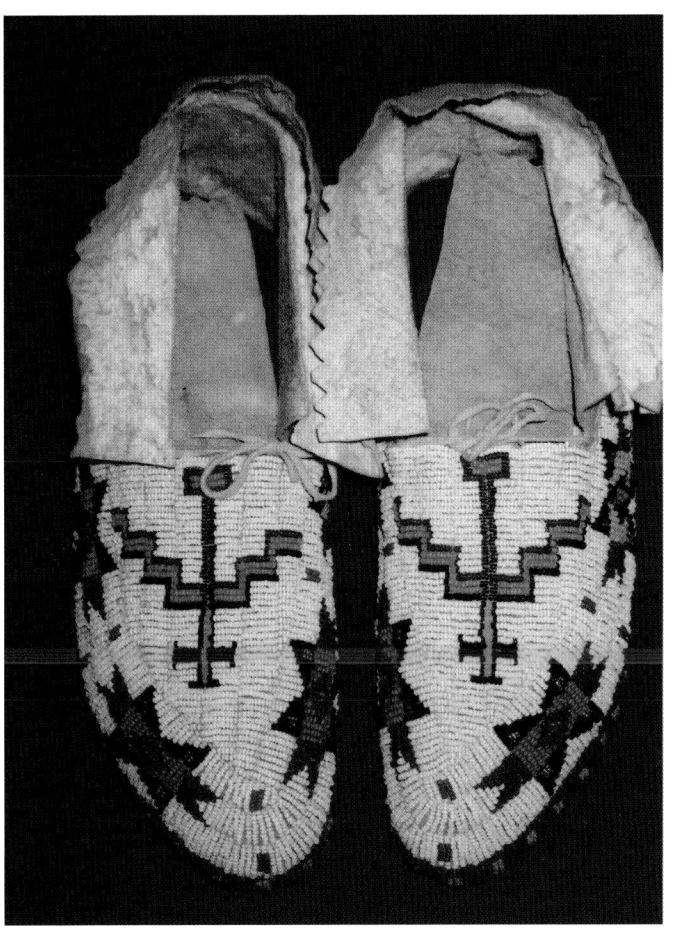

WESTERN SIOUX MOCCASINS

Western Sioux moccasins of the second half of the nineteenth century were the classic shoe Type 14 with separate hard rawhide sole and buckskin upper with a tongue, sometimes forked, and a collar of varying size. The earlier examples are often of buffalo hide. Many are solidly beaded in, for the most part, a fairly limited range of colors—white, dark blue, rose (with a white core), then in descending frequency, light blues, greens, yellow, and metallic beads. Generally Sioux beaded objects were sinew-sewn in lazy-stitch technique, each lane about 8–10 beads wide. Early seed-beaded designs of the 1850s and 60s were basic triangles and rectangles on a white background but evolved into complex geometric patterns by the late nineteenth century. Older examples of moccasins tend to be beaded using Venetian beads and later Bohemian beads. Sioux fully beaded moccasins have usually 1–3 outside lanes of beadwork all the way around the upper and several covering the instep, sometimes in the so-called buffalo track design, although the interpretation of Sioux designs appears to have been largely speculative; some say they are in part inspired by patterns on imported rugs.

CHEYENNE MOCCASINS

Cheyenne moccasins of the second half of the nineteenth century were similar in construction to those of the Sioux and Arapaho, all of the two-piece, rawhide-soled Type 14 with beadwork designs applied in the lane-stitch (lazy-stitch) technique. However, there are usually a number of points of difference in both bead designs and layout which distinguish typical Cheyenne work from the more plentiful Sioux work encountered in museums and private collections.

Above left: Western Sioux moccasins c. 1890. Solidly beaded with the so-called buffalo-track design over the instep and buffalo heads facing the wearer. The designs in the outer lanes may represent ghost dancers. MGJ

Above: Cheyenne moccasin beaded designs.

Below: Partly beaded Cheyenne moccasins probably from Oklahoma, c. 1900. The beaded designs are MGJ

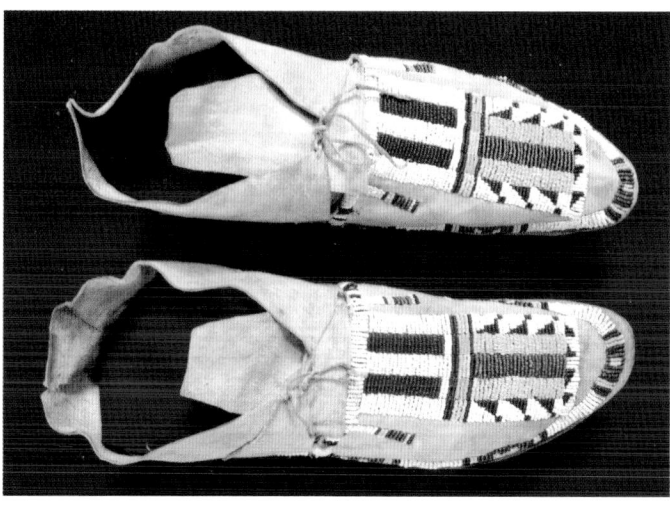

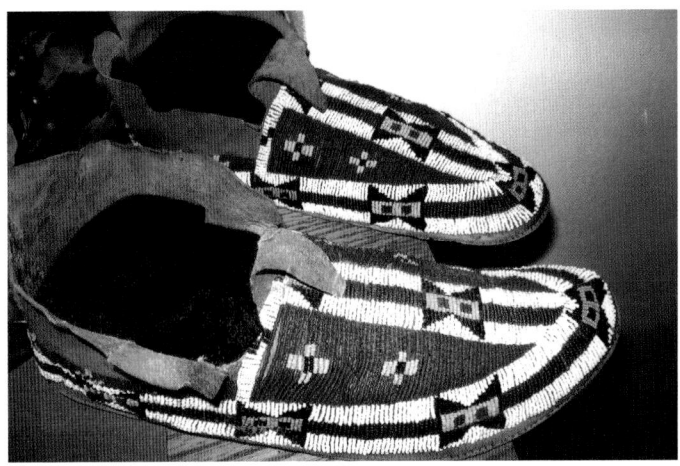

Certain beadwork elements that suggest Cheyenne provenance include small geometrical solid color units, blocks, triangles, thunderbird images in the center and side lanes, and vertical steep triangles or half triangles, these often using a single color. The Cheyenne beadworkers' guild often used the sacred Cheyenne colors of red, yellow, blue, or black in combination with a white background. Other colors include green and orange. There is often a vertical lane of beadwork applied after the completion of sinew sewing between the uppers to the rawhide sole and over the heel seam at the back, and a horizontal lane running along the front under the tongue where the lanes running from the toes finish. Another characteristic is the use of a skin welt sewn in between the uppers and rawhide sole. Generally the Cheyenne used smaller beads than the Sioux.

CROW MOCCASINS

The oldest known Crow moccasins were of the side-seam buckskin design, Hatt Type 12. Gradually, during the second half of the nineteenth century, the rawhide-soled Type 14 was adopted. One of the oldest Crow

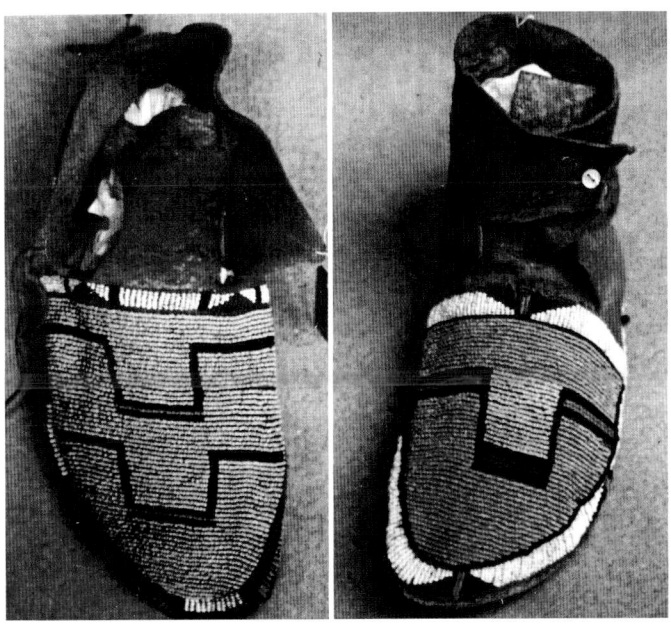

moccasin decorative features was an inverted "keyhole" design placed over the instep, in what is sometimes referred to as "round beadwork," with another rectangular-shaped figure on a fully beaded pink or blue background and a lane of lazy-stitch beadwork around the foot profile. A long U-shaped element over the instep was another popular design. Floral designs were being adopted by the 1880s bearing similarities to those of the Red River Métis, a likely source for these. White buckskin moccasin-boots are popular today for parade and powwow regalia for girls.

BLACKFEET AND ASSINIBOINE MOCCASINS

The Blackfeet had a variety of buckskin construction techniques for their moccasins. They had four major types: the shoe form Type 14 with a rawhide (hard) sole,

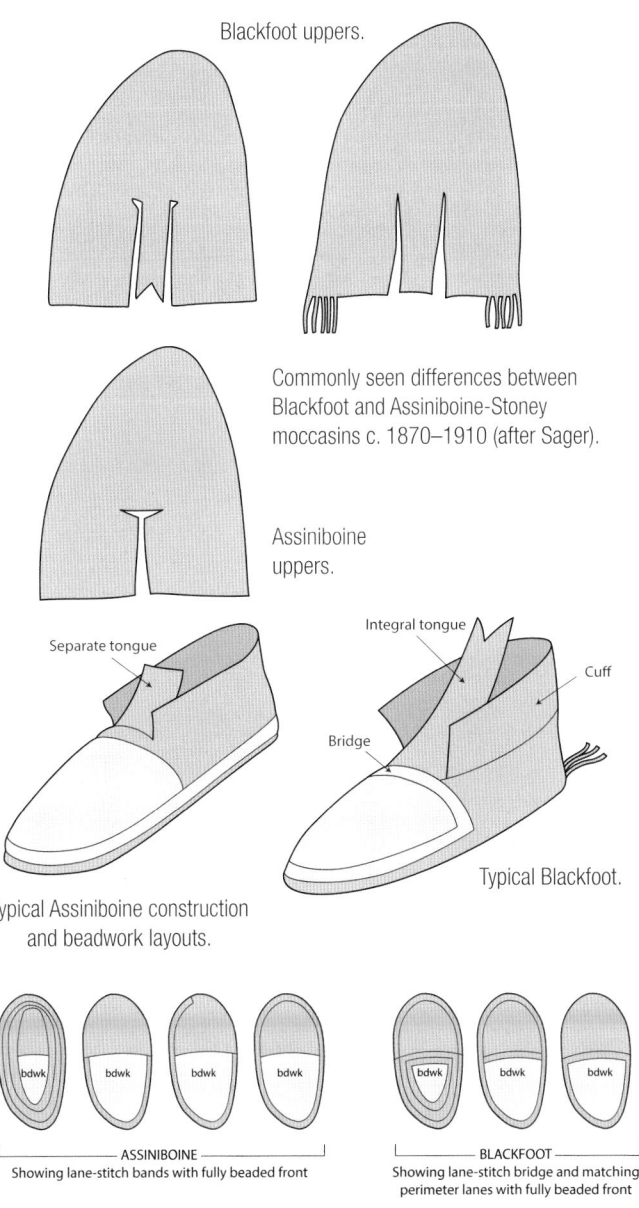

Blackfoot uppers.

Commonly seen differences between Blackfoot and Assiniboine-Stoney moccasins c. 1870–1910 (after Sager).

Assiniboine uppers.

Separate tongue

Integral tongue

Cuff

Bridge

Typical Blackfoot.

Typical Assiniboine construction and beadwork layouts.

ASSINIBOINE
Showing lane-stitch bands with fully beaded front

BLACKFOOT
Showing lane-stitch bridge and matching perimeter lanes with fully beaded front

Beadwork layouts on late 19th century Assiniboine and Blackfoot moccasins (after Dave Sager).

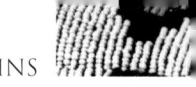

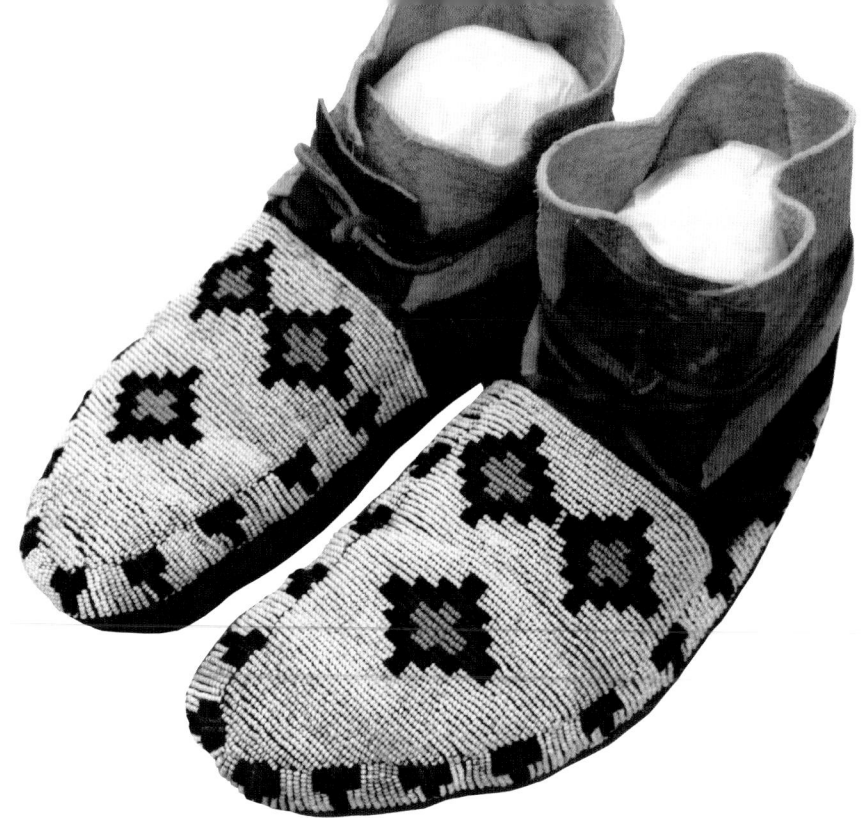

Stoney, Assiniboine, Plains Cree, and Sarsi, which highlight the problems of inventing tribal categories. However, one style of late nineteenth-century Blackfeet moccasin decoration featured the semi-floral designs based on patterns that occur on moccasins attributed to the Red River Métis and Eastern Sioux, who probably learned them from Catholic mission schools. Fully beaded Blackfeet moccasins are usually beaded with checker designs of three or four colors on a white background and are often similar to Assiniboine examples, although suggested traits such as the lane-stitch bridge across the top of the instep matching the perimeter lane around the imprint line and different tongue details are unlikely to be invariably true, particularly after about 1900.

Opposite, above: Moccasins, sinew sewn, yellow-dyed buckskin, Cheyenne c. 1900. Characteristic seven-beaded "bow-tie" elements in the lanes adjacent to the soles, three on each side and one at the toe. The bridge lane adjacent to the tongue is also a Cheyenne trait. DL

Opposite, below left: Crow moccasins with "horse-track" design. MFVB

Opposite, below right: Crow moccasins showing the lazy-stitch border around the foot imprint and over the instep. MFVB

Above: Assiniboine moccasins c. 1890: Usually Assiniboine moccasins have a separate tongue sewn to the upper section of the moccasin whereas many Blackfoot moccasins had integral tongues and a band of beadwork adjacent, a lane-stitch bridge across the instep which matched the perimeter lane around the foot imprint line (Dave Sager personal correspondence 5/9/08). This is a side seam construction Type 12. IW

CALIFORNIAN MOCCASINS

In the course of studying the buckskin costuming of the Shasta Indians of northern California in the 1920s Kroeber reported: "The moccasin was sewed with a single straight seam up the front and carried a heavy sole of elk or bearskin. For winter wear the inner sole was cut out and the foot rested upon the fur side of the bearskin. Sometimes the winter moccasin was made large enough to allow the foot to be wrapped with squirrel skin, wildcat fur or moss." At the same time he claimed that soled moccasins are not Californian, though he agreed that late influences from the north and east were possible. In fact Kroeber was uncertain about the buckskin costuming being generally typically Californian. Elsewhere, he described the front-seam style as the typical central and northwestern Californian type. As with moccasins of Types 1–10 the front seam is puckered. Kroeber attributed it to the Yurok, Hupa, Miwok, and Lassik; the last had a variant form in which a single seam from the little toe to the outer ankle sufficed.

The moccasins of the Modoc and Klamath have U-shaped insets and flaps around the ankles. The Atsugewi apparently had a similar form, Types 5 and 6.

We can therefore generally include northern and central Californian moccasins with Type 1 but they are not common.

Southern California was a region where sandals were worn. (True sandals of vegetal fiber have been found at Fort Rock Cave, Oregon, which have been dated as at least 9,000 years old.) However, the desert Cahuilla also wore a high-top moccasin for travel in the mountains. The hard sole curls over the thick but soft uppers. The upper has its single seam at the back, the front is open to the top of the instep and is probably Type 17.

the shoe form with a soft sole again Type 14, the side seam Type 12, and the dual side seam Type 11. In recent times they also have added a leg wrap to form boot-like moccasins. In some of these forms the moccasins were sewn partly inside-out. However, old Indians interviewed in the early twentieth century claimed they relied on the one-piece soft-soled moccasin until the two-piece hard-soled form came into use during the early–middle nineteenth century. The majority of Blackfeet moccasins are only partly decorated and this is confined largely or entirely to the front. Ewers claimed that there were six main styles of decoration: crooked nose, round, cross-striped, U-shaped, three-pronged, and floral. The first three were executed in quill or beads, the latter three in beadwork only. There is evidence that during the early reservation era considerable intertribal exchanging of material culture took place between the Blackfeet and the Plateau tribes (Kutenai, Flathead) and with the

3. THE GREAT PLAINS, PRAIRIES, AND PLATEAU

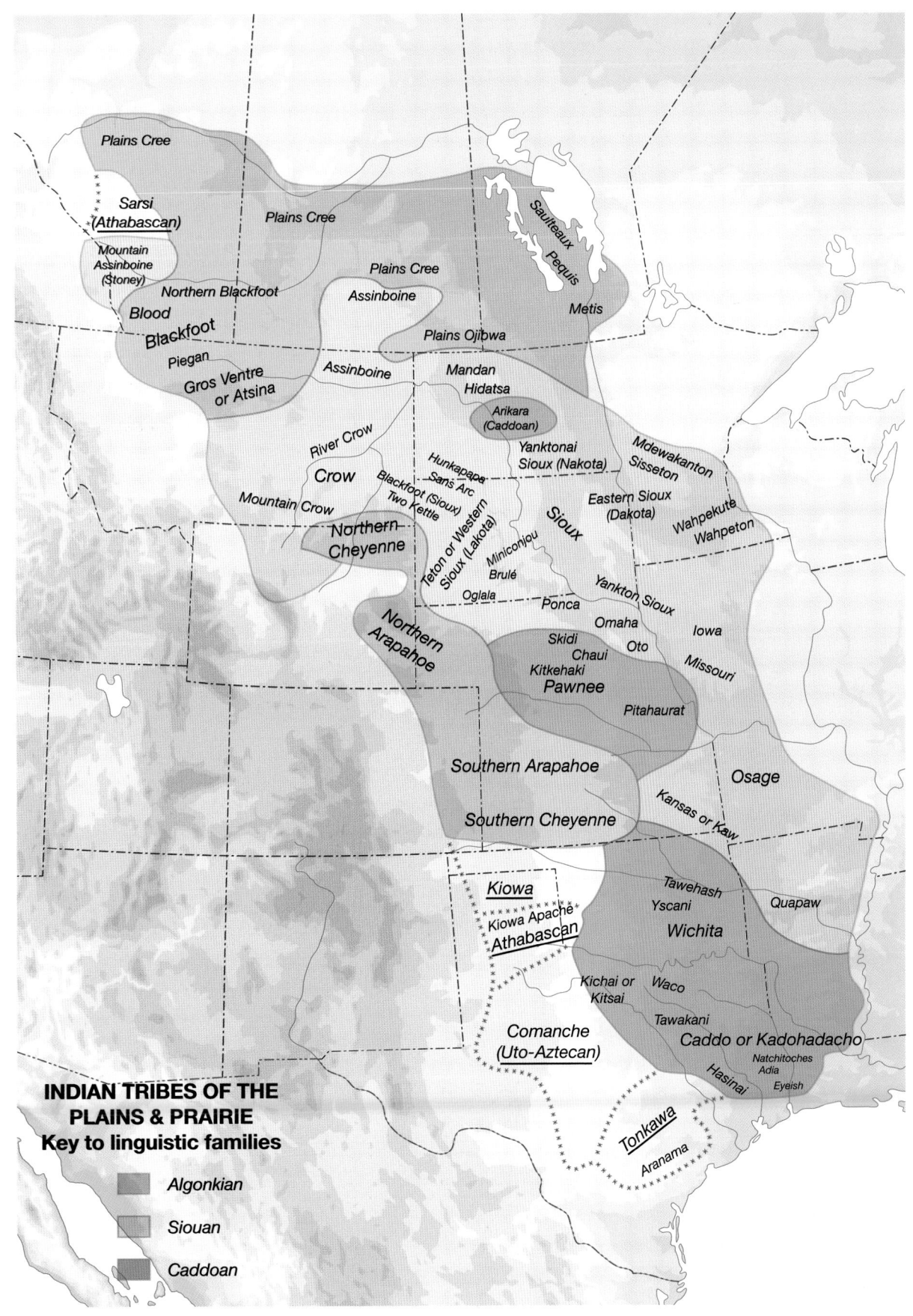

Plains Cree

Sarsi (Athabascan)

Mountain Assinboine (Stoney)

Northern Blackfoot

Plains Cree

Blood

Blackfoot

Assinboine

Plains Cree

Saulteaux

Pequis

Metis

Piegan

Gros Ventre or Atsina

Assinboine

Plains Ojibwa

Mandan

Hidatsa

Arikara (Caddoan)

River Crow

Yanktonai Sioux (Nakota)

Mdewakanton Sisseton

Crow

Hunkapapa

Sans Arc

Blackfoot (Sioux)

Two Kettle

Eastern Sioux (Dakota)

Wahpekute

Wahpeton

Mountain Crow

Northern Cheyenne

Teton or Western Sioux (Lakota)

Sioux

Miniconjou

Brulé

Oglala

Yankton Sioux

Ponca

Omaha

Oto

Iowa

Missouri

Northern Arapahoe

Skidi

Chaui

Kitkehaki

Pawnee

Pitahaurat

Southern Arapahoe

Osage

Southern Cheyenne

Kansas or Kaw

Kiowa

Tawehash

Yscani

Quapaw

Kiowa Apache

Athabascan

Wichita

Kichai or Kitsai

Waco

Comanche (Uto-Aztecan)

Tawakani

Caddo or Kadohadacho

Natchitoches

Adia

Eyeish

Hasinai

Tonkawa

Aranama

INDIAN TRIBES OF THE PLAINS & PRAIRIE
Key to linguistic families

Algonkian

Siouan

Caddoan

INTRODUCTION

The Great Plains of North America stretch some 1,800 miles from the Rio Grande to beyond the Canadian border in the north, and from the Mississippi and Missouri Rivers in the east to the Rocky Mountains in the west, a vast region which may be roughly divided into two main parts, the Prairies (called Parklands in Canada) and the High Plains. The former was long grass country between the Mississippi and the Missouri and home of various agricultural groups; the latter comprised short grasslands and sage-brush, home of the Plains nomads. The area has dramatic weather systems with extremes of heat and cold, sustained periods of dry weather, and occasional heavy rainfall. Major rivers run east from the mountains to the Missouri where old cultures based on maize agriculture had been introduced 1,500 years ago along the Missouri, Republican, and Platte Rivers and were characterized by semi-sedentary native villages. These peoples were the ancestors of the Pawnee, Arikara, Hidatsa, and Mandan, and had descended from Mississippian culture—itself a northern offshoot of Mexican culture.

The Plains region was home to huge numbers of bison, deer, antelope, wolves, coyotes, and grizzly and black bears. The High Plains culture was once defined by the anthropologist Clark Wissler as characterized by dependence on the buffalo, limited use of roots and berries, little fishing and agriculture, use of the tipi as

Above right: Probably an Ojibwa Indian, often called Saulteaux in western Canada marginal to the Parklands and Plains of Manitoba and Saskatchewan, c. 1900.

Below: Iron trade tomahawks and pipe tomahawks. WR

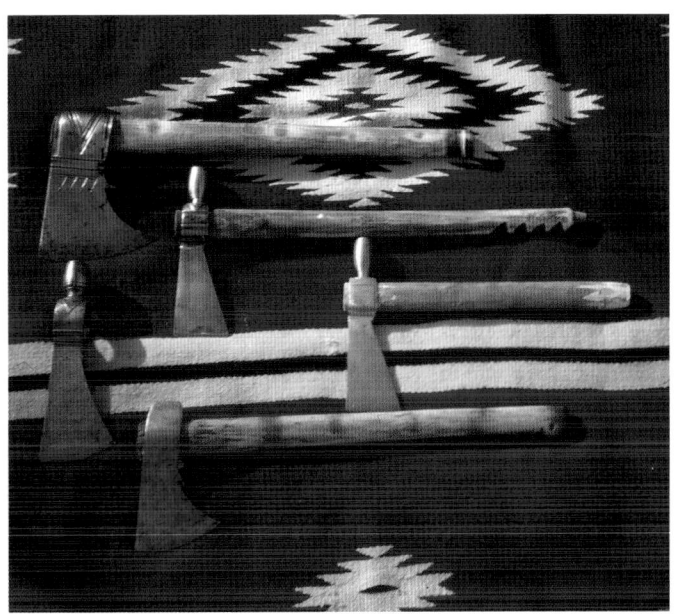

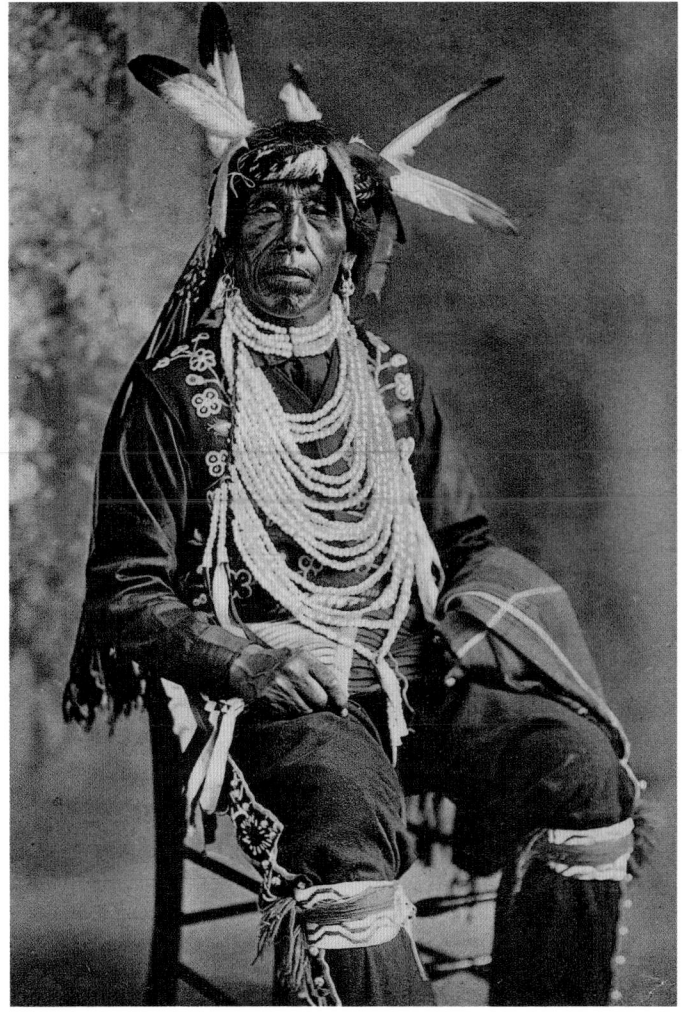

a movable dwelling, and of the travois (an A-framed structure on which packs could be loaded to be drawn by dogs or horses). However, this description fits only the late occupants of the High Plains after the arrival of horses and firearms. Plains Indian culture partly developed from these two revolutionary imports from Europe. The horse arrived with the Spanish colonies of the Southwest during the sixteenth century, and then in the seventeenth century the animal spread quickly north and west, one route being via Apache groups to the Ute and Shoshoni then to the Plateau Indians and hence to the Northern Plains. Firearms were in the hands of the Ojibwa and Cree, obtained from colonial French and British fur traders, by the mid-seventeenth century; they forced marginal Woodland and Parklands people west and eventually onto the Prairies and Plains. Horses and firearms reached the agricultural tribes on the upper Missouri—the Mandan and Hidatsa—by the eighteenth century and they in turn traded them to tribes remote from the frontier. Tribes such as the Blackfeet, Crow, Cheyenne, Arapaho, and later the Western Sioux moved into true High Plains country, transformed from pedestrians into truly nomadic people largely dependent on the buffalo which were available in huge numbers. For a century these Plains Indians would be formidable warriors waging war on each other and non-Indians alike.

Plains Indian women were usually responsible for making goods from animal skins. These included men's shirts, women's dresses, moccasins, and tipis. The skins of animals were removed and, through a process of tanning, the natural fibers were broken down by the application of oils from the animals' brains to produce soft workable buckskin material for clothes and ceremonial regalia.

After an animal had been killed and skinned the hide was soaked in water, then staked out on the ground and scraped to remove the remaining flesh and tissue. If a shirt, dress, or leggings were to be made from the hide, the hair and epidermal layer would be removed also. Boiled brains were then applied to the hide to unstiffen the fibers and it was then washed. After the excess water had been removed the hide was rubbed with sandstone

Below: Stoney Indian John Hunter (Sitting Eagle), c.1950, at Banff Indian Days, Alberta. His costume is typical of the later full-dress male ceremonial costume of the Alberta Stonies and Blackfeet worn at Banff Indian Days and the Calgary Stampede.

Opposite: Eagle feather headdress presented by the Western Sioux leader Sitting Bull while in Canada, to Major Walsh of the North West Mounted Police, prior to Sitting Bull's return to the U.S. in 1881. Walsh gave the headdress to Sir William Van Horne who then donated it with its case to the Royal Ontario Museum, Toronto, in 1913. ROM

and worked until soft so that the resulting buckskin could be used for clothing. Sometimes the hide was smoked to give some protection against water. Buckskin was produced from various animals including antelope, deer, elk, and in the west bighorn sheep. Bison was used principally for tipi covers and robes. Sewing was done with sinew obtained from the spine and fibrous tissue of deer and buffalo. Untanned skins became rawhide from which various shaped containers were made.

Three main forms of decoration for ceremonial clothing were used by Plains Indians—painting, quillwork, and beadwork. Paint could be rubbed into the hide in large colored areas, or in pictographic forms, being applied by men using a stylus of bone or antler to record personal warrior or tribal exploits or protective symbolism. Quillwork involved the removal of quills of the porcupine (and occasionally birds) which were sorted and dyed with colors derived from roots, berries, and mosses, or later from colors boiled out from trade cloth, or later still, after 1850, from commercial dyes obtained from white traders. The quills were then softened by moisture, chewing and flattened by drawing between teeth and fingernails. There were several different methods used by Plains Indians to decorate clothing with quills—basically wrapping, sewing (appliqué), braiding, and weaving.

European glass beads, largely manufactured in Venice, came to America with the earliest explorers. They were of fine quality and in a range of colors with reflective qualities which appealed to the Indians and hence thought to have religious qualities. The earliest European traders brought to the Plains predominantly (but not exclusively) large "pony beads" or "pound beads" from about 1800 and these can be seen used in conjunction with quillwork on the arm and shoulder strips of men's warrior shirts on surviving museum specimens. The colors were mainly blue and white, with some black and red. From about 1850 onwards the smaller seed beads began to be traded to the Plains Indians in a huge range of colors, together with cloth, dentalium shells, cotton thread, and later shell and bone hair pipes.

Two principal techniques have been developed to sew beads to buckskin or cloth, the first called "lazy-stitch" or "lane-stitch," which was ideally suited for the refinement of geometrical designs such as diamonds, triangles, and rectangles, which probably descend from earlier simpler pound-bead designs. Some art historians have suggested that the development of complex geometrical designs in beadwork, such as those seen on Western Sioux beadwork of the late nineteenth century, may have been a result of exposure to designs on Middle Eastern rugs seen at trading posts. The second beadwork technique is called appliqué and was particularly common to the northern Plains tribes such as the Blackfeet. This involved two threads, one to string the beads and the other to couch down. Sinew was used as the sewing medium but gave way to thread-sewn beadwork in the late nineteenth

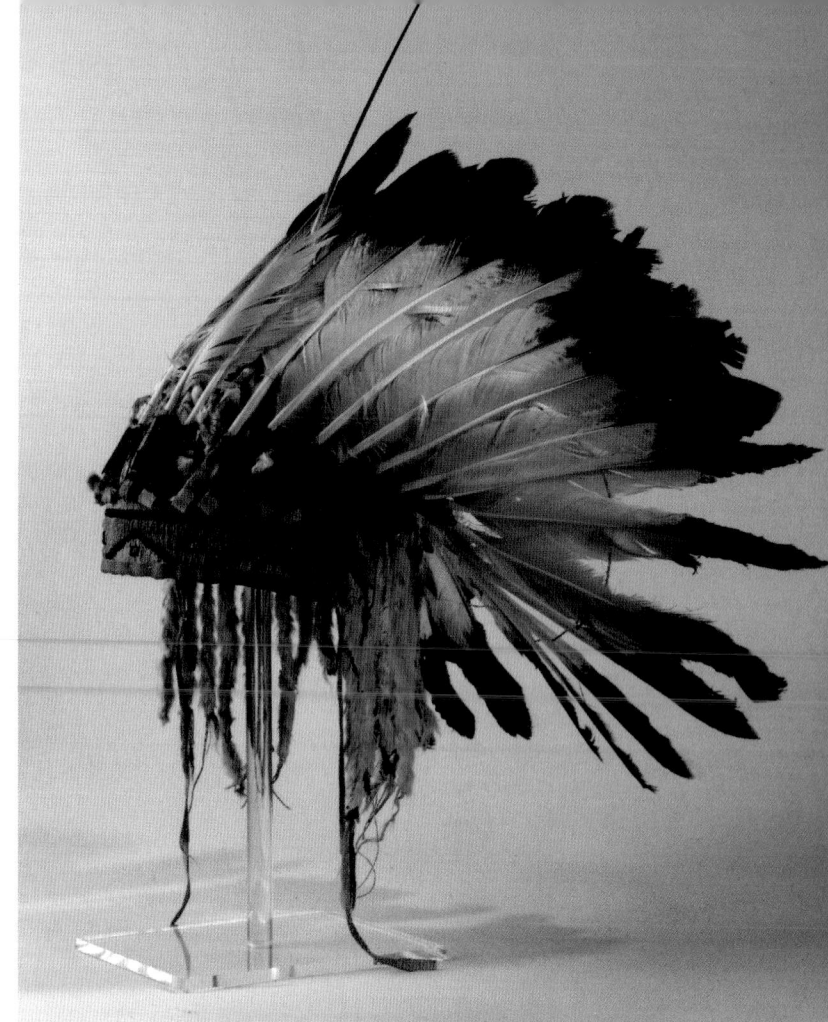

century particularly in the north. While most traditional Plains art was geometrical and representational (animal, human, or anthropomorphic), in the northeast the Plains Cree and Plains Ojibwa, who were in transition between Woodland and Plains culture, had, by 1800, absorbed a degree of Europeanization of their art resulting in the increasing use of floral realism, in quillwork at first, and later in beadwork. The theory that decorative geometric designs in quills and beads used by the Plains Indians were but conventionalized symbols of older realistic and religious images was tested by two anthropologists, Kroeber among the Arapaho, and Wissler among the Western Sioux, with results that were, at best, inconclusive. The names employed later by art observers, such as tipi, mountain, cloud, and meat rack, describe only the shapes not necessarily their meanings. The exposure to Euro-American designs on carpets had probably blurred such references by the late nineteenth century.

The religious patterns of the nomadic equestrian Plains tribes represented a part reformulation of the old Prairie people's religion adapted to a nomadic culture and partly an amalgamation of features from different groups—for example the Sun Dance. Their world was divided into the everyday world and the supernatural, a mysterious realm whose structure could be encapsulated in this world by sacred people or objects, but was conceived as a part of the great cosmic structure. Over this world the sky elevated its dome, the seat of the great powers, including the Supreme Being, the star gods (among the Pawnee, Wichita, Arikara, and Blackfeet) and

Above: Parfléche. MFVB

Few Plains garments survive which pre-date 1800. Most of the earliest surviving male shirts and female dresses date to the early decades of the nineteenth century when European trade for furs and buffalo hides had been established on the western frontier. The French and British Canadians were the first to establish trade with the northern Plains Indians via a series of trading posts tied to Lake Superior or Hudson Bay. The new United States laid routes to the same source via the Missouri from St Louis. Throughout the early nineteenth century, a number of fur traders, scientists, explorers, and artists made the trip by riverboat along the Missouri to visit the trading posts which had been established along that river as far as present-day Montana. These posts were located to trade with the Mandan, Hidatsa, and Arikara on the banks of the Missouri and with some of the remote and mobile southern Assiniboine, Crow, Blackfeet, and Gros Ventre, whose hunting grounds included both the upper Missouri and some of its tributaries such as the Yellowstone. The Mandan and Hidatsa were a source of cultural stimulants for the northern Plains. A schism among the Hidatsa produced two Crow divisions, the River and the Mountain Crow—one had formed farming settlements in southern Alberta during the early decades of the eighteenth century in old Snake territory, before rejoining their relatives. Another cultural shock wave came with the spread of various groups of Cree and later Ojibwa and with them the influence of more white traders and mixed bloods. Also came European clothing, and European-derived color pigments, knives, guns, traps, needles, thread, awls, bottles, and glass beads. Europeanization spread the use of the cloth breechclout for men, female strap dresses, skin and blanket coats, shoulder pouches, saddlebags, Micmac pipes, lead inlay work on catlinite pipeheads, silk embroidery, and geometric beadwork derived from woven quillwork and floral beadwork.

Two elements of Plains material culture may have come directly from the Woodland Indians, painted rawhide box trunks from bark containers, and two forms of pictographic art. One is perhaps related to the painted robes from the Illini, the other to the incised memory aids of the Ojibwa on bark. The rectangular flat parfleshe containers are now thought to be a fairly recent innovation except perhaps the incised Crow examples which may be a Plateau influence. Some buckskin apparel and large round combat shields may also be Plateau inspired; the tipi may have developed from Subarctic prototypes, and steatite sculptures and carving of pipes and their wooden stems have the ring of Siouan origins. Decorated clothing of the boreal forest hunter was believed to please the game spirits; now decorated clothes brought health and prosperity and displayed and recorded warrior status.

the thunderers and other atmospheric beings (Sioux). This world has a round surface and in its four quarters, the cardinal directions, the four winds reside.

The marginal tribes show varying degrees of affinity to the religious patterns of the central Plains group. The Shoshonean groups (Shoshoni, Comanche) evinced certain Basin and Plateau traits, the Caddoan groups of Texas shared many constitutive traits with the agrarian population of the lower Mississippi, and relative newcomers to the Plains area from the east (Shawnee, Delaware, Creek, Cherokee) more than held their own in warfare with the Plains tribes. The beliefs of the marginal Cree and Plains Ojibwa (Bungi) represented a mixture of Plains and Woodland religions. While adopting the Sun Dance they also retained the Medicine Lodge (Midewiwin), a curative, graded society with membership by payment, providing long life and eternity for the soul.

PORCUPINE QUILLWORK TECHNIQUES OF THE PLAINS AND WOODLAND INDIANS

The distribution of the North American porcupine, including the eastern porcupine sub-species, covered most of Canada's woodland, subarctic, parklands, plains, and cordillera. It extended into the U.S. in forested regions at high altitude, the Rockies, the Appalachians, the Ozarks, and also around the Great Lakes and in New England. Its southern range has often been incorrectly reported but some Indian groups obtained quills in trade with the more northern tribes. Quillwork has been reported among the Cherokee and Lower Mississippi Valley tribes, although it is not known if these reports refer to work of indigenous tribes or if obtained via intertribal trade. Most quillwork used sinew for cords and sewing and was done by women whose tool kits contained bone marker, awl, knife, quill flattener, and pouch to carry quills.

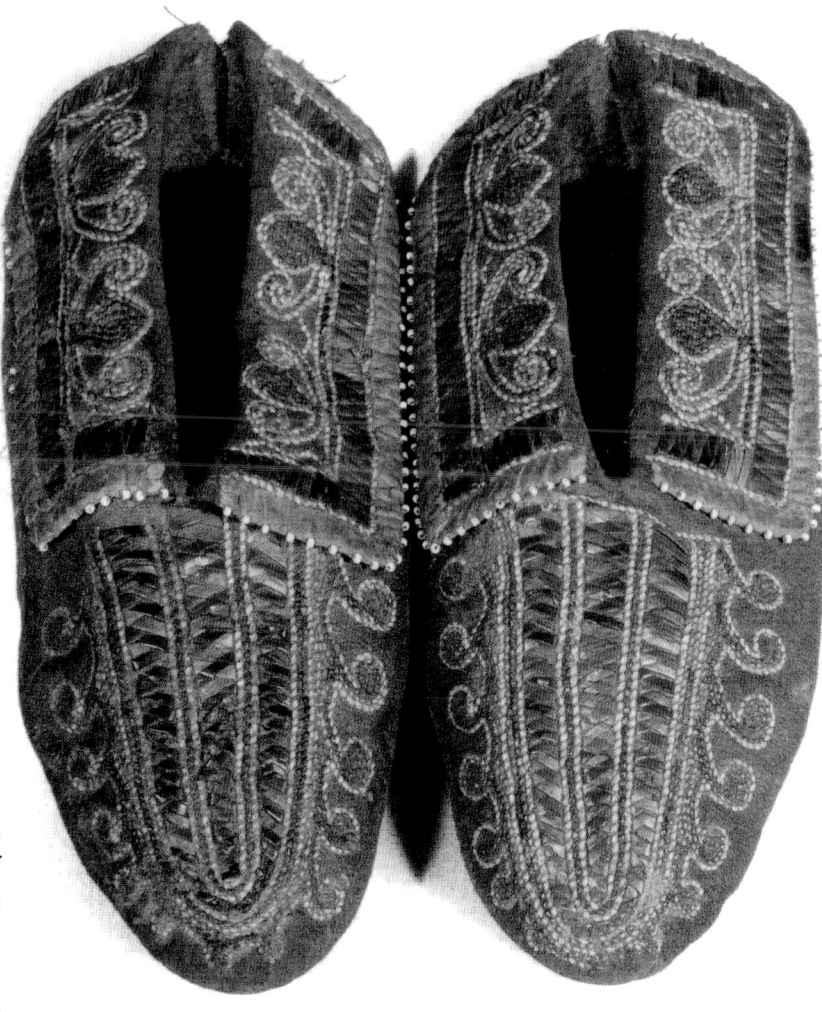

Below left: Quill weaving (woven quillwork). Bow loom for weaving quills (bottom) and weaving method practiced by the Northern Athabascans, Cree, Ojibwa, and Métis. Until the introduction of aniline dyes in the 1850s, the colors used for quillwork were derived from plants and roots or later from natural pigment dyes provided by European traders such as indigo, logwood, redwood, or obtained by boiling out trade blankets.

Below right: Quill plaiting or braiding. From top to bottom—one-quill plaiting; two-quill plaiting; plaiting method for Plains and Woodland pipe stems.

Left: Knee sheath and carved wooden knife hilt in the form of a thunderbird.

Above right: Buckskin moccasins, probably Iroquois, with quillwork decoration, c. 1800.

QUILL WRAPPING

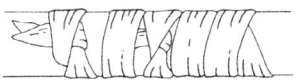

simple wrapping; rawhide slates
on Plains pipebags

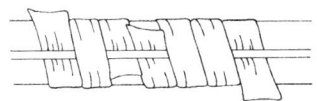

wrapping with cord

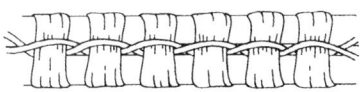

variation of wrapped double
rawhide strip

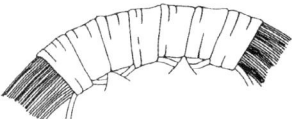

wrapped coil of hair or vegetable

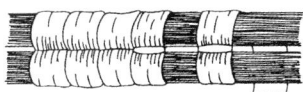

wrapped double coil

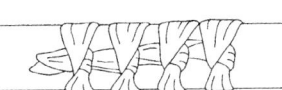

variation of simple wrapping

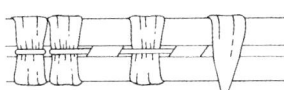

wrapped double rawhide stripe

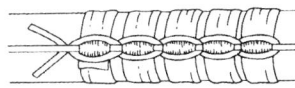

wrapping two cords

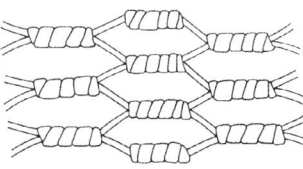

network—Ojibwa, Cree, and Métis

QUILL SEWING (APPLIQUÉ)

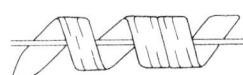

simple line (single quill; one thread);
floral designs, Cree, Ojibwa, and Métis

sawtooth variation (single quill;
one thread)

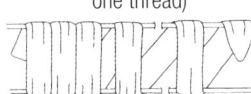

simple band (single quill; two thread);
Blackfoot shirt strips, blanket strips, pipe bags,
pad saddles, moccasins

variation of simple band
(single quill; two thread)

variation of simple band (single quill; three
thread); often Hidatsa work additional thread
usually commercial thread

zigzag band (single quill; two thread); most
Plains tribes inc. Sarsi. Pad saddles, shirts,
moccasins, sheaths

sawtooth (single quill; one thread); Cree, Métis

one quill edging (one thread); used to trim edges
of pouches; Cree, not common on Plains items

variation of simple band (single quill; two thread)

variation of simple band (single quill; three thread)

variation of zigzag band (single quill; two thread)

QUILL SEWING (APPLIQUÉ) cont

two quill diamond (two thread); Blackfoot,
Hidatsa, Mandan, Cree, Crow, Sioux, Iowa, and
Assiniboine men's shirts

two quill triangle (two thread)

four quill diamond (two thread)

checker-weave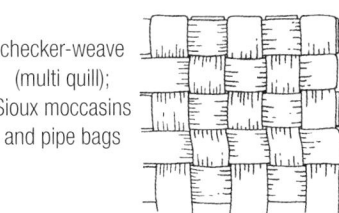
(multi quill);
Sioux moccasins
and pipe bags

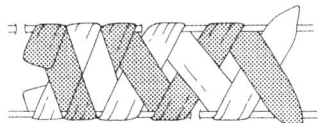

variation of two quill diamond
(two thread)

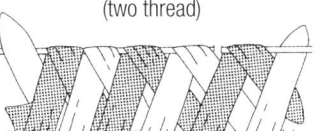

variation of two quill triangle
(two thread)

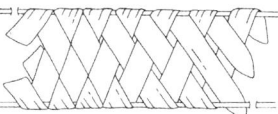

three quill double diamond
(two thread); Northern Plains
men's shirts

plait-like (multi-quill); Sioux, Crow, and
Blackfoot shirt strips

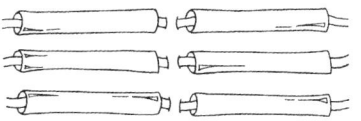

quill threading (multi-quill);
Blackfoot moccasins and pipebags

PLAINS AND PLATEAU BEADWORK

Lazy-stitch (lane-stitch) beadwork dominates the art of the central Plains tribes such as the Western Sioux, Cheyenne, and Arapaho during the second half of the nineteenth century. The beads were usually sewn directly to the object (usually skin) using sinew as thread in arched ridges. The Sioux used 8–10 beads and the Cheyenne often used 10–12 slightly smaller beads for the width of each lane. Lanes usually run lengthways on shirt and leggings strips but parallel to the bottom (horizontally) on pipe bags. On moccasins and knife sheaths lanes follow the shape of the object in places, and on large objects such as women's dresses and men's vests the border lane runs all around the edges and the balance is filled in with horizontal rows.

The bead colors used on Western Sioux beadwork are: white for large backgrounds, dark blue to almost black,

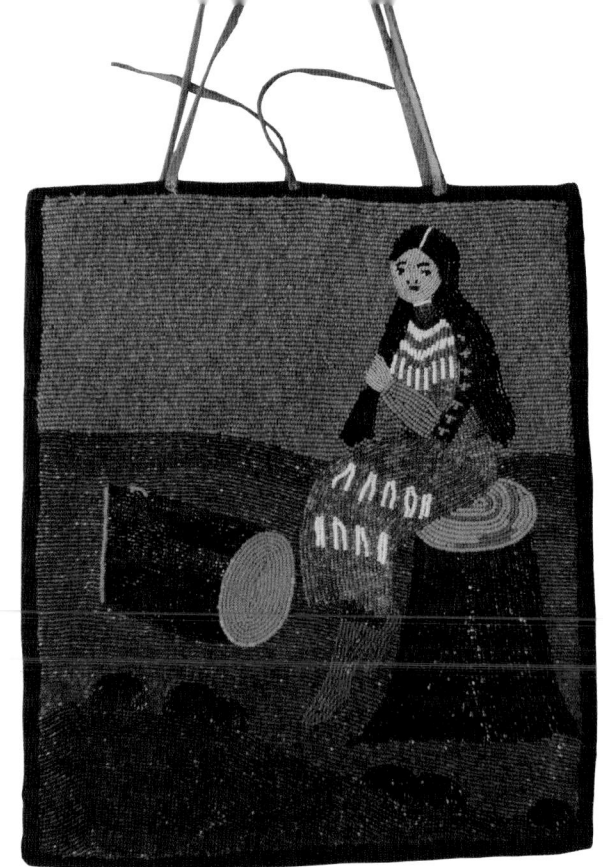

Above: A Plateau flat bag made in overlay or spot stitch beadwork, possibly Nez Perce, early twentieth century. Formerly MGJ Collection

Below: Plains beadwork techniques.

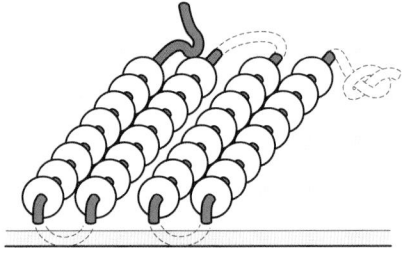

Lazy stitch

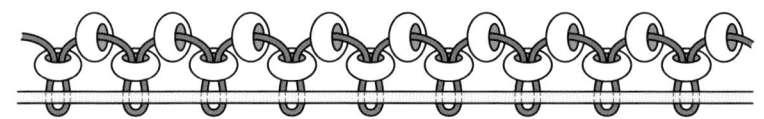

Edge beading

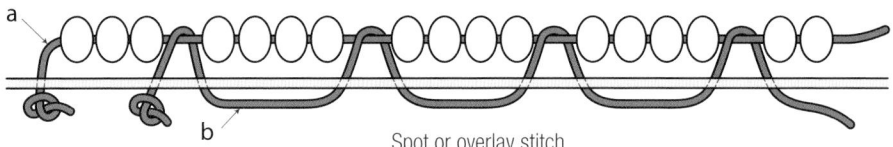

Spot or overlay stitch

Beads are strung on one thread (a) and sewn down to the backing with another (b)

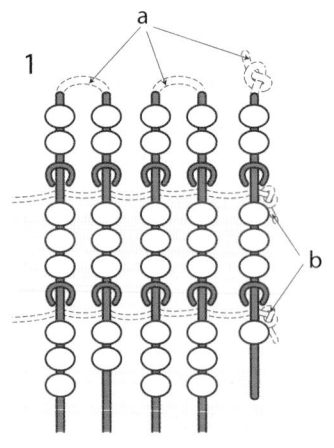

Beads are strung on thread (a)
and sewn down with thread (b)

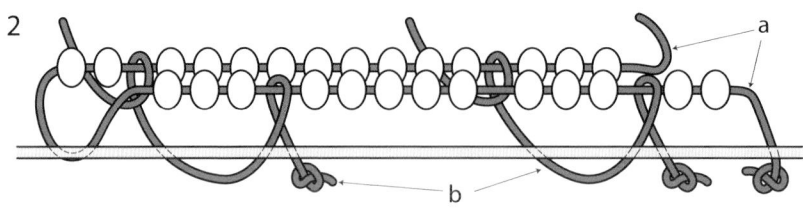

Crow stitch
1 plan
2 cross section
3 end cross section

rose with opaque white center, light blue, periwinkle blue, green, dark green, and yellow; there are occasionally metallic beads, pink, orange, and silver; all are usually Italian or Bohemian beads. After 1920 Czechoslovakian beads became popular. Early designs of the 1850s and 1860s were simple blocks, lines, and rectangles but later Sioux designs became increasingly complex and the triangle became the most frequently used figure. Whole compositions were usually symmetrical.

Like the Sioux the Cheyenne worked with a limited group of colors but used more than the Sioux. White was again favored for backgrounds, with dark and light blue, dark green, medium green, black, rose with opaque center, pink, yellow, and orange. Sacred beadwork in recent times was done only in white, black, red,

and yellow—more identified with the four directions home of the sacred people "Maheyuno" placed there by "Maheo" who filled all creation with life and supernatural power. The use of black probably underlines their Algonkian heritage. Common Cheyenne designs are the so-called stripe design, bands of solid color broken up to produce designs as seen on pipe bags, woman's moccasin-boots, and cradle hoods. Squares, blocks, and rectangles are found in the beaded strips on men's shirts and women's dresses, and stepped triangles on legging strips, moccasins and also pipe bags. Steep triangles were a feature of the 1890s and elaborate realistic designs occur on beaded vests in the form of warrior figures, or small thunderbirds and horses on moccasins.

In contrast the northern Plains and Plateau (Intermontane) tribes used the spot-stitch (appliqué) technique for their beadwork although not exclusively. Popular Blackfeet designs included stepped diamond patterns and long feather-shaped elements. Women's dresses were often decorated in large beads in a loose lazy-stitch technique. Most beadwork used thread for sewing allowing the easy adoption of floral designs. The Crows and some Plateau people developed a fairly complex form of appliqué known as the "Crow stitch."

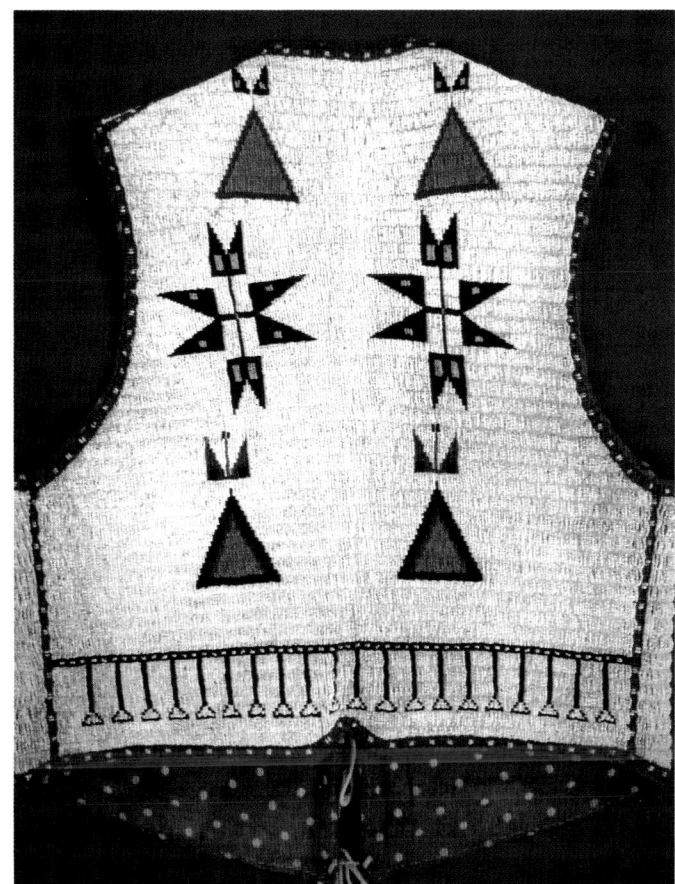

Above: Fully beaded vest (waistcoat), sinew-sewn lane-stitch beadwork. Western Sioux (Teton) c. 1890. Buckskin foundation lined with cloth. MGJ

Left: Western Sioux "scouts" jacket with figured beadwork, c.1890.

PLAINS CRADLES

The Cheyenne and Sioux used two types of cradles, one had a deep straight-sided bag of buckskin often covered with beadwork and, in the case of the Cheyenne, attached to a pair of laced boards pointed at the top. The second type was a triangular hood when flat and a rectangular piece of cloth which is folded around the baby. The Crow and Plateau tribes used a flat board basis curved at the ends covered with buckskin with a shallow bag.

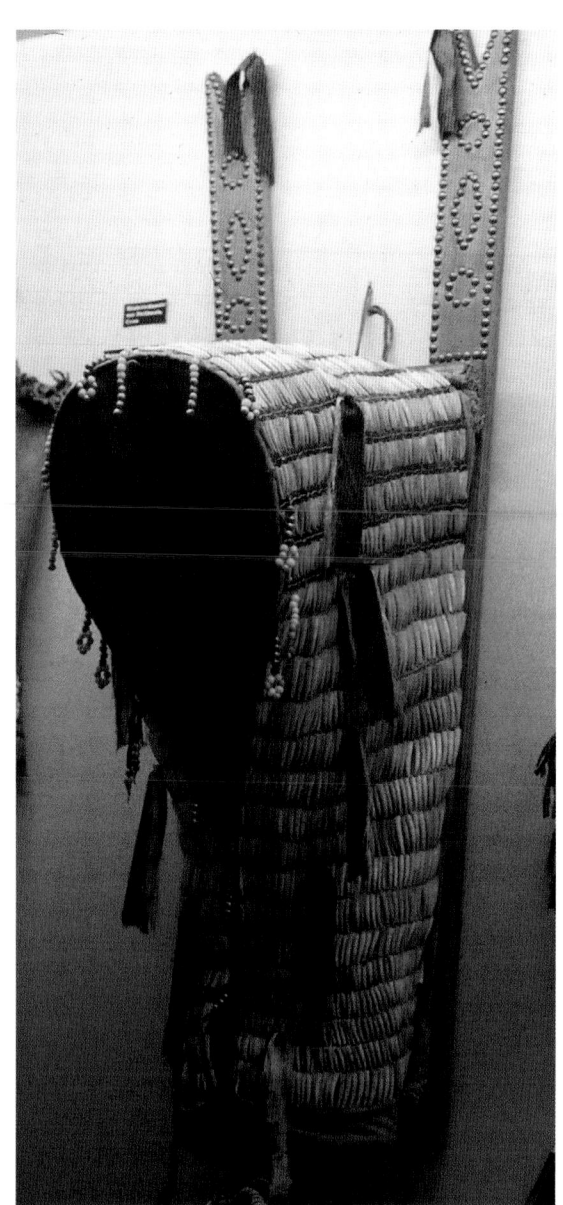

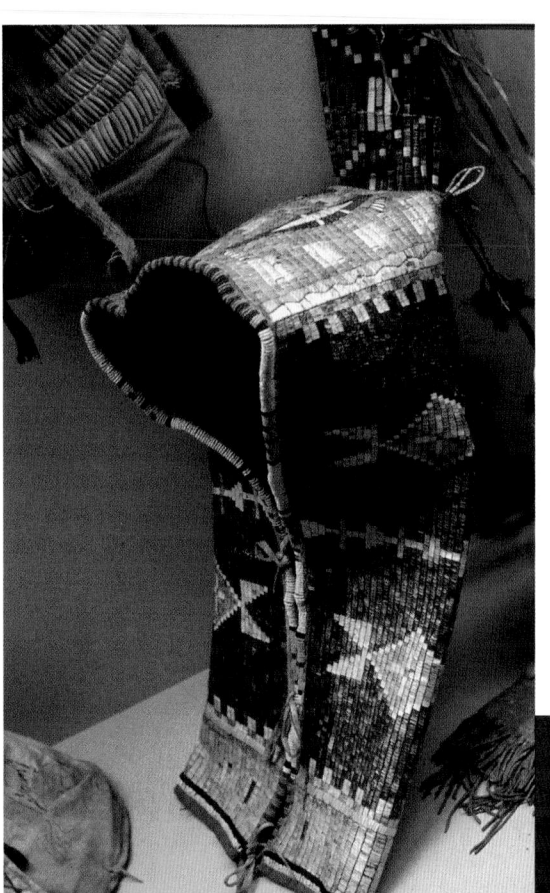

Left: Porcupine quillwork and beadwork cradle, probably Western Sioux, and dating from the mid-nineteenth century.

Right: Lattice type cradle, possibly Cheyenne, with dentailium shell decoration, dating from the mid-nineteenth century. LMS

Below: Cheyenne cradle hood beaded in stripe design, c.1890.

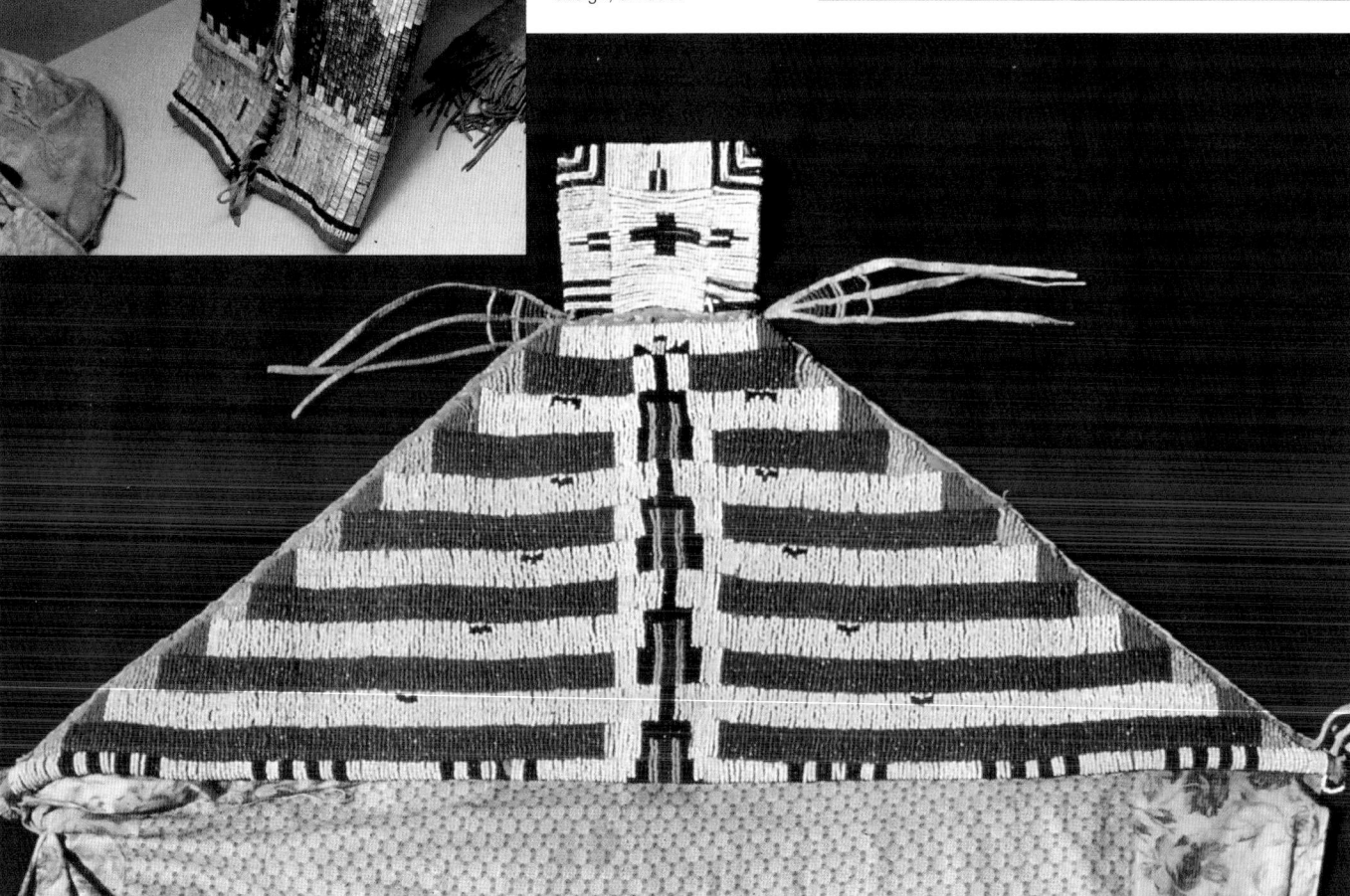

PLAINS AND PLATEAU FLORAL BEADWORK

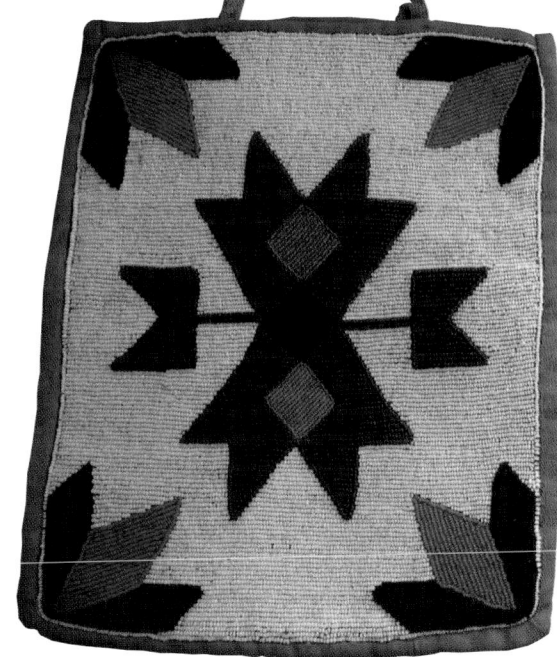

Abstract floral motifs emerged among the northeastern marginal Plains Indians sometime before 1830. The source of some of these early floral and leaf designs

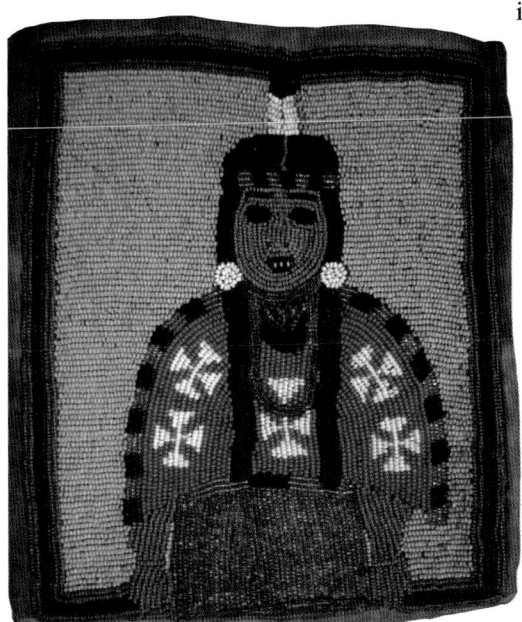

in quillwork seems to have been decorated material made by the Red River Métis and Saulteaux (Ojibwa) around Fort Garry, Manitoba. Their trading of their wares with Eastern Sioux, at first in Minnesota, fostered at least two styles of beadwork by the middle of the nineteenth century. One form included floral elements executed in lazy-stitch, usually quite narrow units; the other floral style in appliqué beadwork was often without consistent stems. This second form seems also to be related to the Blackfeet, Sarsi, and Stoney floral beadwork of the 1870s on, and the same basic style also reached the Crow whose later artists tended towards increasing realism with solid beaded backgrounds (blue) copying designs on curtains, blouses, dishes, and other commercial materials. The Plateau tribes also imported floral designs by 1860; some objects with floral beadwork were photographed by the North American Boundary Commission at Fort Colville, Washington, in that year. Many authorities have pointed out the influences of mixed-blood Canadian traders working for the fur trade companies in the American Plateau region, and the Cordillera tribes of present day British Columbia. In about 1920 a newer, and fairly distinctive floral beadwork style emerged among the southern Plateau tribes and the Crow associated with dance regalia. Vests, gauntlets, belts, and women's dress yokes were beaded

with realistic flowers (for example, roses) on a white or blue beaded background and continue to be made by the Tenino, Wasco, Shoshoni, and Ute today.

Floral designs in beadwork from the central High Plains tribes are limited, although they occasionally occur in Western Sioux quillwork and beadwork, but are more commonly recorded from their eastern branches. In Oklahoma the Kiowa and Comanche adopted some Delaware–Caddo beadwork motifs of a floralistic Prairie style which appeared on late nineteenth century and early twentieth century beaded covers for lattice cradles.

There is no doubt Indians have greatly admired these leaf and flower shapes and adopted them along with the availability of a wide range of glass seed beads of many colors, cotton thread, and trade cloth, which greatly facilitated the style's production and diffusion. The general lack of religious connotations may likewise have led to its widespread acceptance by most tribes.

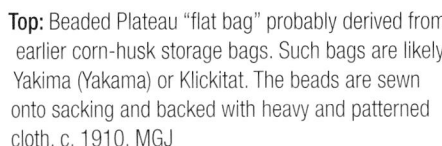

Top: Beaded Plateau "flat bag" probably derived from earlier corn-husk storage bags. Such bags are likely Yakima (Yakama) or Klickitat. The beads are sewn onto sacking and backed with heavy and patterned cloth, c. 1910. MGJ

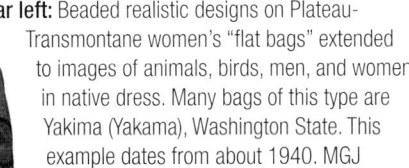

Far left: Beaded realistic designs on Plateau-Transmontane women's "flat bags" extended to images of animals, birds, men, and women in native dress. Many bags of this type are Yakima (Yakama), Washington State. This example dates from about 1940. MGJ

Left: Vest or waistcoat with fully beaded front, probably Nez Perce, c.1910. Note how the outline of the designs are traced with a single or double row of beads and then filled in, sometimes at an angle. Floral designs probably came to the Plateau about 1840 via Métis and Canadian Indians working as fur traders in the Transmontane region.

PLAINS INDIAN MEN'S CEREMONIAL SHIRTS

Ceremonial and warrior shirts of the Plains Indians have received considerable attention from art historians over the years most notably Wissler, Taylor, Conn, and Holm. Each has brought his own terminology for the construction details which the following text will try to simplify. The Plains Indian man's shirt was constructed from dressed animal skins, often complete hides, of the pronghorn antelope, various members of the deer family, elk, or occasionally moose in the north, but only very rarely bison. Bighorn sheep skins were also used, particularly on the northwestern Plains. Without physical and microscopic examination it is often very difficult to identify the animal skin. An average size hide was about 5 ft 6 in from nose to tail which would provide sufficient skin for a shirt about 3 ft long for the two-skin construction of the central Plains.

The origin of the historic Plains skin shirt is likely to have been the same as the fitted and protective tunics of the Subarctic Cree and Northern Ojibwa. Probably the oldest extant garment of this type is the caribou hide tunic (a coat-like shirt or possibly a dress) in the Tradescant collection in the Ashmolean Museum, Oxford, England. A single skin forms the back and sides with a front panel and one-piece sleeves with gussets at the armpits. There are porcupine quillwork strips at the front, rear, and on shoulder epaulettes in woven and several wrapped techniques. The specimen dates from before 1656 but cannot be assigned to any one tribal group, although its complexfitting suggests European influence—and we know from Nascapi and Cree tunics that such tailoring would not be beyond native ingenuity. Other notable specimens which might indicate that the genesis of the Plains shirt came from the north and east are the buckskin shirts with tube-like fitted torsos and sleeves now in the Musée du Quai Branly, Paris and the National Museums, Liverpool, England. Although these shirts have no documentation it is likely

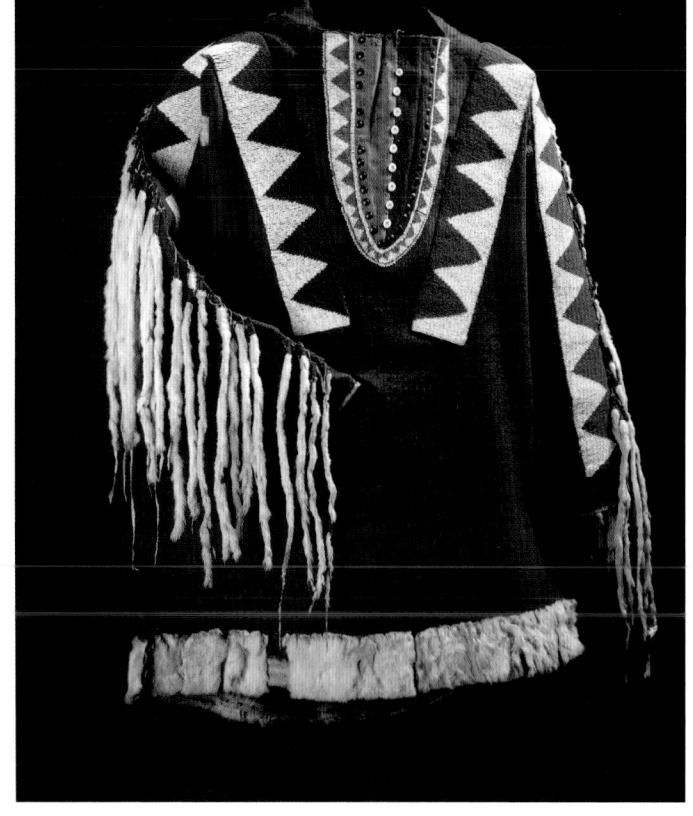

Above: Red trade cloth man's shirt presented by the Plains Cree chief Sweet Grass (Weekaskookeesayyin, born a Crow) to Lt. Gov. Alexander Morris in 1876 during treaty negotiations at Fort Pitt. Beaded overlay-stitch strips trimmed with ermine skin tubes. A reserve bearing the name Sweet Grass is in Saskatchewan. ROM

Below: Man's skin shirt attributed to Wanata a Yanktonai Sioux chief, c. 1830. The shirt has painted warrior scenes probably showing some Euro-American influence in style. The chest disk is decorated with porcupine quillwork with black areas of possible maidenhair fern or other vegetal material. NMS

they come from the eastern Plains or western Great Lakes respectively.

These examples suggest that the very earliest northeastern Plains men's shirts were actually fitted garments echoing their Subarctic–Woodland origins and traditions. However, the shift to the new environment probably required the animal's hides to represent the inherent spirit and power of the animal to be now transferred to the wearer for success in hunting and warfare. The use of the animal's head as a neck flap now reconstructs the whole animal upon the wearer and imbues him with the characteristics of the animal. Thus it became important to retain the natural profile and

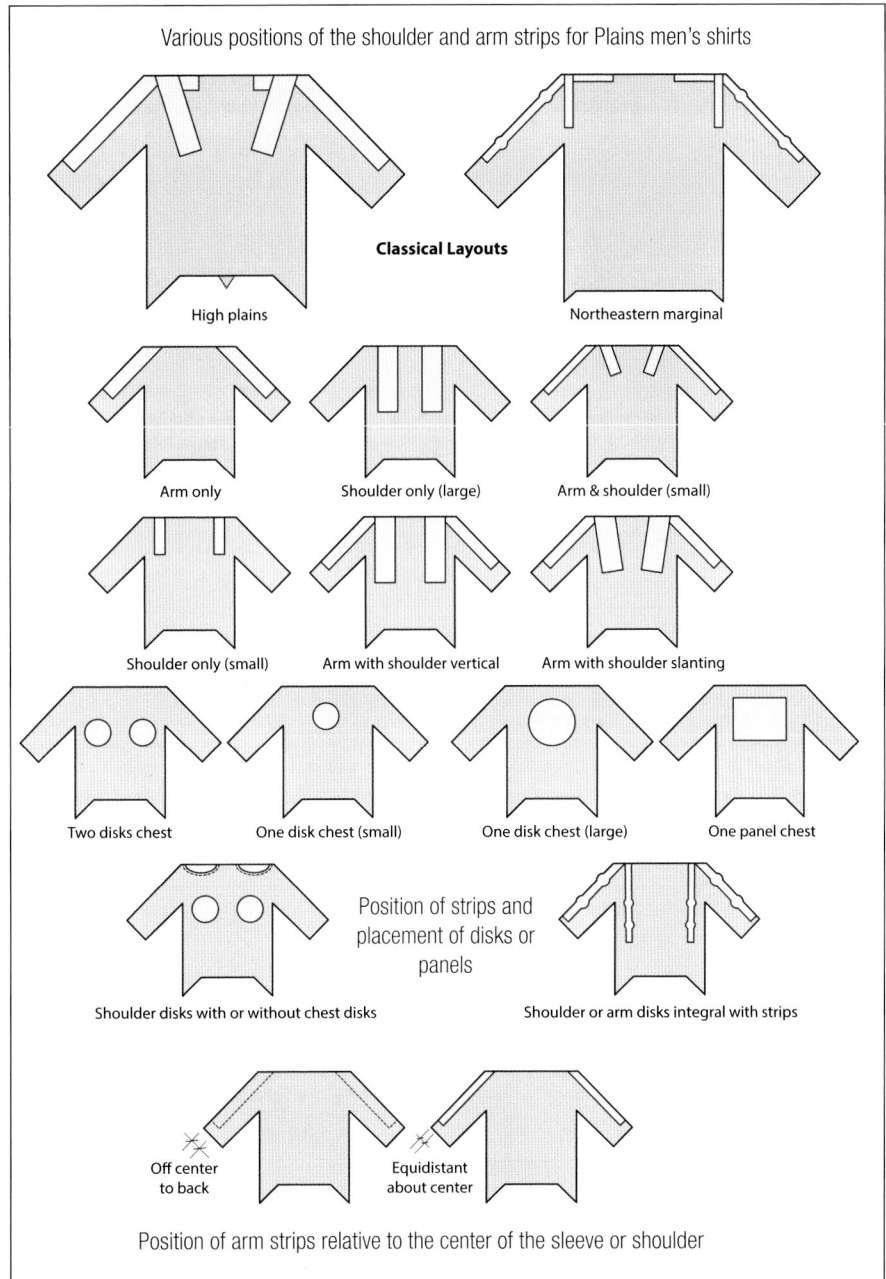

Various positions of the shoulder and arm strips for Plains men's shirts

Classical Layouts

High plains

Northeastern marginal

Arm only

Shoulder only (large)

Arm & shoulder (small)

Shoulder only (small)

Arm with shoulder vertical

Arm with shoulder slanting

Two disks chest

One disk chest (small)

One disk chest (large)

One panel chest

Position of strips and placement of disks or panels

Shoulder disks with or without chest disks

Shoulder or arm disks integral with strips

Off center to back

Equidistant about center

Position of arm strips relative to the center of the sleeve or shoulder

content of shirts—early examples "untailored" through to more recent "tailored" specimens—and although mindful of variations, his reasoning appears based upon a chronological sequence. Conn identified Wissler's two-skin poncho shirts as "binary" shirts and differentiates between those of the Intermontane and Southern Plains areas and the "deer leg" type of the Central and Northern Plains. He also introduced the term "fitted" rather than "tailored" for skin clothes modified to fit the body, such as those of the Subarctic and Arctic peoples, but fails to identify the long three-skin shirt of the northern and northeastern marginal Plains Indians whose specimens may also display a number of fitted characteristics.

Most surviving early Plains Indian men's shirts lack reliable documentation regarding tribal identification. However, examples, particularly from the first half of the nineteenth century, clearly show that many were used by warriors to display elevated leadership in warfare and for social recognition, with vivid painted war events or repeating rows of human figures. Brownstone (2001) suggested that the shirt surface could be divided into ten sections for pictographic references, two arms, either side of the upper torso, either side of the lower torso, then into the back and front. Triangular figures, bunched horse tracks and rows

shape of the animal skins when making a Plains shirt. They perhaps also developed the quilled epaulettes and disks of Subarctic tunics into the larger bands and disks we associate with the Plains and Parklands peoples. These features could have been originally derived from European influences, although there is a danger in reading all changes as being European-inspired.

Wissler, in 1915, one of the first to examine the structural characteristics of men's shirts, adopted the term "poncho" for any loose-fitting Plains Indian skin shirt, which hardly seems appropriate since it is a term for a South American cloak or cape of rectangular shape with a split in the middle for the head. This description in reality only covers the short two-skin shirt of some Intermontane (Plateau–Crow) and southwestern Plains (Ute, Jicarilla, Southern Cheyenne) specimens of certain periods of the nineteenth century. In 1981 Taylor proposed a structural classification based on the tailored

Above: Detail of a quillwork disk decoration from a Cree or Ojibwa man's skin shirt, c. 1830.

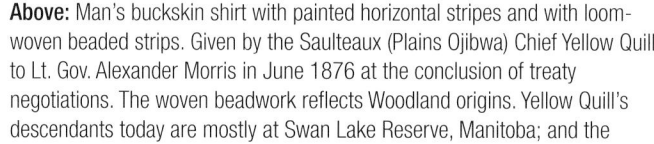

of pipes are possibly attributed to branches of the Sioux, Arikara, and Hidatsa peoples.

Recently an Indian painted shirt surfaced in Europe, with designs front and back. The shirt is tailored to fit the body, which may relate it to fitted garments of the eastern Subarctic although the neck refinements suggest European influence. However, the painting may place it in the genre of the four painted skin robes in the Musée Branly, Paris, attributed to the Illinois (Illini) and from the early eighteenth century. These painted lines, rectangles and elongated triangles, possibly bird shapes, may represent a regional or even prehistoric art style which flourished on the eastern margins of the Great Plains.

The following is a tentative reformulation of the structural features of the epideictic Plains Indian man's shirt.

LONG SHIRT: three-hide construction, front, back, and sleeves. This is clearly shown in the painting of Karl

Above: Man's buckskin shirt with painted horizontal stripes and with loom-woven beaded strips. Given by the Saulteaux (Plains Ojibwa) Chief Yellow Quill to Lt. Gov. Alexander Morris in June 1876 at the conclusion of treaty negotiations. The woven beadwork reflects Woodland origins. Yellow Quill's descendants today are mostly at Swan Lake Reserve, Manitoba; and the Kisistin(o) and Nut Lake Reserves, Saskatchewan were once known as Yellow Quill's reserves. ROM

Left: Assiniboine warrior wearing a quilled shirt painted by Karl Bodmer in 1833.

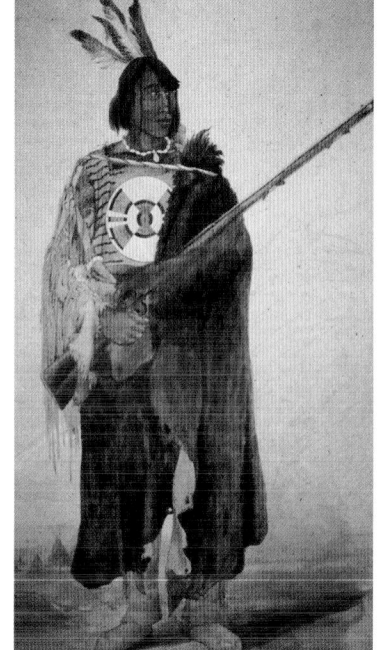

Bodmer and George Catlin of the 1830s, and there are surviving examples, particularly in European museums. Some examples from the northeastern Plains are partly fitted. Front, back, and sleeves are mainly unclosed, but dissimilar-shaped legs hanging underneath the sleeves indicate that the sleeves are cut from the front legs and back legs of one (the third) skin. The length makes it unlikely these shirts could be worn when riding horses so they are therefore chiefly ceremonial and for pedestrian use. They are shown in paintings of Blackfeet, Assiniboine, Cree, Crow, and upper Missouri tribes; few

postdate 1850. A number of huge shirts appear to have been made with four hides.

BINARY SHIRT: two-skin construction, upper two-thirds of each hide forms the back and front, the remaining third forming the arms. The deer-skin legs hang down at the bottom corners and under the sleeves. Bodmer's painting of "Big Soldier at Fort Lookout" of 1833 is probably the first known image. The style is probably a Teton (Western) Sioux refinement of the long shirt (possibly to save skin) but was still largely unfitted until the early reservation period when sleeves and sides began to be sewn together. Used by tribes including Western Sioux, Yankton and Yanktonai Sioux, middle Missouri River tribes, Cheyenne, and Arapaho. Could be easily worn when riding in parades or in warfare. The use of the original hide shapes may have been regarded as transferring the animals' characteristics of strength and courage to the wearer.

SHORT OR PONCHO SHIRT: two-skin construction, one hide (or two half hides) form the front and the back covering only the chest. The other hide is cut to form the sleeves and fringing. Tribes are Crow, Plateau tribes, Ute, Jicarilla, and Southern Cheyenne. The style dates to the second half of the nineteenth century.

Later and recent versions of all three forms have survived, particularly among the Stoney and Blackfeet in the north, with progressively fitted buckskin suits with matching leggings made without regard to the original shape of the buckskins. Later varieties have also emerged from the Hidatsa and Southern Plains tribes.

There is little doubt that the tribes that moved from a Woodland and Subarctic environment to the Parklands

Profiles of Plains and Plateau men's shirts based on specimens in the American Museum of Natural History, New York (after Wissler, 1915).

Shirt neck flap shapes: cloth or hide

- No flap
- Long narrow
- Vee-shaped ends
- Vee shape center
- Large vee-shaped
- Small vee-shaped
- Small rectangle
- Large rectangle
- Vee-shaped with rounded base
- Long vee-shaped
- "U"-shaped
- Truncated

Nez Perce · Lakota (Teton Sioux) · Lakota (Teton Sioux)

Nez Perce · Arapaho · Crow

Gros Ventre · Lakota (Teton Sioux) · Lakota (Teton Sioux)

Arapaho · Plains Ojibwa · Cheyenne?

Shirt fringes: hair or ermine

- Fringe to shoulder seam and or sleeve seams
- Fringe to arm strip only
- Fringe to shoulder strip only
- Fringe to shoulder and arm strips
- No significant fringing
- Horizontal fringing

and northern Plains during the early historic period took with them ancient fitted forms of skin clothing including the upper body male tunic-shirt and probably women's skin dresses. With the basic garments old decorative details such as painted and quilled disks and woven and appliqué quill bands now developed into the huge chest disks and long shoulder and arm strips that we associate with the true High Plains ceremonial shirts that were described and recorded by early nineteenth-century artists such as Bodmer, Catlin, Kane, and others.

Tribal attributions have been suggested for early specimens not only based on the methods of cutting the hides but also the placement and size of the decorative bands, designs and techniques used in the quillwork (or later beadwork) for such bands, the size and position of quilled disks on the front and back, the shape of the neck flap appendages (triangular, square or trapezoidal), amount of fringing, and the styles of any painted or pictographic work. Shirts were sometimes decorated with quill-wrapped human hair dangles often scalp-locks of enemies, eagle feathers or ermine fur. Ermine were recognized as a fierce fighting animal and thus transferred energy to the shirt-wearer. Many shirts were painted with battle scenes, equestrian or pedestrian war or horse-raiding exploits, which reinforced the esoteric nature of these garments for display and ceremonial use. The following gives some generalized tribal or area styles for early specimens but is by no means complete or inclusive.

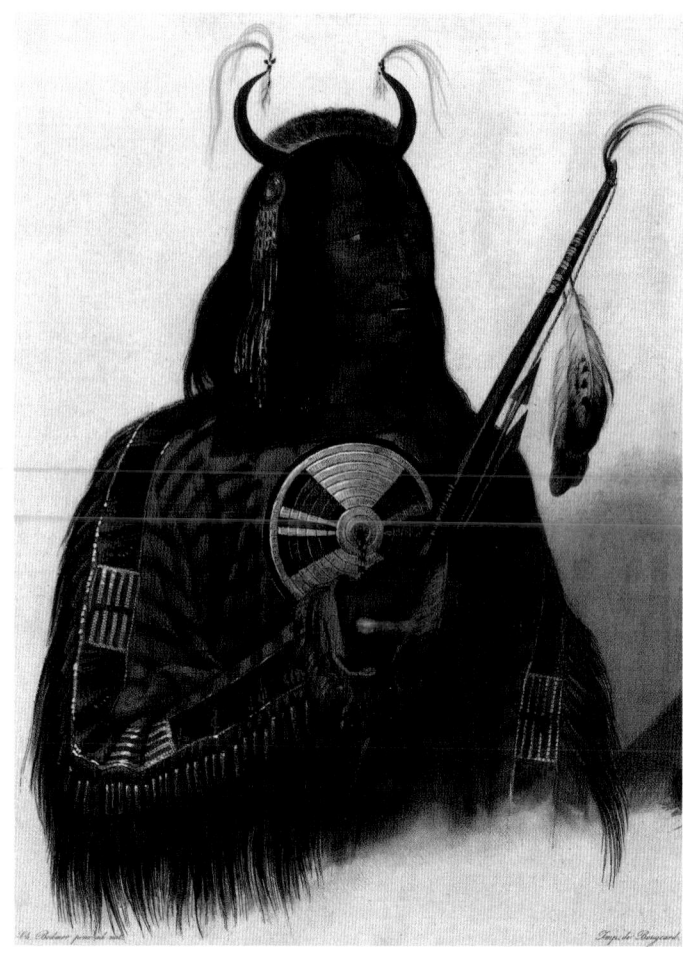

Above: Noapah or Noapeh, Assiniboine warrior, painted by Karl Bodmer from a sketch made at Ft. Union on June 27, 1833.

Below left: Cheyenne shirt with quilled strips. MFVB

Below: Crow shirt with quilled strips, c. 1840. MFVB

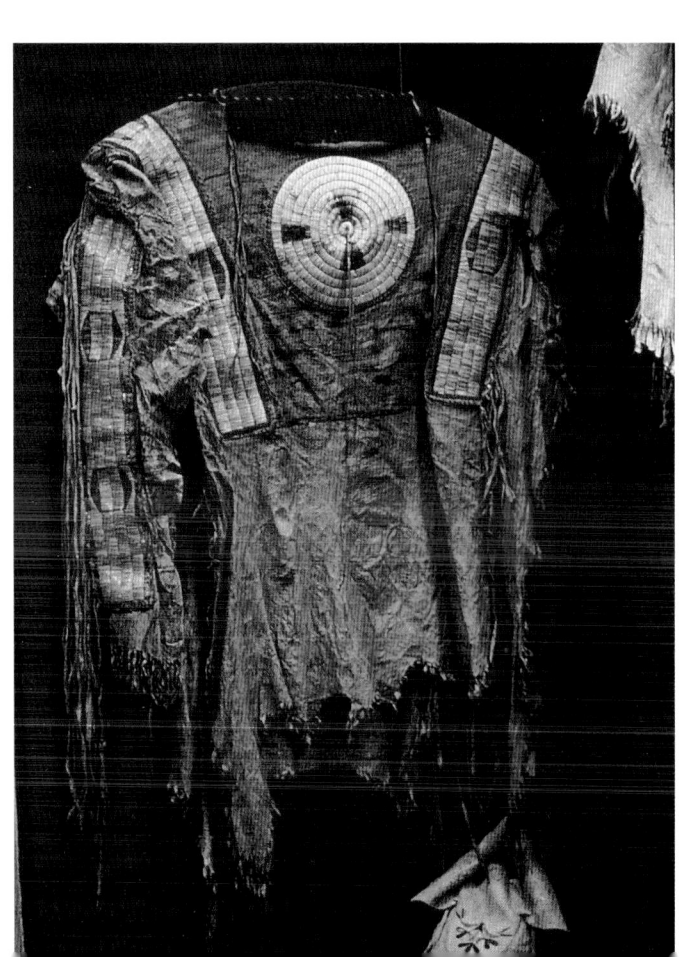

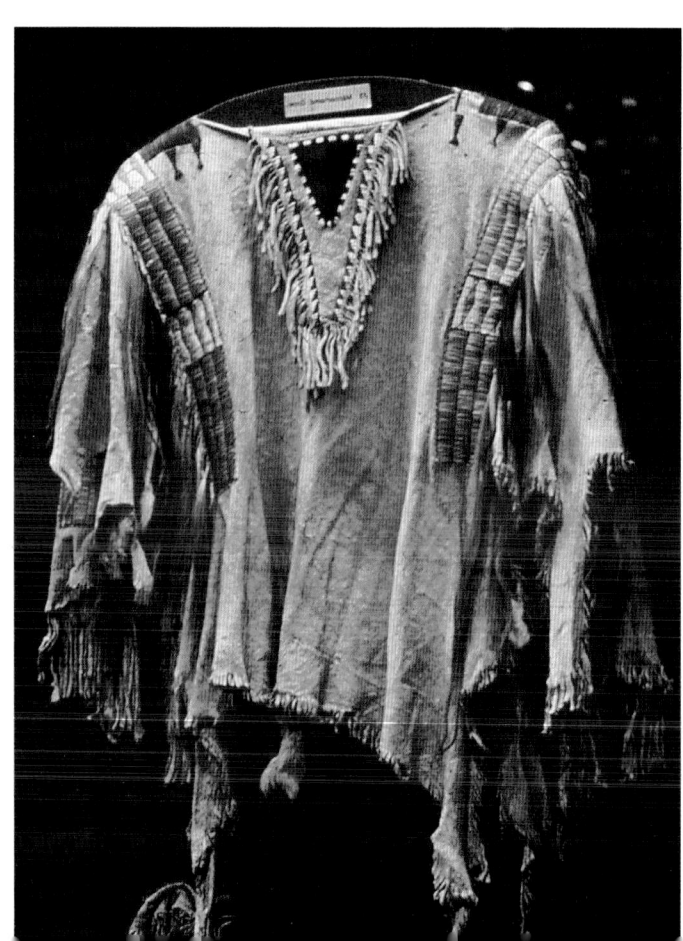

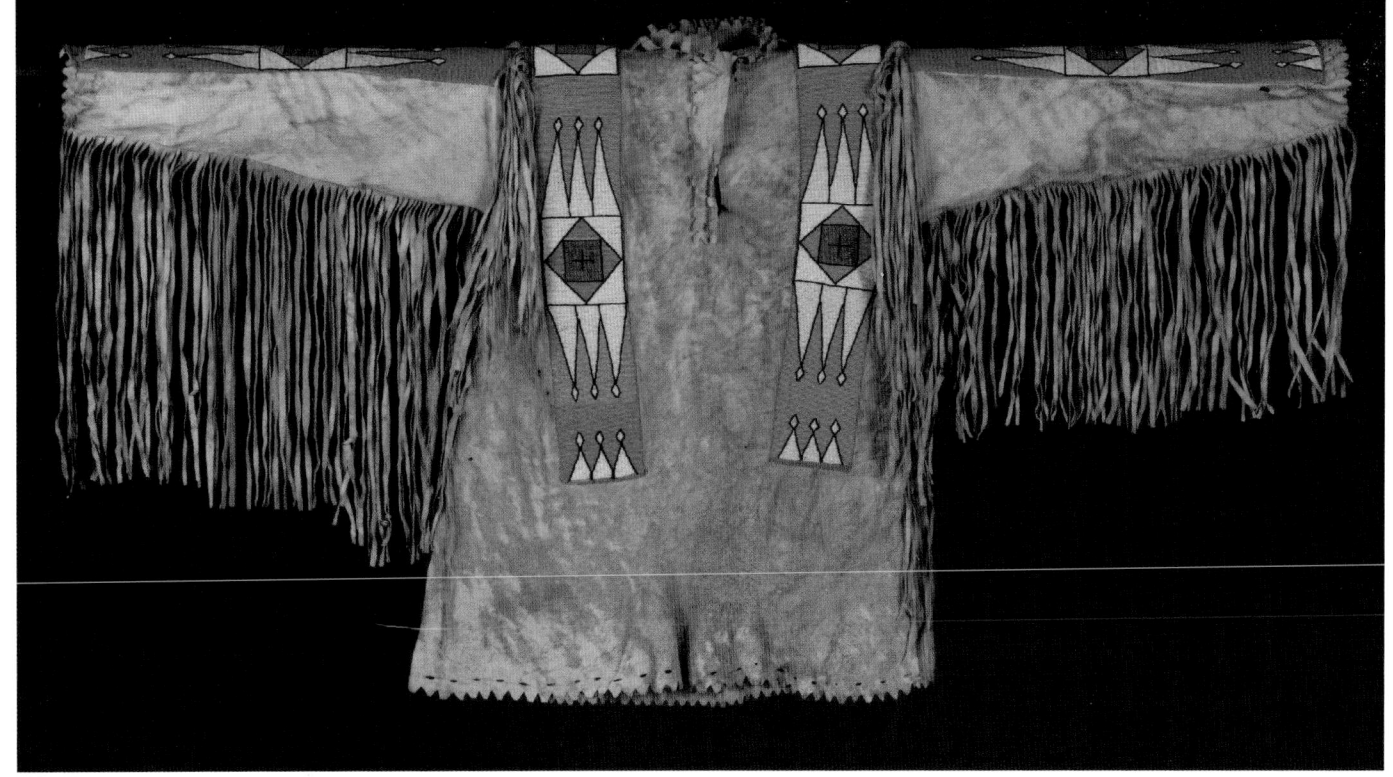

Right and Center right:
Beadwork details.

Far right: Neck flap details.
University of Cambridge
Museum of Archaeology
and Anthropology U.K.

21" 13" 13" 21"

Thongs & slit under
at front

8"

4½"

Tartan cloth neck binding

Blue ribbon & sequin

1" 3½"

1½"

Open flap
this edge
front

10" front

Green-blue
pigment to
upper area

Sewn

Fringe
separate

10"

Sequin

Red & blue
ribbons

13" back

Roll back sleeve &
separate fringe
sewn on

10"

8"

9"

Sewn & fringed

7"

Fringed but
not sewn

Change in
pigment colour

Yellow pigment lower area

Fringes
1½" long
⅛" wide

Extra piece sewn in

8"

25"

Fringed

Front Back

20" 20"

Beadwork 6 lanes ½" wide 8 beads each lane

Heavy blue pigment line to edge of beadwork

Metal sequins sewn
on along edge of strip

6 lanes each 8 beads

Metal
beads

Horse hair fringes
sinew bound to
buckskin loops

½"
lanes

Separate strips for beadwork
3½"

Buckskin loops
with horse hair
fringes (many missing)
on body of shirt

Neckflap is a
separate "vee"
shaped buckskin

Sinew

Separate fringe sewn on

104

Opposite, above: Man's buckskin shirt with beaded strips given by Night Bird (Nepahpenais), Saulteaux (Plains Ojibwa) to Edmund Morris the artist (son of Alexander Morris) c. 1908. Night Bird was from the Cowesses(s) or O'soup Reserve in the Qu'Appelle Valley, Saskatchewan. However, Night Bird is said to have obtained the shirt from a Cree who lived on the White Bear Reserve. ROM

Opposite, below: Layout of a Teton Sioux man's buckskin shirt, c. 1885.

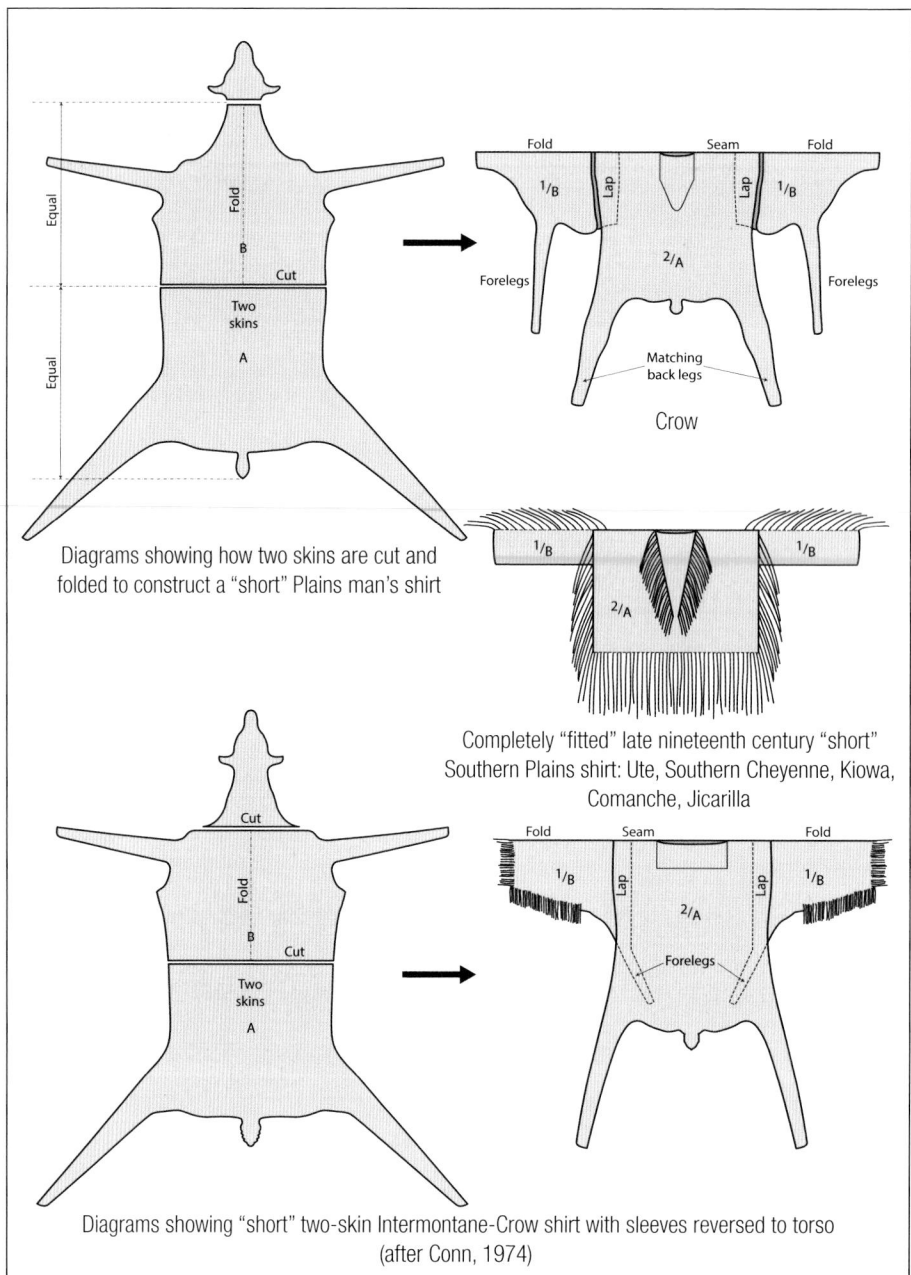

Diagrams showing how two skins are cut and folded to construct a "short" Plains man's shirt

Crow

Completely "fitted" late nineteenth century "short" Southern Plains shirt: Ute, Southern Cheyenne, Kiowa, Comanche, Jicarilla

Diagrams showing "short" two-skin Intermontane-Crow shirt with sleeves reversed to torso (after Conn, 1974)

PLAINS CREE: Specifically Parklands Cree living between the Woodland and Plains regions, (marginal Plains). Long, part-fitted, three-hide garments somewhat intermediate between Subarctic tunics and true High Plains shirts. Narrow strips of appliqué or woven quillwork, small in length and width, at the junction of the sleeve, body, and shoulders, and along the arms. Sometimes quilled disks are integrated in the arm strips. Narrow quilled rectangular neck flaps were usual, and below, a single large quilled disk on the chest and back. Below the chest sometimes an horizontal fringe wrapped with quills has been noted. A general fitted appearance, which suggests northern Plains–Canadian Parklands provenance.

PLAINS OJIBWA: Probably shared Cree styles although later arrivals in the Parklands area. They have a tradition of two chest disks of quillwork or later beadwork. A number of beaded shirts dating from a later period, were made with trade cloth replacing buckskin, but retained the large torso disks, somewhat diminutive shoulder strips, large arm strips with integral disks, and Woodland Ojibwa style beadwork on the neck piece and sleeve ends. George Catlin painted a Plains Ojibwa Chief "The Six" in 1832 at the mouth of the Yellowstone River wearing a skin shirt with double chest quilled disks and pictographs of a middle Missouri River style.

ASSINIBOINE: In 1833 the artist Karl Bodmer accompanied the German explorer Prince Maximillian of Wied to the upper Missouri and painted Assiniboine warriors at Fort Union. They are depicted wearing skin shirts with large chest disks with "whirlwind" designs and arm strips with blue and white pony beadwork. Shirts were heavily fringed with hair locks (of horse and human hair). Neck flaps were usually rectangular, sometimes with red trade cloth replacing skin.

BLACKFEET: Prince Maximillian also described Blackfeet men's shirts during his visit to Fort McKenzie in the summer of 1833. He reported that their leather shirts were made of bighorn sheep, trimmed with human hair or horsehair dyed in various colors and hanging down in front and back, were lined with red cloth, and had decorative strips of yellow-colored porcupine quills or of sky-blue glass beads. He also claimed that after new yellowish-white shirts became dirty they were often painted a reddish-brown color. He commented about the round disks worn on the front and back of these shirts and claimed that these circular quilled disks were in fact a trait copied from Assiniboine examples. In the summer of 1832, however, George Catlin painted the Blackfeet Indian Iron Horn at Fort Union, situated at the mouth of the Yellowstone River at its junction with the Missouri, wearing a buckskin shirt with a large rectangular chest panel. Twelve

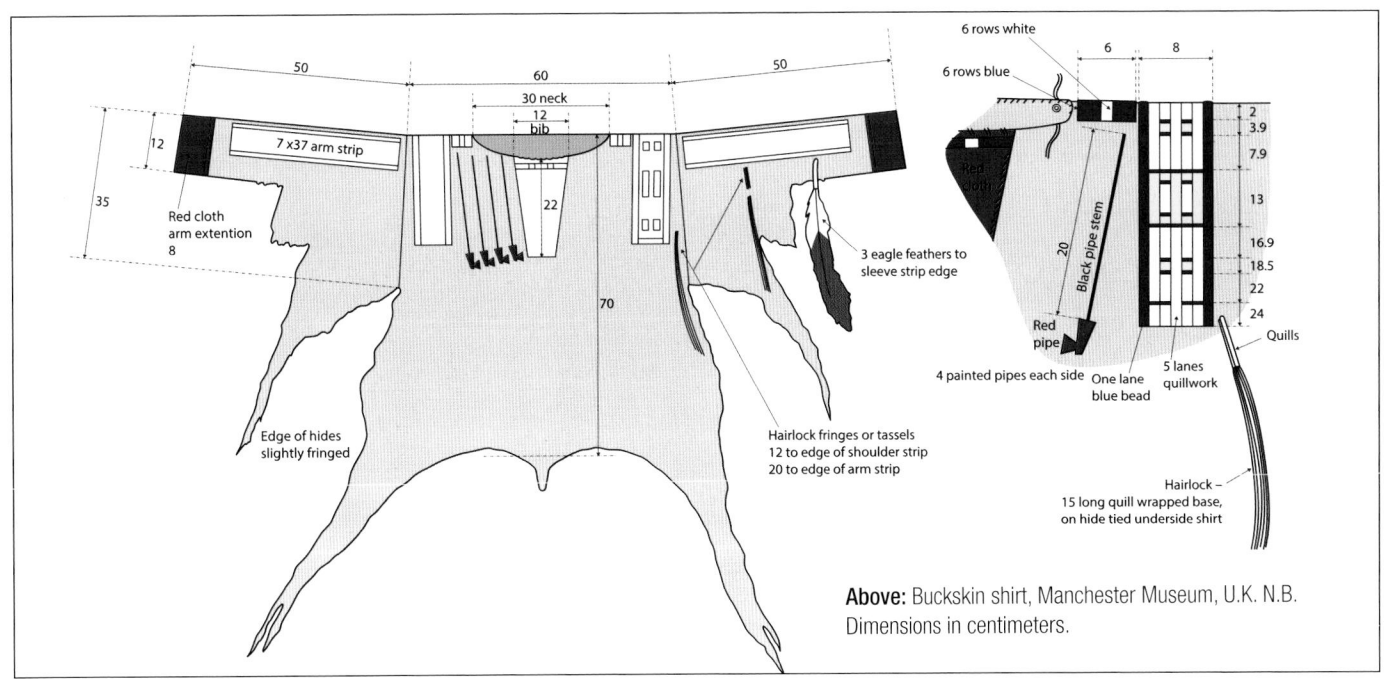

Above: Buckskin shirt, Manchester Museum, U.K. N.B. Dimensions in centimeters.

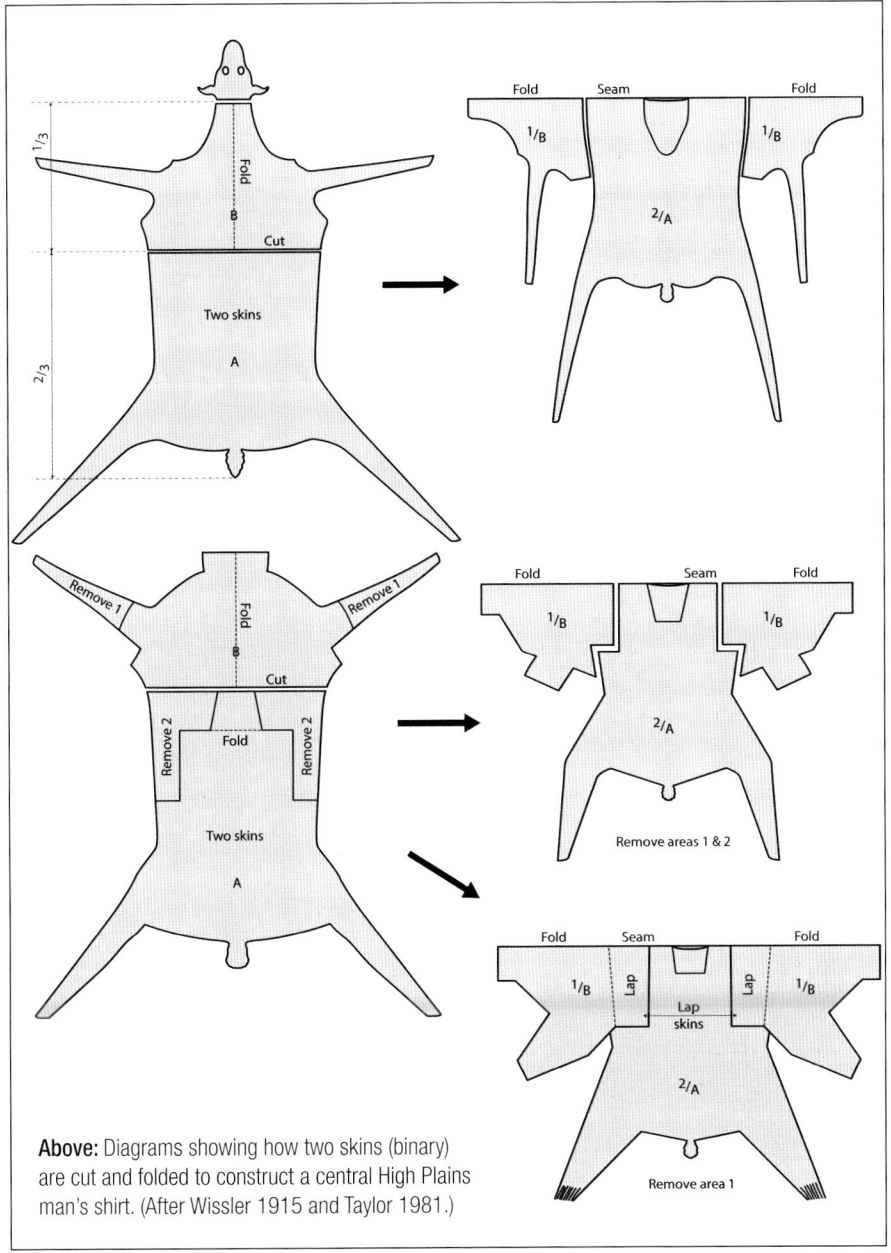

Above: Diagrams showing how two skins (binary) are cut and folded to construct a central High Plains man's shirt. (After Wissler 1915 and Taylor 1981.)

early nineteenth-century shirts are known with similar rectangular-style panels on the chest, which have been fairly well studied and attributed to the Blackfeet; perhaps they had special significance since several are painted with scenes representing war exploits and animals with special spiritual power. Both three-lane and five-lane quillwork bands were used and beadwork first in border lanes of sinew-sewn blue pony or pound beads and later in solid strips of seed beadwork in designs of blocks, elongated triangles, diamonds, and on disks of whirlwind designs. It has been suggested that the Assiniboine had a strong influence on some of these features. A number of Blackfeet shirts have black or brown parallel stripes painted horizontally across the body and sleeves, also the body areas are often painted with blue and red ochre or tadpole designs (a transformation symbol) to effect protective and sacred power. Sometimes blue painted spots were added to the upper area of shirts, which may have indicated exposure to enemy bullets. These shirts with military or religious associations were often ceremonially transferred to, or purchased by, new owners to maintain the continuation of the shirts' "power." They also used several methods of applying quillwork, including multi-quill plaiting giving diagonal and zigzag patterns.

As far as can be determined from the paintings of both Bodmer and Catlin the skin shirts shown are most likely to have been the "Long" style during the early decades of the nineteenth century.

MIDDLE & UPPER MISSOURI RIVER TRIBES: The Missouri River tribes, Mandan, Hidatsa, Arikara, Gros Ventre, and some branches of the Sioux such as the Yanktonai made magnificent untailored, hair fringed and quilled warrior shirts. Many also display painted heraldry consisting of pictographs of mounted or equestrian warriors in battle scenes on the front and back. Some historians have speculated that European traveling artists may have gradually influenced the native styles after their appearance during the 1830s as details became more realistic and refined. They also painted stripes, pipes, and hand-print symbols with complex quillwork strips (both porcupine and bird) often in five lanes, plus outside lanes of pony beadwork.

They combined yellow-orange and white porcupine quills, some dark brown (almost black) and blue-dyed porcupine or bird quills; areas of brown or black plant fiber were also incorporated. These shirts also may include pony beadwork or seed beadwork combined with quillwork. While most museum specimens that come from the upper Missouri area are probably of Siouan origin, for example Mandan, the Hidatsa also obtained shirts from their relatives the Crow.

CROW: Prince Maximillian considered that the Crow and their relatives the Hidatsa were the most elegantly dressed Indians of all. He noted that the shirts worn by Hidatsa men were actually obtained by trade from the Crow, and made from bighorn sheep skins embroidered and ornamented with porcupine quills. Perhaps, therefore, some extant examples given Hidatsa provenance may have been made by the Crow.

Some early Crow shirts were made from three skins; two forming the front and back and the third the sleeves, with unequal size front and rear legs hanging below. The Crow and Hidatsa had plaited quilled strips often intertwined in an extended multi-quill complex of criss-cross patterns.

At some period Crow also wore shirts with shoulder and arm strips using the quill-wrapped horsehair technique (double-lane and single-lane), although some were probably also made by the Nez Perce or other Plateau Indians and obtained from them in exchange. However, by the 1850s they were wearing clothes decorated with pony beads and at least one short poncho shirt with seed beadwork survives from the period or shortly thereafter. Crow shirts made during the last four decades of the nineteenth century are quite distinctive having adopted a style of beadwork bands in color, design, and technique that probably also originated among the Plateau Indians, or derived from painted and incised rawhide container designs. During this period shirt strips used seven colors of seed beads with a marked preference for light blue backgrounds, or sometimes lavender, with dark blue beads to outline designs, and white borders sewn in a technique popularly known as "Crow stitch." Many of the Crow shirts made of two hides of various deer or antelope, and in true "poncho" style, with two half skins forming the front and back, the other half skins both arms, this binary garment barely long enough to cover the chest; we can term this the short-style. These shirts had very heavy buckskin or ermine-skin fringing.

SIOUX: Sioux Warrior shirts probably varied in style between the northern groups such as the Upper Yanktonai and the southern groups like the Teton, particularly the Brulé and Oglala subgroups. The shirts of the southern divisions were originally the badge of the Wicasas or "Shirt Wearers" and heavily fringed with hair locks, sharing features with Cheyenne and Arapaho. One documented shirt from the Yanktonai, which is claimed to have belonged to the famous Chief Wanata, is painted with realistic pictographs (perhaps

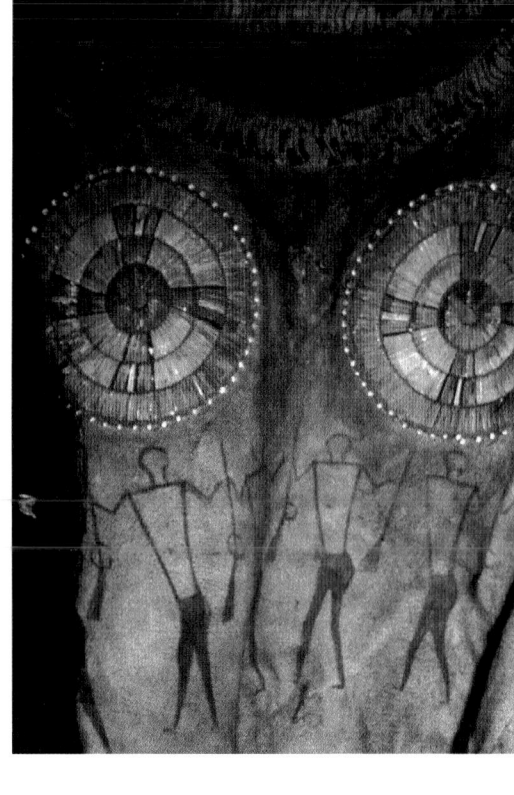

Above: Shirt torso detail with two quilled rosettes in yellow and orange colors seen on a number of surviving museum specimens, likely from the upper or middle Missouri River area, c. 1830. Note the painted warrior figures holding guns.

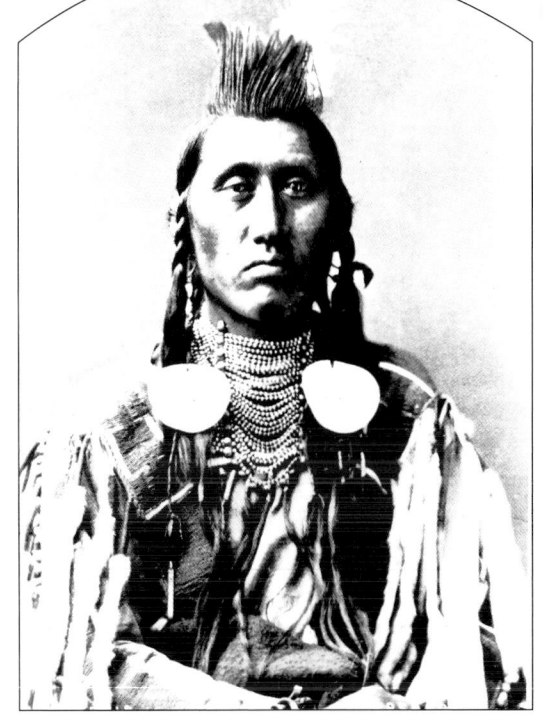

Left: Pretty Eagle, a member of the Crow delegation to Washington D.C., 1880. He wears a typical Crow style shirt of the later half of the 19th century. Photographer C.M. Bell

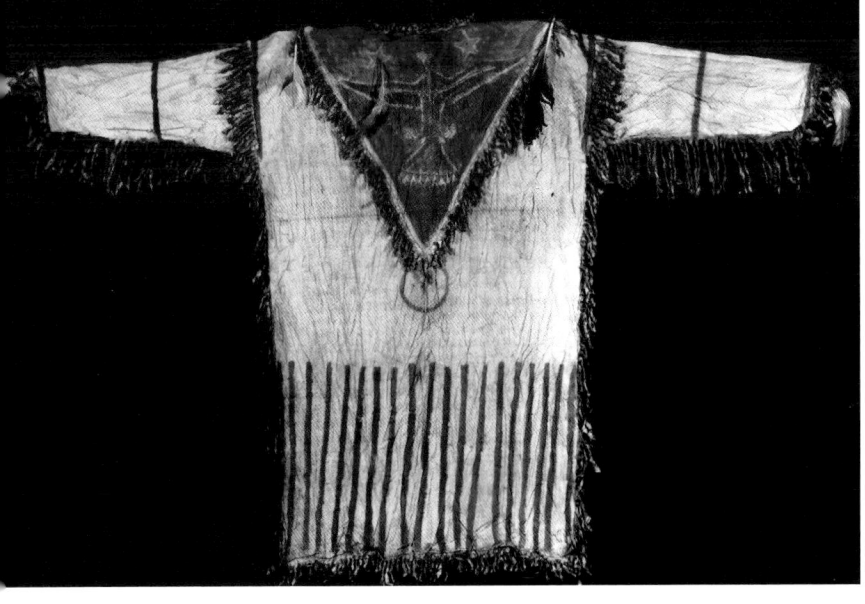

Europeanized) and may be representative of a northern Sioux style, although the quilled rosettes and small shoulder strips may have an Assiniboine association. Teton Sioux shirts were often painted, the top half blue or greenish blue representing the sky and the presence of the Great Spirit, and the lower half painted yellow to symbolize earth or rock. Triangular or trapezoidal neck flaps were common among the Brulé and Oglala, and rectangular among other Sioux groups. Painted symbols on shirts included pipes, horse footprints, and dragonflies, with strips edged with hair-lock fringes and occasionally hung with eagle feathers.

Early nineteenth-century quilled bands were made in the narrow-laned, two-thread single-quill technique that became superseded by sinew-sewn pony beadwork during the period 1830–60 and later by seed beadwork. The exclusivity of wearing these powerful warrior status symbols, along with eagle-feather bonnets gradually reduced during the reservation life. Later strips were executed in lazy-stitch technique in increasingly complex geometrical designs perhaps copied from imported rugs.

The painting of Big Soldier by Karl Bodmer at Fort Lookout in 1833 suggests the southern branches of the Teton and Yankton probably used the two-skin construction in preference to the longer three-skin construction of the more northern tribes.

CHEYENNE AND ARAPAHO: As far as is known, early Cheyenne and Arapaho shirts were similar to those of the Western Sioux particularly the Oglala, although quillwork (and later beadwork) had a more delicate appearance. Their shirts were often painted with celestial symbols and yellow to represent the sun. Quillwork and beadwork incorporated sacred colors and designs including the use of black (rarely if ever used by the Western Sioux). Southern Cheyenne also used poncho shirts, and a type shared with the Comanche and Kiowa.

GHOST DANCE SHIRTS: A dramatic and powerful resurgence of tradition developed with the so-called Plains Ghost Dance movement of 1890 and its tragic consequences at Wounded Knee in South Dakota when a small incident sparked the infamous massacre of Sioux men, women and children. In trances dancers could see ancestors—hence "Ghost Dance"—and the decoration of ritual clothing with religious symbols would give protection against white man's bullets. Some clothing was later made for reenactments of the tragedy. Both men's shirts and women's dresses were often made of muslin.

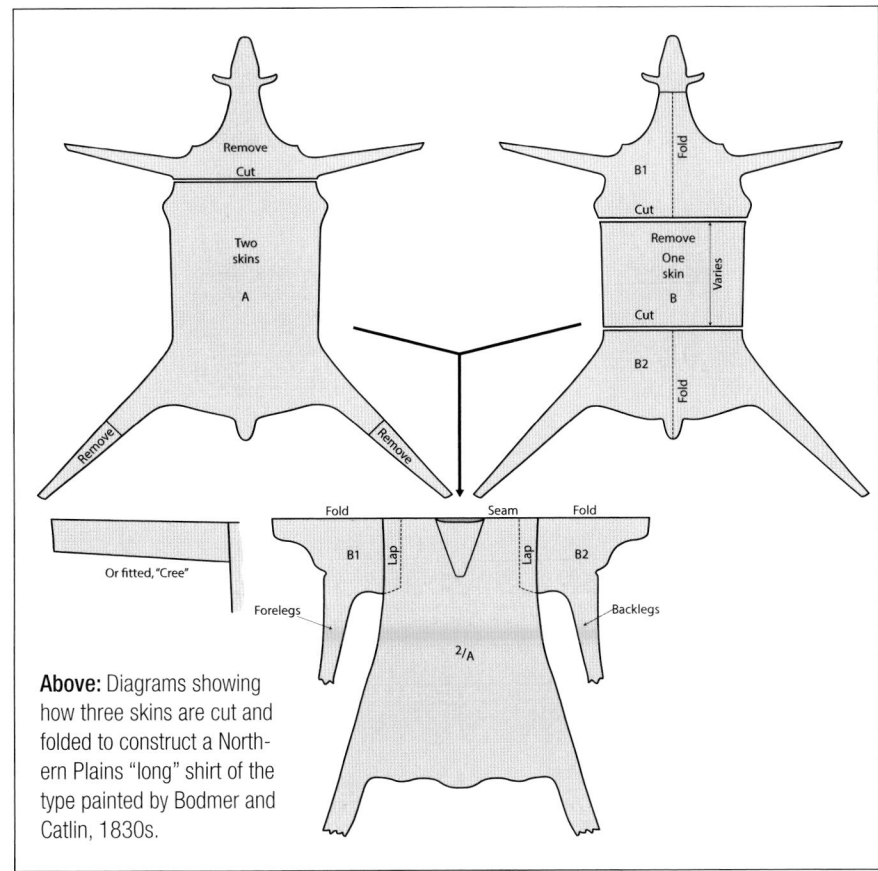

Above: Diagrams showing how three skins are cut and folded to construct a Northern Plains "long" shirt of the type painted by Bodmer and Catlin, 1830s.

A STYLE OF SOUTHERN PLAINS SHIRT

The sketches of George Catlin indicate the use of woman's buckskin dresses and buffalo robes by Comanches, but he does not show buckskin shirts on his male subjects. At first, one might be tempted to suppose that buckskin shirts, of the type common in the central and northern Plains, were lacking in the south; however, the use of other items of clothing generally similar to those found in the north would tend to suggest that poncho shirts and longer shirts were used in the south but only in limited numbers. Berlandier described Comanches in Texas in 1830 wearing shirts without any ornamentation and a skin fastened around their bodies to hide their nakedness. The Comanches around Santa Fe, he reported, "wear a sort of shirt that falls to the knee."

Certainly by the time of the settlement of the Southern Plains tribes in western Oklahoma, tailored shirts had become quite common and are all very similar in style. An examination of several photographs of Comanche, Southern Cheyenne, and Kiowa men of the period 1880–1910 and later tends to show a similar style of buckskin shirt of a highly tailored variety with little decoration. No doubt a few other Oklahoma tribes adopted this shirt, Pawnee and Arapaho in particular, and one old Comanche man still wore such a shirt in the late 1950s.

The accompanying sketch is a probable Southern Cheyenne specimen in the writer's collection, and it has a number of characteristics of its period (c. 1900). It is a highly tailored garment; none of the original hide shape is noticeable except for the suggestion of an arc at the bottom of the front and back. The arms are made from separate pieces of hide and sewn on horizontally from the shoulder and with a buckskin looped fringe added on the top edge at about mid-length. This rather strange position for fringes is a common characteristic of these shirts—they tend to hang down the sleeve when worn. The

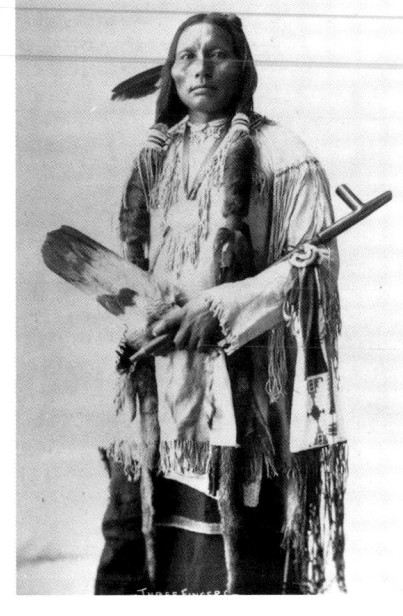

front and back hides are cut square and the line the seams make from shoulder to waist is vertical when the shirt is laid flat and the sleeve is sewn at rightangles to achieve this "flat-square" effect. The long fringes from the neck pieces, sleeves, and shoulders give a pleasing effect and the lack of beadwork is compensated for by the quality of the buckskin and the fringe work. The lack of beadwork may be due to a previous lack of quillwork in quantity among the southern Plains tribes before 1860, as these tribes were geographically out of the porcupine area. Hair-locks and fur trimming are also noticeably limited. Norman Feder, formerly of the Denver Art Museum, suggested that these shirts were probably developed from an old Kiowa or Comanche shirt style and originated in Oklahoma rather than from a northern or western influence as others have speculated.

The Cheyenne usually left the basic shirt white with touches of color at times only around the neck and bibs. The Kiowa and Comanche almost always colored their shirts in green or yellow. The Comanche particularly, but also the Kiowa, tended to twist their fringes.

The southern Plains and adjacent Intermontane Indians also used the poncho shirt, often close-fitting and decorated with unusually long triangular neck flaps and long fringes, painted in solid colors (yellow) or lightly beaded, or in wide shoulder bands (Jicarilla). Usually the backs and fronts of these shirts are the same except for the neck openings which may be modified to suit the individual.

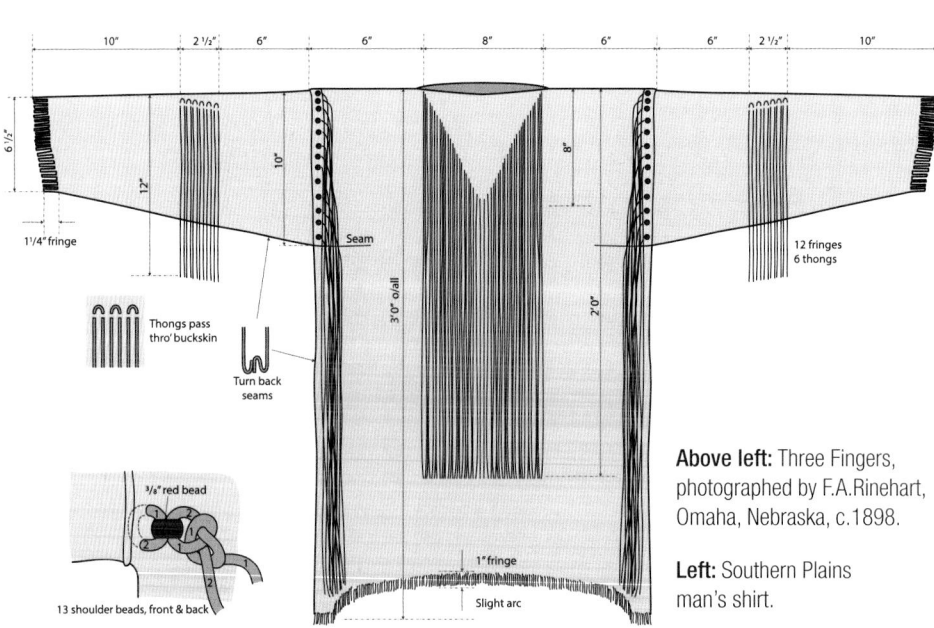

Above left: Three Fingers, photographed by F.A.Rinehart, Omaha, Nebraska, c.1898.

Left: Southern Plains man's shirt.

HIDATSA SHIRT

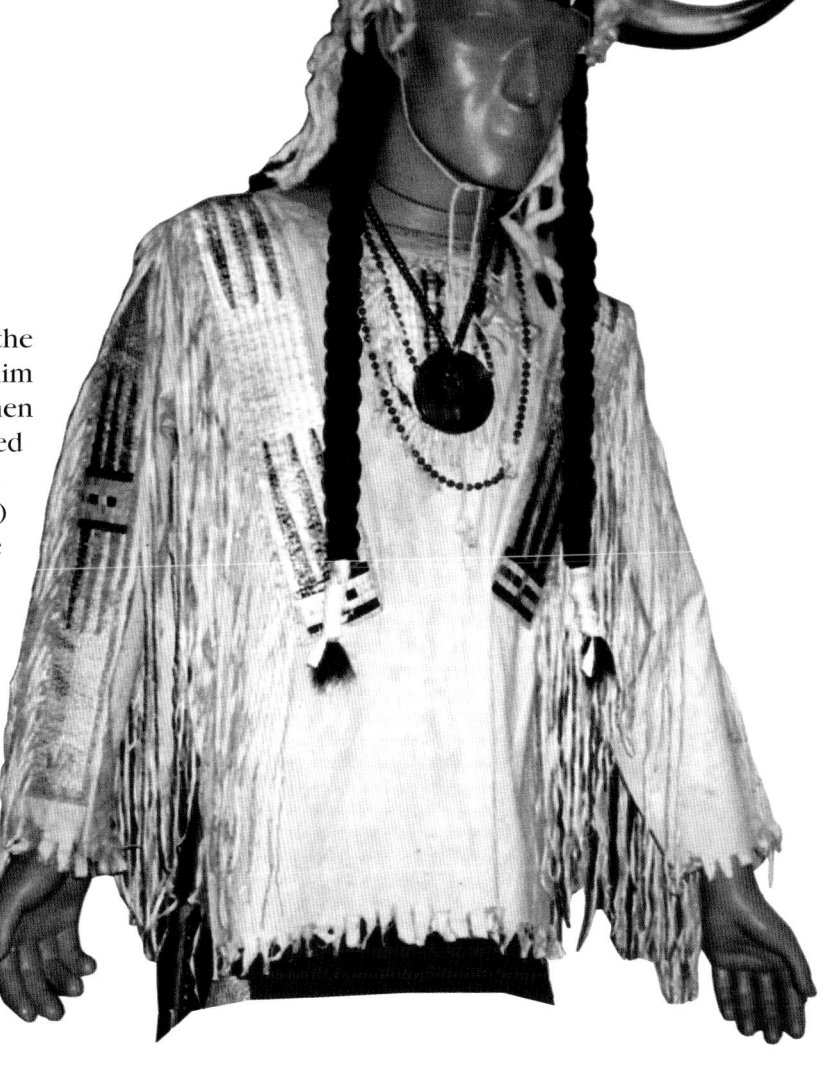

The shirt shown in the illustration was formerly in the collection of Mr Ian West of England and before him in the Denver Art Museum and once worn by the then curator Frederick Douglas for a color photograph used in National Geographic magazine.

The shirt is constructed from light (natural color) buckskin and is a "tailored" type with little of the original hide shape remaining, being cut square across the bottom and sides and with tube arms. The extensions at the bottom of each arm are recent and may not form part of the original shirt. A heavy long buckskin fringe is added at the sides of the quilled strips, which are on separate pieces of buckskin; the fringes are formed by thongs threaded in and out at the edges of the quilled strips. These quilled strips are in the so-called "plaited technique" except for the design areas which are executed in a "two-thread, two-quill" method in bright colors.

The shirt is interesting because it has close similarities to other shirts usually worn by Hidatsa men, and from photographic evidence there appears to have been a standard style, probably extending to other Fort Berthold Indians and the Assiniboine during the period 1880–1920. The cutting of the buckskins into a tailored shirt and the style and appearance of the quilled strips (likely colored with commercial dyes) certainly makes it late nineteenth century, probably c. 1895. It seems to be the case that the Hidatsa, Mandan, Arikara, Gros Ventre, Blood (Blackfeet), and Assiniboine were still using and trading this style of quilled strips for shirts when most other tribes were using seed beads almost exclusively; this is perhaps, particularly true of the Hidatsa, although the possibility of trading should not be forgotten. The design of blocks and feather shapes is also fairly standard on the Northern Plains at that time, and appears

Above: Hidatsa man's buckskin shirt, c.1900. The yellow background for the quilled arm and shoulder strips is typical of the Ft. Berthold style of 1880–1920 period. Buffalo Bill Historical Center, Cody, Wyoming. BBHC

Below left: Buckskin shirt with quilled strips in yellow-dyed background, probably Hidatsa, c. 1880. Note the painted hand symbols.

Below: Drawing showing dimensions of a Hidatsa shirt, with quilled shoulder and arm strips similar to the other examples pictured.

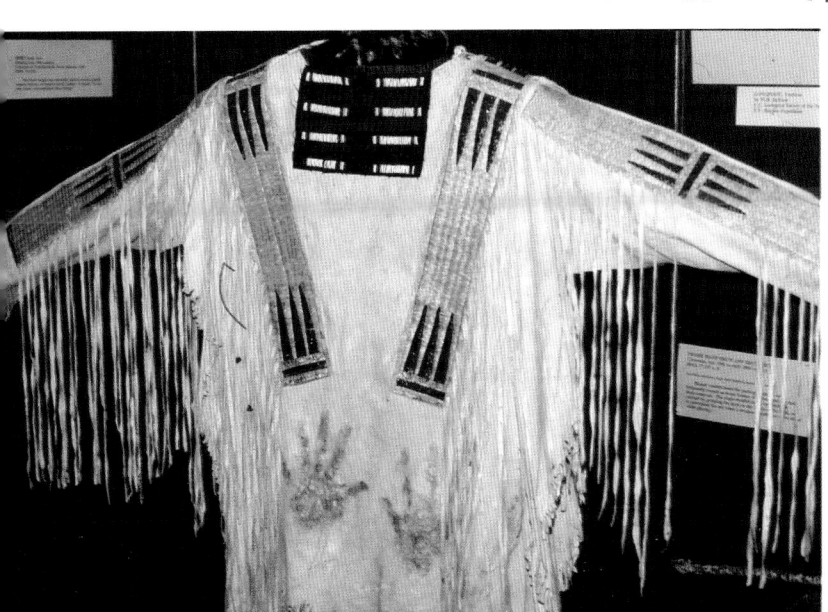

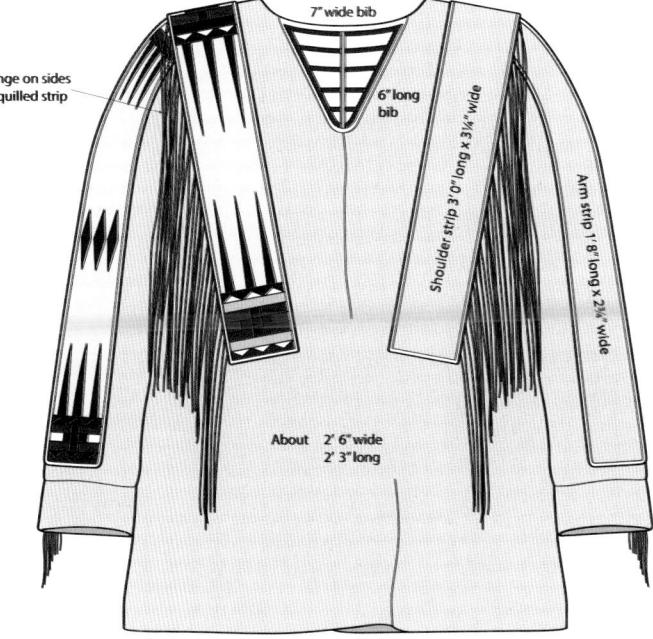

Fringe on sides of quilled strip

7" wide bib

6" long bib

Shoulder strip 3'0" long x 3¼" wide

Arm strip 1'8" long x 2¾" wide

About 2' 6" wide 2' 3" long

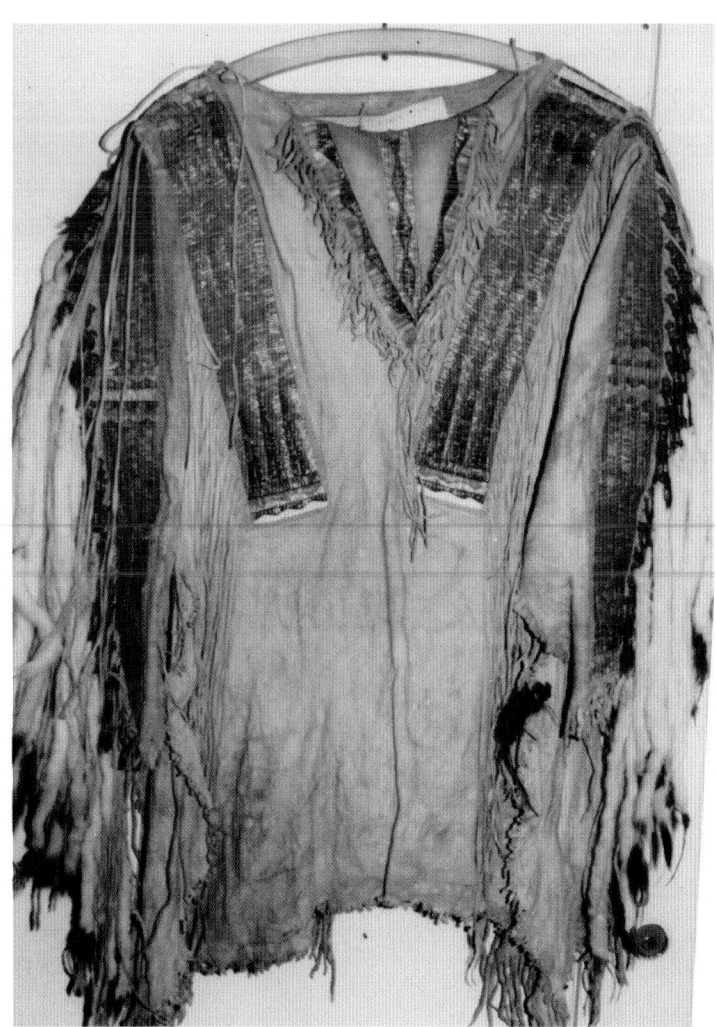

Above: Man's buckskin shirt, probably Hidatsa, c. 1890. The quillwork is also similar to others in the section and probably to a style traceable to the Hidatsa of the Fort Berthold Reservation. This style perhaps spread west to the Assiniboine at Fort Belknap Reservation, Montana. The heavy ermine skin decoration could also suggest a Blackfoot provenance. Haddon-Bevan Collection, cat no. 1902-86B. UCMAA

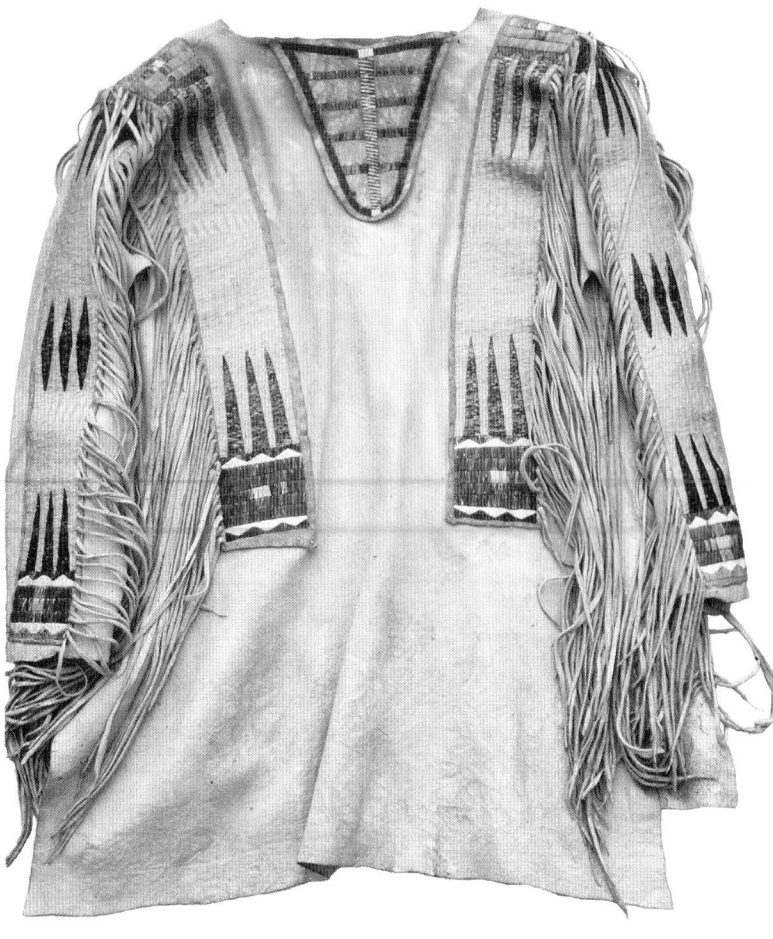

Above: Hidatsa shirt with quilled strips, c. 1890. Formerly Denver Art Museum and I. West Colln

Left: Bears Arm, from a sketch of a photograph taken in 1933 and published in Alfred W. Bower's book Hidatsa Social and Ceremonial Organization.

in quillwork and beadwork, particularly Assiniboine and Blackfeet work.

Two similar shirts are in the collection of the Cambridge University Museum in England and several Hidatsa men have been photographed wearing similar shirts—Bears Arm and Crow-Flies-High in Bismarck in 1881, and Old Dog as seen in Densmore's Mandan and Hidatsa Music. These shirts are all characterized by light-colored skin, triangular neck flaps, and yellow-orange color quillwork background for the strips with long "feather" and block designs. While the shirts illustrated are likely Hidatsa-made, similar examples were no doubt used or made by the Assiniboine, Gros Ventre, and possibly Blood.

PLAINS INDIAN MEN'S LEGGINGS

The paintings of Catlin and Bodmer show male leggings made of skin, with tabs on the bottom edge. This is due to the simple construction with each legging formed from a single folded skin, with little of the hide wasted. This leaves the head in three sections and with the head then partly removed the remaining tabs are visible at the bottom when the leggings are being worn. Deer, antelope, and Rocky Mountain sheep and goat hides were used all over the Plains. Sometimes the front legs were trimmed so that the finished legging was very narrow and fitted, and a gusset added above the ankle, a detail noted on Sioux leggings. The tail was also often left intact and the back legs supplemented to hold the leggings to a belt around the waist. Where the edges are brought together to close the leggings there are usually decorated bands of quillwork or beadwork and fringing of horse or human hair wrapped with sinew or pericardium tissue (heart case membrane). There may also be ermine skins, or buckskin fringing cut from the original skin or added. During the later nineteenth century leggings were formed by rectangles of folded buckskin without regard to the original shape of the hide and ultimately skin was replaced by trade cloth.

A rare variation of buckskin leggings, known as front-seam leggings, was used by the eastern Plains and Prairie tribes such as the Sac and Fox, Oto, Osage, and others. In this case each legging was cut from a whole hide.

Above: Typical layout of a front-seam legging cut from a single hide.

Opposite, above: Late nineteenth century man's skin leggings with beadwork strips, probably southwestern Plains, Jicarilla.

Opposite, below: Variations to the cut of hides to form early Plains indian men's leggings.

Below L–R: Man's buckskin legging, probably Blackfeet, c. 1820–1930. Hide type with beaded strip using "pony beads" with red trade cloth inserts. MFVB; Pony beadwork on what are probably Blackfeet leggings of c.1830–1840. RAM; Blackfeet leggings with painted stripes, hair fringes and blue pony beadwork.

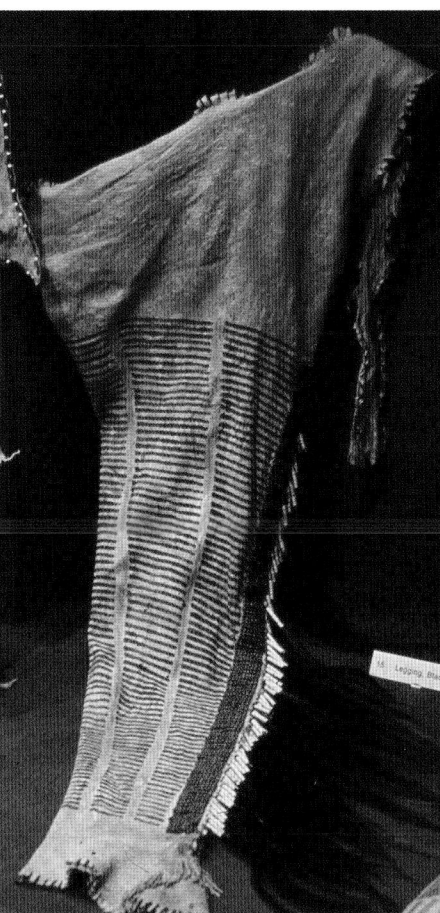

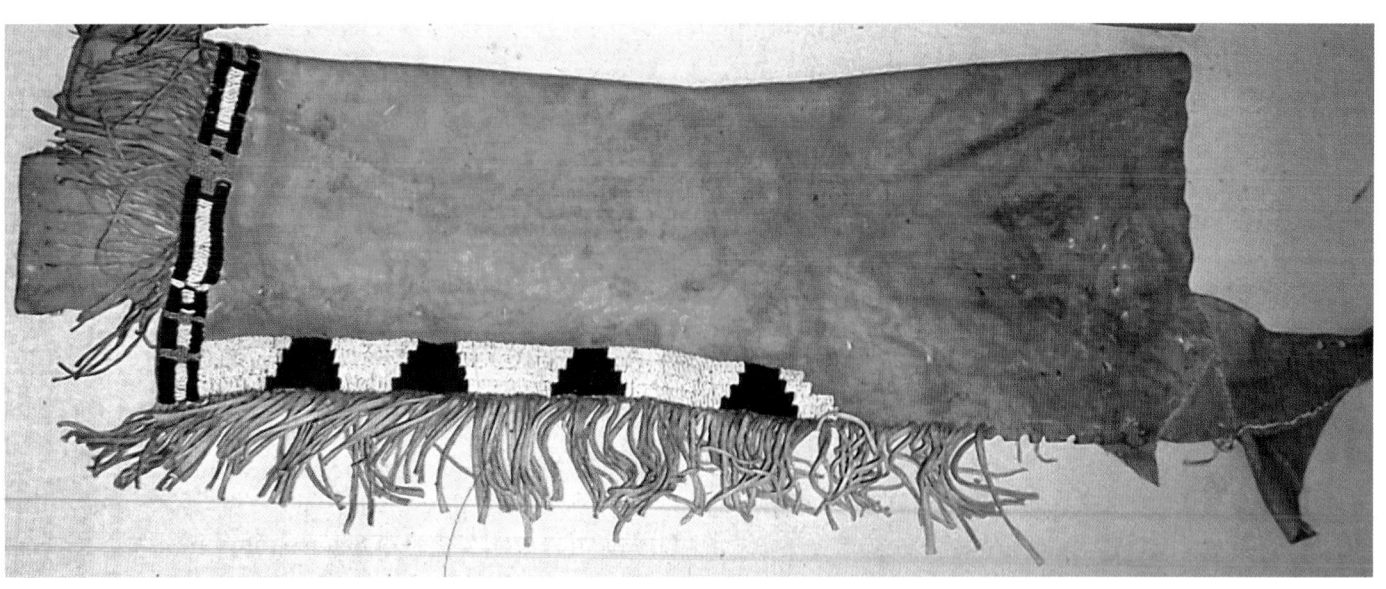

Added
gusset

Remove

Variations in the treatment
of the foreleg sections

BLACKFOOT "STRAIGHT-UP" BONNET

The following description of the Blackfoot "straight-up" bonnet is largely based on the Blood Indian bonnet in the British Museum, London, which belonged to an Indian named Little Ears. The origin of this style of head-dress is still unknown, but it may be related to early headdresses reported in the eastern parts of North America where feathers were fixed rigidly to a head-band, and stood upright.

This style of headdress among the Blackfoot (usually known as Blackfeet in the U.S.) was replaced by the Sioux-style bonnet during the later decades of the nineteenth century and is now rarely seen outside museums. However, it was not only used by the Blackfoot but other northern Plains and Plateau tribes before the spread of the popular circle bonnet. The Blood are one of three Blackfoot tribes.

The foundation or headband is a stiff rawhide band about ⅛ in. thick and long enough to reach around the head. The width can vary but 2½ in. is average. Buckskin thongs are attached at the back. See fig. 1.

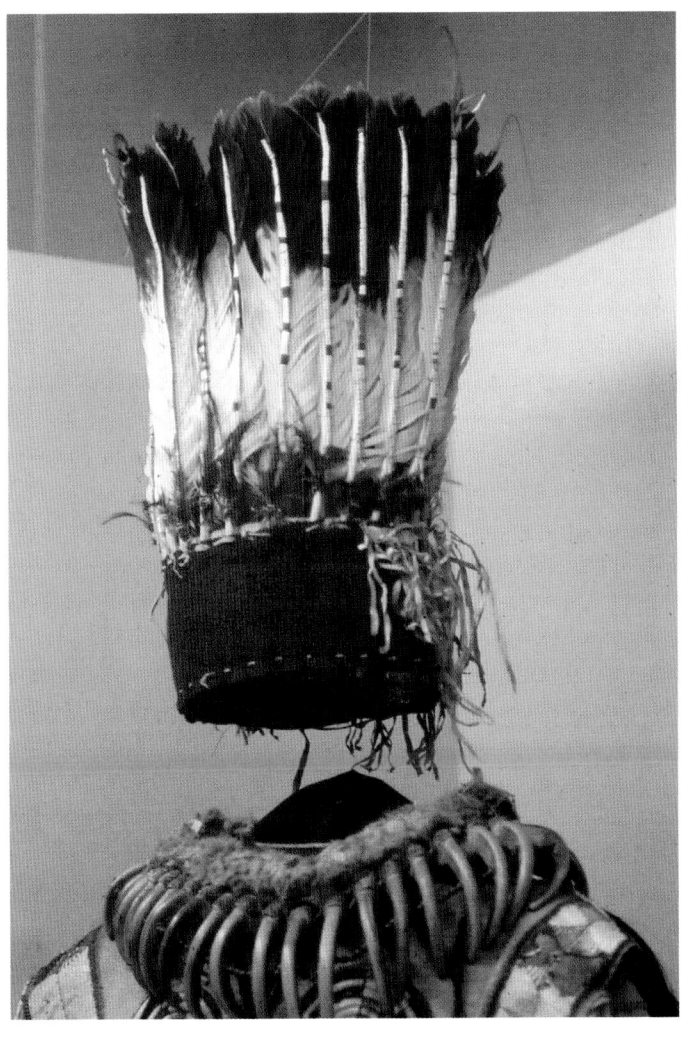

Fig. 2.

Sinew or thread binding

Fig. 1

2½"

Buckskin thongs ⅛" thick, knotted behind rawhide

Fig. 3

¾"

⅜"

Thong holding feathers pulled tight

Thong thro' loops

1½"

Fig. 4

Quills and base lashing visible above red cloth

Stitching calico/red cloth between feathers

Joint in calico/red cloth

Left: Mato-Tope's straight up eagle feather bonnet, c. 1830. Collected from the Mandan, 1833–1834. LMS

Opposite: Loma Flathead Indian wears a straight-up bonnet, c. 1907.

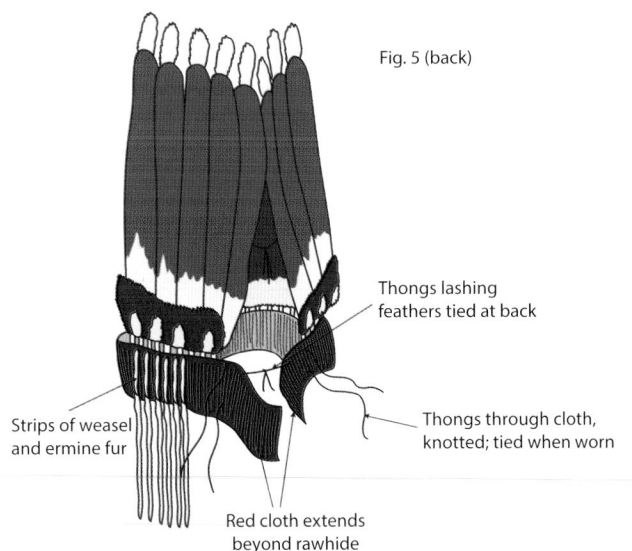

Fig. 5 (back)

Thongs lashing feathers tied at back

Strips of weasel and ermine fur

Thongs through cloth, knotted; tied when worn

Red cloth extends beyond rawhide

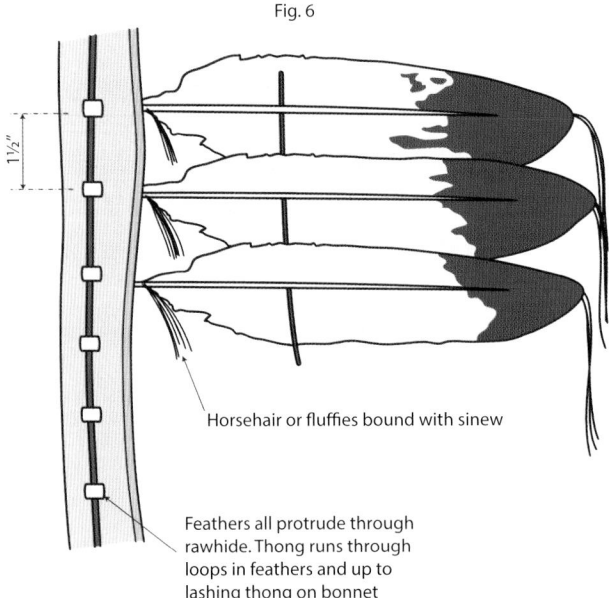

Fig. 6

1½"

Horsehair or fluffies bound with sinew

Feathers all protrude through rawhide. Thong runs through loops in feathers and up to lashing thong on bonnet

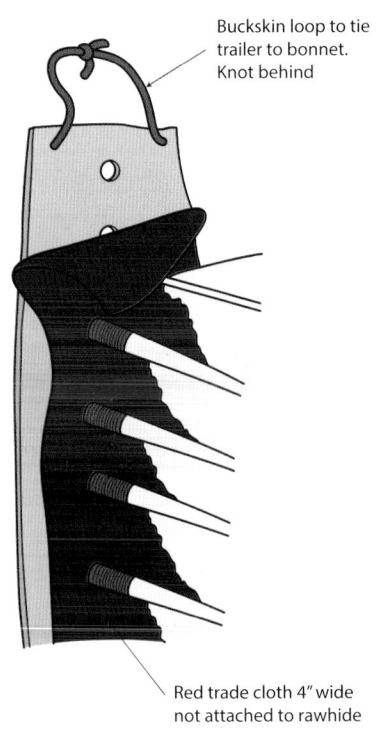

Buckskin loop to tie trailer to bonnet. Knot behind

Red trade cloth 4″ wide not attached to rawhide

Blackfoot straight-up bonnets are usually composed of 16–28 eagle tail feathers about 12–14 in. long, arranged in no apparent order. The butt of each quill is pointed and turned inside its own hollow center in the usual fashion to make a loop. Small eagle, owl, and chicken feathers are attached at the base with sinew or thread binding and they are usually dyed red or yellow. See fig. 2.

Around the rawhide headband 1½ in. from the lower side are made pairs of holes about ³⁄₁₆ in. in diameter. The prepared feathers are threaded onto a piece of buckskin thong or white string in a row, and then lashed with another thong to the rawhide headband between the intermittent pairs of holes as in fig. 3. A spacer, or control string 5½–6 in. above the feather base, passing through the quills, encircles the feathers and is tied in the usual method of bonnet construction.

The next step is to cover the rawhide headband with red trade cloth and/or calico. The Blood Indian bonnet in the British Museum has calico inside and red trade cloth outside. The two pieces, equal in width to the rawhide band, are stitched together along one edge, placed around the band and again stitched on the top side intermittently between the feathers as in fig. 4.

The ends of the calico and red cloth project beyond the ends of the rawhide band for about 3 in. The tie thongs are brought through the calico and red cloth and are knotted and tied when being worn. The thong used to lash the feathers to the rawhide base is also tied in the back. See fig. 5.

Around the bonnet, except for 6 in. at the front, are attached strips of white fur in two lanes, one just below the feather base, the other at the edge of the headband. Beadwork, brass tacks, coiled fringes, and cockades are used to decorate the front 6 in. of the bonnet. The cockades of chicken feathers on a thin stick seem to be of European manufacture. The bases of the feathers can be bound in cloth, but were often left unwrapped.

The single trailer extending for 45 in. down the wearer's back is made from a strip of thin rawhide 3½ in. wide covered with red cloth. It is tied on separately. The rawhide is holed for each feather about 1½ in. apart. About 30 eagle feathers are used in this trailer, prepared as for the headdress. A buckskin loop at the top of the trailer is attached to the headband extensions when in use. See fig. 6.

The Blackfoot were not the only tribe to use this style of headdress as mentioned above. The Flathead and Nez Perce both used this style and it was still in vogue as late as about 1900. However, the basic style was used on the Upper Missouri and throughout the northern Plains before the development of the circle bonnet between

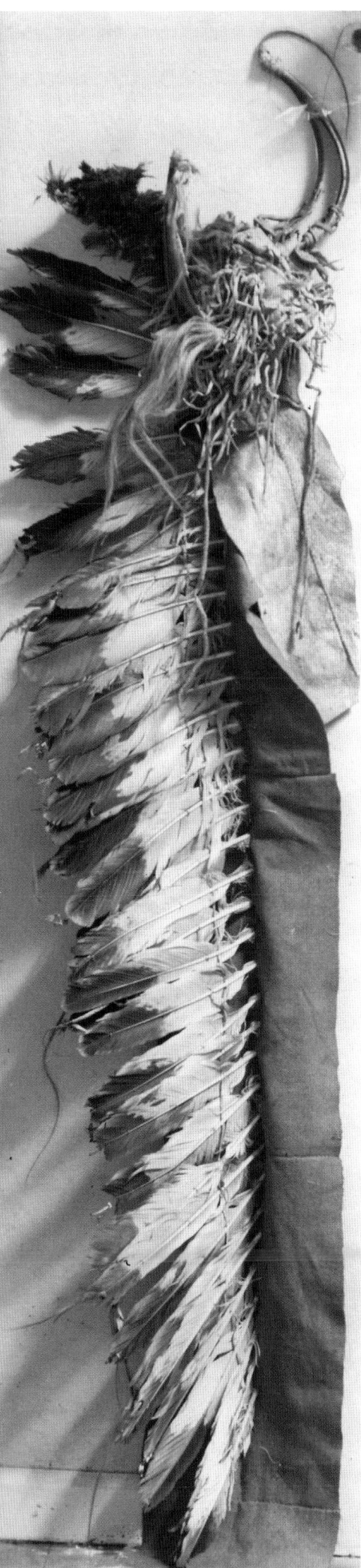

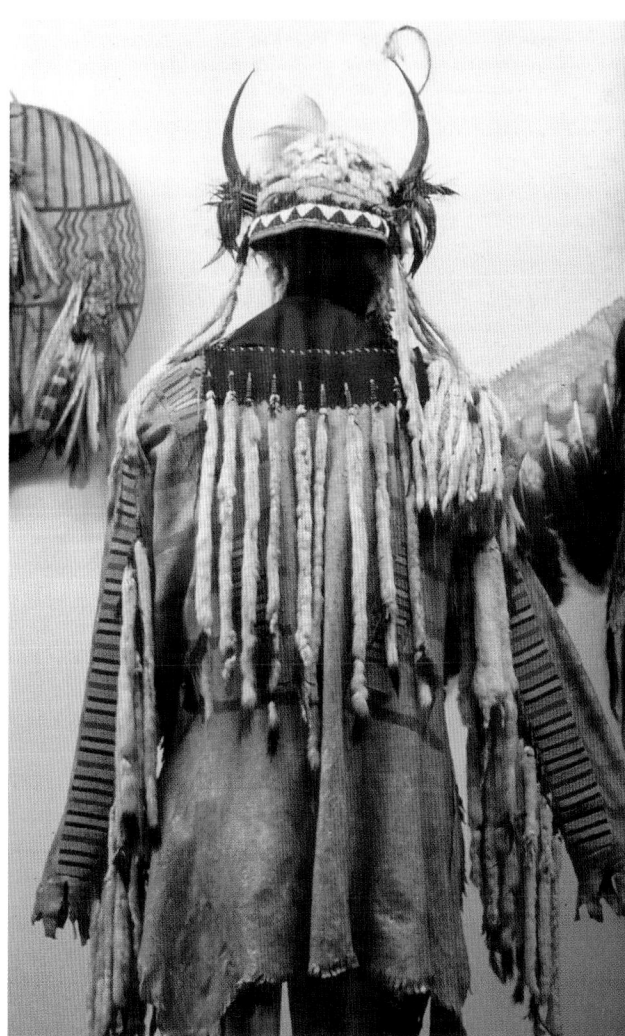

c. 1800–30. By the 1830s the Missouri River tribes had developed a transitional bonnet. In this the feathers were no longer fixed rigidly to the headband, but were just looped on. The control string, however, was so short that the bonnets did not spread out in the "Sioux Style." Although the technique was different, the transitional bonnet gave a "straight-up" appearance. Some bonnets show combinations of both styles, but the Blackfoot were the last to use the true "straight-up" headdress.

Another bonnet of the "straight-up" style was collected by Prince Maximillian from the Mandan second chief Mato-Tope in 1834 and is now in the Linden Museum, Stuttgart, Germany. The headdress has a basic headband of rawhide covered with red trade cloth. There are twenty-nine eagle feathers laced to the band through holes bored in each quill about 1½ in. from the lower end. Each feather is decorated with a quill-wrapped rawhide strip up each side spine terminating with a tip of orange horsehair. Despite the headdress being collected from the Mandan it has been considered as being Blackfoot-made. The Mandan were also making flaring style headdress by this period as Catlin's portrait of Wolf Chief in 1833 clearly shows.

Some of the finest Blackfoot bonnets are shown in the drawings of Paul Kane and later, Winold Reiss and references to these artists will help understand the construction of old style bonnets. It will be noted that some old bonnets have the feathers bent outwards to give a flare effect. Quills wrapped around rawhide strips, or in olden times, wooden sticks, are often attached to the ribs of each feather.

Above right: Blackfoot shirt with ermine skin decoration and horn bonnet. Probably Assiniboine or Blackfoot. Both c. 1870–1890. LMS

Right: Chief Walking Buffalo (George Maclean), wearing a buffalo headdress, Stoney Indian, Alberta, c. 1950.

Left: Split-horn headdress with cloth trailer and eagle feathers, possibly Assiniboine or Blackfoot. Early nineteenth century. PRM

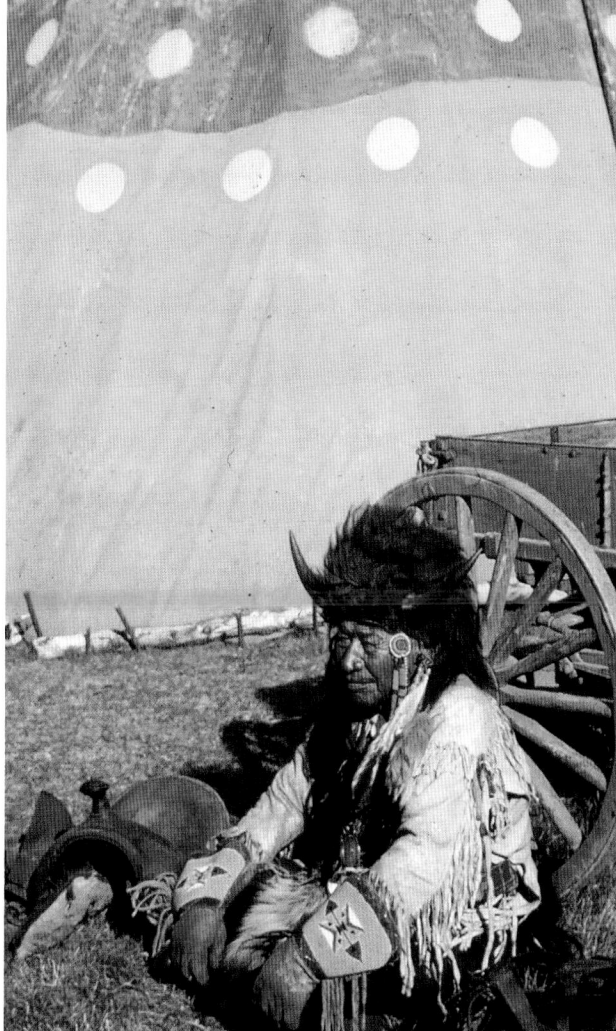

A PLAINS CREE BONNET

The Plains Cree also made headdresses of the popular flaring style as well as straight-up bonnets of the old Blackfeet style. An interesting Cree variation is a bonnet in the Hudson's Bay Company collection, now in Winnipeg.

The feathers are tied through the foundation about ½ in. from the edge all around and a control string through each feather is tied at the rear in the conventional way. The foundation is made of light gray felt of double thickness in the form of a wide headband to circle the head about 24 in. all around, being a maximum of 4 in. wide at the front and 3 in. at the back.

On each side is attached a conch shell 1½ in. diameter attached through a single hole in its center to a buckskin thong knotted outside. To the knot are tied colored silks. The edge of the beaded browband has large seed beads sewn every ⅛ in. The ends of the feathers are bound with colored silks—pink, light blue, dark red, and white—with the total length of binding 2½ in.

The feathers are 12–12½ in. long, and are eagle tail feathers, mostly dark. The bonnet comprises thirty-four feathers, seventeen to each side. To the top of each feather is attached with pine or spruce gum a tuft of soft white horsehair 10 in. long, which is stuck on the outside of the feather about ½ in. down from the tip. The horsehair is covered with three or four dark red dyed chicken feathers ¾ in. long, and over this a piece of white fur ½ in. wide (white rabbit or ermine) is attached.

Below: Plains Cree bonnet from the Hudson Bay Company Collection.

Bottom of each quill is cut off square; a buckskin thong is bound to quill with thread and knotted under felt crown.

Edge beading on brow band

Silk strands at joining of ermine skins to rosette

Note knots inside to hold each quill

Silk wrapping at feather base

Ribbons bunched and attached to skull cap of double felt thickness, on both sides of the cap

MEN'S FULL DRESS FROM THE NORTHERN PLAINS, 1900–2000

The following descriptions and photographs are of men's shirts and leggings made during the period 1900–2000 from the Blackfoot tribes (North Blackfoot, Piegan, and Blood), Stoney, and Plains Cree.

Shirts

The shirts are of the highly tailored type, that is the bodies are square cut and arms are tapered tubes sewn in at the shoulder. The hides are natural white buckskin of deer, elk, or even moose. The sides are usually left open except for a couple of buckskin ties. Some of the decorative media (ermine "tubes," fluffy feathers, etc.) appear to be of a commercial type obtained from white traders since the tubes are sometimes backed with wool or cloth clearly indicating non-Indian preparation. The chicken feathers also used with the tubes are probably white trade material and perhaps even the buckskins themselves were obtained from white traders or were tanned by Indians elsewhere in many cases.

The Sarsi material is also included here as they did produce the same styles, although the use of lazy-stitch beadwork is not uncommon from them.

Above right: Blackfoot shirt disk, c. 1900. McCM

Below, left and right: Layout of Northern Blackfeet shirt. UCMAA

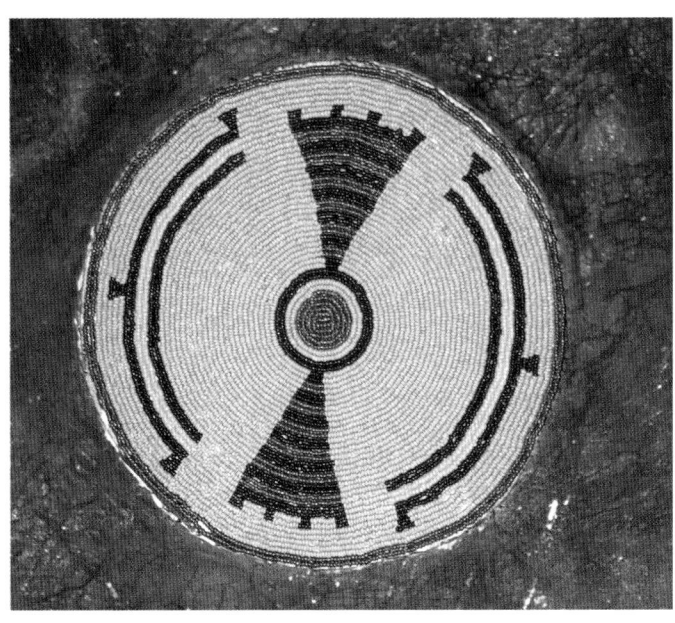

Modern shirts use whatever deer hides are available, usually two large skins for the front and back and two smaller hides for the sleeves. Offcuts during tailoring provide inset fringes if required and neck flaps. The degree of tailoring would be less on early modern shirts than those of very recent origin. Very modern shirts have the sleeves sewn into tapering tubes with inset fringes, then sewn to the shoulders, with an additional fringe at seam or beaded strip edge. Fringes can be inset or fold back; this is usually determined by the amount of hide available. All sewing is done inside out with a heavy thread. The sides of the shirt body are mostly looped together at intervals with a buckskin thong.

There have been some revisions in style during the modern period. During the first twenty-five years of the twentieth century many buckskin shirts did not have the elaborate fringes common on very recent shirts. In this period shirts were also made from cloth and the styling and cutting for cloth shirts probably determined the tailoring on later modern shirts when buckskin

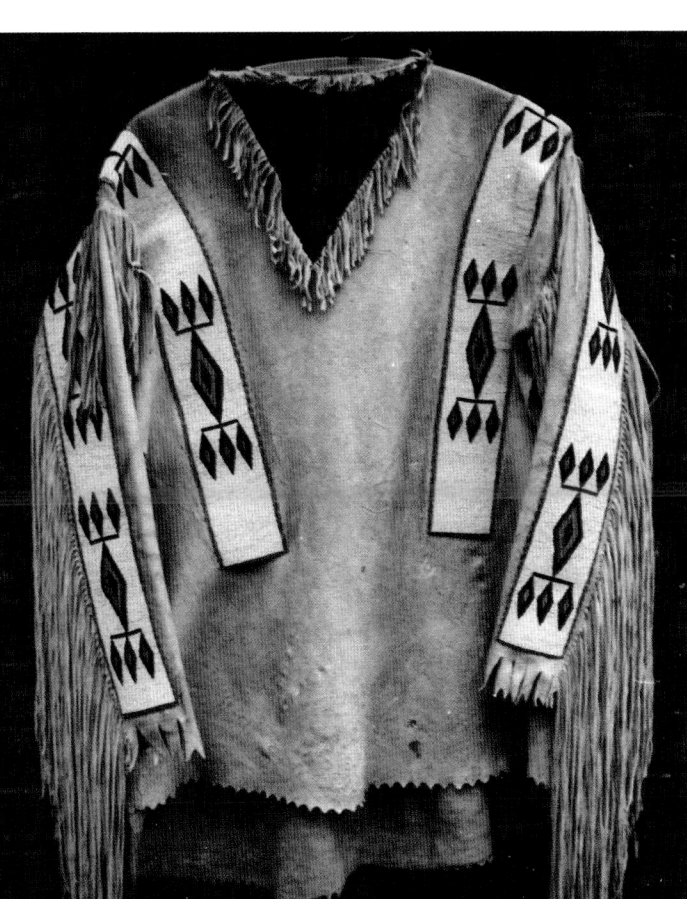

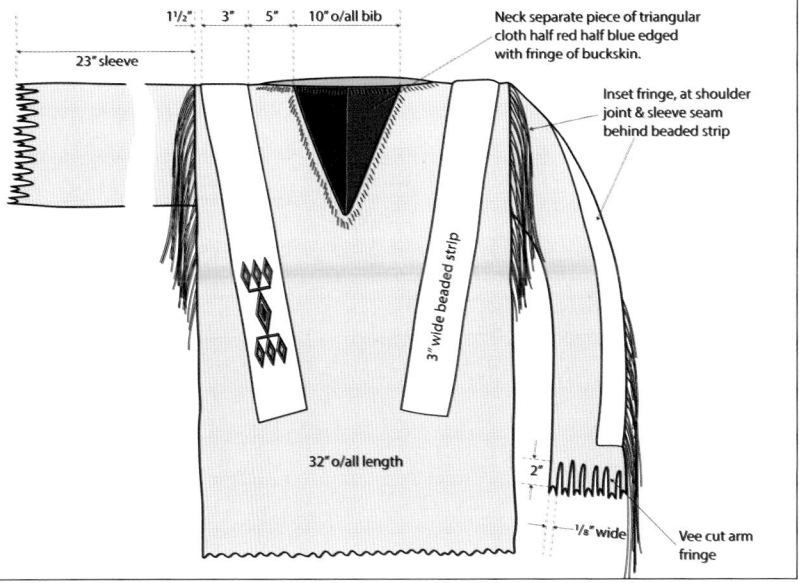

23" sleeve

1½" 3" 5" 10" o/all bib

Neck separate piece of triangular cloth half red half blue edged with fringe of buckskin.

Inset fringe, at shoulder joint & sleeve seam behind beaded strip

3" wide beaded strip

32" o/all length

2"

⅛" wide

Vee cut arm fringe

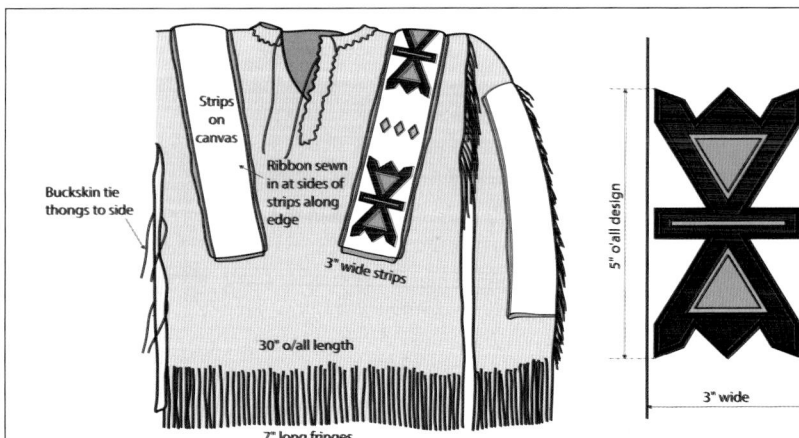

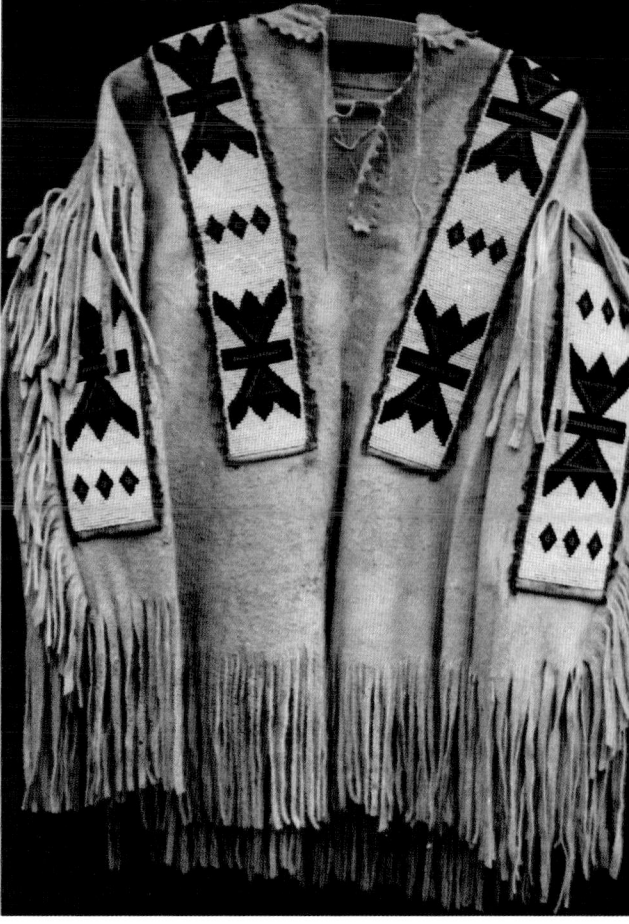

became fashionable again. In the earlier period it was usual for a "pancake" or large beaded rosette, either of red cloth or buckskin to be attached to the front chest and back of the shirt, in the same way as the large quilled disks had adorned nineteenth-century shirts. It is also noticeable the bottoms of the shirts were cut in an arc, as the hide shape. Today the bottoms are usually cut off straight, though sometimes with a wavy or zigzag pattern. Neck flaps were often missing on early modern specimens or a piece of red cloth was attached along a neck opening. Today the favorite style is a large V-shaped neck flap sewn to the chest with beadwork designs to match the shoulder strips. These are attached close to the fringe, hence well back on the sleeve. Sleeve and shoulder beaded strips match in design and color.

Leggings

Modern twentieth-century leggings are simply constructed from two rectangular pieces of buckskin, folded and sewn or looped lengthways into tapered

Above and Right:
Layout of Chief Red Dog's shirt from Star Blanket (Plains Cree) Reserve, Saskatchewan, c. 1920 with detail of beaded design. UCMAA

Below and Below right:
Layout of Piegan (Blackfeet) shirt. UCMAA

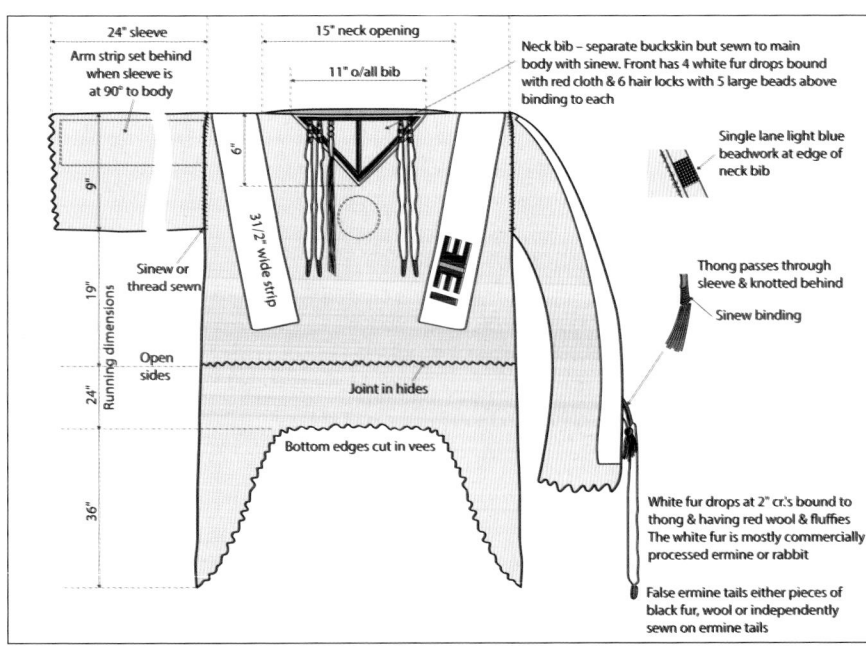

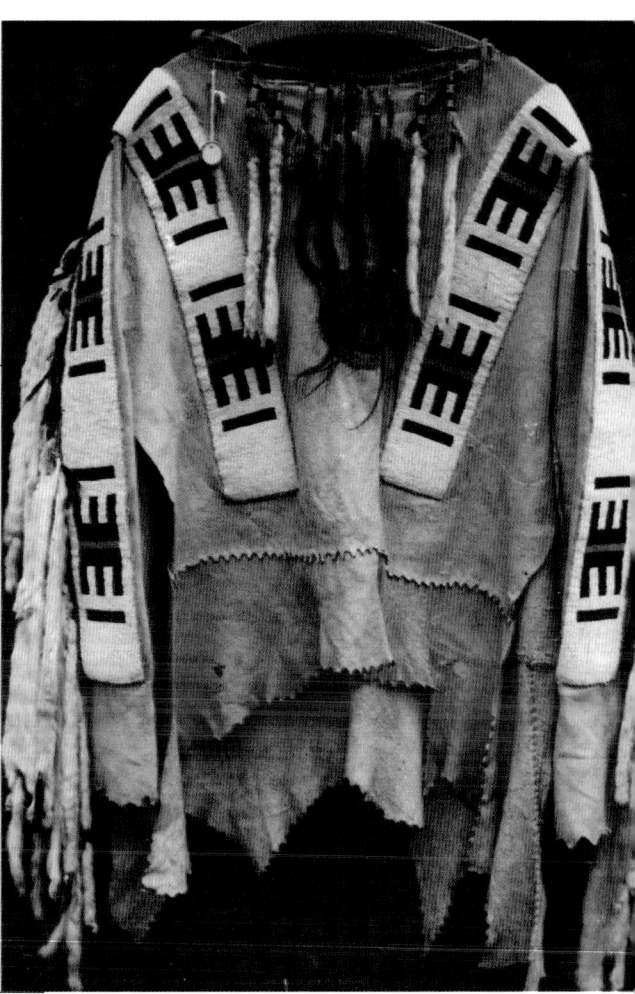

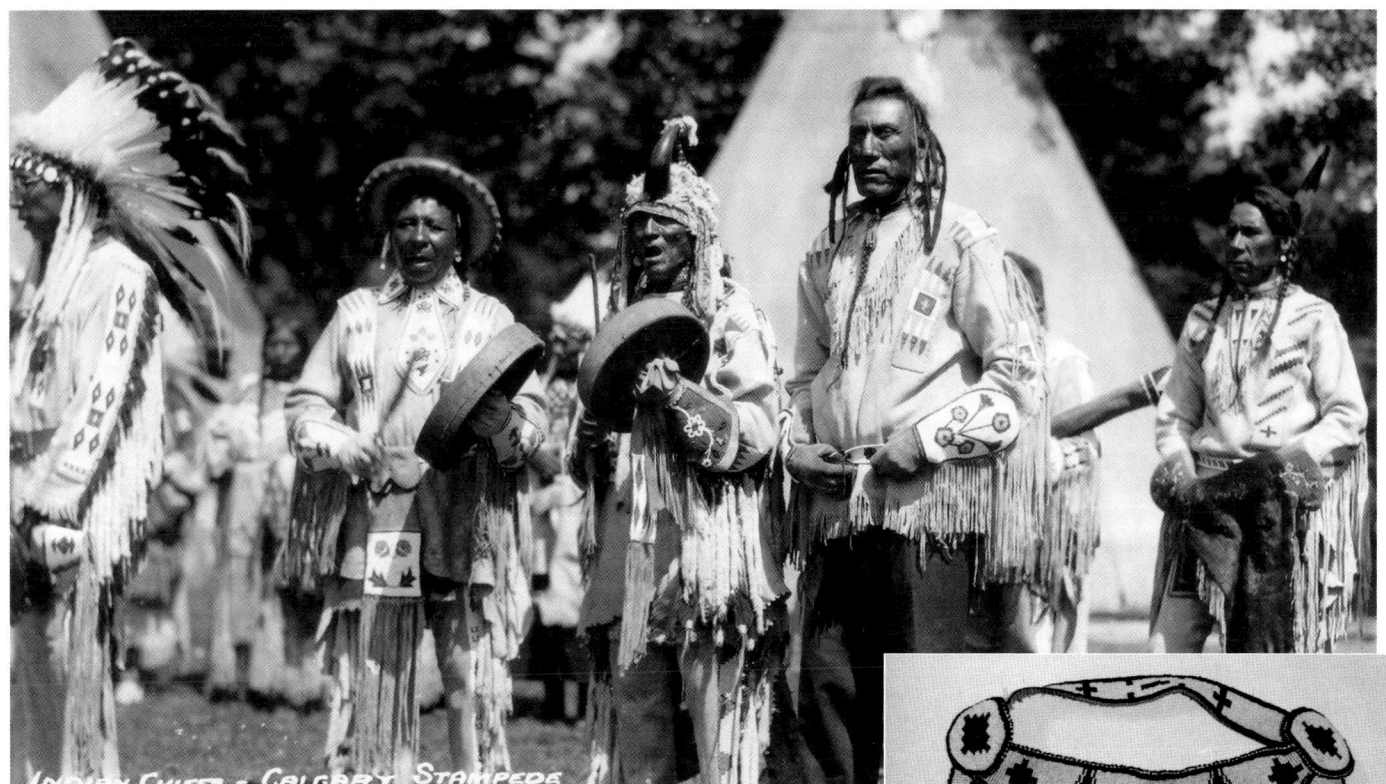

INDIAN CHIEFS - CALGARY STAMPEDE

Above: Singers holding hand drums and wearing ceremonial attire at the Calgary Stampede, c. 1920. One drummer is wearing one of the single-horn buffalo headdresses that were worn among the three Blackfoot tribes.

Inset: Blood beaded headstall for a horse c. 1900. Donald Ellis Gallery

Right: George Crawley, Stoney, at Banff Indian Days, Alberta, Canada, c. 1950. The Stoney (Nakoda), a branch of the Assiniboine Indians, continued their annual "Indian Days" each year until recent times. They usually wore heavily beaded dress and pitched their painted canvas tipis, as most tribes do, for a few days each summer. Nicolas Morant, Banff.

Opposite, above: Horses and child dressed in parade regalia and a man holding a guncase and wearing matching beaded buckskin shirt and leggings. Blackfoot, at Calgary Stampede, c. 1920.

Opposite, below: Blackfeet chiefs, Wolf Plume, Curley Bear, and Bird Rattler, c. 1910.

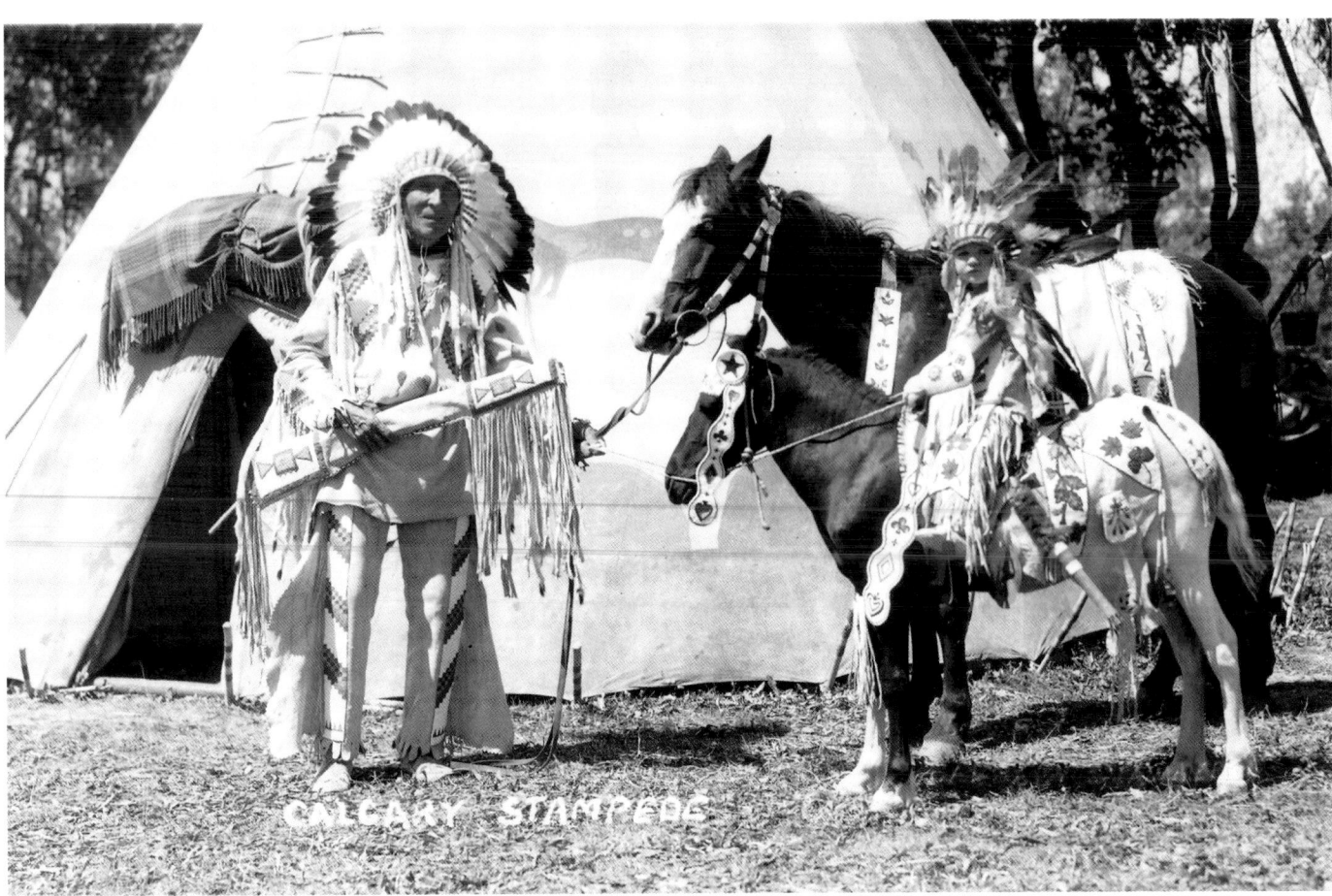

tubes. Early modern leggings were sometimes of cloth, in red or blue, or even made from trade blankets. Today buckskin is used with beaded strips to match those used on the shirt, attached close to the seam.

A wide flap is a common feature on modern leggings, although tube leggings without flaps were common until 1930. Along the flap edges, small V-cuts or wavy cutting give added decoration. The ankle edges are sometimes cut as the flap edge or fringed, or hemmed and bound with red cloth looped with a buckskin thong. Tube leggings sometimes have an inset of fringe with ermine fur drops looped on the fringes or edge of the beaded strips.

Painting of tadpole symbols or horizontal stripes appear on early modern leggings as on nineteenth-century specimens, and some modern leggings have a triangular beaded ornament on the back at about mid-calf.

White buckskin is the only material now used to produce the best full dress leggings, although cloth with ankle panel variations were once common. It would seem that today some hides being used may be commercially tanned, since native tanning is now limited. Northwestern tanning is characteristically light in color and unsmoked hence "white buckskin."

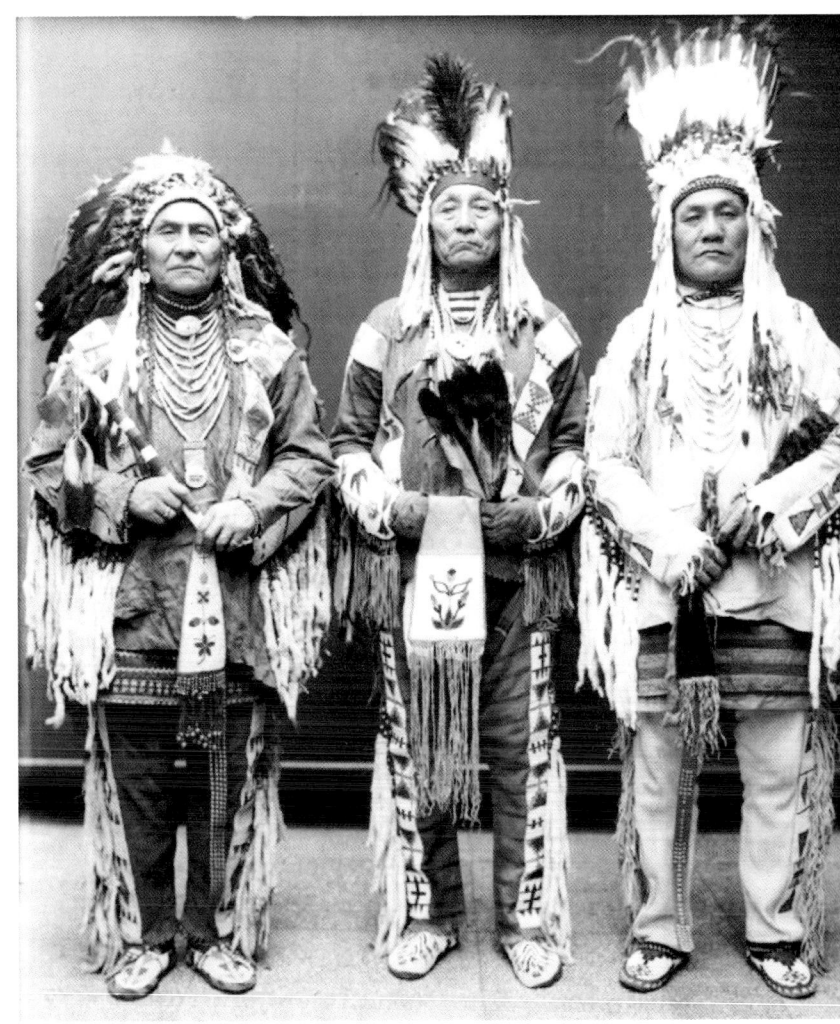

BLACKFEET CROWN BONNETS

In recent times the Blackfeet have not tied the wisps of horsehair to the tips of eagle feathers but simply used ordinary chewing gum. The gum is chewed until quite soft, then a small dab of it is wrapped around the end of the wisp of horsehair and twisted around it for half an inch in length. Then the tip of the eagle feather is laid on a flat hard surface and the horsehair and gum pressed right into the web of the end of the feather. The Indians say that this actually strengthens the end of the feather and does not make it brittle, as is the case when they are glued together, a problem that sometimes causes the tip to break off later, particularly if using turkey feathers. Then small circlets of buckskin, rabbit fur, ermine or frequently circular pieces of white table-oilcloth about $\frac{3}{16}$ in. are used to wrap spirally around the red flannel and bindings. The feather base fluffies are usually left white, but major plumes and crown feathers are sometimes missing. The brow bands are beaded in the overlay-stitch technique about 2 in. wide by 10 in. long and sometimes slightly curved to fit the arched front shape of the headdress. Often strings of seed pony beads hang from the bottom edge of the rosettes—these are called "bleeding hearts." Most bonnets consist of 30–36 feathers which can be imitation eagle feathers made using white turkey feathers 14 in long, lengthened as noted above, and often dyed brown-black, copying the markings of immature eagle feathers.

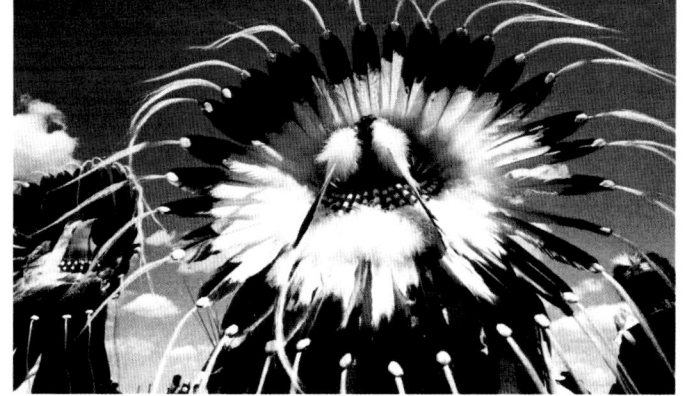

Above: Rear view of a Blackfoot crown bonnet, late twentieth century. Note the feather base red cloth wrapping with bands of white binding, horse or cow hair tips to each feather and fur tips.

Center and Below: Details of one of two eagle feather headdresses made by Blood Indian Jack Lowthorn in 1957 for presentation to Sir Douglas Bader during the Sun Dance at the Belly Buttes and his adoption into the Kainai Chief-tanship in Alberta. Note the method of attaching the feathers to the skull cap (an old cowboy hat) which have been wrapped with red cloth and bound diagonally with white tape. Blood (Blackfoot) bonnets of the twentieth century usually had strings of beads hanging from the edge of the beaded rosettes. The rear view shows how the buckskin thong passes through each quill about a one third distance from the base holding the feathers to the skullcap and each tip.

ROACHES

Porcupine hair or turkey beard head roaches were known throughout eastern North America, probably to augment a warrior's head in battle or during reenactments and warrior society dances. It became associated with the spread of the so-called Grass Dance during the nineteenth century and widely used by Plains Indians. Today it is standard head gear for male dancers at powwows.

Right: View of a roach from back showing a bone spreader carved with incised thunderbird design. Dave Sager

Below: Porcupine hair and deer hair roach, Sioux 1920s. The base is also porcupine hair. Eagle feathers held in a German silver spread which gives flare to the headdress. Buckskin thongs pass from the spreader through the base and tied under the chin. MGJ

Below right: Detail of a bone roach spreader which holds feathers and spreads or flares the porcupine hair. Also shows a porcupine quilled attachment. Dave Sager

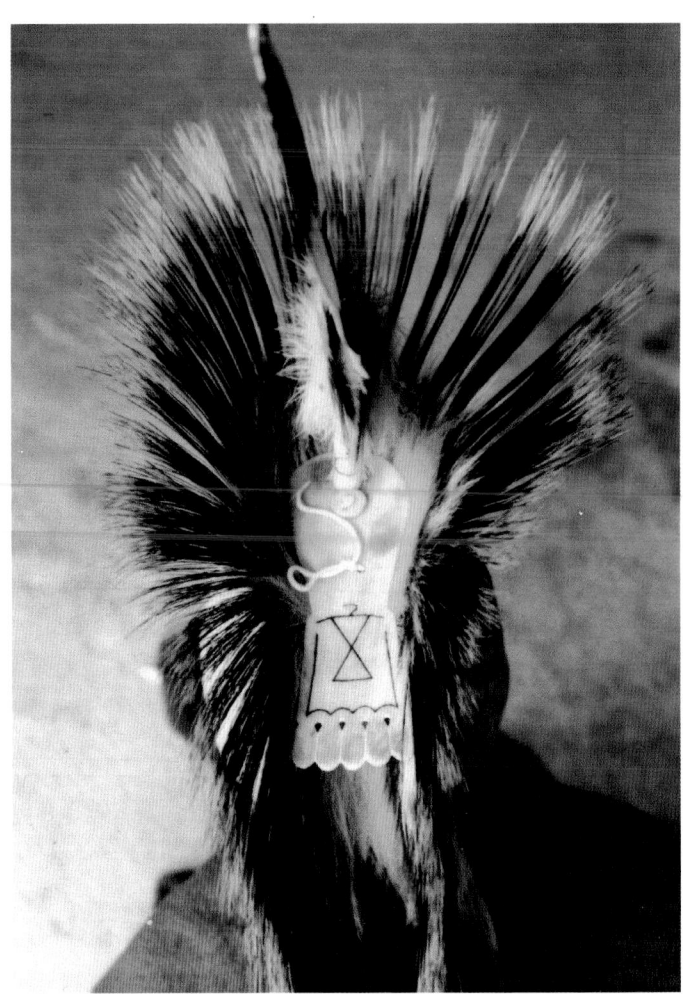

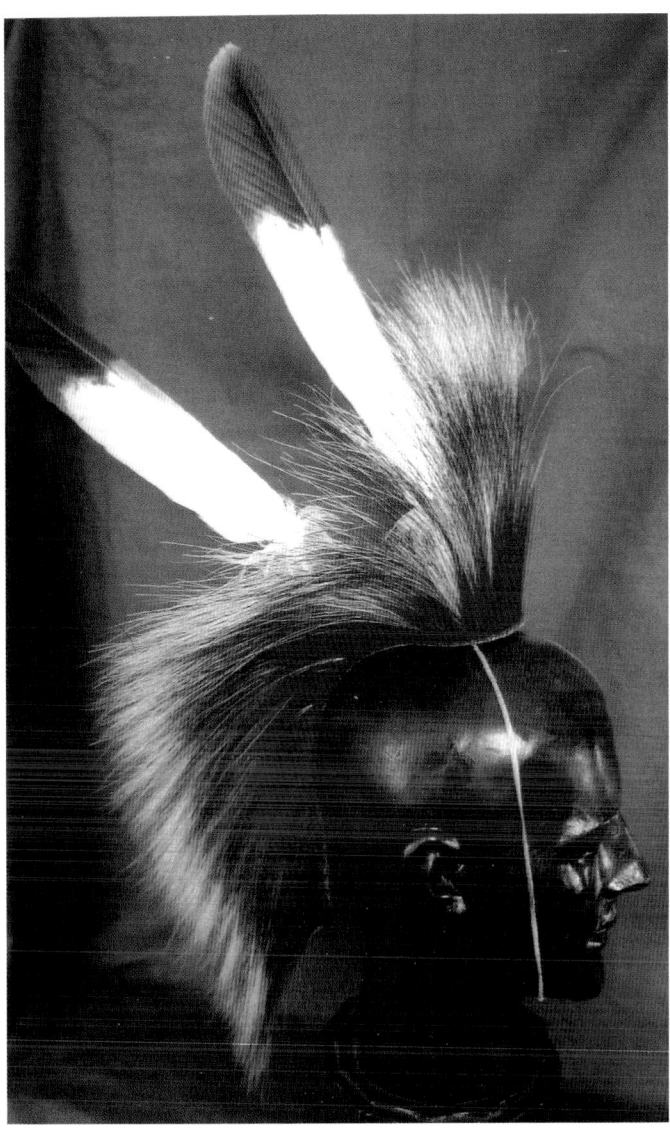

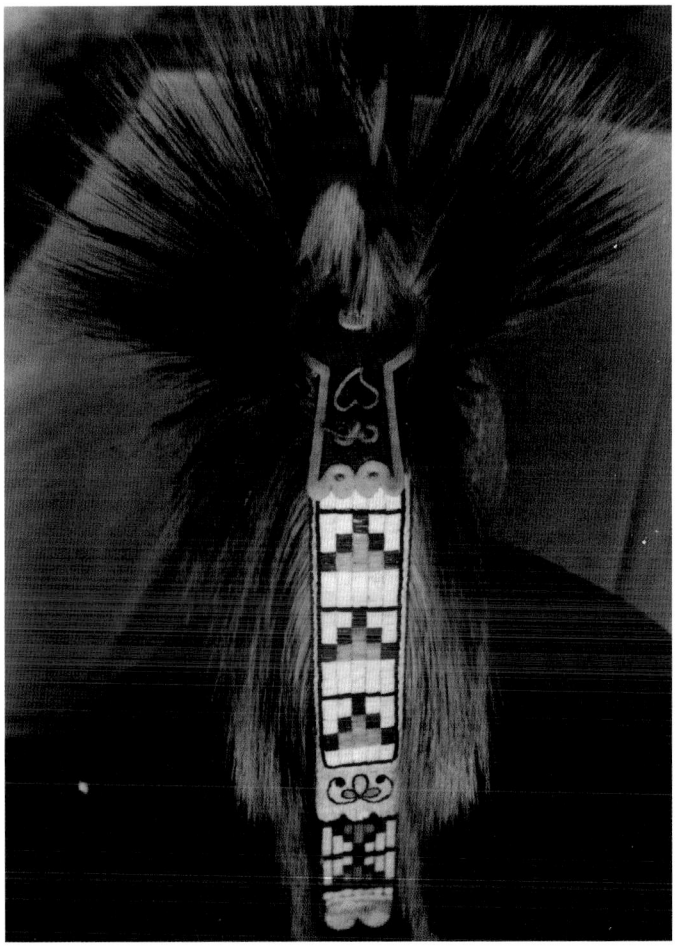

WOMEN'S DRESSES

In pre-European contact times the basic woman's dress for much of eastern North America was a knee- or calf-length wrap-around deer-hide skirt, usually with the edges meeting on the left thigh. It survived into the historic period and even to modern times with the addition of a square-cut blouse of calico or cloth, or one with a large ruffled round Bertha collar with the skirt extended to the ankles. The hide in the skirt itself was long ago replaced with European trade materials among most eastern and mid-western tribes, however. In aboriginal times in cold weather the upper body was wrapped with a skin or fur robe, or covered with a simple poncho.

Among the northern Woodland and Subarctic peoples, and the tribes bordering the Northern Plains, the so-called strap dress was used, a long slip-like skirt hung from the shoulders by straps and reaching to well below the knees. Sleeves were added to this in winter. During the eighteenth and early nineteenth centuries reports support the widespread use of the strap dress by Eastern (Santee) Sioux, Yankton Sioux, Blackfeet, and Ojibwa, and cloth versions where still made and worn by Plains Cree and Plains Ojibwa women in the early twentieth century for ceremonial dances.

Another style of woman's dress used at an early period was the side-fold dress, of which very few have survived; in fact it may have been a rare construction. This type of dress was made from one large hide which wrapped around the wearer and was sewn up on one

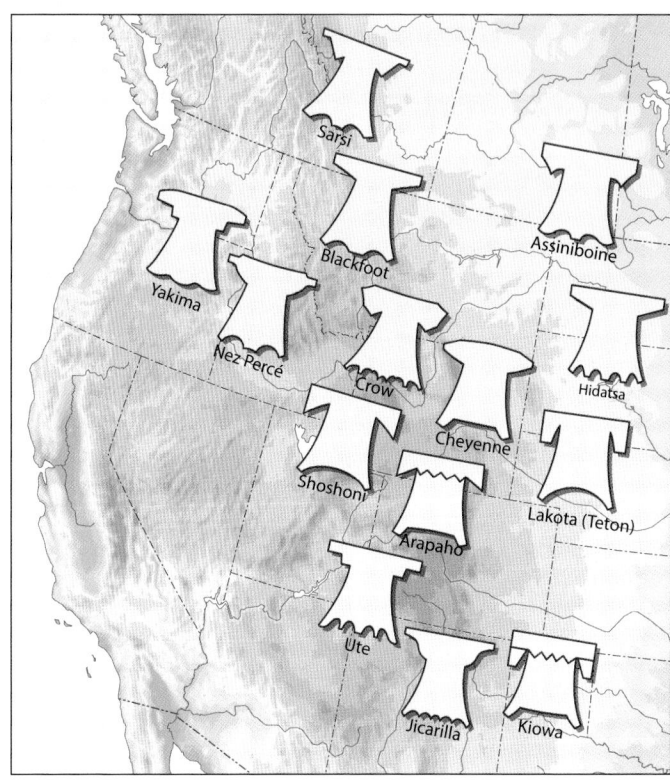

Above: Profiles of Plains and Plateau women's dresses based on specimens in the American Museum of Natural History, New York (after Wissler, 1915).

Below left: Plateau woman's dress from complete hides collected Coleville Reservation, Washington state.

Below: Woman's dress, Northern Plains, probably Sioux, c. 1850. Bighorn sheep or deerskin, elk teeth, pony beads, 42 inches. Persistent use of the "H" beaded design on shoulders suggests Siouan attribution or possibly Crow. Typical two-hide dress with fold-back tail. Sometimes an added narrow shoulder piece was added to facilitate this detail.
National Museum of the American Indian 5/3776

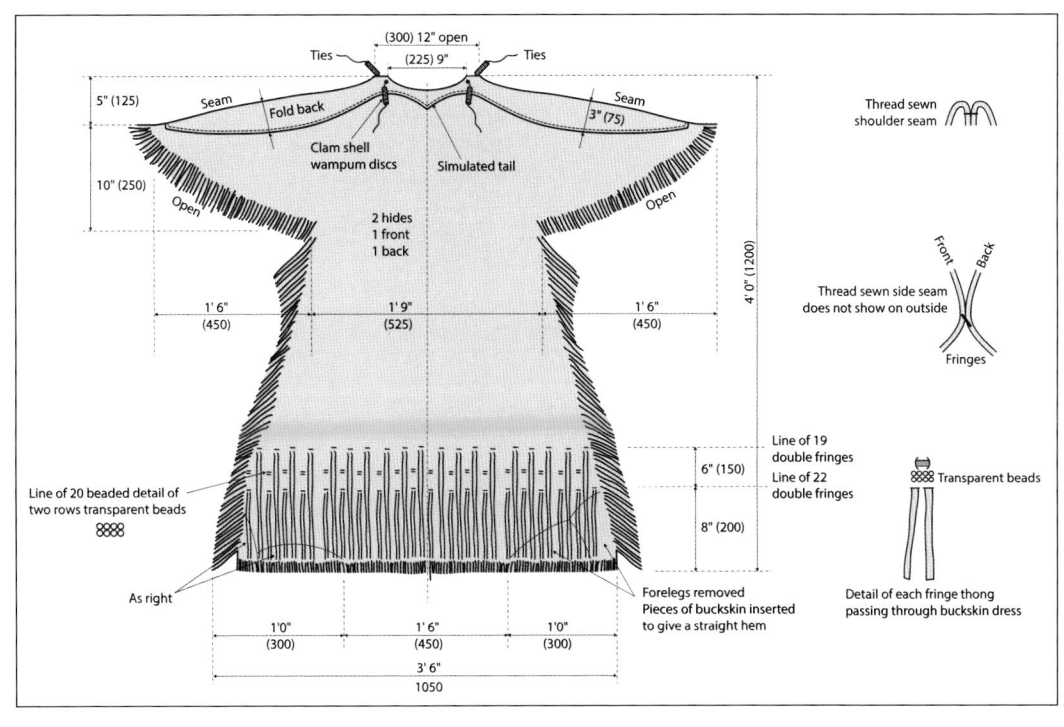

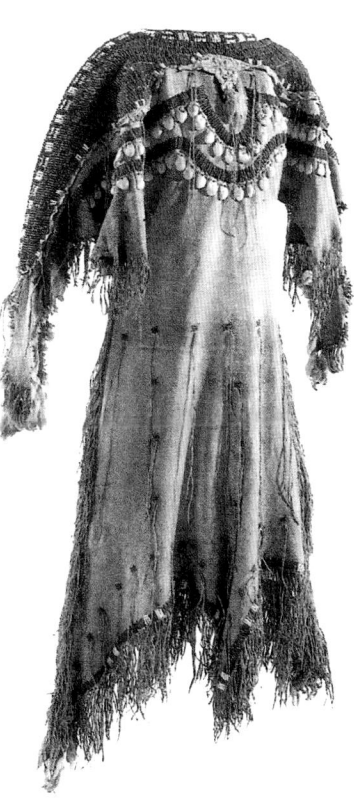

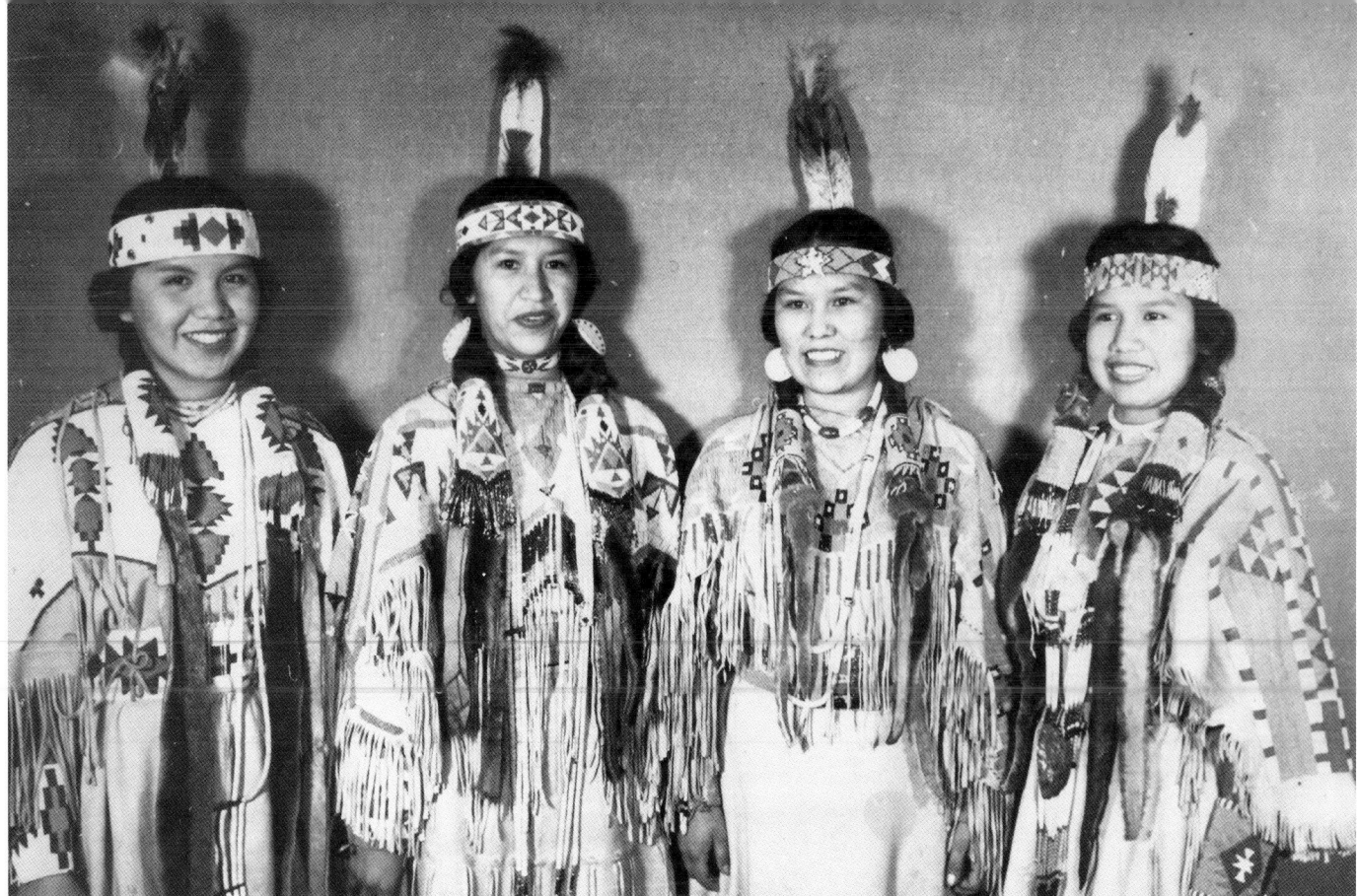

Above: Yakima girls, c. 1955. L–R—Yvonne Musmusto, Arlene Wesley, Jennet Wesley, Helen Miller. All are wearing beaded buckskin dresses.

Below: Diagram showing how a side-fold woman's skin dress was cut from a single large hide.

side (with one seam)—hence the name side-fold dress. The quilled buffalo heads worked in the decoration of one of the few extant examples suggest it was worn by a high-ranking woman whose function was to organize buffalo hunts. It is likely this construction derived from the use of robes and was restricted to the northeastern margins of the Plains, to the Cree, Eastern Sioux, and possibly Cheyenne, who once lived in a more easterly location than their later-nineteenth-century domain.

Women on both the Plains and Plateau wore the two-tail or two-skin dress, a garment constructed of two large elk or deer (or mountain sheep) hides, tail-up then folded down a few inches front and back to create a straight shoulder seam. The top edge of the skins with the haunches and tails formed an undulating contour across the upper front and back of the garment. In contrast to the solidly seed-beaded yokes of the mid-to-late nineteenth century Sioux dresses, Plateau beadworkers preferred the larger pony or necklace beads, massing them in two or three heavy waves of wide lazy-stitch banks across the front and back. In one of the two most popular Plateau configurations a broad band of solid color background is interrupted at intervals by bold vertical triangles or rectangular blocks of contrasting colors. The hides of female animals were preferred as the wearer was believed to acquire the unique properties of her sex. This construction was widely used by the Blackfeet and neighboring tribes, Crow, Mandan,

Hidatsa, and most Plateau tribes. Like the Plateau tribes, the Blackfeet also massed bands of lazy-stitch beadwork across the bodice, emphasizing the dip below the tail into a large U-shaped detail, which the Sioux and others considered a spiritual female device. Early nineteenth century dresses also used blue pony beads and elk teeth, and the Blackfeet often added symbolical ornaments of red and blue trade cloth representing a buffalo head or the animal's kidneys.

Perhaps because of the diminishing availability of large elk hides during the nineteenth century, the two-tail dress evolved into a three-hide form but maintained the general two-skin shape. The change was the introduction of a third skin to form the upper bodice with a seam approximating the bust line. Other revisions included the introduction of tapered sleeves, made separately and sewn closed. The classical Sioux dresses were made of this construction with the yoke area almost completely covered with seed-beaded lazy-stitch

ARTS & CRAFTS OF THE NATIVE AMERICAN TRIBES

Sleeves from back

b b1

a

a

b b1

c c1

c c1

Straps

c c1

Leggings

The skirt

d

Leggings

e

The skirt

d1

d d1

Sleeves from front-underside

b1 b

c1 c

Left: Patterns for a Plains Cree and Plains Ojibwa woman's strap dress (after Wissler 1915).

Below left: Construction details of Plains Indian women's dresses.

Opposite, left: General outlines of Eastern Woodland, Subarctic, and Plains women's dresses (after Douglas 1950 and 1951).

Opposite, right: Blackfoot dress, c. 1830. NMS

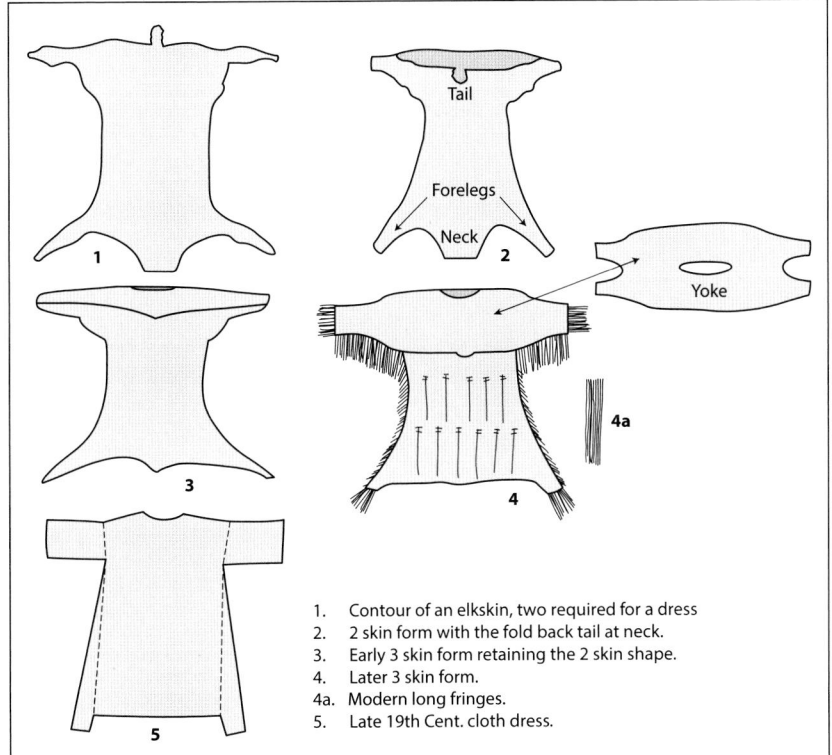

Tail

Forelegs

Neck

Yoke

1

2

3

4a

4

5

1. Contour of an elkskin, two required for a dress
2. 2 skin form with the fold back tail at neck.
3. Early 3 skin form retaining the 2 skin shape.
4. Later 3 skin form.
4a. Modern long fringes.
5. Late 19th Cent. cloth dress.

three-hide dress was made with two hides forming the front and back; the third was a cape-like section of yoke and sleeves sewn to the front and back below the bust. The forelegs of the animal skins were left intact on the dress or more recently emphasized by attachments or tabs decorated with tin cone jingles. The Southern Cheyenne usually had three horizontal beaded bands of lazy-stitch beadwork. At the seam between the yoke and skirt, buckskin tabs were cut and along the bottom edge a narrow wavy line of beadwork. Kiowa and Comanche dresses are characterized by conservative amounts of beadwork and heavy fringing. Modern dresses sometimes have extra long fringing which sways when the women are dancing.

During the early reservation period trade cloth was often used as a replacement for hides and women made loose semi-tailored "bat-winged" dresses in red or blue color. The Sioux would cover the top with rows of dentalium shells while Crow women would make sleeved red cloth dresses with contrasting colored insets at the neck and shoulders and rows of cowrie shells, elk teeth, or imitation elk teeth carved from bone.

In conjunction with dresses women wore moccasins and separate buckskin leggings to the knee height decorated with geometrical beadwork designs in lazy-stitch, leather belts with German silver conchos or brass tacks, huge necklaces of vertically strung hairpipes and beaded belt sets of knife case, whetstone

often in blue color background, with small designs symbolizing supernatural beings or female references worked in.

Southern Plains women made three-hide dresses, perhaps derived from the Apache and other southern tribes, who used a separate poncho (yoke) and skirt combination. The Jicarilla Apache dress was either long, plain and heavily fringed, or the yoke was separate and distinctively shaped along the bottom edges. The separate yoke was sometimes fully beaded. The classic

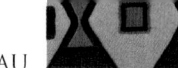

Eastern wrap-around skirt: buckskin later cloth

Wrap-around cloth skirt with added blouse

Wrap-around cloth skirt and blouse with ruffled collar

North Woodland and Subarctic strap dress

Strap dress with added cape, hood and sleeves for cold weather

Rare side-fold dress from the Northeastern Plains

Plateau and Plains two-skin dress with fold-back tail at neck

Skin dress with detachable yoke Apache occasionally Sioux

Three-skin Plains dress but retaining the two-skin shape

Three-skin Southern Plains dress, Southern Cheyenne, Kiowa etc

Three-skin ghost dance dress, Southern Arapaho

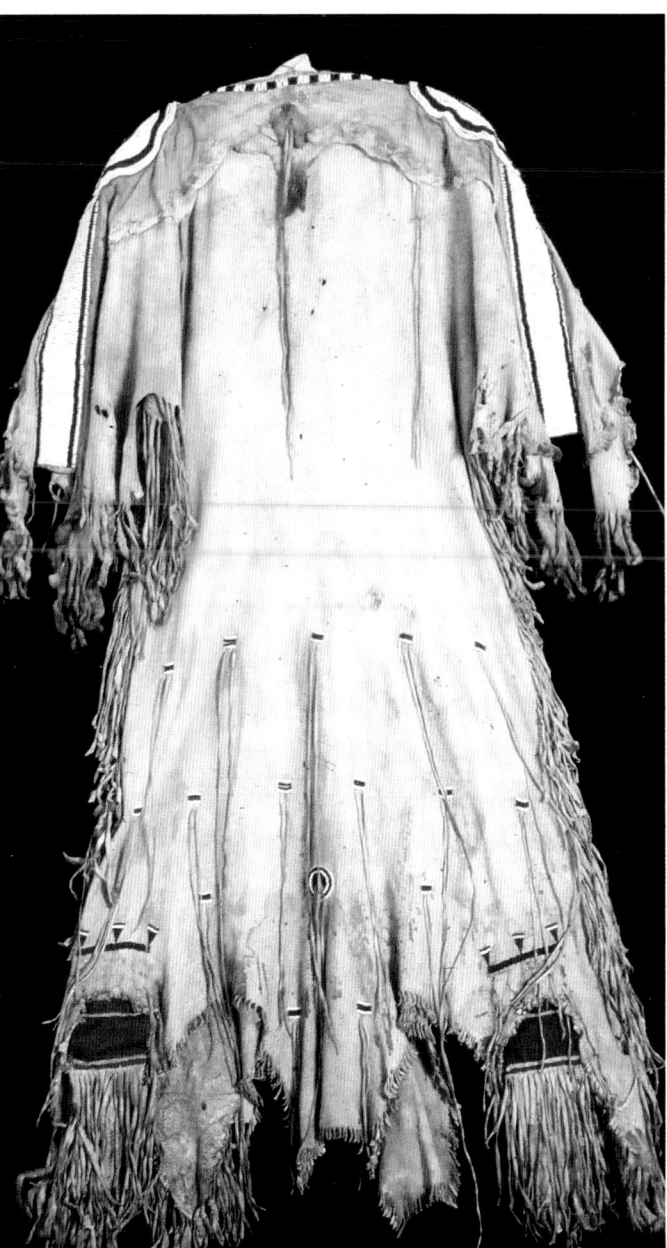

case, strick-a-light pouch, and awl case, all with matched beadwork. In modern times the Oklahoma tribes have produced cloth dresses of the old Woodland style decorated with cut and fold ribbonwork.

The sketch shows a woman's buckskin dress reportedly collected from the Grand Coulee area of Washington State which is at the southern end of the Colville Indian Reservation and likely made in that area. It has many of the characteristics of Plateau women's dresses of the late nineteenth and early twentieth centuries, although this dress is without the mass undulating beadwork often associated with Plateau specimens.

This plain dress allows for the easy record of its structural details. The dress is made from two complete deer hides, with one forming the front and the other the back. The dress is formed with the tail ends at the top so that the hind legs join at the shoulders except for the leg edges which are turned down in a foldback and sewn down to give a "yoke" effect front and back. The tails of the animals thus form a U-shaped detail at the center or in this case a V-shaped device forming the simulated tails. This yoke outline becomes the basis for the undulating beadwork decoration for many dresses. The shoulder seam is then sewn inside out along the top edge leaving an open slit for the head with buckskin ties to close when being worn. The skins are also sewn together along the sides but left open under the arms. The bottom edge has the forelegs removed and inset pieces of buckskin are sewn in to make a straight hem which is a detail which distinguishes Intermontane (Plateau) dresses from those of the Blackfeet who used a similar pattern but without the insets.

Another detail which often signifies a Plateau style are the two parallel rows of buckskin fringing usually in the lower half of the dress often with a small beaded detail where the thong passes through the hide and terminating at the hem line. The hem, front and back are fringed about 1¾ in., the sides 7 in., and about 1¾ in. under the arms which are in this case left open. The thread sewn seams are likely sewn inside out as there are no stitches visible from the outside except at the stressed shoulder seam. Wissler (1915) pictures a near structurally identical dress from the Yakima (Yakama) and Her Many Horses (2007) reported a number of two-hide dresses of this type.

SHIELDS, KNIFE CASES, BOW AND ARROW CASES

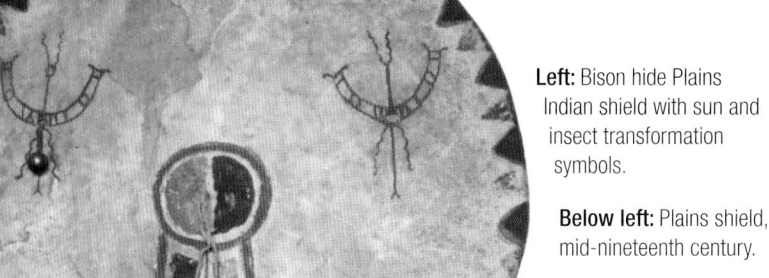

Shield-bearing pedestrian warriors are seen on rock-art sites on the northwestern Plains and Great Basin that seem to predate the appearance of the horse. Early Spanish explorers described large buffalo-hide shields able to cover the whole body as being in use on the southern Plains. Shields were progressively reduced in size for use on horseback and generally held on the left arm to cover the upper body, leaving hands free to hold weapons. Heavy rawhide shields could stop an arrow and deflect or deaden the ball of a muzzle-loading flintlock. Bows of considerable length were popular in eastern North America and were also used by Plains tribes but for use on horseback they became reduced in size too. Long bows and lances of pre-horse days were replaced with the bow-lance—more a warrior society emblem than an actual weapon during intertribal mounted warfare. Bison-hide shields were painted with complex religious, dreamed, and mythological concepts to provide protection during battle. Designs associated with sky and earth powers,

Left: Bison hide Plains Indian shield with sun and insect transformation symbols.

Below left: Plains shield, mid-nineteenth century.

Below center: Northern Plains rawhide knife sheath with beadwork.

Below right: Bow and arrow case with shoulder strap, possibly Cheyenne. 1850.

Opposite, above: Little Crow, Santee Sioux leader of the Indians in the War of 1862, wearing elaborate headdress and holding a quilled pipestem. Painting by Frank B. Mayer, c. 1851.

Opposite, center: A calumet, a wooden stem decorated with eagle feathers, each quilled; used for ceremonial occasions.

Opposite, below: Catlinite pipe bowl with lead inlay, Sioux c. 1870.

animal powers, and transformation images were used. Buckskin covers, also painted, were occasionally used to house the shield when not in use, and were also sometimes exposed to the sun for "power" during tribal ceremonials. Light buckskin and canvas painted representations of shields were used during the late nineteenth century and today male Grass Dancers often hold similar facsimiles at powwows. Bows and arrows were sometimes kept in combined quiver and bow cases of mountain-lion skin. Old rawhide knife sheaths were often quilled and later ones beaded.

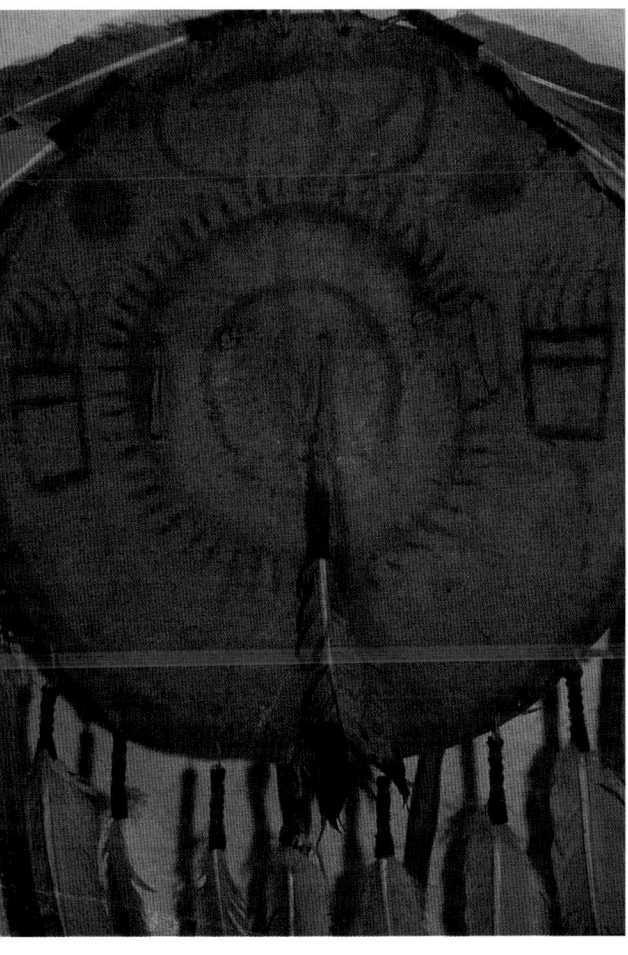

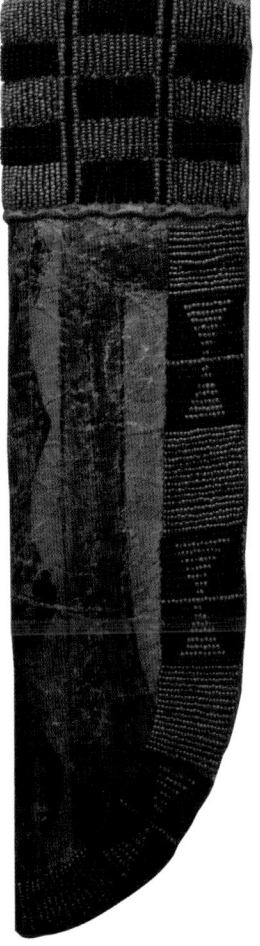

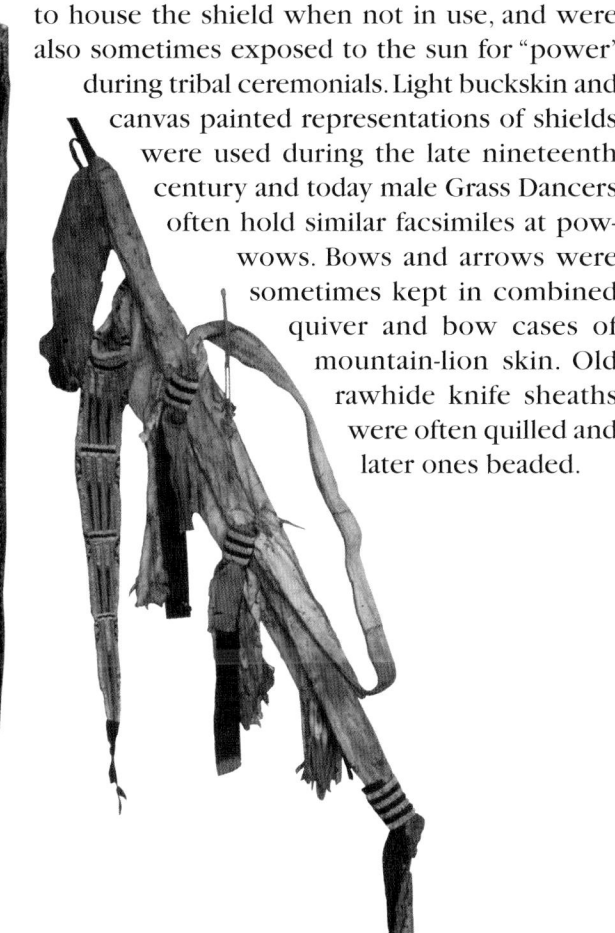

PIPES

The ritual use of tobacco was widespread in North America, particularly among the civilizations east of the Mississippi before European contact. The use of ceremonial pipes seems to have diffused along the Mississippi to the Great Lakes, Woodlands and village Plains tribes probably before A.D. 1500. Among the Siouan and Caddoan tribes of the eastern Plains the ceremonial pipe complex seems to have grafted onto the "Calumet" ceremony. Calumets were highly decorated wands of feathers, with animal parts including heads and necks of birds. The calumet (from Norman-French), originally a tube pipe, reed, or flute, or especially a shepherd's pipe, now became one or two highly symbolic shafts of reed or wood with or without a pipe bowl, representing the male and female deities. These are usually perforated for a pathway for the breath or smoke, and heavily decorated.

The Calumet dances were performed for war or for peace and alliances. On the High Plains ceremonial smoking helped meditation, vision experience and confidence for hunting and warfare, and purification for ceremonial participation. Smoking lifted participants' thoughts to the spirits above, the smoke providing a path between earth and sky. Among the Sioux the pipe was used in all their seven rites to influence the supernatural powers and many pipes were thus sacred. Many pipe bowls were made of a red stone "catlinite" quarried in present-day Minnesota at the so-called "pipestone quarry," which was often considered neutral ground for warring tribes. The stems were usually ash, oak or hickory, the soft pith removed by pushing a hot wire through, alternatively the wood was split a channel scraped out, and then reglued. Among the High Plains tribes quillwork, carving, burned, or incised designs decorated the stems. During ceremonies the mouthpiece was offered to the four cardinal points, earth and sky—to the Sioux the pipe was wakan, holy or sacred. Used thus the pipe is communion, eucharist, and altar together.

The Original Spread of the "Peace Pipe" Custom

If the first path of diffusion of the Calumet dance led up the Ohio River to the Iroquois through a tribal origression such as Pawnee–Iowa–Fox–Illinois–Miami, diffusion can also be inferred from a northern Mississippi center hypothetically located at the Pipestone quarry near the Falls of St. Anthony where surrounding hostile tribes met on neutral ground to mine catlinite. The

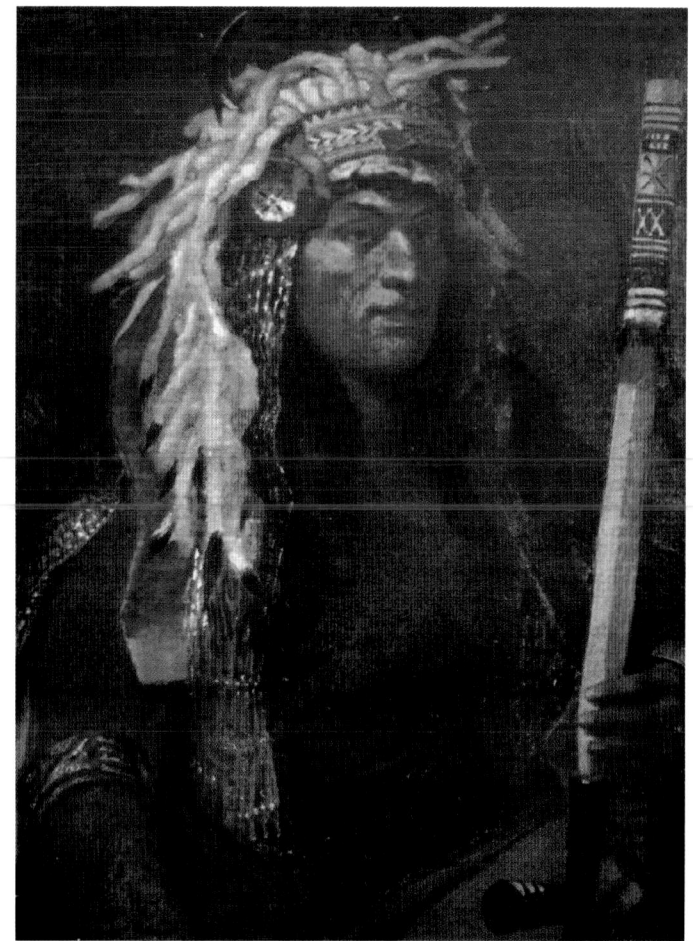

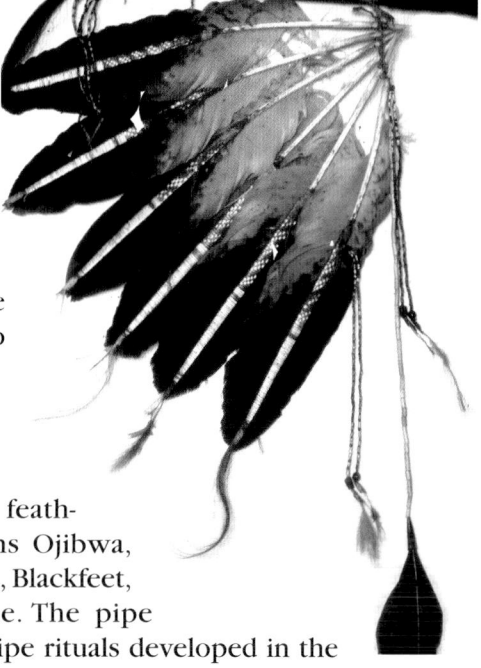

quarry may be called the focus of the "peace pipe" concept. To the east of it lay Green Bay, the rendezvous of the Far Indians—certain bands of the Ojibwa and Ottawa who were agents in spreading the use of the peace pipe eastward to the Iroquois between 1680 and 1725. From the same center the western shift spread the catlinite pipe and feathered stem to the Plains Ojibwa, Assiniboine, Plains Cree, Blackfeet, and possibly Cheyenne. The pipe bundle and medicine pipe rituals developed in the northern Plains area. The Pawnee "Hako" and the medicine pipe bundle ceremonies are distinct rituals and prevail on the southern and northern Plains respectively. The Sioux had both ceremonies. Diffusional influences from the Hako area also passed overland from tribe to tribe as far as the Ottawa above the Straits of Mackinac and to the Sioux.

PLAINS AND PLATEAU INDIAN SADDLES

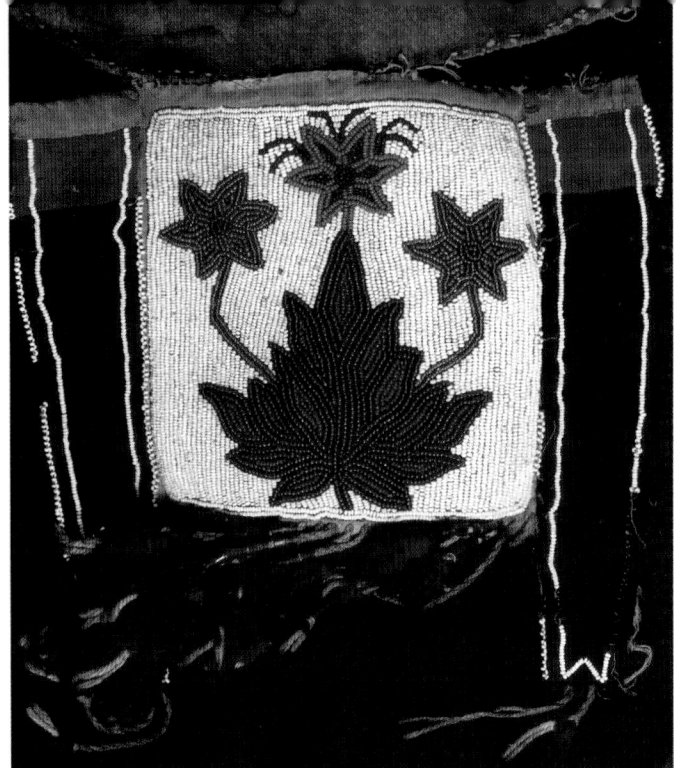

No Plains Indian had seen the modern horse before Coronado's exploration of the southern Plains in 1541, and a century passed before they began to acquire them. Horses appear to have been traded north, or spread north in wild herds, generally in two major routes. One route may have led via the Rocky Mountains to the Plateau tribes; or they may have moved directly north through the vast Plains from tribe to tribe. The Blackfeet probably obtained their first horses from the Plateau, while the Sioux, moving west from pressure by the armed Ojibwa, probably got them about 1720. The Cree and Assiniboine acquired theirs perhaps by 1740. The grass-fed Indian pony became somewhat reduced in size from that of its Spanish and North African ancestors, the Indians becoming skilled bare-backed

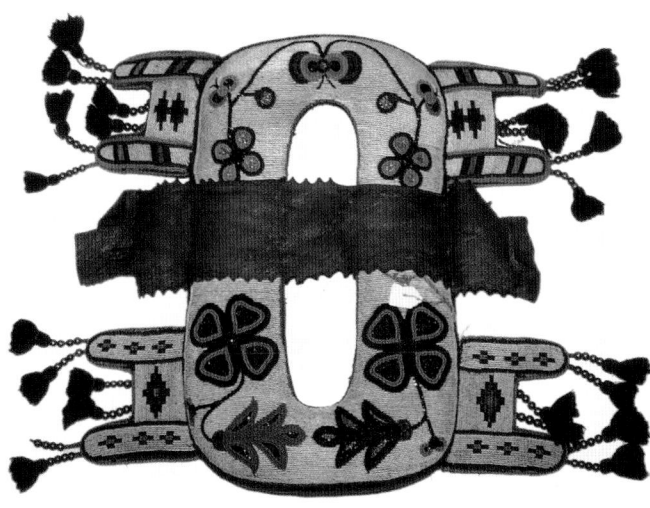

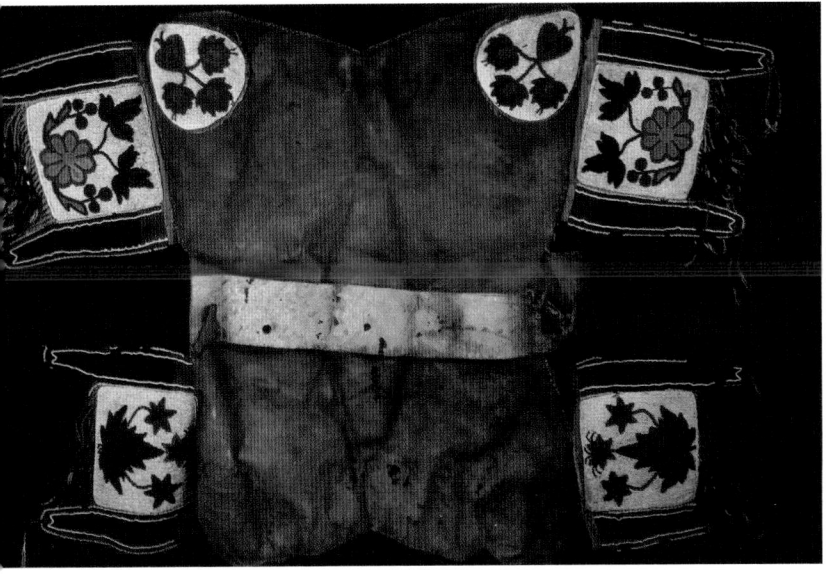

horsemen adapting the animal for hunting buffalo from horseback with bows and arrows. These tough, sturdy, and long-winded horses became indispensable to the nomadic and warrior culture that flourished until the new United States pushed its borders west.

There were three major types of Plains Indian saddles, each based on Spanish models: the "pad saddle," a soft pillow stuffed with animal hair; the "woman's saddle" composed of a wooden frame with a characteristic high pommel and cantle, all covered with rawhide which is cut, fitted, sewn, and shrunk to hold the saddle firmly together; and the third the "pack-saddle" with a low curved pommel and cantle. All types were held to the horse by girths and employed stirrups.

Pad saddles collected before 1850 are usually decorated with geometric or floral designs in porcupine quillwork near the four corners of the pads. Later these designs were in either geometric beadwork or more commonly floral patterns; sometimes beadwork completely covered the saddle. The Crow added beaded attachments to their women's saddles. For parades, decorated saddle blankets, saddle bags, bridles, cruppers, masks, headstalls, and martingales were used and can still be seen at the famous Crow Fair held every summer in August on their reservation in Montana.

Top and Bottom: Pad saddles of a type usually attributed to the Plains Cree, Plains Ojibwa and Métis of the Northern Plains of the late nineteenth century and widely traded. Note the floral beaded areas of the corners and hanging attachments. Formerly Chandler Institute, Mission, South Dakota and by kind permission of Mr Ian West, UK.

Center: Pad saddle collected on the Day Star Reserve Saskatchewan, c. 1900. Note the floral and geometric beadwork and the open center noted on several examples. MS

PARFLECHE CASES

Storage parfleche cases were folded envelopes of raw-hide. The large envelope parfleches were used to store foods, clothes and religious paraphernalia. They were usually made in pairs with painted designs on the end panels which when folded became the front. There were holes in the end panels and sides through which buckskin thongs were threaded to hold the case closed. Parfleche cases were made from rawhide obtained from the skin of large animals such as buffalo, elk, moose, deer, antelope, and even horse.

The rawhide was made in the following manner. After the skin was removed from the carcass it was fleshed and washed and then the green hide was staked out. The hide was then rubbed with a mineral substance, dehaired, and sized on the flesh side. While wet the rawhide could be stretched into a variety of shapes which when dry become rigid.

A number of forms were produced including tubular feather bonnet containers, women's utility bags (usually small and rectangular), and large storage envelopes with folded ends and sides. All were decorated with painting or incising in predominantly geometric designs.

Until the arrival of commercial paints from traders the pigments used to color parfleche cases came from natural minerals and vegetable materials, such as lignite, ochre, copper ores, maple bark, cactus, moss, and lichen. Major colors were yellow, red, greens, blues, rose, violet, black (limited), but rarely orange. Some Crow and Intermontane cases were incised rather than painted, particularly early ones. Parfleche cases were made by all Plains and Plateau tribes and by some Prairie groups such as the Sac and Fox, who also produced box-shaped

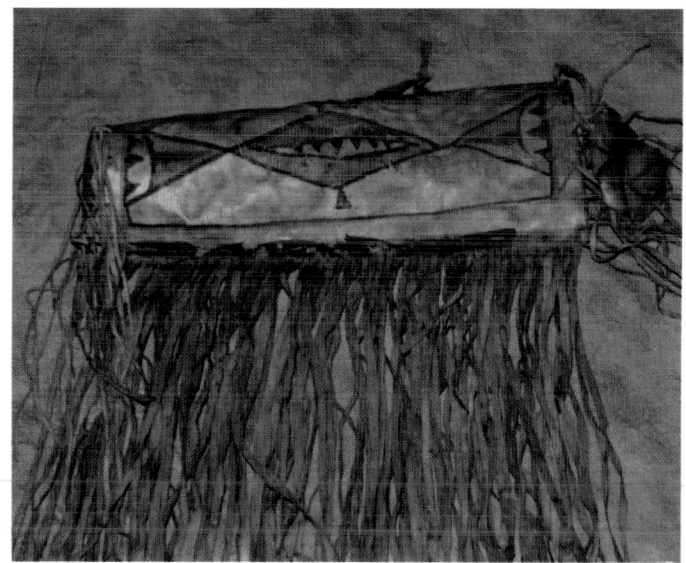

Above: Blackfoot tubular war bonnet case.

Below: Blackfoot case with designs showing wide borders.

Bottom: Folding a parfleche.

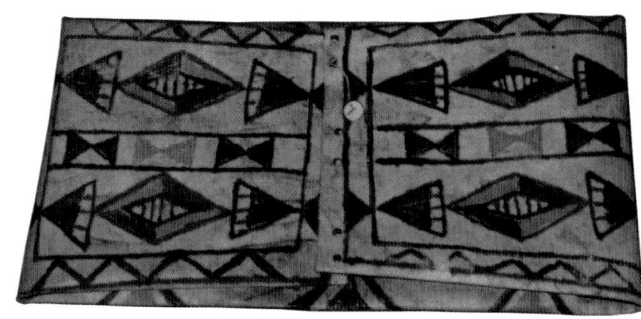

cases. Some distinguishing tribal characteristics are as follows:

Arapaho: Blue popular, block designs, major design fields split on main axis into two, three or four panels, narrow borders, absence of horizontal lines.

Cheyenne: Delicate small designs, narrow solid-color borders, carried through at right angles.

Blackfeet: Often incorprate large curved symmetrical designs and wide borders.

Sioux: Wide borders with a central band of similar design dividing the major design field into two.

Plateau tribes: Heavy bold simple geometric figures of squares and triangles in strong colors.

Crow and Plateau Intermontane tribes: Early incised examples.

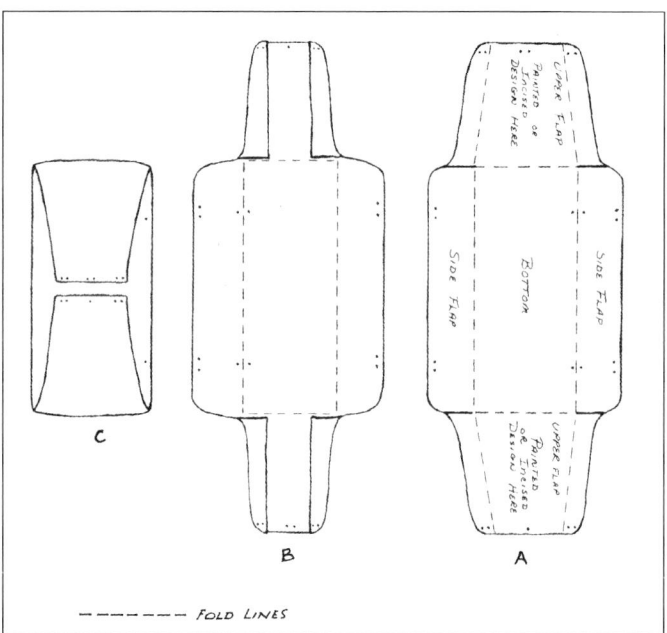

FOLD LINES

PLAINS INDIAN TIPIS

The importance of the buffalo to all Plains peoples cannot be underestimated. It provided food, clothing and shelter. From its hide they made robes, lines, cinches, and shields; its sinew gave them thread; its paunch carried water and meat could be boiled in it; ribs and dorsal spines gave knives; shoulder blades made hoes, and arrowpoints; horns provided cups, spoons, and ladles. From its hair they braided rope; from its brain they tanned deer hides to make them soft. For shelter, the buffalo provided the skins to make a tipi cover, which was pieced together with as many as twenty hides, roughly on plan in the form of a near semicircle. The near destruction of the buffalo effectively ended the traditional Plains culture after 1870. When buffalo hides were no longer available, Indians began to use canvas duck obtained from the U.S. Army as a substitute and this material is still employed today for tipis made as temporary shelters at powwows or peyote meetings. The use of tipis generally has spread far beyond the Plains.

Early forms of tipis were relatively small in size before the arrival of the horse, which allowed the transportation of larger, heavier covers and longer poles. The basic construction was fairly constant throughout the Plains. Covers were hoisted onto a tilted cone of straight, slim, peeled poles (usually about twenty poles of lodgepole pine, cedar, or spruce) slotted into a foundation of three or four poles. Three-pole foundations were used by the Cheyenne, Arapaho, all branches

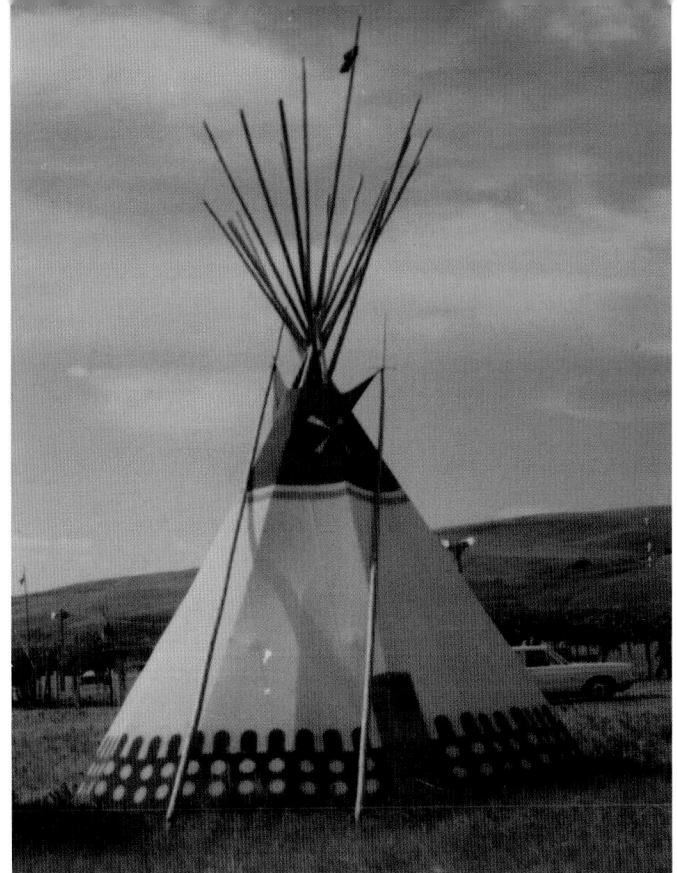

of the Sioux, Assiniboine, Stoney, Gros Ventre, Plains Cree, Mandan, Arikara, Kiowa, Kiowa-Apache, Pawnee, Ponca, Oto, and Wichita. Four-pole foundations were used by the three Blackfeet tribes (North Blackfeet also called Siksika, Piegan, and Blood), Sarsi, Crow, Shoshoni, Omaha, Comanche Hidatsa, Kutenai, Flathead (Salish), and Nez Perce. Poles were collected and prepared by a man and his wife. Foundation poles were measured and tied together over the cover spread on the ground, then hoisted up and the remaining poles slotted into the crotches. In the three-pole foundation, a tripod, one pole faced east and formed a door pole (on the south side of the door). In erecting the four-pole foundation the poles were set on the ground in a rectangle, two front and two back. When erected the front and back poles were sloped differently so that the tipi remained lower at the rear when completed and the front poles appeared as a "swallowtail" below the apex of the remaining poles.

No lodge was a perfect cone, but was rather a tilted cone, the back being steeper than the front to brace against the prevailing westerly winds. The entrance was a doorway which faced east towards the rising sun. The cover was hoisted onto the frame with a single lifting pole, pulled around each side and laced together at the front with slender wooden lacings pins, and the bottom

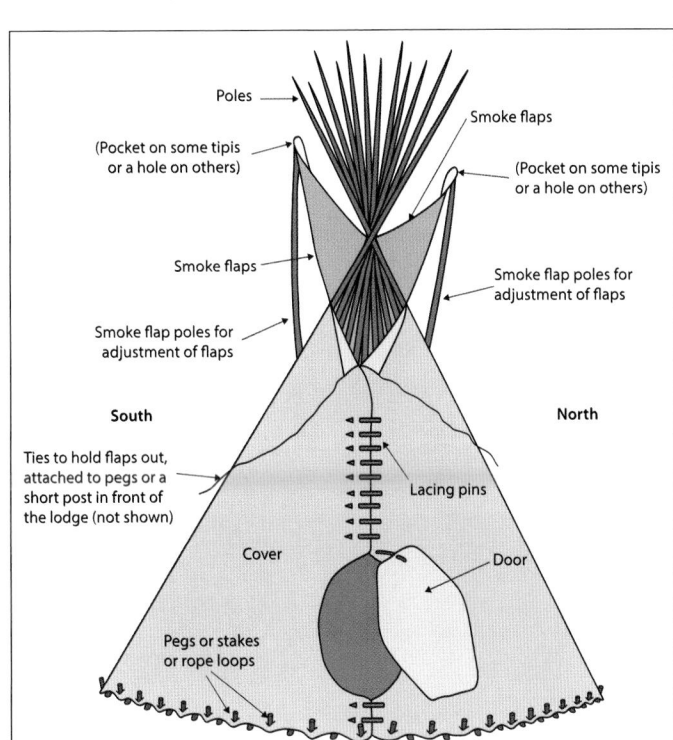

Left: Components of the tipi (after Ewers 1978).

Above: Blackfoot painted tipi, c. 1950. The black band with white discs represents stars in the night sky. The red "spirit door" is directly at the back. The cross below the smoke hole represents a butterfly or moth or insect that "transformed" itself. Note external smoke flap poles.

Above right: Tipis at Banff Indian Days, Alberta, c.1950.

Right: Typical details for a modern Sioux-style canvas tipi cover.

edge staked down. The lifting pole slotted in directly at the rear opposite the door position.

The cover included two "ears" or extensions, which formed the smoke flaps. These were held by two external poles, which, when adjusted to the prevailing wind direction, helped to drag the smoke through the gap left at the top of the lodge. In recent times some tribes had their own profiles or shapes for smoke flaps. A liner about 5 or 6 feet high, originally skin, but now also canvas, ran around the inside of the poles. A fireplace of stones was made centrally, somewhat towards the rear. Family beds were usually on the south side of the lodge and those of guests on the north. At the rear were placed backrests of slender rods, also weapons and medicine bundles. Alternatively Blackfeet men sat on the north side and women on the south.

The Blackfeet and Kiowa (originally also from the north) are noted for their painted tipis. Each lodge and its paintings were the property of the owner, and usually

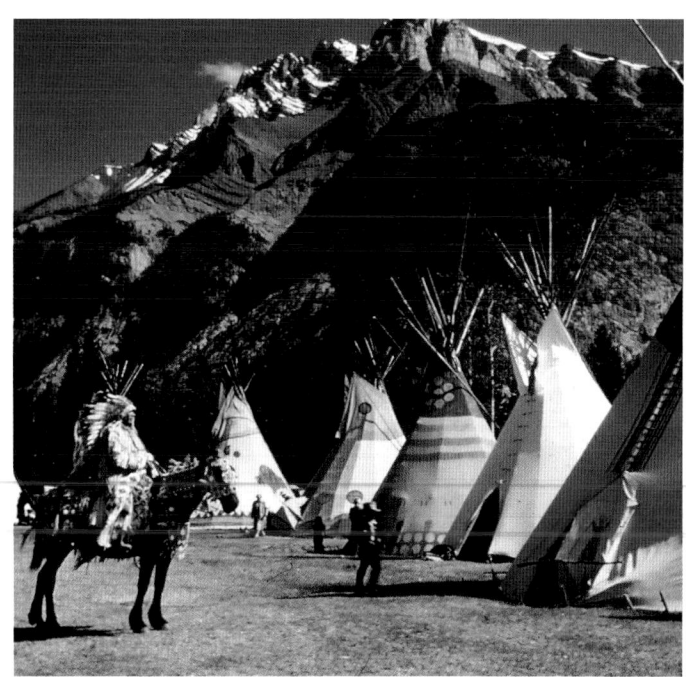

Detail A

3/8″ hole buttonholed or similar

tie
3″ slit hem all round
top side (u/s right)

9″ 9″ 12″
3/4″
1½″

note these dimensions to be ½″ and 2″ on right-hand size

Detail B

One piece like this to each corner

5½″
2½″
7″
fold and sew

turned right-side out and added to lap to form pocket (sewn on topside)

15′3/16″ cord
15′3/16″ cord

Tie tape 1″ wide 2′ long stitched topside

Detail B

1′0″

Detail A

10′6″ 7′0″ 7′0″ 10′6″

3/8″ hem all along top edge

half circle line

Radius point

tie tape 1″ wide 2′ long stitched u/s

half circle line

Nom 3′0″

1′0″ 3′0″ 3″ 9″ 9″ 9″ 9″ 9″ 9″ 12″
1½″ 2″ 1½″
12″
seam
1½″ apart
3/8″ dia holes buttonholed

9″ x 12″ reinforced u/s 2 thickness

Gusset

3′0″

g
c
e f
f
ff = 6″
f e = 3′0″
c f = 9″
f g = 9″

Gusset

3/8″ hem all along top edge

9″ x 12″ reinforced u/s 2 thickness

spacing of holes as left

12″ x 24″ triangular reinforced two thicknesses u/s

Nom 6′0″ or ⅔ Ø

u/s = underside

Canvas cover 8oz or 10oz white unwrot canvas. Weather side to view

section

seam

18′0″ radius

Nom 6′0″ or ⅔ Ø

seam

hem necessary

seam

Detail C

Nom 3′0″

Peg ties 3/16″ cord or tape 1″ wide attached (sewn underside) at 2′6″ spaces all around base

Detail C

Canvas Cover
Seams to good heavy thread neat and tidy

TYPICAL DETAILS FOR A MODERN SIOUX-STYLE CANVAS TIPI COVER

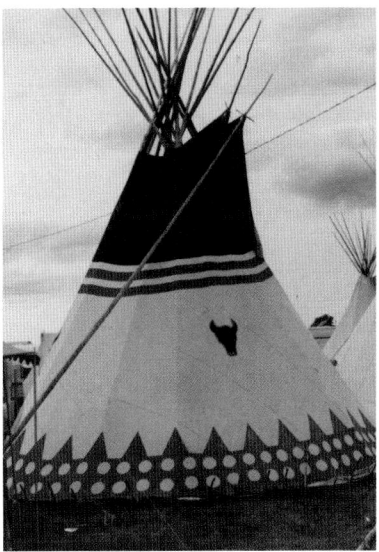 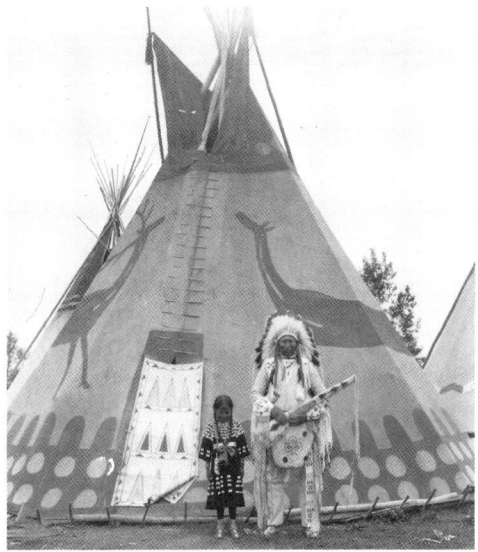 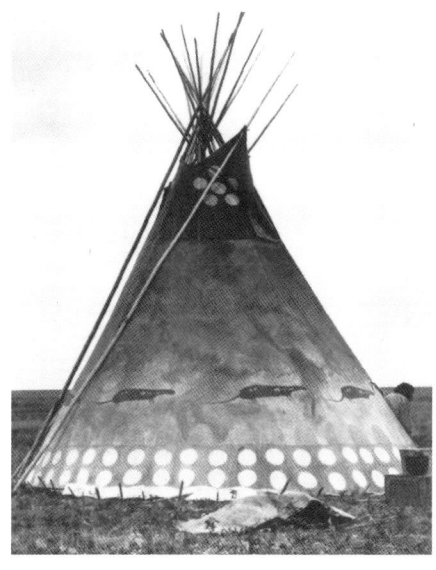

derived from dreams. The painted cover, like a medicine bundle, could only be transferred along with its "power" by the appropriate ceremony. Many Blackfeet tipis were popularly named from their distinctive design, often an animal, such as the Black Buffalo Lodge, the Yellow Painted Buffalo Lodge, the Otter Lodge and so forth. The buffalo lodges had a buffalo bull painted across the front and a cow at the rear. When new covers were required the designs again had to be transferred with ceremony. Many covers had a black (or red) horizontal band about 18 in. deep with a double row of white discs representing fallen stars at night. Above the band were painted pointed or oval figures which represented mountains, occasionally with cattail rushes between. Painted life-lines of animals had highlighted eyes, knees, tongues, genitals, kidneys, horns, hearts, and tails. At the back below the smoke hole was often painted a cross, which is usually considered an important "transformation" symbol like a butterfly or moth, and other similar details may represent the Morning Star. Smoke flaps were often painted with spots representing the Pleiades (on the north flap) and the Great Bear (on the south flap). Directly at the back a false "medicine door" was often depicted.

The importance of symbolism in the decoration of objects cannot be understated. It is usually associated with the acquisition of supernatural power from such sources as the sun or powerful underwater or sky spirits. Energy transfer processes can be represented by a thunderbird-claw motif as used by the Cree or Blackfeet, or by the horns of the buffalo motif. Caterpillars and tadpoles, and spiders and insects generally, were considered to be imbued with mysterious powers to transform into new beings or create weather changes. The moth was connected with whirlwind power, which Crazy Horse, a leader of the Sioux, supposedly used effectively at the Battle of the Little Big Horn in 1876. These creatures could be painted on tipi covers, robes, or shields, quilled or beaded as symbols on clothes or moccasins, or carved on wooden effigies and pipe-stems.

Left: Blackfoot painted tipi with red band and white discs, the red conical figures represent mountains. Note the cross sticks on the external smoke flap poles to hold flap in position. Photograph by Louis Jull, Browning, Montana, 1983.

Middle: Front of a Blackfoot painted tipi with elk design, c. 1910. Pollard photograph.

Right: An Otter tipi. Note the "swallowtail" effect of the two poles coming out at the rear of the apex of the lodge. McClintock photograph.

NORTHERN PLAINS STONE CLUBS

The stone-headed clubs described here date between 1870 and 1910, and are from the northern Plains. It is probable that these clubs and their like were not used in conflict as might appear, but rather as ceremonial or costume accessories. This type of club seems to be the more recent variety of the old hammer club which had practical use but little decoration. The early hammer club was often merely a piece of stone held in the grip of a hard rawhide or split wood loop which in turn was bound to a shaft, with sinew or buckskin applied wet.

The later clubs, described here, are of two varieties. One, the loop version, is constructed similarly to the old hammer club, and the second is the drilled version, where the stone head has a hole into which the wooden shaft is pushed. The loop in the second type is simply a light buckskin or cloth strap over the stone; this is often decorated with beadwork. On all these clubs the shaft is usually covered with buckskin and decorated with beadwork, quillwork, horsehair, or even paint.

It is not likely that these later types, often mistakenly called "war clubs," were actually weapons; in fact many are light and quite fragile, useless as real weapons. Consider too the date of manufacture, late nineteenth century—at this period stone headed war clubs would

Figs. 1 to 3 Early Stone Clubs.

Fig. 4 Stone-headed club, possibly Sioux, c. 1880.

Fig. 5 A club of the "drilled" type, with a buckskin cover over the head extending to a fringe two inches below the head. The shaft is covered with white buckskin. Manitoba Cree, c. 1900.

Fig. 1

Rawhide loop over stone head, sometimes stone is grooved.

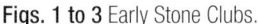

Loop

Groove

Fig. 2

Loop over a raised center band on head

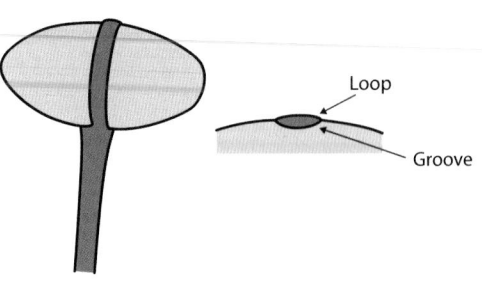

The loop of rawhide or buckskin bound to handle with sinew. Buckskin sheath covers binding.

Fig. 3

Buckskin or cloth cover forming loop without rawhide under. The shaft is fixed to the head by means of a hole drilled in stone.

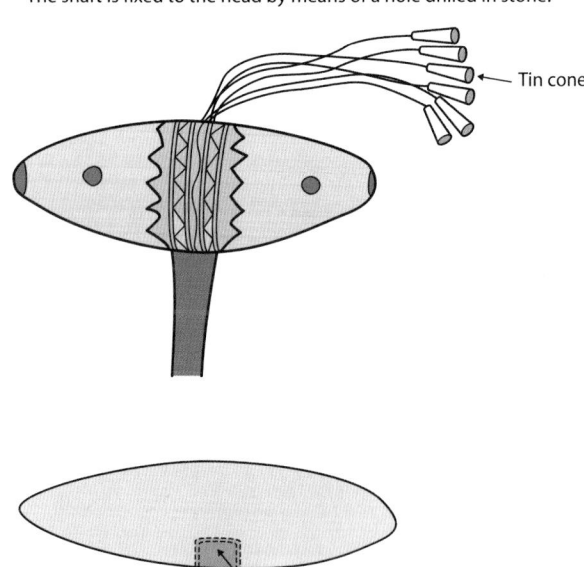

Tin cones

Shaft fixed into hole

Bird quill wrapping

Eagle feather

Black blocks

8" of beadwork on buckskin

Smooth grey stone

Green beadwork

Buckskin over a cloth loop

Fig. 4

Fringe of white buckskin about 1"

Grey plaited horse hair

Shaft 24" long

White horse hair

3½" of beadwork on buckskin

Buckskin

Fig. 5

6½" 3½" grey smooth stone

Detail of beadwork over loop

Thin white buckskin

Curly or wavy pink horsehair

End of Shaft

scarcely be effective weapons. The term "ceremonial club" is therefore more appropriate than "war club" for the majority of surviving stone-head clubs.

Clubs made before about 1870 may well have been intended to be used as weapons. There is an old stone-head club in the American Museum in Britain, formerly from the Wellcome Collection, which is likely to be 200 years old, and is the true loop type, the shaft having pony beads wrapped around. This club was probably a weapon and it can be noted that the stone is rounded at the ends, whereas many late nineteenth-century clubs seem to taper almost to a point.

These clubs had a wide distribution from New Mexico to Canada and well into the Plateau area. The later types, for the tourist trade, were made in many cases by the various Sioux groups, but some also by the Western Apache; these latter usually have solid-beaded handles. Many clubs were expertly made and decorated, and were used as costume accessories by many Northern Plains tribes. A clue to their age is whether the head has a drilled shaft hole or merely a groove (for the heavy rawhide or wooden loop) in the stone to hold the head in place. The drilled shaft hole indicates a more recent example. The highly symmetrical stone heads have led some people to believe the heads were made by whites and traded to the Indians. In fact many Indians were engaged in making them with steel drills, files, and other European tools.

Generally the more interesting type, and the older, is the type where the loop makes the fixture to the shaft, often helped by a slight groove in the stone. A strong "wet-hide" loop is fixed tightly around the stone head in the groove and sinew bound to the shaft. The drilled-hole version is a modification with a simple method of

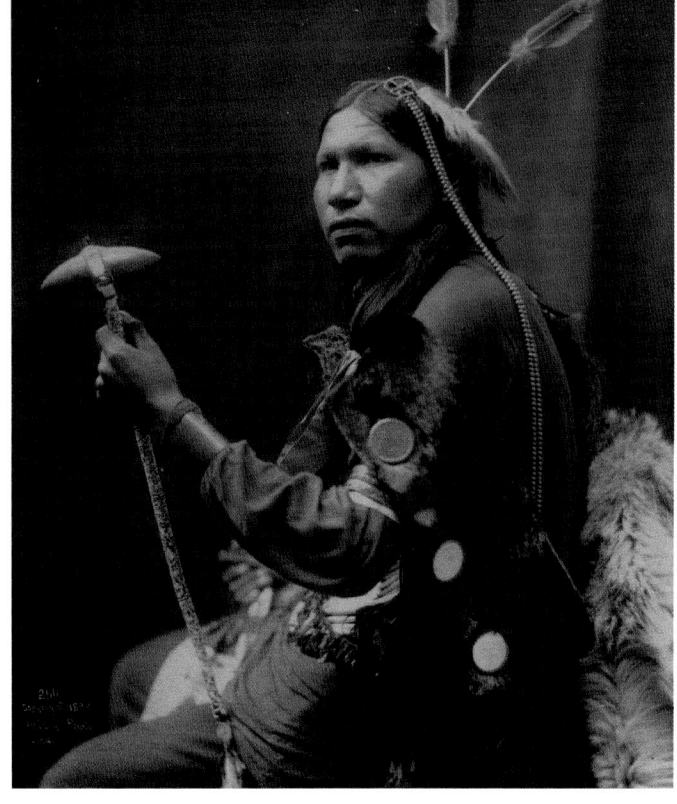

Afraid of Hawk, Western Sioux (Oglala), 1899. He holds a stone-headed club with beaded handle. Heyn photograph, Omaha

fixing the shaft to the head. Large numbers of this type have been made for the "curio trade." One variation of the original type has a raised section on the head, rather than a groove, onto which a tight rawhide loop is fixed.

Fig. 4. shows a club of the "drilled" variety. An 8 in. buckskin tube covers the shaft and is extended over the stone head. This area is totally beaded in green seed beads, with black blocks over the head and intermittent bands of black, amber, and red beads; there is also some yellow edge beading over the loop. The center area is plaited horsehair, and the shaft end is again beaded over a buckskin tube which extends beyond the wooden

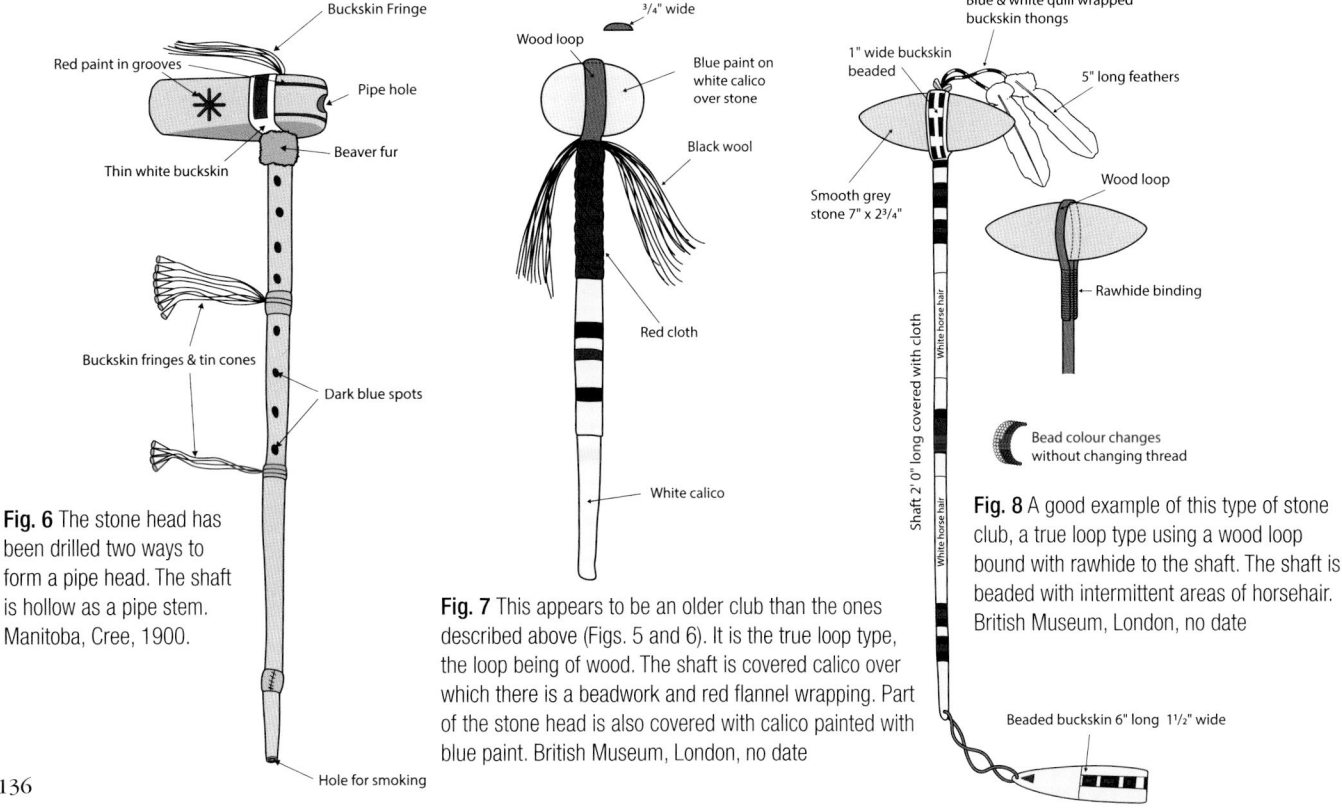

Fig. 6 The stone head has been drilled two ways to form a pipe head. The shaft is hollow as a pipe stem. Manitoba, Cree, 1900.

Buckskin Fringe
Red paint in grooves
Pipe hole
Thin white buckskin
Beaver fur
Buckskin fringes & tin cones
Dark blue spots
Hole for smoking

Fig. 7 This appears to be an older club than the ones described above (Figs. 5 and 6). It is the true loop type, the loop being of wood. The shaft is covered calico over which there is a beadwork and red flannel wrapping. Part of the stone head is also covered with calico painted with blue paint. British Museum, London, no date

¾" wide
Wood loop
Blue paint on white calico over stone
Black wool
Red cloth
White calico

Fig. 8 A good example of this type of stone club, a true loop type using a wood loop bound with rawhide to the shaft. The shaft is beaded with intermittent areas of horsehair. British Museum, London, no date

Blue & white quill wrapped buckskin thongs
1" wide buckskin beaded
5" long feathers
Smooth grey stone 7" x 2¾"
Wood loop
Rawhide binding
Shaft 2' 0" long covered with cloth
White horse hair
Bead colour changes without changing thread
Beaded buckskin 6" long 1½" wide

shaft and has horsehair attached. The tribe of origin is unknown (possibly Sioux), but the date is c. 1880.

Comparisons of the details of stone-headed clubs in various collections shows that the construction was always the same, whether the loop or drilled varieties. The types of stone used has been confusing. Flint, carborundum, and quartz have been tentatively mentioned, many heads are of light gray stone, and some are of steatite, shales, and even granites. The Oglala Sioux used a light clay content sedimentary stone found near the town of White Clay, Nebraska.

Above: Blackfoot buckskin guncase, with beaded butt and muzzle ends, c. 1890. MGJ

Below: Beaded muzzle end of a Crow or Intermontane area guncase. WR

NORTHERN PLAINS AND PLATEAU GUNCASES

About the same time as the arrival of the horse to the northern Plains, c. 1730, the tribes were also acquiring guns from white traders via Cree and Ojibwa middlemen. Guns also played a significant role in the change of lifestyle to a nomadic warrior culture dependent on the bison. The earliest mention of firearms in Indian hands was with the Iroquois c. 1630, and purpose-made guns for Indian use were widely traded by the Hudson's Bay Company to the western tribes by the 1770s. These were the famous "Northwest" guns, most of which had barrel lengths of about 56 inches. During the nineteenth century barrel lengths were shortened by the horse-using Plains Indians to 30, 36, and 42 inches.

Although the majority of guncases were produced in the northern parts of the continent, there are also a number of examples shown in early photographs of Apache, Navajo, Kiowa, and other southern tribes. In the north gun scabbards seem to have had a widespread distribution among such tribes as the Plains Cree, Assiniboine-Stoney, Blackfeet, Sarsi, Crow, and Sioux, and among the Plateau tribes, Nez Perce, Flathead, and Umatilla.

One of the earliest documented guncases is a Northern Athabascan specimen collected by Dr John Rae's expedition to northern Canada in 1854. Many guncases have been collected from various Northern Athabascan tribes such as the Kutchin and Slavey, and a number also from the Northwest Coast people. The Blackfeet received guns from the Cree as early as 1728 and the explorer David Thompson reported that their guns were kept in leather cases. The popularity of guncases in the north may be due in part to the continuance of trade until the late nineteenth century of percussion "trade rifles." These were prized by Indians, Métis, and whites as ideal for hunting. After the Civil War, surplus rifles and pistols were distributed from trading posts in

large quantities to the Sioux, Cheyenne, and other central and southern Plains tribes, so that because of their availability they were not so highly prized and keeping them in good condition was not so important. It should be noted that the Sioux did not produce as many guncases as the Blackfeet during the later decades of the nineteenth century. The lengths of some northern cases show that they were made for the long-barrel trade gun.

There may be some merit in ascertaining the type and date of guns used by the dimensions of the cases. However, Indians often altered their guns, particularly the "trade guns," to carbine length and to make fowling pieces by shortening the barrels. This presents many problems and consequently it is probably better to examine the guncases independently from the guns they held and date the cases from the beadwork and quillwork decoration known to be popular among a tribe at a particular date.

Although Crow guncases of the 1880s are often considered the most handsome, the Blackfeet made guncases until recent times and consequently more of these have survived in museums and collections. Because of the considerable decoration on guncases they appear to have had a dual purpose of functional use and artistic display. No matter how they now appear—on the wall of a Cree log cabin, hanging in a Crow tipi, or held proudly by Blackfeet at the Calgary Stampede—they are one of the most handsome of Indian artifacts.

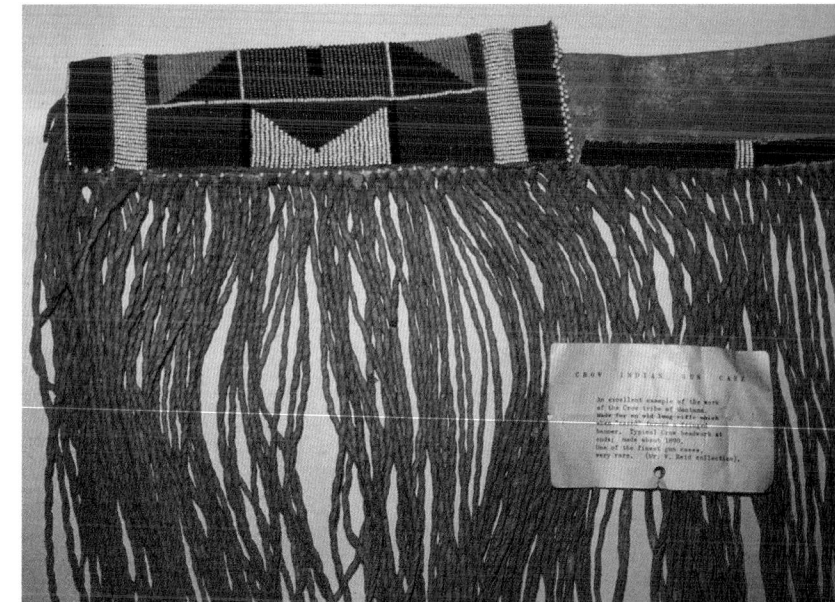

4. SOUTHEASTERN NATIONS

The map shows Indian tribes of the Southeast with a key to linguistic families.

INDIAN TRIBES OF THE SOUTHEAST
Key to linguistic families

- Muskogian
- Siouan
- Timucuan
- Iroquoian

Map labels: Manahoac, Moneton ? Linguist affiliation in doubt, Saponi, Nahyssan, Monacan, Tutelo, Occaneechi, Shoccoree, Eno-Shakori, Sissipahaw, Yadkin, Keyauwee, Woccon, Sugeree, Waxhaw, Cheraw, Cape Fear, Catawba, Wateree, Congaree, Winyaw, Saluda c.1750 (Algonkian), Pedee, Waccamaw, Santee, Sewee, Kaskinampo, Yuchi, Cherokee, Cheraw, Chickasaw, Koasati, Tali, Muskogee or Creek, Lower Creek, Cusabo, Stono, Edisto, Taposa, Chakchiuma, Ibitoupa, Tiou, Napochi, Upper Creek, Tuskegee, Okmulgee, Oconee, Mikasuki, Guale, Tunica, Yazoo, Koroa, Alabama, Chiaha, Yamasee, Orp (Siouan), Muklasa, Appalachicola, Hitchiti, Tamathli, Taensa, Choctaw, Icafui, Tacataruru, Natchez, Grigra, Tohomé, Sawokli, Yui, Mobile, Chatot, Aguacaleyquen, Saturiwa, Caddo or Kadohadacho, Natchitoches, Avoyel, Houma, Acolapissa, Pascagoula, Osochi, Adia, Oklelousa, Biloxi (Siouan), Pensacola, Apalachee, Yustaga, Utina, Freshwater Indians, Caddoan, Hasinia, Eyeish, Tangipahoa, Potano, Acuera, Ocali, Bidai, Opelousa, Quinipissa, Ocale, Atakapa, Bayogoula, Washa, Chawasha, Timucua, Chitimacha, Urrip, Surruque, Seminole (18th/19th C) inc. Mikasuki-Hitchiti, Akokisa, Tocobaga, aracoxi, Mococo, Ais, Pohoy, Guacata, Calusa, Jeaga, Tekesta

INTRODUCTION

There is no reason to believe that the Southeastern tribal formations that became known to the seventeenth- and eighteenth-century European colonists were not descended from the prehistoric Mound Builder peoples. However, the results of the earliest contacts in the sixteenth century had drastically changed native cultures and severely reduced the native population due to the introduction of European diseases. Following the de Soto expedition of 1539–40 the Gulf and Florida tribes had largely disappeared through the combined efforts of missionaries and the effects of the diseases they introduced. Only among the Natchez did Mississippian culture survive late enough to be viewed by French settlers. The reformed interior tribes became known as the historic Creek, Choctaw, Chickasaw, and Seminole

(all Muskogian speakers), and the Cherokee, a people distantly related by language to the Iroquois of the Northeast but with surprisingly little else in common.

The Cherokee reflected Southeastern culture with similarities in their green corn festivals, sacred ark and new fire rites, religious regard for the sun, divining crystals, priesthood, animal spirits, theory of disease and medical practices, but no medicine societies as in the north. These tribes became drawn into political alliances with European powers and into their trading patterns, eventually adopting many white influences. Mixed-blood leaders combined traditional dress with the calico shirts and frock-coats of European-styled clothing, together with native front-seamed leggings, garters, moccasins, sashes, and bandolier bags. Women wore cotton fabric dresses with ribbonwork. In order to retain their domain the Cherokee nation adopted a system of constitutional government modeled on the newly independent United States, a process which ultimately failed with the removal of these nations to

Indian Territory (Oklahoma) in the 1830s and 1840s, a process known to the Cherokee as "The Trail of Tears," which involved the loss of a quarter of their numbers. These nations became known as the "Five Civilized Tribes," resembling southern whites in their activities as farmers, landowners, and even slave owners, but whose independence finally closed at the end of the Civil War. However, a portion of the Seminole (Creek emigrants to Florida) continued to remain in the Everglades despite three wars with the Americans, retaining distinctive dress and developing their own form of "patchwork" clothing.

We do have some knowledge of original native village life from the drawings made by John White at the village of Secotan, in present-day North Carolina, in 1587. What he recorded probably reflects both Northeastern and Southeastern cultures. He shows warriors' and women's dress, farming, ritual, and ceremonials involving "striking the war post." These priceless images remain in the British Museum.

Above right: Creek Indian, c.1830. Painted by Lukas Vischer. Shows typical hybrid dress prior to removal to Indian Territory from Alabama.

Below: Mistipee a Creek by Charles Bird King, 1826. He wears a bandolier bag with a V-shaped flap characteristic of Creek examples.

Below right: Tahchee or Dutch, a Cherokee chief, who moved west before the main body of the tribe (The Trail of Tears 1838–39) in order to lead a lifestyle free of white influences. From a lithograph used in "The Indian Tribes of North America," McKenney and Hall, John Grant, edition, Edinburgh 1933–34.

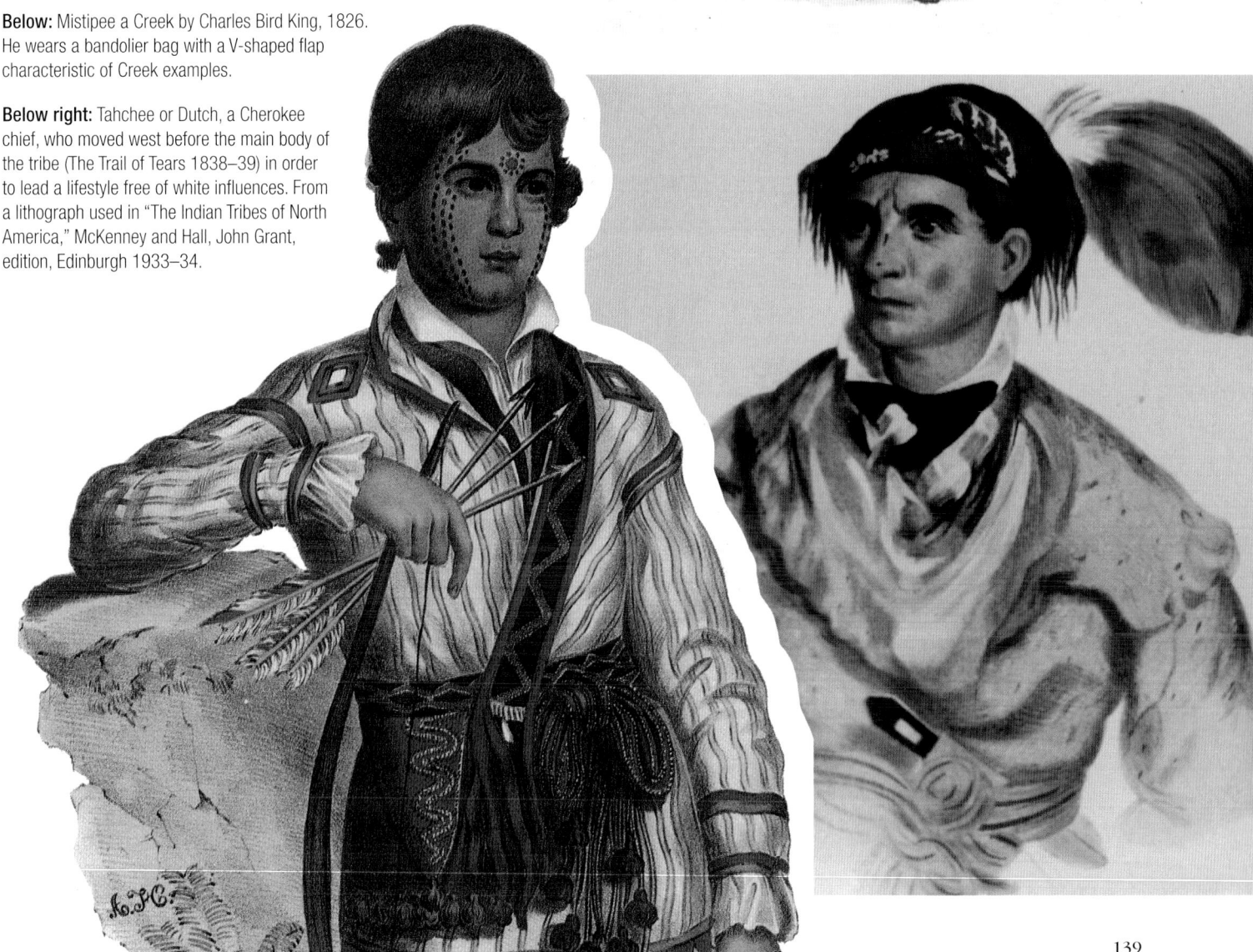

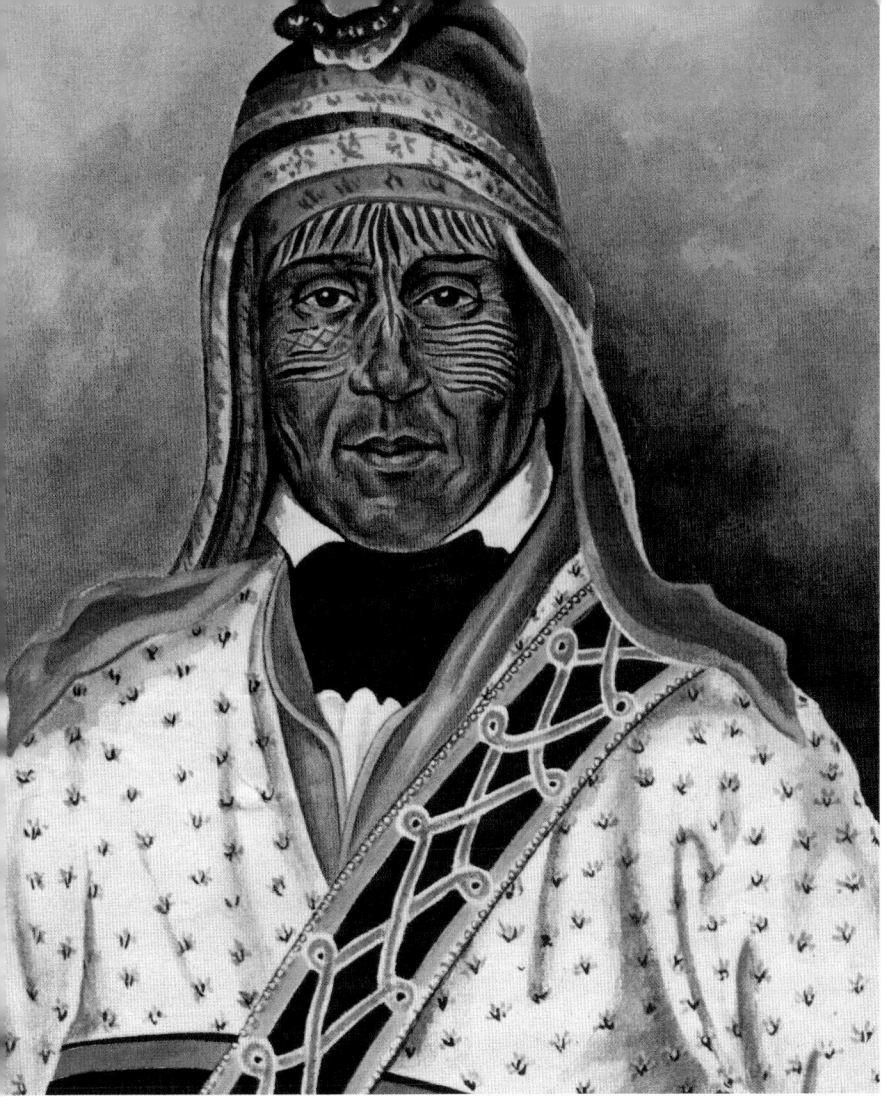

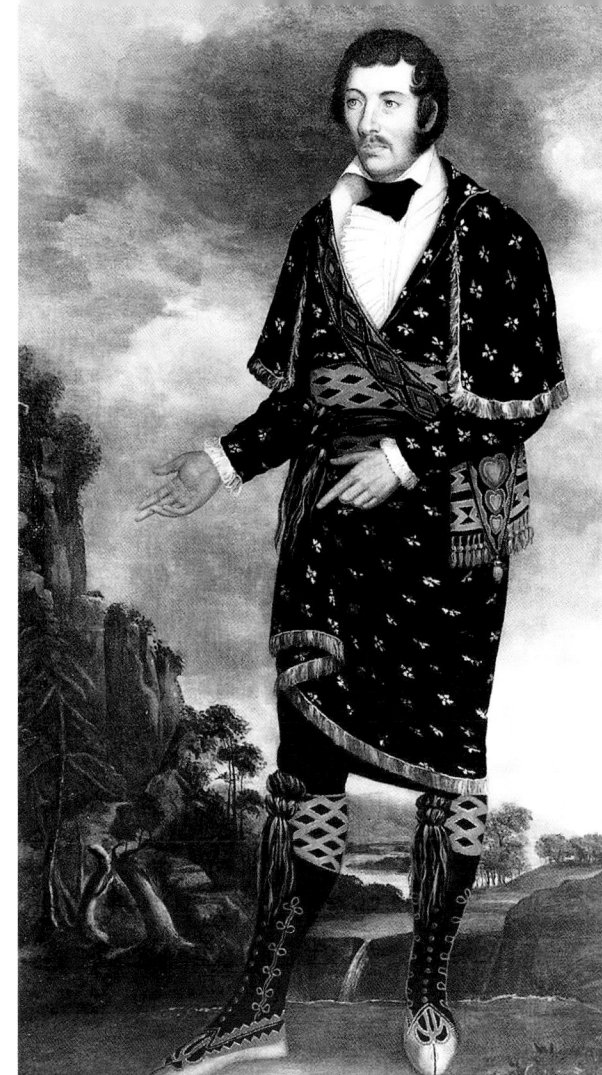

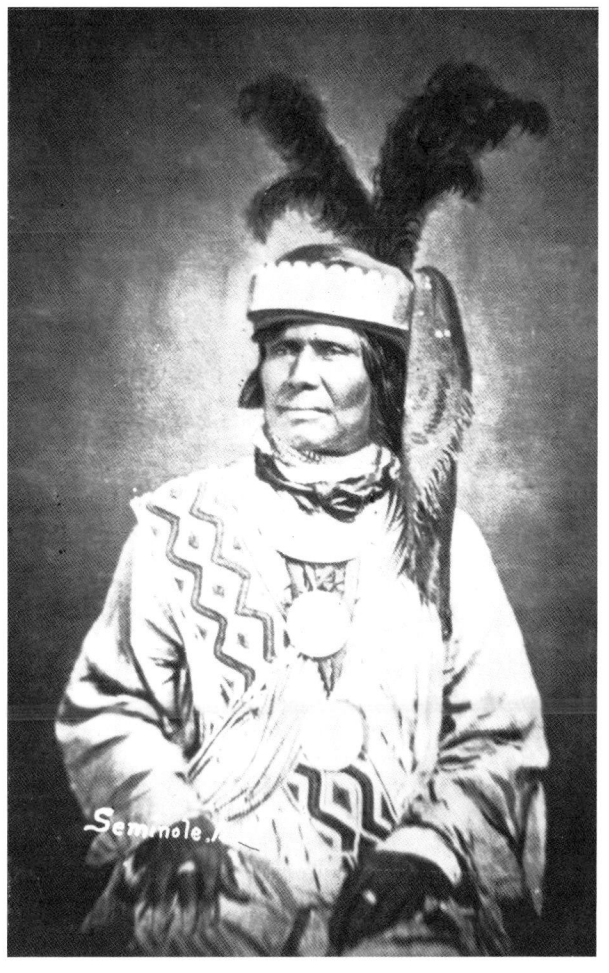

Above: Yoholo-Micco, a Creek chief 1790–1838, based upon a lithograph from a painting by Charles Bird King, c.1831–33, and used in McKenney and Hall's The Indian Tribes of North America originally published 1837–1844 which used many of King's works (and others), copied by Henry Inman.

Above right: William McIntosh, a mixed-blood Chief of the Lower Creeks, wearing a "V"-shaped flap pouch when painted by Nathan Negus in 1820 (not by Washington Allston as once believed). Son of a Creek woman and a Scottish trader he became leader of the pro-American faction of the Creeks during the British-American conflict of 1812. Courtesy Alabama Department of Archives and History, Montgomery, Alabama.

Right: Billy Bowlegs, noted Seminole chief, from a Daguerrotype, c.1852. A leader during the Third Seminole War (1856–58), he wears a silver headband with traded ostrich feathers, and bandoliers of braided wool and beadwork.

Opposite, above: Yuchi chief and wife, Georgia, 1736. The heavily tattooed man wears a robe (buffalo or bear) and buckskin moccasins. His leggings and breechclout are blue and red trade cloth. The woman wears what appears to be a trade cloth blanket. Watercolor by Philip Georg Friedrich von Reck.

Opposite, below left: The Supreme Commander of the Yuchi Indian Nation, Kipahahalgwa, Georgia, 1736. He is wearing soft-soled moccasins probably of the one-piece type, and leggings of red-dyed deerskin (or alternatively red trade cloth) leggings. He wears a trade shirt and has elaborate tattoos, feathers in his ears, and face paint. Watercolor by Philip Georg Friedrich von Reck. Original in the Royal Library of Denmark. Although the Yuchi were a separate people they were (and still are) often considered part of the Creek Confederacy.

Below right: Yaha Hajo (The Mad Wolf) a Creek chief, visited Washington in 1826 but later moved to Florida becoming a Seminole War leader. He was part of a deputation sent west prior to removal that he subsequently opposed. He was killed during the Seminole conflict in 1836. From a lithograph used in McKenney and Hall, from a painting by Charles Bird King, 1826.

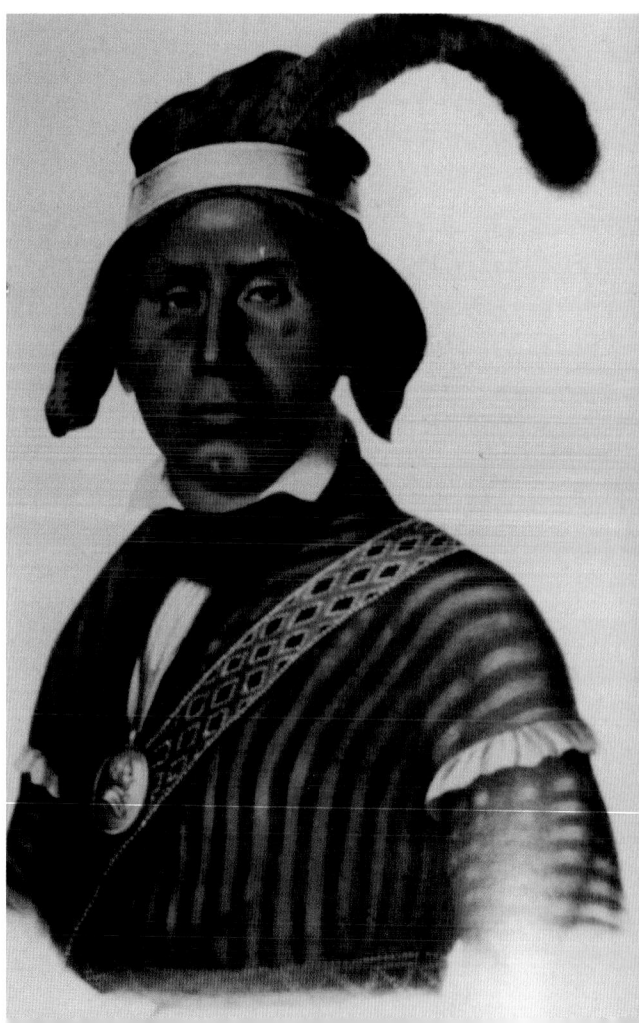

SOUTHEASTERN AND SEMINOLE DRESS

The extent of the use of skin garments in the south-eastern region of North America remains difficult to establish but a description of a Natchez man's dress by Du Pratz from the early eighteenth century states:"The men are dressed in deerskins which they make like our jackets and descend halfway down the thighs."This description suggests a form similar to the garments we now describe as Plains Indian male shirts. The British Museum has a group of Southeastern objects, including a buckskin coat of Creek origin, and several similar coats have also survived attributed to the Cherokee that are cut in European style. The use of skin in this way supports the probable existence of earlier buckskin garments for the upper body, used particularly in cool weather throughout the Southeastern area, except perhaps in Florida. Commentators have noted the fine texture of Tunica tanning and how the resulting buckskin was widely traded and in the 1970s the Tunica remnant of Louisiana were recorded as making men's shirts using buckskins. Therefore, despite the European cut, shape, and materials used in the construction of Seminole dress, their Creek ancestors no doubt wore hide garments not unlike those described for the Natchez. The use of buckskin for leggings and moccasins in fairly recent times suggests it was widely employed for early and pre-contact clothing. De Soto, for example, reported the use of buffalo robes by the Cherokee in 1540.

By the mid-eighteenth century buckskin seems to have given way gradually to European trade cloth and calico, particularly for shirts, coats, dresses, and robes. All eastern tribes were extensively revising male and female costume during the eighteenth century but incorporated earlier native traits into the newer styles using traded materials.

Following the move, beginning in the eighteenth century, of Lower and Upper Creeks to Florida to become the peoples we know as Seminole and Miccosukee, their clothing was mainly of cloth, except for leggings and moccasins. Their distinctive dress was augmented by accessories which consisted of finger-woven and beaded sashes, silver and other metalwork, and cloth bandoliers for men, cotton or calico skirts, blouses, necklaces, and incised silverware for women.

Above: Cherokee buckskin coat with silk embroidery, c.1850. NMAI

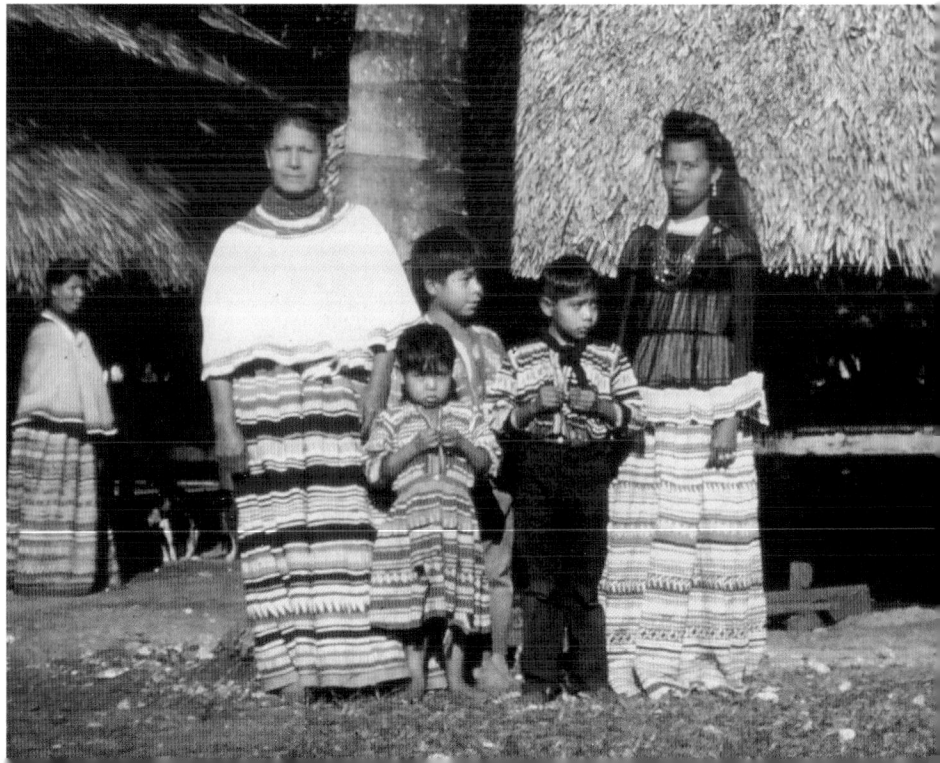

Above: Southeastern bandolier bag made by Bill Dyar of North Carolina, a near replica of the original in Derby Museum, U.K. Note the wild turkeys and a nighthawk in the beadwork.

Above right: Cherokee buckskin coat. BAM

Right: Seminole women and children wearing 'patchwork' clothing in front of a chickee. This traditional palm-thatched roof and no sides dwelling has interior sleeping platforms.

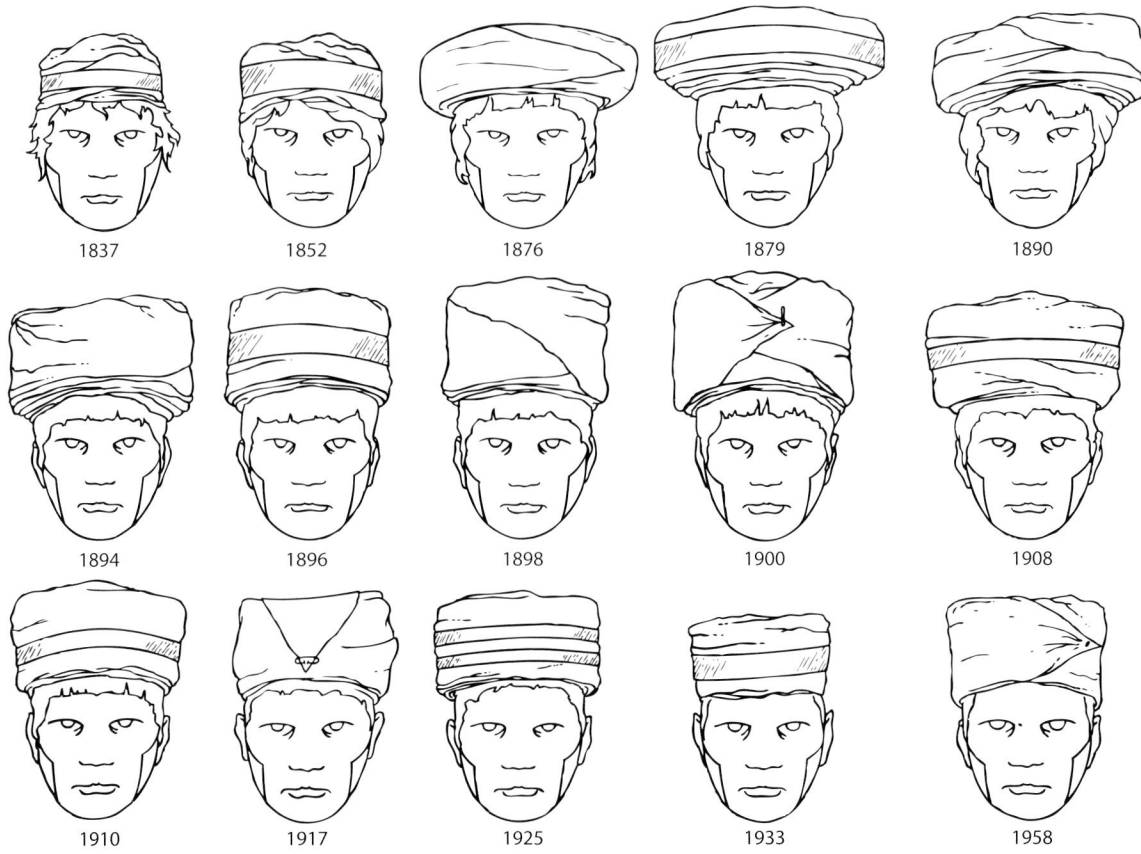

1837	1852	1876	1879	1890
1894	1896	1898	1900	1908
1910	1917	1925	1933	1958

Above: Seminole men's turbans (after Sturtivant, 1967).

Below: Seminole group, Florida, c.1895. A few of the Seminole people escaped removal to Indian Territory by surviving in the dense southern Florida swamplands. Before the 20th century development of their distinctive patchwork quilting, they had adopted European-type clothes fashioned in unique styles, with these horizontal bands of contrasting colored cloth stitched to coats and skirts.

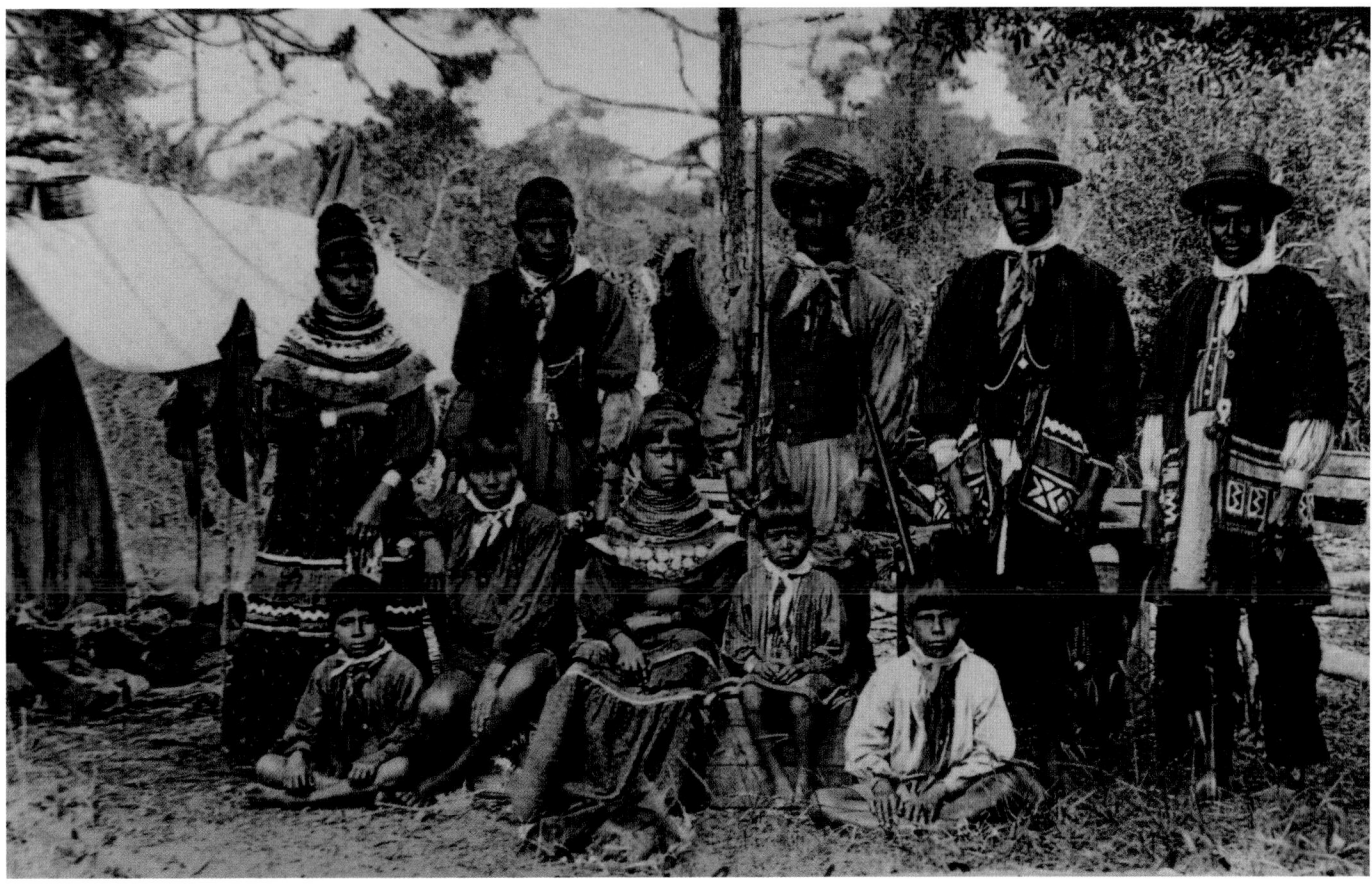

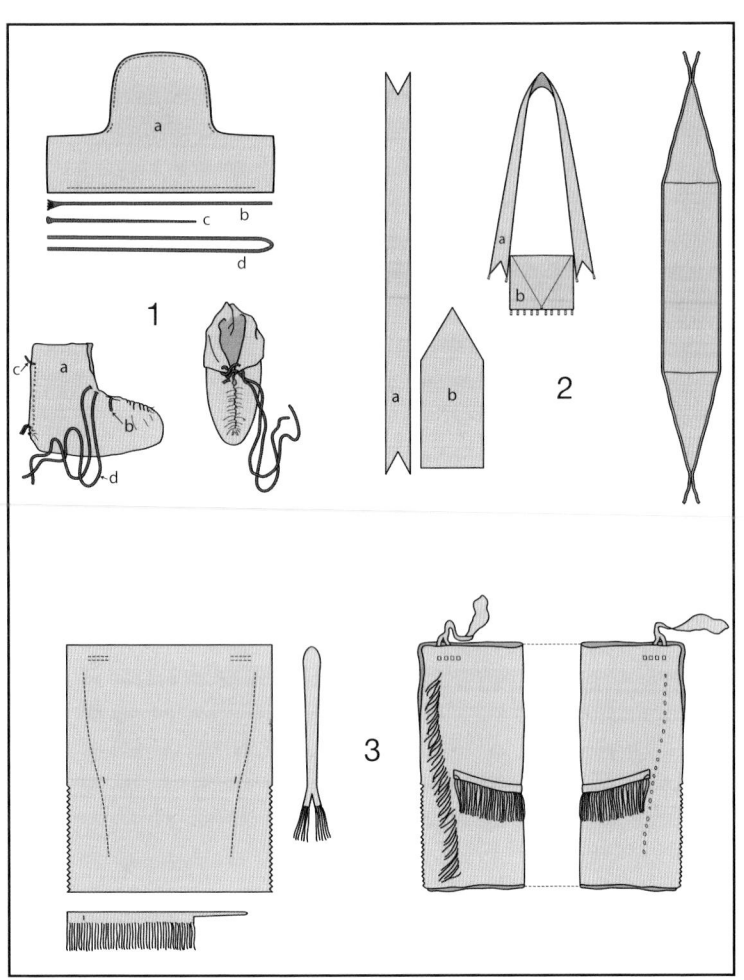

Seminole men wore crescentic silver gorgets suspended around the neck and turbans of commercial wool.

Seminole moccasins were usually each cut from one piece of buckskin, with a straight front center seam and heel seam, and laced together with thongs of buckskin that gave heavy puckering along the seams. Characteristically these thongs or laces had knots or buttons at the end so they did not pull through; top edges of moccasins were sometimes serrated. Southeastern buckskin is often of very fine texture, often cream, sometimes smoked or dyed a red-brown color with oak-sap. Creek, Choctaw, and Cherokee moccasins were all of the same general construction.

Seminole leggings were usually red-dyed (sometimes white) buckskin and were typologically indistinguishable from those of the Creeks, each being formed from a single folded rectangle with a belt tie and a fringe added at the knee.

Left: Items of Seminole dress (all after Sturtivant, 1967). 1—moccasins; 2—bandolier and breechclout; 3—leggings.

Below, left and right: Creek man's coat, early nineteenth century, and close-up detail. Cloth coat in Euro-American form with contrasting colored horizontal bands, perhaps the genesis of the later Seminole patchwork. MAM

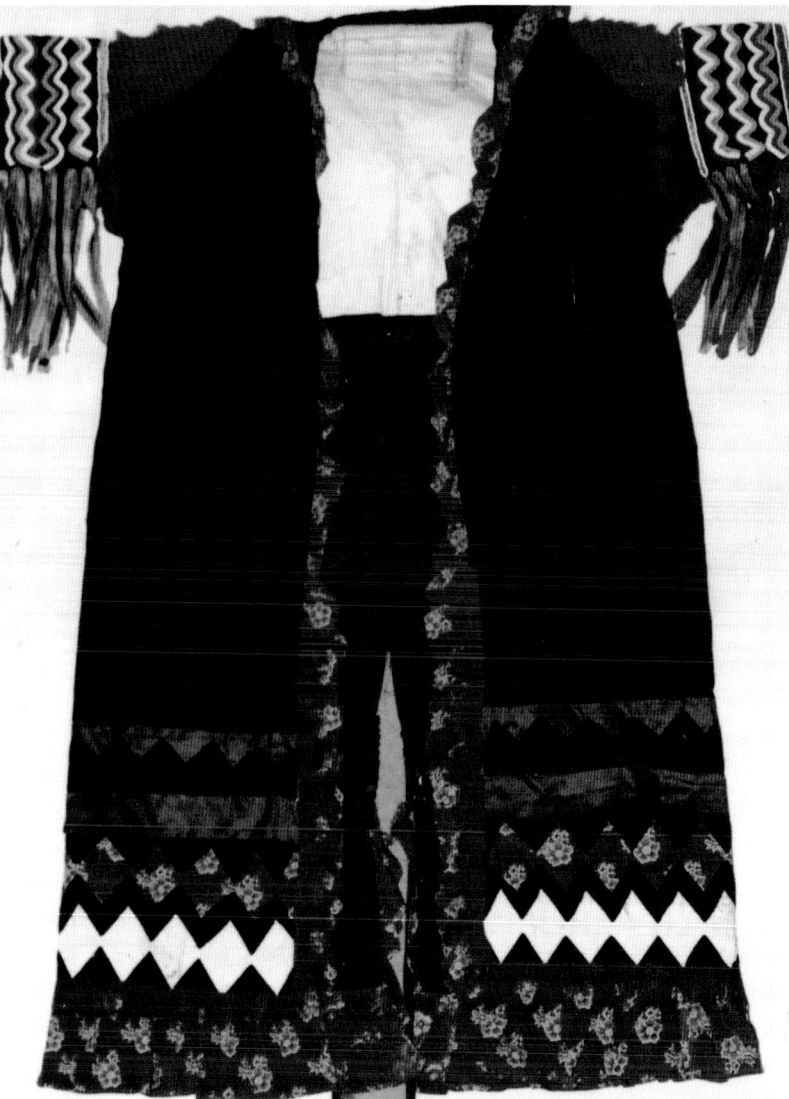

SEMINOLE SHIRTS

The Seminole man's "long shirt" seems to be the oldest of the four basic and distinctive cloth shirt forms, this type being characterized by a complete front opening. Several celebrated Seminole leaders were painted in the early nineteenth century wearing such shirts or coats, as were various Creek and Cherokee contemporaries. It has been suggested that the cut was copied from British military/hunting coats. The "plain shirt" is also a form dating from the mid-eighteenth century, and was often worn under the long shirt. Both were used occasionally until the 1950s among the Florida Seminole, particularly the Creek-speaking Cow Creek Seminole band. The Plain shirt was often tucked inside the pants. The third style, called the "big shirt," appeared about 1900. This is characterized by a front opening to the waist only, with the remainder being left as a skirt. A fourth style the "modern shirt" is finished at the waist so ordinary store pants can be worn at the same time. These appeared first about 1920.

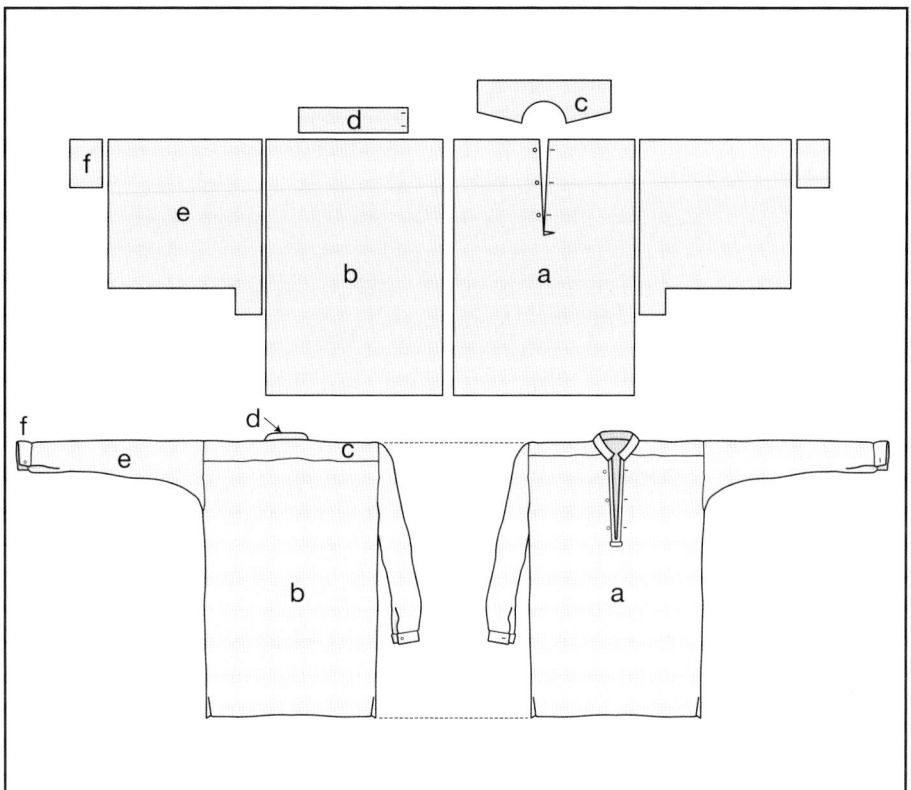

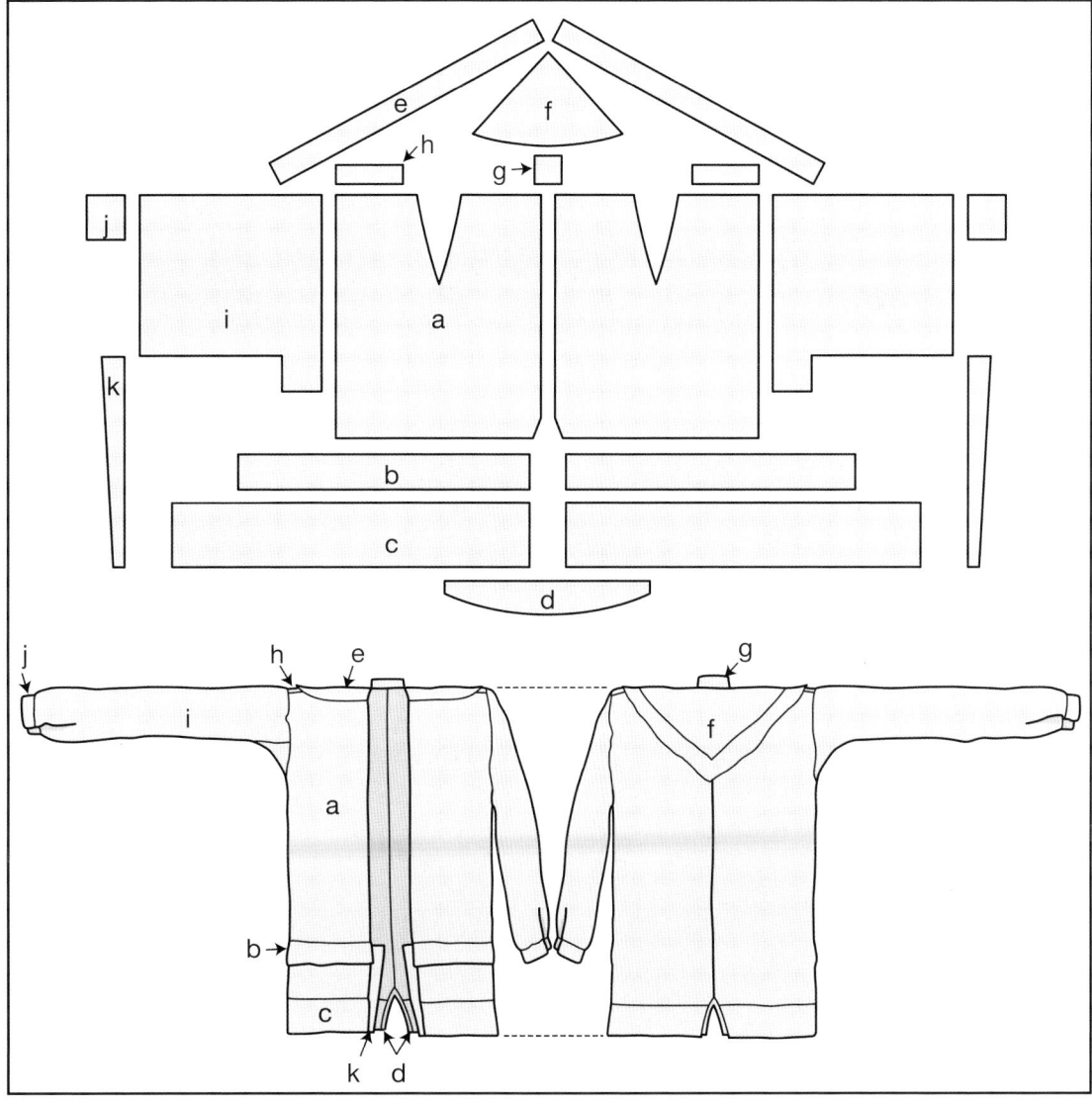

Opposite, above: Seminole man's shirt from the late nineteenth century (after Sturtivant, 1967).

Opposite, below: Seminole man's long shirt from the late nineteenth century (after Sturtivant, 1967).

Right: Seminole man's modern shirt from the mid-twentieth century (after Sturtivant, 1967).

Below: Seminole man's long big shirt early twentieth century (after Sturtivant, 1967).

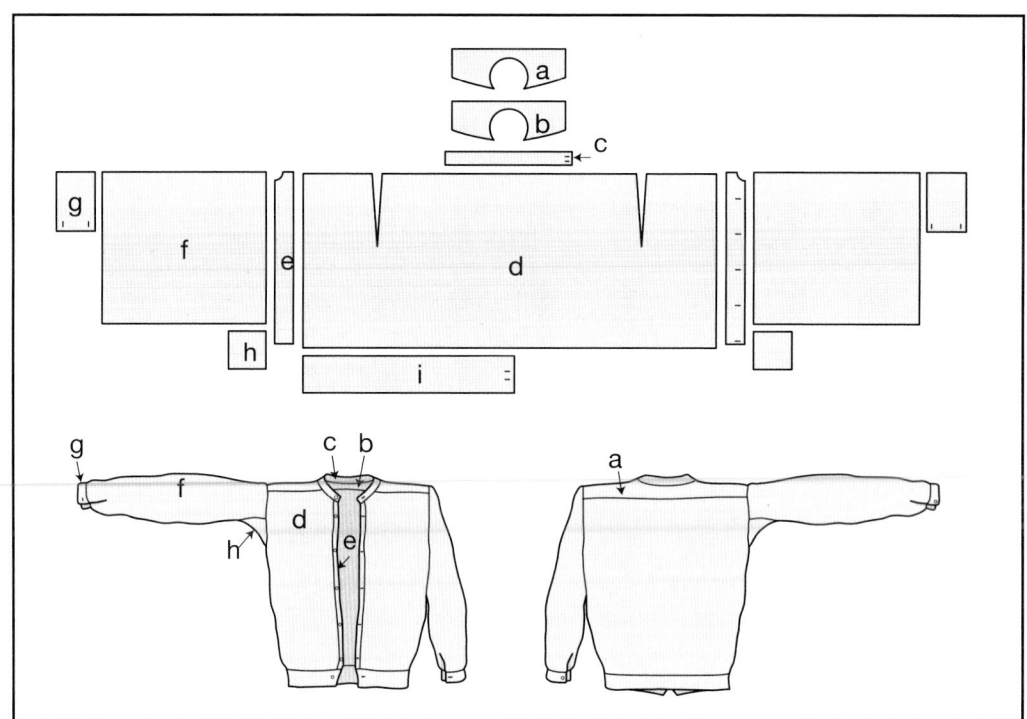

PATCHWORK

The origin of the colorful patchwork associated with the twentieth-century Seminole is unknown, but this seems to have appeared first on long shirts where it replaced horizontal contrasting-colored bands of appliqué material about 1910. It seems later to have been applied to women's garments and men's big shirts. The Miccosukee Seminole, one of the two groups of Seminoles in Southern Florida, claim to have originated the craft when they began to sell their patchwork garments and alligator hides to the tourists who began invading Florida from about 1915. Its development was also partly the result of the arrival of hand-cranked sewing machines in Seminole camps about 1890.

Several theories have been put forward by scholars concerning the origin of patchwork. One suggests African-American influence (the Seminole had welcomed numbers of runaway black slaves during their bitter wars with the United States), another speculates that it began with colonial quilting or can be traced to experimentation with cutting and sewing pieces of solid-colored cloth. The process begins by tearing segments of cloth which are then cut and sewn numerous times to form long horizontal bands in various and ever changing designs.

In the early nineteenth century a typical woman's upper garment would be long-sleeved with a small cape-like bodice with ruffles. This developed into a blouse which became progressively longer over time. It was worn with an ankle-length skirt which was tied at the waist and decorated with appliqué in contrasting color bands.

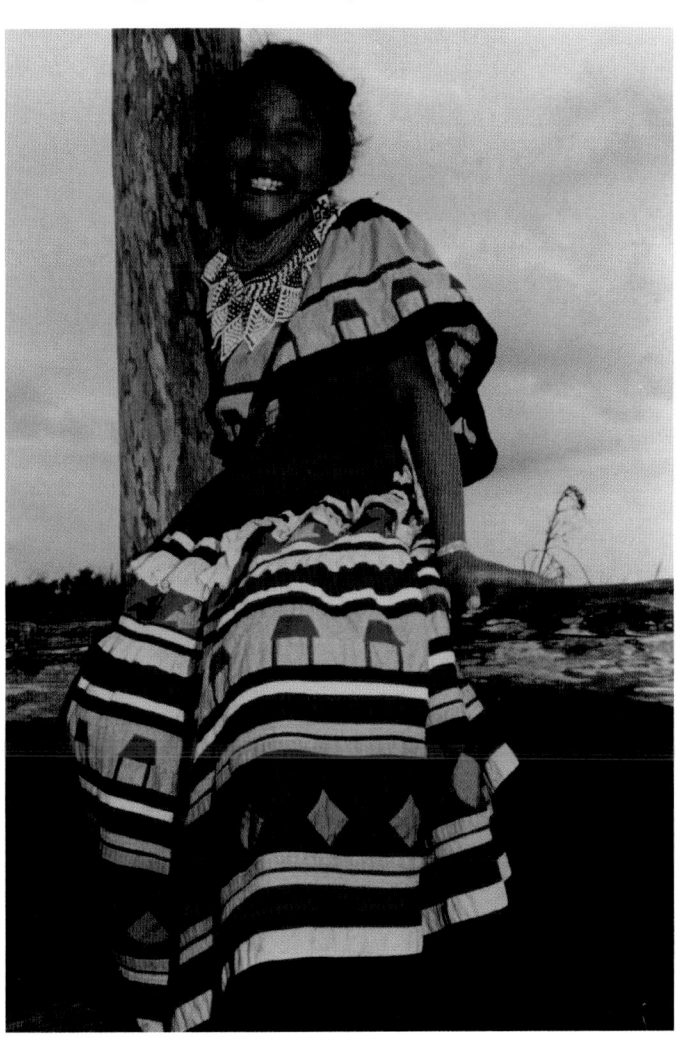

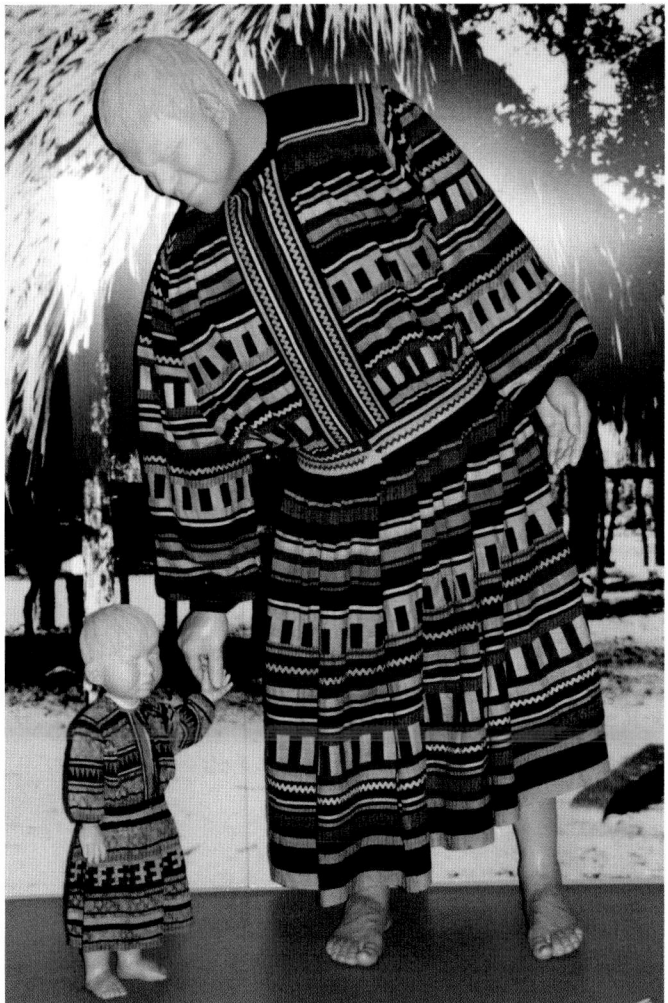

During the early years of the resettlement of the Creeks in Indian Territory there appears to have been interaction with the Delaware and Shawnee also forced to Kansas, Arkansas, or even Texas from the Ohio country. Other periods of contact between the Southeastern Indians were the Seminole Wars during which Shawnee and Delaware scouts were employed in Florida. The Shawnee had also established a colony among the Creeks during the eighteenth century. Coats, bandoliers, and other items of decorated dress may have been inspired by Creek forms but the beadwork decoration of zoned motifs, repeated elements of adjacent contrasting color, seems unique. An amalgam of Creek, Shawnee, and Delaware decorative motifs no doubt contributed to the development of the intertribal "Prairie Style" of the Missouri River valley tribes ultimately settled mainly in Oklahoma.

Opposite, above: Florida Seminole man's patchwork jacket, c. 1990. MGJ

Opposite, below left: Seminole girl with patchwork skirt and cape, c. 1980.

Opposite, below right: Seminole man's and child's patchwork attire, c. 1930. NMAI

Above and Below: Florida Seminole skirts and belt with patchwork designs, c. 1960. MGJ

Left: Florida Seminole doll with patchwork and ric-rac, c. 1990.

Patchwork patterns were used to cover both women's and men's clothing and patchwork garments were sold at commercial camps in Southern Florida, together with dolls and baskets. The patterns in patchwork were given names suggested by their shapes—rain, turtle, tree, sacred fire, arrow, or letters such as T and F. The recent reconnection with the Oklahoma Seminole has seen the transfer of Florida Seminole crafts to Oklahoma.

For the most part, the Southeastern tribes did not adopt the truly floral beadwork so common elsewhere in North America but did develop elaborately ornamented cloth bandolier bags, baldrics, and coats with beadwork that contain designs representing alligators and humans in spirit forms, as well as snakes, turkeys, ball-game sticks, and other phenomena in highly complex shapes, often symmetrical in layout. Some historians have speculated on a connection with ancient Mississippian art and others even suggest Afro-American influences. Some Creek, Seminole, and Cherokee bandolier bags certainly pre-date removal to the west and this may be so even if they are constructed of trade cloth and decorated with seed beads and tassels. The Cherokee, however, also used silk embroidery on buckskin coats in floral designs, and the Choctaw used a scroll motif, a wave-like design repeated laterally on their baldrics and belts, which appears to have ancient concatenations.

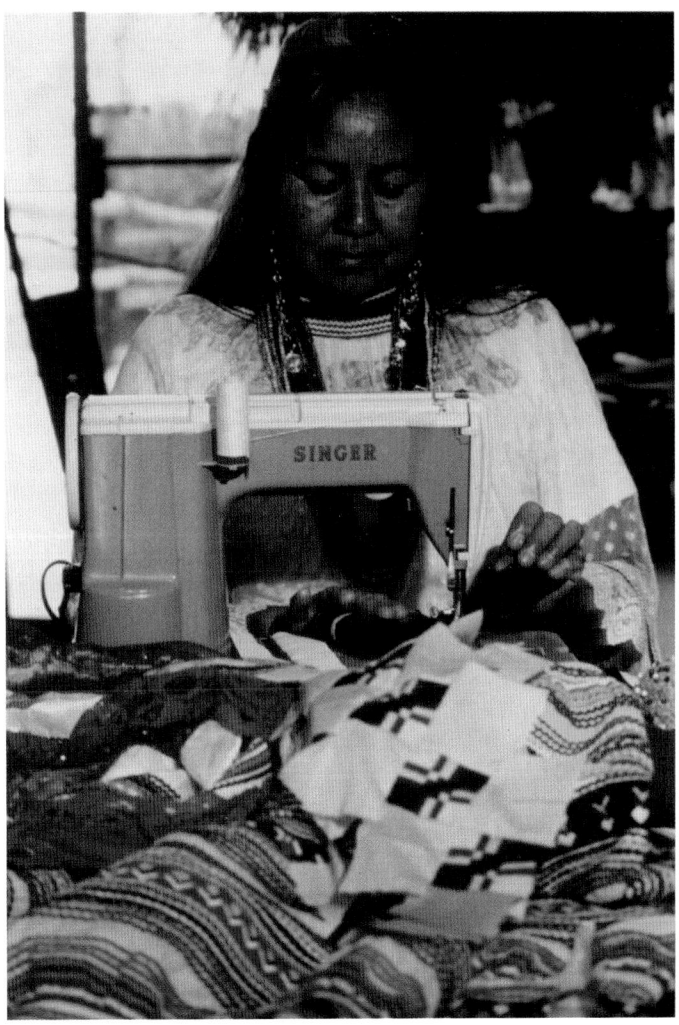

SOUTHEASTERN BANDOLIER BAGS

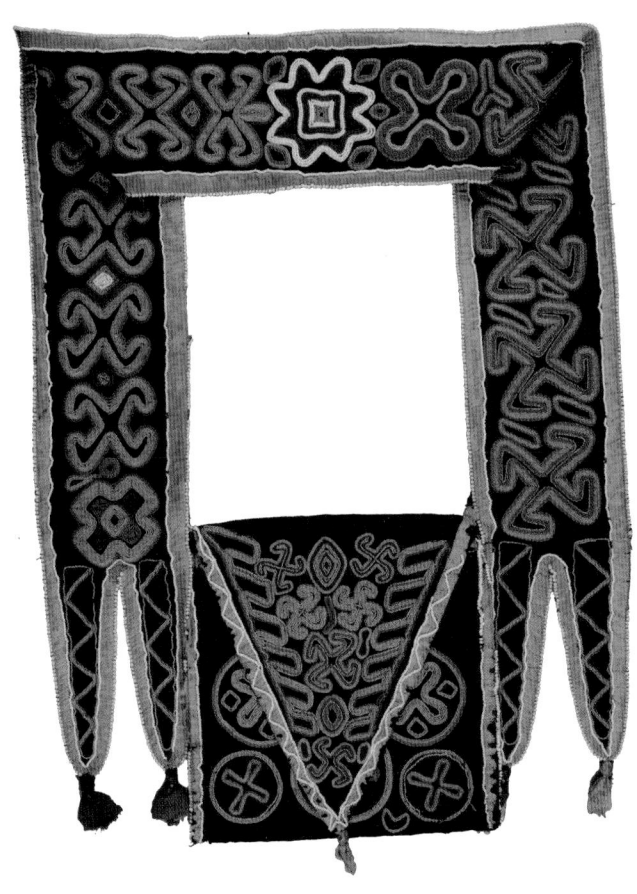

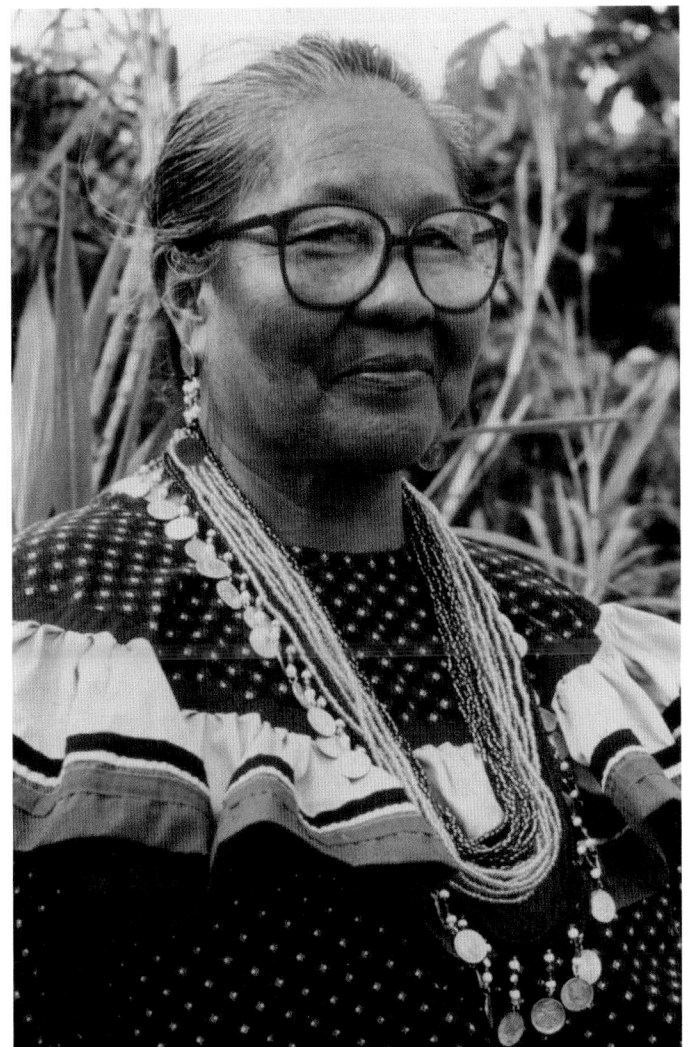

Above: Cloth shoulder bag, 1830–1850, likely Creek or possibly Cherokee. The refined beadwork style may link this specimen with Cherokee examples but the hooked "X" motifs and swastikas suggest an affinity with the Creek-Seminole type. Courtesy John Painter Collection

Above left: Miccosukee Seminole woman of Southern Florida working on patchwork-decorated clothing. The descendants of the few Seminoles who remained in Florida after three wars against the Americans are now divided into two groups, those who traditionally spoke Creek and those who spoke Hitchiti or Miccosukee. Photograph by Roz Cox, c. 1980.

Left: Florida Seminole woman wearing a dress with a ruffled "Bertha" collar, rows of beads and coin necklaces. Photograph by Roz Cox, c. 1980.

Opposite, above: Creek-Seminole-type dark cloth bandolier bag, with two-lobe shoulder strap and "V"-shaped pouch flap. Probably a water turkey in the beaded flap design, c. 1830–1840. NMAI

Opposite, below: Three Southeastern shoulder pouches of the Muskogian type, probably Creek-Seminole, c. 1820–30. All three have remarkable beaded designs with possible alligator or other zoomorphic designs on the triangular-shaped flaps, which were slightly rounded at the ends. The straps have beaded designs with features which may represent ball-game sticks, and triangular shapes with hooked appendages which are repeated on other examples and clearly have meaning for their owners or makers. MAM

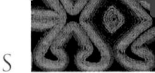

SOUTHEASTERN ARTS AND CRAFTS

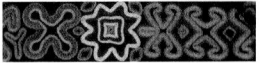

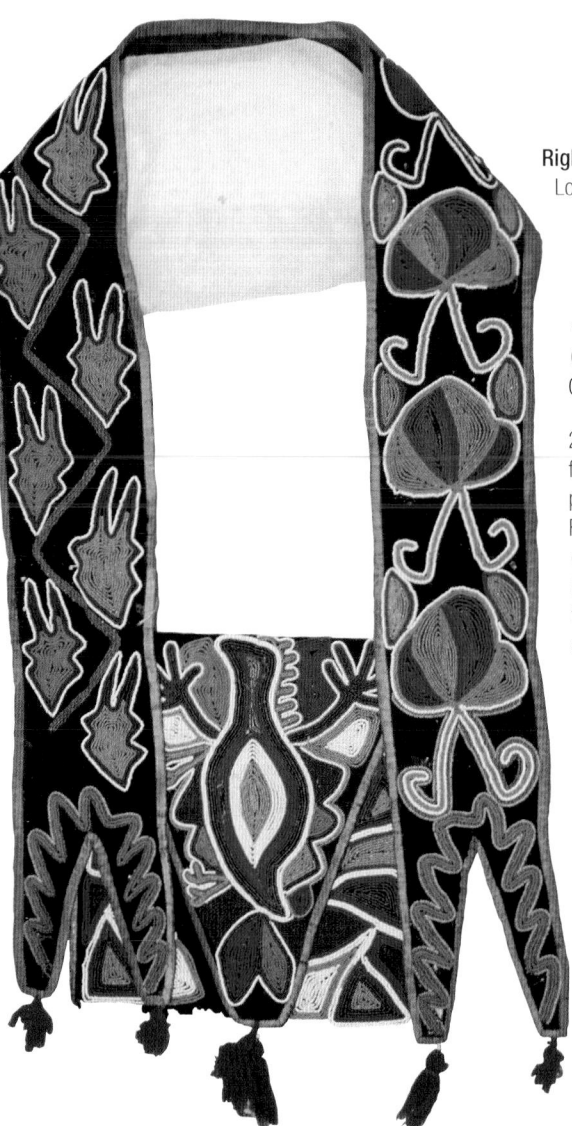

Right: Chitimacha basket from Louisiana, by Lydia Darden, 1972–73.

Below right:

1. A belt of finger-woven wool, made by Mary Shell, Cherokee. Tahlequah, Oklahoma.

2. Dolls—male and female—with quilted patchwork dress. Seminole, Florida. Seminole patchwork or quilting was developed by the Florida branch of the tribe after they obtained sewing machines in the 1890s.

3. A pair of ball sticks used in two forms of an ancient game still played by descendants of several Southeastern tribes. Choc-taw, Mississippi. MGJ

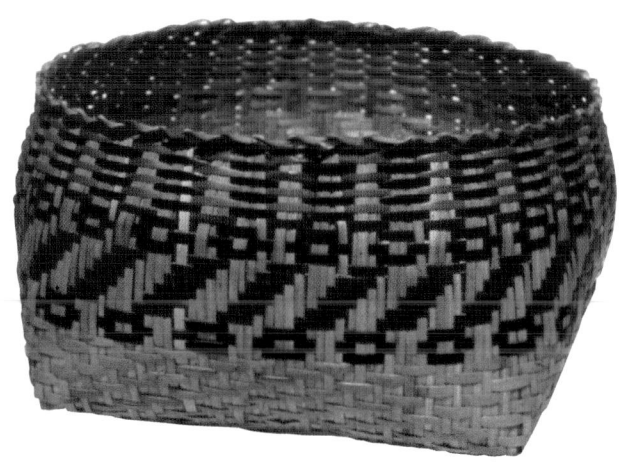

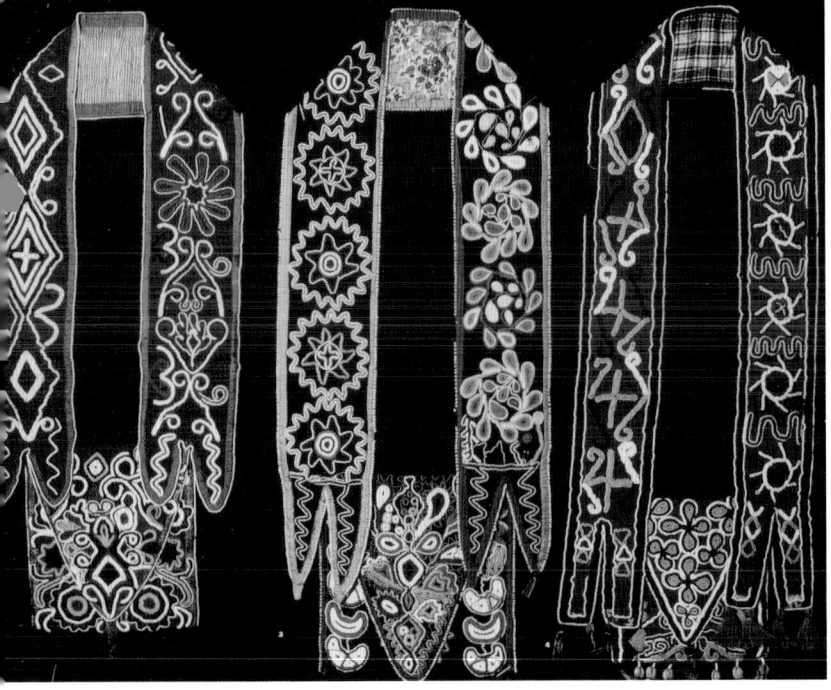

5. SOUTHWEST

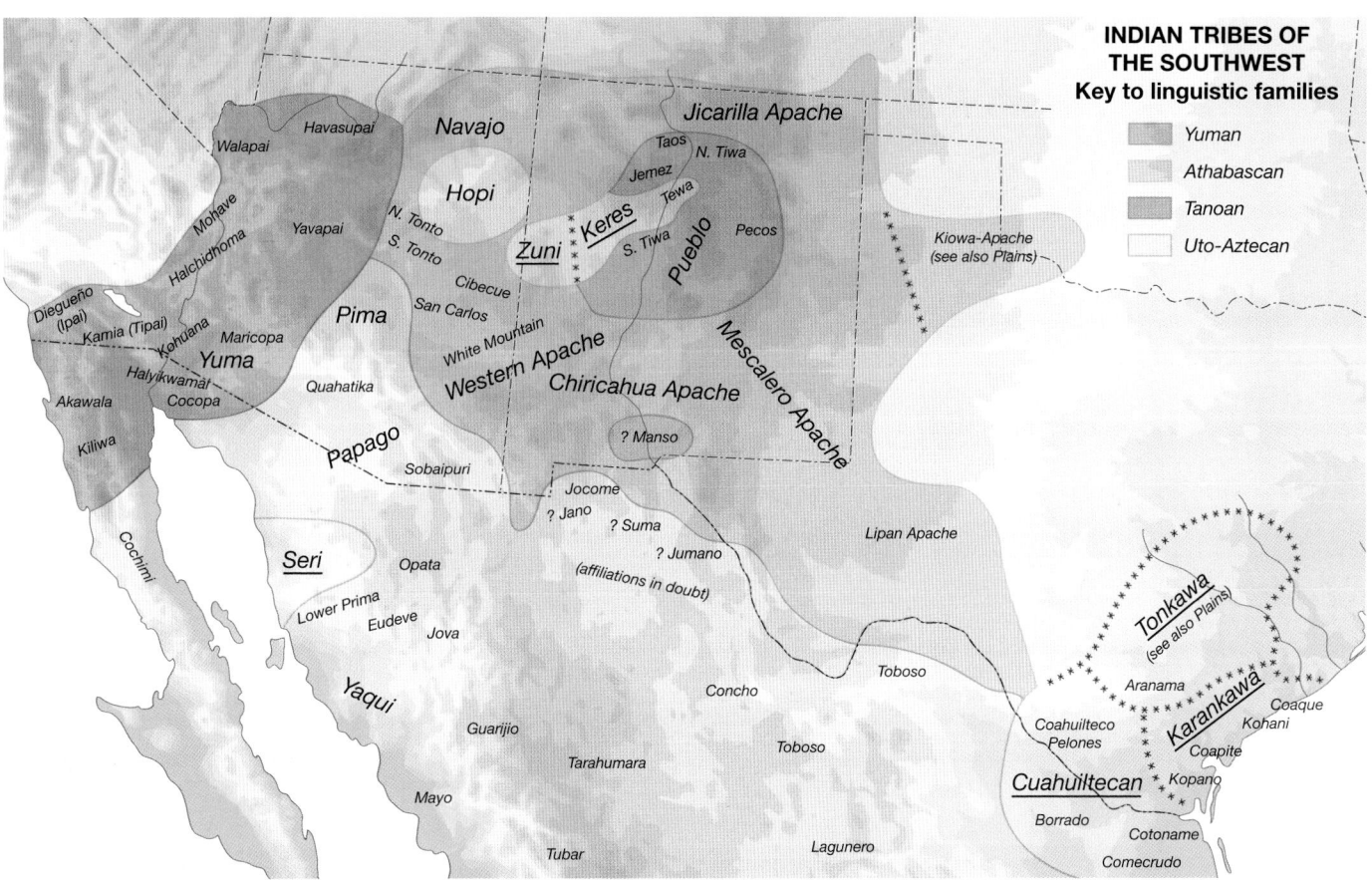

INDIAN TRIBES OF THE SOUTHWEST
Key to linguistic families

- Yuman
- Athabascan
- Tanoan
- Uto-Aztecan

Southwest culture derives from two sources: an ancient agricultural tradition and a much later northern hunting tradition which the Athabascan-speaking Navajo and Apache introduced from about A.D. 1400. Three major prehistoric cultures contributed to the older cultural traditions of the region:

- **Mogollon** (c. 500 B.C.–A.D. 1400) acquired agriculture and pottery from what is now Mexico. Mainly pit-house farmers, the Mogollon culture originated in Cochise County, Arizona, and spread to neighboring areas.

- **Hohokam** (c. 300 B.C.–A.D. 1450) developed farther west, centering along the Gila River around the site of modern Phoenix. The Hohokam people developed irrigation canal systems, fine pottery, and stonework. Both the Mogollon and Hohokam cultures declined during the early fifteenth century, and the modern Pima and Papago are most probably their descendants.

- **Anasazi** ("ancient ones") is a collective term to cover a people who lived at sites within eastern Arizona, western New Mexico, and adjacent Colorado (c. 250 B.C.–A.D. 1350). The earliest phases are termed "Basketmaker" (250 B.C.–A.D. 700) and "Modified Basketmaker" (A.D. 400–700). These were followed by three Pueblo periods: the "Development Period"; then the "Great Pueblo Period," characterized by large towns with fine masonry apartments, which were abandoned c. 1276 when drought forced the people south to the Hopi and Zuni pueblos and the Rio Grande. Finally, the "Regressive Pueblo Period" (1300–1700) climaxed with Spanish occupation.

Although many Pueblo villages were established after Spanish contact, most are located close to earlier sites. From the Spaniards they adopted horses, wheat, fruit trees, sheep, and cattle—and the use of adobe bricks made from molds to rebuild larger rooms in the Pueblo structures. From the early 1700s until the American annexation of the Southwest in 1848, the Pueblos and Spanish (and Mexicans, after the 1820s) stood back-to-back fighting off the Athabascans, who had first appeared in the fifteenth century. Although warfare between the Navajo and Apache and the Pueblo and Spanish often reached alarming proportions, the northern raiders still adopted weaving, pottery, masked dances, and even some agriculture from the Pueblos. The Athabascans retained their roving, hunting, and raiding northern ways, however; hardy, skilled in combat, incredibly observant, and gifted at concealment, they were without equal as warriors.

ADOBE USE AND ADOBE CITIES OF THE SOUTHWEST

Adobe, the use of mud-brick construction, has been and continues to be practiced widely throughout the world. The signature characteristic of the traditional architecture of the Southwest people since the pre-Columbian era, it was practiced within the present boundaries of the United States almost exclusively in the Southwest, that is in the region of the present states of New Mexico and Arizona, as well as southern Colorado, southern Utah, and surrounding areas. Adobe was also widely used in pre-Columbian times in Mexico and elsewhere in present-day Latin America.

The centerpiece of adobe construction is a brick made from a mixture of sand, clay, and water, reinforced by sticks or straw. These are formed into bricks using frames and dried in the sun. Adobe bricks are extremely efficient thermally, providing good insulation to keep out hot ambient temperatures in the summer and retain heat during cold winters.

When an adobe brick building was completed, a skim coat of adobe material was usually placed over the bricks to smooth and finish the surface. Doorways and windows typically had a log (often cottonwood) header or lintel on top to carry the weight of the wall above the opening. The roofs were likewise framed in wood, with log beams supported by brick walls spanning each room. Fireplaces and chimneys were built of adobe bricks. Ovens for cooking were also built of adobe, and were usually located outside.

In the Southwest there were two separate categories of pre-Columbian cultures that utilized adobe architecture. First, there were four ancient civilizations which disappeared in pre-Columbian times. Second, there were a number of individual city-states with adobe towns which existed at the time of European contact, most of which still exist today.

First, we consider the former. Preserved for posterity by the dry air of the high desert are the remains of ancient adobe cities which flourished for over a millennium, roughly between 1200 B.C. and A.D. 1300.

These people are recognized by archaeologists as comprising four distinct pre-Columbian cultures. They are the Anasazi people of the Four Corners area (the region around the intersection of the boundaries of Arizona, Utah, Colorado, and New Mexico); the Hohokam and the Patayan of present-day Arizona; and the Mogollon of southern New Mexico, northern Chihuahua, and northeastern Sonora.

Though these cultures vanished several hundred years prior to the arrival of European explorers, the adobe cities (called pueblos by the Spanish) which they built can still be seen. Hohokam structures are

Below: An old house at the Hopi First Mesa village of Waalpi (Walpi), Arizona, as seen in 1920. LoC

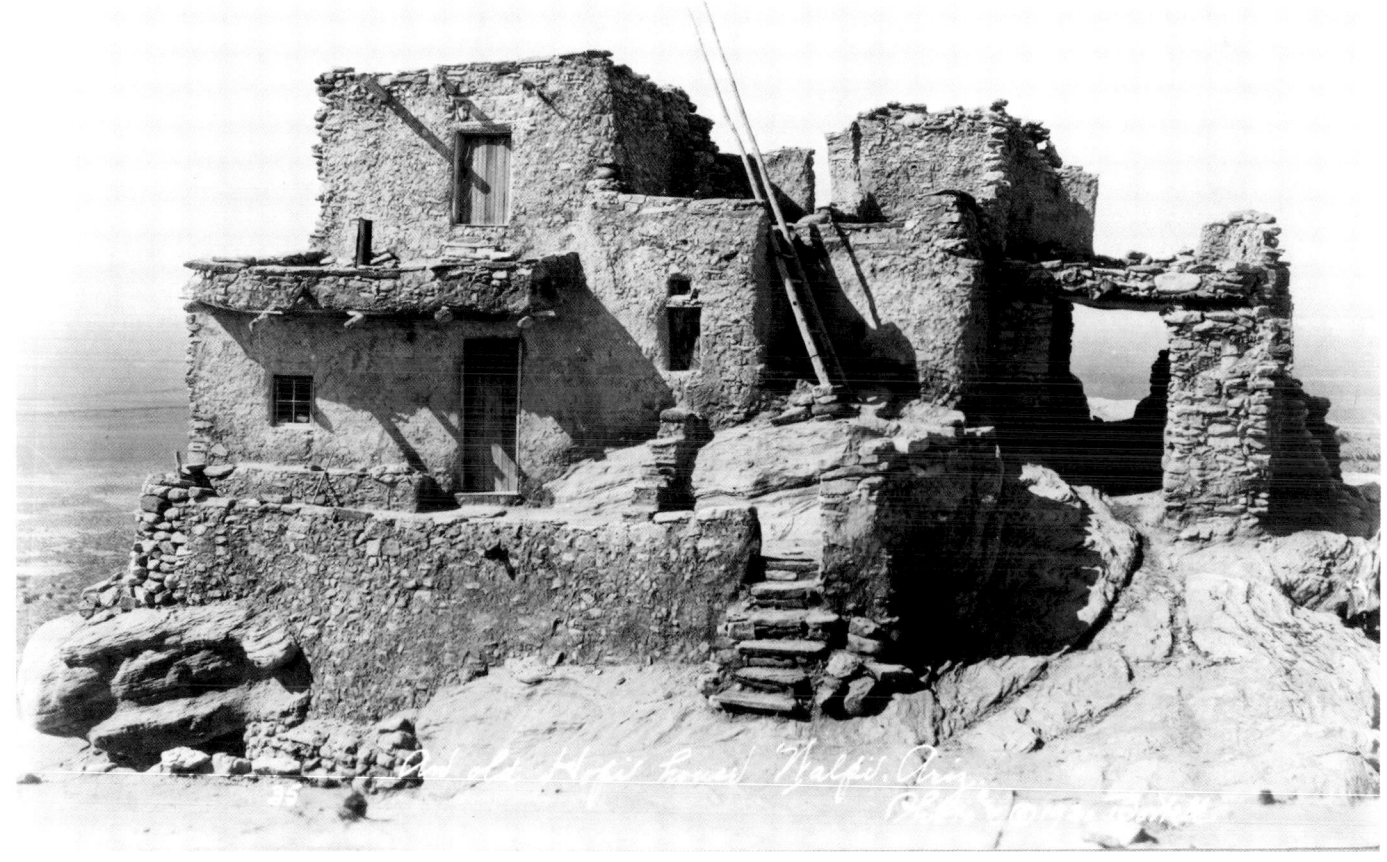

Above: The northernmost of all the pueblos, Taos sits at the base of the Sangre de Cristo Mountains. It is an impressive multistoried pueblo built after the Pueblo Revolt of 1680 only a few hundred yards from the site recorded by the early Spanish explorers. New Mexico Tourism Department photo by Mike Stauffer

located at Casa Grande National Monument in Arizona, while a Mogollon city is preserved where it was constructed in a natural cave at the Gila Cliff Dwellings National Monument in New Mexico. Another important series of sites is located in the geographic center of New Mexico, near Montainair. Preserved as the Salinas Pueblos National Monument, these include Abo, Quarai, and Gran Quivira.

The best preserved and most prevalent of the ancient sites are those of the Anasazi, who built cities with multistory apartment houses and "great houses" with more than a hundred rooms. Major Anasazi sites are located at Mesa Verde National Park and Hovenweep National Monument in Colorado, as well as at Canyon de Chelly National Monument in Arizona. In New Mexico, major sites include those at Chaco Culture National Historical Park, Aztec Ruins National Monument, and Bandelier National Monument. In addition, there are numerous smaller sites, called "pueblitos," throughout the region.

It should be pointed out that the term "Anasazi" is the term for "Ancient Ones" or "Ancient Enemy" in Navajo. The term for the Anasazi in their own language is unknown because their civilization vanished around 1350. Because the Navajo (Diné) are the civilization who superseded the Anasazi in their former land archaeologists currently shy away from the term, calling the people "Ancient Pueblo" or "Ancestral Pueblo," though the term "Pueblo" was also assigned to pre-Columbian city-dwellers by outsiders—the Spanish in the sixteenth century.

The center of religious life within the Pueblo is the kiva, the underground ritual chamber symbolizing the entrance to the underworld. Large enough to accommodate many people (traditionally men), they are usually circular or oval in shape.

While the four cultures referenced above were lost in pre-Columbian times, the "Pueblo" tradition continues in the form of the pueblos which still exist in the Southwest today. (See Southwest Pottery Traditions, pp. 177–181.) Indeed, these cities, including those of the Hopi (Oraibi) and Zuni (Acoma), are among the oldest continuously occupied cities in the United States.

In addition to these centuries-old sites, adobe-style architecture, based on traditional methods and styles, is still widely used in contemporary home construction throughout the Southwest. This is both for aesthetic reasons and because the energy efficiency of the adobe makes it very practical.

APACHE DRESS

The Apache (Inde), like the Navajo (Diné), are an Athabascan-speaking people, who arrived in the Southwest after the year 1000. In contrast to the Hopi, Zuni, and other Pueblo people whose roots in the area are much older, both the Apache and Navajo, the Athabaskan newcomers, were traditionally more nomadic. In turn, in contrast to the Apache, the Navajo were scarcely so. They traveled widely within their dinétah, or homeland, which was the northeast quadrant of present-day Arizona, the northwest corner of New Mexico plus adjacent parts of the other "Four Corners" states (Utah and Colorado), but the Apache roamed much farther.

From the eighteenth century, there were four major related, but distinct, Apache groups in the Southwest: the Chiricahua of southwestern New Mexico, the Mescalero of southeastern New Mexico, the Jicarilla of northeastern New Mexico, and what ethnographers refer to as the Western Apache, in eastern Arizona. In turn, these major groups were divided into numerous distinct subgroups. For example, the Western Apache included the White Mountain and San Carlos Apache whose present reservations east of Phoenix are the largest of all Apache reservations anywhere. Outside the Southwest, there were the geographically separate

Above: One important surviving Apache ritual is the Girl's Puberty or Coming Out Rite, during which the girl is believed to have special curative powers derived from the mythological White-Painted Woman who taught the Apache the ceremony. During the ritual the girl wears a yellow painted and beaded serape (a long blanket-like shawl). On each of the four nights of the ceremony impersonators of the mountain spirits—the Gaan—dance with elaborate wooden and hooded headdresses to drive away any evil which may disrupt the proceedings. Pictured is a group of Gaan dancers photographed by Edward Curtis around 1906. LoC

Below left: Chiricahua Apache leader, Geronimo (Goyathlay) as photographed by H.H. Clarke in Oklahoma City, c. 1909. LoC

Below: Das-Luca, Skro-Kit, and Shus-El-Day, three White Mountain Apache men, c. 1909. LoC

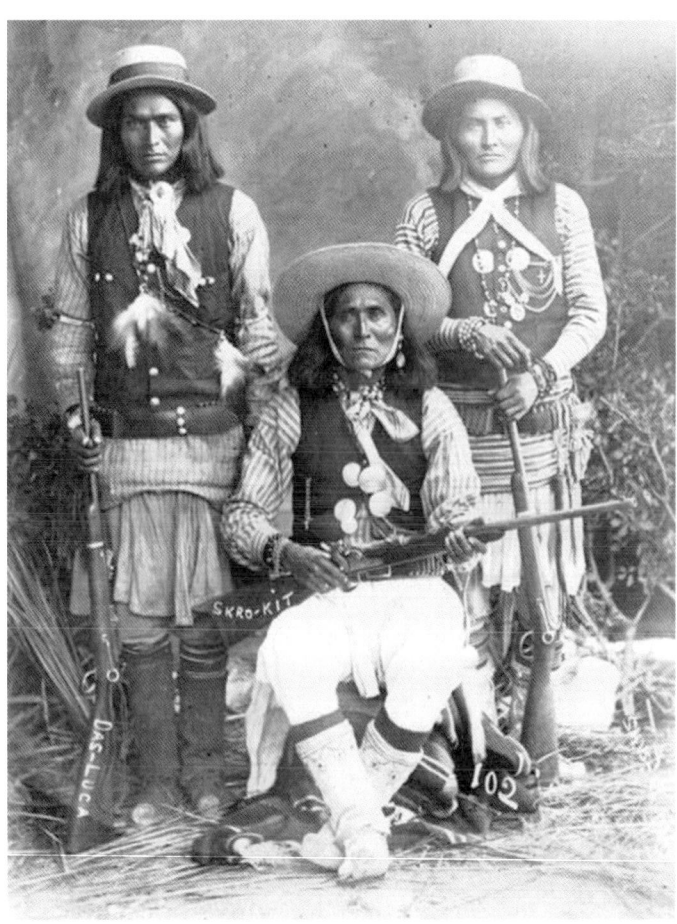

HOPI KACHINAS

One of the most unique and visually intriguing aspects of Southwest ritual life and pictorial art is that of the Kachinas, which are spirit deities represented in human form by costumed dancers or in doll form associated with the instruction and initiation of children into Kachina societies. Though the Kachinas are most closely identified with the Hopi, they are also part of the ritual life of the Zuni and some of the Rio Grande pueblos, such as at Acoma and Laguna.

The annual Hopi Kachina ceremonial cycle begins at the Winter Solstice in midwinter with the annual opening of the kiva—the subterranean chamber symbolizing the entrance to the underworld—and progresses through the false spring, or Powamu Dance (a ritual celebrating the ceremonial planting of beans) in February. Dances associated with festivals and rituals feature men wearing paint and costumes that represent specific Kachinas. In July, after the Summer Solstice, the Kachina season ends when the Kachinas go back into the underworld.

There are more than 400 Kachinas symbolizing nearly every principal element of the natural or supernatural world. There are Kachinas representing the sun and the stars, thunderstorms, and the wind. There are also the Corn Kachinas, such as Humiskatsina and Nuvak'china (Nevakkatcina). There are the Snow Kachina and the Snow Kachina Girl (Nuvak'chin Mana), who help bring water to the crops. There are also Kachinas that embody each of the species of wild and domestic animals

Lipan Apache in central Texas, and another group north of Texas on the southern Plains. Now called "Plains Apache," these people were long referred to as the "Kiowa-Apache" because they were allied with and culturally similar to the separate (and linguistically unrelated) Kiowa tribe.

Like most nomadic peoples, the Apache did not develop many of the art forms, such as pottery and metal smithing, that are associated with the sedentary tribes such as the Pueblo people.

When it comes to clothing, the Apache of the Southwest did not develop a weaving tradition as the Navajo had, but acquired leather and cloth, as well as finished goods, through trade sources. As with other Southwest people, Apache women traditionally wore buckskin dresses, while the men wore leather shirts, breechcloths and high-topped moccasins. By the early nineteenth century, however, they had begun to adopt Mexican and American clothing styles. Meanwhile, the dress of the Plains Apache was like that of other Plains people, rather than being similar to the Southwest Apache.

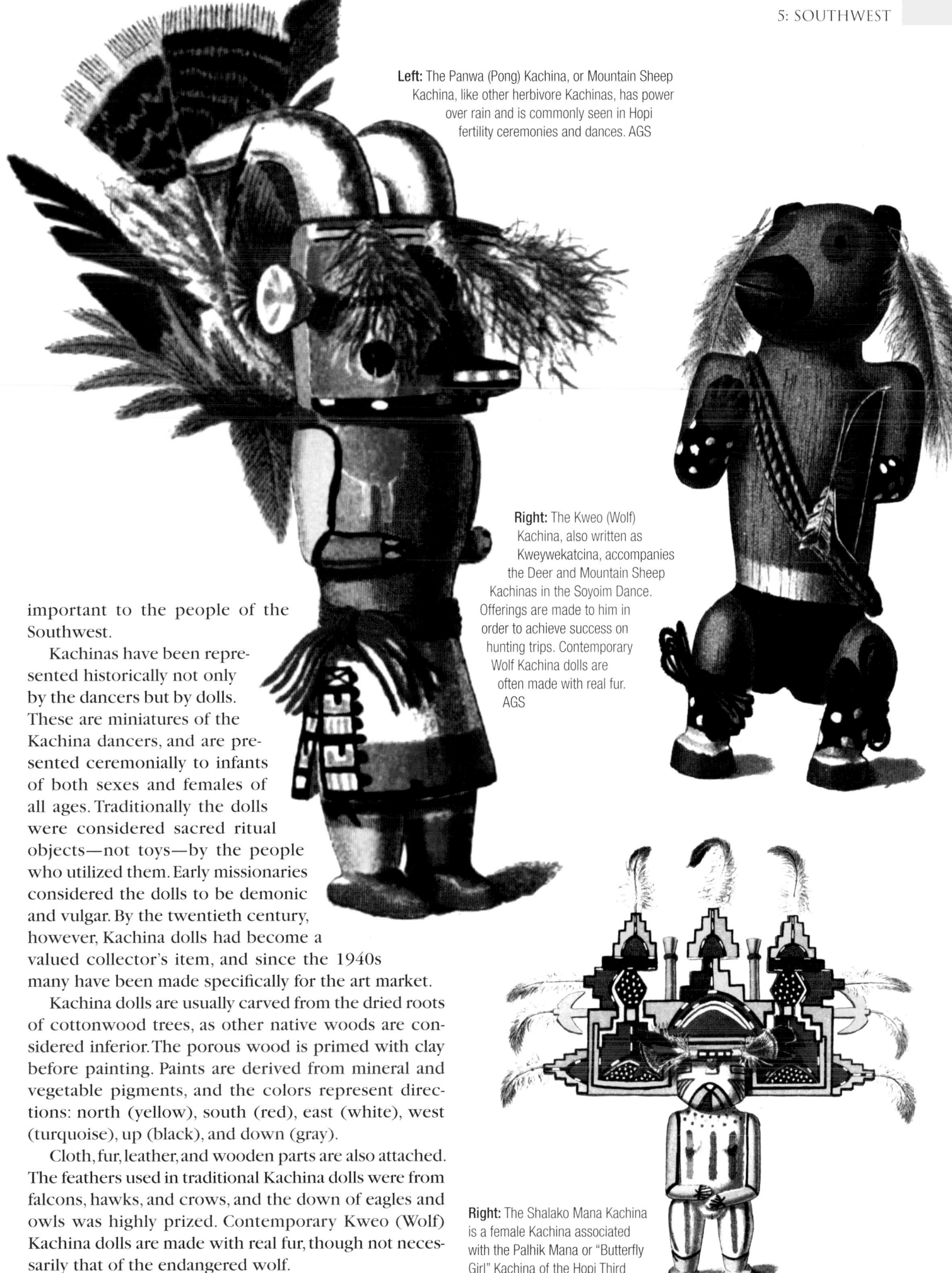

Left: The Panwa (Pong) Kachina, or Mountain Sheep Kachina, like other herbivore Kachinas, has power over rain and is commonly seen in Hopi fertility ceremonies and dances. AGS

Right: The Kweo (Wolf) Kachina, also written as Kweywekatcina, accompanies the Deer and Mountain Sheep Kachinas in the Soyoim Dance. Offerings are made to him in order to achieve success on hunting trips. Contemporary Wolf Kachina dolls are often made with real fur. AGS

Right: The Shalako Mana Kachina is a female Kachina associated with the Palhik Mana or "Butterfly Girl" Kachina of the Hopi Third Mesa. AGS

important to the people of the Southwest.

Kachinas have been represented historically not only by the dancers but by dolls. These are miniatures of the Kachina dancers, and are presented ceremonially to infants of both sexes and females of all ages. Traditionally the dolls were considered sacred ritual objects—not toys—by the people who utilized them. Early missionaries considered the dolls to be demonic and vulgar. By the twentieth century, however, Kachina dolls had become a valued collector's item, and since the 1940s many have been made specifically for the art market.

Kachina dolls are usually carved from the dried roots of cottonwood trees, as other native woods are considered inferior. The porous wood is primed with clay before painting. Paints are derived from mineral and vegetable pigments, and the colors represent directions: north (yellow), south (red), east (white), west (turquoise), up (black), and down (gray).

Cloth, fur, leather, and wooden parts are also attached. The feathers used in traditional Kachina dolls were from falcons, hawks, and crows, and the down of eagles and owls was highly prized. Contemporary Kweo (Wolf) Kachina dolls are made with real fur, though not necessarily that of the endangered wolf.

NAVAJO BLANKETS AND RUGS

Navajo textiles are the tribe's signature art form, and one of the most important art forms in the Southwest. Origin-ally utilitarian, Navajo saddle blankets, shoulder blankets, serapes, women's dresses, and particularly in later years, rugs became a vitally important element in the commercial relations between the Navajo people and the greater economy of the United States and world by the late nineteenth century.

They remain as such to this day. Contemporary Navajo rugs are popular among both decorators and collectors alike, while nineteenth- and early twentieth-century Navajo textiles are in the permanent collections of major museums. By the late twentieth century, the highest level of the art form had made its way from the category of "craft" or "applied art" to that of "fine art."

The Navajo weaving tradition originated some time before the seventeenth century, and certainly before

Above: A nineteenth century Navajo blanket pattern.

Below: A Navajo woman weaving a rug or blanket, with a herd of sheep in the background, as photographed by William Carpenter, c. 1915. LoC

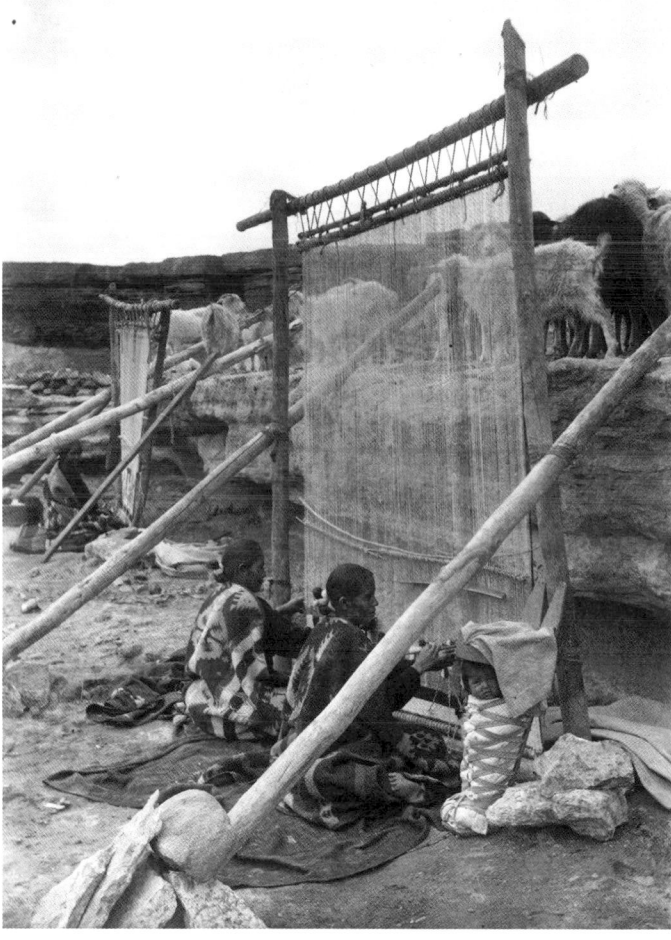

Above: An early twentieth century Navajo textile pattern.

Right: Three Navajo women weaving with flock of sheep on the ledge above as photographed by Pennington and Rowland, c. 1914. Photographers often included domestic sheep in pictures of weavers to represent the source of Navajo wool. LoC

Below: A Navajo woman weaving on horizontal loom in camp at Keam's Canyon, Arizona, while a child, Nedespa, cards wool, another woman spins wool (left) and yet another woman weaves at a belt frame (right). Photographed by James Mooney, c. 1892 or 1893. LoC

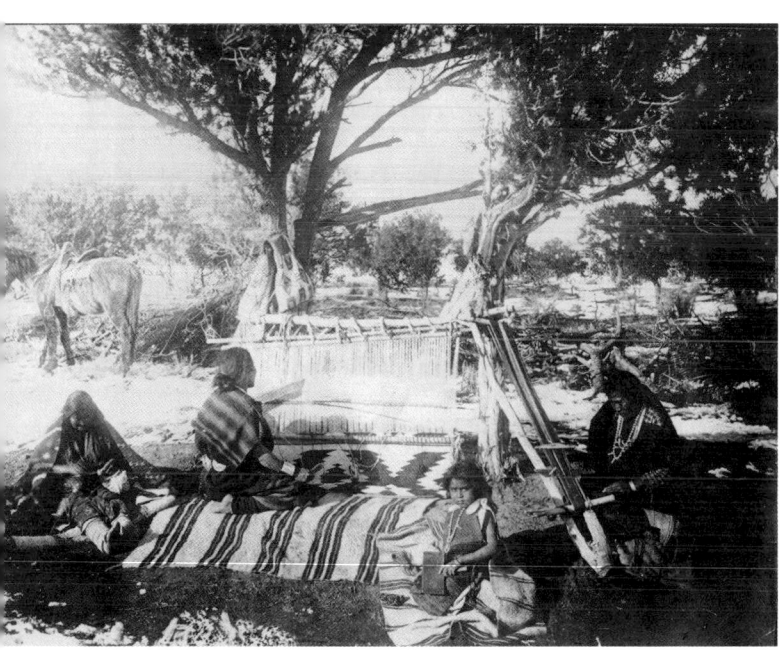

the eighteenth century, although the exact origins are uncertain. It is possible that the techniques were learned from more sedentary pueblo-dwelling tribes. According to Navajo mythology, however, the tradition was learned from the supernatural "Spider Woman," who taught Navajo weavers how to build and use looms, just as spiders weave webs.

Originally, the weaving was done using undyed cotton obtained in trading with other tribes. However,

by the early eighteenth century, Navajo weavers were converting to wool as they began to obtain sheep from the Spanish in Mexico. Indeed, the Navajo worked to develop a breed based on the Spanish churro (or churra) sheep, a breed that was compatible with the climate in the Southwest. Parenthetically, in the early twentieth century, the United States government began introducing the French rambouillet stocks into the breeding population. This was because they are hardier and produced more meat than the Navajo churro. However, their wool was not as suitable for weaving, and this resulted in lumpy blankets. By the 1930s, this experiment was terminated.

It can take a Navajo weaver from a couple of months to more than a year to hand-weave a blanket. The image of a Navajo woman seated at the floor before her upright loom became a favorite of nineteenth-century ethnographer-photographers, as well as with twentieth-century postcard photographers. The looms themselves were originally made of wood, though metal parts and metal looms were eventually introduced.

Early patterns were created using natural colors, although hues such as indigo were later obtained by trading. In terms of patterns, early nineteenth century Navajo blankets were designed mainly with contrasting colored stripes, with small rectangles being included by around 1840. Serrated, or stepped, diamonds and triangles were introduced into patterns around 1860,

becoming larger over the coming decades. By the nineteenth century, the Navajo were importing European yarn, particularly red "bayeta" yarn from England, because red was highly valued by the weavers, and harder to obtain as a dye than were other colors.

Navajo blankets, called "serapes" by the Spanish, evolved into valued trade items, and reached the outside economy in Mexico and the United States by the turn of the nineteenth century. Josiah Gregg, in his 1844 book *Commerce of the Prairies*, discusses Navajo blankets as a trade item.

J.T. Hughes, in *Doniphan's Expedition*, 1847, tells of the quality, writing that "The chief presented Colonel Doniphan with several fine Navaho blankets, the manufacture of which discovers great ingenuity, having been spun and woven without the advantage of wheels ... by a people living in the open air, without houses or tents. Of these the colors are exceedingly brilliant, and the designs and figures in good taste. The fabric is not only so thick and compact as to turn rain, but to hold water as a vessel. They are used by the Navahos as a cloak in the day time, and converted into a pallet at night."

In 1850, single blankets were being sold for the modern equivalent of nearly $1,500. Coincidentally, this is in line with prices today for contemporary Navajo blankets, though antique blankets sell for vastly higher sums.

Before the turn of the twentieth century, traders began influencing the design of the patterns on the blankets. The most influential traders in the marketing of Navajo textiles were probably J.B. Moore of Crystal, New Mexico, and John Lorenzo Hubbell, who began operating his famous trading post at Ganado, Arizona in the 1870s. According to noted Navajo textile expert, Mark Sublett, writing in *Western Art Collector* magazine, "Hubbell preferred a color scheme of red, white, and black, with natural grays. By the 1930s, Ganado area weavers had thoroughly adopted the color scheme, but had moved away from Classic-inspired weavings to new patterns with a large central motif—often a complicated diamond or lozenge shape—with a double or triple geometric border. These rugs frequently had a deep red 'ground' or field on which the central motif was superimposed, and are now known as the Ganado regional style."

Dr. Sublette believes that one of the most popular designs influenced by Moore was the Storm Pattern, "generally defined as a central rectangle connected by zigzag lines to smaller rectangles in each corner. The storm pattern often is said to have symbolic meaning: the zigzags are lighting, the corner rectangles are the four sacred mountains of the Navajo or the four directions or the four winds."

In terms of the market for Navajo blankets, the recession of 1893 reduced demand considerably, but there was a revival of interest in the art form in the 1920s. This was, in turn, followed by the Great Depression

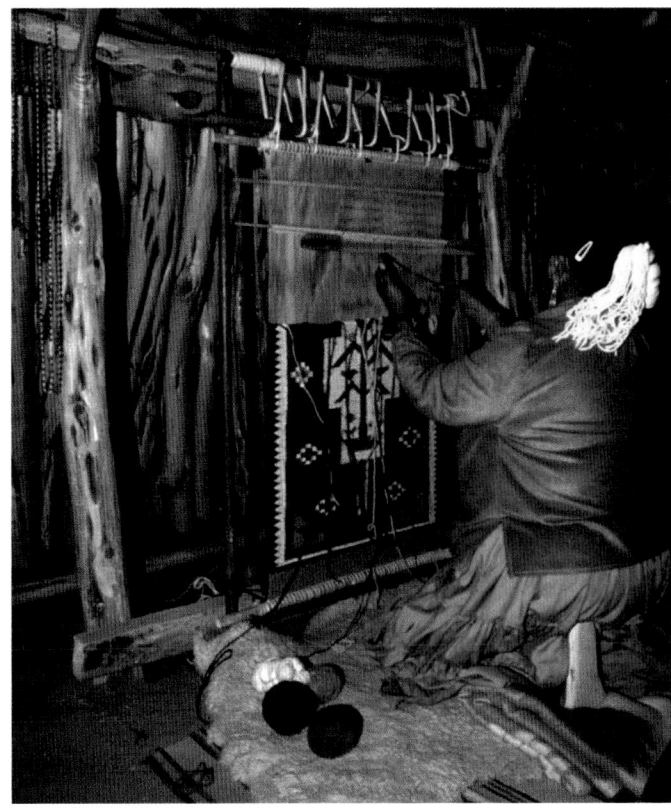

Above: A contemporary Navajo weaver at work on the Navajo Reservation in northern Arizona. Arizona Office of Tourism

Below: A Navajo woman seated, holding yarn, as photographed by Edward Curtis, c. 1904. LoC

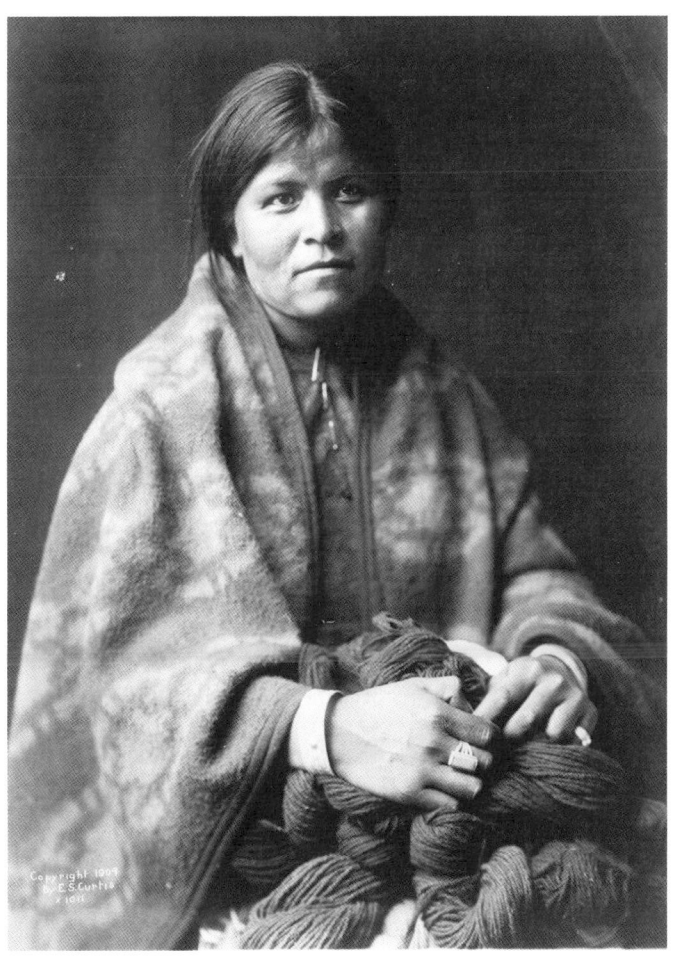

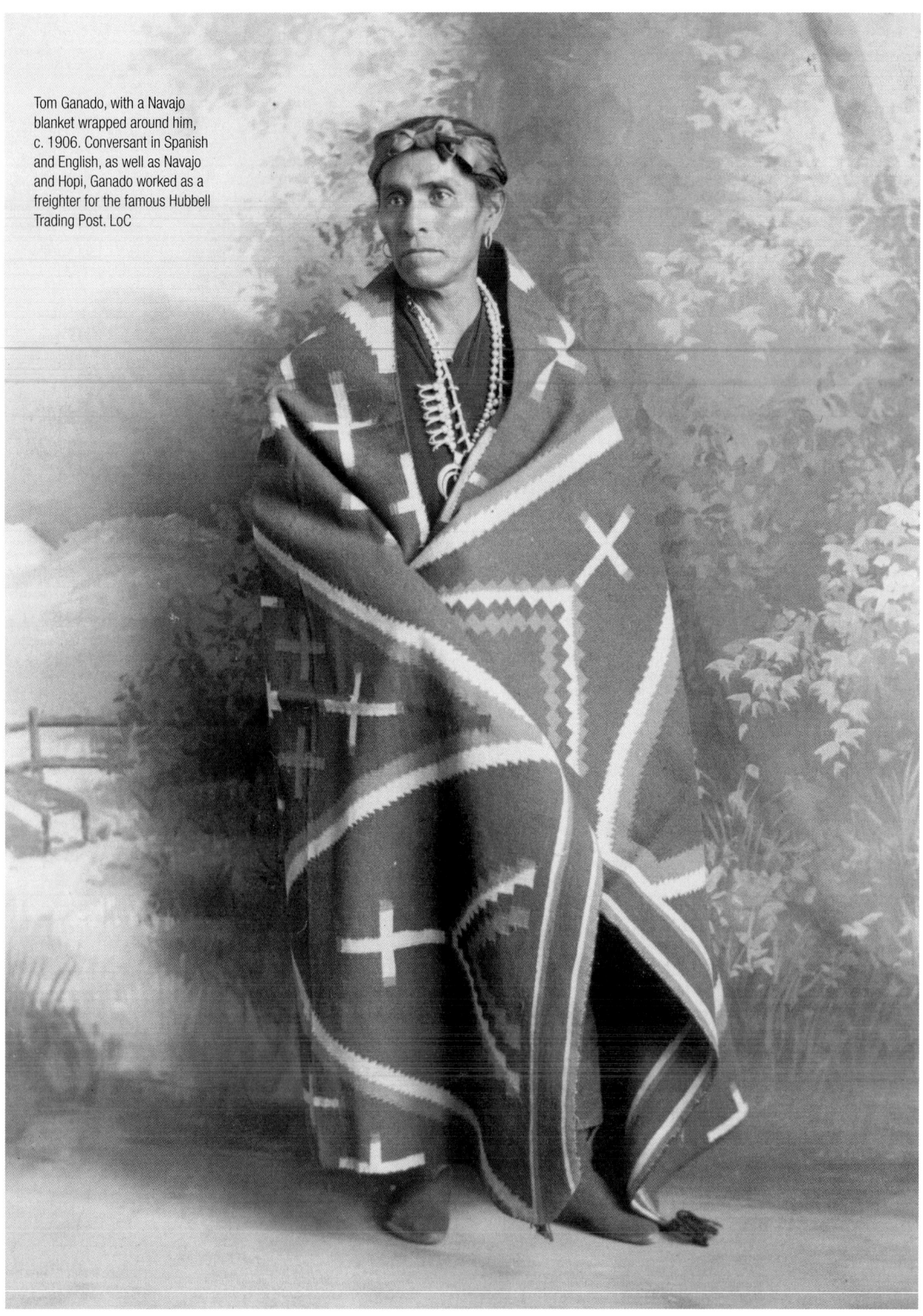

Tom Ganado, with a Navajo blanket wrapped around him, c. 1906. Conversant in Spanish and English, as well as Navajo and Hopi, Ganado worked as a freighter for the famous Hubbell Trading Post. LoC

period of the 1930s, and another revival of interest in Navajo textiles in the 1940s.

Lee and Eric Anderson, writing in A History of Navajo Weaving, observed that in the twentieth century "[a] combination of factors helped revive the Navajo weaving industry: continued demand for a good quality rug and the contribution of several farsighted people." Both the Andersons and Dr. Sublette credit Mary Cabot Wheelwright, founder of the Wheelwright Museum in Santa Fe, with being the catalyst for the introduction of vegetable dyes and softer, more subtle colors in the middle of the century. Out of the revival, Dr. Sublette notes, there developed several new "regional" styles which were based on a revival of early banded patterns. He observes that the resulting textiles "were not literal copies of older pieces, but were creative variations on banded designs using a wide palette of newly developed vegetal dye colors made from indigenous plants, as well as new, subtly colored chemical dyes."

Styles and patterns continue to change and evolve. In the 1960s, Gilbert S. Maxwell reported in *Navajo Rugs: Past, Present and Future* that half of all Navajo textiles were considered "regional," versus 25 percent that were considered "general" in style. By the end of the 1970s, H.L. James wrote in *Posts and Rugs* that the respective proportions had flipped to 25 and 40 percent respectively. By the end of the twentieth century, according to Eric Anderson, regional patterns were up to 40 percent, with general patterns being below 10 percent. At that time, he noted that a rapidly growing proportion of contemporary specialty designs accounted for about a third of all Navajo textiles.

Today, because of economic trends, the number of Navajo weavers, as a percentage of the Navajo population, is lower than at any time in the past century. While the prices of rugs have increased enormously, the amount of time involved in weaving one still limits the cost-effectiveness.

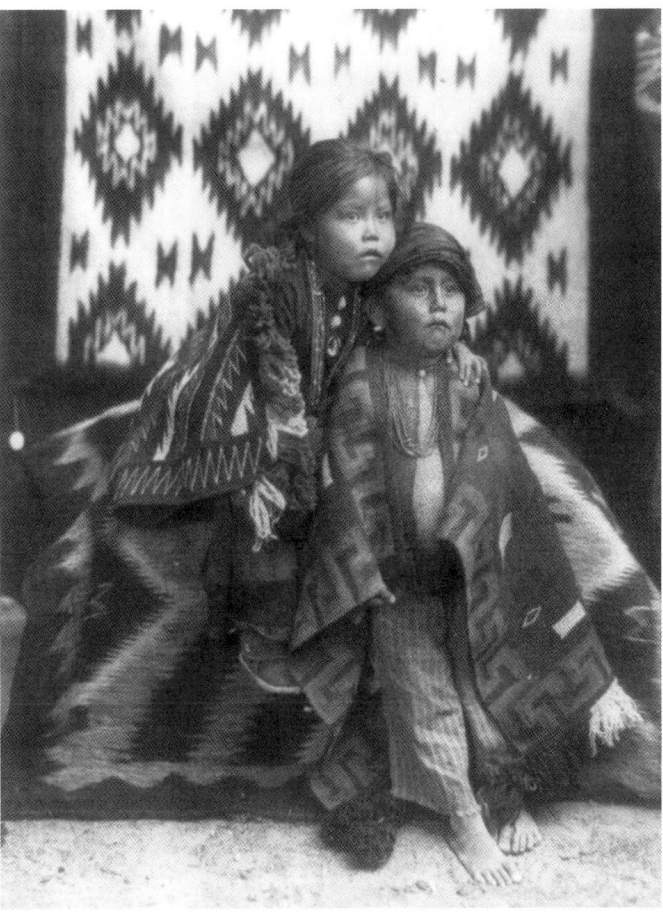

As Lee and Eric Anderson note "this is not true for the well known, award winning, weavers that dot the reservation. For them, the art is rewarding and, for those aspiring to greatness, these rewards are very attainable. For this reason, Navajo weaving is not a dying art; rather, it is becoming a very selective, highly competitive one."

Above: A Navajo brother and sister, as photographed by Pennington and Rowland, c. 1915, with a traditional Navajo blanket. LoC

Below: A nineteenth century Navajo textile pattern.

NAVAJO DRESS

As noted in the section of this book on Navajo blankets and rugs, the art of weaving was highly developed among the Navajo well before the nineteenth century. This made Navajo textiles of all types, not just blankets, also highly sought commodities in trading with other tribes. Navajo weavers traditionally wove cloth from native cotton, but readily incorporated wool into their tradition after the introduction of sheep via Mexico in the eighteenth century. The sheep also provided a source of leather in Navajo dress, especially in footwear. As with other Southwest people, the Navajo had traditionally used buckskin, but later also used leather from oxen as well as from domestic sheep.

Originally, the Navajo fabrics used in clothing, like those of other textiles, were of natural colors, such as browns, grays, and blacks. Eventually, both natural and imported dyes, such as indigo, as well as imported yarn, were incorporated into the process.

George Wharton James, who studied Navajo textiles extensively in the early twentieth century, writes that "red bayeta was undoubtedly the first touch of color [from imported yarn] introduced into [Navajo] dresses. It is a part of the romance of commercialism that the development of the art of dyeing and consequent enlargement of the artistic faculty in designing and weaving blankets of extraordinary patterns among the Navajos should have sprung from the introduction of a peculiarly woven and finished red cloth (bayeta) from the mills of the north of England."

James goes on to explain that the Navajo weaver was "led to unravel a piece of bayeta, re-spin it, and reweave it into her own fabric. This re-spinning was done for two purposes. Sometimes in unraveling the yarn became somewhat untwisted, and it was essential to re-spin it to give it proper strength for weaving. Again, the weaver desired a finer thread and a tighter texture than the piece of English woven 'baize,' hence she re-spun the yarn to give her the desired results."

Below: Juanita Manuelito, wife of Navajo leader Manuelito (center), with their two daughters and three grandchildren. At left is Shizie Manuelito and her daughter, and at right, Ahkinbah Manuelito, her daughter, and a boy, probably George Manuelito. They were photographed in 1901 by George Wharton James. LoC

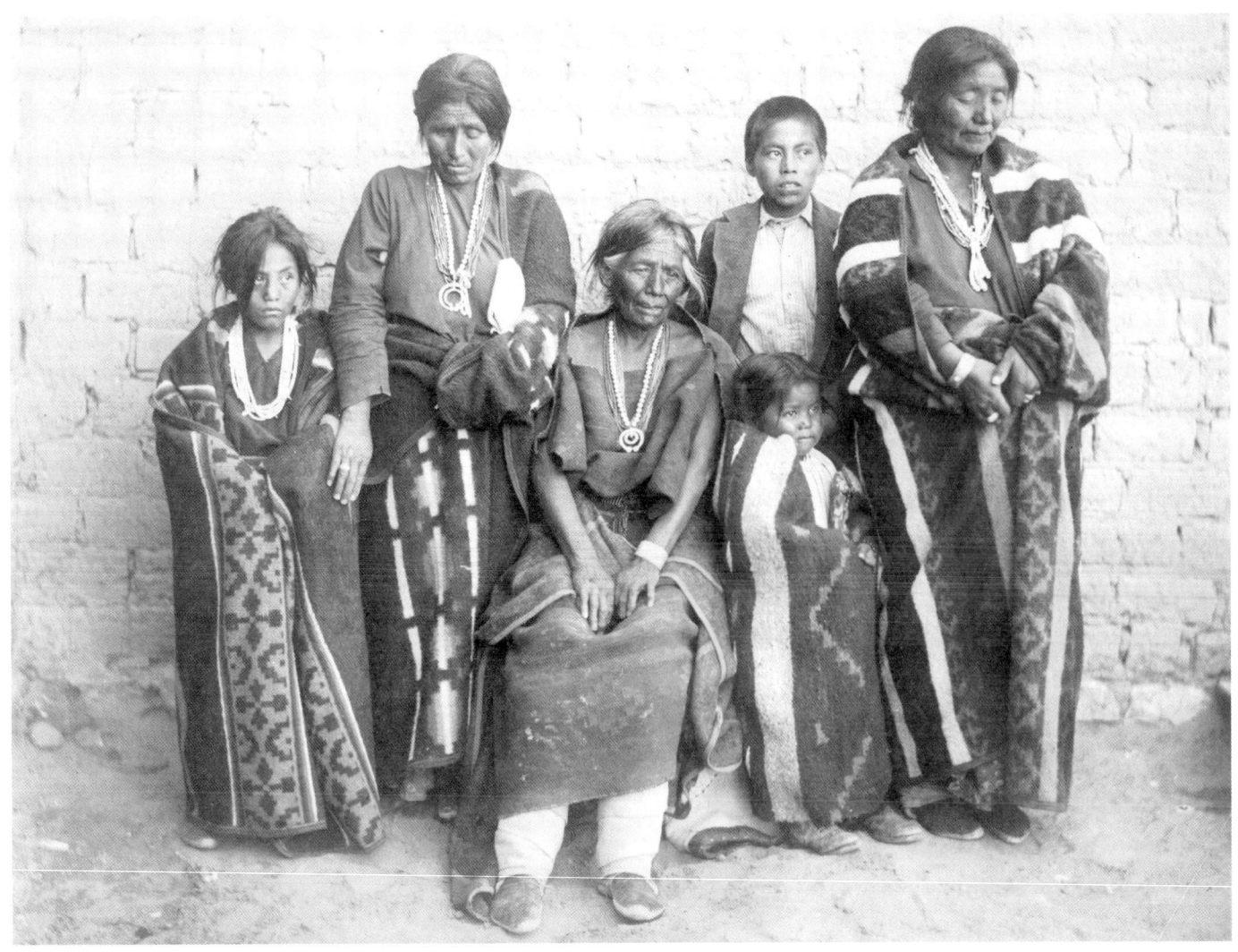

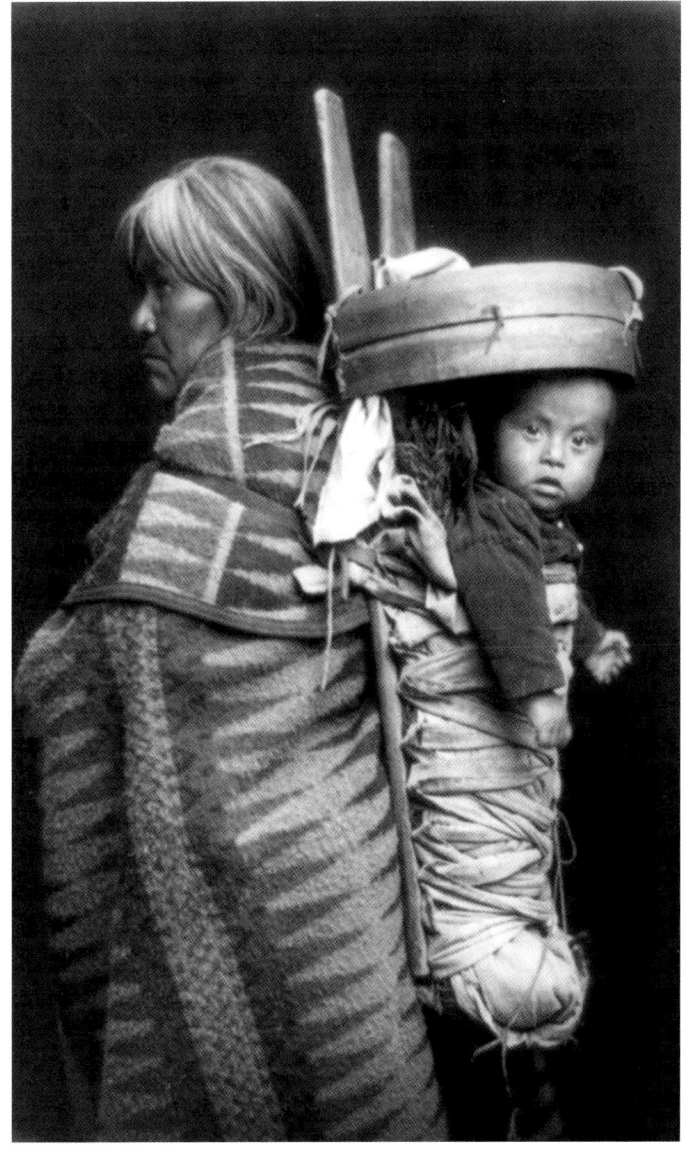

Writing on the subject of native clothing, Linda Martin, the associate editor of *Native Peoples Magazine*, who is Navajo herself, points out that by the 1880s, sewing machines and steel needles, and colorful calicos, wools, and velvets were more readily available and much sought after. With this, Navajo women adopted the Victorian standard of dress-high collars, fitted sleeves, and full skirts. Navajo women constructed tiered skirts from square fabric panels, crafted shirts with collars, and mastered fancier tailoring known as "tucking." Such trimmings as rows of silver buttons came later. She adds that in the twenty-first century, this classic Navajo style has deviated very little, yet "has been elevated to sophisticated levels that parallel the achievements of contemporary Native women."

Today, the classic Navajo women's dress style remains not only fashionable, but timeless. As Gallup-based designer Virginia Yazzie-Ballenger, says, "the Navajo style of dress is a classic design that has held its own over time."

Linda Martin refers to the traditional fluted broom skirt and velveteen blouse as "a fashion staple equal to the classic 'little black dress,' [that has] transcended the kitsch of the '50s era 'squaw dress' and the glamorized 'Santa Fe Style' made popular in the '80s. No longer considered costumes, the Navajo skirt and blouse—worn with pumps, cowboy boots or moccasins—has come to epitomize the spirit of Western femininity... Whether covered head to toe in velvet, satin, or cotton, the dress and manner of Navajo women expresses a modest, quiet dignity."

Meanwhile, in the Southwest, the Navajo garment industry has evolved from market stalls to clothing boutiques. Navajo women are now fashion designers and textile artists in their own right. Among these are Bessie Yellowhair, Wanda MacDonald, and Margaret Wood, whose work has been featured at the Heard Museum's Fashion Fusion exhibition.

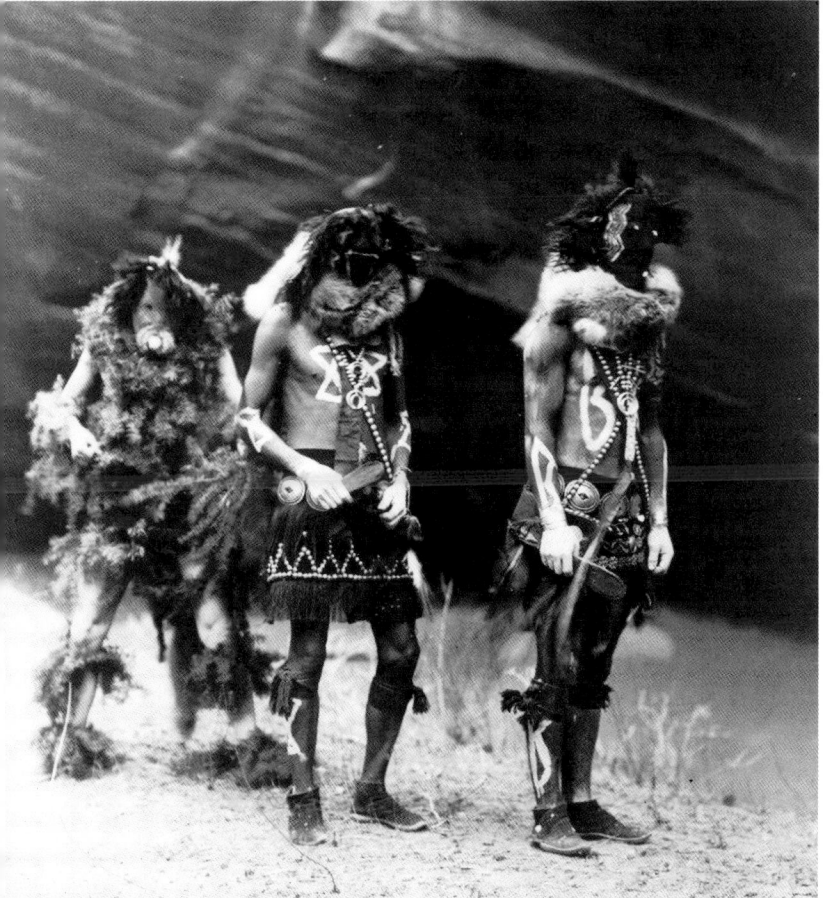

Above left: Navajo women and children as photographed by Pennington and Rowland, c. 1914. LoC

Left: Three Navajo in ceremonial dress, representing Tonenili, Tobadzischini, and Nayenezgani, the Yebichai war gods, as photographed by Edward Curtis in about 1904. LoC

SOUTHWEST BASKETRY

Basketry, or the weaving of utilitarian baskets using vegetable fibers, is common to cultures throughout the world. Such was the case among the peoples of the Southwest. All of the principal Southwest tribes, from the Apache and Navajo to the Hopi, Zuni, and other Pueblo peoples, had practiced basket weaving since before contact with Europeans.

The traditional materials were plants native to the deserts and mountains of the Southwest, such as bear grass, devil's claw, and yucca. The traditional method of weaving in most places was the coiled basket technique. Because the material, unlike pottery, is subject to physical deterioration, less is known about pre-Columbian basketry traditions than about pre-Columbian Southwest pottery.

The complexity of the baskets was proportional to the lifestyle of a given tribe. The more nomadic peoples generally had less complex wares than did the people living in pueblos. It should be noted, however, that the Apache, who were a very nomadic people and practiced agriculture only to a limited extent, developed a great deal of expertise in basketry. At a time when the other major Southwest tribes were developing a pottery tradition, the Apache concentrated on baskets, which better suited a mobile lifestyle.

Styles varied from place to place, as did the emphasis on basketry versus pottery. For example, among the Hopi, polychrome pottery became the artistic trademark on the First Mesa, while coiled basketry became the specialty of the Second, and wicker and twill basketry the style found on the Third.

In the twentieth century, Southwest basketry did not develop a collectible market to the same level as with Southwest pottery, or California basketry. However, some Southwest artists have emerged as important practitioners of the craft. One such is Arizona artist Annie Antone, a Tucson-born member of the Tohono O'odham (formerly called Papago). She specializes in traditional coiled baskets but these have unique, highly graphic, pictorial imagery. The imagery is occasionally inspired by ancient Hohokam pottery designs. Her work has been exhibited globally, from the Heard Museum in Arizona to the British Museum in London. She has been invited to exhibit and demonstrate basketry at the Smithsonian Institution numerous times.

Below: A contemporary Hopi basket weaver at work at the Tlaquepaque Village in Sedona, Arizona. Tlaquepaque Arts and Crafts Village

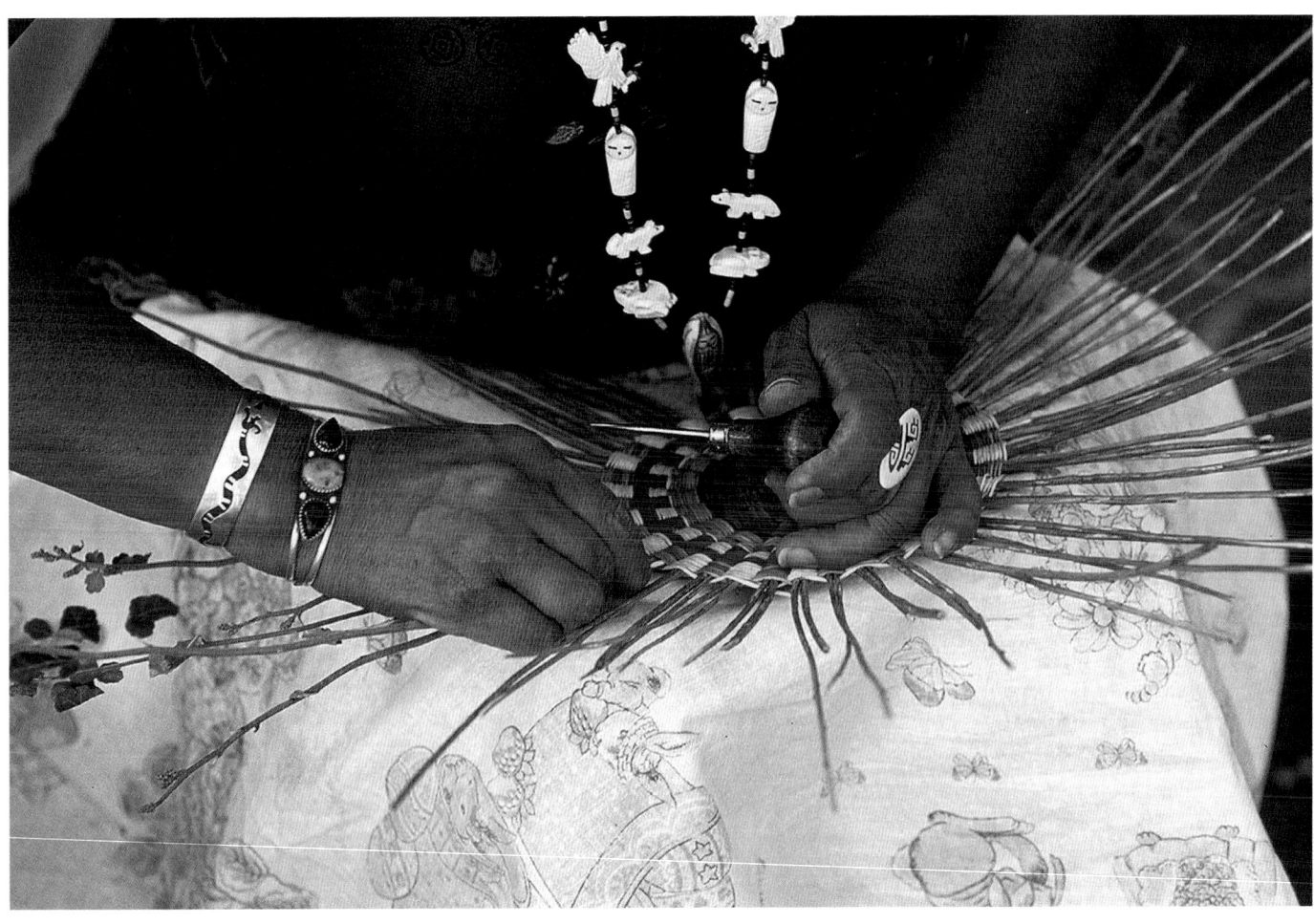

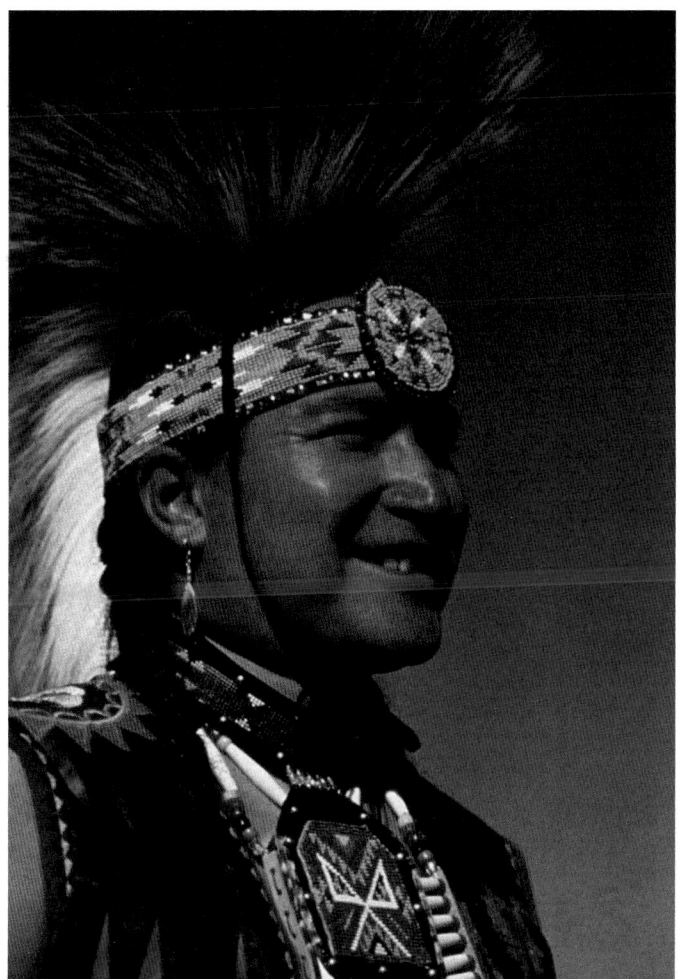

Above: Jones Benally in traditional attire, sings on the Navajo Reservation, Arizona. Arizona Office of Tourism

Below: Decked out in beaded headband, a Hopi dancer takes part in a festival in Tucson, Arizona. Arizona Office of Tourism

Below right: A Yavapai jeweler displays his wares at Fort McDowell, Arizona. Arizona Office of Tourism

SOUTHWEST BEADWORK

Beadwork is generally defined as the art of attaching beads to a surface such as cloth or leather for personal adornment, using a needle and thread. It has been seen in many cultures throughout the world for many centuries. Compared to other forms of jewelry, beadwork was traditionally never a prominent medium in the Southwest, as it was in other parts of North America, such as on the Plains or farther east among people such as the Sioux and Ojibwa, except among the Apache tribes. Buckskin women's dresses of the Western and Mescalero Apache, worn during the Girl's Puberty Rite, were often beaded and worn with a heavily beaded necklace and cape. The Jicarilla Apache men wore beaded shirts and leggings similar to Plains tribes. The Pueblo Indians also wore Plains costume with beadwork resembling those found in Oklahoma. Today, when traditions transcend traditional boundaries, most Indian beadwork comes from the Plains rather than from the Southwest in the form of Pan-Indian costume.

In pre-Columbian times, North Americans carved beads from wood or animal bones and teeth, or utilized shells. With the arrival of European traders, especially the British and French by way of the east and north, European-made colored glass beads were a highly popular trade item among the native people. This led to the origination of a beading tradition among the people who interacted with these traders, an interaction that made little impact on the Southwest. In the Southwest, people obtained shell beads through trading with coastal people, and the Navajo did carve small beads from turquoise, but these were used primarily in necklaces and bracelets.

Having said this, it is important to point out that contemporary Navajo artists have developed a beadwork tradition of their own. In her recent book, *Navajo Beadwork: Architectures of Light*, Ellen Moore studies the work of twenty-three individual artists, examining influences and their ideas. According to the University of Arizona, it provides "a valuable record of ethnographic research and a rich source of artistic insight."

SOUTHWEST DRESS

The traditional materials for clothing in the Southwest, as in many other areas of North America and the world, were cloth and leather. Historically, cloth in the Southwest was woven from native cotton, although with the introduction of sheep via Mexico, wool became available by the eighteenth century.

Because weaving had long been well developed in the Southwest, especially among the Navajo, cloth was much more available for clothing than it was in other adjacent regions, such as the Plains, where the use of buffalo leather was predominant. However, intertribal trade made both leather and cloth available to some degree in all areas. It is also important to point out that many Southwest peoples traded with the Navajo for both cloth and finished garments.

The traditional dress of most Southwest people consisted of breechcloths and kilts for the men, and longer dresses for the women. Over this, women often wore dark blue woolen blankets tied with an embroidered belt. The women, especially among the Hopi, Navajo, and Zuni, wore a woven shawl, called a "manta" over their shoulders. Those which were made for ceremonial

occasions or weddings, were elaborately decorated with embroidery. Today, original mantas from the nineteenth and early twentieth century are highly sought by collectors.

In the Southwest, footwear consisted of leather moccasins, usually made with buckskin rather than buffalo. By the late nineteenth century, leather from oxen and domestic sheep had become common. Leather leggings were often attached to the moccasins. Among the Hopi, the women painted their moccasins white for ceremonial dance events, and wrapped white buckskin strips around their shins as leggings.

The use of elaborate feather headdresses by the men, such as were worn among the Plains people and others, was rarely seen in the Southwest. If anything, a man would wear a headband. Face painting was also uncommon, except for ceremonial occasions.

Trade with other indigenous North American people made outside goods available in the Southwest, and so too did trade with Mexico, and later with the eastern

Below left: A woman in traditional dress at the Isleta Pueblo, c. 1910. LoC

Below: A Hopi woman's bridal wear, c. 1900, included thick leggings, a dark dress, and a white blanket draped across her shoulders. LoC

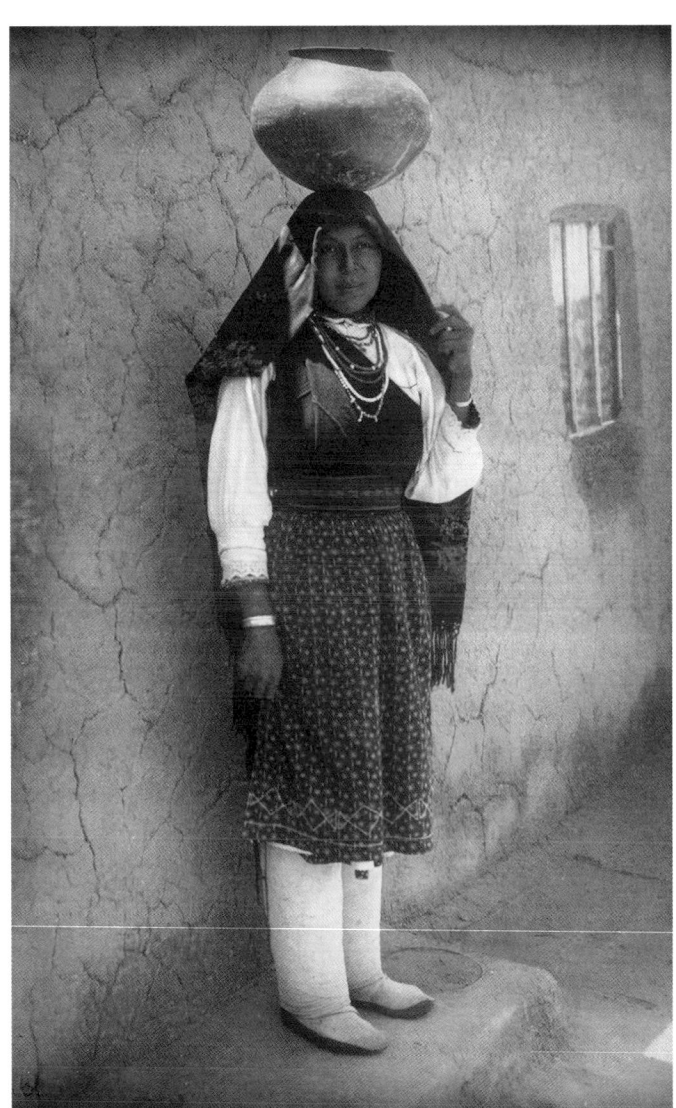

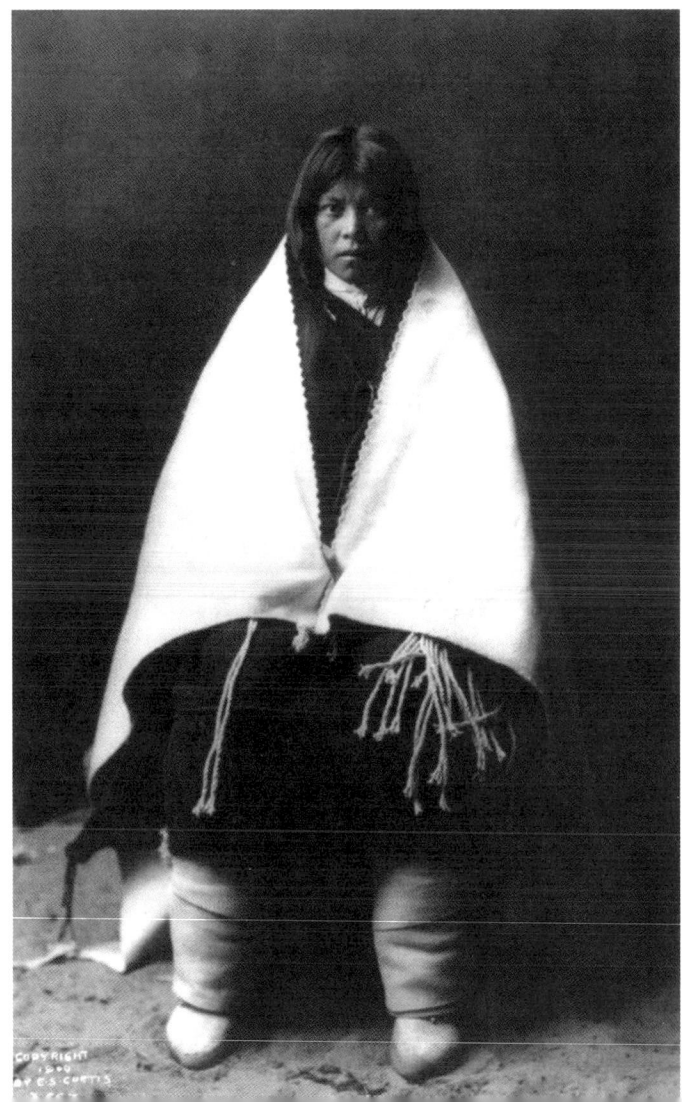

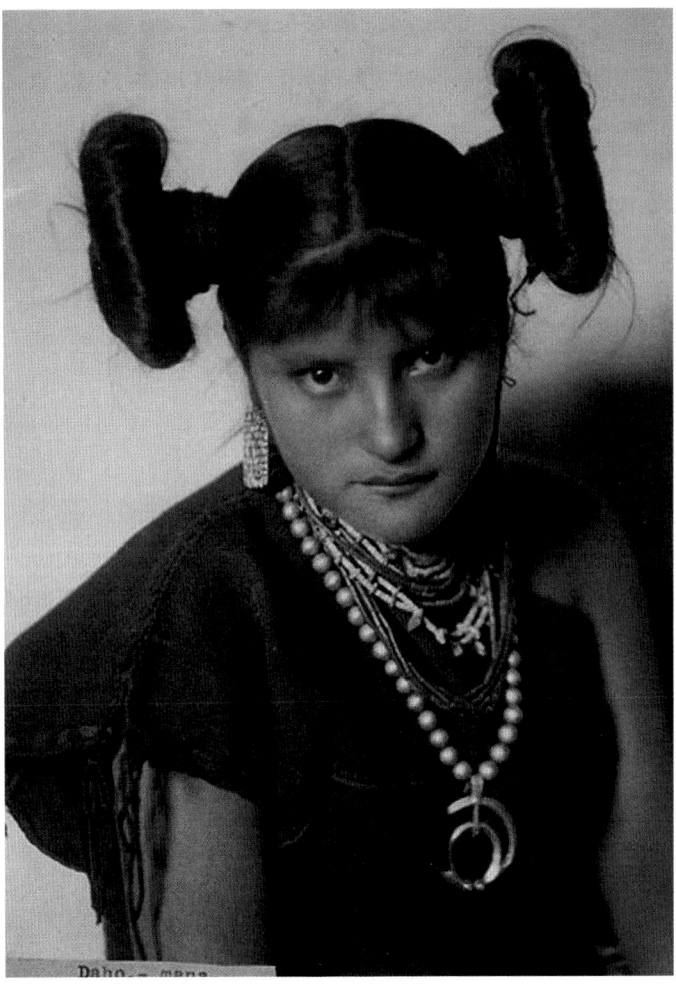

United States. Among the first items affecting dress were colored yarns, especially red, which were used in making cloth. By the nineteenth century, finished European or European-style clothing and footwear became widely available. These items were readily accepted and widely used, though traditional styles continued to be worn in daily life through most of the century.

In the Southwest, men traditionally cut their hair short in front and wore it longer elsewhere. Among the non-nomadic tribes, such as the Hopi, Zuni, and Pueblo people, it was common for the long hair to be tied back in a braid. During the nineteenth century, it became common for the men to cut their hair to shoulder length or shorter.

Women's hairstyles consisted of a figure-eight style bun called a chongo, especially among the Zuni. Hopi women adopted a most unique hairstyle which was a favorite of early photographers who visited their Three Mesas in the nineteenth century. Between the time of puberty and their marriage, young Hopi women traditionally wore their hair in elaborate butterfly whorls at the sides of their heads. These were seen as emulating the shape of the squash blossom, which was a symbol of fertility. To create the whorls, the young woman's mother would wind the hair around a curved wooden frame to shape it. In his field notes, the photographer Edward Curtis reports that this arrangement of the hair

Above left: A portrait of Daho-Mana, a young Hopi woman in the traditional hair style and wearing a silver necklace, as photographed by James Mooney, c. 1893. See also picture on p. 171 that shows the squash-blossom style of silver necklace. LoC

Above: Two women in traditional dress at the Nambe Pueblo, c. 1910. LoC

Opposite, above: A Hopi cobbler mending moccasins, c. 1908. LoC

Opposite, below: Scene from the famous Hopi Snake Dance, c. 1902. LoC

"imitates the squash-blossom and indicates virginity." He added that by the early twentieth century, the style had "become rare, except on ceremonial occasions."

Ritual costume is complex, colorful and typically involves masks, such as seen most notably in the Hopi Kachinas. Among the important events in the Hopi ceremonial calendar are the Powamu (bean dance), held in February and involving purification rituals, and the annual Snake Dance, which involves the use of live snakes, usually rattlesnakes.

Today, commercial dyes and commercially produced clothing manufactured in traditional styles make any native Southwest festival a colorful event.

040649. HOPI MENDING MOCCASINS.

SOUTHWEST JEWELRY

Jewelry has been a popular form of human adornment throughout the world since prehistoric times, with each part of the world having particular indigenous styles, utilizing specific materials. In North America, beads and porcupine quills were commonly used materials on the Plains and in the Woodlands, while along the coasts and seashores, seashells were used and traded to inland people.

In the Southwest, the signature gemstone was turquoise, a beautiful stone which derives its distinctive blue-green color from the presence of copper phosphate. Rare in much of the world, it was popular in ancient Egypt and Persia, but rarely exported to Europe until after the Renaissance. Within the United States, turquoise is found almost exclusively in the Southwest.

Turquoise jewelry has been fashioned by the indigenous people of the region since prehistoric times, and has been found in the Anasazi ruins at Chaco Canyon, as well at Mogollon and Hohokam sites. Tribes still present in the Southwest, such as the Hopi, Navajo, and Zuni, as well as the Pueblo people, incorporated turquoise into their own jewelry traditions.

For these people, turquoise has long been more than just an ornament, more even than a precious gemstone. The Pueblo people have had a centuries-old belief that turquoise is a fragment taken from the sky that has been preserved in stone, while the Zuni associate blue turquoise with the male element of the sky, and green with the female element of the Earth. The Hopi perceive turquoise as being capable of endowing magical powers, and taming flood waters. Both the Navajo and Apache, meanwhile, associate it with the bringing of rain. The Apache traditionally believe that turquoise can be found at the end of the rainbow.

Another material that is widely associated with Southwest jewelry traditions is silver, or metal alloys that are silver in color and/or which contain some silver. The widespread use of such metals in Southwest jewelry covers a much shorter time span than does the use of turquoise, although long before they began working in silver and silver alloys, Southwest metalsmiths had been working with copper and iron to create both jewelry and utilitarian items.

Southwest silversmithing dates to the early nineteenth century, when refined silver from Spanish sources in Mexico made its way into the Southwest in the form of coins or trade goods. As coins, both Mexican and American, became the principal source for the metal used, cheap alloys gave way to the 90-percent-plus silver content of the nineteenth century coinage in both countries. In addition to the traders, silversmiths from Mexico also visited the pueblos and Navajo villages early in the nineteenth century, demonstrating their art, selling their wares, and perhaps inspiring some would-be Southwest silversmiths.

Various sources, including John Adair in his 1944 book *The Navajo and Pueblo Silversmiths*, as well as Carl Rosnek and Joseph Stacy three decades later in *Skystone and Silver*, believe that silversmithing among the Southwest peoples did not begin until the 1850s. They agree that the first important Navajo silversmith to achieve lasting recognition in the outside world was Atsidi Sani (Old Smith), who was active in the 1860s during the period (1864–8) when the Navajo people were rounded up and interned en masse by the U.S. Army.

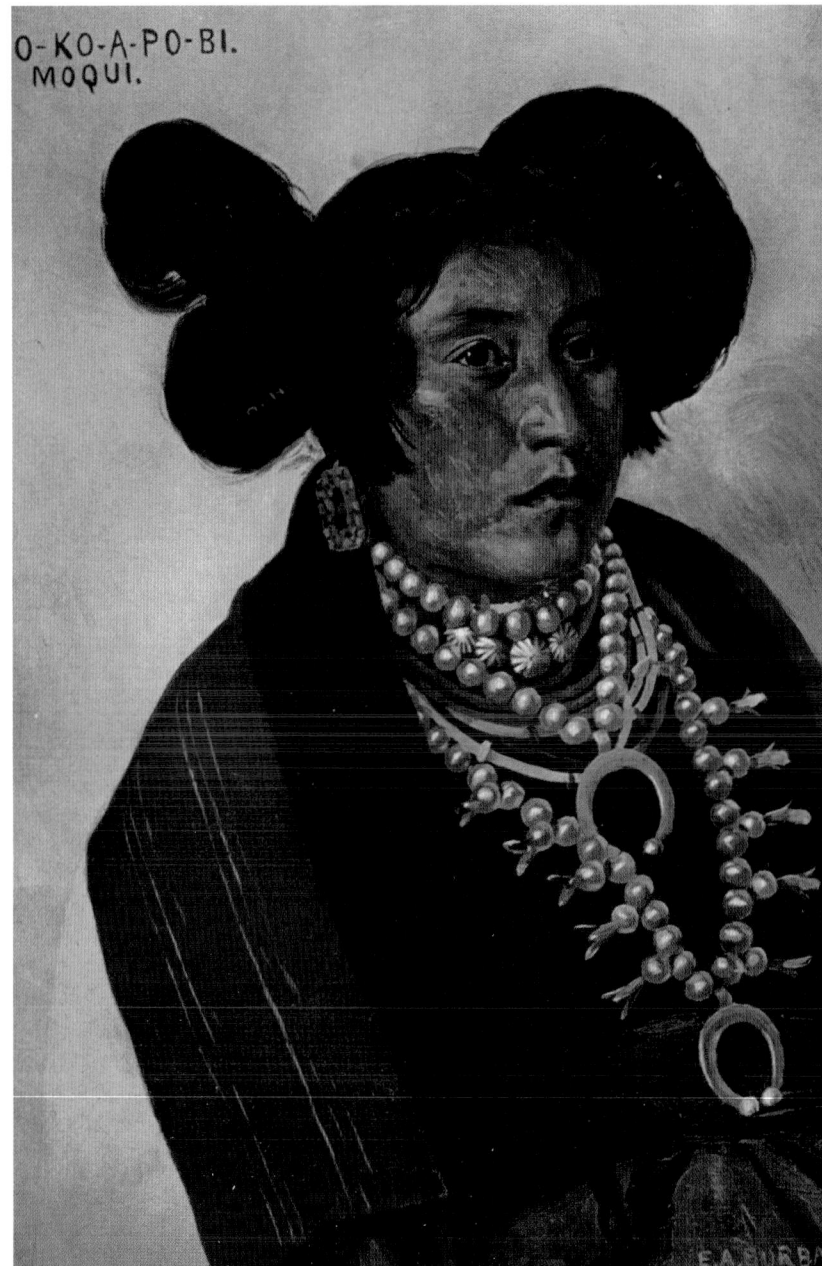

Opposite: Dancers in traditional costume at a recent Native American Victory Days Parade on the Fort McDowell Yavapai Reservation. Arizona Office of Tourism

Right: A portrait of Okoapobi, a Hopi woman wearing a traditional silver squash blossom necklace, painted by Elbridge Ayer Burbank, c. 1900. LoC

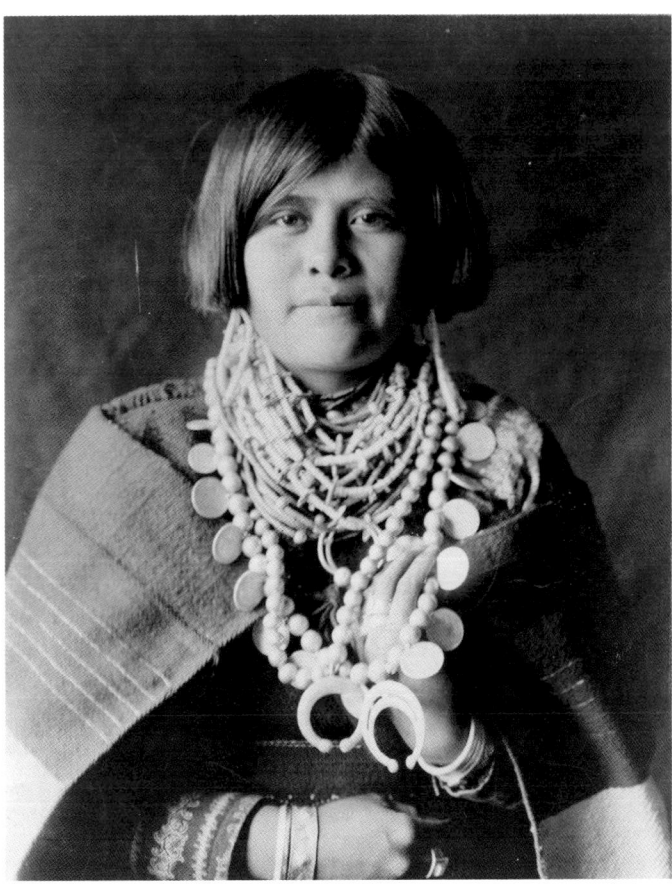

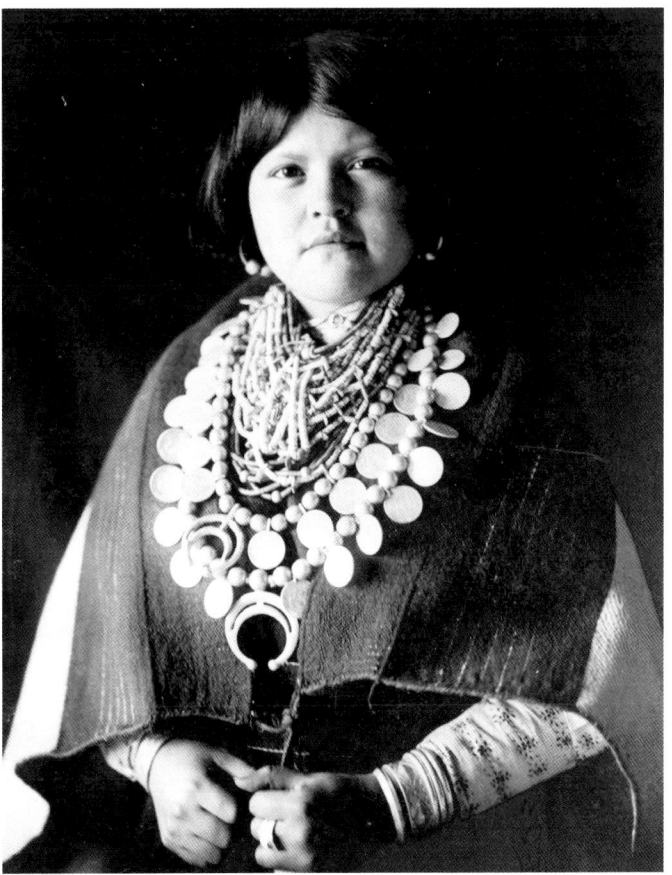

Above: This photograph by Edward Curtis, c. 1903, of a Zuni girl wearing several necklaces, provides a good view of the traditional Zuni jewelry style. LoC

Above: A Zuni woman wearing an elaborate silver necklace, c. 1903. LoC

Below: A Navajo silversmith at work, as photographed by Pennington and Rowland, c. 1914. LoC

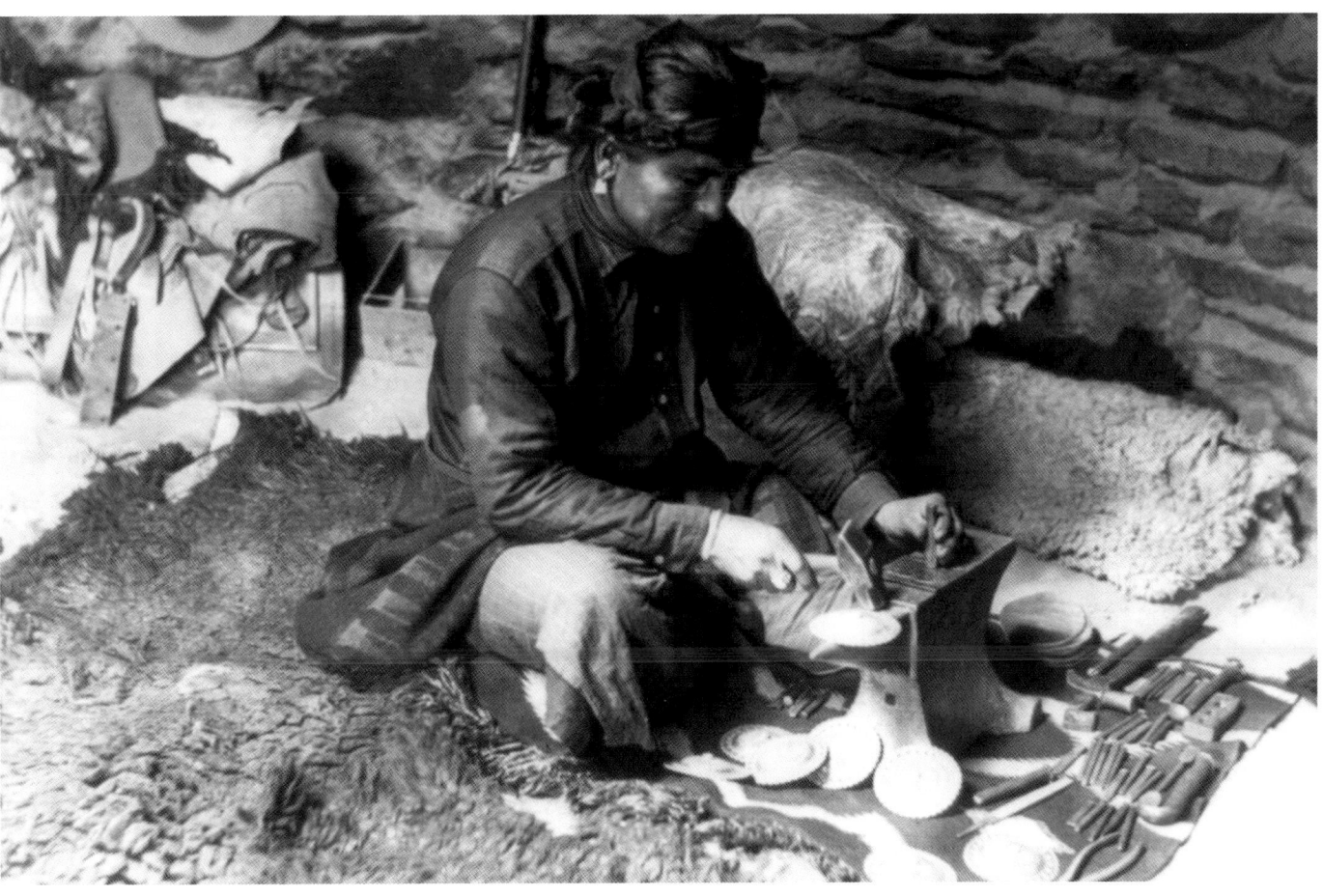

Copyright 1904
By E.S.Curtis
X 1019

Above: A Navajo woman wearing a silver squash blossom necklace and a concho belt,
with a blanket draped over shoulders, as photographed in 1904 by Edward Curtis. LoC

In turn, Atsidi Sani shared his techniques with members of his tribe and his family. One of them, Atsidi Chon (Ugly Smith), is credited with having passed the tradition on to Lanyade, the first great Zuni silversmith. In the 1870s, it was Lanyade who taught the art to the first important Hopi silversmith, Sikyatala.

Adair, Rosnek, and Stacy go on to note that the earliest Southwest silver jewelry consisted of hammered work such as bracelets and necklaces, as well as the familiar concho belts, which are still a popular item of Southwest jewelry.

By the 1880s, the repertoire of jewelry items being created by Southwest silversmiths as trade goods had expanded, and now included more finely crafted items, such as belt buckles, bolo ties, earrings, hair ornaments, pins, and rings. All of these types of items have remained popular locally, as well as with outside consumers, ever since.

Also by this time, Southwest jewelers had begun incorporating turquoise into their silver goods, forming the foundation for the familiar and enduring Southwest tradition.

If silver and turquoise pieces constitute the signature jewelry tradition of the Southwest, then the single piece that is the signature element within that tradition is the squash blossom necklace. As Lee Anderson points out, the squash blossom necklace is "the cornerstone of most Indian jewelry collections." He describes it as "truly an Indian creation," but one that has its roots deep in non-Indian culture and history. The centerpiece of the necklace, both literally and figuratively, is the crescent-shaped pendant, which the Southwest people had first seen as an iron ornament on the horse bridles of the Spanish Conquistadors in the sixteenth century. He adds that "these ornaments soon graced the necks of the local Indian populace. Their acquisition was a matter of pride and the ornament, reproduced in the various metals, was proudly displayed during ceremonials. These pendants, originally brought from Spain, reflected the influence of earlier Moorish conquests and the occupation of Spain. As generations came and went, the pendant, referred to as a najahe or naja, became symbolic with various ceremonials."

The squash blossom necklace combines the crescent centerpiece with strings of silver beads that are interpreted as being in the form of squash blossoms, the symbol of fertility among the indigenous farmers of the Southwest. However, the Navajo originally described these beads simply as "yo ne maze disya gi," meaning the "bead which sprouts out." It may or may not have actually represented a squash blossom.

Because of the evolution of silversmithing techniques, it is generally believed that the silver squash blossom necklace in its familiar form did not appear until around 1880. While the necklace originated among the Navajo, the incorporation of inlaid turquoise

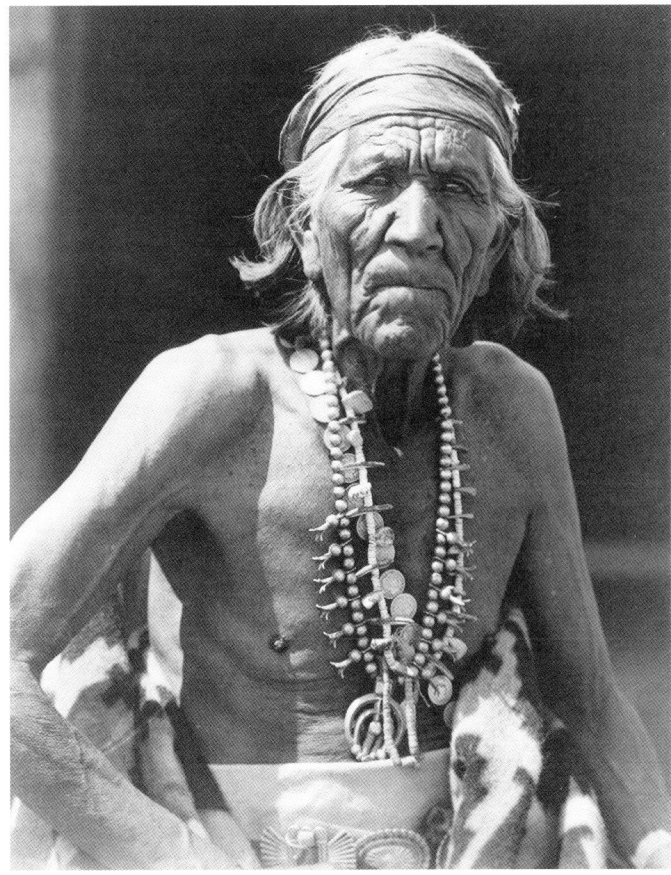

Above: Many Goats of the Navajo, wearing a squash blossom necklace, as photographed by Roland Reed in 1913. LoC

Below: Jewelry being worn by an Apache girl about fourteen years of age, c. 1903. LoC

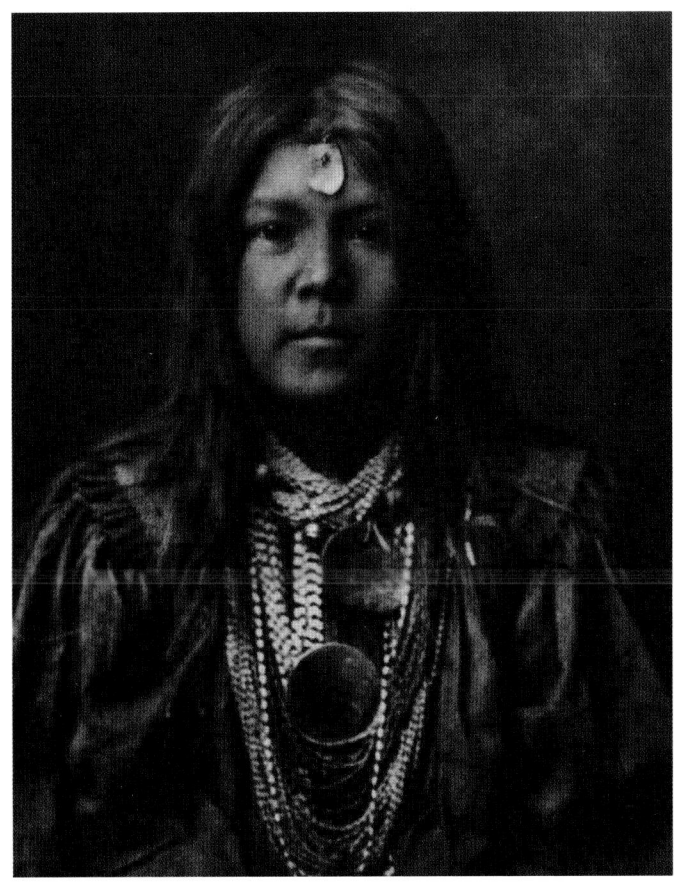

in the design is believed to have first been done by Zuni jewelers.

Just as Southwest jewelry was an important and high-value trade commodity in the nineteenth century, it has remained as such through the twentieth century to today. Through the years, much has been done to encourage the development of the art form. For example, in 1938, the Museum of Northern Arizona in Flagstaff, Arizona, working with Hopi silversmiths Paul Saufkie and Fred Kabote, began a program of developing a style that was exclusively Hopi.

As Lee Anderson writes in *The History of American Indian Jewelry*, "The 'overlay' technique they created involved the cutting of designs in a heavy gauge silver sheet and then soldering this to a solid silver sheet. The designs were usually adapted from the pottery shards found in the Sikyatki Pueblo ruins of the fifteenth and sixteenth centuries. These pre-Hopi designs were mostly bird motifs. The Hopi Guild also used Kachina symbols, animal and clan motifs."

At the turn of the twenty-first century, the tradition is alive in the Southwest, with many important and award-winning jewelers and silversmiths. Born into the Hopi tradition is jeweler Preston Duywenie, who is married to contemporary pottery artist Debra Trujillo Duywenie. Beverly Etsate is an acclaimed contemporary Zuni inlay artist and is the daughter of well-known Zuni jewelers Rosalie and Augustine Pinto.

Important contemporary jewelry artists among the Navajo are Calvin Begay, Thomas Charley, Jimmy Harrison, Bennie Ration, Tommy Singer (the son of Navajo shaman Tsinnigine Hathali), David Tune, and Timmy Yazzie, who is also part Pueblo out of San Felipe.

Charlene Sanchez-Reano, meanwhile, is a contemporary jeweler born at San Domingo who married jeweler Frank Reano at the Kewa (formerly Santo Domingo) pueblo. Other notable contemporary jewelry artists with roots at the Kewa pueblo are Ava Marie Coriz, Joseph Coriz, Angie Reano, and Joe Reano.

By the end of the twentieth century, a new page in the history of Southwest jewelry had been turned. While old traditions survived, new traditions were forming. As Lee Anderson writes, "today's Indian silversmiths are, in many cases, also goldsmiths and lapidaries. They cross tribal design boundaries with will and abandon. No longer can you look at a piece and say, 'It's Zuni style so it must be Zuni-made.' The artist of today may incorporate into a single piece all the styles available, plus his or her own innovation. Indian jewelry today transcends tribal styles."

Right: Dia Molnar, a Navajo woman, is seen here in November 2008, wearing a traditional Navajo dress made by her aunt and traditional jewelry made by another Navajo tribal member. U.S. Government photo by Kendra Williams

SOUTHWEST POTTERY TRADITIONS

The making of utilitarian pottery has been common in various cultures worldwide, and across North America, for millennia. In the Southwest, traditions of finely decorated pottery are particularly notable. Archeological discoveries show that this tradition flourished within the ancient Anasazi, Mogollon, and Hohokam civilizations a thousand years ago.

Archeological data indicate that pottery progressed from a functional pinch-pot greyware to a more decorative style by the eleventh century, while decorative colors other than black and white were being used by the fifteenth century.

From pre-Columbian times to the present day, pottery has been an important element of the decorative art being produced in the Southwest. Indeed, from the late nineteenth century, potters who once made ceramics only for routine daily use have evolved into artisans, who ply their trade with an eye to collectors and the fine art market.

Among the most highly prized Southwest ceramics are those which have been part of the Pueblo traditions, both ancient and contemporary. A notable, and widely copied, Mogollon decorative style developed in the Mimbres River valley. Known as Mimbres Pottery, ware that utilizes Mimbres motifs is still being produced by contemporary artisans in the Southwest.

As noted above in the section on the Adobe Cities, the contemporary Pueblo tradition continues in the Southwest today among the Zuni and Hopi, as well as among the people of the Rio Grande pueblos of northern New Mexico.

The Zuni and Hopi have lived in mountaintop pueblos since the 1690s, where they moved in order to defend themselves from the Spanish, though they inhabited the region for about a millennium prior to that. The Zuni pueblo is atop Dowa Yalanne in northwestern New Mexico. The Hopi (shortened from "Hopituh Shi-nu-mu," meaning "the Peaceful People") remain on the "Three Mesas" in northeastern Arizona. Among the best known cities are Waalpi (Walpi) and Hano (Tewa) on the First Mesa, and Oriabi on the Third Mesa. Each had its own separate

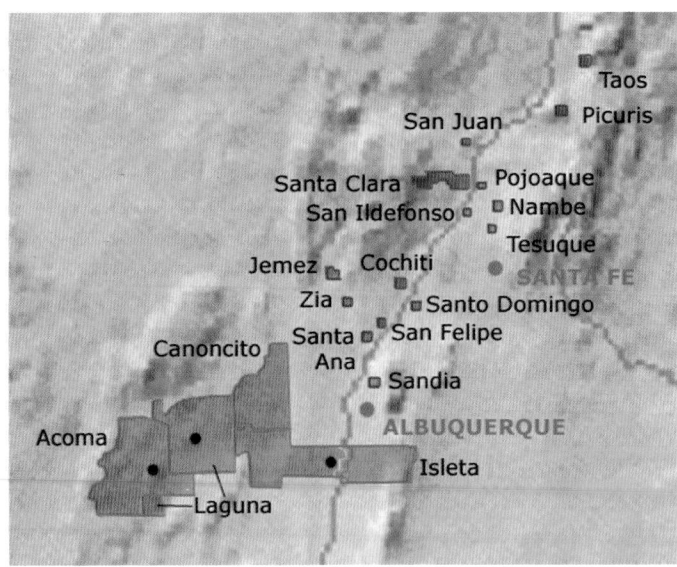

Above: A map of Rio Grande Pueblos in New Mexico, showing their relation to the cities of Albuquerque and Santa Fe, and to the Rio Grande itself. Canoncito is a Navajo reservation. Created by Nikater, based on copyright free images from Demis and licensed through Creative Commons

Below: A ceramic Hopi jar by the legendary potter Iris Nampeyo, c. 1880. She developed her own style based on the traditional designs. Phyzome photo, licensed under Creative Commons

culture and pottery style, which was similar, though not identical to the others.

The Rio Grande pueblos are grouped as to the language spoken. The Keres- or Keresan-speaking pueblos are those of Acoma, Cochiti, Kewa (formerly Santo Domingo), Laguna, and Zia. The Tewa (or Tano) pueblos are those of Nambe, Ohkay Owingeh (formerly San Juan), Pojoaque, San Ildefonso, Santa Clara, and Tesuque. The Tiwa (or Tigua) pueblos are Taos and Picuris in the north, as well as Isleta and Sandia, near Albuquerque, in the south.

In the Southwest tradition, the ware is built up with coils of clay rather than being turned on a wheel as in ceramic traditions in other parts of the world.

Specific traditional forms of Southwest pottery include bowls and the spherical wide-mouthed jar known as the olla, which was traditionally used for carrying water. Most of the oldest pre-Columbian pottery was decorated in black, though Pueblo ceramics since the nineteenth century were commonly decorated in red plus black.

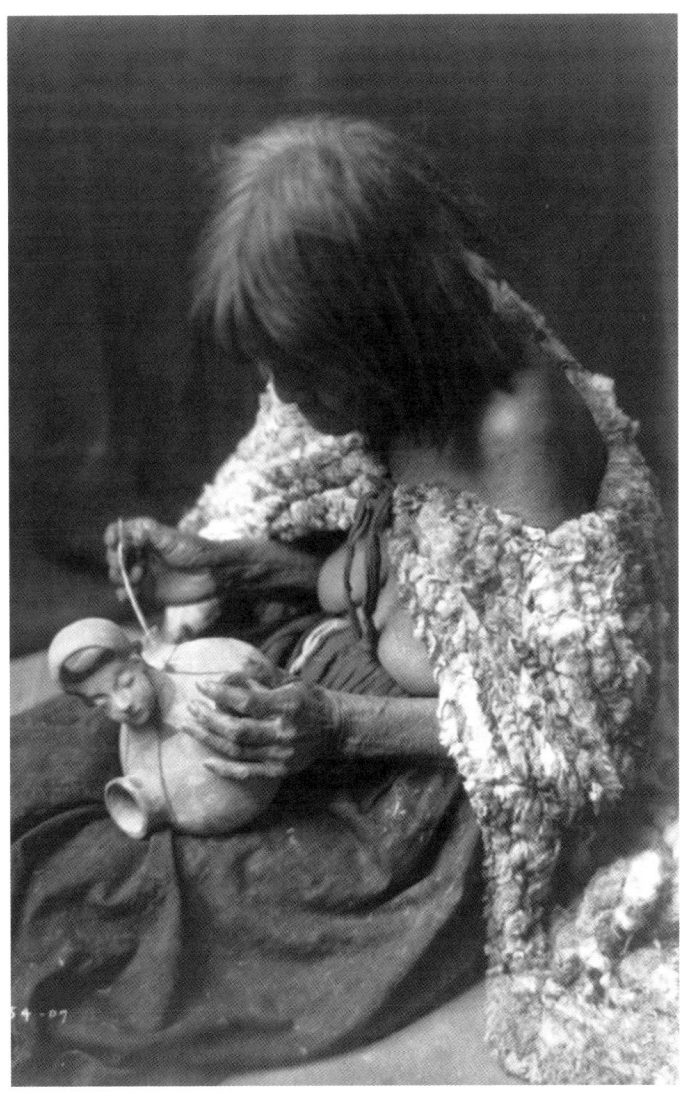

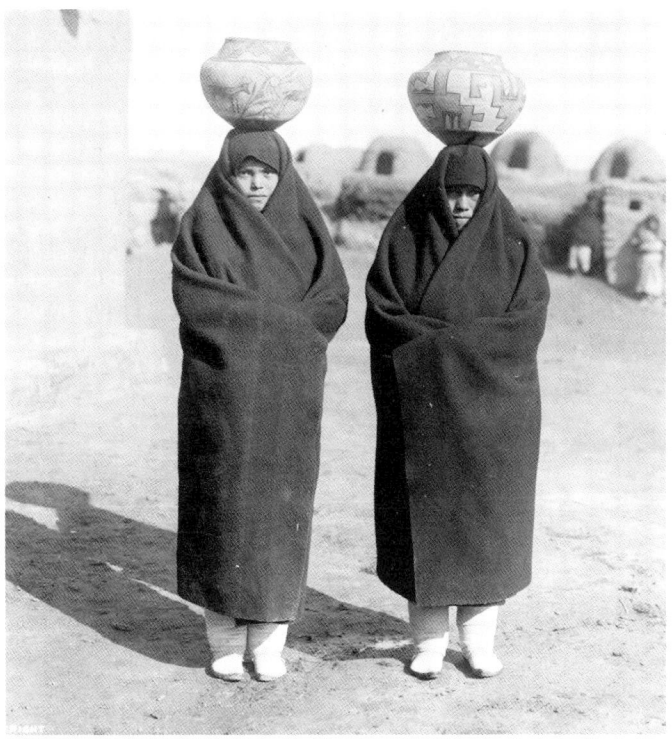

Above: A pair of Zuni women carrying large water jars decorated with traditional Zuni designs, c. 1903. LoC

Left: An old Mojave woman with a rabbit skin blanket around shoulders, painting a design on a piece of pottery with a yucca stem brush, as photographed by Edward Curtis, c. 1907. Created for the tourist market, the piece has a startlingly non native motif. LoC

Below: Iris Nampeyo, the famous Hopi potter, building her kiln, as photographed by Edward Curtis in about 1906. LoC

The clay itself ranges in color from nearly white to deep red, with the latter known as "redware." Both San Ildefonso and Santa Clara were known for their black-on-black pottery. Known as "blackware," it dates back to before the eighteenth century, and was reintroduced in the early twentieth century. At the Acoma pueblo, strictly black on white pottery is traditional, and it is still made.

By the fourteenth century, long after the disappearance of the Anasazi civilization, a major center of pottery making had emerged at the Hopi city of Sikyatki. Since abandoned, it was located close below the First Mesa. Here, Hopi potters were developing innovative clay mixtures, as well as new firing techniques, to produce pottery with a smoother, more durable texture than elsewhere, and a broader variation in colors, from pale yellow to deep oranges and reds. This was achieved both by the color of the clay and by herbal dyes. For about 200 years, Hopi Sikyatki polychrome ware was the state of the art in Southwest pottery. Thereafter, the quality of Hopi ware deteriorated until the Sikyatki style was revived in the late nineteenth century.

Leading the renewal of the Hopi tradition were potters such as Iris Nampeyo (1860–1942) of the Hano Hopi. Her Tewa name, Num-pa-yu, means "snake that does not bite." One of the most renowned of all Southwest potters, she proved her artistic skill as a child, basing her work on traditional designs. She began making a good living in her teens, selling her wares through a local trading post. By the turn of the century, she had a worldwide following. Though she began losing her sight in 1925, she continued to make pots by touch. The painting was done by her daughters, who continued her tradition.

Below: An excellent view, c. 1903, of a pottery jar in a distinctive Zuni motif. LoC

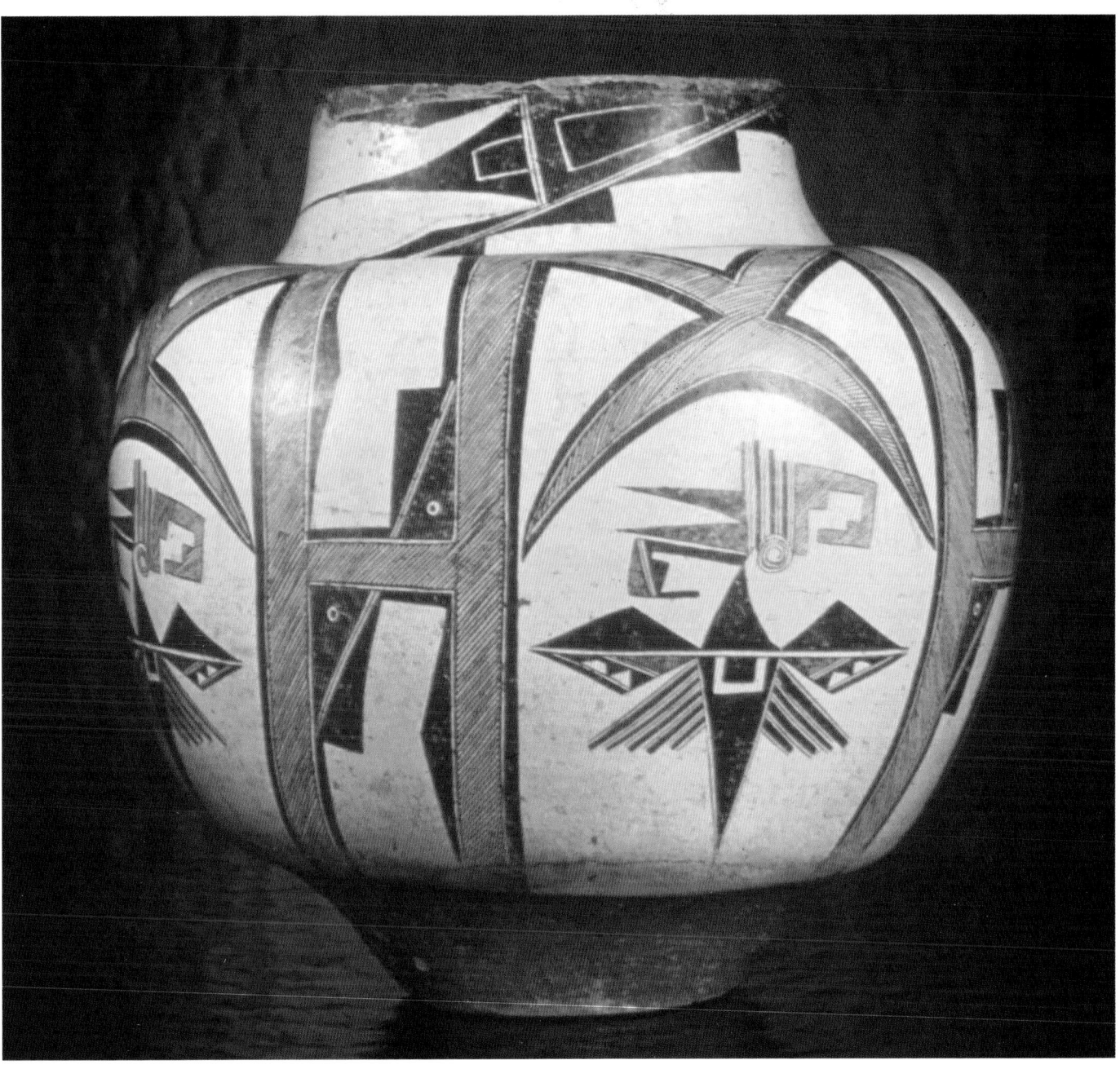

Among her descendants well known for their own pottery work are her daughter, Fannie Nampeyo; her granddaughter, Elva Nampeyo; her great-granddaughter, Dextra Nampeyo Quotskuyva; and her great-grandson, Nolan Youvella Nampeyo. Dextra has become one of the best-known descendants of the matriarch Nampeyo. In 1995, she was declared an "Arizona Living Treasure" and in 1998 she received the first Arizona State Museum Lifetime Achievement Award.

Another important family of Hopi potters is descended from Helen Naha (1922–93), known as "Feather Woman." Her granddaughter, Tyra Naha and great-granddaughter Amber Naha-Black are also award-winning potters whose work is in collections such as that of the Heard Museum in Arizona.

At the San Ildefonso pueblo, Maria Montoya Martinez (1881–1980) and her husband Julian "Pacano" Martinez (1879–1943) were key artists in the revival of the black-on-black blackware tradition. When such pottery was rediscovered by archaeologists around the turn of the twentieth century, Maria Martinez was the first contemporary San Ildefonso potter to revive the making of pots in the style. Though it took years of experimentation, she rediscovered a way to use smoke to tint the red clay black. Julian meanwhile developed the process for producing San Ildefonso blackware with both matte and glossy surfaces on the same pot. By 1920, Maria's work was well known globally. In her later years, Maria worked along with her son Popovi. With a grant from the National Endowment for the Arts, she started a pottery workshop in 1973, which passed the tradition to succeeding generations.

San Carlos pueblo artists Sara Fina Guiterrez Tafoya (1863–1949) and Jose Geronimo Tafoya (1863–1955) were matriarch and patriarch of a clan of Santa Clara potters which has done much to revive the blackware art at Santa Clara. Their daughter, Margaret Tafoya (1904–2001), continued her mother's tradition of making very large pots with finely polished surfaces. She became one of the most important creators of fine blackware in the twentieth century. She also occasionally made redware, and worked with her husband Alcario Tafoya (1900–95) as her parents had done.

Among their descendants who became well-known potters are Virginia Ebelacker (1925–2001) and Lee Tafoya (1926–96), as well as Mary Esther Archuleta, Toni Roller, Luann Tafoya, Shirley Tafoya, Meldon Wayne Tafoya, Jennie Trammel, Nathan Youngblood, and Nancy Youngblood, who has won around 300 awards for traditional pottery.

At the Santa Clara pueblo, important contemporary potters include Anita Louise Suazo, the daughter of Jose Nerio Suazo and noted potter Belen Tapia (1914–99), as well as the husband and wife teams of Margaret and Luther Gutierrez, and Linda and Merton Sisneros, who are known for both blackware and redware. Also at Santa Clara, Joseph Lonewolf is well known for designs reminiscent of the Mimbres motifs.

In the twentieth century, the Acoma pueblo was home to such great ceramic artists as Lucy M. Lewis (1898–1992) and Marie Zieu Chino (1907–82). They led the revival of early Acoma styles, as well as Mimbres motifs. Marie, who was well known for her fine-line, black-on-white pottery and vases, won her first award at the age of fifteen, and went on to become quite famous. Her youngest daughter, Vera Chino Ely, is a highly regarded contemporary artist in her own right.

Top: A San Ildefonso Pueblo blackware pottery motif. AGS

Above: A Cochiti Pueblo redware pottery motif. AGS

Basic and Complex Navajo Pottery Patterns
as documented by Dr. J. Walter Fewkes of the US Bureau of Ethnology in 1898

Southwest Pottery Patterns

Parallel lines in zigsag pattern

Parallel lines with marginal serrate

Lines with alternate triangles

Single line with hourglass figures

Single lines with arrowhead motif

Single line with closed fret

Single line with open fret

Single line with broken fret

Open fret with attachment displaced

Simple rectangular design

Rectangular reversed S-form

Rectangular S-form with crooks

Rectangular S-form, terraced triangles

S-form with interdigitating spurs

Square with rectangles & parallel lines

Crook, feathers, and parallel lines

Triangle with parallel and oblique bands

Double triangle with terraced edges

Crook with serrated end

Key pattern with rectangle and triangles

Rectangle, triangle, and serrated spurs

Double triangle with two breath feathers

W-pattern with terminal crooks

W-pattern, terminal terraces, and crooks

W-pattern with bird form

W-pattern with median triangle

W-triangle with median trapezoid

Mimbres

Mimbres

Mescalero Apache

Tohono O'odham

Pima

Pima

6. CALIFORNIA

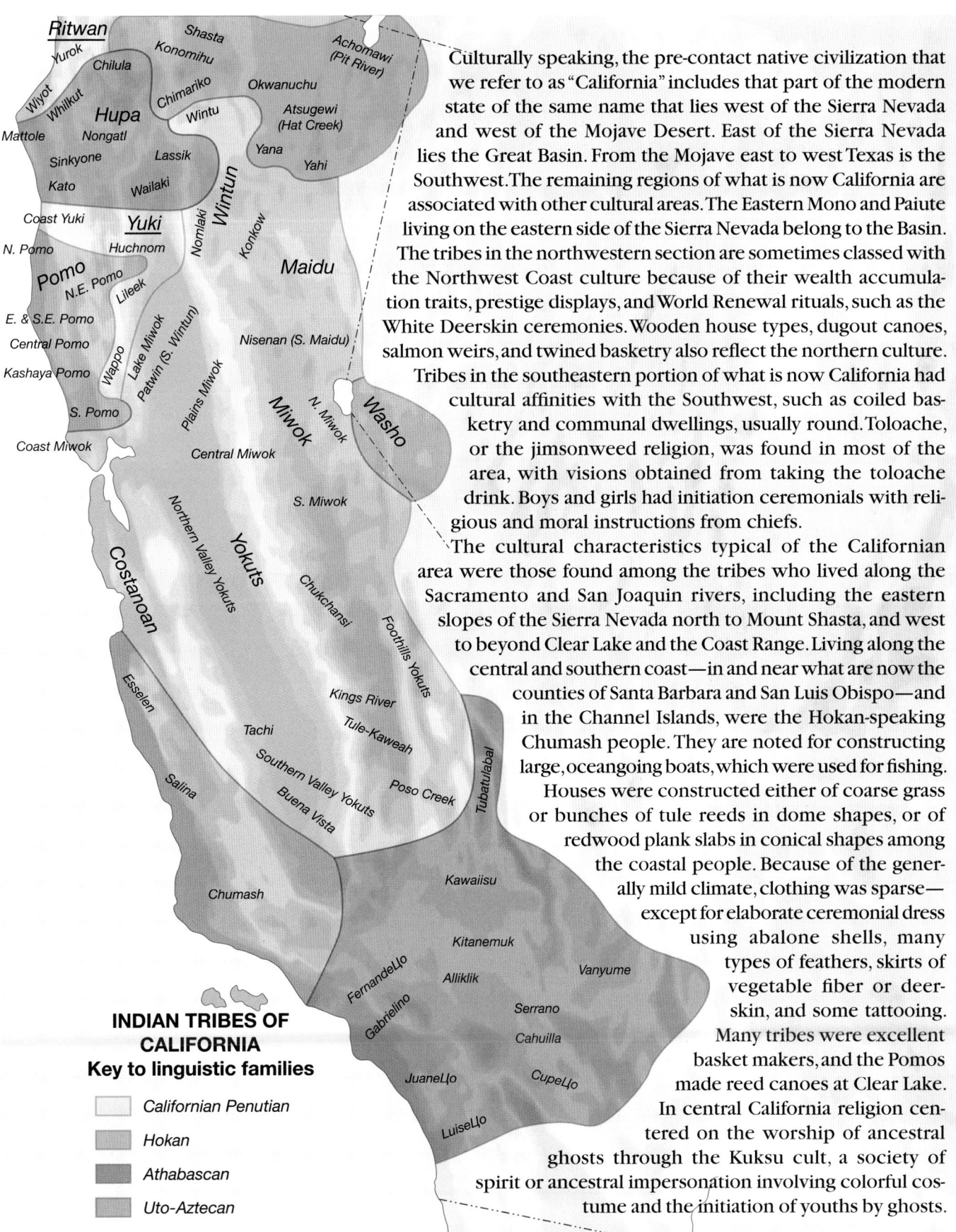

INDIAN TRIBES OF CALIFORNIA
Key to linguistic families

- Californian Penutian
- Hokan
- Athabascan
- Uto-Aztecan

Culturally speaking, the pre-contact native civilization that we refer to as "California" includes that part of the modern state of the same name that lies west of the Sierra Nevada and west of the Mojave Desert. East of the Sierra Nevada lies the Great Basin. From the Mojave east to west Texas is the Southwest. The remaining regions of what is now California are associated with other cultural areas. The Eastern Mono and Paiute living on the eastern side of the Sierra Nevada belong to the Basin. The tribes in the northwestern section are sometimes classed with the Northwest Coast culture because of their wealth accumulation traits, prestige displays, and World Renewal rituals, such as the White Deerskin ceremonies. Wooden house types, dugout canoes, salmon weirs, and twined basketry also reflect the northern culture.

Tribes in the southeastern portion of what is now California had cultural affinities with the Southwest, such as coiled basketry and communal dwellings, usually round. Toloache, or the jimsonweed religion, was found in most of the area, with visions obtained from taking the toloache drink. Boys and girls had initiation ceremonials with religious and moral instructions from chiefs.

The cultural characteristics typical of the Californian area were those found among the tribes who lived along the Sacramento and San Joaquin rivers, including the eastern slopes of the Sierra Nevada north to Mount Shasta, and west to beyond Clear Lake and the Coast Range. Living along the central and southern coast—in and near what are now the counties of Santa Barbara and San Luis Obispo—and in the Channel Islands, were the Hokan-speaking Chumash people. They are noted for constructing large, oceangoing boats, which were used for fishing. Houses were constructed either of coarse grass or bunches of tule reeds in dome shapes, or of redwood plank slabs in conical shapes among the coastal people. Because of the generally mild climate, clothing was sparse—except for elaborate ceremonial dress using abalone shells, many types of feathers, skirts of vegetable fiber or deerskin, and some tattooing. Many tribes were excellent basket makers, and the Pomos made reed canoes at Clear Lake. In central California religion centered on the worship of ancestral ghosts through the Kuksu cult, a society of spirit or ancestral impersonation involving colorful costume and the initiation of youths by ghosts.

CALIFORNIA BASKETRY

Basketry was the signature art form of the California people, just as blanket weaving was for the Navajo of the Southwest. It was a medium at which California tribes excelled, and one which defined an important artistic tradition that is still alive today, notably in the vast swath of territory north of San Francisco Bay and south of the Siskiyou Range. In this area, the tribes that were most notable for their basketry were the Hupa, the Miwok, the Pomo, the Yokuts, and the Yurok.

California basket makers often wove their wares so fine that they were watertight, making them excellent as utilitarian containers. Traditionally, the baskets were made for cooking or storage, but were also used for fish traps, and fragile baskets made with feathers were given as gifts or as tributes. The materials used included various grasses and rushes, as well as redbud and willow. Among most tribes, the basket weavers were women, and the art was traditionally passed by example from mother to daughter.

The making of baskets was so widespread and the basket makers so prolific that it seemed to some outsiders to be not just the primary avocation among the northern California people, but the only one. Probably with tongue in cheek, photographer Edward Curtis observed in his field notes that "basketry was the principal, and [as of 1924] the only, manufacturing industry of the Yokuts." He went on

Above: A Paiute Indian woman making a basket, as photographed by Charles C. Pierce, c. 1902. LoC

Left: This Yokuts basket with pictographs representing men and women, dates from the late nineteenth or early twentieth century. SFSU

Below left: Paiute basketmaker, as photographed by C. D. Nichols in northern Nevada, near the California border, c. 1904. LoC

Below: A narrow-mouthed Yokuts basket tufted with feathers, circa late nineteenth or early twentieth century. SFSU.

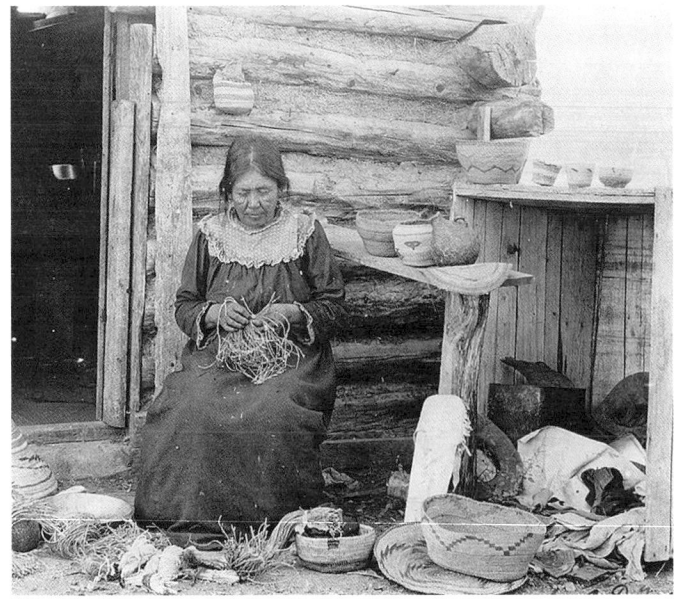

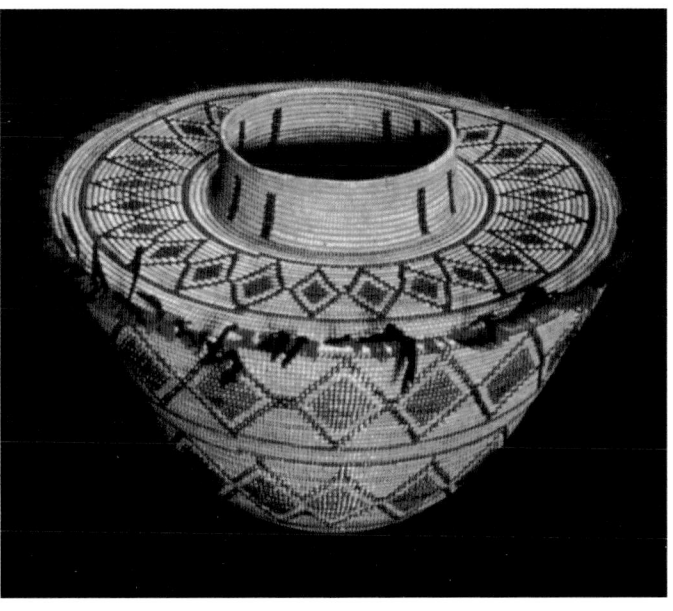

to provide more useful information, adding that "both the coiled and the twined process are followed, but the better baskets, and by far the greater number, are coiled. The examples shown in the plate are coiled, and of the kind used for cooking liquid foods by means of heated stones."

Coiling, especially among the Pomo, involved a spiral stitched around a foundation of willow sticks. Meanwhile, the typical Pomo twining involved the wrapping of a woof thread perpendicularly around the warp foundation. The twined weaves used by the Pomo included diagonal, lattice twining, and three-strand twining, as well as three-strand braiding.

As with many indigenous North American arts and crafts, the fine California baskets were an important trade item in the nineteenth century that became the object of serious collecting by outsiders in the twentieth century. Among the important Pomo basket weavers who made names for themselves in the twentieth century, and whose work resides in important collections, are Elsie Allen (1899-1990) and Mabel McKay (1907-93). Allen, who was also well known for teaching traditional Pomo basketry at the Mendocino Art Center, had learned the craft from her mother, Annie Ramon Gomachu Burke (1876-1962) and her grandmother, Mary Arnold (1845-1925), both of whom were accomplished weavers. Mabel McKay was also a shaman who believed that she had been taught weaving in her dreams. She later lectured at universities and served as a cultural consultant for anthropologists.

Another important center of California basket making was in the vicinity of Yosemite Valley and

just across the Sierra Nevada near Mono Lake. Among the important twentieth-century basket makers from this area are Carrie McGowan Bethel (1898–1974) and Nellie Charlie (1867–1965) of the Kucadikadi (Northern Paiute); Louisa Keyser (Dat-So-La-Lee c. 1829–1925) of the Washoe; and Lucy Parker Telles (1870–1956), who was part Mono Lake Paiute and part Miwok. As Brian Bibby writes in Native American Art of the Yosemite Region, these women "became known for their exceedingly fine, visually stunning and complex polychrome baskets." All of these women gave weaving demonstrations in Yosemite National Park, and both Carrie Bethel and Lucy Telles also did so at the 1939 Golden Gate International Exposition. Three decades after Bethel's death, one of her baskets sold at auction for $216,250.

Prominent among the more recent California basket makers is Susan Billy of the Pomo. The great niece of Elsie Allen, she started weaving in 1973 at the age of twenty-two. Like her great aunt, she contributed a great deal to the preservation of the traditional art. As she is quoted in the 1986 Coe Native Traditions Collection catalog, Susan Billy explains that "I feel that the generations before me tried all the different materials and found these to be the best, so I'm pretty strict on that. We use willow—sometimes stripped, sometimes with a thin bark left on. Then we use three main colored fibers: white is sedge grass root, bulrush root for black, and new shoots of the redbud for a reddish-brown color …

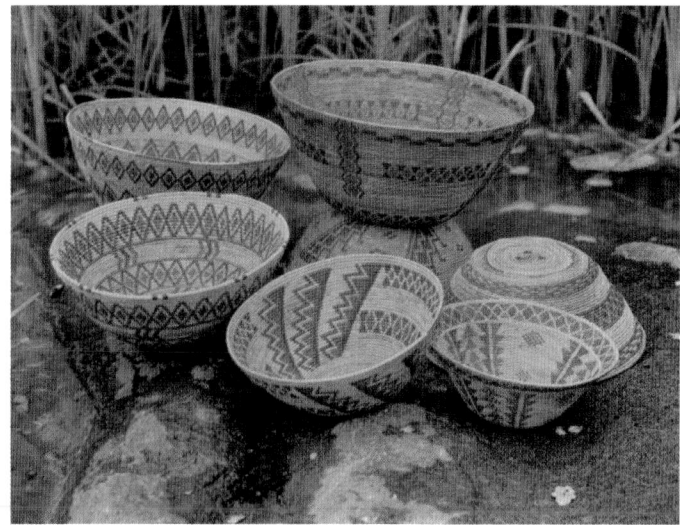

Above: Karok baskets as photographed by Edward Curtis, c. 1923. LoC

Opposite, above: A Yokuts basket with pictographs representing birds, butterflies and flowers, circa late nineteenth or early twentieth century. SFSU

Opposite, below: A Miwok basket with a simple geometric design, circa late nineteenth or early twentieth century. SFSU

Below left: Chukchansi (Yokuts) cradle baskets photographed by Edward Curtis, c. 1924. LoC

Below: A Hupa female shaman photographed by Edward Curtis, c. 1923, wearing dentalium shell headbands, a necklace, and holding up two baskets. LoC

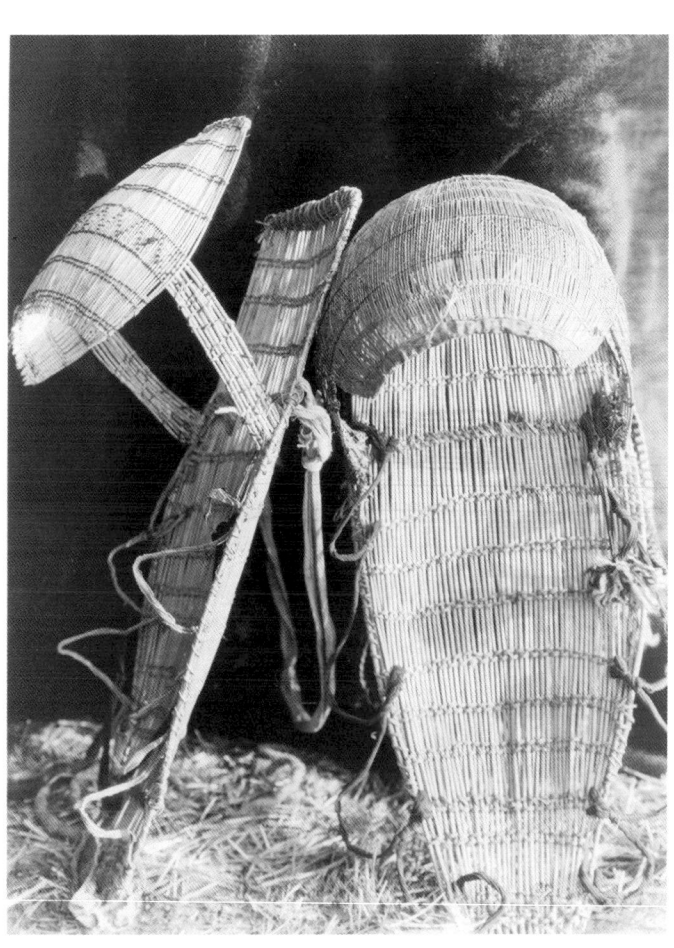

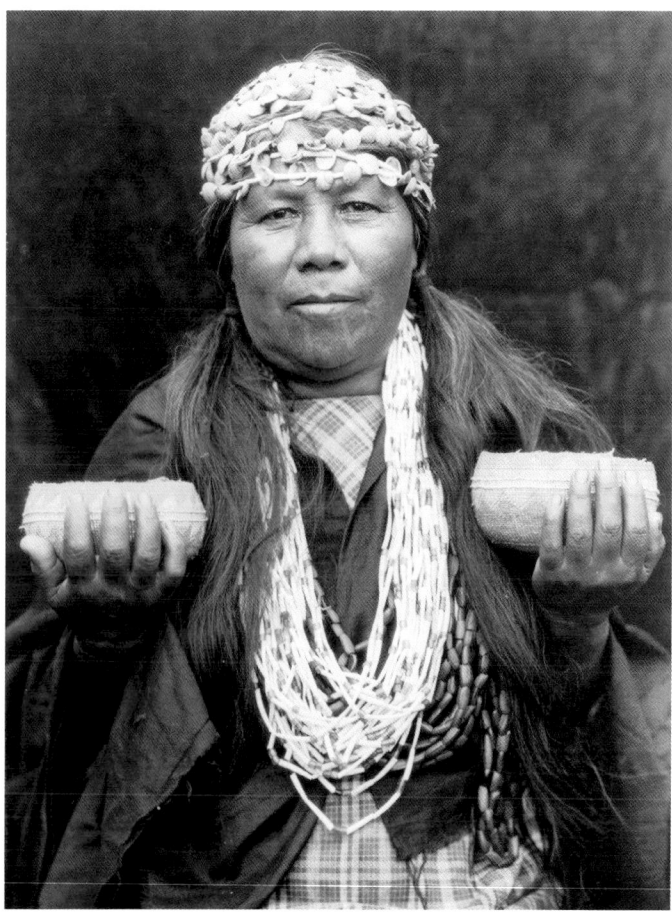

We have to dig our own materials, they can't be bought anywhere, and it's very hard today to find the places where the materials grow and be able to gather them. The way that rivers have been dammed up, the way that the waters run different now, wipes out the roots and things that used to grow along the sides of the rivers... A lot of the willows have been cut down along the sides of the roads, where they've put in paved roads that used to be just dirt roads. And so we've lost a lot of our gathering sites, and I really feel that contributes to the fact that a lot of people aren't weaving today. It's so difficult, you have to be very determined to be a basket weaver today."

By the end of the twentieth century, there was a perception that the age-old art of California basketry was endangered. To address this situation, a statewide council, known as the California Indian Basket-weavers Association (CIBA), was formed in 1992. Head-quartered in Woodland, CA, since 2005, CIBA has nearly 300 members across the state. CIBA objectives include "helping bas-ket-weavers gain greater exposure and acceptance among the dominant society for their basketry traditions, and by providing opportunities for weavers to realize an economic benefit from their basketry skills and knowledge. Our work increases the likelihood that basketweaving, as an indigenous life way, is economi-cally feasible."

Above: A Maidu basket from the vicinity of California's remote Lassen County, circa late nineteenth or early twentieth century. SFSU

Left: Essie Pinola Parrish (1902–1979), was a Kashaya Pomo spiritual leader, as well as a prominent basket weaver. She lived and worked in Sonoma County, California. SFSU

Below: A miniature Pomo trade basket, decorated with hummingbird feathers, circa early twentieth century. SFSU

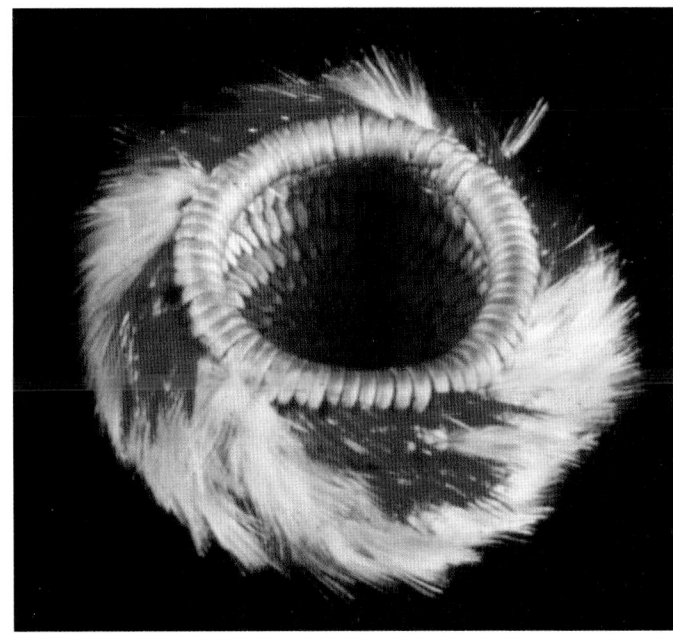

CALIFORNIA DRESS

Traditional dress among indigenous people is governed by climate, and California presents a broad range of climatic conditions. People who lived in the Mojave Desert, the hottest climate in North America, naturally adopted a different wardrobe than those on the fog-shrouded north coast or those who lived year round in the snowy shadows of the Siskiyou or the Sierra Nevada. The styles of the desert people in southeastern California were similar to those of Southwest tribes, just as those of the Paiute people living in the Sierra Nevada, and especially on the eastern slopes of that range, were like those of the Paiute and Shoshone people of the adjacent Great Basin region.

In the southern California coastal areas, where most of the earliest Spanish missions were concentrated, loincloths gave way to European garb just as the "Mission Indian" tribal names were Hispanicized. For example, the Kumeyaay people living near Mission San Diego became the "Diegueño," and the Payomkowichum living near Mission San Luis Rey at present-day Oceanside became the "Luiseño" people. A key element of the mission influence on clothing styles was that women should no longer be seen topless. By the end of the eighteenth century, the Mission Indians dressed in the same garb as the Spanish.

More substantial clothing, including buckskin outerwear was common as one moved north along the coast into the area of the Chumash people. This ocean-going tribe lived near the locations of Mission Santa Barbara and Mission San Luis Obispo, whose names are those of modern cities and counties. The trend continued yet farther north in the land of the Costanoan or Ohlone in the area roughly between Monterey Bay and San Francisco Bay. In these places, the missionaries generally preceded other European influences, so more "modest" missionary-influenced dress was adopted by the end of the eighteenth century as it had been farther south.

North of San Francisco Bay, and in the interior of California, traditional styles survived well into the nineteenth century and the early twentieth century. Though tribes such as the Hupa, Miwok, Pomo, Yokuts, and Yurok were not linguistically homogenous, their lifestyles and clothing styles were similar.

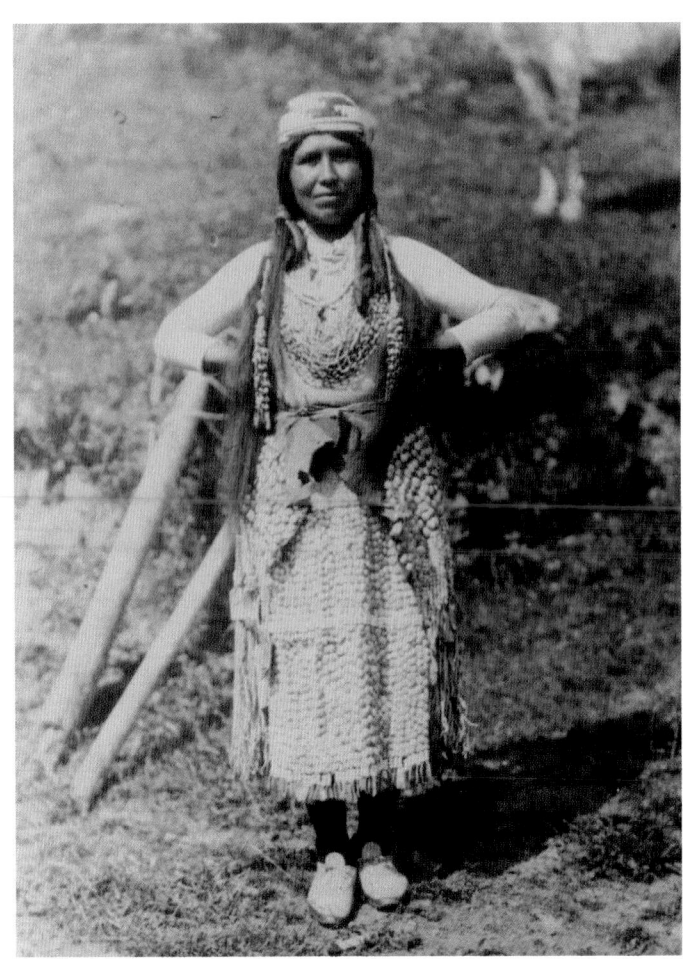

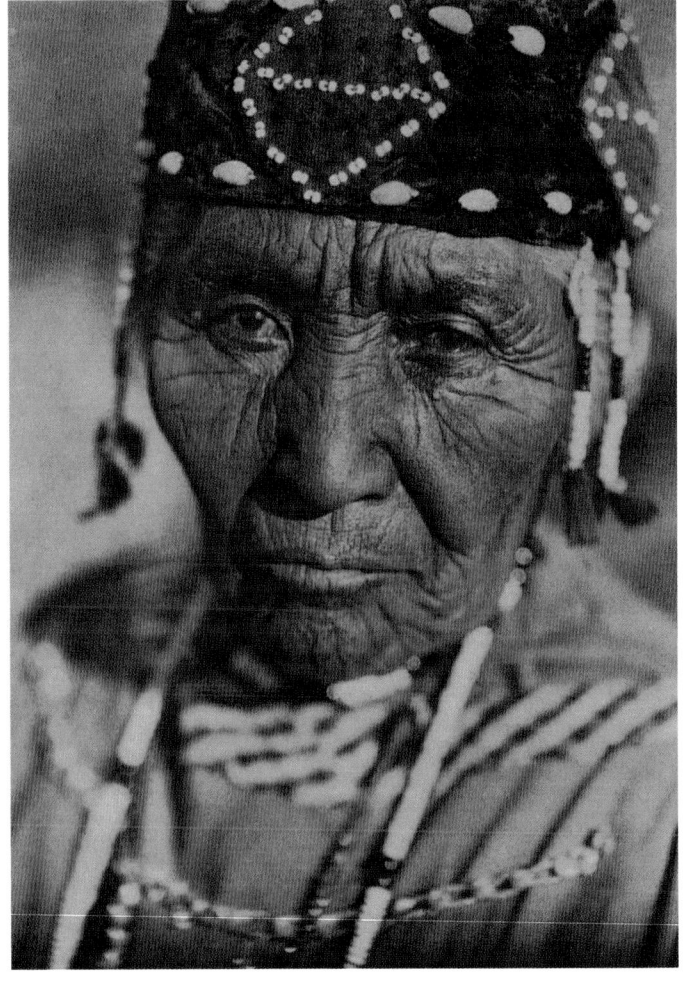

Above right: A Yurok woman in a traditional full length shell skirt. Large numbers of dentalium shells in a costume indicated the affluence and community status of the individual wearer. AGS Archives

Right: A Klamath woman, described as the wife of "Modoc Henry," olivella shell-studded fur or cloth hat and shell disk necklace. LoC

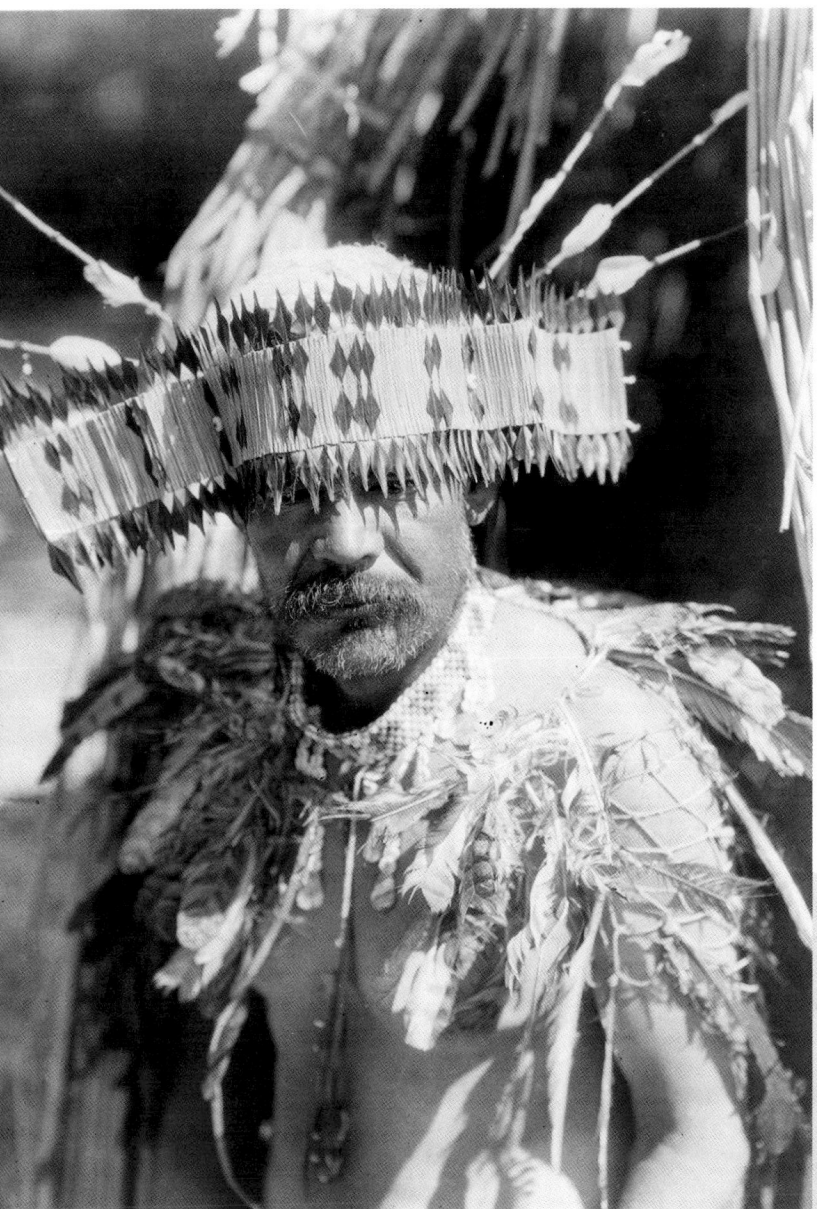

In the summer, men often wore breechcloths, while the women wore long woven grass skirts decorated with beads and shells. As the weather turned cooler and the rainy season began, buckskin robes and dresses were worn. Because deer and elk were plentiful in the coast ranges, leather was widely available. As elsewhere across most of North America, footwear consisted of leather moccasins.

In his early twentieth-century field notes, photographer Edward Curtis provides an excellent description of the "gala costume" of Hupa women, writing that "the deerskin skirt is worn about the hips and meets in front, where the opening is covered by a similar garment. Both are fringed and heavily beaded, and the strands of the apron are ornamented with the shells of pine nuts."

It is notable that among the northern California people, who included some of the most outstanding basket makers on the continent, that woven basket hats were worn by the women. Another adornment included woodpecker feathers, especially those of the indigenous acorn woodpecker. Tattoos were also seen, with Yurok.

Above : A man in Pomo dance costume and headdress, c. 1924. LoC

Right: A Hupa mother wearing a basket hat and holding a basket cradle, c. 1927. LoC

Opposite: A Hupa man wearing a White Deerskin Dance costume, as photographed by Edward Curtis, c. 1923. Albino deerskins were the most valuable kind, and ownership of them indicated high social status. LoC

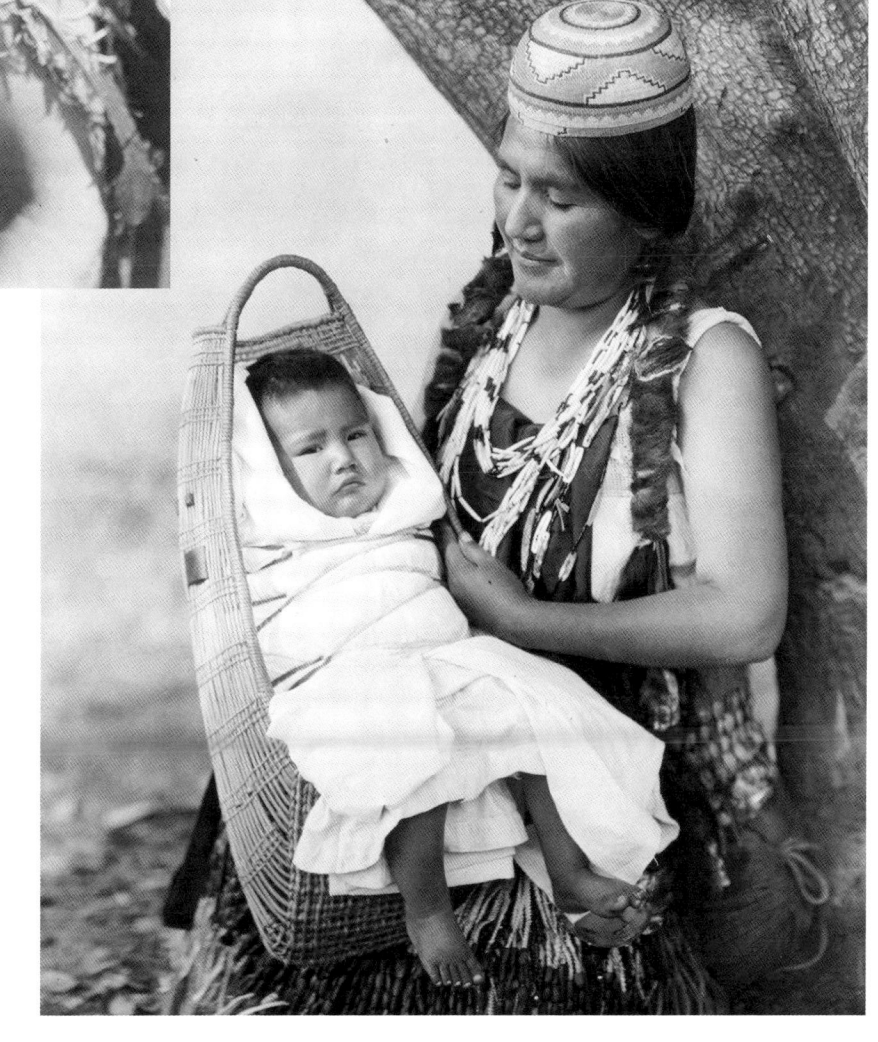

CALIFORNIA JEWELRY

Because of the proximity of California to the Pacific Ocean, seashells played an important role in the jewelry traditions of California. With a coastline nearly 850 miles in length, and a tidal shoreline of more than 3,000 miles, California has more coast than any other state except Alaska, and the overwhelming majority of the state's pre-Columbian population lived within 200 miles or less of the Pacific.

The specific types of seashells used by the indigenous people living in the hills and valleys between the Sierra Nevada and the Pacific included mussels and clams, with the most widely used being the tiny, but plentiful dentalium, or tooth shells. The most prized of the shells used in jewelry were the large and colorful ones of the abalone.

The abalone is a marine gastropod mollusk, or sea snail, indigenous to the coast of California from the Santa Barbara Channel northward, whose meat is still regarded as a delicacy. The large shell of the abalone, roughly the size of a man's open hand, is also highly valued for the beautiful iridescent color of the nacre, or mother-of-pearl, interior. This color can range from a silvery blue-green to a silvery pink or purple. Traditionally, the large abalone shells were cut and worked by native jewelers as earrings, necklaces, and pendants. The shells are still a popular material for jewelry, although the harvesting of abalone has been strictly controlled in California since the late twentieth century.

A number of species that are part of the family *dentaliidae* dentalium (plural, dentalia) shells were made into necklaces and other jewelry. The shells were found in deep waters offshore, and traded to inland people, who prized them very much, and who were jealous of the coastal people because of them. In his *Handbook of the Indians of California*, Alfred Kroeber wrote that to the non-coastal peoples, "since the direction of these sources [of dentalium] is 'downstream' to them, they speak in their traditions of the shells living at the downstream and upstream ends of the world, where strange but enviable peoples live who suck the flesh of univalves."

Below left: A Tlakluit (Wishram) bride, c. 1911, wearing a heavily beaded buckskin dress, several necklaces, of shell beads, and a headdress of beads and hollow-centered Chinese coins. LoC

Below: A portrait of a young Tlakluit (Wishram) woman, c. 1910, wearing braids, a shell bead choker, and abalone shell disk earrings. LoC

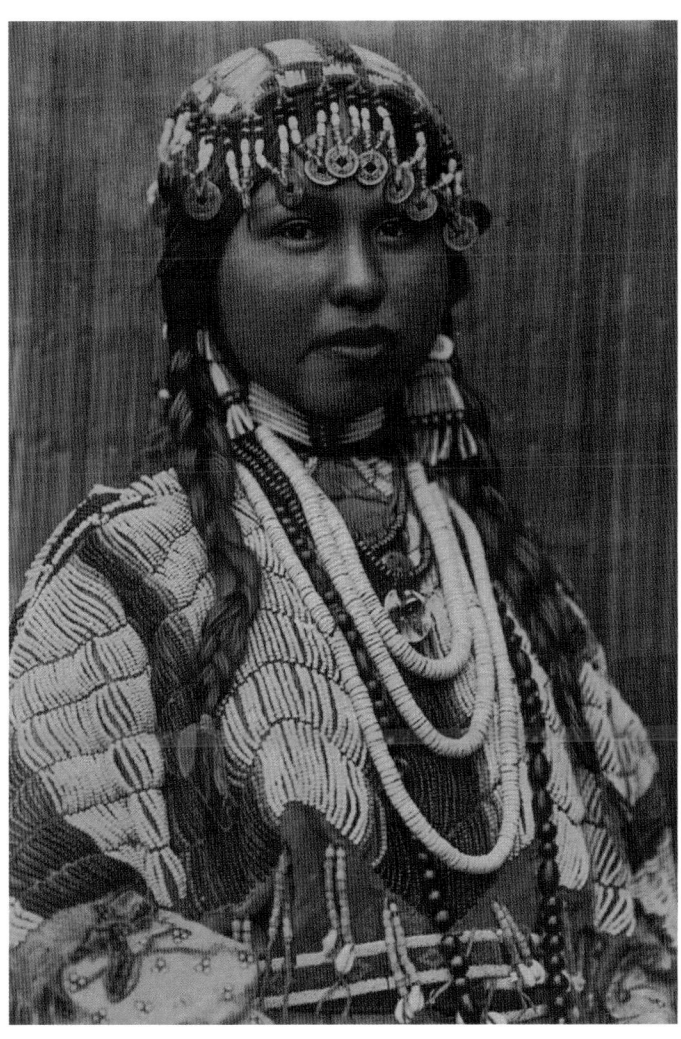

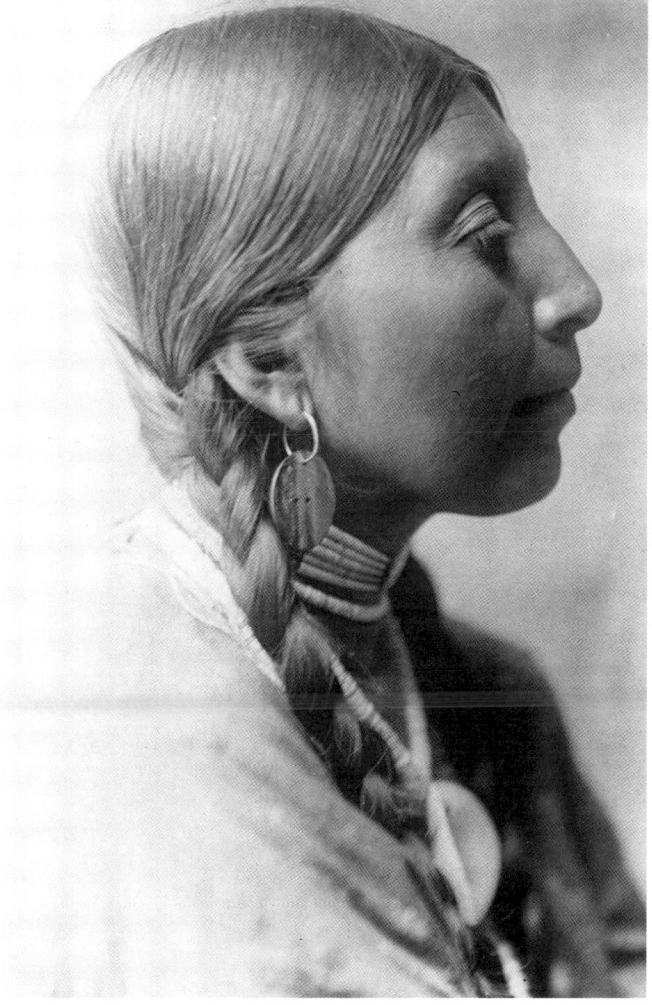

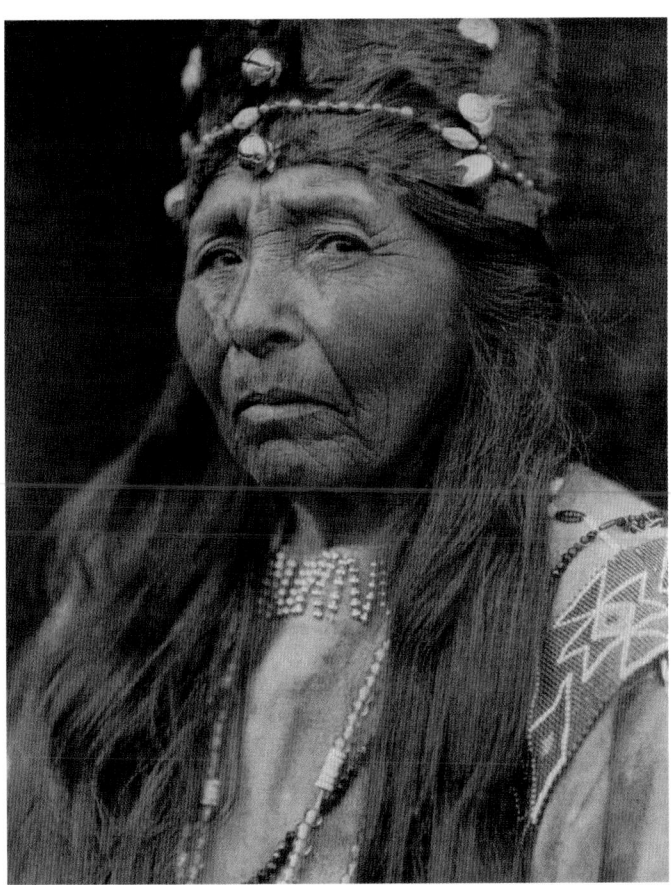

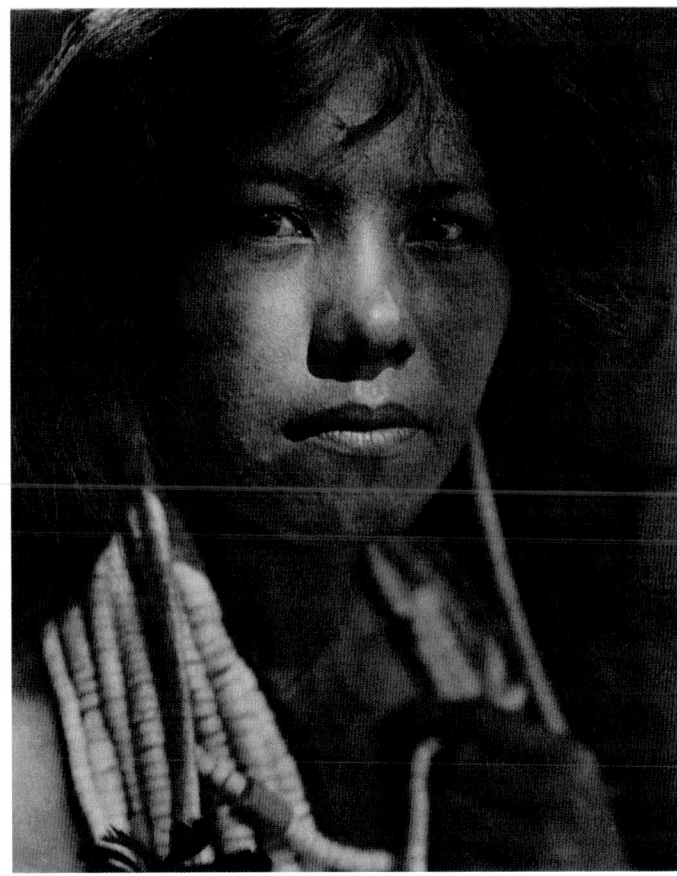

Not only did the people of California use dentalium, but so too did those of the coastal Pacific Northwest, from Oregon northward through present British Columbia and Alaska, especially the Nuu-chah-nulth (Nootka). Late nineteenth-century photographs of the Tlakluit (Wishram) people of central Oregon, north of the present California border, show examples of women extensively bejeweled with dentalium, not just with necklaces, but with the shells woven into the hair and clothes of brides. Indeed, dentalium was seen as an indicator of wealth.

Dentalium shells were used throughout the region not only as trade item, but as a form of currency with a mutually agreed value. Prices for services and goods, such as dugout canoes, were quoted in lengths of strung dentalium shells, and there were bankers who conducted transactions using strings of shells. Dentalium "currency" was often "retired" by placing it in the grave of its owner. By thus controlling the quantity of dentalium in circulation, the pre-Columbian California economy could control inflation.

As turquoise was the signature gemstone of the Southwest people, a favored stone in California was magnesite, or magnesium carbonate, which can range in color from pale yellow to rose pink. Magnesite is formed by way of the carbonation of serpentine or of olivine, the latter being known in its gemstone quality as peridot.

In addition to seashells and stones, California and neighboring people often used colored bird feathers as decoration in both jewelry and basketry, although they did not wear elaborate feather headdresses as did the people of the Plains.

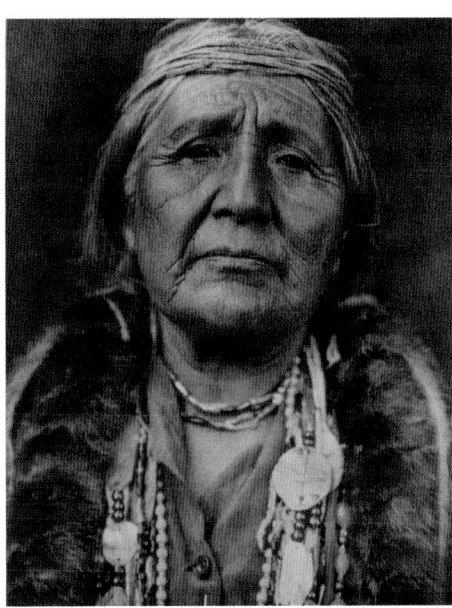

Top left: Shells are the centerpiece of the jewelry adornment of this Klamath woman, c. 1923. LoC

Top right: A Pomo woman wearing clam shell beads, pierced and strung on a stem of the scouring rush (horsetail). The feathered ornament is an ear pendant, which in this case, because of its length and weight, is attached to a strand of hair. The large, dark colored bead on one strand of the necklace is a cylinder of magnesite. LoC

Above: An older Hupa woman with Abalone shell earrings, c. 1923. LoC

7. NORTHWEST COAST

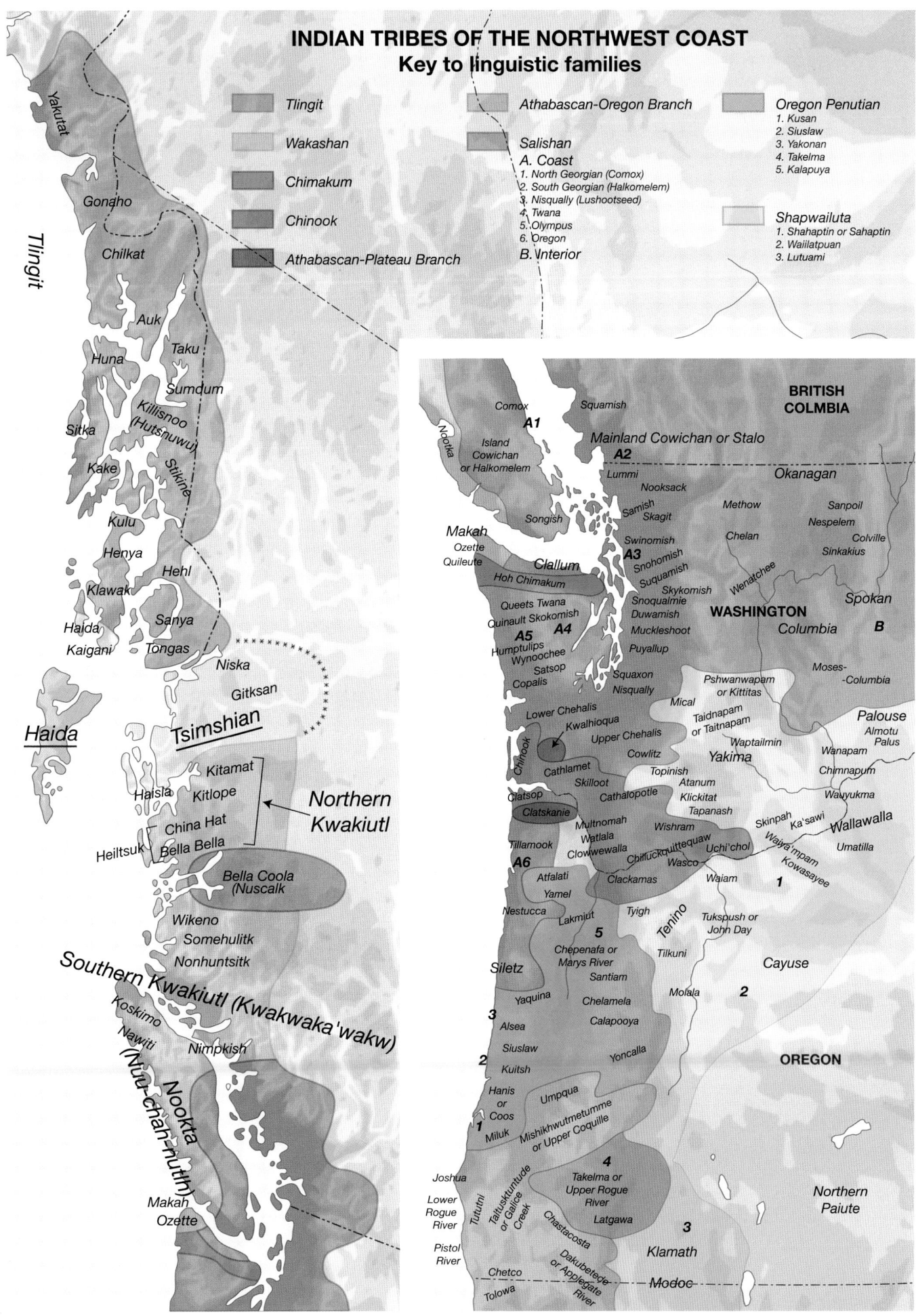

INDIAN TRIBES OF THE NORTHWEST COAST
Key to linguistic families

- Tlingit
- Wakashan
- Chimakum
- Chinook
- Athabascan-Plateau Branch

- Athabascan-Oregon Branch
- Salishan
 - A. Coast
 1. North Georgian (Comox)
 2. South Georgian (Halkomelem)
 3. Nisqually (Lushootseed)
 4. Twana
 5. Olympus
 6. Oregon
 - B. Interior

- Oregon Penutian
 1. Kusan
 2. Siuslaw
 3. Yakonan
 4. Takelma
 5. Kalapuya

- Shapwailuta
 1. Shahaptin or Sahaptin
 2. Waiilatpuan
 3. Lutuami

Yakutat

Tlingit

Gonaho

Chilkat

Auk

Taku

Huna

Sumdum

Sitka

Killisnoo (Hutsnuwu)

Kake

Stikine

Kulu

Henya

Hehl

Klawak

Sanya

Haida

Kaigani

Tongas

Niska

Gitksan

Haida

Tsimshian

Kitamat

Haisla

Kitlope

China Hat

Heiltsuk

Bella Bella

Northern Kwakiutl

Bella Coola (Nuscalk)

Wikeno

Somehulitk

Nonhuntsitk

Southern Kwakiutl (Kwakwaka'wakw)

Koskimo

Nawiti

Nimpkish

Nootka (Nuu-chah-nulth)

Makah Ozette

Nootka

Comox
A1

Squamish

BRITISH COLMBIA

Island Cowichan or Halkomelem
A2

Mainland Cowichan or Stalo

Lummi

Okanagan

Nooksack

Makah

Songish

Samish
Skagit

Methow

Sanpoil

Nespelem

Ozette

Swinomish

Chelan

Colville

Quileute

Clallum
A3

Snohomish

Sinkakius

Hoh Chimakum

Suquamish

Skykomish

Wenatchee

Spokan

Queets Twana

Snoqualmie

WASHINGTON

Quinault Skokomish
A4

Duwamish

Columbia

B

Humptulips

Muckleshoot

Wynoochee

Puyallup

Satsop
A5

Copalis

Squaxon

Nisqually

Moses-Columbia

Mical

Pshwanwapam or Kittitas

Lower Chehalis

Palouse

Kwalhioqua

Taidnapam or Taitnapam

Almotu Palus

Upper Chehalis

Waptailmin

Wanapam

Chinook

Cowlitz

Yakima

Chimnapum

Cathlamet

Topinish

Skilloot

Atanum

Wauyukma

Clatsop

Cathalopotle

Klickitat

Clatskanie

Tapanash

Skinpah

Ka`sawi

Wallawalla

Multnomah

Wishram

Wiya`mpam

Tillamook

Watlala

Clowwewalla

Chilluckquittequaw

Uchi'chol

Umatilla

A6

Atfalati

Clackamas

Wasco

Kowasayee

Yamel

Waiam

1

Nestucca

Lakmiut

Tyigh

Tenino

Tukspush or John Day

5

Siletz

Chepenafa or Marys River

Tilkuni

Cayuse

Yaquina

Santiam

Molala

2

3

Alsea

Chelamela

OREGON

Siuslaw

Calapooya

2

Kuitsh

Yoncalla

Hanis or Coos

Umpqua

1

Miluk

Mishikhwutmetumme or Upper Coquille

4

Joshua

Takelma or Upper Rogue River

Northern Paiute

Lower Rogue River

Tututni

Taltuskuntude or Galice Creek

Latgawa

3

Pistol River

Chastacosta

Klamath

Chetco

Dakubetede or Applegate River

Modoc

Tolowa

The Northwest Coast culture area is a narrow strip of land between the interior mountains and the Pacific Ocean, relatively isolated from the rest of the continent. The peaks of this culture were formed by the Haida-Tsimshian-Tlingit of the far north and the Kwakwaka'wakw (Southern Kwakiutl) of British Columbia with the Nuu-chah-nulth (Nootka) of Vancouver Island. They developed the red cedar woodcarving art of totem poles, house fronts, masks, and other ceremonial items, distinctive totem painting, and basketry.

Potlatch is the most distinctive feature of Northwest Coast culture. From the Nuu-chah-nulth *patshatl*, meaning "to give," this ceremony includes speeches, songs, dances, feasting, and gift distribution. Although these occasions once lasted for several days, a modern potlatch is unlikely to extend over more than a weekend.

Potlatch was held to enhance and confirm the host's status within the society, and to legalize his claims to a noble title. In the past, they were held to celebrate births or marriages, or to declare a daughter's first menses. Others occurred on the death of a leader, to mark the raising of a totem pole for prestige purposes, or to honor a deceased chief. They are held today for births, namings, weddings, anniversaries, graduations, special birthdays, and as memorials for the dead.

Invited guests show approval of the host's claims by accepting payment in the form of food and goods. In the nineteenth century, the First Nations' wealth increased from contact and trade with Europeans—especially via the fur trade with the Hudson's Bay Company. Thus wealth display and gift giving at potlatches could reach ostentatious heights: nowadays gifts are more modest. To the south, into Washington and Oregon, the distinctive northwest culture is less strong—although the Coast Salish produced some carving and fine basketry, and the Chinook held occasional potlatch ceremonies.

In the south, the Chinook traded salmon, dentalium shells, and sometimes slaves from California in return for material culture from the north. Houses were more simply made. In southern Oregon and northwestern

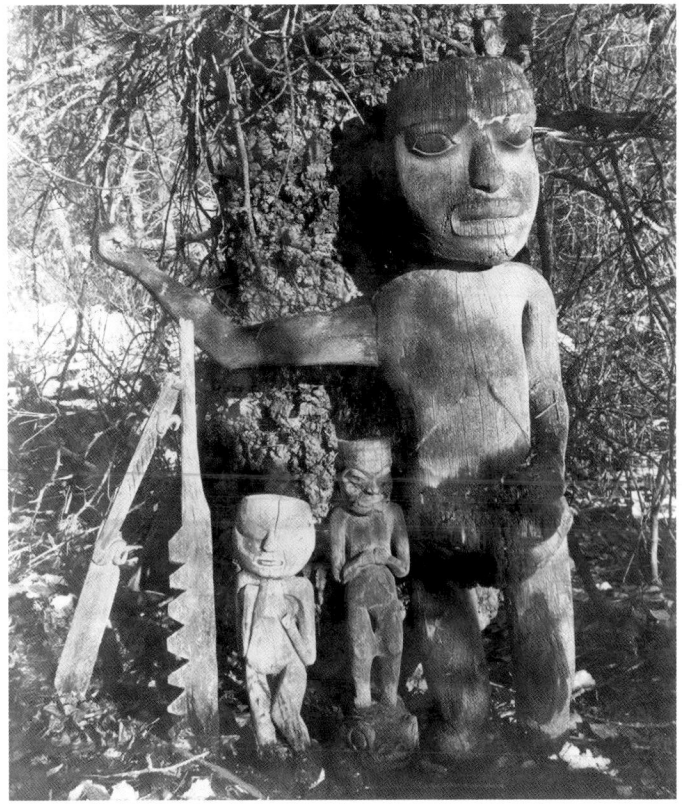

California, redwood (not cedar) was the primary wood used. Deerskin robes and skirts replaced the woven cedar bark robes of the north. The southern peoples made fine basketry or imported it from California groups farther south.

Northwest Coast culture suffered a collapse in the late nineteenth century, when populations were decimated by introduced diseases, such as smallpox and influenza. Additionally, missionary influence and plans for assimilation into white culture encouraged rejection of traditional cultural practices. Potlatch was outlawed in 1885, although the law was widely flouted, especially among the Kwakwaka'wakw (Southern Kwakiutl). It remained on the statute books until 1951. Items of ceremonial regalia confiscated during this time have only been returned during the last twenty-five years.

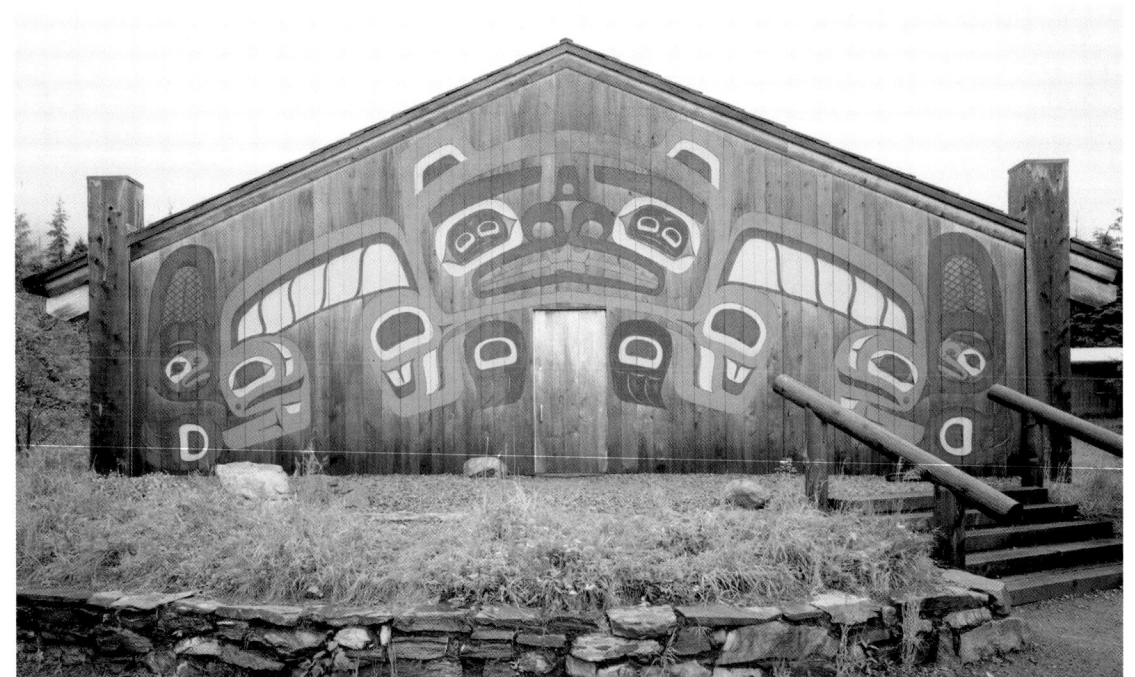

Above: A group of wood carvings mark the grave of a Tlingit shaman on the Chilkat River in Alaska, c. 1895. LoC

Left: The facade of the Tribal House at Saxman, near Ketchikan, Alaska. LoC

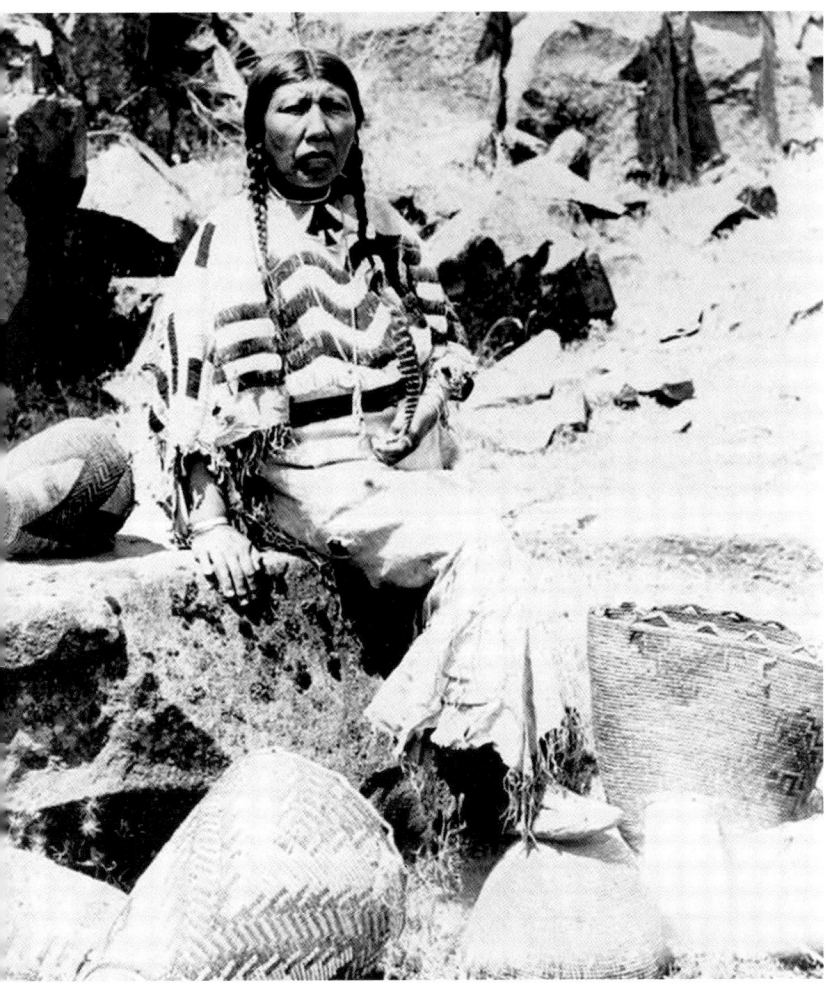

Above: A Klikitat woman with her baskets, as photographed by Benjamin Gifford. The klikitat lived on the north side of the Columbia River and later on the Yakima Reservation in Washington State, c. 1900. LoC

Opposite: A display of Tlingit baskets, masks, wooden figures, a ceremonial painted board, and other objects. LoC

Below: Tlingit spruce root baskets and a lidded Aleut grass basket. The Tlingit people live in southeast Alaska, while the traditional Aleut homeland is in the Aleutian Islands and far western mainland Alaska. Alaska Photo Library

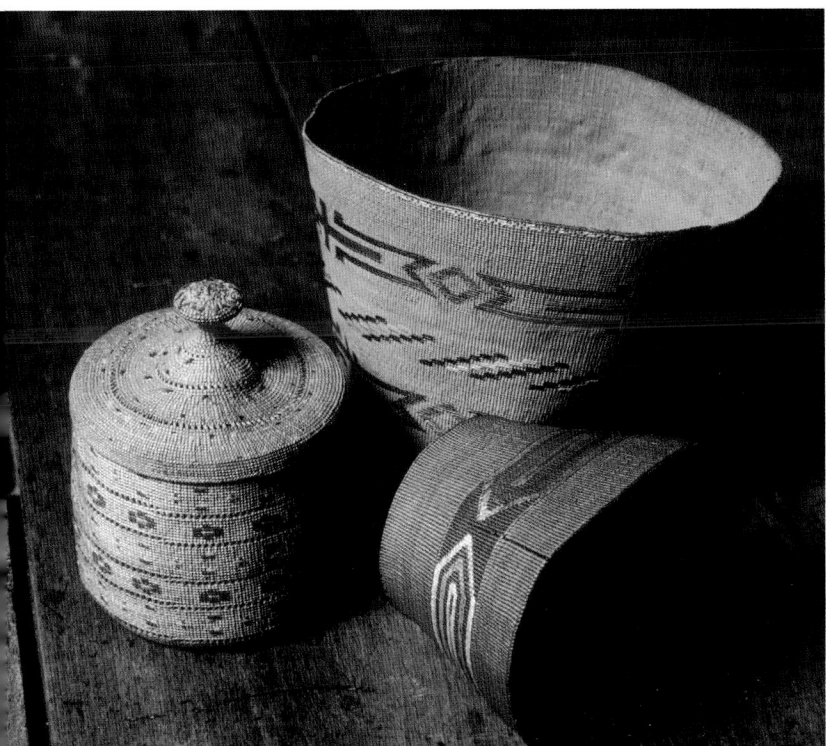

NORTHWEST COAST BASKETRY

Basketry was widely practiced by Northwest Coast people, with the weaving traditionally done by women. The girls were taught by their elders, and all learned to weave as part of their routine domestic role in society. Those women who showed an outstanding aptitude and skill were often excused from other household chores to practice the art of basketry.

As in other cultures around the world, baskets were traditionally used in the Northwest for storing and transporting goods, as well as for gathering wild fruit and berries. Northwest Coast men used baskets to carry fishing or hunting equipment, including bait, as well as woodworking tools. Boats were equipped with baskets containing rocks for use as anchors, and quivers for carrying arrows were baskets. Also woven in similar fashion were trays and bowls, as well as matting.

As with California weavers, the Northwest basket makers were able to weave baskets so tightly that they could contain water. However, some baskets were woven more coarsely so that as clams or other shellfish were collected, the seawater would drain out. Open-weave red cedar bark baskets were also used for cooking berries prior to drying for storage through the winter. Other open-weave baskets were used for straining grease when boiling meat or fish.

The materials that were used varied from tribe to tribe. For example, the Tsimshian and others used fibers made from the bark of either the red or yellow cedar to weave both clothing and baskets, while people such as the Haida and the Tlingit used the fiber of the roots of spruce trees. The Canadian Museum of Civilization notes that this characteristic has allowed archaeologists "to trace the occupancy of Prince Rupert Harbour village sites to Tsimshian populations dating back to at least the first millennium BC."

Cedar bark would typically be gathered when the sap was running, usually between April and July. The sap allows the bark to be pulled off easily, and for the basket maker to obtain long, even strands, taking only a couple from each tree to protect it. The desirable inner bark would then be peeled away for basket making.

In the words of contemporary Haida basket maker Lisa Telford in commentary recorded by the Smithsonian Institution, the Haida baskets "start with eight warps, four crossing four, then twining begins. There are twelve endings. There is a complicated ending with six strands that is done with a row of twining at the same time. I don't know the name of that ending, I call it the nightmare six-strand ending."

As California women wore woven basket-style hats, Haida women also made finely woven spruce root hats,

or ceremonial crowns, for their chiefs. It is known from early Russian engravings that high-ranking men wore such hats as early as the eighteenth century, and probably before. It has been observed that such hats had woven basketry rings added to mark each Potlatch that its owner had given, or each time he had participated as a dancer at a Potlatch or other feast. In its collection, the Canadian Museum has some Northwest Coast woven hats with more than twenty such rings.

Decorated trade baskets used the same "formline" or outline patterns and geometric shapes that formed the basis for designs in other media. Whereas the basket weavers farther south, such as those in California and the Southwest, used geometric patterns almost exclusively, Northwest weavers occasionally also used many of the animal motifs that were common in painted or carved objects in the region. These images were, as in the other media, often related to the clan affiliation of the basket's owner. The Canadian Museum notes, however, that in basketry, the "design motifs have not been thoroughly analyzed."

Charles Frederick Newcombe, a British physician turned ethnographer, was one of the first outsiders to study Northwest Coast basketry seriously as part of his general interest in Northwest culture. He settled in Oregon in 1880, but later moved to British Columbia. Here, he collected artifacts for both the British Museum in London and the Field Museum in Chicago. In unpublished notes in the possession of the Canadian Museum, Newcombe documented the names of many Haida basket designs, including "slug trail," "comb pattern," "shadow," "small waves in calm waters," "the crossing of the sticks of a drying frame for fish," and "little breeze on the water."

As traditional arts died out during the early twentieth century because of Canada's restrictive laws, Northwest Coast basketry seemed as though it was becoming a lost art. However, by the time that there was a rediscovery of native crafts in the 1950s, there were still people around who could pass along the old traditions. With this, the making of baskets as collectible items was reborn on a larger scale than before.

The great matriarchs of twentieth-century Haida basket making included Isabella Edenshaw, the wife of Haida sculptor Charles Edenshaw, as well as their daughter, Florence Edenshaw Davidson, and their

Left: A Kwakwaka'wakw woman in British Columbia preparing cedar bark for weaving, c. 1914. LoC

relative Selina Petrovich. Not only were these women noted weavers, but they taught the art to succeeding generations. Florence's daughter, Primrose Adams, and her granddaughter, Isabel Rorick are important weavers.

In an oral history interview preserved by the Burke Museum of Natural History and Culture in Seattle, Selina Petrovich said that in her early days in Howkan, Alaska, she learned basketry by watching her elders, "then I worked upstairs by myself, trying to do it and having to take it all out. It was so hard, sometimes I wept." She later taught her daughter, Delores Churchill, as well as her granddaughters, Holly Churchill, April Churchill, and her niece Evelyn Vanderhoop, all of whom became acclaimed basket makers in their own right. Delores Churchill also studied Raven's Tail and Chilkat weaving with Cheryl Samuel, and studied under Tlingit weaver Jennie Thlunaut. Holly Churchill's work has been exhibited at the Anchorage Museum of History and the Smithsonian Institution.

Among the notable contemporary Haida weavers taught by both Delores and Holly Churchill are Diane Douglas-Willard and Lisa Telford, as well as Haida/Tlingit artist Janice Criswell, who teaches Northwest Coast basketry at the University of Alaska Southeast. In 1992, she was one of the weavers who wove the "Hands Across Time" robe that is now in the Alaska State Museum.

Many of the contemporary Haida basket makers live in Old Massett, British Columbia, which has long been a center for basket making.

Among the Tsimshian, two notable contemporary basketry artists who have worked with Delores Churchill are Loa Ryan and Lindarae Haldane Shearer, who also learned from her aunt, Lillian Buchert. Lindarae operates Laughing Berry Designs in New Metlakatla, Alaska.

The significance of Northwest Coast basketry and the attraction of the baskets themselves is best expressed by basket maker Lisa Telford, who told the Smithsonian that: "You can't get over how exquisite these [classic nineteenth century] baskets are. To be able to touch something that's so very beautiful, so fine, that someone made a hundred years ago—knowing they just made and sold them for nothing—is the experience of a lifetime."

NORTHWEST COAST DRESS

The traditional daily dress of the Northwest Coast people consisted generally of simple garments made from leather, but more often from woven plant material, usually softened cedar bark. Because of the climate, a form of raincoat, often of woven bark fabric, was always close at hand. Leather footwear was worn, but because leather was subject to deterioration in the damp climate of the Northwest, people often went barefoot. Again because of the climate, sealskin was preferable to buckskin because of its water-resistant properties.

The Haida also wore large elkskin capes decorated on the sides with paint and fringing emblematic of high rank. For example, a Kaigani Haida elkskin cape of the Prince of Wales archipelago in Alaska that is decorated with the image of a killer whale (orca) containing a raven in human form within it, is thought by the Canadian Museum of Civilization to symbolize "an honorary rank like captain of a war canoe."

Ceremonial garments were naturally more ornate and more complex than those worn daily, and often included the Chilkat robe or Chilkat blanket. These exceptional textile works originated among the Tlingit, and are discussed in a separate section within this book.

As the Canadian Museum notes, many items of everyday clothing were "woven from red or yellow cedar bark. After the bark was peeled in long strips from the trees, the outer layer was split away, and the flexible inner layer was shredded and processed. The resulting felted strips of bark were soft and could be plaited, sewn or woven into a variety of fabrics that were either dense and watertight, or soft and comfortable … Their clothing was not made to keep them warm. It was made to keep them dry. They oiled their ponchos to make them waterproof."

The Museum adds that during the summer months, the men "wore no clothing at all except tattoos and jewelry. In the winter, they usually rubbed fat on themselves in order to keep warm. In battle the men wore red cedar armor and helmets, along with breech cloths made from cedar." For more formal occasions, the "women wore skirts and capes of cedar bark, while men wore long capes of cedar bark into which some mountain goat wool was woven for decorative effect."

Hats woven by basket makers were worn for both practical and ceremonial reasons. The Canadian Museum mentions that "Haida women excelled in basketry [hats] woven on a stand with a wooden form appropriate to each size and shape. Male artists painted the hats with the crests of the commissioning family; the colors of paint were restricted to red and black (with occasional touches of blue or green)."

For the women who wove the Northwest basketry, these hats became the most popular of their wares among the tourist trade that developed in the region late in the nineteenth century. For example, Charles and Isabella Edenshaw, who were highly regarded artists at the turn of the twentieth century, spent many winters collaborating (with Isabella weaving and Charles painting) on hats specifically for the tourist trade.

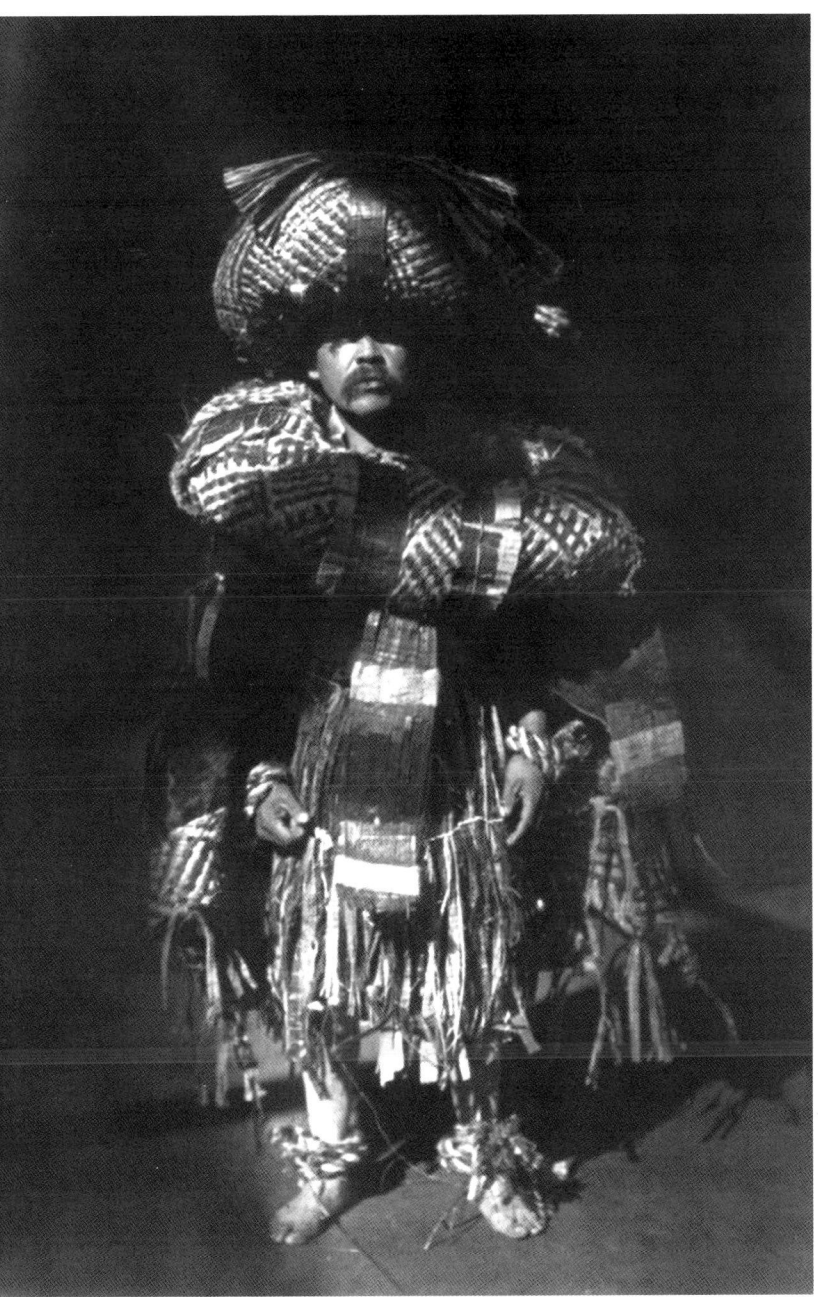

Left: A Kwakwaka'wakw man in an elaborate costume, c. 1914. LoC

Opposite, above: A Kwakwaka'wakw Kominaka dancer in skull adorned costume, c. 1910. LoC

Opposite, below: A Kwakwaka'wakw man wearing a hat in the form of a Tluwulahu mask depicting the Loon on top of a man's head to facilitate the loon changing into the form of a man. LoC

Sometimes the chiefs and other eminent men would wear hats carved from wood and lavishly decorated with furs and abalone shell inlay. The Canadian Museum contains eighteenth-century engravings by Russian artists depicting Northwest Coast chiefs wearing woven hats painted with formline crest designs.

The Museum adds that the item of chiefly regalia "that had the most prestige and recognition among the northern tribes was the frontlet, a carved wooden plaque worn on the forehead. The frontlet plaque was carved of yellow cedar, birch or maple, in bas-relief, affixed to a cap that was edged with stiff sea lion whiskers and that had a train of ermineskin…The train of densely packed ermineskin may be conceptually linked to Konankada, who is sometimes depicted as a painted housefront surrounded by white clouds or flocks of seagulls that signal the beginning of eulachon runs on the Nass River. The whale tail of Konankada is always attached to the back of this type of headdress."

Personal adornment in the nineteenth-century Northwest was similar to fashions seen in some quarters of Western society in the twenty-first century, including facial tattooing and nose and ear piercing.

The Canadian Museum mentions that wealthy Tsimshian people made necklaces from dentalium shells, beaver teeth, beaver claws, and clam shells, adding that "they also used beads, feathers and bones to decorate their clothing. Meanwhile, chiefs and their wives and children wore bracelets, labrets (lip plugs), earrings, pendants, and elaborately decorated clothing, as symbols of spiritual power and prestige."

Formal dress was a demonstration of lineage, as well as of wealth or station in society. A clan emblem was usually included in a wardrobe, and it was always important to make note of the clan affiliation with the person or persons who tailored one's formal wear. While today's clothing styles among the Northwest people are essentially identical to those of mainstream Americans and Canadians, the clan emblems are still often seen.

A ceremonial garment which became extremely important among the Haida, Tlingit, and Tsimshian people after contact with Europeans was the button blanket. Wool blankets which had been obtained from traders, especially dark blue duffle blankets from the Hudson's Bay Company, were decorated by the addition of shells and other adornments. Originally, dentalium shells were sewn on in the shape of a family crest. Soon the style included the addition of red cloth, and pieces of shiny, iridescent abalone shell, which were added to reflect light during dancing around a fire. Later, buttons acquired from traders replaced the dentalium, and the blanket got its popular name.

Describing the button blanket among the Tsimshian, the Canadian Museum notes that "following the introduction of European woolen cloth, a new type of clothing was made from dark blue trade blankets, decorated with red flannel crest designs and pearl buttons."

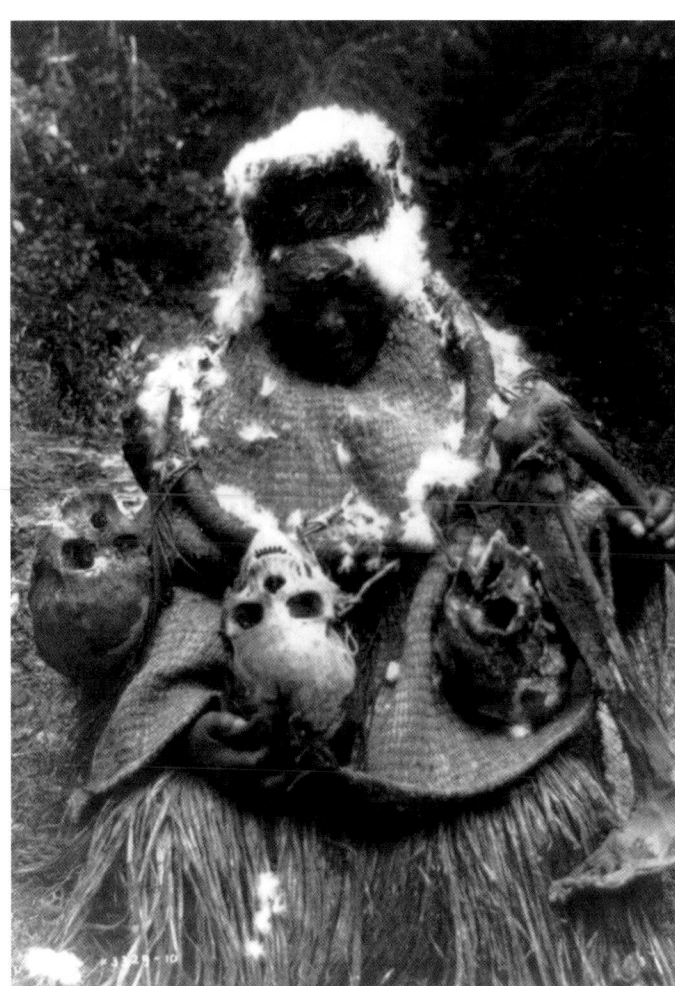

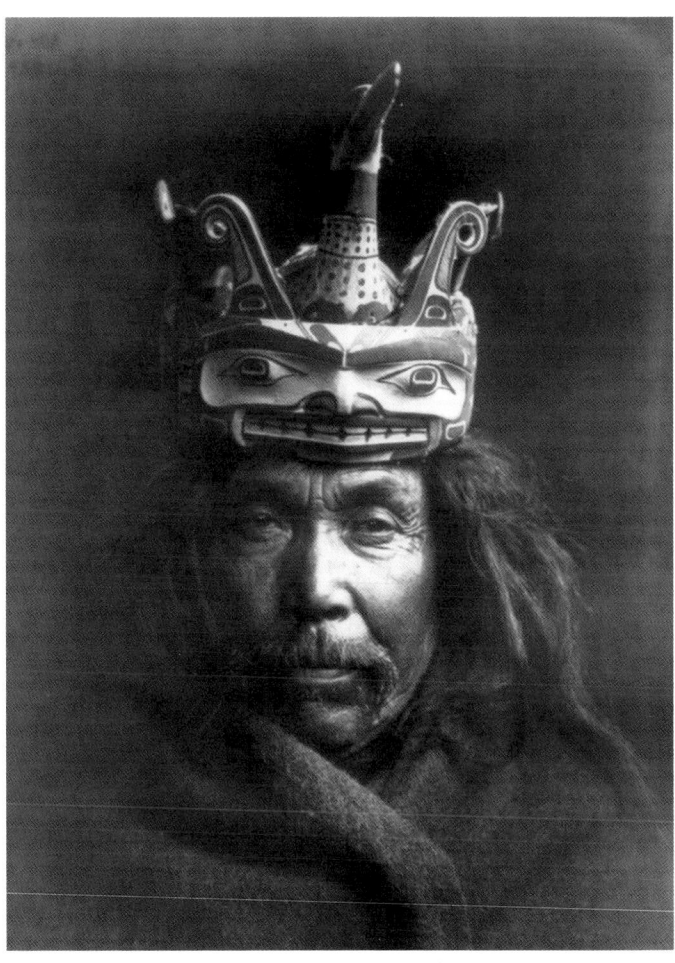

Below: Kaw Claa, a Tlingit woman, in her full potlatch dancing costume, replete with nose ring and bear claw headdress, and beaded octopus bag, c. 1906. LoC

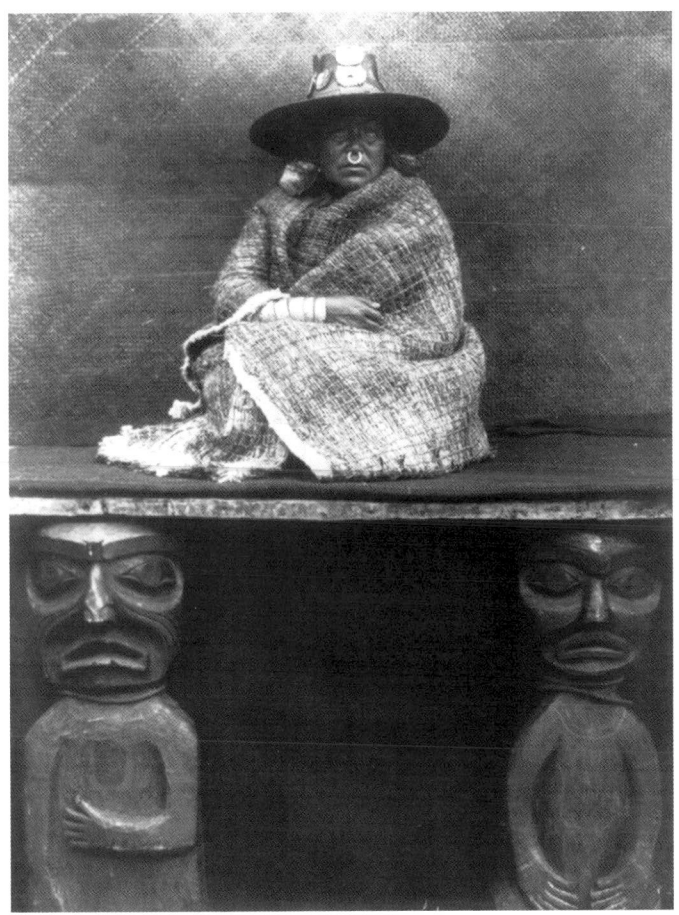

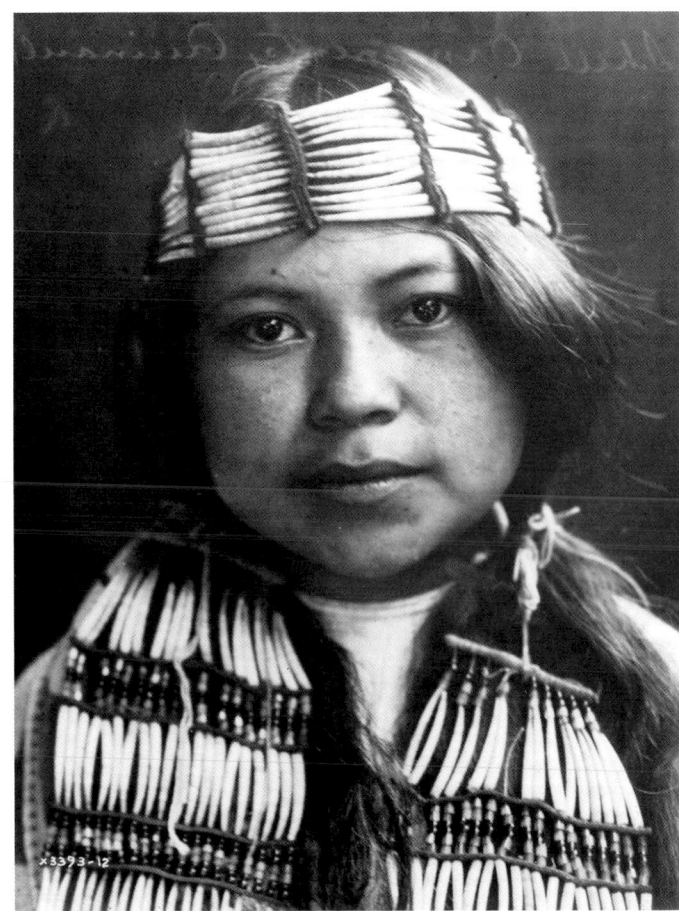

In the Museum itself, there is an exhibit depicting a Tsimshian chief "wearing a wool button blanket over his shoulders, a leather shirt, a painted leather apron with deer hoofs attached to the fringes, and leggings. He is holding a Raven rattle. On his head is a headdress depicting Nagunaks, the keeper of souls in the underworld; his face has the features of Bear and his red hands may reflect the fact that he held the souls of the dead until they were ready to be reincarnated in humans. The chief's black mask with taunting white eyes was part of a ceremonial dance costume."

By the late twentieth century, the button blanket had become, according to the Canadian Museum, "the most popular piece of contemporary feast attire among the people of the North Coast … A modern Potlatch can bring forward a hundred or more button blankets from the participants. At a traditional naming ceremony, it is now considered essential to present the recipient with

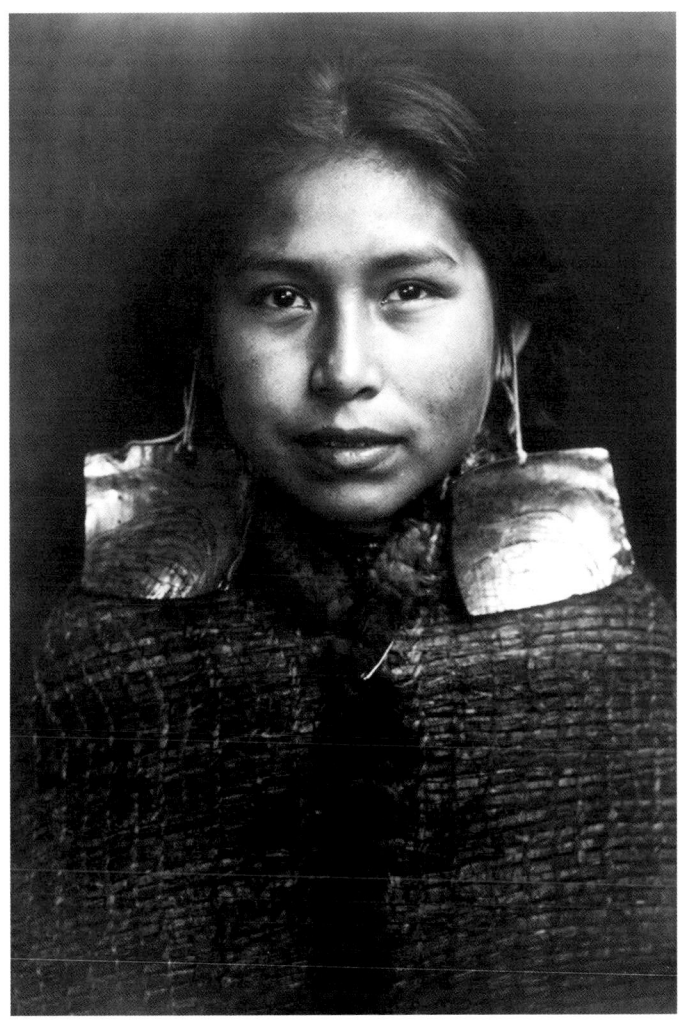

Above: The daughter of a Kwakwaka'wakw chief wearing a hat with metal ornaments, very large earrings, and a nose ring. She is seated on a blanket-covered board supported by two wooden carvings that are said to represent her slaves, c. 1910. LoC

Above right : A Quinault girl wearing dentalium shell ornaments, c. 1913. LoC

Right: Margaret Frank, a young Kwakwaka'wakw woman, wearing abalone shell earrings, was photographed in 1914 by Edward Curtis. Abalone shell jewelry was considered a sign of nobility and was traditionally worn only by members of this status. LoC

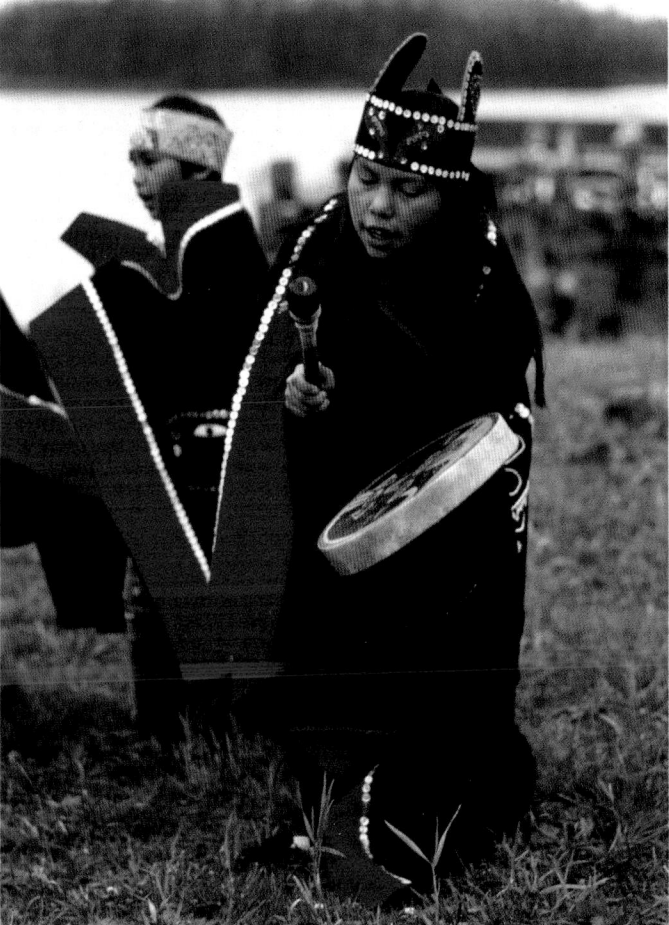

a special blanket decorated with a family crest. A century after the button blanket was first developed, it has become a symbol of social and artistic rebirth among the Haida...Today, buttons are sometimes used to fill entire zones of the design elements and even the whole field of the background."

In the twenty-first century, Dorothy Grant, a well-regarded contemporary Kaigani Haida fashion designer, has a line of clothing called "Feastwear," which is decorated in button-blanket style. Dorothy Grant apprenticed with Florence Davidson, the daughter of the legendary artist Isabella Edenshaw. Ms. Grant's garments, including spruce root hats, as well as button blankets, can be found in art collections throughout the world. Other Dorothy Grant lines include boiled wool outerwear, silk taffeta dresses, holiday jackets and light weight wool dresses, all with Haida motifs appliquéd or embroidered on them. Dr. Margaret Hess of the Canadian Museum of Civilization commissioned a Dorothy Grant button blanket depicting the "raven bringing light to the world" to be worn for the unveiling of a bronze sculpture on the same theme by Robert Davidson at the Museum of Anthropology in Vancouver. Her designs have also been featured at New York's Fashion Week and worn by people such as Robin Williams, David Suzuki, and British Columbia Lieutenant Governor Iona Campanella.

In a 2010 interview with Brittany Luby of the University of British Columbia, Dorothy Grant reflected that "Haida art has a look of almost universality to it. It has to do with the 'Innovation' idea—that art should not be stagnant, but progressive, no matter what the culture. As for Haida people, we have always looked for new mediums to convey Haida Art. This way, we keep ownership of it and no one else can say they did that first...Think of fashion as a bridge between cultures. It's a way for people of nations...to understand the art in fashion, rather than a totem pole...it's more about progression of Haida people. They first must see the evolution of Haida art and its people and what we have evolved from."

Another well-known contemporary Haida textile artist is Stephany Pryce, who has been creating button blankets and wall hangings since the early 1990s.

Above left: Young Tlingit ceremonial dancers on Prince of Wales Island. One of the islands of the Alexander Archipelago in the Alaska Panhandle, it is the fourth largest island in the United States. Alaska Photo Library

Left: Young contemporary Tlingit Chilkat dancers at Haines. Alaska Photo Library

CHILKAT BLANKETS

The Chilkat blanket, or robe, is the signature form of traditional ceremonial attire among the Northwest Coast people. Because it could take a year to weave one, they were very valuable and ownership carried immense prestige. A chief would typically wear such a robe during the Potlatch festivities to symbolize his great wealth. Therefore, giving away a Chilkat blanket or robe at a Potlatch was seen as the epitome of generosity. Chilkat blankets or robes were never worn as a day to day garment, but only on special occasions. Leaders and people of great importance were often buried in their Chilkat blanket.

The name originated with the Chilkat kwaan (tribe) of the Tlingit people, whose traditional home was on Alaska's Chilkat River. However, the blankets and robes have been a part of the traditional culture of all Tlingit, as well as the Haida, Kwakwaka'wakw, Tsimshian and others on the Northwest Coast since before the nineteenth century, and it is not known with whom the tradition originated. An important Tlingit weaver of Chilkat textiles from around the turn of the twentieth century was Mary Ebbets Hunt.

George Emmons, an ethnographer who did work on the Northwest Coast in cooperation with the Field Museum and the American Museum of Natural History, recalled a native legend concerning the mythical origin of the weaving in his 1907 book *The Chilkat Blanket*:

"Long ago there lived on the Skeena River, in British Columbia, a Tsimshian woman, a widow, of the village of Kitkatla, and her only daughter, 'Hi-you-was clar' (rain

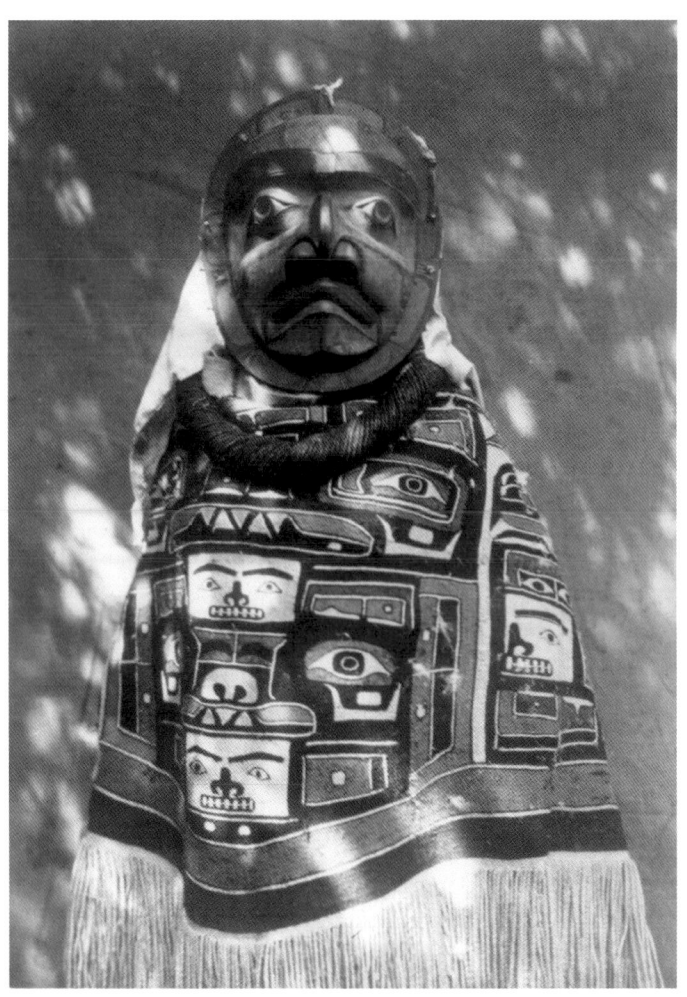

Above: A Kwakwaka'wakw woman wearing a fringed Chilkat blanket, a Hamatsa neck ring, and mask representing a deceased relative who had been a shaman. LoC

Below: A Chilkat blanket made before 1910. The pattern, a painted board, was designed by the men and represented clan or lineage crests. The blanket was then woven by a woman, in the traditional tribal division of labor. LoC

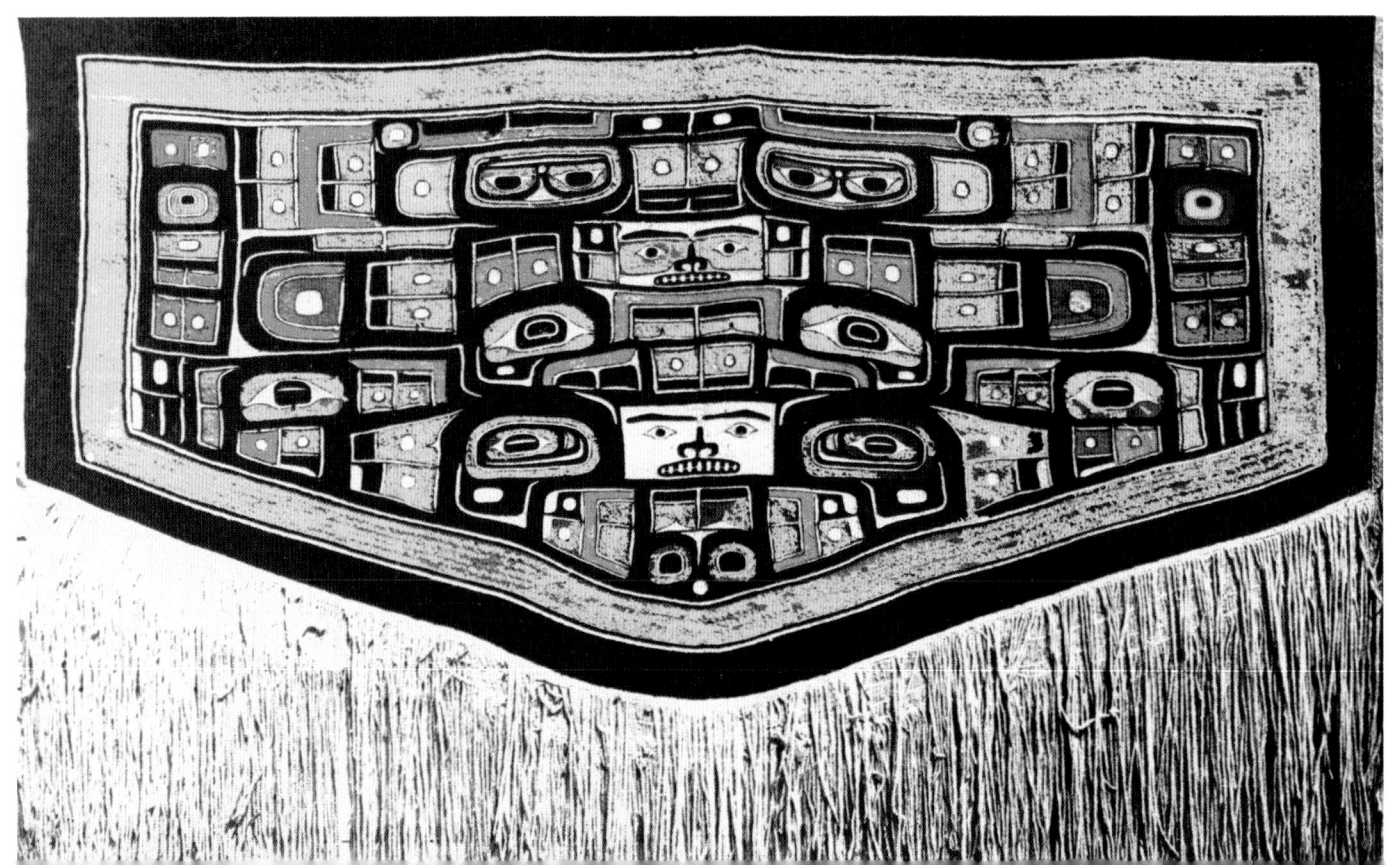

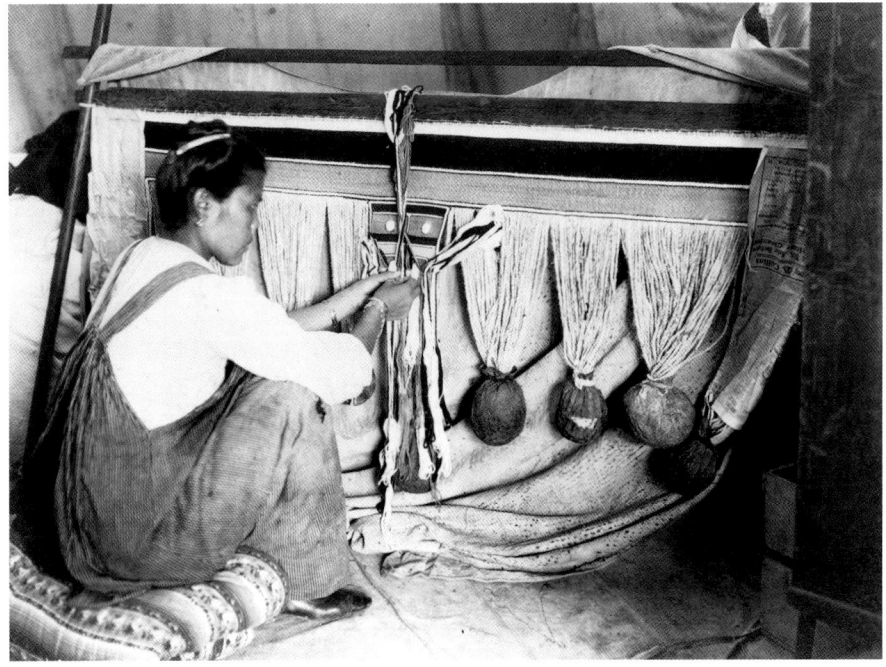

Left: A woman weaving a Chilkat blanket in Alaska, c. 1910. The weaving, done by the women, was on a single bar loom. The materials used were cedar bark and mountain goat wool. It traditionally took about a year to weave a single blanket, and the same is true today. LoC

Below: Three brothers, head men of the Kak Von Ton, two of them wearing Chilkat blankets, one wearing a bird headdress and bone or ivory necklace, photographed c. 1907. LoC

mother). It had been a season of extreme want. The deep snows of winter still covered the lowlands, and the spirit of hunger stalked abroad as a famished wolf. Day after day the girl sat, half dazed from want of food, staring vacantly at the intricately carved and painted picture that covered the rear partition of the house; for, although poor, they were of high caste, and their surroundings spoke of past greatness. The picture finally took possession of her, and setting up a rude frame, she forgot her suffering, and lost herself in the work of weaving an apron of like design. Later her hand was sought by the son of the chief and, in the exchange

of presents, her handiwork was given to the father-in-law, who honored the occasion by a great feast, at which he wore the apron, and sacrificed many slaves in token of his appreciation of the gift."

Chilkat weaving, according to Cheryl Shearer in *Understanding Northwest Coast Art*, is one of the "most complex weaving techniques in the world," unique in that the artist can create curvilinear and circular forms within the weave itself. The weaver works in vertical sections, as opposed to moving horizontally from end to end. The looms that are used in Chilkat weaving have only a top frame and vertical supports, with no bottom frame, so the warp threads hang freely.

Traditional materials included the wool of mountain goats, dyed with tree lichen and oxidized copper, as well as dog fur and cedar bark, though domestic sheep wool was used after contact with Americans and European traders. The long wool fringe on the bottom of the blankets and robes was intended to be shaken during the dance. Form lines, abstract renderings of animals, and symmetric geometric forms are common to other Northwest Coast art media, and are present in Chilkat designs.

Audrey Hawthorn writes in Kwakiutl Art, that with Kwakwaka'wakw Chilkat blankets and robes, the design was traditionally first painted by a man, and then woven by a woman in accordance with the design. In turn, these designs would usually show a multitude of ancestral and mythological individuals.

In addition to blankets and robes, Chilkat weavers have also produced other garments, such as aprons, bags, dance tunics, hats, leggings, shirts, and vests.

The art of Chilkat weaving, like so many Northwest Coast art forms, entered a nadir in the first half of the twentieth century, and was on the verge of disappearing when it was revived late in the century. By this time

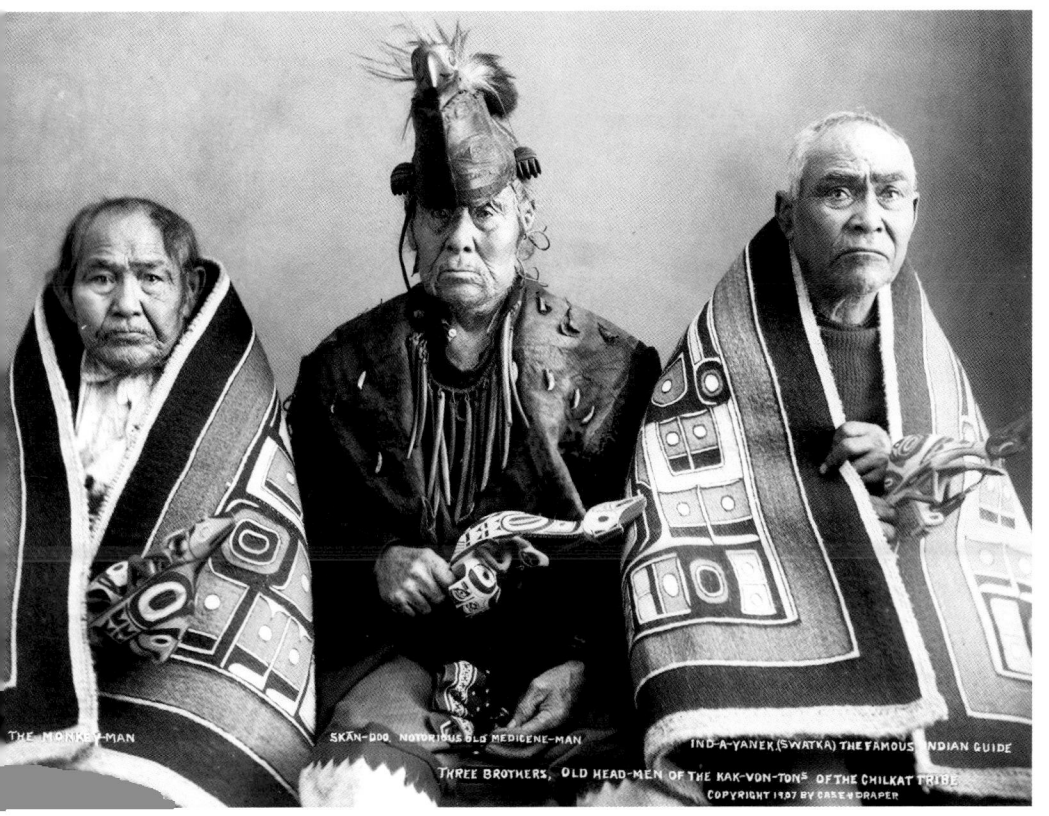

THE MONKEY-MAN

SKAN-DOO, NOTORIOUS OLD MEDICINE-MAN

IND-A-YANEK (SWATKA) THE FAMOUS INDIAN GUIDE

THREE BROTHERS, OLD HEAD-MEN OF THE KAK-VON-TONS OF THE CHILKAT TRIBE
COPYRIGHT 1907 BY CASE & DRAPER

only about a half dozen people were left who understood the process.

The person recognized as having spearheaded the Chilkat revival is Tlingit weaver Jennie Thlunaut (1892–1986) of Klukwan, Alaska. She reportedly first wove a Chilkat blanket with her mother at age ten, and completed her first solo blanket at age eighteen. Working as a weaver part-time as she raised her children, she had managed to complete more than fifty Chilkat blankets during her lifetime. By the 1980s, she had become quite famous, and was invited to the Smithsonian Institution to demonstrate her work. As her biographers, Rosita Worl and Charles Smythe, have recalled, "she will be remembered as one of the most eminent and celebrated weavers of Tlingit ceremonial robes."

The famous Haida basket maker Delores Churchill studied with Jennie Thlunaut, as did two contemporary Tlingit weavers of Chilkat blankets, Anna Brown Ehlers and Clarissa Rizal, who is quoted as having said "Jennie amazed us with her speed at weaving…Her fingers seemed to fly through the warp, and she didn't even use a pattern."

Today, the wearing of Chilkat robes as part of a traditional festival is best seen at "Celebration," the biennial festival of Tlingit, Haida, and Tsimshian tribal members in Juneau. Organized by the Sealaska Heritage Institute, Celebration is held in even numbered years and is one of the largest gatherings of Southeast Alaska native peoples. Dozens of Chilkat blankets or robes can be seen being worn by dancers as they were originally intended to be displayed.

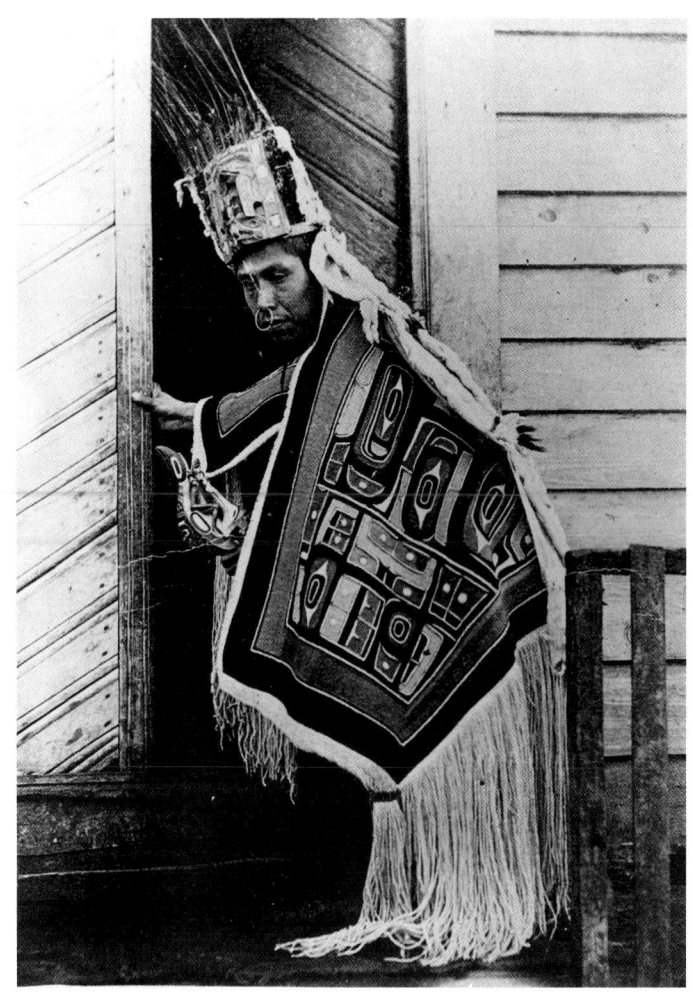

Above: Kitch Hawk, also known as "Jake the Bracelet Maker," wearing a Chilkat blanket and headdress, c. 1888. LoC

Below: Contemporary Tlingit Chilkat dancers at Haines. Alaska Photo Library

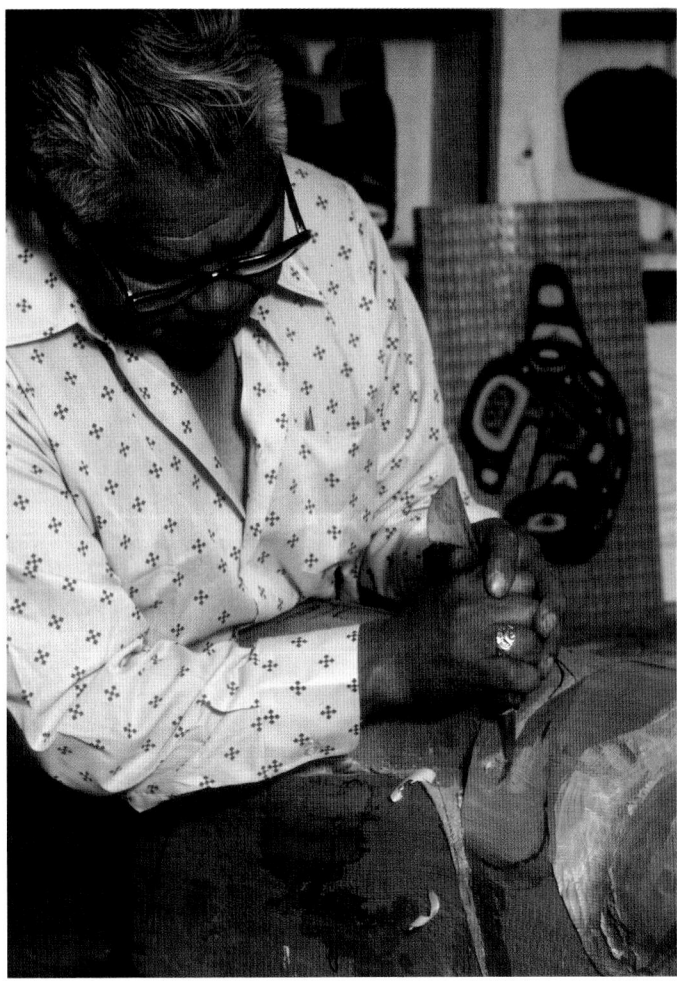

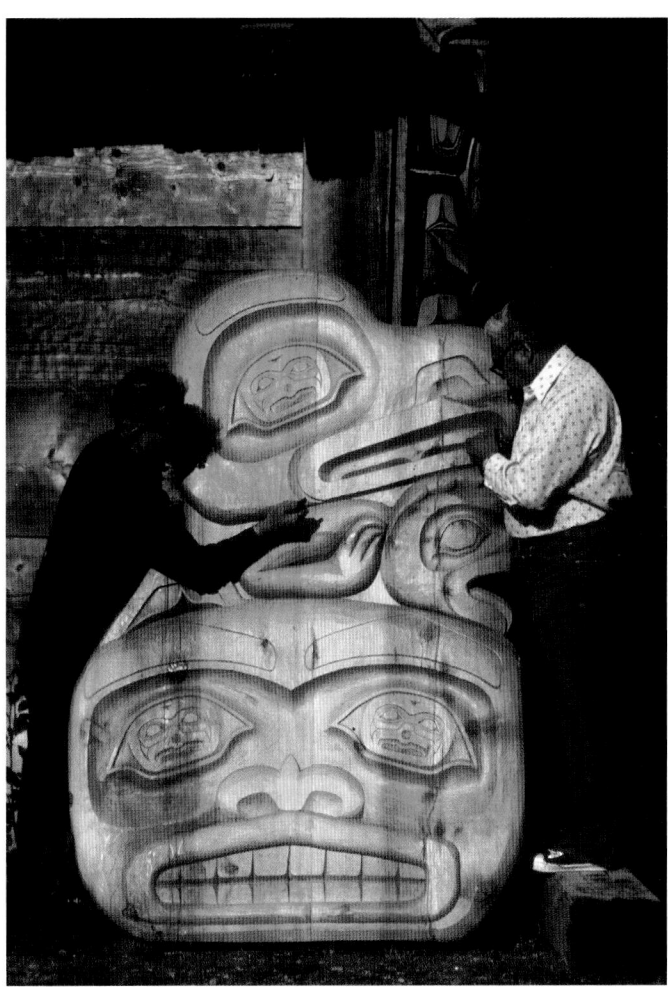

Above left: A contemporary artisan from Klukwan carving a totem pole at Haines, today a center of traditional native arts in southeast Alaska. Alaska Photo Library

Above right: A pair of men carving a contemporary sculpture at Haines, Alaska. Alaska Photo Library

Below: Contemporary native totem carvers at Haines, surrounded by Tlingit performers in traditional costume. Alaska Photo Library

NORTHWEST COAST WOODWORKING

Woodworking was, and remains, very highly evolved among the Northwest Coast people. As described by William Reid in his survey of Northwest Coast art, *Out of the Silence*, the Northwest style was "an austere, sophisticated art. Its prevailing mood was classical control yet it characterized even the simplest objects of daily life. These seagoing hunters took the entire environment as art form."

It was also a very sophisticated culture. While their neighbors in California, the Great Basin and the Subarctic lived in humble grass or brush houses, known as wikiups, the Northwest people built large timber and plank structures for living and for ceremonial purposes.

Their place as outstanding woodworkers was due, at least in part, to the abundant availability of Western red cedar (*Thuja plicata*), a tree that can grow as tall as 200 feet, with a diameter of 12 feet. Cedar is known for its long runs of tight, straight grain with few knots, and is a soft wood that is easily worked. Also used is the wood of the tree called "yellow cedar," which is actually Nootka Cypress (*Callitropsis nootkatensis*). It can exceed 100 feet in height with grain that has many of the same desirable properties as red cedar.

The two woods are also practical for building because of their durability and resistance to insect pests. Though they are not as resistant to deterioration as redwood, they last much longer than pine or fir lumber. With the damp conditions on the North-west Coast, it is important to have a wood that will stand up. Nevertheless, most work done by Northwest carvers has decayed over time and been lost. Few Northwest Coast artifacts predate the nineteenth century.

Stone adzes and blades were the primary tools used for woodworking before contact with Europeans in the eighteenth century. It was long believed that stone woodworking tools were used exclusively, but recent archeological excavations have turned up iron tools in Alaska that are 500 years older. These were probably acquired in trade with people from Asia or Siberia. Meanwhile, discoveries of stone woodworking tools date Northwest Coast woodworking back at least 5,000 years.

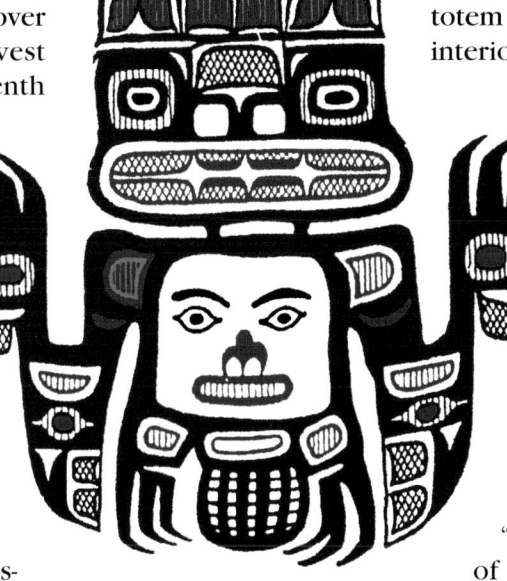

Tlingit Grizzly Bear Motif.

Red cedar, as well as yellow cedar, is indigenous to the coastline of present-day Oregon, Washington, British Columbia, and the panhandle of Alaska, as well as major offshore islands such as Vancouver Island and the Queen Charlotte Islands (now called Haida Gwaii, or Islands of the People).

Here, the principal woodworking tribes were (and still are) the Haida of the Haida Gwaii, the Kwakwaka'wakw (formerly Kwakiutl) of Vancouver Island and adjacent British Columbia, the Nuu-chah-nulth (Nootka) of Vancouver Island, and the Tlingit of southeastern Alaska, as well as the Tsimshian and Nisga'a of northern British Columbia. Other Northwest Coast tribes in the same region include the Heiltsuk (Bella Bella) and the Nuxalk (Bella Coola).

Similar work done by tribes on the Olympic Peninsula of Washington and among the Coast Salish of Oregon is not considered by ethnographers and the native art community as being part of the "Northwest Coast" art tradition. The latter is distinguished from other artistic traditions by the use of a "formline" or outline, and the use of geometric shapes.

The imagery was abstract because of the necessities of the materials. Totem pole images were carved in a certain way because of the shape and proportions of a cedar log. As Edward L. Keithahn wrote in his book *Monuments in Cedar*, "Certain parts were greatly enlarged or eliminated, others suppressed, bent or folded until they fit into their allotted space … Balanced designs were desirable and to achieve balance the artist employed dissection. For example, to fit Raven on a drum, the Raven might be split down the back and laid open resulting in a two-headed Raven which did not exist in Indian mythology."

The signature object of woodworking in the Northwest Coast tradition is the totem pole, discussed below. Carvings on interior and exterior parts of houses and buildings were also traditional, as were paintings with similar motifs. Two important, publicly accessible houses decorated with carvings, paintings and totem poles in the Northwest Coast style are the Tlingit Chief Shakes House near Wrangell, Alaska, and a Kwakwaka'wakw ceremonial house in Victoria, British Columbia.

Celebrated among the Tlingit, "Chief Shakes" is a hereditary title of great distinction dating back to the eighteenth century. The Chief Shakes House near Wrangell is a replica of the traditional ceremonial houses. It was constructed

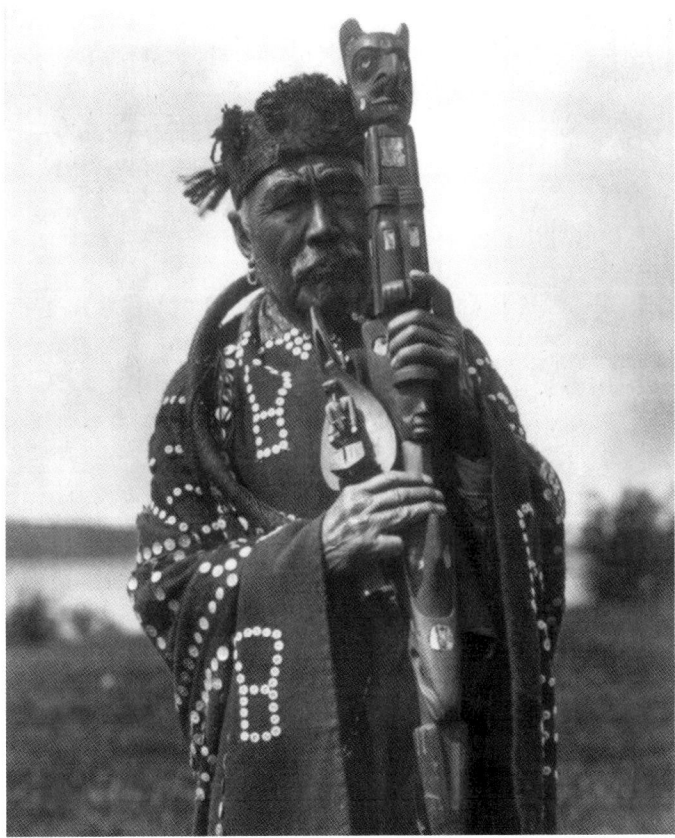

Above: Hamasaka, a Kwakwaka'wakw principal chief, holding a carved ceremonial staff and a shaman's rattle, while wearing a Tluwulahu costume, and a button blanket. LoC.

Below: Haida Beaver Motif.

Among the names of great twentieth century Kwakwaka'wakw wood artists, that of Mungo Martin, (Nakapenkem 1879–1962), certainly stands out. Urged by his mother to take up carving, he learned the art from his stepfather, Charlie James, also a famous Northwest artist, and carved his first totem pole in about 1900. During the twentieth century, he became a culturally important carver, and worked with other Kwakwaka'wakw artists such as Dan Cranmer, Tom Omhid, and Willie Seaweed to train younger people for the traditional craft. Among those whom he trained were his son David Martin, and his grandsons, the contemporary Kwakwaka'wakw artists Richard, Stanley, and Tony Hunt. His niece Ellen May Neel (1916–66) was the first woman known to have carved totem poles professionally.

One of the first great Haida sculptors of modern times was Charles Edenshaw (1839–1920), who carved in both wood and argillite, creating bentwood boxes, rattles, masks, and staffs, as well as totem poles. His commissioned projects include work in the American Museum of Natural History, and he served as a consultant to anthropologists such as Franz Boas. His wife, Isabella Edenshaw, was a renowned Haida basket maker. He is the great-grandfather of contemporary Haida artists Robert and Reg Davidson.

One of the best known late twentieth-century Haida sculptors was Bill Reid (1920–98), whose work is located at the Canadian Embassy in Washington, D.C., at Vancouver International Airport, and is pictured on the Canadian twenty dollar bill.

Tlingit artist Jim Schoppert (1947–1992) earned his MFA at the University of Washington and went on to become one of the most influential Northwest Coast artists of the twentieth century by creating sculptural works that were largely non-traditional from a Tlingit perspective. Among contemporary Tlingit artists, Tommy Joseph (b. 1964) of Sitka, Alaska, has earned commissions from around the world by creating totem poles and other works in wood that use many of the traditional motifs that one might have seen in Tlingit towns at the end of the nineteenth century.

Two Nisga'a (Niska) mater carvers of note are Norman Tait (b. 1941) and his nephew Ron Joseph Telek, aka Jagam Txalp (b. 1962). Considered to be the preeminent modern Nisga'a artist, Tait has totem poles on display throughout British Columbia and at the Field Museum in Chicago, and he has received commissions from Japan and Germany.

in the 1930s when there were still people alive who could remember the old ways of woodworking. It was dedicated in 1940, along with the installation of Charlie Jones, the heir to Chief Shakes VI, as Shakes VII.

The Kwakwaka'wakw ceremonial house in Victoria, was built in 1953 by sculptor Mungo Martin and David Martin of the Kwakwaka'wakw with carpenter Robert J. Wallace. Called "Wawadit'la," it is based on the house of Chief Nakap'ankam in Tsaxis (Fort Rupert), British Columbia. Totem poles in the traditional styles are included at the site of both of these houses.

The production of carved wooden objects for sale to collectors began in the late nineteenth century and progressed slowly until the middle twentieth century. Many earlier objects not originally carved for sale were purchased and these now reside in museum collections around the world. Parenthetically, many Haida sculptors also worked in stone, specifically argillite. This tradition began in the nineteenth century as a means of creating trade goods, and it continues into the twenty-first century.

Right: A contemporary Tlingit artist at Haines, Alaska, with a carved screen showing Eagle and Raven images. Robin Hood, Alaska Photo Library

Below: This Kwakwaka'wakw ceremonial house, seen here surrounded by totem poles, was built in 1953 by Mungo Martin and David Martin of the Kwakwaka'wakw with carpenter Robert J. Wallace. Called "Wawadit'la," it is located in Victoria, British Columbia and based on the house of Chief Nakap'ankam in Tsaxis (Fort Rupert). Rather than displaying his own crests on his totem pole, which is customary, the famous sculptor Mungo Martin chose to carve the crests representing the A'wa'etlala, Kwagu'l, Nak'waxda'xw, and Namgis Nations of the Kwakwaka'wakw in order to honor all the Kwakwaka'wakw people. Photo by Ryan Bushby, licensed for publication under a Creative Commons Attribution Share Alike Generic license.

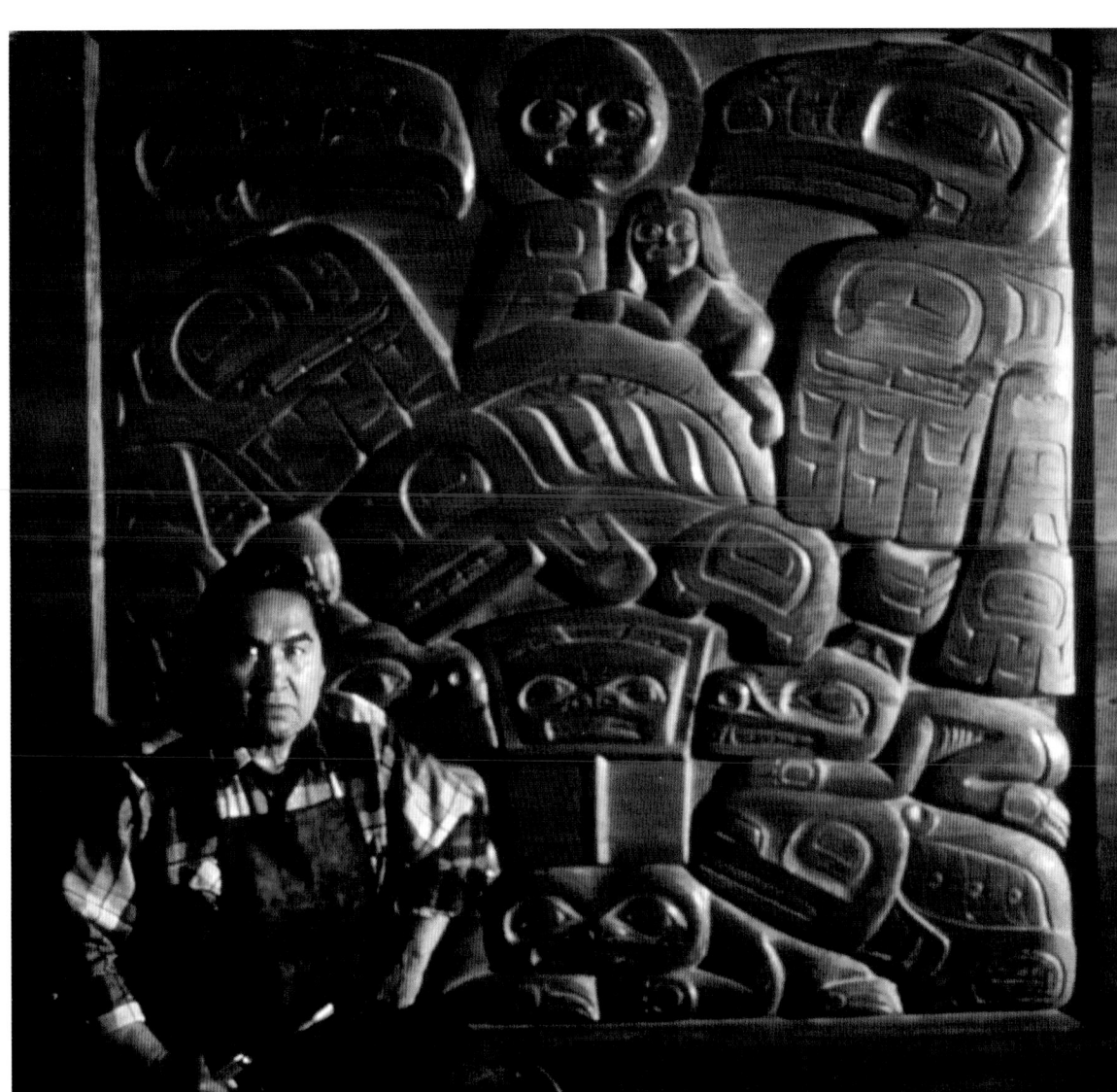

NORTHWEST TOTEM POLES

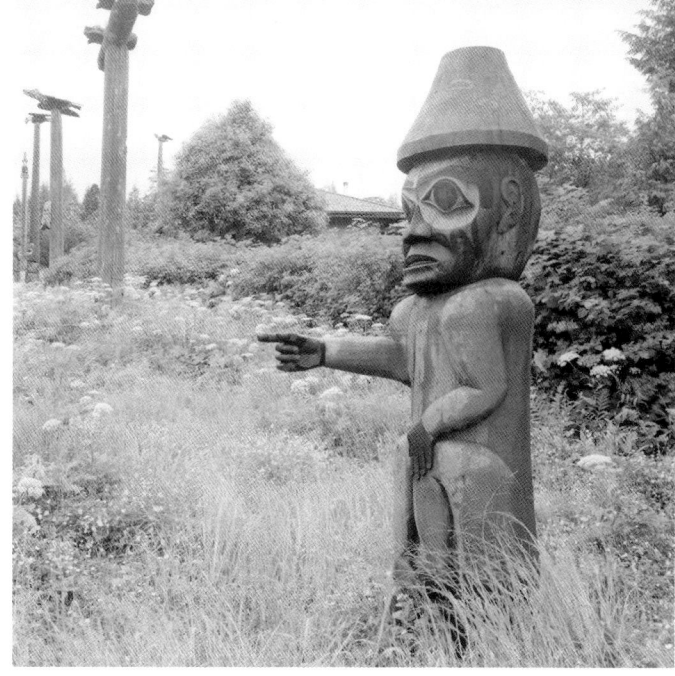

The most outstanding examples of the Northwest Coast woodworker's art are totem poles, which are often carved from a single red cedar trunk. Though they were probably not common prior to about 1830, oral traditions indicate that they certainly existed in limited numbers prior to that. The first mention of them by a European observer is thought to be that of John Bartlett, who visited a Haida village in the Queen Charlotte Islands in 1791.

To the people of the Northwest Coast, the poles were not "totem" poles. This term totem is derived from ototeman, a word in the Ojibwa language of the Algonquian linguistic family, a reference to symbolic animals. The word ototeman was, in turn, borrowed and bastardized by nineteenth-century anthropologists as "totem," meaning a specific animal which is associated with a specific clan group, who in turn believe themselves descended from this "totem animal." Hunters from the group will therefore not kill one. The term "totem pole" consequently was defined as a pole with totem animals carved on it. The Haida word for the poles was gyáa'aang, meaning simply a "man who stands upright." This is the straightforward literal description as explained by a Haida carver to the American anthropologist Viola E. Garfield, and reported in her 1948 book *The Wolf and the Raven: Totem Poles of Southeastern Alaska*.

Early missionaries to the Northwest Coast were horrified by the totem poles, believing the "idolatry" inherent in the images to have been created to pay tribute to heathen gods worshipped by misguided savages. However, the images of animals on a pole before a house were no more esoteric than the equivalent European coats of arms, which usually contain semi-biographical imagery. As William Reid wrote in his survey of Northwest Coast art, *Out of the Silence*, "these poles told of the mythological beginnings of the great families, at a time before time, when animals and mythic beasts and men lived as equals and all that was to be was established by the play of raven and eagle, bear and wolf, frog and beaver, thunderbird and whale…They told the people of the completeness of their culture, the continuing lineages of the Great families, their closeness to the magic world of myth and legend."

The actual iconography of these images had its roots in story-telling rather than mysticism.

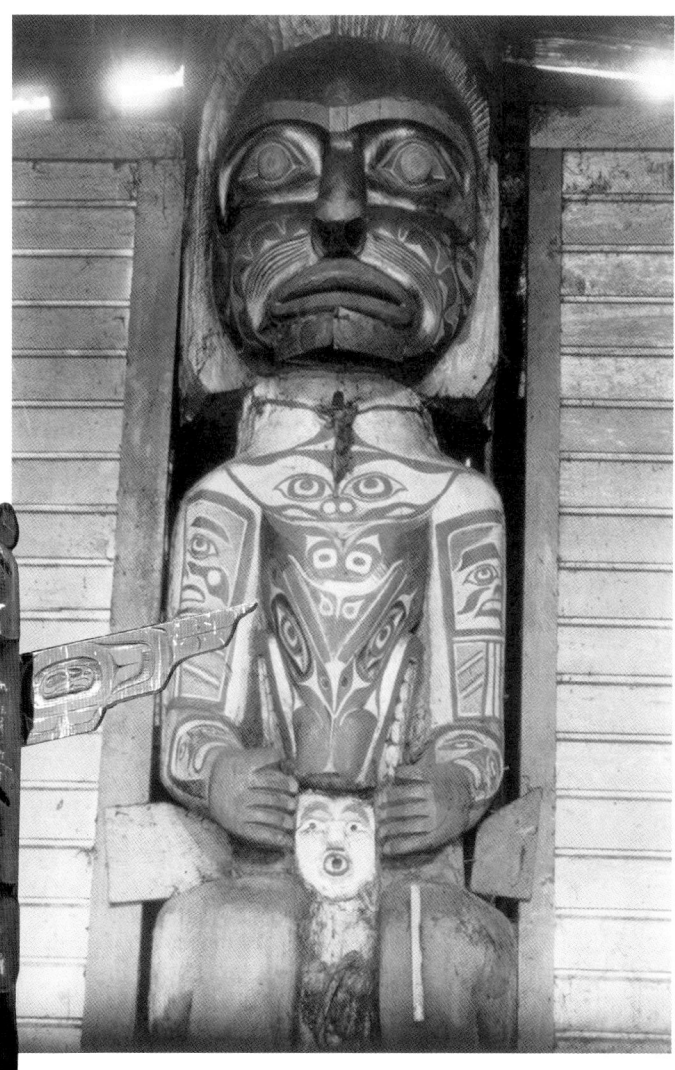

Top: Totem poles line the entrance to the Totem Park at Saxman, near Ketchikan, Alaska. LoC

Above: The interior supporting columns of a Kwakwaka'wakw home bearing carvings commemorating incidents in family history, depicting the guardian spirit of the founding members of the family. LoC

Left: Topped with the traditional representation of an Eagle, this totem pole overlooks the S'Klallam cemetery. Jean Boyle photo from the Kitsap Peninsula Visitor & Convention Bureau.

As pointed out by Robin K. Wright, curator of Native American Art at the University of Washington's Burke Museum, "the figures carved on Northwest Coast poles generally represent ancestors and supernatural beings that were once encountered by the ancestors of the lineage, who thereby acquired the right to represent them as crests, symbols of their identity, and records of their history."

It is believed the earliest predecessors to totem poles were structural interior house posts. Developed later were posts at the outside corners of clan houses, and those flanking the façade or entrance. Similar poles were carved to hold the ashen remains of a cremated body or as a grave marker for a dead shaman.

Originally, the Kwakwaka'wakw and Nuu-chah-nulth people were likely to use elaborate interior carvings to commemorate their ancestors and sacred beings, while the detached exterior poles were erected mainly by the Haida, Tlingit, and Tsimshian. However, later in the nineteenth century, the Kwakwaka'wakw and Nuu-chah-nulth, as well as the Heiltsuk and the Nuxalk also began carving and installing totem poles outside their ceremonial houses. Maryanne Kathleen Basti of Yale writes in *Totem Poles of the North American Northwest Coast Indians*, that "in 1820, the iron adze was introduced by the Northwest traders. As a result of this addition, the period from 1830–1880 is referred to as the Golden Age of Totem Poles."

As Dr. Wright notes, "only the best artists were commissioned to carve the monumental heraldic poles that were placed in front of and inside northern Northwest Coast houses proclaiming the identity, status, and history of the noble people who owned them.

"In ancient times, few noble families could afford to commission these sculptures, but during the nineteenth century the number and size of poles increased

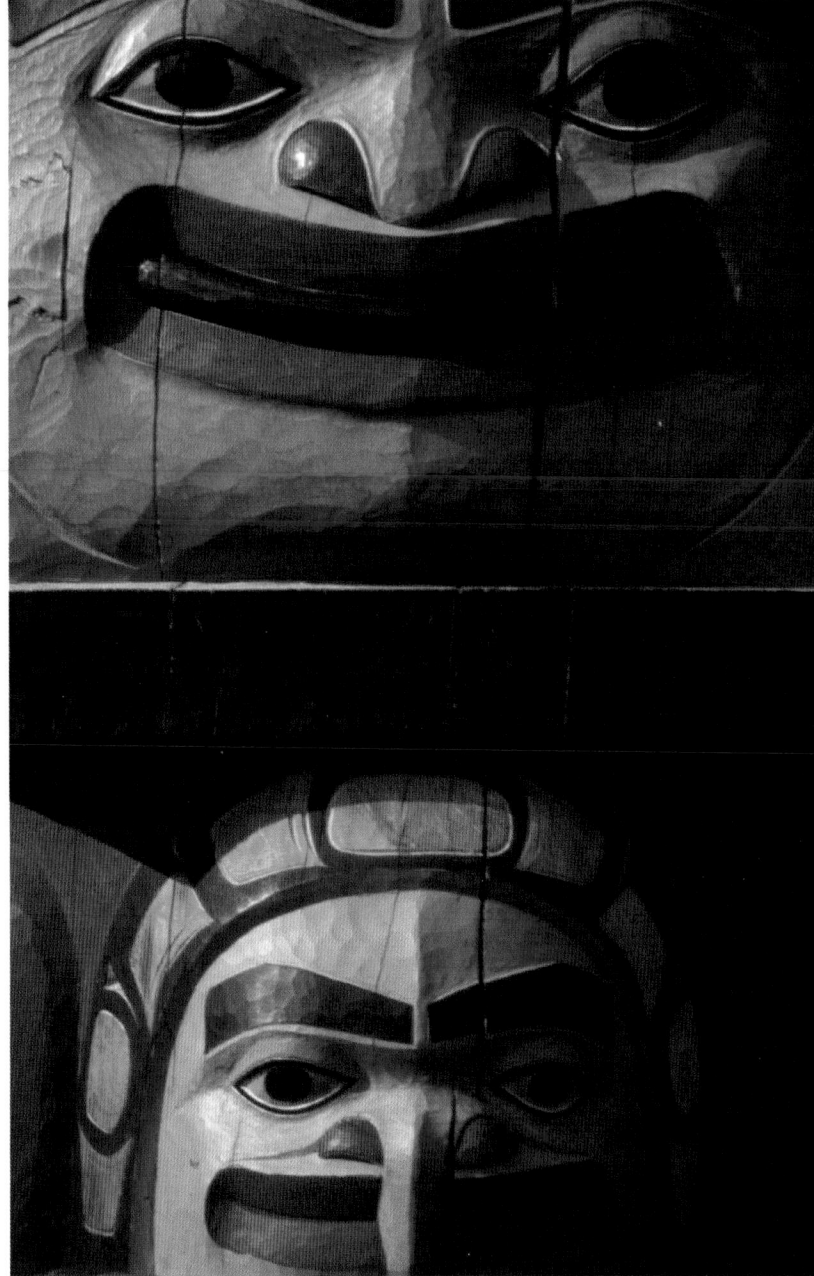

Above right: A detail of a section of a totem pole on display in Juneau, Alaska. The bottom figure is said to represent the mosquito. Bill Yenne photo

Left: This contemporary totem pole in Juneau, Alaska is colorfully painted in traditional Northwest colors. Bill Yenne photo

dramatically due to a variety of factors, including the increased wealth brought by the fur trade, improved availability of iron tools, and the dynamic social and political environment characterized by new wealth, population loss, family relocations, and chiefly rivalries."

Traditionally, carving was done by a group of craftsmen who had been formally trained in an apprenticeship system. The desired size, the symbols, and the story were related in full detail prior to the work beginning, and the pole was carved according to these specifications. The size of the totem poles was controlled only by the length of the cedar logs from which they were crafted, and they frequently reached a height in excess of fifty feet.

By the late nineteenth century, just as the totem pole renaissance, or "the Golden Age of Totem Poles," was in full swing, the craft was brought to a halt by Canadian legislation which outlawed many traditional

ALASKA

Yakutat

Klukwan
Chilkat

Hoonah
Juneau

Tlingit

Angoon

Sitka

Kloqwan

Wrangell

Tuxecan

Klawock
Kasaan

Hydaburg
Ketchikan
Sukkwan
Saxman
Howkan
Kaigani
New Metlakatla
Cape Chacon

Langara Is.
Frederick Is.
Virago
Yan
Hippa
Tow Hill
Cape Ball
Massett
Tsahl
Skidegate

Cumshewa
Skedans
Tasu
Tanu

Ninstints

QUEEN CHARLOTTE IS.

Haida

Niska

Kincolith
Nass River
Gitwinksithk
Gitlakdamiks

Cape Fox
Tongas
Gitiks
Port Simpson
Prince Rupert

Kitwancoola
Kitwanga
Hazleton

Kitsalas
Kitsegukla

Gitskan

Krisalas

Kitamat

Port Essington

Tsimshian

Hartley Bay

Haisla

Kitlope

China Hat
or Haihais

*Haisla and Heiltsuk combined
are Northern Kwakiutl*

Kimsquit

Heiltsuk

Bella Bella

Bella Coola or Nuxalk

BRITISH COLUMBIA

Rivers Inlet
Smith Inlet

Southern Kwakiutl

Hope Is.
Nahwitti

Blunden Harbour
Watson Sound
Kingcome Inlet
Knight Inlet

Southern Kwakiutl (Kwakwaka'wakw)

Koskimo
Quatsino
Ft. Rupert
Alert Bay
(Nimpkish)

Gilford Is.

Turnour Is.
Holmaco villages

Kyuoquot
Klahoose villages
Comox

Zebalos
Cape Mudge

VANCOUVER IS.

Sliammon
villages

Campbell River
Pentlatch
villages

Sechelt villages
Squamish villages

Coast Salish

*Nootka
or Nuu-Chah-Nulth*

Nuchatl Nootka So.
Hequiat Friendly Cove
Clayoquot

Alberni
Comox
Nanaimo

Capilano
Mainland Cowichan
villages "Stalo"

Ohiaht

Island "Cowichan"
(Halkomelem) villages

Songish
villages "Straits"

NORTHWEST COAST VILLAGES

WASHINGTON

ceremonies and expressions. The principal aim of these laws was to eliminate the Potlatch, which was a feast or party where the host proved his wealth by essentially giving his wealth away to his guests to gain prestige. As with many modern equivalents, such as weddings and bar mitzvahs the lavishness of the Potlatch was proportional with the value of the prominence that one derived. Considered wasteful and unproductive by the Canadian government—not to mention the difficulty of taxing such transfers of property—the Potlatch was banned from 1885 to 1951. Even then the law was merely deleted from the legal code, not formally repealed. But because totem poles had been part of the "extravagance" associated with the Potlatch, the raising of new ones had terminated in Canada.

The sixty-six-year ban on keystone cultural components is still a sore point among the indigenous people of Canada. In 1980, nearly three decades after the prohibition ended, Agnes Alfred of the Kwakwaka'wakw said in an oral history recording preserved at the U'mista Cultural Centre in Alert Bay: "When one's heart is glad, he gives away gifts. Our Creator gave it to us, to be our way of doing things, to be our way of rejoicing, we who are Indian. The Potlatch was given to us to be our way of expressing joy."

Opposite: A totem pole with a human face at the Totem Bight Park in Ketchikan, Alaska. Eric Luse, Alaska Photo Library

Below: The image of the Raven tops this totem pole in Juneau, Alaska. Bill Yenne photo

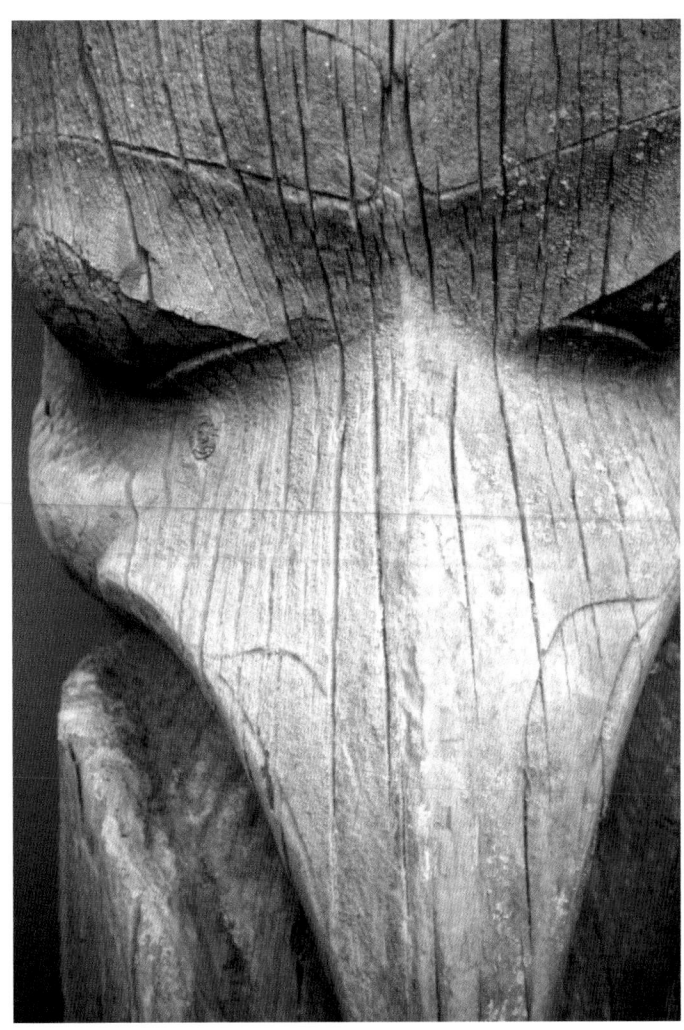

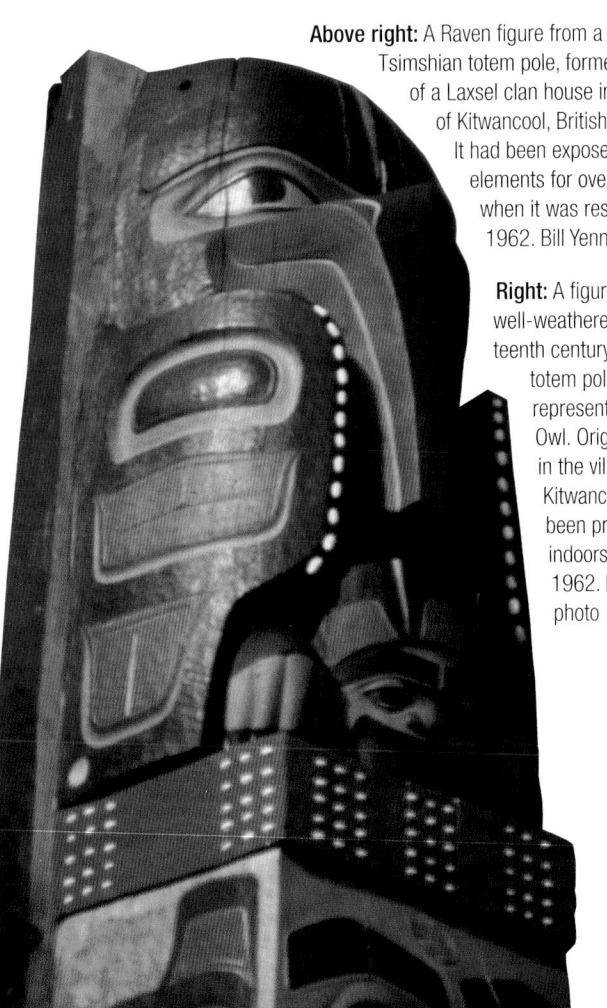

Above right: A Raven figure from a weathered Tsimshian totem pole, formerly in front of a Laxsel clan house in the village of Kitwancool, British Columbia. It had been exposed to the elements for over 90 years when it was rescued in 1962. Bill Yenne photo

Right: A figure from a well-weathered nineteenth century Tsimshian totem pole, possibly representing the Owl. Originally in the village of Kitwancool, it has been preserved indoors since 1962. Bill Yenne photo

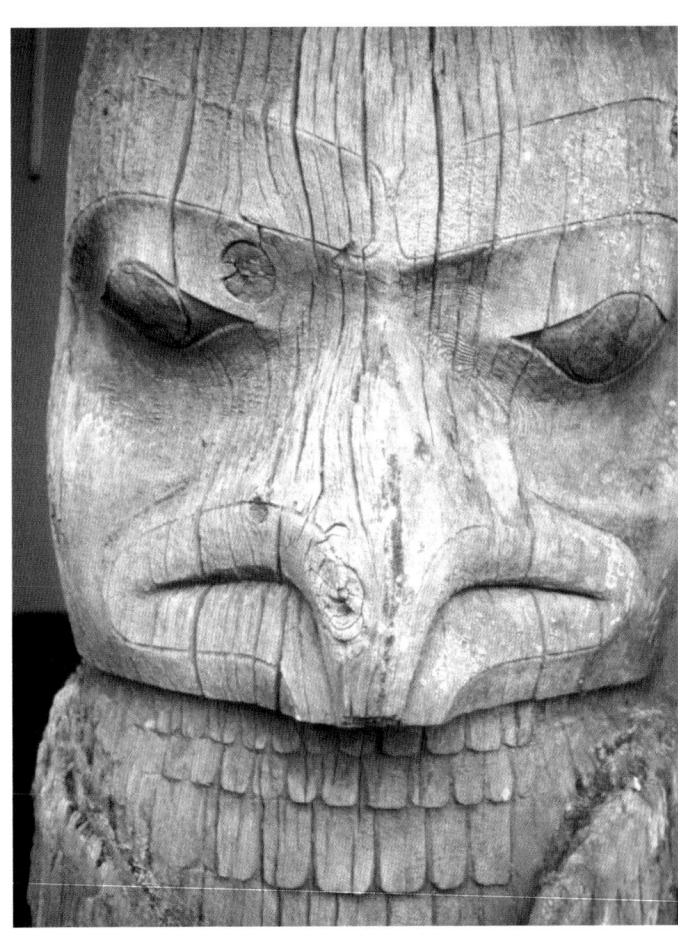

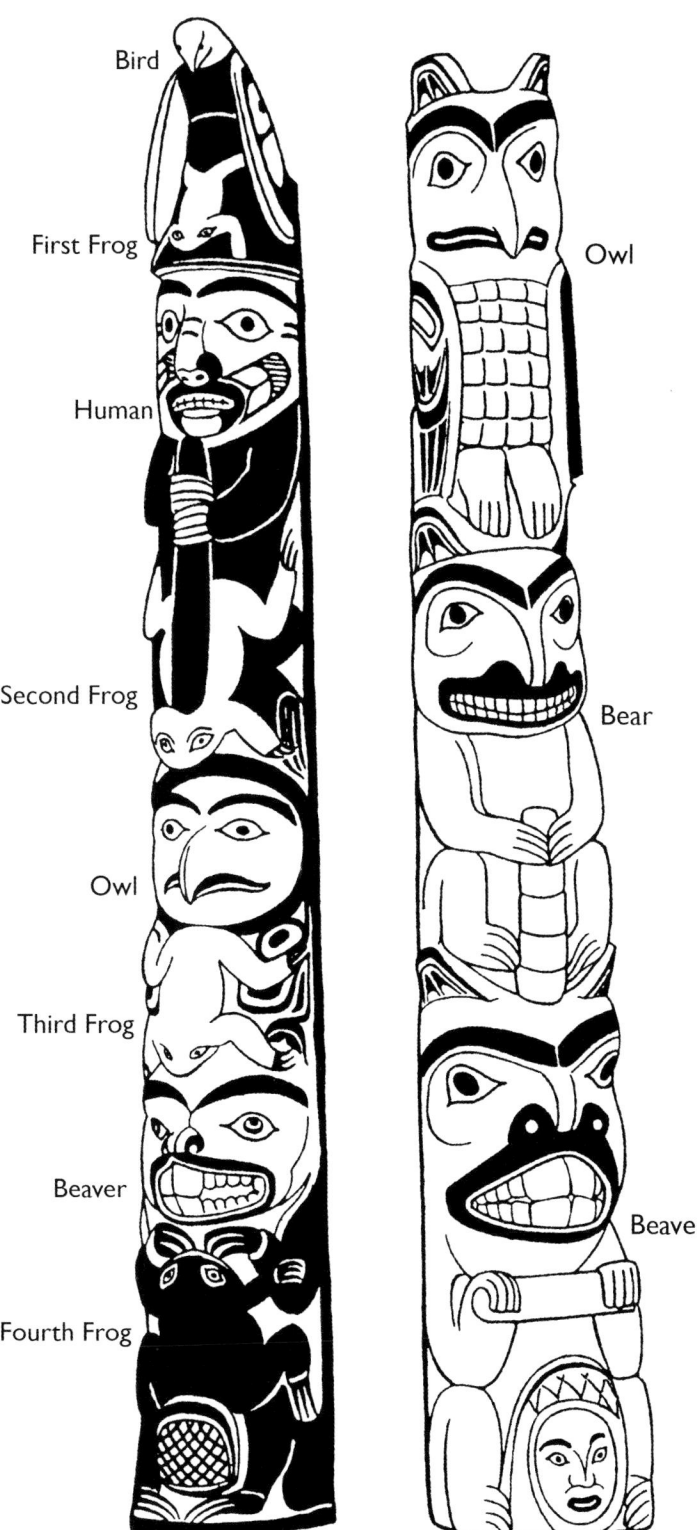

Bird

First Frog

Human

Second Frog

Owl

Third Frog

Beaver

Fourth Frog

Owl

Bear

Beaver

Above left: Haida Frog Totem Pole.

Above right: Haida Owl Crest Totem Pole.

In the United States, however, there had been an increasing interest in totem poles. They were brought down from Alaska to be exhibited at the Chicago

Columbian Exposition in 1893, the St. Louis World's Fair in 1904, and the Portland Lewis and Clark Centennial in 1905. A Tlingit "Totem Park" in Sitka, Alaska, became the Sitka National Monument in 1910. Additional parks were established in Alaska over the coming years.

After the Potlatch ban was lifted in 1951, Canada made a complete reversal of public policy, encouraging that which had previously been forbidden. The government proceeded to commission artists such as Mungo Martin to create new totem poles for public display, with traditional Potlatch ceremonies often being part of the formal dedication.

As described in the section of this book on Northwest Coast Woodworking, it was in 1952 that the British Columbia Museum (now the Royal British Columbia Museum) in Victoria, British Columbia, commissioned Martin to construct a Kwakwaka'wakw ceremonial house in Thunderbird Park adjacent to the museum itself. The museum had been preserving existing totem poles as part of a conservation effort since 1940, but in 1952 it began a major restoration project with Martin as the program's head carver. Other museums and public institutions across Canada followed suit, commissioning totem poles from contemporary artists.

When Martin died in 1962, he was succeeded in the British Columbia Museum project by his son-in-law, the equally celebrated master carver Henry Hunt. In turn, Hunt's sons Richard and Tony both worked on the project, as did other notable native sculptors such as Tim Paul, Lawrence Bell, David Gladstone, and Bill Reid. The original poles in the exterior locations in Thunderbird Park were replaced with new versions by 1992, and the originals moved inside the museum for preservation.

However, it is believed by some that because decay is natural, to preserve a pole is to deny a natural process. Describing the traditional custom in her book *Americans Before Columbus,* Elizabeth Chesley Baity notes that "once a pole was erected, it was never repaired or repainted. It was left to fall prey to the elements. Indians could not engage in repairs except with great formality and expense and no new honors realized." Maryanne Basti adds that "socially and economically it was cheaper to erect a new pole. Totem poles were personal monuments that the Indians seemed content to have last only one man's lifetime."

Though a ten-foot pole may now demand prices in the low five figures, there has been a growing demand since the late twentieth century for new totem poles carved by qualified carvers, such as Dick Joseph and Harold Alfred of the Kwakwaka'wakw, or Tommy Joseph, Wayne Price, and Doug Chilton of the Tlingit. With restrictions on native ceremonies having long since been lifted, and with skilled native artists in Alaska and British Columbia accepting commissions, it can be said that a new renaissance in the art of the totem pole is ongoing in the twenty-first century.

NORTHWEST COAST MASKS

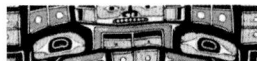

As with many cultures around the world, masks are an important part of ceremonial life which have become an important decorative art transcending the original function. Masks were important to most Northwest Coast tribes, including the Tlingit, Tsimshian, and Haida, but especially among the Kwakwaka'wakw. Today in British Columbia, the Kwakiutl [Kwakwaka'wakw] Museum of Cape Mudge and the U'mista Cultural Centre of Alert Bay contain rich collections of nineteenth-century and early twentieth-century masks.

In the Northwest, masks were important traditionally as a component of ritual life, and were an essential part of dance. Here, they were used to define the persona of the dancer who was depicting animals, forces of nature, people, and imaginary creatures. Specific masks were associated with specific supernatural beings, and with specific secret societies. Masks were also an important part of the Potlatch ritual dance performances, where they were used to illustrate the spirit beings (geni loci) encountered by ancestors.

Laurie Close of the Vancouver Island University, writing of their cultural significance, observes that "the masks of the Kwakiutl [Kwakwaka'wakw], were woven into and dramatically displayed in the rich ceremonial life...The Kwakiutl borrowed, adapted, and elaborated many themes into complex series of dances, ceremonies, and theatrical performances. Masks were a very important part of these activities since they gave life to various mythological, elemental, bird and animal figures which the people claimed as their ancestors from the early days. These supernatural beings had given privileges and special powers to a family, often in the form of a family crest, song, or dance. The family would then portray particular mythological figures as part of their heritage."

The masks were traditionally carved from red cedar or yellow cedar and decorated by painting and through the addition of feathers and strands of cedar bark, to simulate fur, and other materials. As explained by Laurie Close: "Most of the masks demonstrated a masterful use of line in their smooth concave and convex curves, with sharp, rigid lines used for effect or emphasis on a feature. These rigid curves usually delineated nostrils, eyes and lips through deeply cut carving and/or the use of contrasting color, adding to the form of the mask. Most of the lines had the tendency to run parallel and taper to

Below left: A Kwakwaka'wakw person wearing an oversize mask and hands representing the forest spirit, Nuhlimkilaka (Bringer of Confusion), c. 1914. LoC

Below: A Kwakwaka'wakw person wearing mask of mythical creature Pgwis (Man of the Sea), c. 1914. LoC

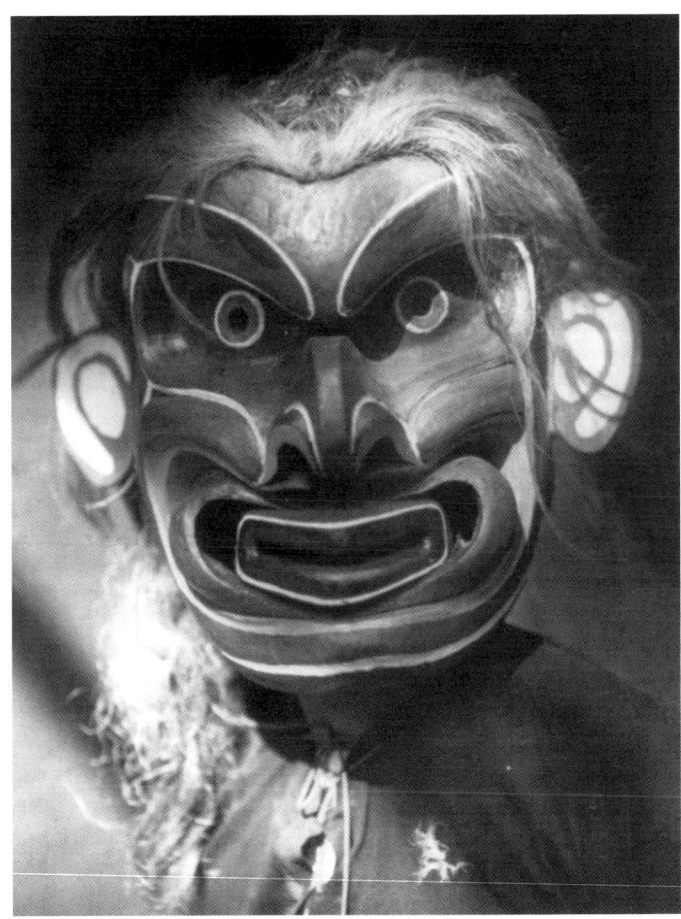

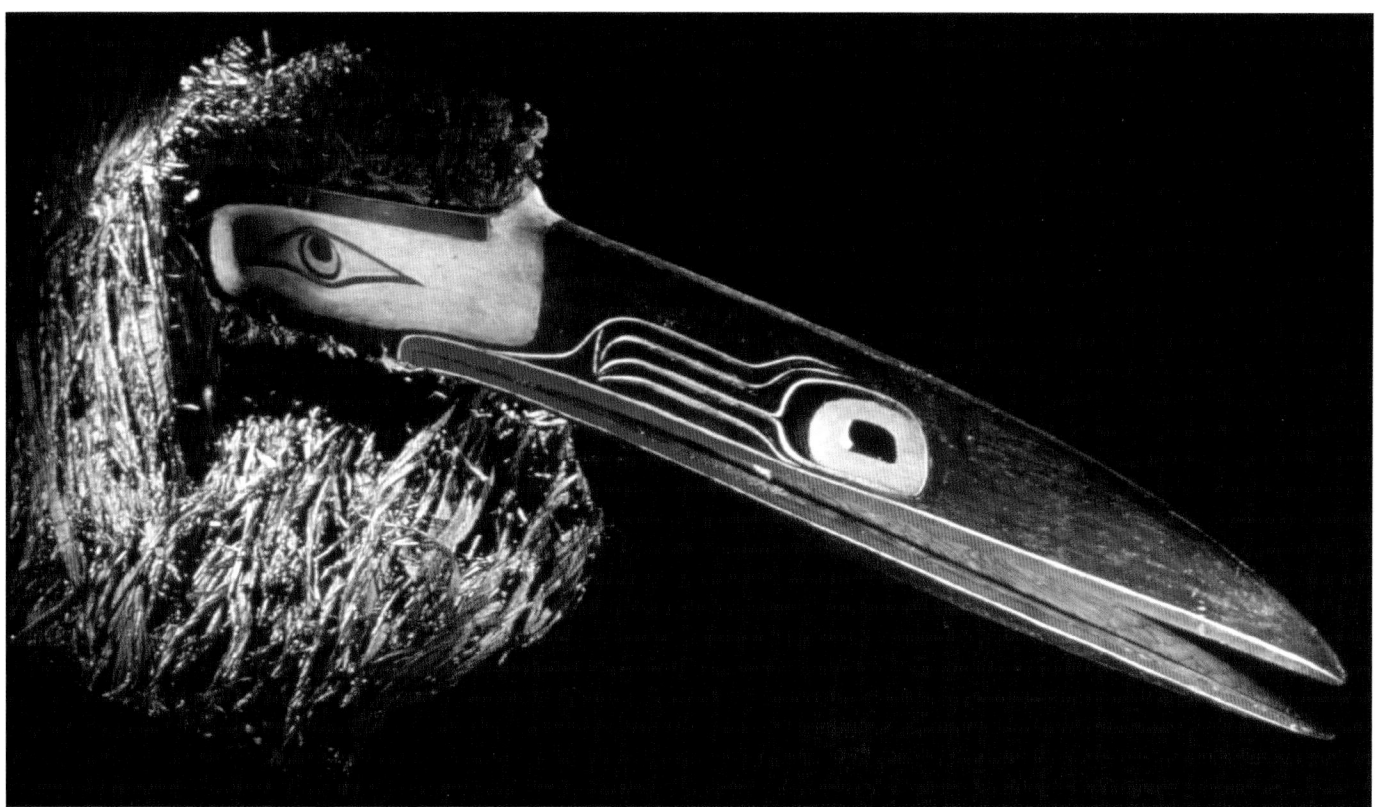

Above: The Kwakwaka'wakw Hokhokw (Giant Cannibal Bird) masks were worn by dancers in the Hamatsa, or Cannibal Society Dance. The one seen here dates from 1894 and is 59 in. long. These long-billed bird-monsters (similar in representation to the Raven) were associated with Bakhwbakwalanooksiwey (the Cannibal at the North End of the World). According to legend, the Hokhokw used his long beak to crush a human skulls in order to eat the brains. U.S. Government

a terminal point at each end creating contrast in shape between the geometric and organic lines. The Kwakiutl especially demonstrated strong, clear carving, and painting was used to enhance, emphasize or embellish the basic form of the mask. The traditional Kwakiutl choices of colors for paint were dark red, black, white, and green."

Among the most striking masks are the Hamatsa, or Raven-Cannibal masks. They consist of large slabs of cedar, split, hollowed, and rejoined to emulate a long-beaked bird. In some cases, there are Hamatsa masks with multiple heads. The Hamatsa is also a Kwakwaka'wakw secret society associated with ritual cannibalism.

Continuing in the cannibal theme are the Wild Man and Wild Woman. In Kwakwaka'wakw mythology, the former is called Bakwas (also Baäwas, Bookwus, or Bukwis). According to the U'mista Cultural Society, the literal translation is "man of the ground embodiment," though he is seen as the chief of ghosts or spirits. He lives in the forest near the ocean, where he offers food to lost humans while trying to lure them into the ghost world. His mask has a leering expression with large teeth, and is painted green with red trim. The U'mista Cultural Society commentary on Bakwas describes him as having "a green hairy body and skeletal face with prominent cheekbones and a hooked nose that curves to touch his upper lip. He lives in the country of ghosts and is the Chief of Woodsmen and keeper of drowned souls. It is unusual to see a [Bakwas] but be careful if you do because it is said that he will entice you into his

world by offering you food … Generally he is shy and afraid of humans."

Parallel ghost beings in other lore include Ba'wis of the Tsimshian, Gagit of the Haida, Urayuli of the Inuit, and Kushtaka of Tlingit mythology. Kushtaka, whose name means "Land Otter Man," is a "shape-shifter" who may be either an otter or a man.

The Wild Woman, Dzunuk'wa (or Tsonokwa), is dreaded by children, who are told they will be kidnapped and eaten by her. In both masks and totem poles, she is depicted as wild-haired, and always with a rounded mouth trimmed in bright red. Of Dzunuk'wa, the U'mista Cultural Society reports that she has no children of her own, so "she collects the children of mortals that she plans to eat. She captures these children and tries to take them to her remote house in the woods, but the children always manage to outwit her and escape. [Dzunuk'wa] is not often seen today because she does not like the sounds of contemporary life, like powerboats."

The U'mista Cultural Society collection also includes the Gikamç or Chief's Dzunuk'wa, a powerful protector of established chiefs. She, like the chief's family, represents wealth. As the Society notes, "Gikamç is not danced at a Potlatch; instead it is displayed at the beginning or end of a Potlatch to signify greatness. Young Chiefs cannot use the Gikamç, in fact, a Chief must be quite established in Potlatch ranking and have given at least four Potlatches in order to display it."

Also part of the Hamatsa lore is the Noohlmahl (Nulamal) interpreted as the "Fool." Cheryl Shearer, in *Understanding Northwest Coast Art* notes that these large-nosed, often silly-looking, masks represent fierce jesters that have been dispatched by the Hamatsa.

Audrey Hawthorn, in her book *Kwakiutl Art*, describes Kwakwaka'wakw masks representing the sun and moon. The former are circular, painted orange, red, and white, or have sheet copper attached. As noted by the U'mista Cultural Society, the sun lives in the upper world (or the sky) and "walks across the heavens" daily from east to west. As a family crest, the image would often be seen on the fronts of houses, and is atop of the world's tallest totem pole, located in Alert Bay. The Society reports that moon masks always appear as a pair, distinguished by the phase of the moon at the top of the mask. The features of a moon mask are "often carved in such a way that the face appears flatter than is typical of other masks, reduced in prominence to suggest a face in the moon."

Also described by Audrey Hawthorn are Komokwa masks, which are carved to represent maritime creatures and are associated with the "Chief of the Sea." She mentions various characteristics, such as fish eyes, gill slits, and scales, with an occasional seabird crest. Circular devices punched or painted have been deciphered as octopus tentacle suckers or air bubbles.

Other animal masks are common. Among these, the wolf is considered highly important among all Northwest Coast cultures, especially various Kwakwaka'wakw groups. Of these, it is considered to be the ancestor of the

Tsawataineuk (Dzawada'enuxw) people of Kingcome Inlet in British Columbia. This mask has a long, narrow snout and rounded ivory-colored teeth.

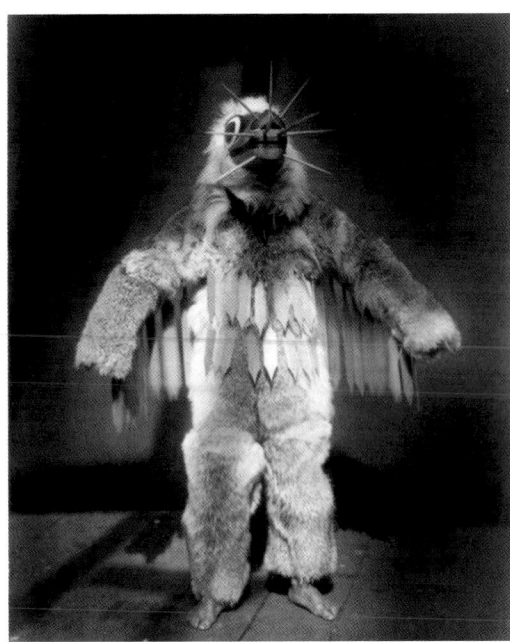

Above: Hamasilahl, a Kwakwaka'wakw ceremonial dancer, wearing mask and a fur garments during the 1914 Winter Dance ceremony. LoC

Below: The Hamatsa dancers known as Kotsuis and Hohhug Nakoaktok, wearing ceremonial dress and classic Kwakwaka'wakw Hokhokw (Giant Cannibal Bird) masks with long beaks, were photographed by Edward Curtis in British Columbia, c. 1914. The Hokhokw masks were difficult to use because the they were heavy and required delicate balancing. LoC

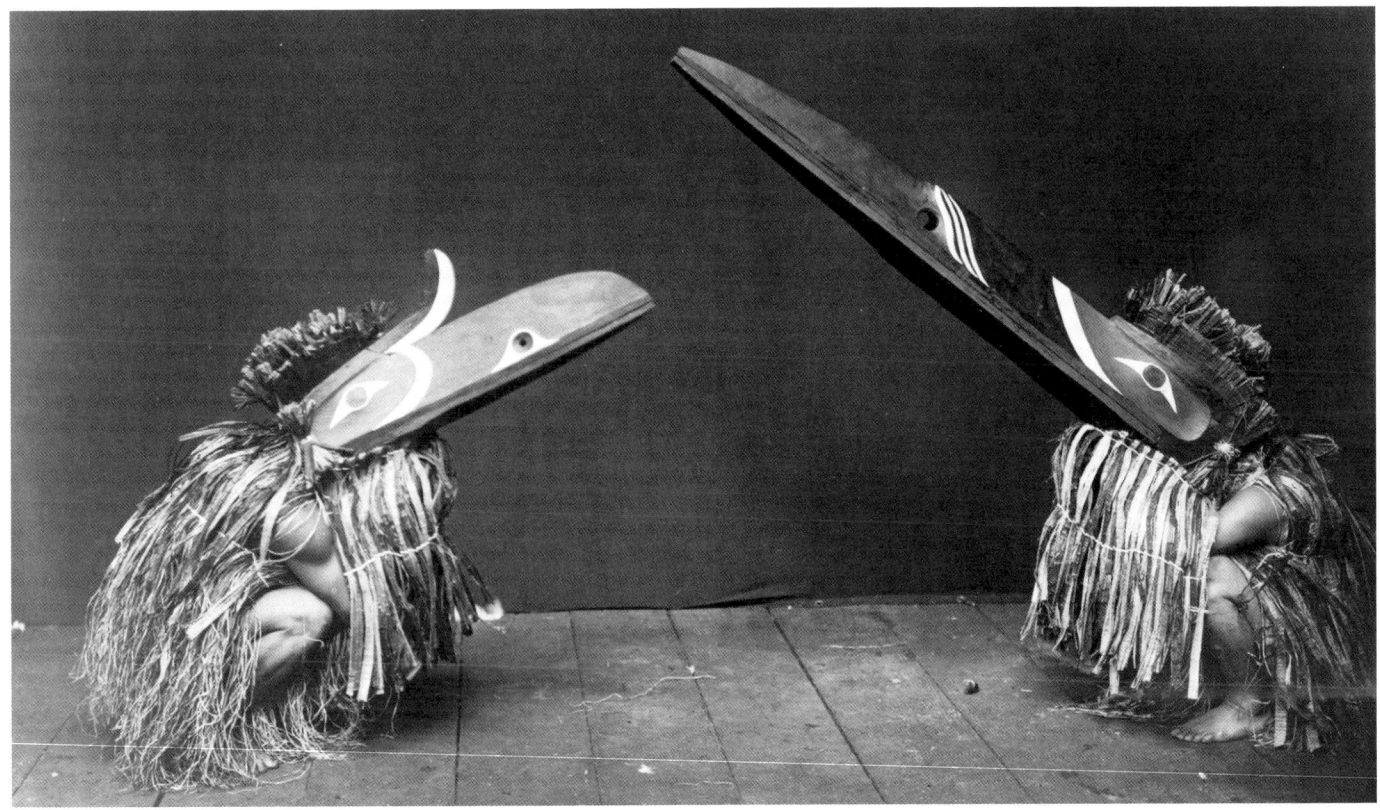

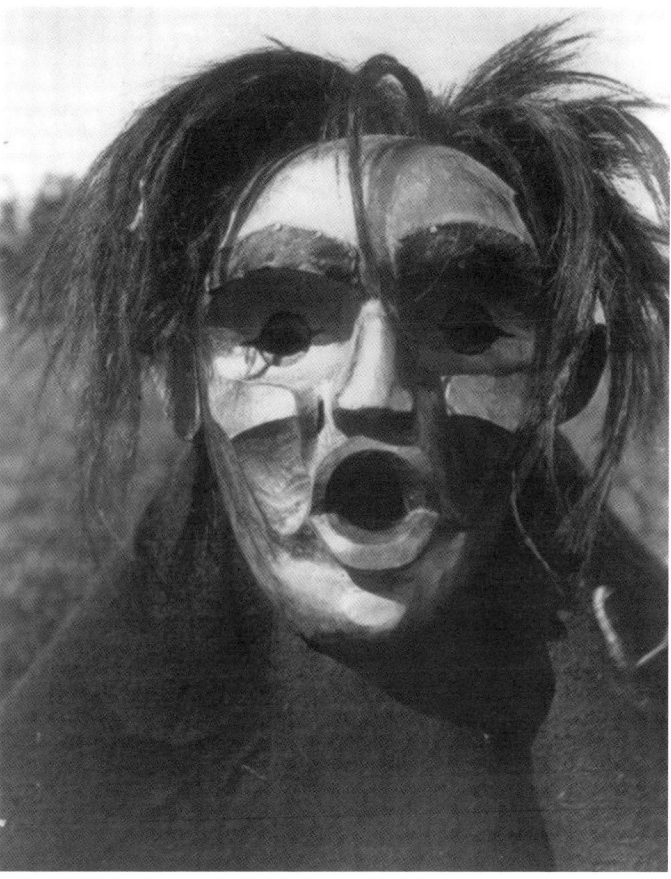

Above: This mask represents Tsunukwalahl, a mythical being, used during the Kwakwaka'wakw Winter Dance. LoC

Below: The ceremonial mask of the Octopus Hunter, c. 1914. It was worn by a dancer portraying the hunter in Bella Bella mythology who killed the giant man-eating octopus. The dance was performed during Tluwulahu, a four-day ceremony prior to the Winter Dance. LoC

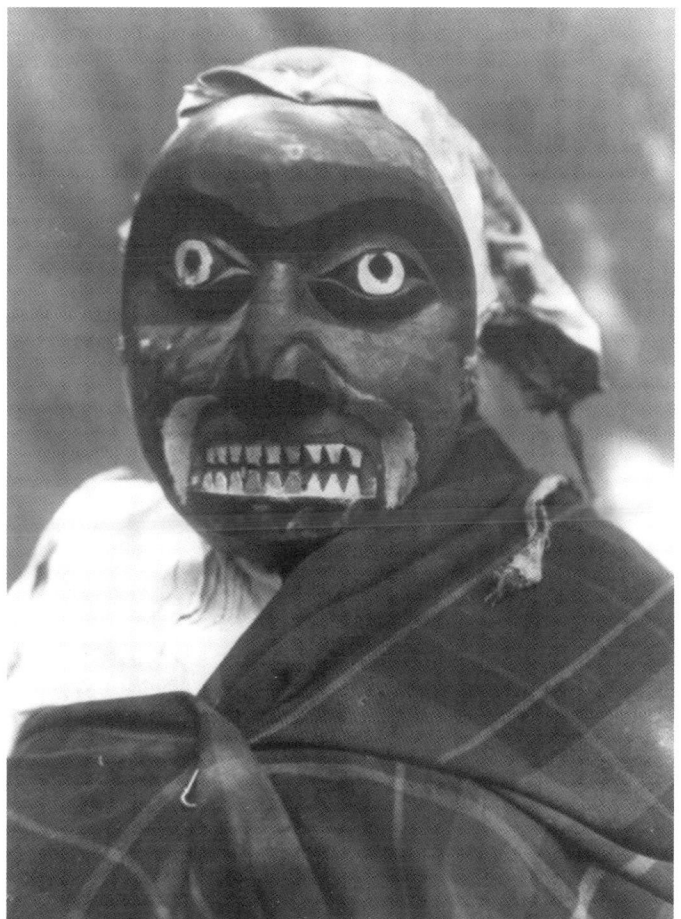

The grizzly bear mask is similar to that of the wolf, but with a more compact snout and larger nostrils. It is used in a dance originating from the Kwakwaka'wakw-related 'Nak'waxda'xw people of Blunden Harbour. Like the wolf mask, the grizzly mask often has fur attached, and it is accompanied by regalia that includes paws made from real bear claws, or petrified whalebone.

Among birds, the eagle and woodpecker are considered alternately as the king of birds. The U'mista Cultural Society notes that "the Eagle's Undersea Kingdom counterpart lives in the realm of 'umugwe' and is depicted with green on its beak and body. The sea eagle is the caller for the Undersea Kingdom dancers and one by one calls out all the undersea dancers at a Potlatch."

The thunderbird, or Kwankwanxwalige, is seen as the spiritual ancestor of the Kwakwaka'wakw, having bestowed many supernatural gifts upon his human descendants. His mask has a black face and green beak, and is trimmed with white feathers. According to the U'mista Cultural Society, the thunderbird "lives in a great house in the sky (Thunder-Bird-Place) with his wife, four children and his younger brother and attendants. There, he is Chief of the sky birds or beings and is the only one who owns a salmon trap. He is capable of sending forth windstorms, lightning and other bad weather. Flapping of Thunderbird's wings can cause thunder and it is said that lightning flashes from his eyes."

The Kwakwaka'wakw also have a tradition of complex kinetic masks which are always an amazing sight when one attends a dance performance. These include the Echo, or Saêa, masks with elaborately carved interchangeable mouthpieces, each of them representing an entity with a different voice. As the U'mista Cultural Society notes, the Saêa is a human-like being who has "the ability to imitate the sound or voice of any creature. She is found in a cave near Blunden Harbour. You will know the Echo is coming because she will imitate the sounds she hears. In the Potlatch, the coming of Saêa is very unique. Something will be shouted by one of the attendants, and it will be 'echoed' from behind the screen or from outside the Big House or Gukwdzi. The startled attendants will begin to shout—with every utterance immediately imitated by Saêa."

Among the most interesting and intriguing Kwakwaka'wakw kinetic masks to watch in the hands of a skilled performer are the intricate Transformation Masks. Designed to portray the dual nature of a specific creature, they are multiple masks in one, with the outside mask hinged so that it can be opened by means of strings to reveal a separate, different mask on the inside. This mask depicts the alter ego or another aspect of the creature depicted on the outside. They are used to delineate the inner animal nature of a person, or vice versa.

As with the Kwakwaka'wakw, the Haida used both masks and puppets to represent wild spirits from the forests, whom the Haida called gagiid. Such masks are characterized by withered or wrinkled faces and scowling mouths. They are frequently painted blue-green in color to indicate that they represent people who have barely escaped drowning, and whose flesh has become cold from the long duration of exposure to frigid waters. According to the Canadian Museum of Civilization, less is known about the supernatural-being masks among the Haida than with other people.

Masks, like totem poles, were seen as a form of idolatry to the outsiders who first witnessed Northwest Coast dances in the nineteenth century. The Canadian Museum of Civilization reckons that the secret societies and their performances began to disappear with the arrival of the missionaries in the mid-1870s. As with totem poles, the use of masks was curtailed when the Potlatch was banned in the 1880s.

The prohibition was strictly enforced, but had unanticipated results. As the *Canadian Encyclopedia* reports, in 1921, a large Kwakwaka'wakw Potlatch "resulted in the arrest of forty-five people, of whom twenty-two were imprisoned, their ceremonial goods confiscated. Knowing that these masks and other ritual objects had been wrongfully taken, the Kwakwaka'wakw in 1967 initiated efforts to secure their return. The National Museums of Canada agreed to return that part of the collection held by the Canadian Museum of Civilization, on the condition that two museums be built." These were the Kwakiutl [Kwakwaka'wakw] Museum in Cape Mudge and the U'mista Cultural Centre in Alert Bay.

The number of nineteenth-century masks that still exist is more substantial than with other Northwest Coast artifacts from that period. This is in part because the market for Northwest Coast masks as collectibles among outsiders began as early as the 1840s. The Canadian Museum of Civilization notes that masks and argillite carvings were "the items most sought after by seamen, traders and tourists, and probably several thousand Haida masks are held in private and museum collections around the world." However, because they were produced for trade so early, it is often hard to distinguish which of the nineteenth-century masks were made for this purpose, and which actually played a role in native ceremonial practices.

The Museum observes that "deciding which masks were made for traditional use rather than for sale is largely a matter of judgment. Indicators of actual use include signs of wear on the leather ties and interior surface, the functionality of the eyeholes, the allowance for facial fit for wearing, evidence of attachments of headcloths or animal fur that was stripped off before sale, and traces of glue and down or cedar bark. The opposite factors such as no means for attaching the mask to the wearer's head, no preparation of the interior to avoid

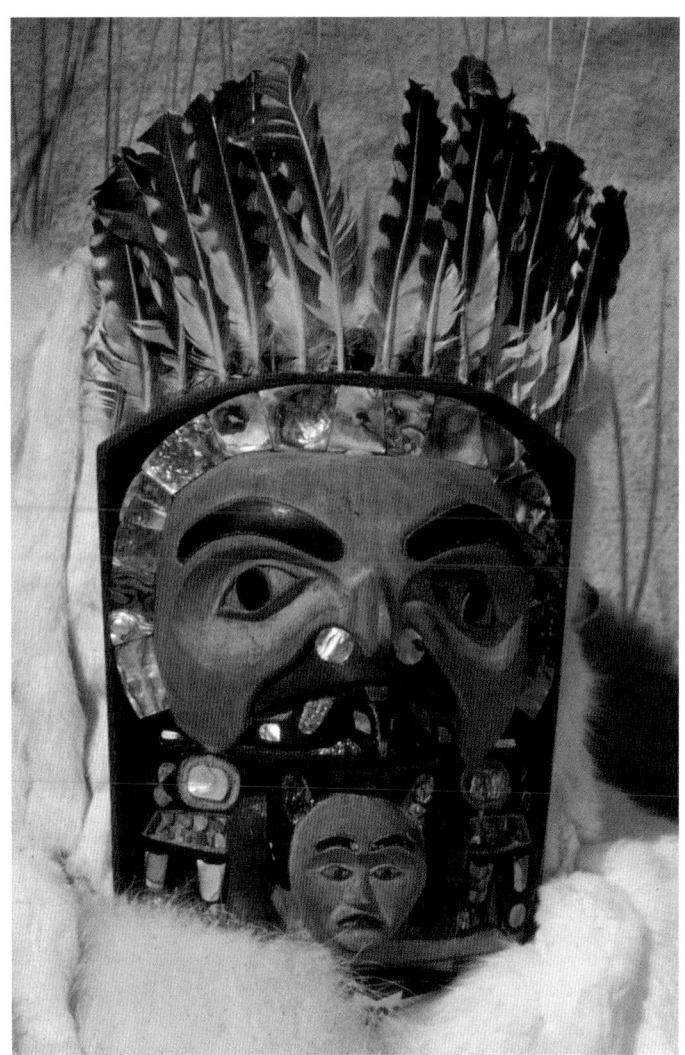

Above: A contemporary Tlingit wooden mask on display at Hoonah, a Tlingit community on Chichagof Island in Southeast Alaska. Alaska Photo Library

rubbing the wearer's nose and no functional eyeholes indicate that a mask was made for tourists."

As with totem poles and many other traditional American Indian art forms, the latter half of the twentieth century marked a strong resurgence of interest among collectors. This in turn opened up opportunities for contemporary artists. By the early twenty-first century, newly carved Northwest masks were selling for a thousand dollars or more in galleries. Among the contemporary Northwest Coast artists carving masks today are Pat Amos, Rylan Amos, Joe Bolton, Gene Brabant, Jay Brabant, Mervyn Child, Vern Etzerza, Tony Hunt, Jason Hunt, Charles Joseph, Arthur Nicolaye, Richard Patterson, Tom Patterson, Heber Reece, Alfred Robertson, George Earl Storry, Elmer Thompson, and Stan Wamiss.

Noted contemporary Nisga'a carver Ron Joseph Telek, also known as Jagam Txalp, uses the transformation of humans into animals as a theme in his work, including his mask making.

NORTHWEST COAST CANOES

The Northwest Coast tribes, many of whom were based on islands, were perhaps the most seafaring of North America's native people, utilizing the availability of some of the continent's tallest trees to build the continent's largest indigenously produced ocean-going ships. Especially skilled in boatbuilding, the Haida are believed to have built the largest Northwest vessels, some measuring up to 60 feet in length.

According to the Smithsonian Institution, "each coastal community of the Northwest developed techniques and styles that helped identify their canoes ... Each canoe had its own spirit and relationship with the water."

The canoes were hewn from single tree trunks, usually of red cedar, then hollowed out to create very thin sides. According to Barbara Waterbury of the Sheldon Museum and Cultural Center in Haines, Alaska, the log was "first hollowed out with an adz then shaped by a process which involved filling it with water heated to a near boil with hot rocks. Hot steam penetrated the log making it soft and workable. At this point thwarts were forced between the sides, pushing them to the desired shape. The boat was then dried and smoked over a pitch fire that also blackened the wood. In the case of larger canoes, separate pieces were added to form the high prow and stern ... A waterproof, durable paint was made by mixing minerals, salmon eggs, and chewed spruce gum, and applied with a bear or porcupine hairbrush. They were next softened by steaming and stretched crosswise to spread the beam beyond the original width of the log."

She adds that large canoes often had a carved figure on the prow and some were painted with crests and emblems.

The canoes were used for a variety of purposes, usually for hunting and fishing, and for carrying people and goods between islands, between the mainland and the islands, or up and down the coast. The boats were also used for warfare and in ceremonies. Weddings usually involved ceremonial transporting of the bride and/or groom.

Exactly how far to sea the Haida and other Northwest people sailed has always been a subject of speculation. There was a long-held, but unproven theory that they might have sailed as far as Hawaii, roughly 2,700 miles

Opposite, above: A detail view of a Jamestown S'Klallam (Clallum) cedar canoe on the grounds of the tribe's 36 acre reservation near Sequim Bay at the southwest corner of the Miller Peninsula in Washington state. Jean Boyle photo from the Kitsap Peninsula Visitor & Convention Bureau

Opposite, below: Carved cedar canoes form the dominant decorative element at the grave of Chief Si'ahl (Seattle), located in Suquamish on Washington state's Kitsap Peninsula. An important leader of the Dkhw'Duw'Absh (Duwamish) people, Si'ahl died in 1866. Jean Boyle photo from the Kitsap Peninsula Visitor & Convention Bureau

Below: A close up view of Kwakwaka'wakw canoes, photographed in 1914 by Edward Curtis. LoC

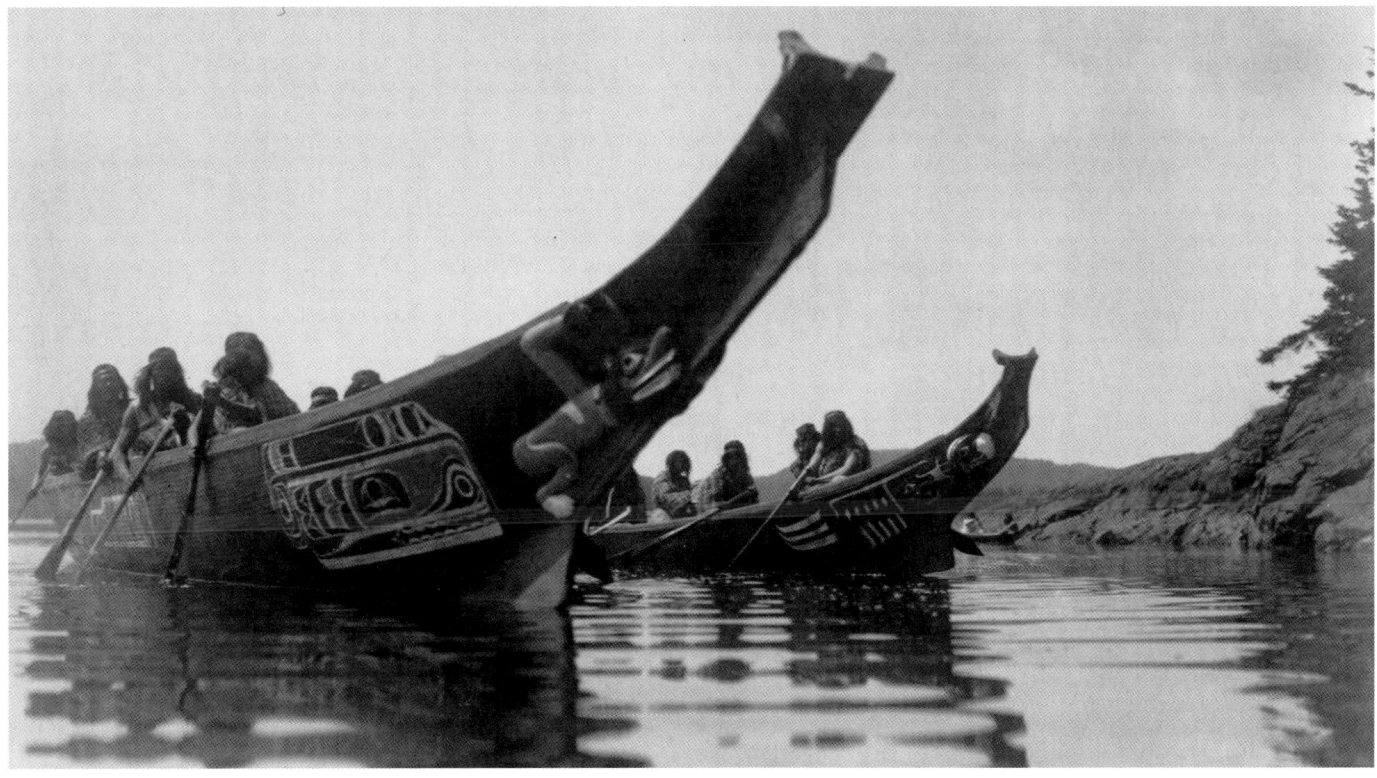

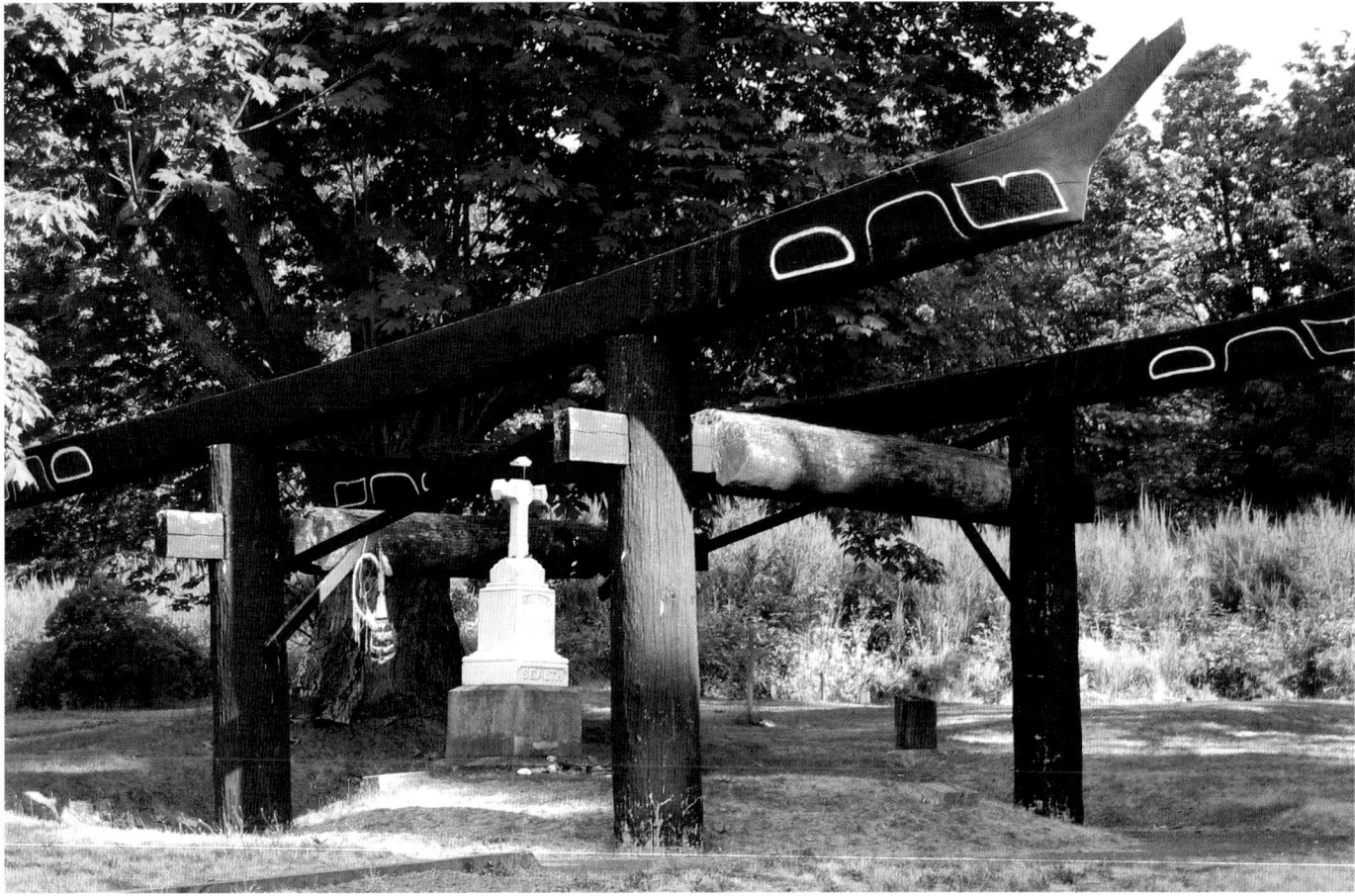

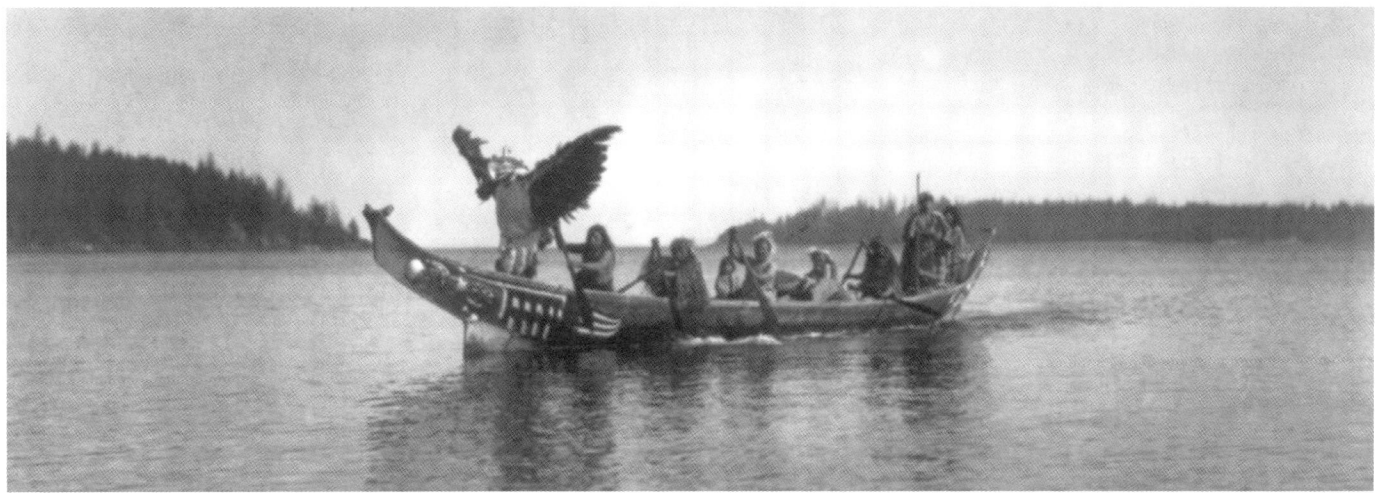

away. In 1973, a man named Geordie Tocher used Haida methods to carve a forty-foot canoe from a Douglas fir log. With this, he, along with his companions, Gerhard Kiessel and Richard Tomkies, managed to reach Hawaii after two months of sailing.

The making of long canoes by the traditional Northwest Coast method continues, although the time and expense involved make it a rare occasion. Early in the twenty-first century, the Smithsonian Institution in Washington, D.C., commissioned the construction of one for display. Using traditional tools and techniques, Tlingit master carver Doug Chilton created a twenty-six-foot canoe from a red cedar log at the Sealaska Heritage Institute in Juneau.

The canoe was installed and formally unveiled at the Smithsonian's Sant Ocean Hall in Washington in September 2008, suspended from the ceiling next to

a life-size model of a northern right whale. Chilton's canoe had a raven figurehead carved on its bow, with a copper disk representing the sun in its beak. It can be noted that in Tlingit lore, it was the raven who stole sunlight and brought it to the world for the people.

Above: In the bow, Qunhulahl, a masked man impersonating the Thunderbird, dances as others row to the shores of the bride's village prior to a 1914 Kwak-waka'wakw wedding. LoC

Opposite, above: A group of Kwakwaka'wakw canoes under sail off British Columbia, c. 1914. LoC

Opposite, below: Two Kwakwaka'wakw canoes pull ashore with the wedding party. The bride and groom are standing on the "bride's seat" in the stern, while a relative of the bride dances on the platform in the bow. LoC

Below: Tlingit rowers in the water near Haines, Alaska, in a contemporary canoe hewn in traditional style. Alaska Photo Library

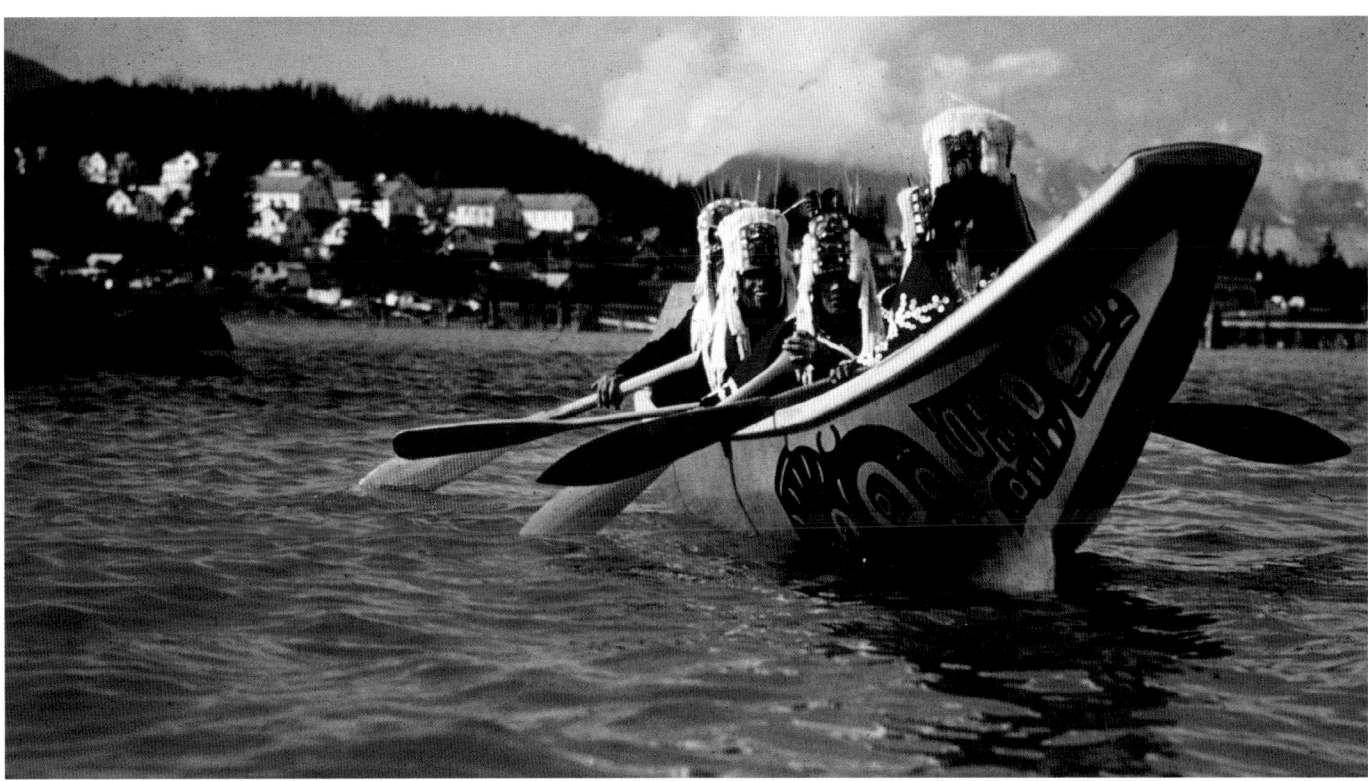

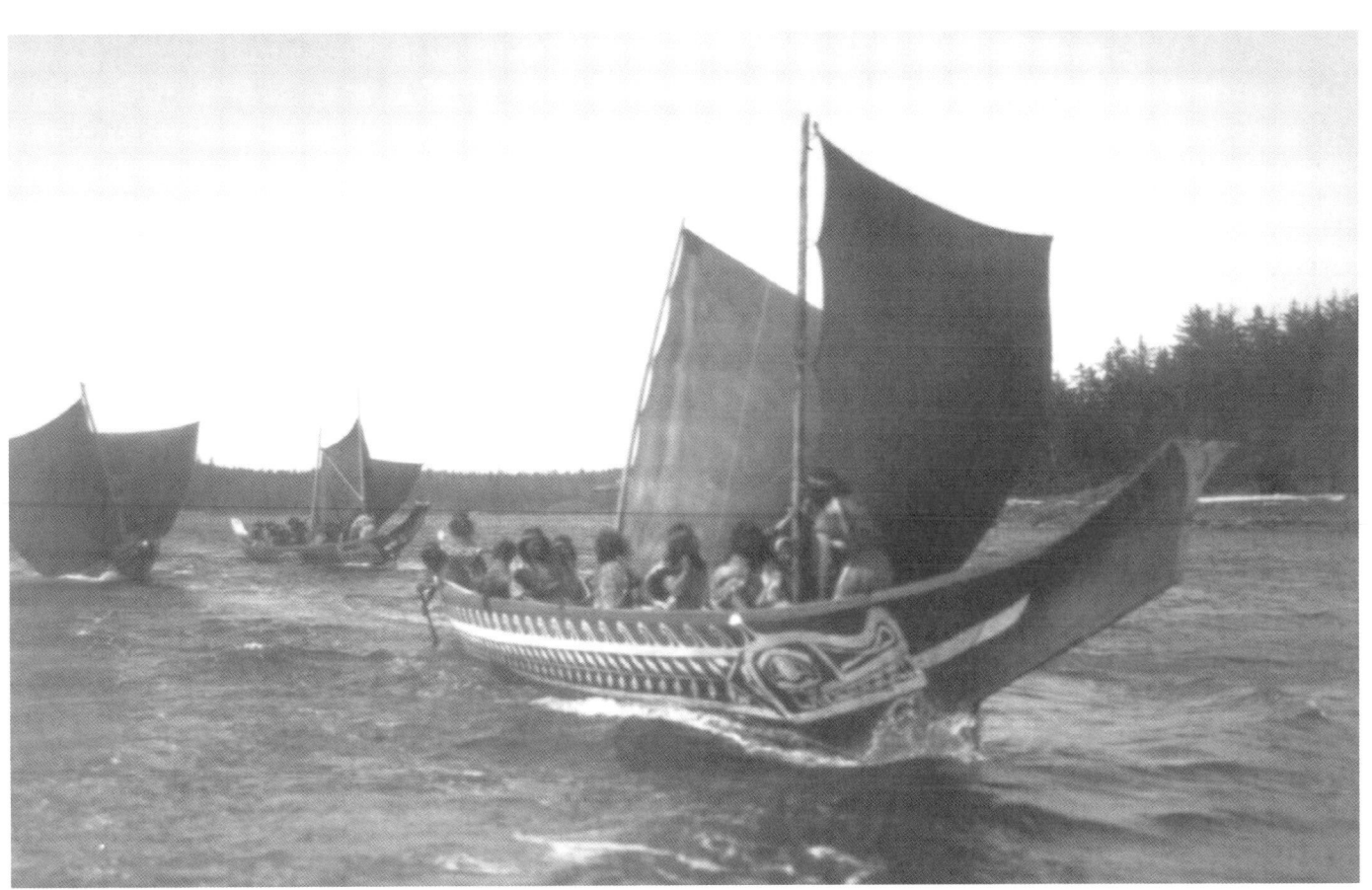

8. ARCTIC AND SUBARCTIC

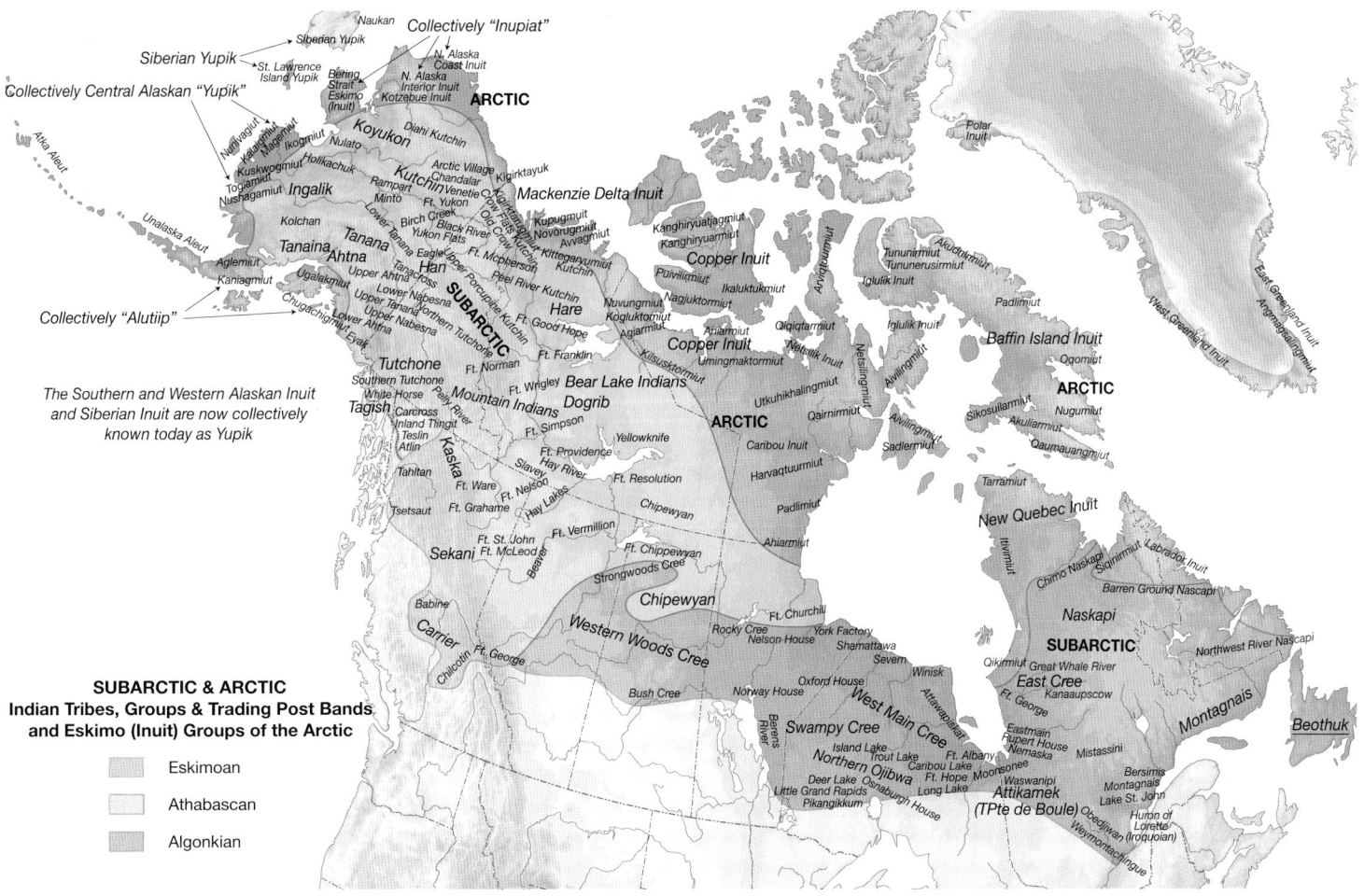

Except for the Beothuk, the Subarctic peoples are drawn from the Algonkian family in the east and the Athabascan family in the northwest. Within this vast area, culture remained quite constant, though flexible, with hunting and fishing the main means of subsistence. Much of the area is Arctic lowlands with abundant coniferous trees such as spruce, tamarack, willow, and alder. Animals of economic significance to the native peoples of the Subarctic include moose, caribou, bear, fox, wolf, otter, and beaver. Important fish include whitefish, grayling, trout, and pike. A significant number of Athabascan groups were found in the great mountain chain of the Yukon Territory and British Columbia, in the lush river valleys of spruce, fir, cedar, and hemlock forests. Only at Cook Inlet, Alaska, were the people partly dependent upon the sea for food. Fishing became more important at the close of the fur trade era. The network of white fur trading posts influenced northern life from the late eighteenth century. European goods gradually trans-formed clothing, housing, and settlement patterns. Artistic traditions changed as floral beadwork on cloth largely replaced porcupine quillwork and painting on hide in the decoration of native costume.

The Arctic Eskimo, now called Inuit and Yupik in western and southwestern Alaska, relied for their subsistence on the sea, and its large population of seals, whales, and walruses. In summer, they turned inland to hunt caribou, returning to the coast in fall and winter to fish and hunt sea mammals through blowholes in the ice. With limited access to trees, the Inuits' tools, spears, harpoons, sleds, kayak frames, bows, and ceremonial masks often had to be pieced together in composite constructions from driftwood, antler, and bone. Two groups, the Chugachigmiut or Chugach on Prince William Sound, Alaska, and the Kaniagmiut of Kodiak Island, were different from most Inuit. Both mummified their noble dead, built houses of wooden slabs that looked like those of the Tlingit on the Northwest Coast, and developed whale-hunting techniques similar to those of the Nuu-chah-nulth (Nootka) far to the south. Houses varied from the igloo of ice blocks among some Canadian Inuit to sod, wood, and whalebone semi-subterranean huts at winter village sites, and seal or caribou skin lodges in summer.

The Aleuts were influenced by Europeans when Russians settled on their islands and began the sea-otter fur trade; conversion to the Russian Orthodox Church followed. The Aleuts made fine waterproof clothing and excelled in basketry. They also used a two-man kayak or baidarka. Unlike the Inuit, they had a structured society of chiefs, commoners, and slaves.

SUBARCTIC INDIAN TRADITIONS

The regions occupied by the Northern Athabascan Indians can be roughly divided into the western groups (Kutchin, Koyukon, Ingalik, Tanana, Tanaina) whose locations can be defined by the Yukon River system and its tributaries, the eastern groups (Slave, Dogrib, Hare, Chipewyan) scattered through the Mackenzie River basin, and the Cordillera tribes of British Columbia (Sekani, Carrier). The environment occupied by these groups is characterized by extremes of climate and accompanying seasonal fluctuations in food resources, with long winters and short warm summers with dense insect life. Food included salmon in the Yukon basin, trout and pike in the east, also berries, nuts, and roots, and animals hunted included moose, bear, hare, muskrat, and most importantly caribou. Wild fowl, ducks, and geese were shot with bow and arrow, fish were taken by nets and traps, and small mammals were snared. Subarctic technology was almost entirely based upon two natural resources: the skins of animals and the bark of birch and other trees. Birchbark was used to cover lodges and canoes cut with bone tools and stitched together with split spruce root. During the contact period a most useful all-purpose tool was the single-edged iron blade "crooked knife" developed by eastern Indians and acquired by trade before the white man appeared. Bark was used for light serviceable containers, vessels, cups, and plates. Vessels were also made of wood or twined split spruce roots.

Animal skins, particularly those of the moose and caribou, provided clothing. Dressing and tanning of skins was done by women by a process of stretching, scraping, rubbing (to soften), and preserving with animal brains, giving a soft texture and an almost white color. Sometimes hides were smoked over a fire to give a rich golden shade and to afford some protection against wet weather. Clothes for men and women consisted of a long-sleeved pull-on shirt or parka, leggings that tied separately to a waist belt and moccasins with high ankle wraps. For women the parka was later to become a dress with shorter leggings secured below the knee. Among western groups such as the Kutchin a distinctive parka was worn with a bottom edge which was pointed or V-shaped in front and back, with moccasins and leggings joined together as a trouser-moccasin. Mittens and hoods were added in cold weather when several layers of clothing might be worn with the fur left on. Moccasins were usually of the two-piece style of a bottom unit with an instep vamp plus ankle wraps; the moccasin-boot was worn principally by the Alaskan Athabascans.

Decoration of clothing employed dyed porcupine and bird quills, and occasionally moosehair, applied in sewn,

Above: Northern Athabascan man's tunic of moose-skin decorated with red and blue trade cloth, beadwork and quiltwork, probably Slave. c. 1850 NMS

Below: Nascapi, caribou-skin man's coat with painted hunting-aid designs, eastern Subartic type c. 1820 NMS.

woven, and wrapping techniques. Dyes were obtained fromplants and roots, usually blue, purple, red, black, and orange. European dyes were also obtained by boiling out colored blankets and by the 1850s traders had introduced commercial aniline dyes. Dentalium shells, from the Pacific coast were also obtained, at first through aboriginal trade and later via European traders, and were highly valued and used to adorn clothes. Red ochre was also rubbed or painted onto skin clothing particularly along the seam lines.

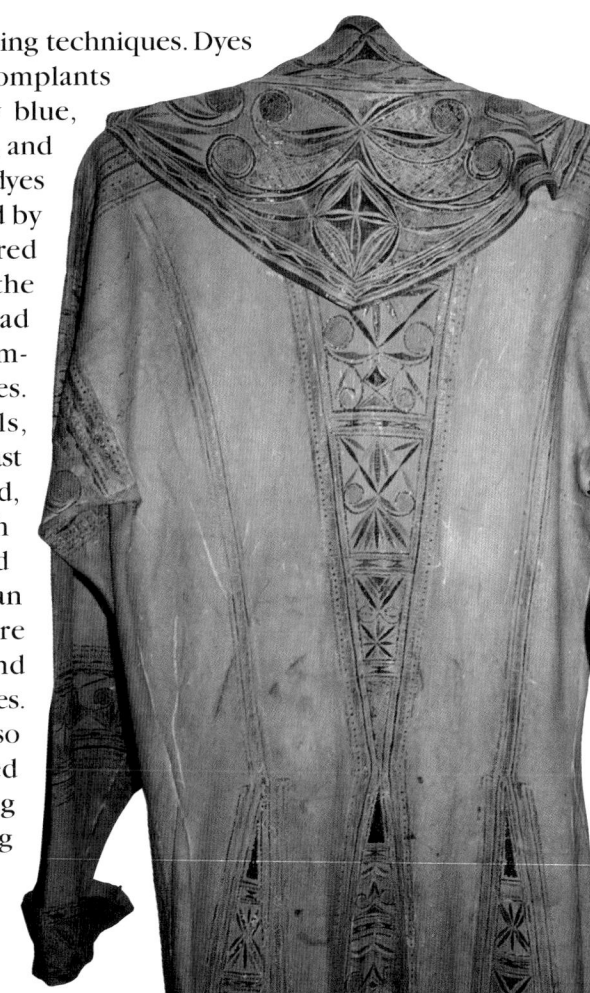

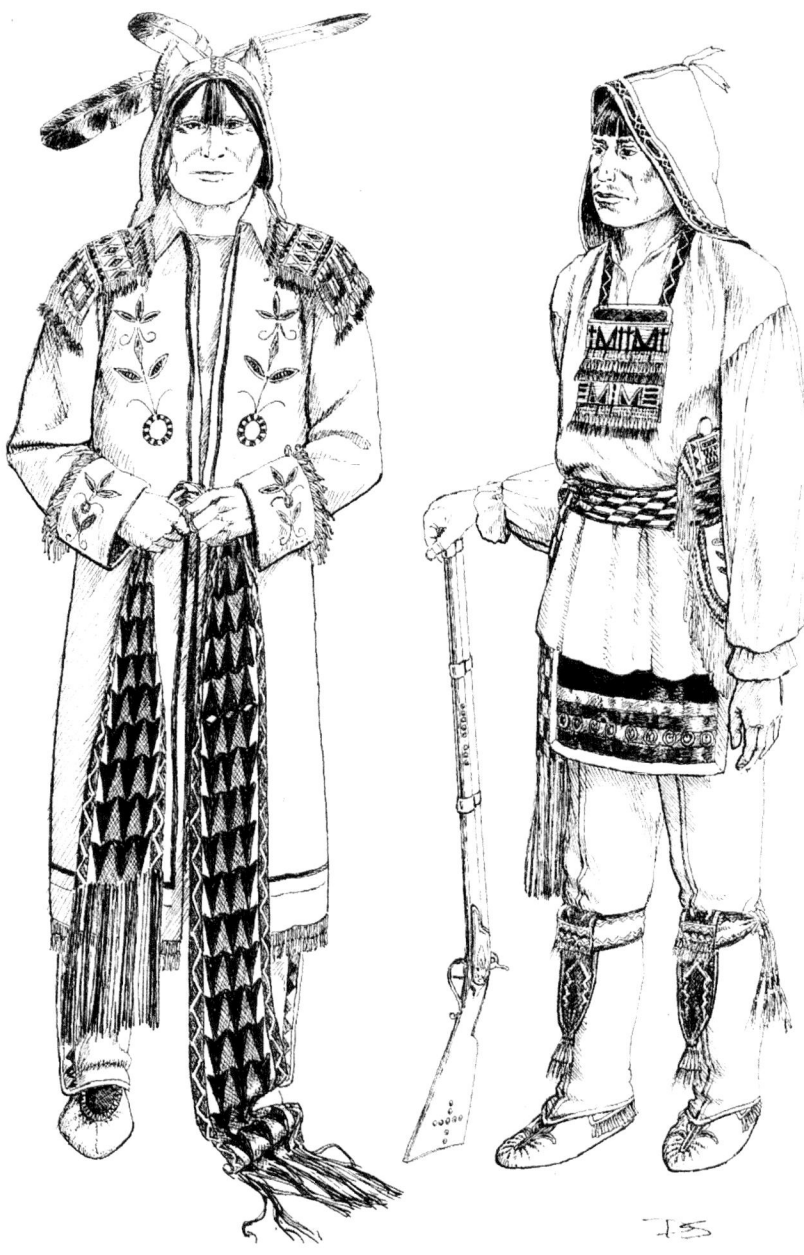

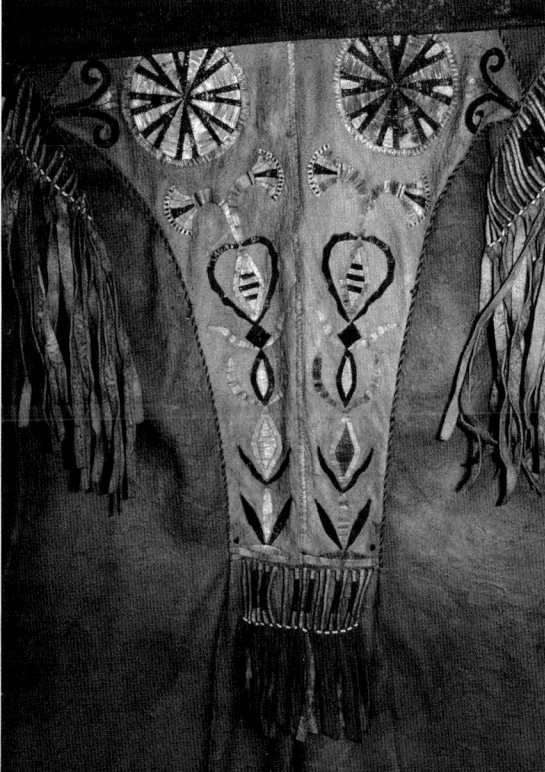

Surviving tunics from the eastern groups of the Northern Athabascans of the Great Slave Lake region have features of European influence including collars, sleeves gathered into cuffs, and the use of red trade cloth for decoration. Red ochred seam lines are a common feature of all Northern Athabascan tunics and dress.

The spectacularly painted caribou skin coats of eastern Canada showing complex fitting have drawn much comment on the origins of their cut and shape. Despite the technical skill of these northern folk, the shaping refinements of vertical seams, collars, and cuffs appear to have derived from European influence, which had begun by the seventeenth century, and possibly even earlier. However, it has been the hugely skilful and complex painting of these coats using two distinct styles of motif, one based on a quadrate layout and the other on the double curve, in reds, blues, and yellow, for which the Nascapi are most famous. Farther west Cree and Northern Ojibwa coats of the eighteenth and nineteenth centuries have a distinctive painting style and are often further decorated with woven quilled bands at the shoulder, perhaps in imitation of European military uniforms. The mixed bloods circulating in the Red River area of present-day Manitoba and other locations are often presented as the refiners of the hide tunic into its most baroque form, open-fronted but superbly decorated with painting, quillwork, or beadwork. Earlier moose-hide Cree coats were embellished with woven and wrapped quillwork along the bottom edge and front opening, with matching rosettes front and back. Hide leggings with woven strips of quillwork were often also highly tailored. Woven quillwork was often made into narrow strips or bands then sewn to garments, pouches, coats, leggings, and horsegear by the marginal Plains Cree. Sewn quillwork was produced in fine quality narrow flower, leaf, and curved motifs. Cree and Ojibwa painting and dyed quillwork colors usually included black, red, green, light and dark blue, and yellow. The delicate block and triangulated geometrical designs are reminiscent, and perhaps the origin of, later beadwork styles of the Blackfeet, Stoney, and true Plains Cree. By the early nineteenth century Russian and Hudson's Bay traders had arrived in the far north, bringing European trade goods, including beads, cloth, and firearms, and thus revising native art and technology.

Above: Dress of the Cree, Ojibwa, and Métis men of Ontario and Manitoba c. 1800–1830. Man on left wears a moose hide open front coat with woven and wrapped quilled epaulettes at the shoulder and narrow floral and disk quillwork to front and on the cuffs. He wears a hood with ears (perhaps some type of symbolic hunting aid) and holds a braided woolen sash in chevron patterns. His moccasins have a U-shaped instep vamp. The man on the right wears a woven quillworked pouch around his neck with letters, a quilled knifecase, and front seam leggings with fur garters. He also wears a cloth hood decorated with ribbonwork, buckskin moccasins with the center seam covered with quillwork, and a woven wool sash. By permission of artist Dave Sager

Left: Quillwork detail from a Cree-Métis coat, early nineteenth century. RSM

NORTHERN ATHABASCAN FLORAL BEADWORK

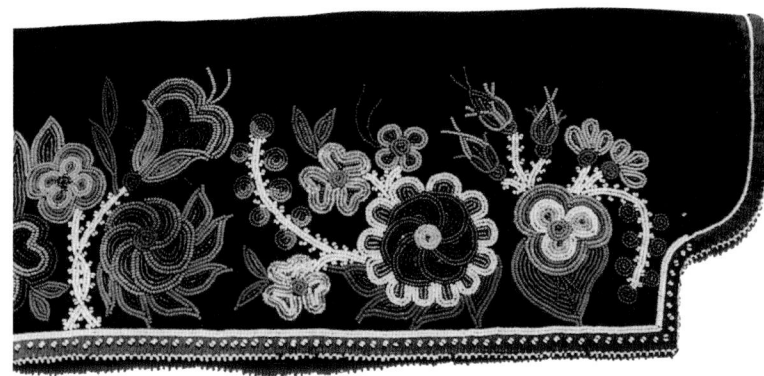

Above: Detail of Northern Athabascan floral beadwork, probably Great Slave Lake-Mackenzie River region of northern Canada. Bottom edge of a woman's cloth legging, c.1900. Courtesy Richard Hook Collection

Beadwork made by the eastern groups of Northern Athabascans in Subarctic Canada was generally stylistically similar. Such groups were the Chipewyan (not to be confused with the Ojibwa), Slave or Slavey, the Mackenzie River groups such as the Dogrib, and eastern branches of the Kutchin group. These peoples produced considerable quantities of often-undocumented examples of floral beadwork now found in museums and private collections. In years past, much of this type of work was incorrectly regarded as "Eastern Woodland" Indian work. The spread of truly European-inspired floral designs no doubt came to this area via the activities of the fur trade, which brought the Athabascans into contact with the Cree, Cree-Métis, and missionaries, who encouraged the techniques of bead and silk embroidery and the use of trade cloth, during the nineteenth century. Their traditional dress had consisted of fitted caribou tunics with pointed fronts and footed trouser leggings, all skilfully decorated with porcupine quillwork and dentalium shells. These were gradually replaced with Europeanized jackets and dresses. Floral beadwork was often executed on dark (often black) cloth or velveteen and applied to jackets, moccasins, mittens, dog blankets, gun scabbards, baby belts, moss bags, and valances. Cree work, by comparison, sometimes utilises red trade cloth.

This northern floral work is often asymmetrical but also contains several repeating symmetrical elements and the general placement of the flowers is tight and densely packed so little background is visible. The floral units often have abrupt color changes and single-line white veins with loops between. The Slavey had highly complex and tight floral designs in multiple colors, sometimes with accentuated petals with metal bead petal tips. Both the Cree and Athabascans used "haired" tendrils to beaded stems and the loop between units. Eastern Kutchin and Mackenzie River area beadwork styles are also characterized by complex floral designs, often symmetrically laid out and with accentuated petals and loops.

Eastern Kutchin, Great Slave Lake and Mackenzie River styles are similar enough to be considered as one. Floral designs arrived in the area from the east and south about 1860. Cree women married to traders and Catholic mission schools were also major factors in the diffusion of the art of bead embroidery in the far north. Floral beadwork was also observed among a group of Western Kutchin in 1867, although their motifs were fewer and sparsely distributed. The earliest availability of beads to the Kutchin may have been from Russian traders, but it was the huge amount and range of colors available from the Hudson's Bay Company that transformed the art in the north. Beadwork is still produced at Arctic Village, Old Crow, Fort Yukon, and Fort McPherson today.

Double-line clear and white-beaded veins with bifurcated tendrils (hairs) linking the floralistic elements are typical of the Western Kutchin and Tutchone–Tanana region beadwork. Open work reminiscent of the coastal Tlingit is also found on specimens from this area. However, the so-called Inland Tlingit rarely employed bifurcated tendrils to edge their usual single-line veins of their "open" foliate and scroll-beaded motifs. Beadwork applied direct to skin or on trade cloth was equally popular. The Tahltan used curvilinear and abstract motifs on their knife sheaths and fire bags that were either copied or related to designs on Tlingit baskets.

The Athabascans and Cordillera bands of central and southern British Columbia also seem to have been influenced by groups such as the Cree and possibly Beaver. Several four-tab pouches and rectangular bags, with woven beaded panels, of red or blue broadcloth have been collected from this area. The floral beaded designs of these groups were linked to thick trunk-like stems, sometimes with realistic eagles or animals. The octopus bag or four-tab pouch made originally with reference to earlier skin bags with animal legs, developed by Red River Métis, had become popular with the Cree, and apparently the form spread to the Northern Athabascans of the Subarctic, British Columbia, and finally to the coastal Tlingit. The Tlingit made large numbers of octopus bags for ceremonial use and as gifts. The beaded design elements are often merely outlines with two rows of beads with centers left open.

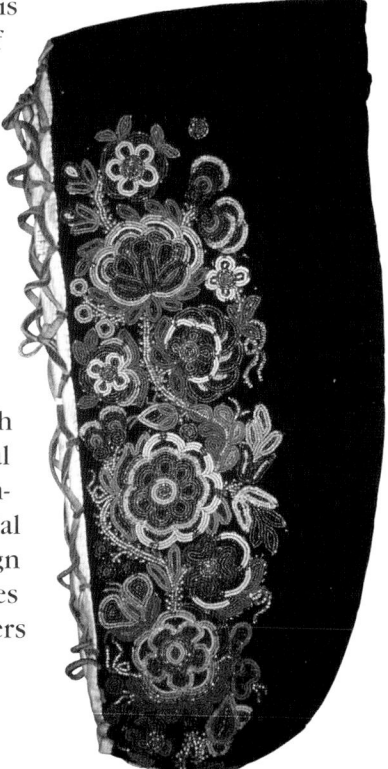

Right: Northern Athabascan baby carrier, 1900.

NORTHERN ATHABASCAN
GUN SCABBARDS

Guncases from the Upper Yukon River drainage are usually slightly tapering tubes of moose hide or caribou hide, with double cloth tabs at the muzzle end, and two areas of red wool cloth or velvet stitched on at the butt end and approximately at the end of the breech.

The cloth areas are decorated with seed beadwork, threaded on sinew and couched down with thread, and edged with wool braid, yarn tassels, and necklace beads. The seam is sometimes directly at the bottom fold of the gun case, but many have the main seam running along the center line of one side with the accented decorative bands joined at the same position. Occasionally the seam runs diagonally across the tube. Gun scabbards from the Liard-Frazer River drainage have the same extended tube shape construction but lack the end tabs, which are replaced with a fringed accent. Sekani beadwork mixes floralistic motifs with imprecise squares, diamonds, and zigzags. Guncases from most Northern Athabascan peoples are further decorated by edge beading around the perimeter of the decorative cloth areas. Sometimes the butt end has a flap and button.

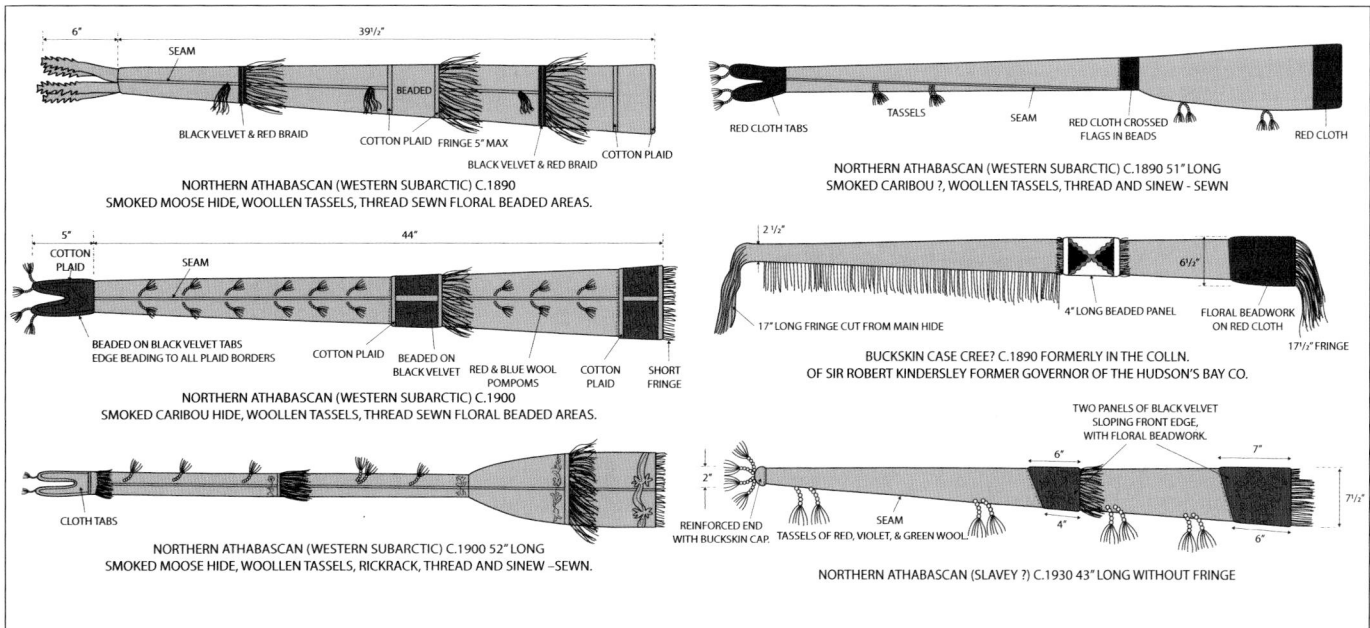

NORTHERN ATHABASCAN (WESTERN SUBARCTIC) C.1890
SMOKED MOOSE HIDE, WOOLLEN TASSELS, THREAD SEWN FLORAL BEADED AREAS.

NORTHERN ATHABASCAN (WESTERN SUBARCTIC) C.1890 51" LONG
SMOKED CARIBOU ?, WOOLLEN TASSELS, THREAD AND SINEW - SEWN

NORTHERN ATHABASCAN (WESTERN SUBARCTIC) C.1900
SMOKED CARIBOU HIDE, WOOLLEN TASSELS, THREAD SEWN FLORAL BEADED AREAS.

BUCKSKIN CASE CREE? C.1890 FORMERLY IN THE COLLN.
OF SIR ROBERT KINDERSLEY FORMER GOVERNOR OF THE HUDSON'S BAY CO.

NORTHERN ATHABASCAN (WESTERN SUBARCTIC) C.1900 52" LONG
SMOKED MOOSE HIDE, WOOLLEN TASSELS, RICKRACK, THREAD AND SINEW –SEWN.

NORTHERN ATHABASCAN (SLAVEY ?) C.1930 43" LONG WITHOUT FRINGE

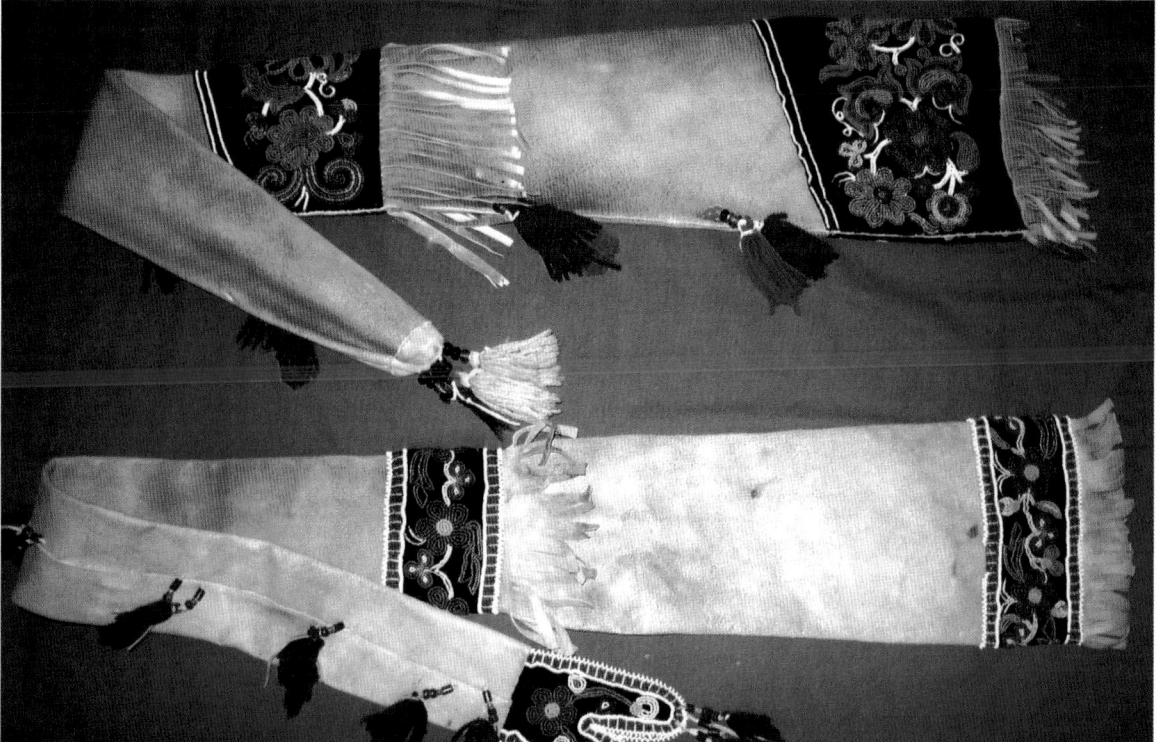

Above: Subarctic guncases.

Left: Two moosehide Northern Athabascan gun scabbards, with panels of beadwork, early twentieth century. MGJ

BAGS AND POUCHES ACROSS CANADA

Native pouches were used to hold pipes, tobacco, and equipment for fire making. However, during the nineteenth century they became more elegantly decorated and less utilitarian. As a result of the effects of the fur trade, the availability of new materials, and the western redistribution of people of Ojibwa–Cree origin, including their Métis descendants, along the old fur-trade routes, several new forms of bags developed.

So-called octopus bags or four-tab bags were usually made of red or blue trade cloth with two pairs of four tabs terminating in tassels of wool yarn. The origins of this style are likely to have been ancient painted skin pouches of the Great Lakes Indians with tabs, fringes, or animal paws hanging down. The cloth octopus bag seems to have appeared about 1840 among the Red River Métis of Manitoba, people largely of Ojibwa origin, and the Cree of northern Ontario. These bags were decorated with a variety of floralistic patterns, often bilaterally symmetrical. During the nineteenth century this form of bag spread to other Cree groups, Cree-Métis, Northern Athabascans, Tlingit, and into British Columbia, each group with its own distinct decorative beadwork style.

A second form of bag which developed about the same period as the octopus bag was the so-called panel bag. Instead of the four tabs below the bag there were panels of woven beadwork, a detail which probably

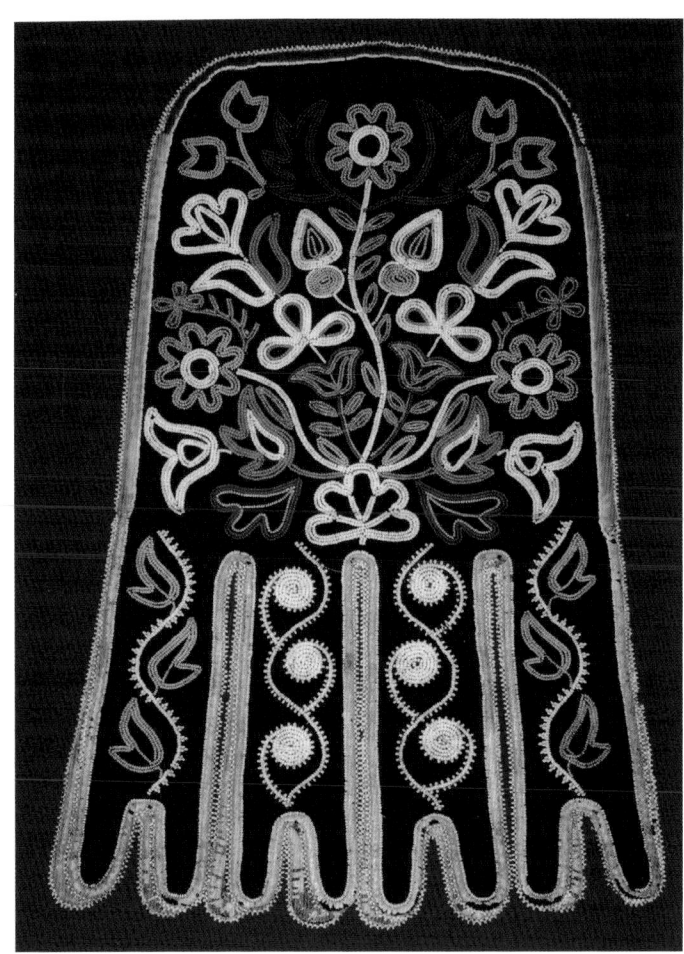

Above: Octopus or four-tab pouch, c. 1870. Probably from northwest Canada, possibly Athabascan or Inland Tlingit. This form has spread from the Red River during the nineteenth century. MS

A Lake of the Woods, Rainy River: Woodland Ojibwa.
B 1. Portage la Prairie: Parklands Ojibwa, Santee, Metis.
 2. Turtle Mountain, Spirit Lake: Parklands Ojibwa, Santee, Metis, Yanktonai.
C Interlake: Northern Ojibwa (Saulteaux).
D 1. Norway House: Swampy Cree.
 2. Island Lake: Swampy Cree.
 3. East Coast: Northern Ojibwa (Saulteaux).
 4. The Pas: Woods Cree.
E Churchill and Nelson River: Swampy (Westmain) Cree.
F Albany, James Bay: Swampy (Westmain) Cree.
G Chipewyan: Chipewyan.
H Athabaska: Slavey, Beaver.
J 1. Battleford, Ducklake, Shellbrook, Carlton: Woods Cree, Plains Cree, Assiniboine, Santee, Ojibwa, Metis.
 2. Edmonton, Hobbema, Saddle Lake: Plains Cree, Cree and Woods Assiniboine.
K Touchwood Hills: Parklands Cree-Ojibwa, Metis.
L File Hills-Qu'Appelle Valley: Plains Cree, Parklands Cree-Ojibwa, Assiniboine, Santee, Metis.
M Crooked Lake: Plains Cree-Ojibwa.
N Montana: Plains Cree-Ojibwa.
O Blackfoot: North Blackfoot, Piegan and Blood.
P Mountain Stoney: Rocky Mountain Stoney.

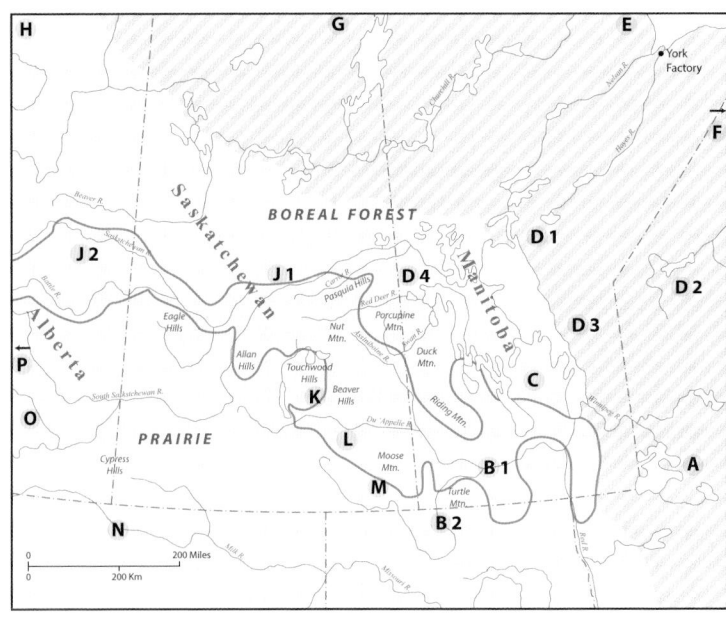

PARKLANDS ——————— CANADIAN SHIELD

MAJOR INDIAN GROUPS AT THE END OF THE FUR TRADE ERA IN CENTRAL-WESTERN CANADA 1850–1900

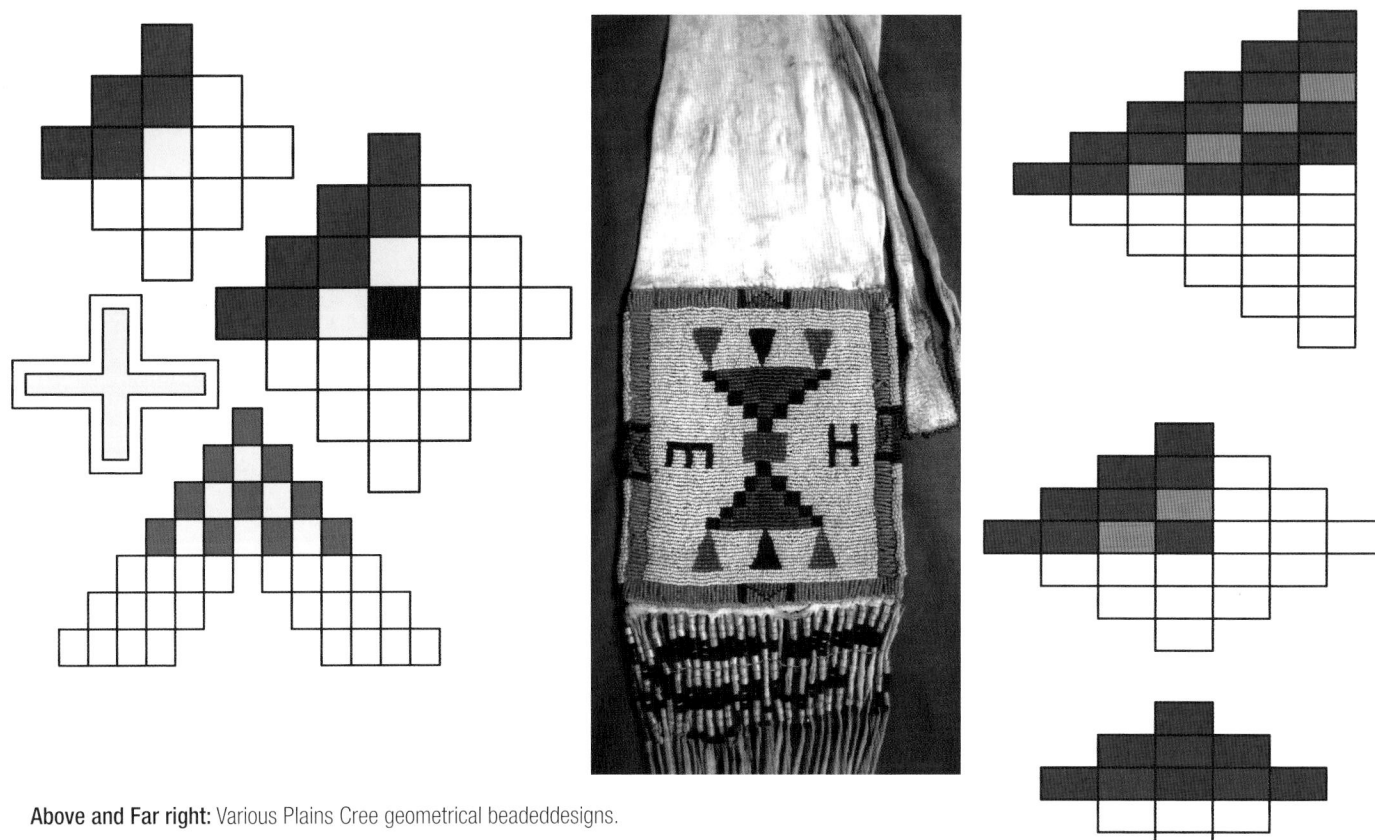

Above and Far right: Various Plains Cree geometrical beadeddesigns.

Above right: Blackfoot pipe bag or tobacco bag, c. 1900. Appliqué beadwork on front only with cane or basket beads on buckskin fringes. Bag belonged to Calf Child, North Blackfoot.

Right: Huron or Iroquois black buckskin shoulder pouch with quill and moose-hair decoration and fringe of tin cones and deer hair. c.1800. RAMM

also descends from an older Great Lakes form that had a netted quillwork panel. A third form was seen in the smaller skin pouches with horizontal bands of loom-woven quillwork, in geometric patterns often attributed to the Cree or Red River Métis, sometimes made with a shoulder strap. A fourth type was the common "fire bag" of the Canadian Parklands and Plains, attributed to the various branches of the Ojibwa (Saulteaux), Cree, Assiniboine, and Blackfeet. This usually comprised a single- or double-sided beaded panel with a buckskin upper section with a scalloped top and a fringed lower section. The beaded panels were decorated with either floral or geometric patterns. The gradual spread of the Ojibwa, Cree, and their mixed-blood descendants across the Northern Plains and the vast Canadian north influenced the changing art and clothing fashions of nearly all tribal groups, incorporating a body of European inspired folk-art in the process.

The term Métis in its old limited sense defined the mixed-blood French and Indian people who settled on the Red River of the north in the vicinity of modern Winnipeg after the merging in 1821 of the two major fur trade companies, the Hudson's Bay Company and the Northwest Company. In order to be free of British-Canadian influence many Métis moved west and

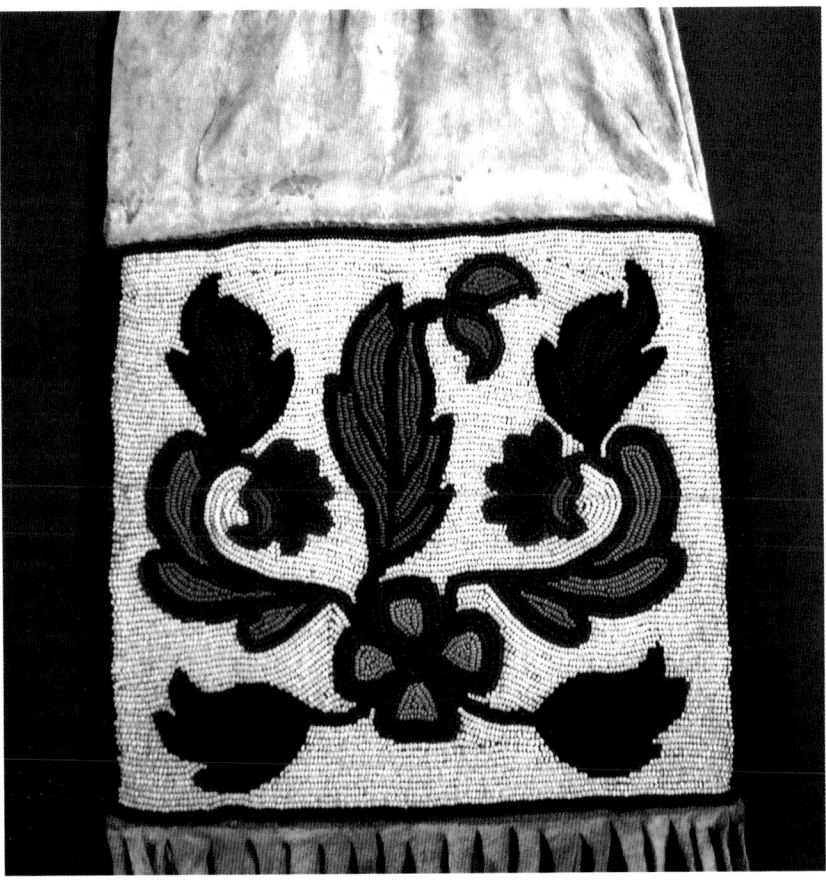

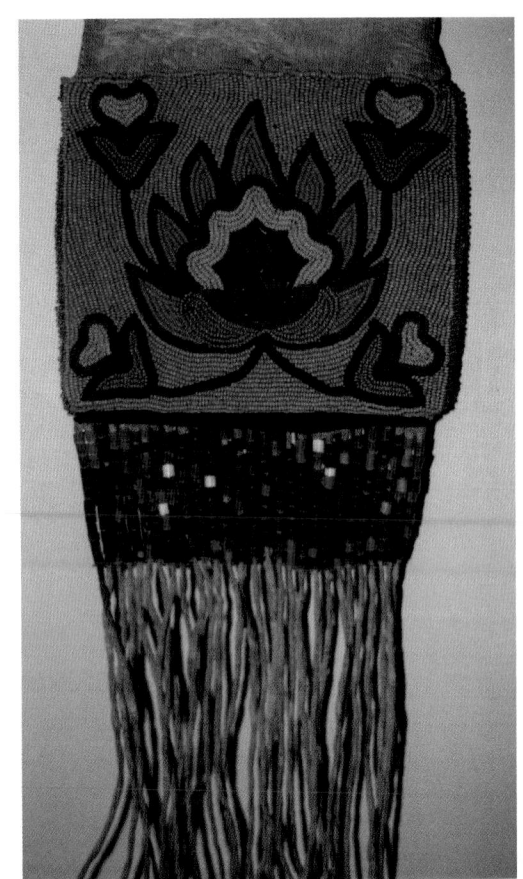

Above: Beaded panel of a firebag or pipe bag, probably Cree, c.1900. Many Parklands groups of Manitoba and Saskatchewan are mixed Cree, Ojibwa, Métis, and Assiniboine making precise attributions of tribal origins or locations difficult. MGJ

Above right: Beaded panel of a buckskin pipe bag, possibly Kutenai. Plateau area, c. 1900.

Below: Panel bag, Red River Métis or Cree, c. 1840. Two forms of trade cloth bags decorated with beadwork became popular in the nineteenth century. One had two groups of four cloth tabs, the other (illustrated) with a panel of woven beadwork in geometrical patterns. The genesis for these pouches were likely to have been the James Bay or Swampy Cree and Northern Ojibwa, developed by their descendants, the mixed bloods located at Red River (present day Winnipeg) Manitoba.

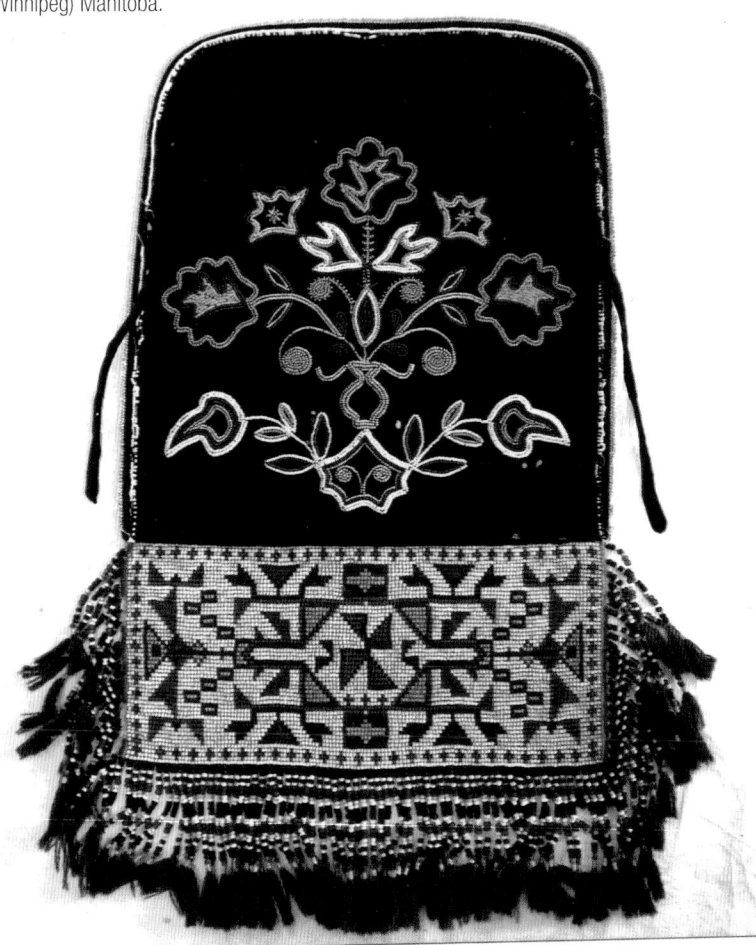

north following the old trade routes, particularly after their two failed rebellions against the Crown later in the century. In a more general sense the term has more recently been applied to many mixed-blood groups in Manitoba, Saskatchewan, and Alberta whose antecedents were never included in formal treaties between the Canadian government officials and Indian tribes and hence without status as Indians. Many of these people are of part Scottish, English, or Irish origin. Although some of the more Europeanized arts, such as silk embroidery and floral beadwork, are sometimes given Métis provenance, there is generally no significant difference between the work produced by individuals and groups with varying degrees of Indian ancestry during any particular period of time. After the close of the French and Indian War in 1763 there were many mixed-blood settlements in the Great Lakes region, with Drummond's Island, Mackinac, Sault Ste. Marie, Chicago, Green Bay, Prairie du Chien, Milwaukee, and Sheboygan the main locations.

CREE, OJIBWA, AND ASSINIBOINE BEADWORK ART IN WESTERN CANADA

Several experts have advised the writer that attempting to classify regional styles for Western Canadian Indian beadwork of the nineteenth century is difficult, and for so-called "tribal" styles almost impossible. The fur trade had witnessed a drift westward of numerous bands of Cree and Ojibwa from James Bay, northern Ontario, and the Great Lakes during the eighteenth century. They scattered over a huge geographical area so that only in linguistic affiliation can these Algonkian people be regarded as tribes. In various areas different peoples interacted and intermarried so their kinship networks crossed tribal lines, and, as Laura Peers has suggested, these kinship networks "were of much greater import in determining

styles in beadwork than anything else… most of us have spent the last century or so inventing nonsense tribal categories and trying to stuff things into them."

Nevertheless Kate Duncan has made a scholarly analysis of tribal and area attributions for decorative art among the Northern Athabascan Indians and has also made attempts to classify some general styles of floral beadwork for the late period 1875–1910, for the Subarctic Cree and Ojibwa. It is from this period that so much decorative material culture survives in Canadian, U.S., and British museums, a time which saw the establishment of the band reserves in Canada and reservations in the U.S. The Canadian reserves for the Plains Cree and Plains Ojibwa were created and forced upon these tribes and others by the Crown and Canadian government by treaties covering much of Manitoba, Saskatchewan, southwest Ontario, and Alberta, made in the years 1871–76. These reserves, which often took the name of a band chief, are located roughly around the Parkland rim, a fertile belt between the Woodlands and true Plains. It

Below right: The dates and areas covered by treaties between the Canadian government and the Canadian tribes.

Below: Tobacco bag, Plains Cree or Stoney, c. 1900. MGJ

Opposite, below: Fully beaded front of a vest, probably Stoney, c. 1900. ROM

Opposite, right: Pattern for a moose-hide Cree jacket, early twentieth century.

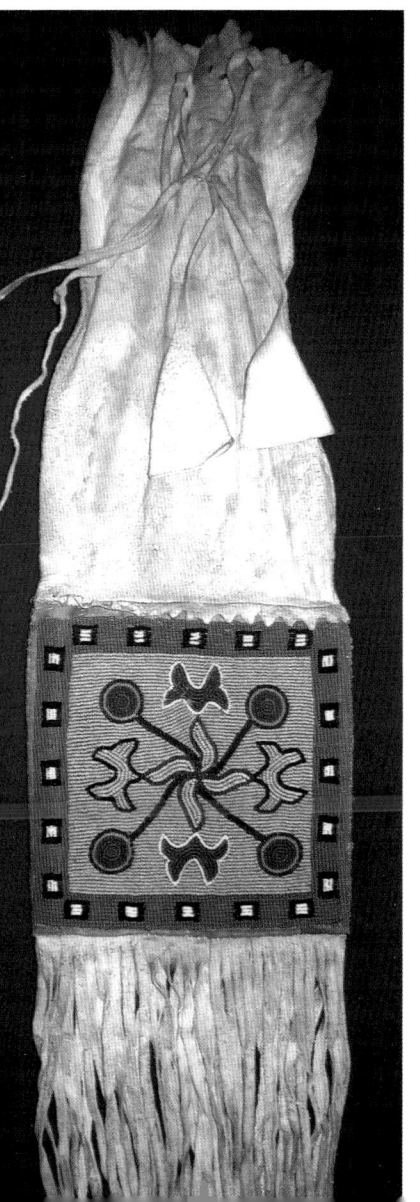

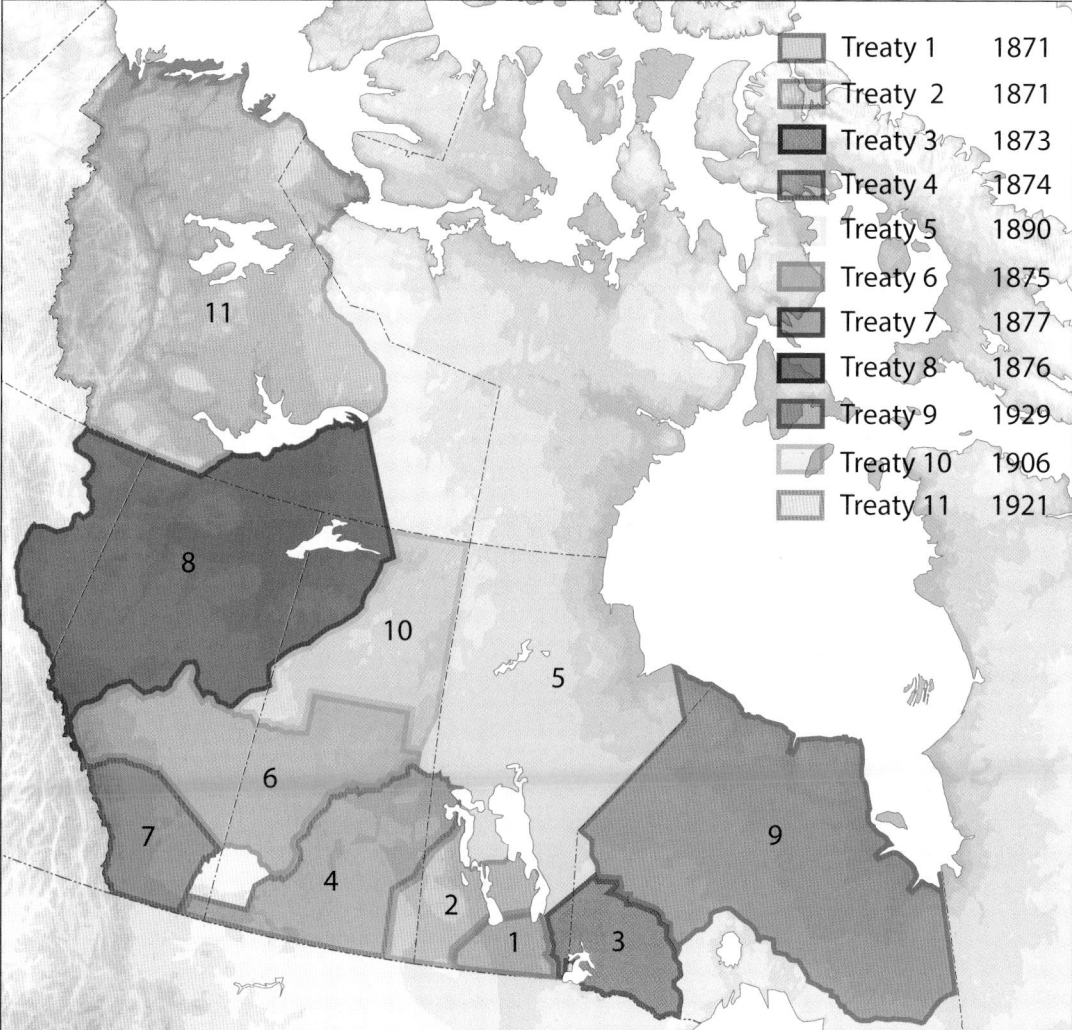

Treaty 1	1871
Treaty 2	1871
Treaty 3	1873
Treaty 4	1874
Treaty 5	1890
Treaty 6	1875
Treaty 7	1877
Treaty 8	1876
Treaty 9	1929
Treaty 10	1906
Treaty 11	1921

is interesting to note that only in two locations—Maple Creek, Saskatchewan, and Rocky Boy, Montana—were Cree or Ojibwa people actually settled in true Plains country and the latter were refugees from Saskatchewan.

The Crees were often dominant when intermarrying with Ojibwa so mixed populations became "Cree" as a result. Typical of these are the Rocky Boy Cree of Montana, a people of mixed Ojibwa and Cree origins Even Rocky Boy himself was Ojibwa. As the western Métis were also a people largely of Cree and Ojibwa ancestry almost the whole area of central western Canada—the Parklands, Woodlands and marginal Plains areas—were populated by an Algonkian derived people of basically similar background. Not surprising therefore their art styles, ceremonial dress and their beadwork styles are nearly impossible to categorize by tribe, although there may be some currency in looking at the various area styles suggested below, at least for the early years of the reserve period. Museum documentation is often vague or disappointing. A tribal designation sometimes accompanies an object but without knowing where it was made or the band reference or name, the specimen becomes almost useless for analysis. In western Canada the activities of

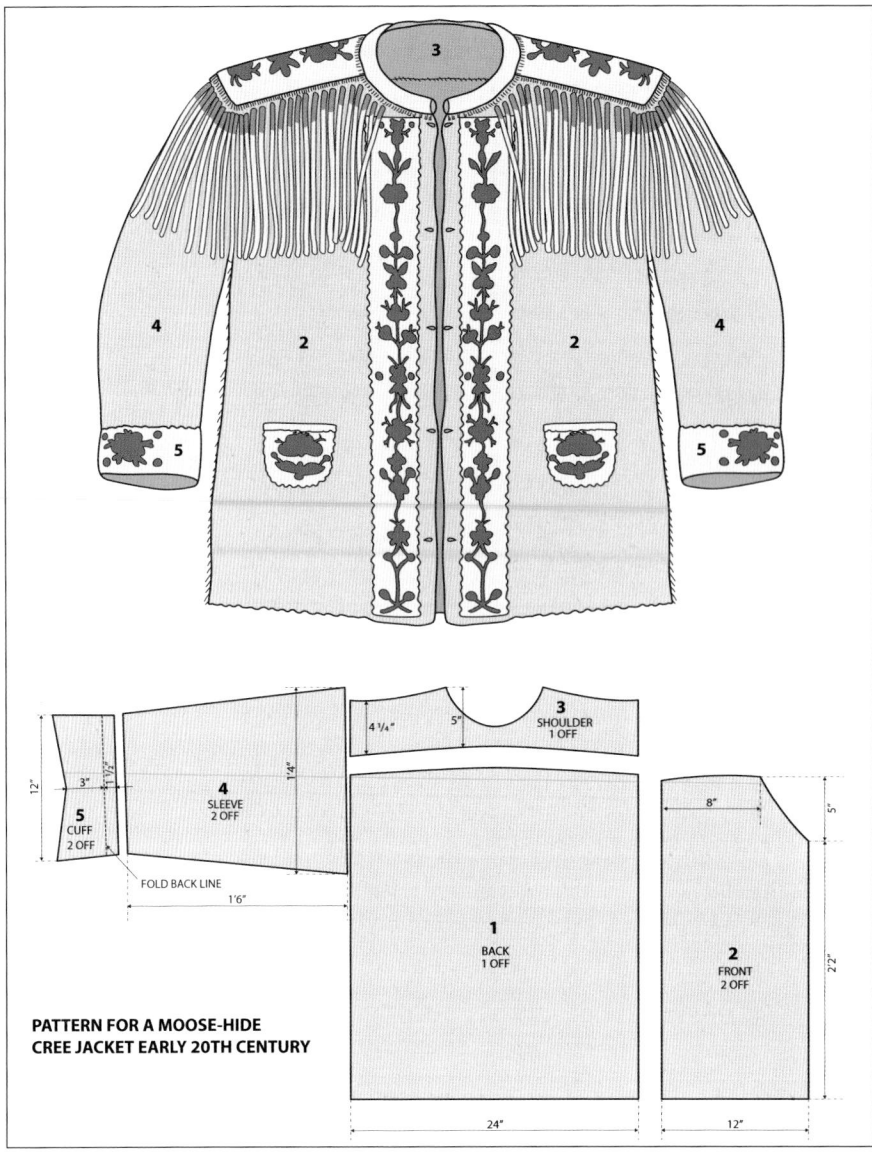

PATTERN FOR A MOOSE-HIDE
CREE JACKET EARLY 20TH CENTURY

the Hudson's Bay Company often resulted in objects made in one location being sold or traded in another. We should also take into account the complexities of Indian moves—families often traveled great distances to find new hunting grounds for furs or work, interacting and joining new bands as they did so.

Another consideration concerns the designations "Plains Cree" and "Plains Ojibwa" when perhaps many were only marginally "Plains" in culture, still lived in Canada's predominantly Parkland zone, and had been by no means horse-rich fully nomadic people. The Assiniboine, Blackfoot (as the Blackfeet are usually known in Canada), Sarsi, and at one time in the eighteenth century the Atsina were perhaps Canada's only true Plains Indians. Relatively few bands of Cree and even fewer Ojibwa fit the classical Plains cultural format, rather better fitting a transitional culture between Woodland and Plains. Some bands did adopt the Sun Dance,

warrior societies, and some Plains material culture, but for many bands these traits appear to have been quite late influences and never completely eliminated their Woodland orientation. During the mid-1700s the Cree and Assiniboine beyond Rainy River moved westward towards the Plains and the Ojibwa filled the "vacuum." Although this process is not fully understood, the westward progression of the fur trade is the usual reason given for this development together with the Ojibwa's conflicts with the Dakota. From the 1790s the Ojibwa were in the Red River region and beyond, trading heavily with the North West Company, while the Cree were more involved with the Hudson's Bay Company. However, groups of mixed Cree, Assiniboine and Ojibwa increasingly appear around the time of the merging of the two companies in 1821. Later smallpox greatly affected the Assiniboine trading with the American posts on the Missouri

233

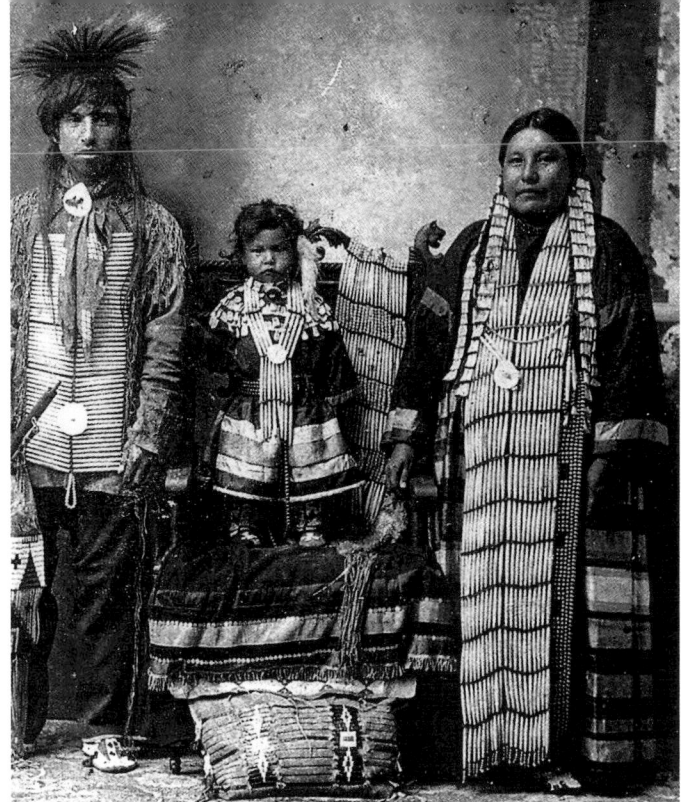

Above: Mr. and Mrs. Claude Irish and Dora Irish Santee Sioux (Dakota), Fort Totten or Spirit Lake Rreservation, North Dakota, early twentieth century. The lady wears vertically strung "hair pipes" (commercially produced bone tubes) and the man wears horizontally strung hair pipes. Originally of silver or shell made for the eastern trade to decorate the hair. Bone hairpipes became popular after around 1872. Indians today continue to use hairpipes for dance regalia. Photograph credits Mrs Dennis Cavanaugh and Louis Garcia, Ft. Totten, North Dakota.

Left: Tobacco bag from Paul's Reserve, Wabamun, Stoney or Plains Cree, c. 1900. LFG

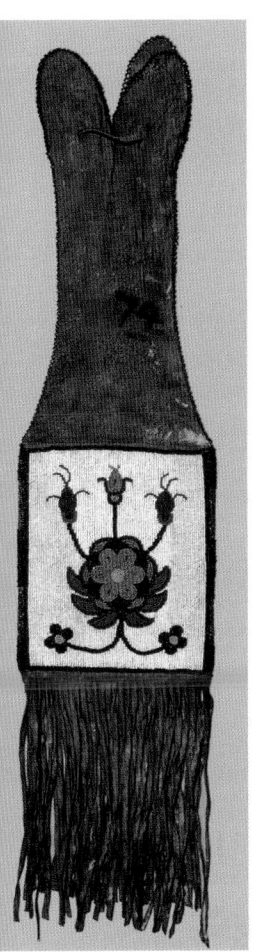

River, reducing their population by perhaps two-thirds and encouraging the formation of multi-ethnic bands. Faced with waves of epidemics many shifted back and forth between ecological zones and Woodland and Plains culture areas and resources. In the west bison had become a major food supply while wild rice was still harvested east of Red River.

The material culture of these native people was affected by European trade goods from the earliest days of contact. Resonating with sunlight, trade goods such as silver, brass, blue beads, red cloth, and ribbons strongly appealed to the native people, perhaps reinforcing their concept of "power" and adding to an indigenous highly developed artistic heritage of painted hide garments and geometric designs in woven, wrapped, and appliqué porcupine quillwork.

The depletion of fur-bearing animals in the east was partly responsible for the westward spread of the Assiniboine and closely followed by the Cree during the eighteenth century. Reliable food resources were other cogent factors. It is highly probable the Cree

and Assiniboine carried west their own style of decorative porcupine quillwork, particularly woven quillwork and the checkered designs of small rectangles seen originally on Subarctic tunics and coats. These designs reappear in beadwork patterns on Northern Plains and Parklands ceremonial dress during the second half of the nineteenth century. However the southern branches of the Assiniboine appear to have developed their styles of quillwork decoration, for example the huge quilled disks that appear on men's warrior shirts that were recorded by Karl Bodmer in 1833. Later, during the mid-to-late nineteenth century, the southern Assiniboine were also exposed to the multi-quill plaiting techniques shared with other Northern Plains people such as the Hidatsa and Blackfeet, and to Western Sioux-like quillwork and lazy-stitch beadwork techniques and designs, particularly at the Fort Peck and Fort Belknap reservations.

By the end of the eighteenth century more Cree and now Ojibwa, including their mixed blood relatives, the Crees with British admixture and Ojibwa with French, were spreading into southern Manitoba and beyond. They brought an increased range of trade materials and European influences, particularly floral embroidery in quills, beads, and silk, that were to affect the whole of the northeastern marginal Plains and Parklands and ultimately the northern High Plains Indians.

There is little doubt that the Hudson's Bay Company in particular was responsible for the redistribution of Indian bands throughout the remote parts of Saskatchewan and Manitoba and rendered the native people almost totally economically dependent on its commercial activities with little regard to their health and education. Perhaps only now have the necessities of the deprived communities been recognized.

Re-examination of Stoney–Assiniboine ethno-history has questioned their cultural position as a typical Plains people thought to have been largely dependent upon the migratory buffalo in pre-reserve days. Although an origin as Sioux (generalized Dakota) rather than Yanktonai in particular is now considered more probable, the possibility that the Stoney–Assiniboine are the only true Nakota speakers and that their supposed predecessors were in fact Dakota speakers (not, after all, Nakota speakers) adds fuel to doubts of a specific Yanktonai break-off. In any case there is no certainty about either the time of separation from their parent stock, which was at least as early as the mid-seventeenth century, and probably a good deal earlier, or about their routes taken to the foothills of the Rockies subsequent to their earliest reported domain somewhere in the vicinity of Lake of the Woods and Lake Nipigon.

One theory holds that they split into two westward-moving branches, one along the forest edge of the Parklands in association with the Cree, the other centered around the Assiniboine River Valley. This southern branch ultimately became the Assiniboine settled

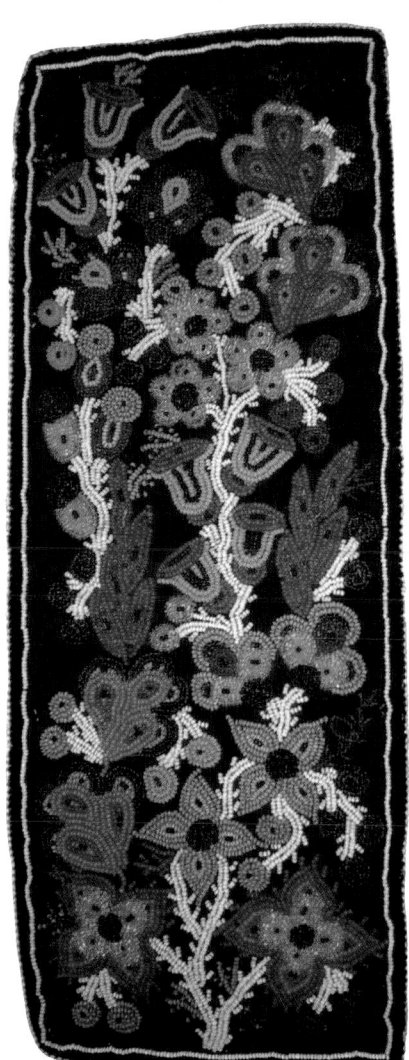

Colour	1	2	3
a	white	blue	red
b	green	orange	blue
c	red	yellow	green

at Forts Belknap and Peck in Montana and the northern branch (the Stonies) finally settled on several small reserves in Saskatchewan and Alberta. Reports from fur traders and explorers of the eighteenth century claimed that variously named Assiniboine groups had entered the foothills of the Rockies west of present-day Edmonton, which would roughly coincide with the general westward movement of the Cree and Assiniboine originally from the Lake Winnipeg area. Another theory speculates that the northern branch alone divides into two, the Wood Stoney between the North Saskatchewan and Pembina Rivers and the Strong Wood Stoney of the Battle River area, both in Alberta, the predecessors of the Alexis and Paul's bands northwest of Edmonton, and the Chiniki, Bearspaw, and Wesley bands near Morley respectively.

Tripartite cultural modes are hypothesized for the Stoney–Assiniboine for the early nineteenth century. The Wood Stoney, in a way similar to the local Cree, adjusted to a yearly cycle of hunting, trapping, and summer fishing and gathering, with a close relationship with the fur trade. The Assiniboine of southern Saskatchewan and Montana were true Plains nomads and largely dependent upon the bison for food, and the Strong Wood Stonies were somewhat intermediate between the two ecological adaptations and never

Above left: Appliqué floral beadwork, c. 1900, particularly associated with the Swampy Cree of Norway House, northern Manitoba, but probably also other northern Cree bands. Allan Hughes Collection

Top left and right: Plains Ojibwa (Saulteaux) beaded symmetrical floral elements.

Above: The geometrical proportions of a common Plains Cree floral beaded unit.

Below: Beadwork detail, Touchwood Cree, Saskatchewan, c.1900. LFG

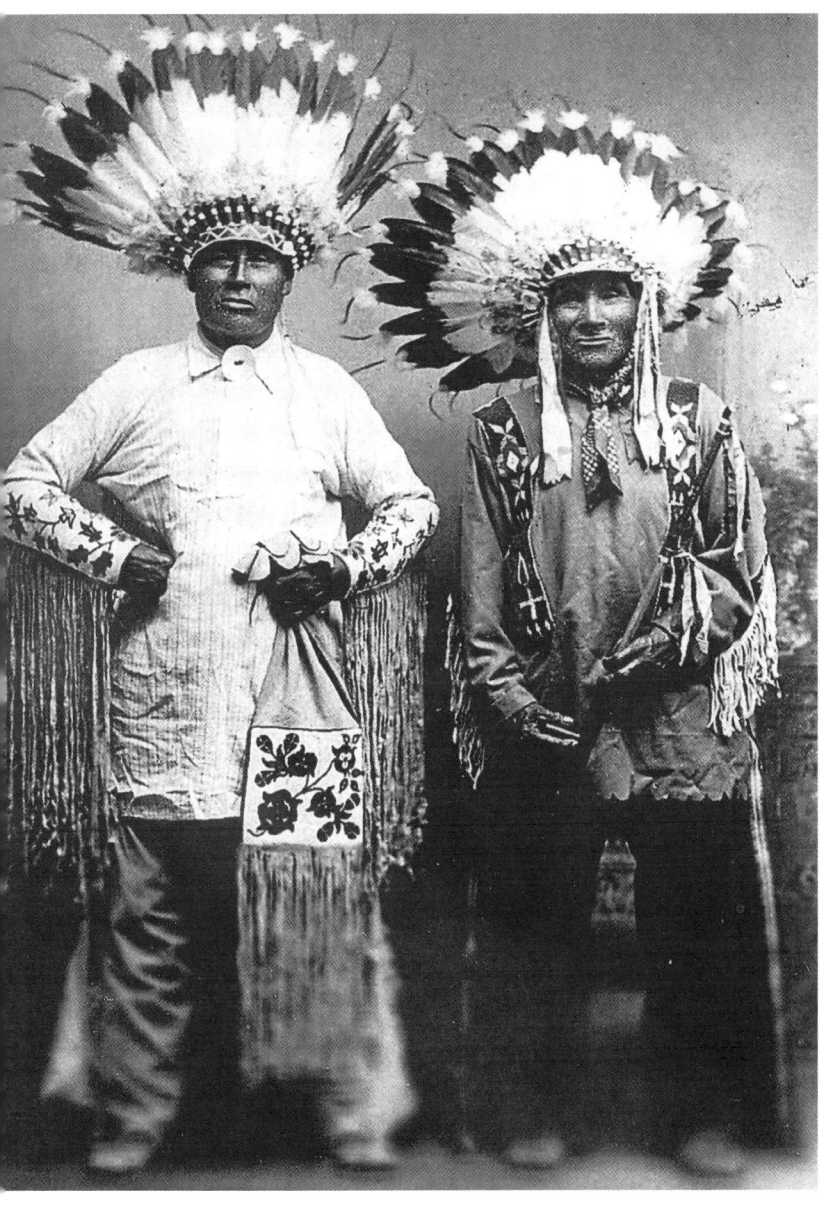

other Stoney groups after a measles epidemic. A split in the Wesley band gave rise to the Bighorn band west of Nordegg, with band status given in 1947. Another minor group from the Bearspaw band, the Pekisko Stoney or Eden Valley, now occupy a small reserve at High River.

The Saskatchewan bands—Mosquito, Grizzly Bear's Head and Lean Man's—settled near Battleford. Pheasant Rump's and Ocean Man's bands are near Moose Mountain (after years at White Bear Reserve) and Carry-the-Kettle at Fort Qu'Appelle. The latter has a reputation of being historically Plains like in culture.

We can speculate about how these various bands could have held traditional cultural values in common after so many years of separation. In material culture, native dress these bands were more likely to reflect their nearest neighbor and other groups, particularly the Cree with whom they have intermarried in the north, the Blackfeet in southern Alberta, and the Gros Ventre and Sioux in Montana with whom they have shared their reservations.

In the summer of 1889 torrential rain damaged the Canadian Pacific Railway's line in the Rockies keeping visitors in Banff for several days. Local Stoney Indians from the nearby twelve-year-old Morley Reserve entertained the marooned tourists with horse races, parades, and dancing. Thus began the annual Banff Indian Day, which was held annually until 1978, which encouraged the local Indians to produce and wear colorful costumes and exaggerated parade regalia with highly developed geometric and florescent beadwork designed to be attractive to onlookers and reflecting

intensive buffalo hunters, nor sustained large-scale Plains forays.

After the treaty with the Crown established band reserves in 1876–77, the Alexis Stoney settled near the Oblate Catholic mission at Lac Sainte Anne, but divided in the 1880s forming a second group (a Protestant one) with the Cree from Alexander's band. This new group was established at Wabamun Lake and called Paul's band. The three Stoney bands now at Morley, Jonas or Wesley, Chiniki or Chiniquay, and Bearspaw had already become distinct by 1841, the Bearspaw band being the most Plains-like and constantly in conflict with the Piegans and Kutenais. The other two bands never totally adopted the horse–bison culture characteristic of the Plains tribes, and there is speculation that the Wesley band may have been a northern or Wood Stoney band originally, although a veneer of Plains culture no doubt derived from the Blackfeet pervaded early Stoney reserve life in the late nineteenth century.

In 1899 a small Wood Stoney band at Ponoka, Alberta, called Sharphead distributed themselves among the

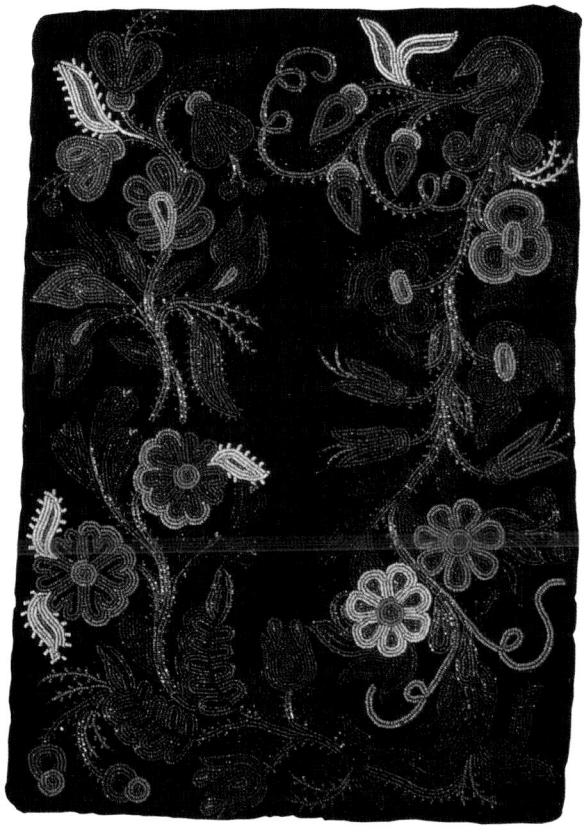

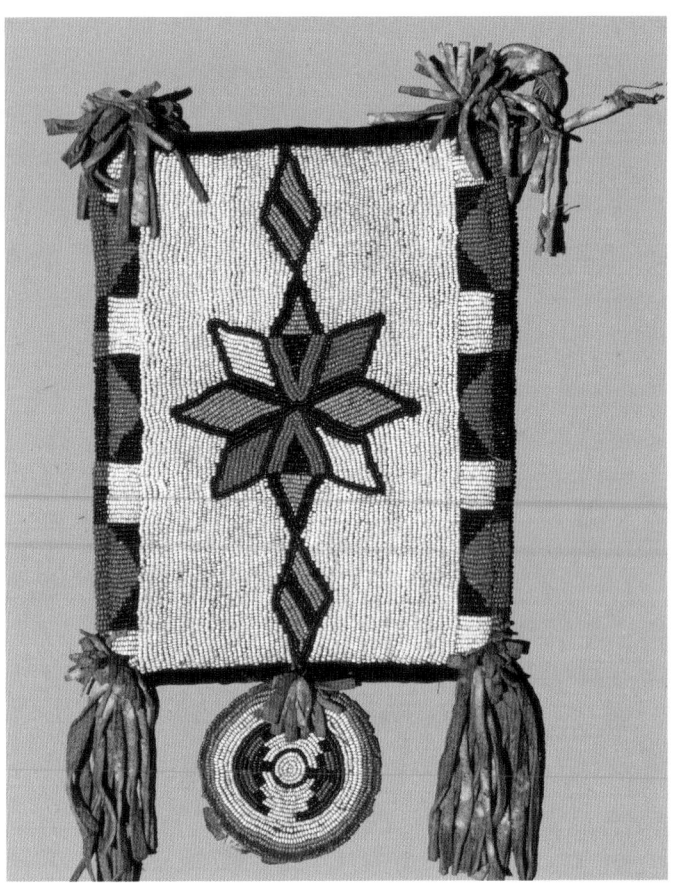

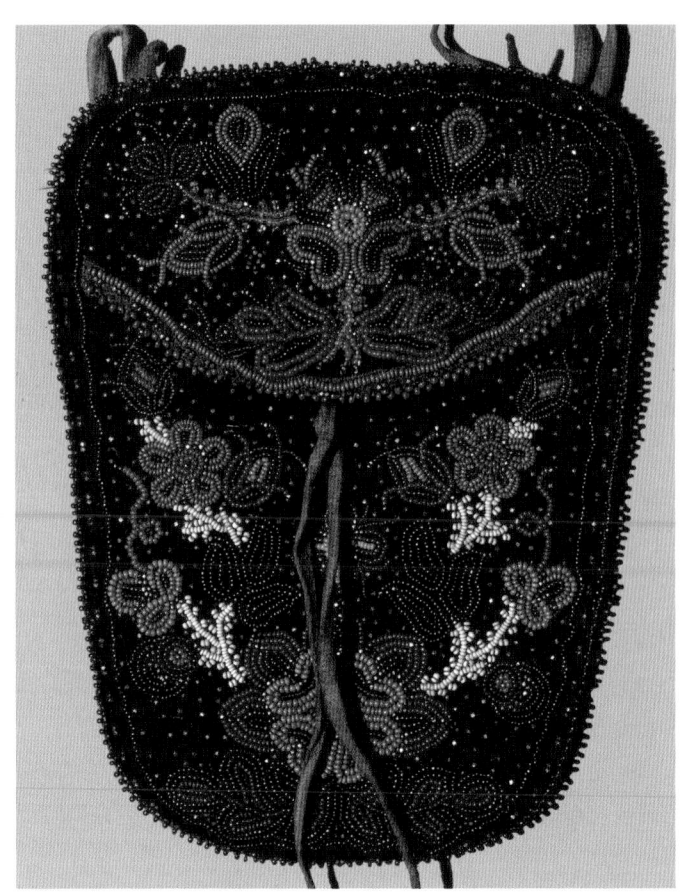

the continued commercial influences on native art. One of their patrons, Norman Luxton, encouraged them to paint their canvas tipis with non-traditional bright realistic designs of animals and birds.

Because of the huge area, native art and decoration is more likely to be recognized by some localized style rather than by tribe at least after the settlement of bands on reserves after the 1870s. The following list indicates a possible grouping of bands who may share similarities in their designs, forms, and techniques of geometric and floral beadwork. There seems no reason to suggest that the art work produced by the Métis elements in these locations would be significantly different from native registered artists.

Above left: Touchwood Cree wall pocket or pouch, c. 1900, from Saskatchewan. LFG

Above: Swampy Cree pouch, c. 1890. LFG

Opposite, left: Early twentieth century Indian men wearing eagle feather headdresses. The man on the right wears a beaded shirt and holds a pipe. On the left the man holds a beaded fire bag and wears beaded gauntlets. They are thought to have been Canadian Santee Sioux (Dakota), in Manitoba. Photograph credits Alvina Alberts and Louis Garcia at Fort Totten, North Dakota.

Opposite, inset: Touchwood Cree banner, c. 1900, from Saskatchewan. LFG

Area	Typical group	Ethnic group
Northwestern Ontario	Albany, Weenusk, Severn	James Bay Cree, Westmain or Swampy Cree
Northern Manitoba	Norway House area	Westmain or Swampy Cree
East coast Lake Winnipeg	Berens River, Bloodvein "Clandeboye" area	Ojibwa and Cree admixture
West side Lake Winnipeg & Lake Winnipegosis	Peguis etc. "Interlake" area	Ojibwa
Southern Manitoba, Assiniboine & Souris rivers	Portage La Prairie	Plains Ojibwa and Santee Sioux (after 1860s)
Southeastern Saskatchewan	Qu'Appelle Valley and Touchwood Hills	Plains Ojibwa, Plains Cree, Assiniboine & Santee
Northern Saskatchewan	Meadow Lake area etc	Woods Cree and Chipewyan
Northern Alberta	Hay River, Lesser Slave Lake etc.	Woods Cree, Chipewyan, Cree-Chip, Slavey
Southern Alberta	(a) Alberta Plains (b) Mountains	Blackfoot, Sarsi, Stoney–Assiniboine
Central Alberta	Saddle Lake and Hobbema	Plains Cree, Woods Cree, Stoney–Assiniboine

ARCTIC BASKETRY

As in most human cultures around the world, basket weaving evolved in the Arctic and Subarctic as a utilitarian craft, and as in most such indigenous traditions in North America, the results of this craft are today valuable collectibles. Here in the north, basket makers traditionally used a combination of coil and twine weaving. These included coiled baskets, often with lids, for storage and gathering, and bowls and plaques for both utilitarian and decorative purposes.

Traditional materials include various grasses, such as ryegrass. Willow, a traditional material elsewhere in North America, is not available in the Arctic. However, weavers in the north also traditionally used baleen, the filtering structure found in the mouths of whales, where it is used for straining edible krill from mouthfuls of seawater. Baleen consists of combs, with what looks like thick, coarse grass at the ends. This material is composed of keratin, the same material as hair, horns, or human fingernails.

According to the *Inuit & Native Art Bulletin*, the major contemporary sources for traditional-style baskets from the region are in the vicinity of Inukjuak, an Inuit (Eskimo) settlement located on Hudson Bay at the mouth of the Innuksuak River in the Nunavik region of northern Quebec. Handmade crafts from here are highly prized.

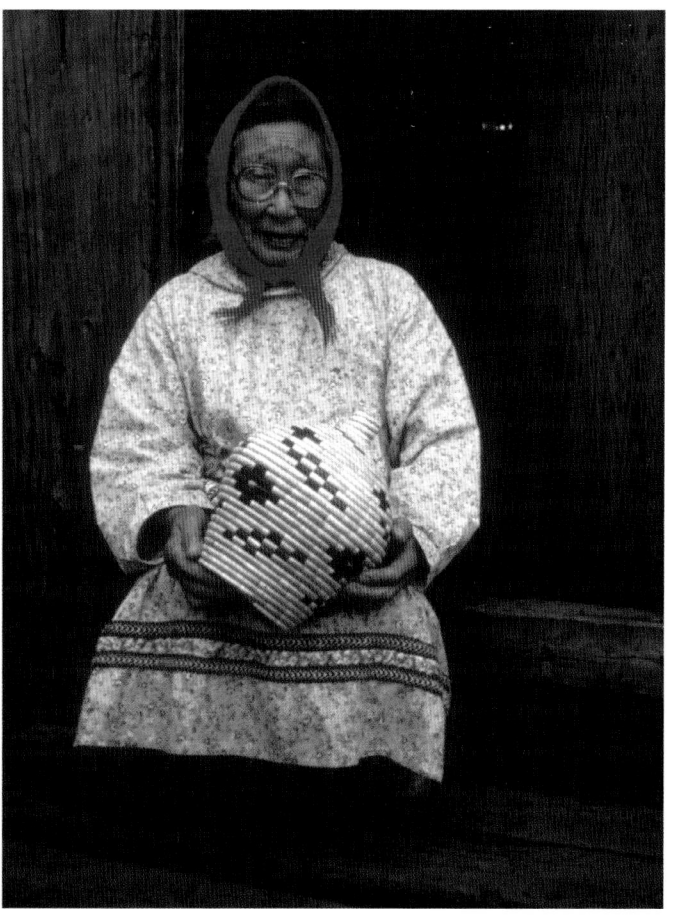

Above right: A contemporary Inuit basket weaver with coiled grass basket at Bristol Bay. Alaska Photo Library.

Right: A Yupik Inuit artist weaving a traditional coiled grass basket at Bristol Bay in far northern Alaska. Alaska Photo Library

Below: Twelve woven Aleut and Inuit baskets displayed with tops, c. 1899. LoC

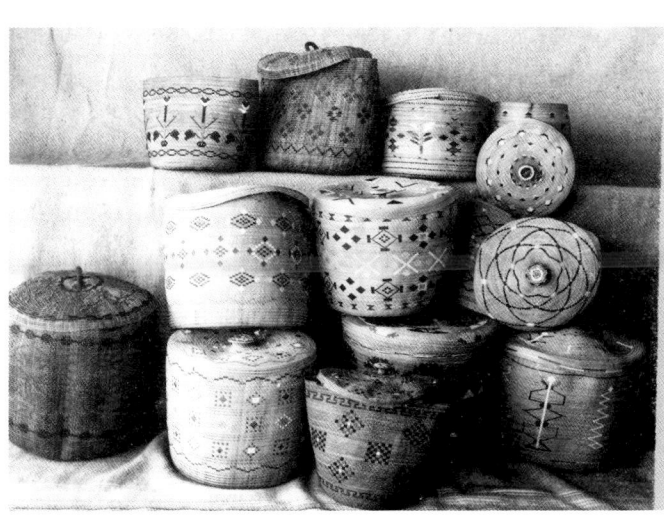

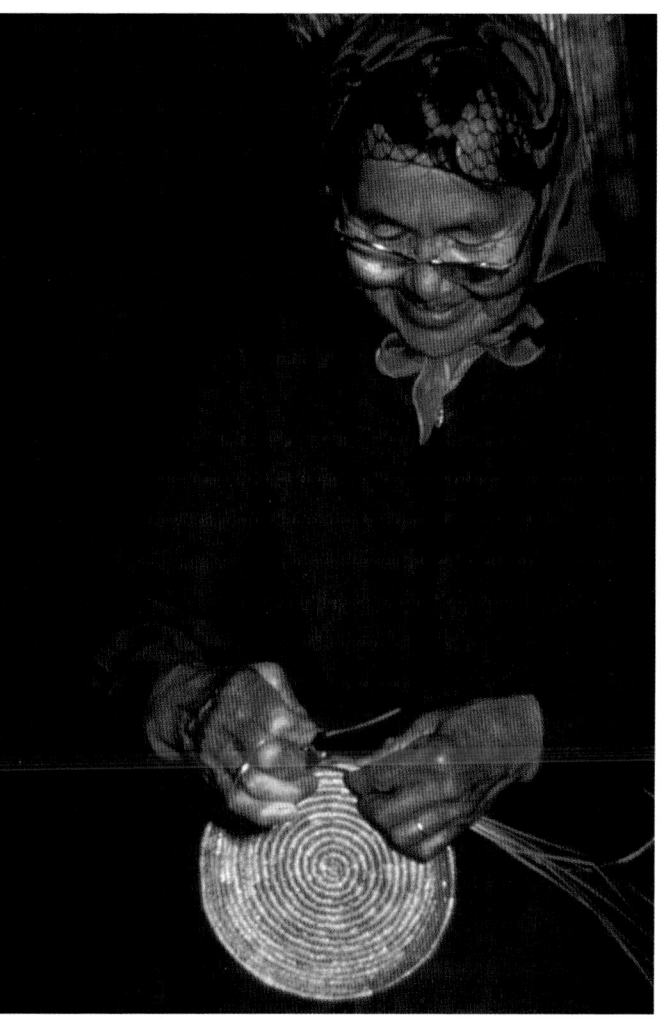

ARCTIC BONEWORK AND SCRIMSHAW

Scrimshaw, the practice of carving pictorial designs or illustrations into whale teeth, was practiced and popularized by European and American whalers throughout the nineteenth century, and probably before. It began as a means of passing the time on long hunts, and evolved into a highly collectible art form.

Meanwhile, the same art form had been developed by the indigenous people of the Arctic and the Northwest Coast, for whom whaling was an important activity. Among these people, especially among the Inuit (Eskimo), the medium included not only whale teeth but the ivory tusks of the walrus as well.

Tools used for the carving were originally stone, but metal tools were obtained through trade from early in the nineteenth century.

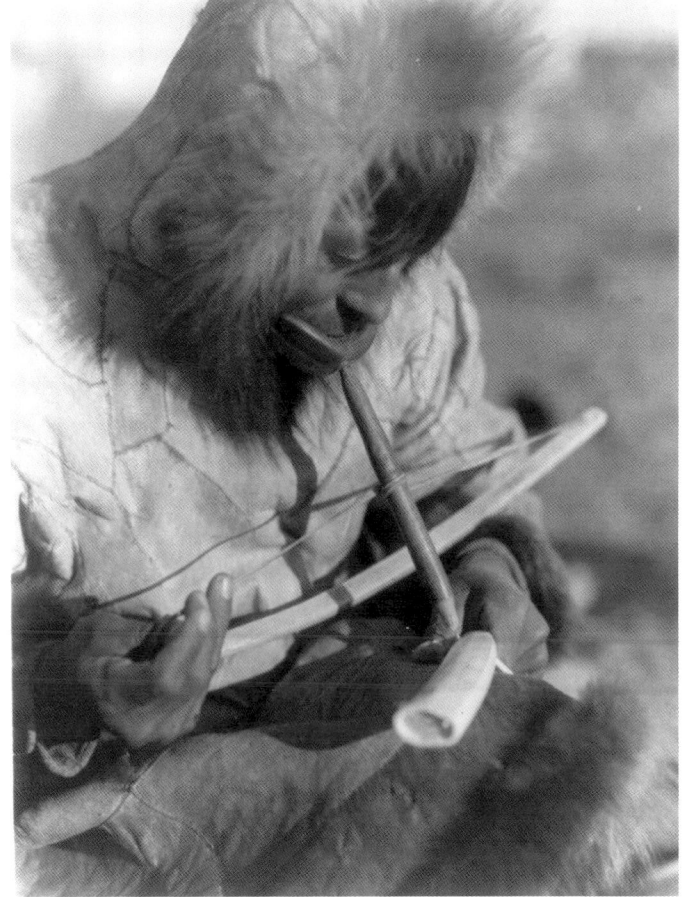

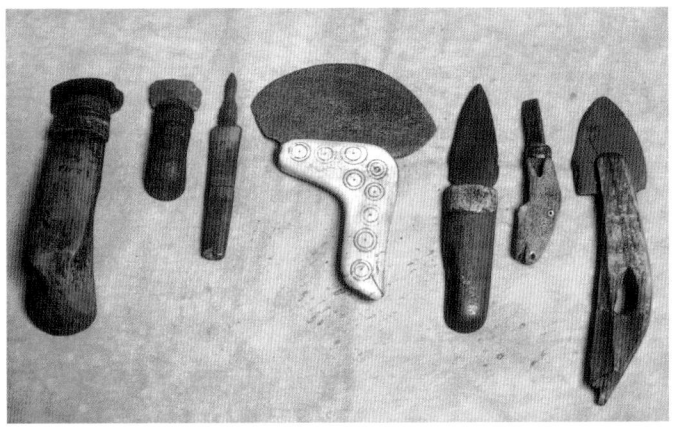

Above: An Inuit man drilling ivory on King Island, Alaska, as photographed by Edward Curtis in February 1929. LoC

Left: A variety of traditional Inuit scrapers, knives and harpoon points on display in Juneau. Alaska Photo Library

Below: A prehistoric Inuit artifact, a bone with scrimshaw. Alaska Photo Library

As whaling declined in the twentieth century, so too did the available stocks of whale teeth for use in scrimshaw. By the end of the twentieth century, most countries had banned whaling. In the United States, the Marine Mammal Protection Act (MMPA), passed in 1972, prohibited whaling in American waters and established a moratorium on the taking of other marine mammals, including the walrus, in United States waters. It also curbed the importation of whale and other marine mammal scrimshaw made after that date. An exception to the ban was that marine mammals could be taken by "Indian, Aleut, or Eskimo for subsistence purposes or for purposes of creating and selling authentic native articles of handicrafts and clothing."

Nevertheless, most native scrimshaw on the market in recent years is identified as being "antique," or pre-1973, in origin. In recent years, however, stocks of walrus tusk ivory buried for over a century have entered the market from excavations on private land on St. Lawrence Island in the Bering Sea.

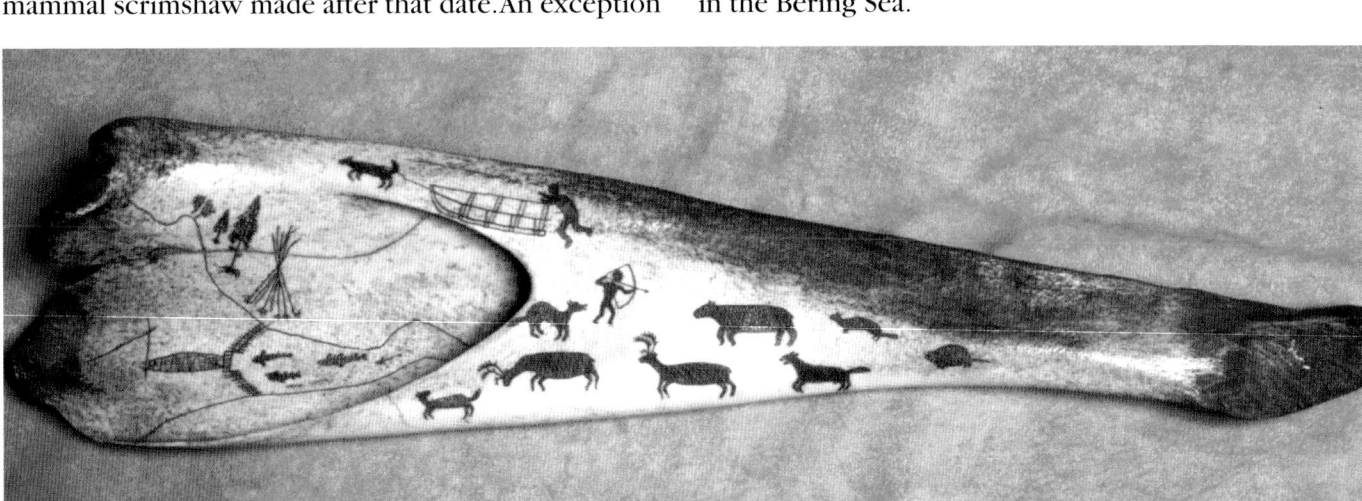

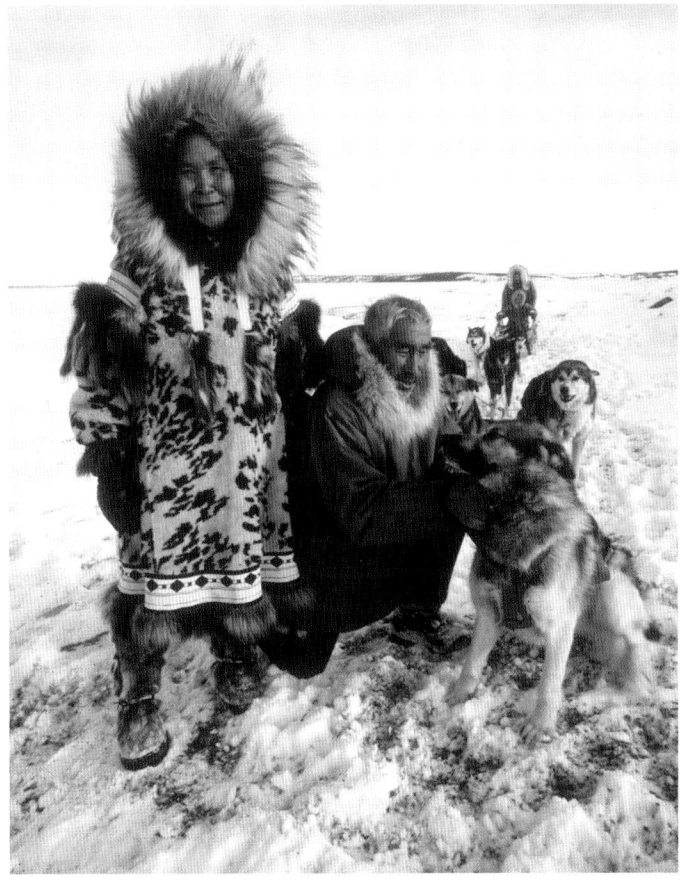

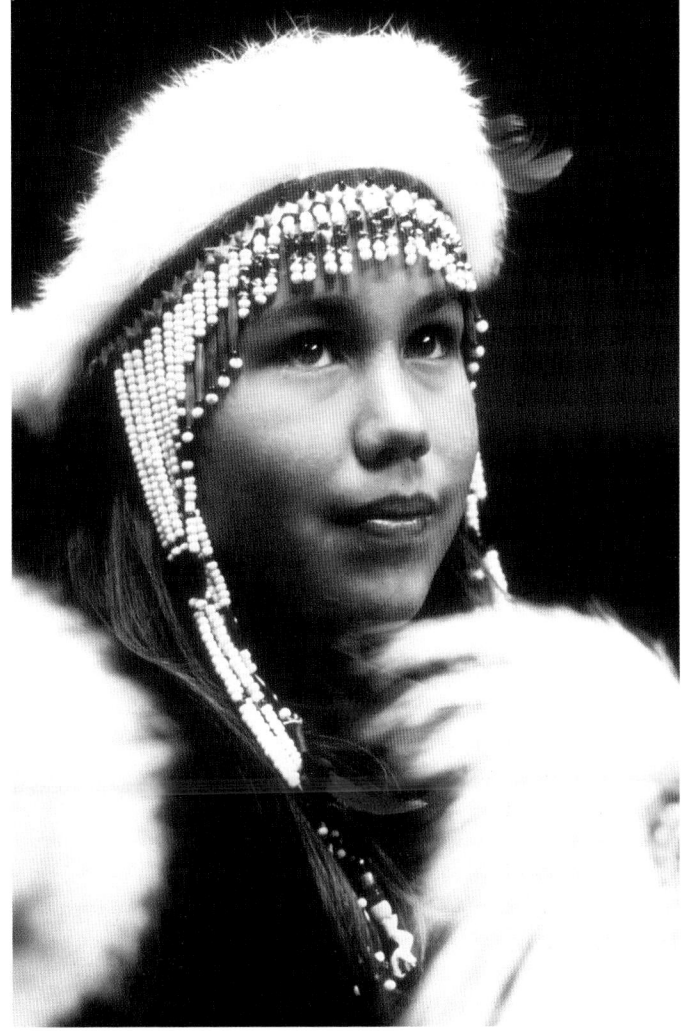

ARCTIC AND SUBARCTIC DRESS

Because the climate of the Arctic and Subarctic is among the world's harshest and most extreme, the traditional clothing of the region was designed first and foremost for warmth—and likewise the contemporary clothing. The image of the person dressed in a heavy parka, looking out from a fur-trimmed hood stares at us from nineteenth-century photographs as well as from photographs taken last winter.

Traditional Arctic clothing, for which the Inuit (Eskimo) word is *annuraaq*, for both men and women, consisted of a double-layer, hooded, pullover jacket and double-layer trousers. The latter were, in turn, tucked into sealskin boots. The hood on the woman's jacket was designed to double as a carrier for an infant. As reported in the 1911 *Encyclopedia Britannica*, the Inuit also "sometimes wear shirts of bird-skins, and stockings of dog or young reindeer skins. Their clothes are very neatly made, fit beautifully, and are sewn with 'sinewthread,' with a bone needle if a steel one cannot be had."

The traditional materials that were used included caribou hide because of its availability and versatility, as well as sealskin because of its water-resistant properties. Other materials included the fur and hides of the bear or fox, as well as of dogs. The fur fringing the jacket hood would often be wolf or wolverine. Not essentially decorative, this fringe was used to protect the face from blowing snow.

Modern Arctic and Subarctic outerwear is essentially of the same design as that of a century ago, although the garments are brought in from out of the area, and are made using advanced lightweight insulated materials such as microfleece, multi-ply nylon, and Vaetrex.

Above left: Inuit people with sled dogs near Kotzebue, Alaska. The dress is traditional, with the old ways retained because they are time-tested and well proven over the centuries. APL

Left: A young contemporary Alutiiq (Yupik) dancer on Alaska's Kodiak Island. Kristen Kemmerling photo via Alaska Photo Library

Opposite, above: A group of Inuit people displaying their reindeer-skin suits in a contest, c. 1916. LoC

Opposite, below left: Inuit people in traditional garb, c. 1894. LoC

Opposite, below right: An Inuit woman photographed by the Lomen Brothers in 1907. LoC

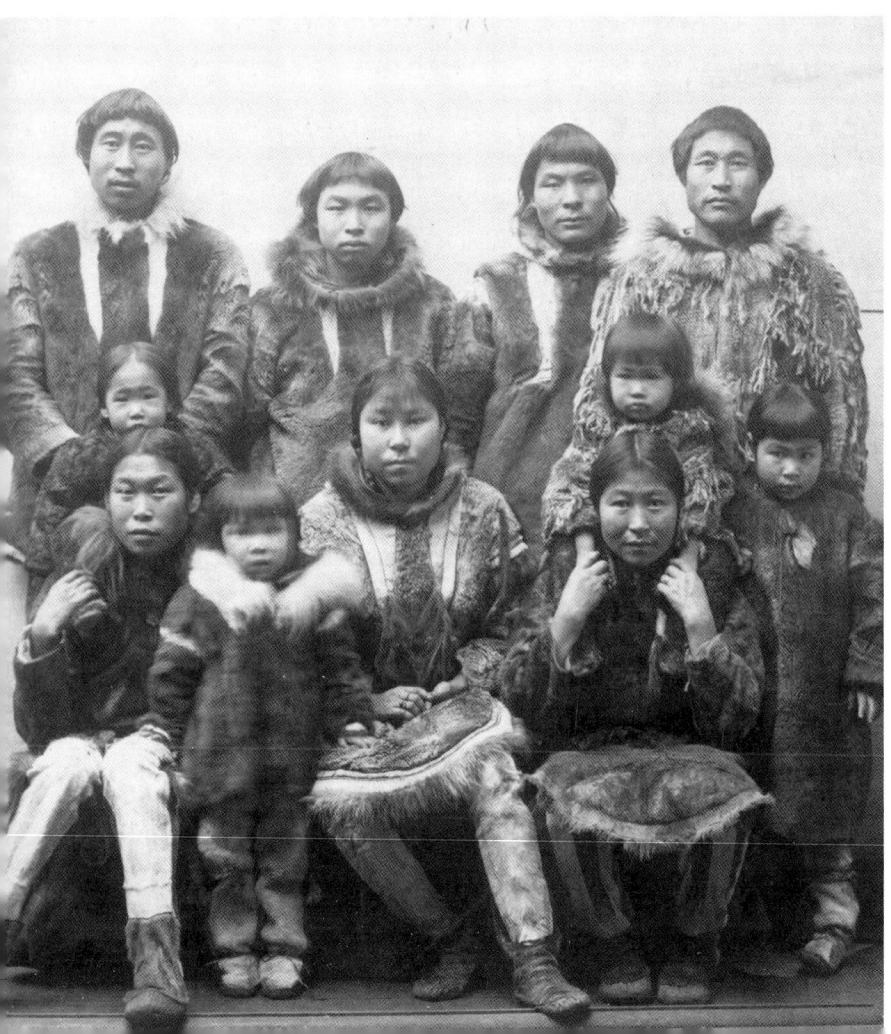
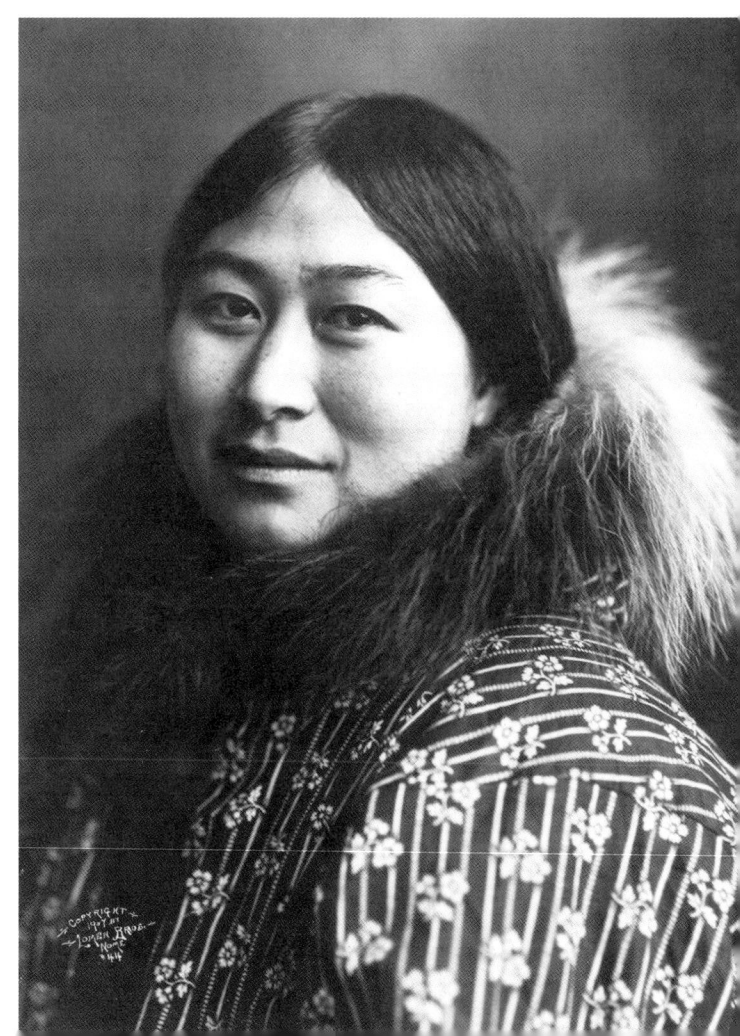

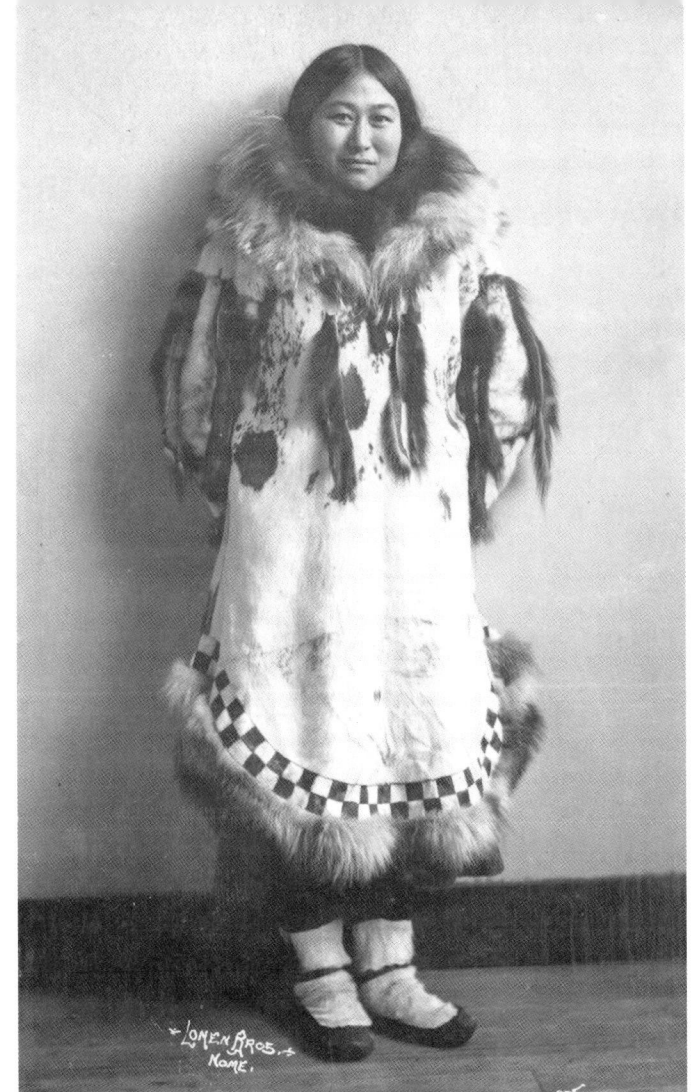

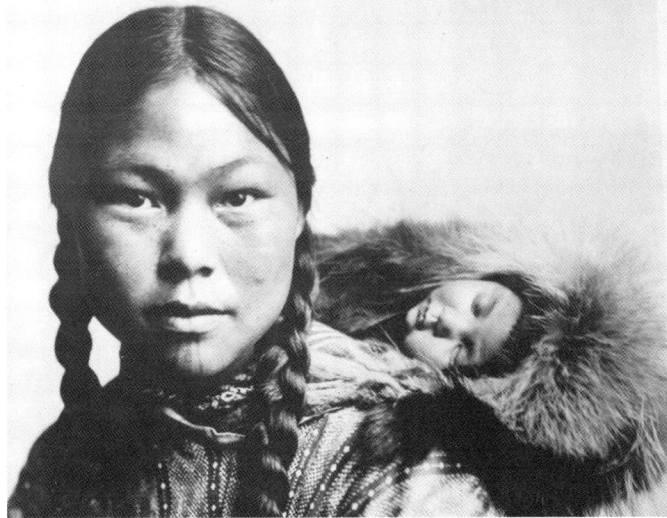

Left: An elaborate hand made coat worn by Newarluk, an Inuit woman, circa 1915. LoC

Above: An Inuit mother with her child on her back, c. 1906. LoC

Below: The Inuit Kaviagamute dancers, August 1914. LoC

OPPOSITE
Above left: An Inuit woman wearing a coat with a large fur collar, c. 1915. LoC

Above right: An Inuit kayaker wearing a waterproof jacket, and holding a toy boat which he made for his son. LoC

Below left: Inuit man in Nunivak, photographed by Edward Curtis in February 1929 wearing ceremonial masks. LoC

Below right: An Inuit shaman with a sick boy, c. 1915. LoC

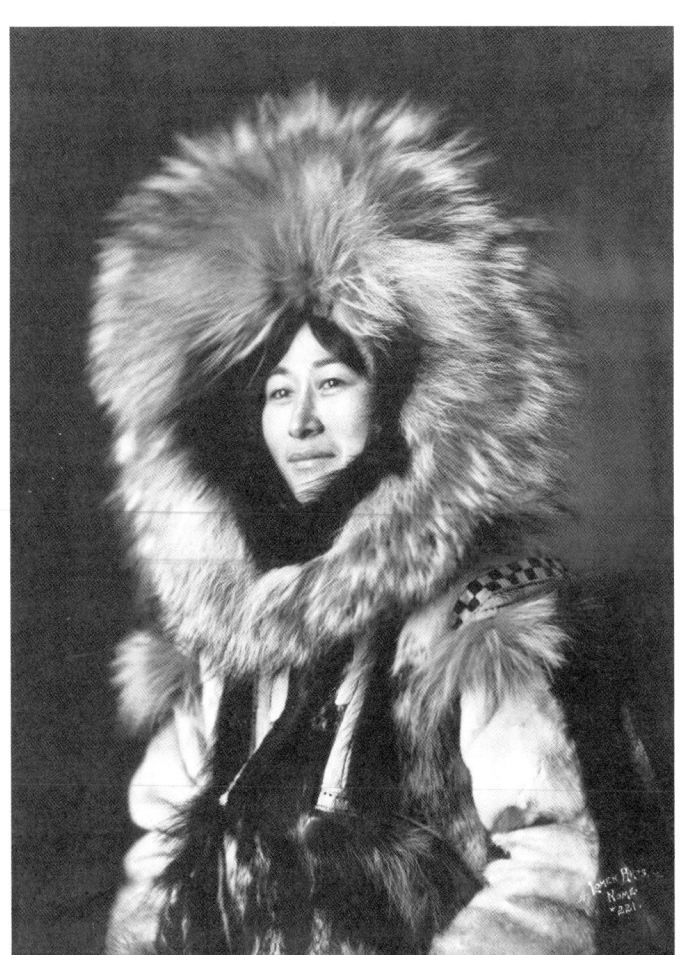

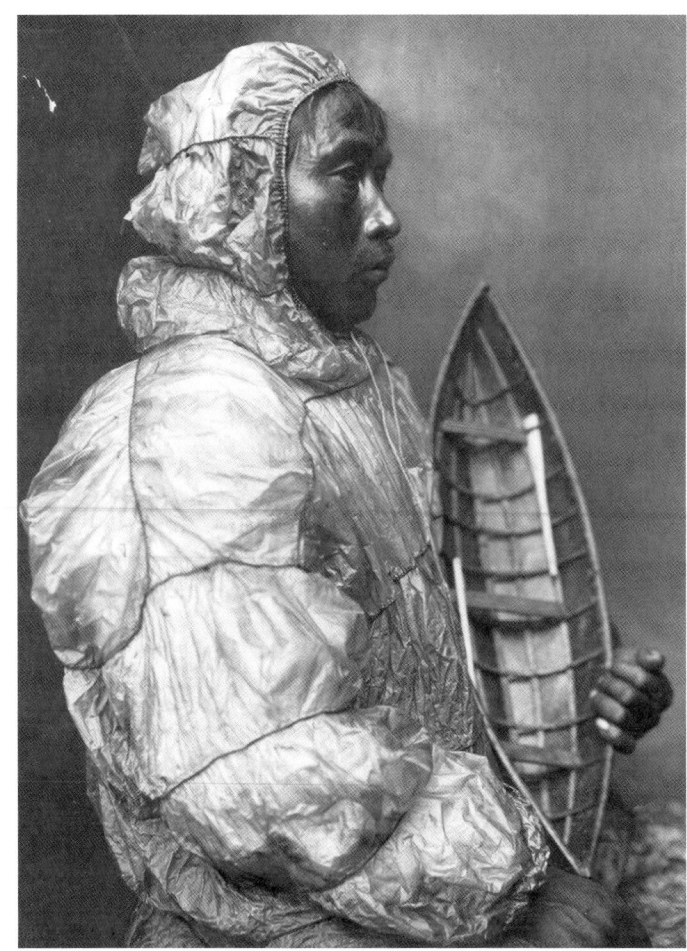

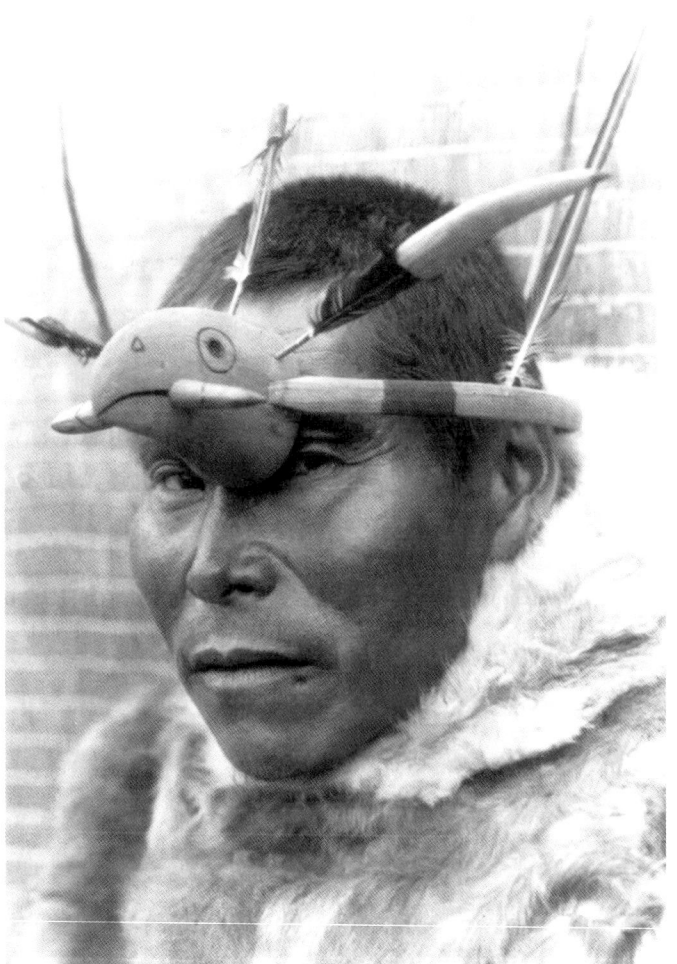

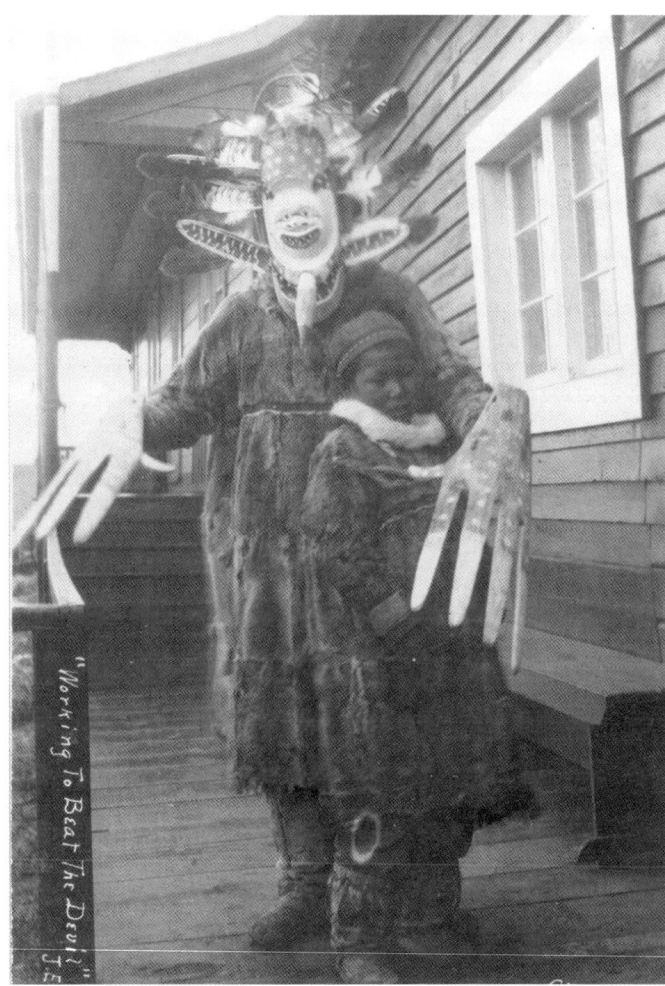

KAYAKS AND UMIAKS

The kayak is a distinctive style of boat uniquely suited to the Arctic environment, and invented there by the indigenous people of the region. Kayaks are a good example of an indigenous invention that entered the mainstream, far beyond its utilitarian roots. By the late twentieth century, kayaking had become a popular sporting activity around the world.

Occasionally referred to as a "canoe," the kayak actually differs from a canoe in important ways. Indigenous canoes around the world were usually large, heavy, multi-person vessels, often hollowed from logs, or woven from plant material. Kayaks are smaller, usually designed for a single person, with an emphasis on being easily maneuverable and lightweight for easy portability when being carried on land.

Kayaks also differ from canoes in that they do not have a fully open top. The person in a kayak sits in a narrow cockpit. This minimizes the possibility of the vessel being swamped in rough water. A capsized kayak is easily righted, and modern sport kayakers practice a maneuver called a "kayak roll" or "Eskimo roll" in which they literally roll themselves 360 degrees under the water and back up to rehearse the process of recovering from being capsized.

Kayaks were developed many centuries ago and used by the people of the Arctic and Subarctic from the Aleutian Islands to Greenland. They were designed for use in lakes and rivers as well as in the waters of the Arctic Ocean, and Bering Sea. They were used primarily for hunting—the term "kayak" is translated as "hunter's boat." The Aleut and Inuit (Eskimo) people constructed the original kayaks using a light wood frame, over which they stretched a naturally water-resistant sealskin covering.

Sporting kayaks were made with fabric over a wood or aluminum frame until the 1950s, when molded fiberglass hulls were introduced. Since the 1970s, molded plastic has been used.

The umiak is a larger, multiperson vessel which is more similar to the traditional idea of a canoe. An ocean-going vessel, it is open-topped and used for carrying goods. While a kayak is typically handled by one person wielding a single double-headed paddle, umiaks are operated by multiple paddlers. Like the kayak, it is made with seal or walrus skin stretched over a frame.

Modern umiaks are made the ancestral way because Arctic people have found the traditionally made vessel to be more versatile, more durable and easier to repair than aluminum canoes. During hunting, the metallic sound of an aluminum boat can also spook the intended prey.

Above: Inuit fishermen arriving in Noatak, Alaska aboard an umiak as photographed by Edward Curtis. LoC

Opposite: Contemporary Inuit kayaks at Kotzebue, on Alaska's Baldwin Peninsula in Kotzebue Sound. On the left is a kayak frame, while on the right is a larger completed vessel. Ernst Schneider/APL

Opposite, inset: Two Inuit women on a hunt with the wife of filmmaker Frank Kleinschmidt (in the kayak) in November 1924. Kleinschmidt's films included the documentaries *The Alaska-Siberian Expedition* (1912), *Arctic Hunt* (1914), and *Primitive Love* (1927). LoC

Below: Inuit boys on a kayak in Grantley Harbor, c. 1915. LoC

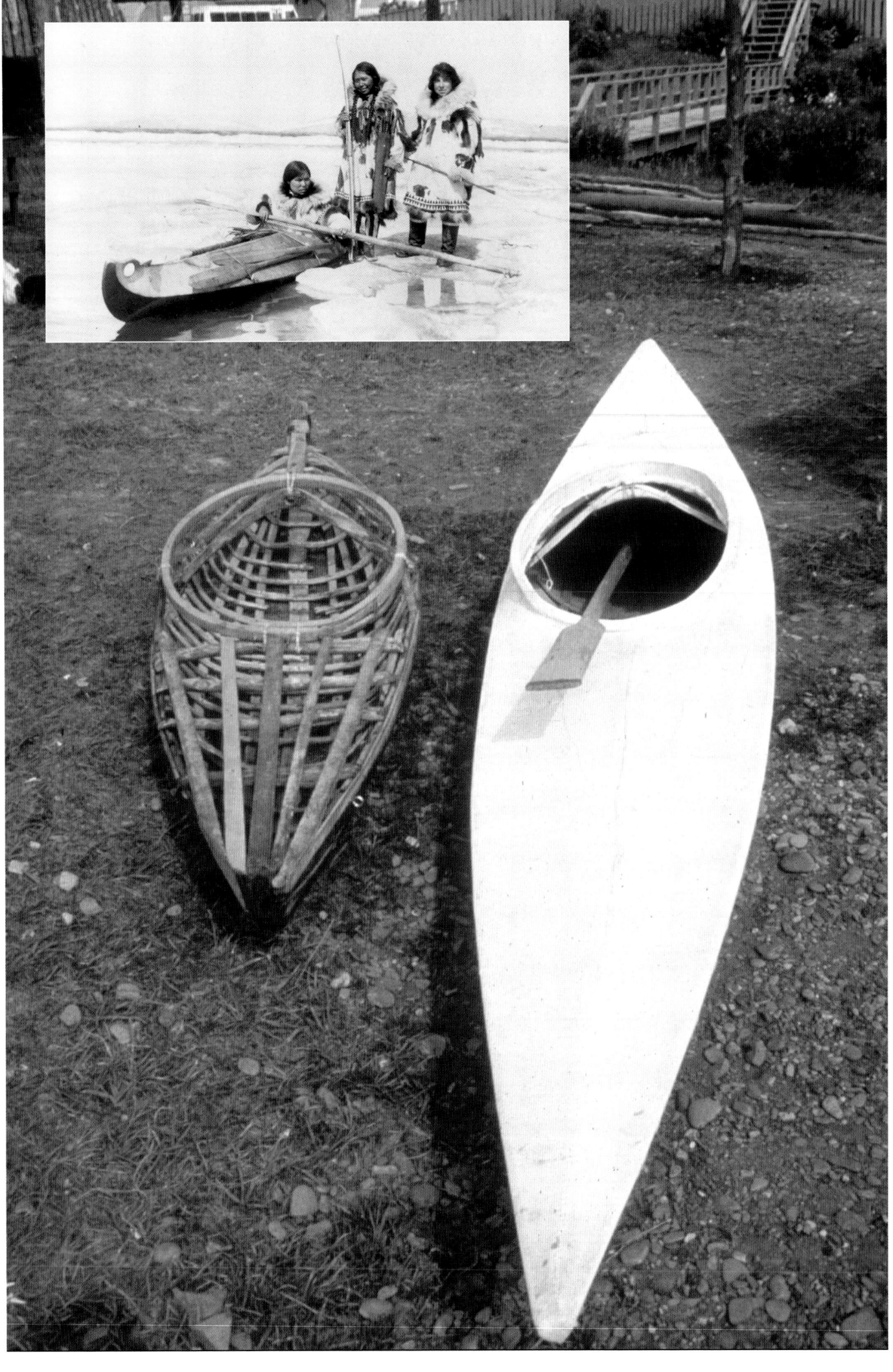

9. CEREMONIAL DRESS OF RECENT TIMES

The major factor in the continuation of wearing Indian clothes for special events has been the development of Pan-Indianism and its primary manifestation, the powwow. The ritual was primarily developed on the Plains but with elements from the Woodlands and Southeast, even the Southwest (the Hoop Dance has its origin among the Pueblos). The development of men's fast dancing and accompanying songs and dress seem to have been based upon the warrior society rituals and dances of the eastern Plains and Prairie tribes of the Missouri River valley such as the Ponca, Omaha, Oto, and Pawnee. Sioux versions of these rituals appeared around 1860–70 and were sometimes called "Omaha" or "War" dances. These dances seemed acceptable to government officials for 4th of July ceremonials since they appeared to be primarily social although they carried some vestige of traditional ceremony. With the forced removal of the Ponca, Pawnee, and Oto to

Indian Territory their warrior society songs and dances became the basis of the "Straight" Dance ceremony with a conservative and stately dance style, which has become a hallmark of the Osage Indians.

In the north, from the Sioux the Omaha Dance spread to the Arapaho, Crow, Assiniboine, Blackfeet, and the Canadian Parklands, where it became known as the "Grass Dance" due to the use of sweetgrass braids worn in the dancers' belts, a feature of the original regalia.

From the Eastern Sioux a quasi-religious version spread to the Woodlands, to the Ojibwa and the Menominee tribes of Minnesota and Wisconsin, where it became known as the "Dream Dance" or "Drum Religion." From the Canadian Plains groups such as the Plains Cree and Plains Ojibwa at least two newer general forms of the Grass Dance originated and have since returned to the areas from which they sprang with much changed dance styles and regalia, notably heavy commercial fringing. With the various categories of dance costume, and dance styles, contests with cash prizes for the best presentations in each are often held. Grand entries or parades, flag presentations, honor songs for servicemen, round dances and 49s (perhaps derived in part from Whiteman's two steps), and stomp dances (of

Far left: Modern Grass dancers in ribbon and fringe attire. LW

Left: Contemporary "Straight Dance" costume for men which lacks the baroque feather bustles of other modern dancer's attire—hence "straight dance." It is worn by dancers at the Hethoshka dances of the Ponca and Inlonschka dances of the Osage in Oklahoma. These ceremonials probably descend from the old warrior and chief's societies of the Missouri River Valley tribes such as the Omaha, Ponca, and Pawnee and taken to Oklahoma (Indian Territory) in the nineteenth century. Here, Abe Conklin wears ribbonwork decorated leggings and blanket, and obligatory white neckscarf and metal pin. Sandy Rhoades

Above: Girls wearing jingle dresses. LW

Below: Fancy dancer displays feather bustles. LW

Above: Canadian wearing a "War Bonnet" and providing the traditional image of the North American indian. LW

Below: Grass dancer with lots of ribbon trimming. LW

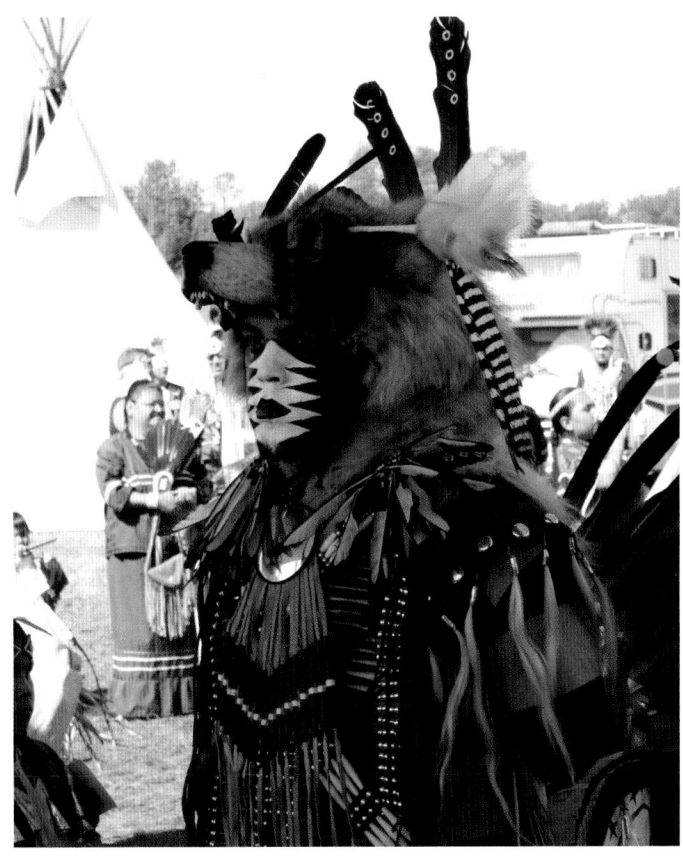

Above: Contemporary Traditional dancer. LW

Below: Girls wearing vertically strung "hairpipes" at a Powwow in Canada. LW

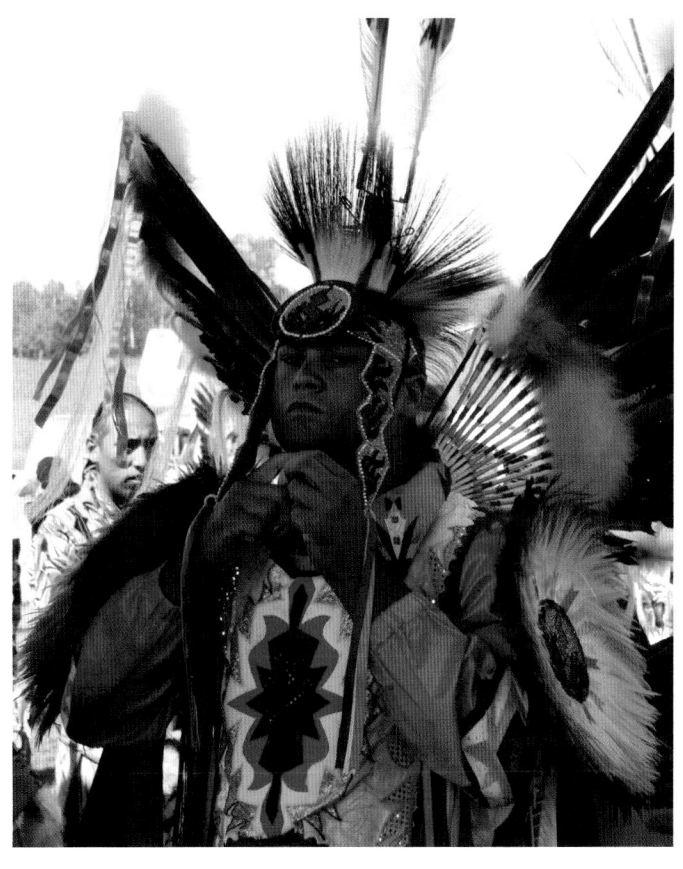

Above: Fancy dancer. LW

Below: The next generation! LW

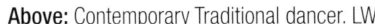

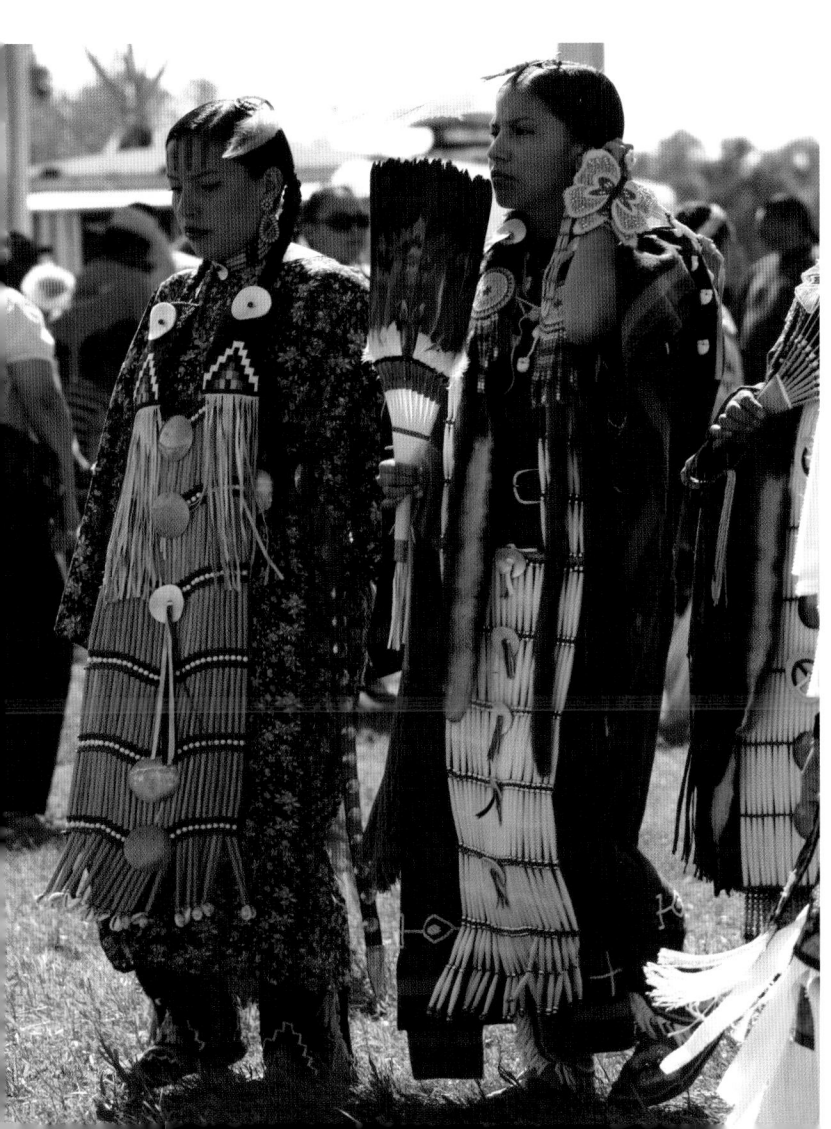

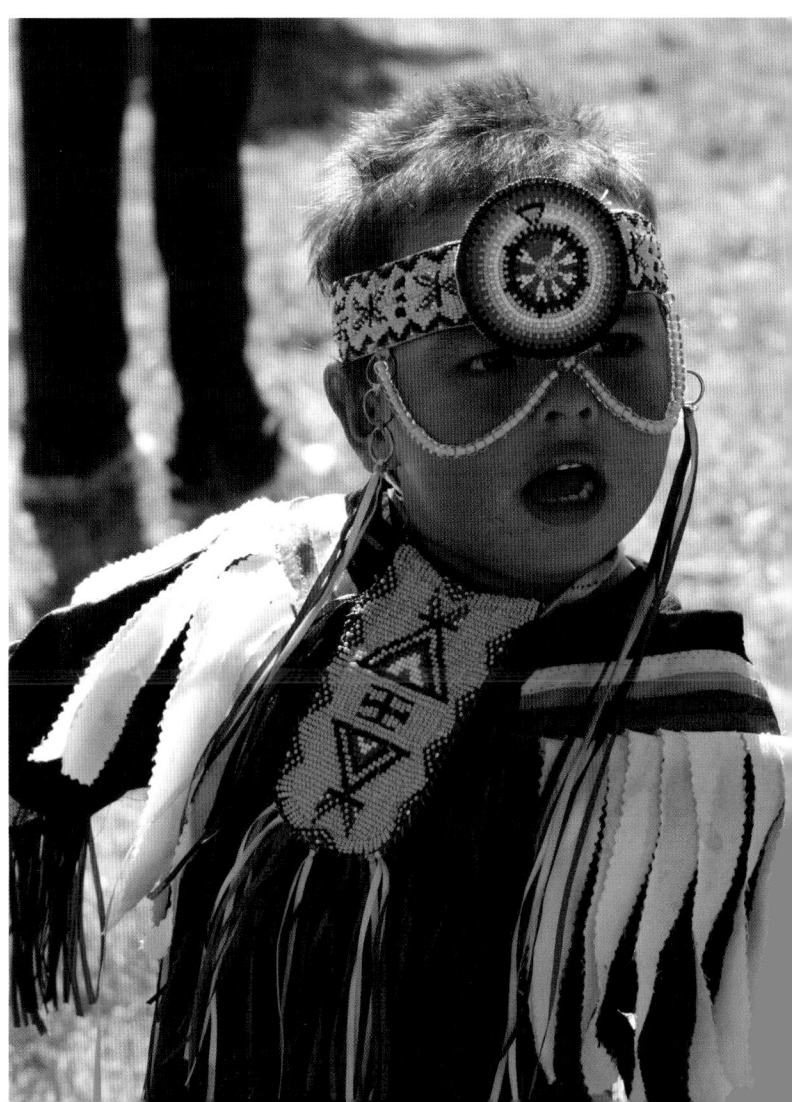

Southeastern origin) all form part of modern Pan-Indian celebrations across the U.S. and Canada.

Western Sioux man's dance costume remained fairly constant for a long period from about 1880 to 1950. The dress included dyed long underwear with an otter fur cape or hairpipe breastplate, cloth aprons, roach headdresses, and beaded armbands, cuffs, and moccasins. Feather bustles worn on the back were usually the older "mess" type relating to the old "Crow" bustle associated with the initial spread of the Omaha Dance. From about 1960 these regalia were gradually influenced by the Oklahoma-style "fancy dance" costumes with tailored and increasingly large feather bustles for neck and back. The style of dancing too reflected this influence from the south. The regalia were characterized by colorful fringes, ribbons, and masses of fluffy feather attachments. However, by the 1980s this in turn was superseded by the so-called "contemporary traditional" man's dance costume, with usually a single large back bustle, matching sets of beaded arm bands, cuffs, and moccasins, and sometimes vests and hip drops. The roach is still the universal headdress. This distinctively Sioux regalia has now spread both north to Canada and south to Oklahoma, and is seen throughout

the U.S. where powwows are held. Sometimes "outfits" may involve elements of all styles combined to suit individual tastes. The once popular warbonnet is now restricted to a few elderly ex-servicemen.

During the early reservation period cloth dresses often replaced buckskin for Sioux women with dancing restricted to sedate peripheral circling of the main dance area. In Oklahoma women's dancing became much more individualistic with tailored buckskin dresses heavily fringed which sway in unison with the drum beat. Cloth dresses or skirts decorated with ribbonwork have also become popular in recent times together with heavily fringed shawls; there is an associated energetic style of dancing. In the north another style of dress has become popular, the so-called jingle dress, a cloth dress with rows of small tin cones. These cones, which give a distinctive sound when dancing, were originally cut from old tin cans but today are commercially made. The origin of the jingle dress appears to have been with the Ojibwa of Minnesota and their relatives in Canada and its popularity spread to the Sioux during the twentieth century. Women have continued to wear vertically strung rows of hairpipes and moccasins extended to the knee and heavily beaded. Accessories include beaded fans and hair wraps.

Below: Northern Plains men's dance costumes from the first half of the twentieth century (sketch by Dave Sager. From left: Sioux, Flathead, Plains Ojibwa, Blackfoot.

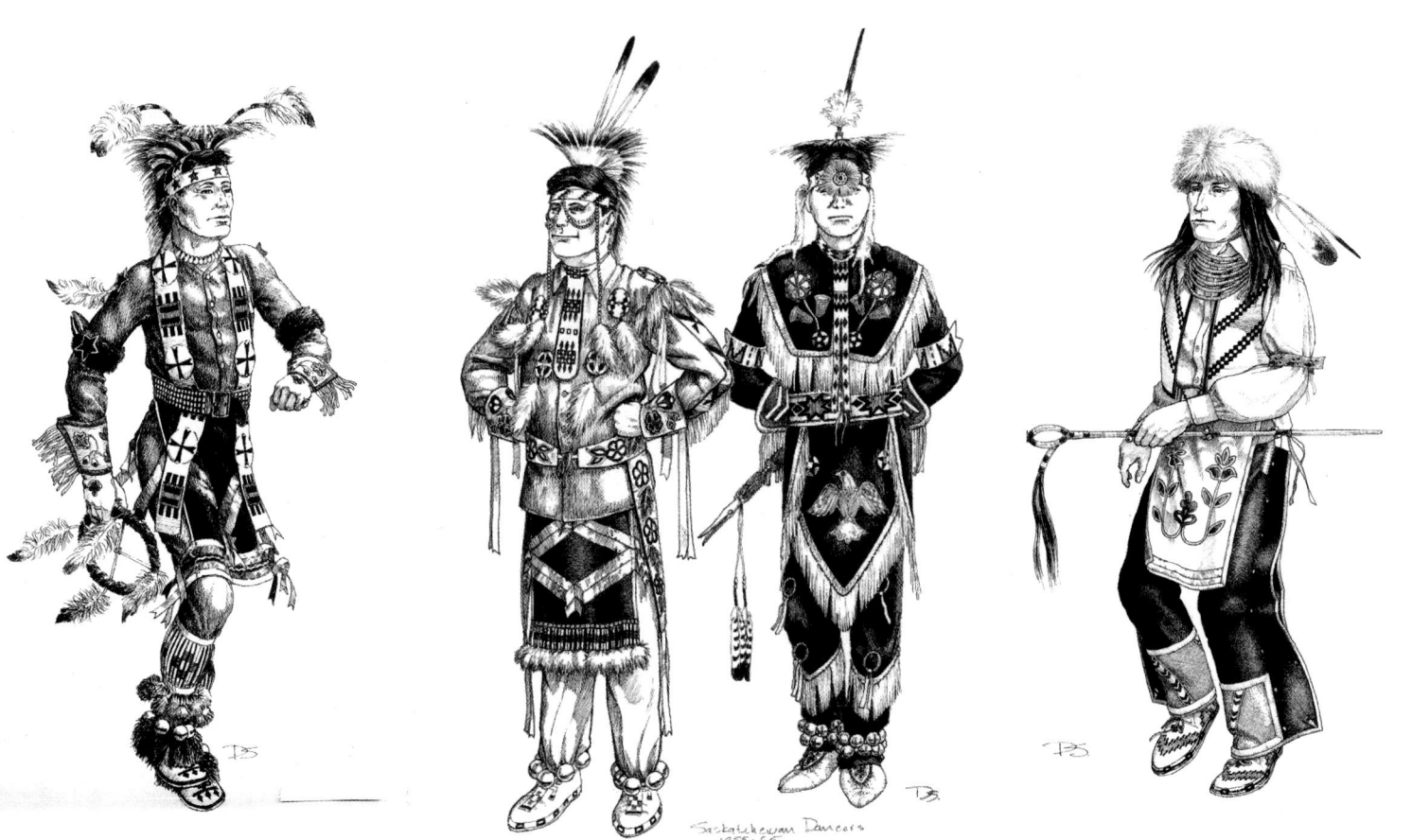

BIBLIOGRAPHY

Art of the Great Lakes Indians, Flint Institute of Art, Michigan, 1973.

The Athabascan Strangers of the North, Royal Scottish Museum, 1974.

Ackerman, Lillian A.: *A Song to the Creator: Traditional Arts of the Native American Women of the Plateau*, University of Oklahoma Press, Norman, OK, 1995.

Adair, John: *The Navajo and Pueblo Silversmiths*, University of Oklahoma Press, Norman, OK, 1944.

Adney, E.T., and H. I. Chapelle: "The Bark Canoes and Skin Boats of North America," *Bulletin* 230, Museum of History and Technology, Smithsonian Institution, Washington, D.C., 1964.

Allen, Laura Graves: *Contemporary Hopi Pottery*, Museum of Northern Arizona, Flagstaff, AZ, 1984.

Amsden, Charles Avery: *Navaho Weaving Its Technique and History*, The Rio Grande Press, Chicago, IL, 1964. Reprint of 1934 issue.

Anderson, Lee and Eric: *A History of Navajo Weaving*, Anderson's Americana, Flagstaff, AZ, 1996.

Anderson, Lee: *The History of American Indian Jewelry*, Anderson's Americana, Flagstaff, AZ, 1996.

Baity, Elizabeth Chesley: *Americans Before Columbus*, Viking, New York, NY, 1951.

Basti, Maryanne Kathleen: *Totem Poles of the North American Northwest Coast Indians*, Yale University, New Haven, CT, 1985.

Beasley, Richard A., Kathy Dye, Mark Kelley, Rosita Worl: *Tlingit Wood Carving*, Sealaska Heritage Institute, Juneau, AK, 2009.

Bebbington, Julia M.: *Quillwork of the Plains*, Glenbow Alberta Institute, Calgary, 1982.

Berlandier, Jean Louis (ed. John C. Ewers): *The Indians of Texas in 1830*, Smithsonian Institution Press, Washington, D.C., 1969.

Bibby, Brian: *Native American Art of the Yosemite Region*, Autry National Center and University of California Press, Los Angeles and Berkeley, CA, 2006.

Bird, George: "The Lodges of the Blackfeet," *American Anthropologist*, Vol. 3, 1901.

Biron, Gerry, *Made of Thunder, Made of Glass*, published by author, Saxtons River, VT, 2006.

Blomberg, Nancy J: *Navajo Textiles: The William Randolph Hearst Collection*, University of Arizona Press, Tucson, AZ, 1988.

Bowers, Alfred W.: "Hidatsa Social and Ceremonial Organization," *BAE Bulletin* 194, Smithsonian Institution, Washington, D.C., 1965.

Brasser, Ted J.: "*A Basketful of Indian Culture Change*," Mercury Series Papers, No. 2. National Museum of Man, Canadian Ethnology Service, Ottawa, 1975.

—— *Bo'jou Neejee: Profiles of Canadian Indian Art*, National Museum of Man, Ottawa, 1976.

—— (ed. McMullen, Ann, and Russell G. Handsman): *A Key into the language of Woodsplint Baskets*, American Indian Archaeological Institute, CT 1987.

Brawer, Catherine Coleman (ed.): *Many Trials: Indians of the Lower Hudson Valley*, The Katonah Gallery, New York, NY, 1983.

Brody, J.J.: *Indian Painters & White Patrons*; University of New Mexico Press, Albuquerque, NM, 1971.

Brown, Alison K.: "The Mary Alicia Owen Collection of Mesquakie beadwork in Cambridge," *Journal of Museum Ethnography*, No. 9, 1997.

Brown, Steven C: *Native Visions: Evolution in Northwest Coast Art from the Eighteenth through the Twentieth Century*, University of Washington Press, Seattle, WA, 1998.

Brownstone, A., and H. Dempsey (eds.): *Generous Man: Essays in memory of Colin Taylor*, Tatanka Press, Wykauf Foehr, Germany, 2008.

Campbell, Tyrone, Joel Kopp and Kate Kopp: "Navajo Pictorial Weaving, 1880-1950," *Folk Art Images of Native Americans*; Dutton Studio Books, New York, NY, 1991.

Coe, Ralph T.: *Lost and Found Traditions, Native American Art 1965-1985*, University of Washington Press in association with The American Federation of Arts, Seattle, WA, 1986.

Collins, John E: *Nampeyo, Hopi Potter: Her Artistry and Legacy*, Muckenthaler Cultural Center, Fullerton, CA, 1974.

Colton, Harold S.: *Kachina Dolls: with a Key to Their Identification*, University of New Mexico Press, Albuquerque, NM, 1949. Revised in 1959 and reprinted in 1983.

Conkey, Laura E., Ethel Boissevain and Goddard Ives: "Indians of Southern New England and Long Island: Late Period," *Handbook of North American Indians, Vol. 15, Northeast*, pp. 177-97, Smithsonian Institution, Washington, D.C., 1978.

Conn, Richard: "Western Sioux Beadwork," *American Indian Hobbyist*, Vol. 6, Nos 9 & 10, Alton, IL, 1960.

—— "Cheyenne Style Beadwork," *American Indian Hobbyist*, Vol. 7, No. 2, Alton, IL, 1961.

—— "Blackfeet Women's Clothing," *American Indian Tradition*, Alton, IL, 1961.

—— *Robes of White Shell and Sunrise, Personal Decorative Arts of the Native American*, Denver Art Museum, Denber, CO, 1975.

Cowdrey, Mike, and Ned and Jody Martin: *American Indian Horse Masks*, Hawk Hill Press, Nicasio, CA, 2006.

Dalrymple, Larry: *Indian Basketmakers of California and the Great Basin*, Museum of New Mexico Press, Santa Fe, NM, 2000.

Davidson, Daniel S.: *Decorative Art of the Têtes-de-Boule of Quebec*, Museum of the American Indian Heye Foundation, New York, NY, 1928.

Dedera, Don: *Navajo Rugs: How to Find, Evaluate, Buy and Care for Them*, Northland Press, Flagstaff, AZ, 1975.

Densmore, Frances: "Mandan and Hidatsa Music," *BAE Bulletin* 80, Smithsonian Institution, Washington, D.C., 1923.

Dewdney, Selwyn: *The Sacred Scrolls of the Southern Ojibwa*, Glenbow-Alberta Institute, Calgary, AK, 1975.

Dillworth, Leah: *Imagining Indians in the Southwest: Persistent Visions of a Primitive Past*, Smithsonian Institution Press, Washington, D.C., 1996.

Dockstader, Frederick J.: *The Kachina & The White Man: A Study of The Influence of White Culture on The Hopi Kachina Cult*, Cranbook Institute of Science, Bloomfield Hills, MI, 1954.

Douglas, Frederic H.: *Plains Indian Clothing*, Denver Art Museum, Denver, CO, 1931.

—— *Basic types of Indian Women's Costumes*, Denver Art Museum, Denver, CO, 1950.

—— *Indian Women's Clothing*, Denver Art Museum, Denver, CO.

Downs, Dorothy: *Art of the Florida Seminole and Miccosukee Indians*, University Press of Florida, Gainesville, FL, 1995.

Dozier, Edward P.: *The Pueblo Indians of North America*, Holt, Rinehart, and Winston, New York, NY, 1970.

Dubin, Lois Sherr: *North American Indian Jewelry and Adornment: From Prehistory to the Present*, Harry N. Abrams, New York, NY, 1999.

Duncan, Kate C.: *A Special Gift, the Kutchin Beadwork Tradition*, University of Washington Press, Seattle, WA, 1988.

—— *Northern Athapaskan Art: A Beadwork Tradition*, University of Washington Press, 1989.

Eddington, Patrick, and Susan Makov: *Trading Post Guidebook*, Northland Publishing, Flagstaff, AZ, 1995.

Emmons, George T.: *The Basketry of the Tlingit*, American Museum of Natural History, New York, NY, 1903.

—— *The Chilkat Blanket*, American Museum of Natural History, New York, NY, 1907.

Erickson, Vincent O.: "Maliseet-Passamaquoddy," *Handbook of North American Indians*, Vol. 15, *Northeast*, pp. 123–36, Smithsonian Institution, Washington, D.C., 1978.

Ewers, John C.: *Blackfeet Crafts*, Dept. of the Interior, Bureau of Indian Affairs, Washington, D.C., 1944.

—— *Blackfeet Crafts*, Haskell Institute, Lawrence, KS, 1945.

—— "The Horse in Blackfoot Indian Culture, with comparative material from Other Western Tribes," *Bulletin of the Bureau of American Ethnology* 159, Washington, D.C., 1955.

—— *Murals in the Round: Painted Tipis of the Kiowa and Kiowa-Apache Indians*, Smithsonian Institution Press, Washington, D.C., 1978.

Feder, Norman: "Grizzly Claw Necklaces," *American Indian Traditon*, Vol. 8, No. 1, Alton, IL, 1961.

—— "Bottom Tab Leggings," *American Indian Tradition*, Alton, IL, 1962.

—— "Front Seam Leggings," *American Indian Tradition*, Alton, IL, 1962.

—— *Art of the Eastern Plains Indian: The Nathan Sturges Jarvis Collection*, Brooklyn Museum, Brooklyn, NY, 1964.

—— "American Indian Art before 1850," *Summer Quarterly*, Denver Art Museum, Denver, CO, 1965.

—— "A Crow Beaded Horse Collar ," *Material Culture Notes*, pp. 10–15, Denver Art Museum, Denver, CO, 1969.

Feder, Norman, and M. G. Chandler: "Otter Fur Turbans," *American Indian Tradition*, Vol. 7, No. 3, 1961.

Fenton, William N.: *The False Faces of the Iroquois*, University of Oklahoma Press, Norman, OK, 1987.

Fewkes, Jesse Walter: *Dolls of the Tusayan Indians*, E.J. Brill, Leiden, NL, 1894.

Fowler, Carol: *Daisy Hooee Nampeyo: The Story of an American Indian*, Dillon Press, Minneapolis, MN, 1977.

Garfield, Viola E: *The Wolf and the Raven: Totem Poles of Southeastern Alaska*, University of Washington Press, Seattle, WA, 1948.

Gidmark, David: *The Algonquin Birch Bark Canoe*, Shire Publications, Aylesbury, U.K., 1988.

—— *Birch Bark Canoe, Living among the Algonquin*, Firefly Books, Willowdale, Ontario, 1997.

Gregg, Josiah Gregg: *Commerce of the Prairies*, Henry G. Langley, New York, NY, 1844; University of Oklahoma Press, Norman, OK, 1990.

Gringhuis, Dirk: *Indian Costume at Mackinac*, Mackinac Island State Park Commission, 1972.

Hail, Barbara A., and Kate C. Duncan: *Out of the North. The Subarctic collection of the Haffenraffer Museum of Anthropology*, Brown University, RI, 1989.

Hatt, Gudmund: "Moccasins and their Relation to Arctic Footwear," *Memoirs of the American Anthropological Association*, III, 3, Lancaster, PA, 1916.

Hawthorn, Audrey: *Kwakiutl Art*, University of Washington Press, Seattle, WA, 1967.

Hayes, Allan and John Blom: *Southwestern Pottery: Anasazi to Zuni*, Northland Publishing, Flagstaff, AZ, 1996.

Hedlund, Ann Lane: *Beyond the Loom: Keys to Understanding Early Southwestern Weaving*, Johnson Books, Boulder, CO, 1990.

Her Many Horses, Emil: *Identity by Design: Tradition, change and celebration in native women's dresses*, National Museum of the American Indian, Smithsonian Institution, Washington, D.C., 2007.

Holm, Bill: *Form and Freedom: A Dialogue on Northwest Coast Indian Art*, Institute for the Arts, Rice University, Houston, TX, 1975.

Holm, Bill: *Northwest Coast Indian Art: An Analysis of Form*, Douglas & McIntyre, Vancouver, BC/Toronto, ON, 1965.

—— "Quill Wrapped Horsehair: Two Rare Quilling Techniques," Studies in American Indian Art, *European Review of Native American Studies*, 2001.

Howard, James H.: "Notes on the Plains Ojibwa," *Museum News*, Vol. 25, Nos 2–4, University of South Dakota, Vermillion, SD, 1964.

—— "The Santee or Eastern Dakota," *Museum News*, Vol. 27, Nos 5–6, University of South Dakota, Vermillion, SD, 1966.

—— "Ceremonial Dress of the Delaware Man," *Bulletin of the Archaeological Society of New Jersey*, No. 33, 1976.

—— "Birch Bark and Paper Cutouts—an art form of the Northern Woodlands and Prairie border," *American Indian Art*, Vol. 5, No. 4, 1980.

Howard, Kathleen L. and Diana F. Pardue: *Inventing the Southwest: The Fred Harvey Company and Native American Art*, Northland Publishing, Flagstaff, AZ, 1996.

Hughes, J.T: *Doniphan's Expedition*, U.P. James, Cincinnati, OH, 1847.

Idiens, Dale: "A Catalog of Northern Athapaskan Indian artifacts in the Collection of the Royal Scottish Museum, Edinburgh," *Art and Archaeology*, 3, 1979.

Idiens, Dale, and Barrie Reynolds: *The Athapaskans: Strangers of the North*, Royal Scottish Museum and National Museum of Canada, Ottawa, ON, 1974.

James, George Wharton: *Indian Basketry and How to make Indian and Other Baskets*, Henry Malkan, New York, NY, 1902. Revised in 1903.

—— *Indian Blankets and Their Makers*, Rio Grande Press, Inc., Globe, AZ, 1974 (first published in 1927).

James, H.L: *Posts and Rugs*, Southwest Parks and Monuments Assn., Globe, AZ, 1976.

Jensen, Vickie: *Totem Pole Carving*, Douglas & McIntyre Ltd., Vancouver, BC, 1992.

Johnson, Michael G.: "Blackfoot Bonnet," *Powwow Trails*, Vol. II, No. 5, 1965.

—— "A Note on Plains Cree Bonnets," *American Indian Crafts and Culture*, Vol. 5, No. 7, 1971.

—— "Material Culture of the Sac and Fox, with emphasis on the Owen Collection of 'Musquakie' artifacts," *Whispering Wind*, Vol. XII, No. 2, New Orleans, LA, 1978.

—— "An Introduction to Porcupine Quillwork on Birch bark," *Indian Artifact Magazine*, Turbotville, PA, 1984.

—— "Iroquois Purses," *Whispering Wind*, Winter 1985, pp. 6–11, New Orleans, LA, 1985.

—— "Penobscot-Maliseet Women's Hoods," *Whispering Wind*, Fall-Winter 1987, New Orleans, LA, 1987.

—— "Leaf-Like Patterns of the Southern Wabanaki," *Whispering Wind*, Vol. 30, No. 8, pp. 4-9, New Orleans, LA, 2000.

Johnson, M. G., and I. M. West: "A Photographic Essay on Indian Guncases in British Collections," *Indian Artifact Magazine*, Vol. 4, No. 1, Turbotville, PA, 1985.

Kahlenberg, Mary Hunt and Anthony Berlant: *Navajo Blanket*, L.A. Praeger Publishers/Los Angeles County Museum of Art, Los Angeles, CA, 1972.

Keithahn, Edward L: *Monuments in Cedar*, Roy Anderson, Ketchikan, AK, 1945.

Kennard, Edward A. & Edwin Earle: *Hopi Kachinas*, Museum of the American Indian, Hye Foundation, New York, NY, 1971.

King, J. C. H.: *Thunderbird and Lightning: Indian Life in Northeastern North America 1600-1900*, Museum of Mankind, British Museum, London, 1982.

Kramer, Barbara: *Nampeyo and Her Pottery*, University of New Mexico Press, Albuquerque, NM, 1996.

Kroeber, Alfred L.: "Handbook of the Indians of California," *Bulletin* 78, Bureau of American Ethnology, Smithsonian Institution, Washington, D.C., 1925.

Krumroy, B.: "Modern Sauk and Fox Woman's Clothing," *American Indian Tradition*, Vol. 8, No. 2, 1962.

Kurtz, Rudolph Friederich (trans. Myrtis Jarrel, ed. J. N. B. Hewitt): *Journal of Rudolph Friederich Kurtz*, University of Nebraska Press, Lincoln, NE, 1970.

Lanford, Benson L.: "Winnebago Bandolier Bags," *American Indian Art*, Vol. 9, No. 3, 1984.

—— "Great Lakes Woven Beadwork," *American Indian Art*, Vol. 11, No. 3, 1986.

Laubin, Reginald and Gladys: *The Indian Tipi: Its History, Construction, and Use*, University of Oklahoma Press, Norman, OK, 1957.

Lyford, Carrie A.: *Quill and Beadwork of the Western Sioux*, Indian Handcraft Pamphlets 1, U.S. Dept. of the Interior, Washington, D.C., 1940.

—— *Ojibwa Crafts*, U.S. Dept. of the Interior, Washington, D.C., 1943.

—— *Iroquois Crafts*, Haskell Institute, Lawrence, KS, 1945.

Macnair, Hoover and Neary: *The Legacy: Tradition and Innovation in Northwest Coast Art*, Douglas & McIntyre, Vancouver, BC/Toronto, ON; University of Washington Press, Seattle, WA, 1997.

Malouf, Carling: "Crow-Flies-High A Historic Hidatsa Village in the Garrison Reservoir Area, North Dakota," *BAE River Basin Survey Papers* 29, Smithsonian Institution, Washington, D.C., 1963.

Mauldin, Barbara: *Traditions in Transition: Contemporary Basket Weaving of the Southwestern Indians,* Museum of New Mexico Press, Santa Fe, NM, 1984.

Maxwell, Gilbert S: *Navajo Rugs: Past, Present and Future*, Bell West Publications, Palm Desert, CA, 1963.

McKenney, L., and James Hall: *The Indian Tribes of North America*, John Grant, Edinburgh, 1933.

McLuhan, T.C: *Dream Tracks: The Railroad and the American Indian, 1890-1930 with Photographs from the William E. Kopplin Collection*, Harry N. Abrams, New York, NY, 1985.

Medford, Claude: "Southeast Indian Buckskin Making," *American Indian Crafts and Culture*, Vol. 5, No. 6, Tulsa, OK, 1971.

Mercurio, Gian and Maxymilian L. Peschel: *The Guide to Trading Posts and Pueblos*, Lonewolf Publishing, Cortez, CO, 1994.

Miller, Marjorie: *Indian Arts and Crafts*, Galahad Books, New York, NY, 1972.

Moore, Ellen: *Navajo Beadwork: Architectures of Light*, University of Arizona Press, Tucson, AZ, 2003.

Morrow, Mabel: *Indian Rawhide*, University of Oklahoma Press, Norman, OK, 1976.

Oberholtzer, Cath: "Silk Ribbonwork: Unravelling the Connections," 31st Algonquian Conference, 2000.

Orchard, William C.: *Beads and Beadwork of the American Indian*, Museum of the American Indian, Heye Foundation, New York, NY, 1929.

Owen, Mary Alison: *Folklore of the Musquakie Indians of North America*, The Folk-Lore Society, London, 1924.

Peers, Laura: *The Ojibwa of Western Canada, 1780 to 1870*, University of Manitoba Press, Winnipeg, MB, 1994.

Pelletier, Gaby: *Micmac and Maliseet Decorative Traditions*, New Brunswick Museum, St. John, NB, 1977.

Pendleton, Mary: *Navajo and Hopi Weaving Techniques*, New York, NY, Macmillan, 1974.

Pierite, Joseph A.: "Present Day Crafts of the Tunica and Biloxi Tribes of Louisiana," *American Indian Crafts and Culture*, Vol. 8, No. 3, Tulsa, OK, 1974.

Reid, William: *Out of the Silence*, Outerbridge & Dienstfrey, New York, NY, 1971.

Ritzenthaler, Robert E., and Frederick A. Peterson: "The Mexican Kickapoo Indians," *Milwaukee Public Museum Publications in Anthropology* 2, Milwaukee, WI, 1956.

Rodee, Marian E: *Southwestern Weaving*, University of New Mexico Press, Albuquerque, NM, 1977.

Rosnek, Carl and Joseph Stacy: *Skystone and Silver: The Collector's Book of Southwest Indian Jewelry*, Prentice Hall, Englewood Cliffs, NJ, 1979.

Sager, Dave: "The Possible Origins of the Blackfeet Crookednose Moccasin Design," *American Indian Art*, Autumn 1995.

—— "The Dual Side Seam: An Overlooked Moccasin," *American Indian Art*, Spring 1996.

Salzer, Robert: "Central Algonkin Beadwork," *American Indian Tradition*, Vol. 7, No. 5, 1961.

Schaafsma, Polly (ed.): *Kachinas in the PueblÒo World*, University of New Mexico Press, Albuquerque, NM, 1994.

Schaafsma, Polly: *Rock Art in New Mexico*, State Planning Office, Santa Fe, NM, 1972.

Schroeder, Albert H. (ed.): *The Changing Ways of Southwestern Indians: A Historical Perspective*, Rio Grande Press, Glorieta, NM, 1973.

Shearer, Cheryl: *Understanding Northwest Coast Art*, Douglas & McIntyre, Vancouver, BC, 2000.

Skinner, Alanson: "Observations on the Ethnology of the Sauk Indians, Part III: Notes on material culture," *Milwaukee Public Museum Publications*, Vol. 5, No. 3, Milwaukee, WI, 1925.

Speck, Frank G.: "Decorative Art of the Indian Tribes of Connecticut," *Anthropological Series Memoirs* 75, No. 10, Canada Dept. of Mines, Ottawa, ON, 1915.

—— "Decorative Art of the Indian Tribes of Connecticut," *Memoirs of the Canadian Geological Survey* 75, Canada Dept. of Mines, Ottawa, ON, 1915.

—— "Native Tribes and Dialects of Connecticut—A Mohegan-Pequot Diary," *43rd Annual Report of the Bureau of American Ethnology*, pp. 199-298, Washington, D.C., 1925-26.

—— "Symbolism in Penobscot Art," *Anthropological Papers of the American Museum of Natural History*, Vol. xxix, pp. 25-80, New York, NY, 1927.

Stephen, Alexander M.: *Hopi Journal*, Columbia University Press, New York, NY, 1936.

Stewart, Hilary: *Looking at Indian Art of the Northwest Coast*, Douglas & McIntyre, Vancouver, BC/Toronto, ON, 1979.

—— *Looking at Totem Poles*, Douglas & McIntyre, Vancouver, BC/Toronto, ON; University of Washington Press, Seattle, WA, 1993.

Stewart, Tyrone, Frederick Dockstader and Barton Wright: *The Year of The Hopi: Paintings & Photographs by Joseph Mora, 1904-06*, Rizzoli International Publications, New York, NY, 1979.

Stewart, Tyrone: "Oklahoma Delaware Woman's Dance Clothes," *American Indian Crafts and Culture*, Vol. 7, No. 6, Tulsa, OK 1973.

Sturtevant, William C.: "Seminole Men's Clothing," *Proceedings of the 1966 Annual Spring Meeting of the American Ethnological Society*, University of Washington Press, Seattle, WA, 1967.

Swanton, John R.: "Indian Tribes of the Lower Mississippi Valley and Adjacent Coast of The Gulf of Mexico," *BAE Bulletin* 43, Smithsonian Institution, Washington, D.C., 1910.

Talayesua, Don C: *Sun Chief: The Autobiography of a Hopi Indian*, Institute of Human Relations/Yale University Press, New Haven, CT, 1942.

Tanner, Clara Lee (ed.): *Arizona Highways Indian Arts and Crafts,* Arizona Highways, Phoenix, AZ, 1976.

Taylor, Colin F. G.: "Plains Indian Headgear," *The English Westerners' Brand Book*, Vol. 4, No. 3, 1962.

—— "Mato-Tope's Warbonnet," *Powwow Trails*, Vol. IV, Nos 1 & 2, 1967.

—— "Iron Tail's Warbonnet," *American Indian Crafts and Culture*, Vol. 5, Nos 4 & 5, 1971.

—— "Analysis and Classification of the Plains Indian Ceremonial Shirt," 5th Annual Plains Indian Seminar, Buffalo Bill Historical Center, Cody, Wyoming, 1981.

—— "Catlin's portrait of Iron Horn: An early style of Blackfeet shirt," *Plains Anthropologist*, 1986.

—— *Yupika: The Plains Indian Woman's Dress*, Verlag für Amerikanistik, Wyk, Germany, 1997.

—— *Hoka Hey! Scalps in Coups: The impact of the horse on Plains Indian Warfare*, Tatanka Press, Wyk, Germany, 2000.

—— "The Crow ceremonial shirt: History and Development of styles, 1800-1900," *Studies in American Indian Art, European Review of Native American Studies*, 2001.

Teiwes, Helga: *Kachina Dolls: The Art of Hopi Carvers*, University of Arizona Press, Tucson, AZ, 1991.

—— *Hopi Basket Weaving: Artistry in Natural Fibers*, University of Arizona Press, Tucson, AZ, 1996.

—— *Southwest Indian Craft Arts*, University of Arizona Press, Tucson, AZ, 1968. Reprinted in 1975.

Thompson, Judy: *The North American Indian Collection: A Catalog*, Berne Historical Museum, Switzerland, 1977.

—— *Pride of the Indian Wardrobe - Northern Athapaskan Footwear*, Bata Shoe Museum–University of Toronto Press, Toronto, ON, 1990.

Titiev, Mischa: *Old Oraibi: A Study of The Hopi Indians of the Third Mesa*, Peabody Museum, Cambridge, MA, 1944.

Trahant, Lenora Begay: *The Success of the Navajo Arts and Crafts Enterprise: A Retail Success Story*, Walker and Company, New York, NY, 1996.

Traugott, Joseph: *Nampeyo of Hano and Five Generations of Her Descendants*, Adobe Gallery, Albuquerque, NM, 1983.

Trimble, Stephen: *Talking with the Clay: The Art of Pueblo Pottery*, School of American Research Press, Santa Fe, NM, 1987.

Turnbaugh, William A., and Sarah Peabody: *Indian Baskets*, Schiffer Publishing, West Chester, PA, 1986.

Turner, Geoffrey: "Hair Embroidery in Siberia and North America," *Occasional Papers on Technology* 7, Pitt Rivers Museum, Oxford, U.K., 1955.

Wade, Edwin L. and Lea S. McChesney: *Historic Hopi Ceramics: The Thomas V. Keam Collection of the Peabody Museum of Archaeology and Ethnology*, Peabody Museum Press, Cambridge, MA, 1981.

Waters, Frank: *Masked Gods: Navajo & Pueblo Ceremonialism*, Sage Books, Denver, CO, 1950.

—— *The Book of The Hopi*, Viking Press, New York, NY, 1963.

Webber, Alika P.: *North American Indian and Eskimo Footwear*, Bata Shoe Museum, Toronto, ON, 1989.

Whiteford, Andrew Hunter: "The Origins of Great Lakes Beaded Bandolier Bags," *American Indian Art*, Vol. 11, No. 3, 1986.

Whiteford, Andrew Hunter, Stewart Peckham, Rick Dillingham, Nancy Fox, and Kate Peck Kent: *I Am Here: Two Thousand Years of Southwest Indian Arts and Culture*, Museum of New Mexico Press, Santa Fe, 1989.

—— *Southwestern Indian Baskets: Their History and Their Makers with a Catalogue of the School of American Research Collection*, School of American Research Press, Santa Fe, NM, 1988.

Whitehead, Ruth Holmes: *Elitekey: Micmac Material Culture from 1600 A.D. to the Present*, Nova Scotia Museum, Halifax, NS, 1980.

—— *Micmac Quillwork*, Nova Scotia Museum, Halifax, NS, 1982.

Wildschut, William, and John C. Ewers: *Crow Indian Beadwork, a descriptive and historical study*, Museum of the American Indian Heye Foundation, New York, NY, 1959.

Wissler, Clark: "Costumes of the Plains Indians," *Anthropological Papers*, Vol. XVII, Pt. II, American Museum of Natural History, New York, 1915 (reprinted Crazy Crow Trading Post, 2006).

Wood, Guy D.: "Seminole Moccasins," *American Indian Crafts and Culture*, Vol. 5, No. 3, Tulsa, Oklahoma, 1971.

Wooley, David (ed.): *Eye of the Angel, Selections from the Derby Collection*, White Star Press, Northampton, MA, 1990.

Wright, Barton A.: *Hopi Material Culture: Artifacts Gathered by H.R. Voth in the Fred Harvey Collection*, Northland Press/Phoenix: Heard Museum, Flagstaff, AZ, 1979.

—— *Clowns of the Hopi: Tradition Keepers and Delight Makers*, Northland Publishing, Flagstaff, AZ, 1994.

—— *Hallmarks of the Southwest*, Schiffer Publishing Ltd., West Chester, PA, 1989.

—— Hopi Kachinas: *The Complete Guide to Collecting Kachina Dolls*, Northland Press, Flagstaff, AZ, 1977.

—— Hopi Kachinas: *A Life Force, in Hopi Nation: Essays on Indigenous Art, Culture, History, and Law*, University of Nebraska Press, Lincoln, NE, 2008.

Wright, Barton A. and Evelyn Roat: *This is a Hopi Kachina*, Museum of Northern Arizona, Flagstaff, AZ, 1985.

Wright, Margaret Nickelson: *Hopi Silver: The history and hallmarks of Hopi Silversmithing*, Northland Press, Flagstaff, AZ, 1972. Revised in 1982 and 1989.

Wright, Robin: *Northern Haida Master Carvers*, University of Washington Press, Seattle, WA 2001; Douglas & McIntyre, Vancouver, BC, 2001.

Wyckoff, Lydia L.: *Designs and Factions: Politics, Religion and Ceramics on the Hopi Third Mesa*, University of New Mexico Press, Albuquerque, NM, 1990.

INDEX OF TRIBES

A FIREFLY BOOK

This paperback edition published by Firefly Books Ltd. 2022

First printing

Library of Congress Control Number: 2021947569

Library and Archives Canada Cataloguing in Publication

Title: Arts & crafts of the Native American tribes / Michael Johnson & Bill Yenne.

Other titles: Arts and crafts of the Native American tribes

Names: Johnson, Michael, 1937-2019, author. | Yenne, Bill, 1949- author.

Description: Previously published: 2011. | Includes bibliographical references and index.

Identifiers: Canadiana 20210326859 | ISBN 9780228103851 (softcover)

Subjects: LCSH: Indian arts—North America—Encyclopedias. | CSH: Indigenous arts—Canada—Encyclopedias. | LCSH: Indians of North America—Material culture—North America—Encyclopedias. | CSH: Native peoples—Material culture—Canada—Encyclopedias. | LCGFT: Encyclopedias.

Classification: LCC E98.A73 J64 2022 | DDC 704.03/97—dc23

Published in the United States by
Firefly Books (U.S.) Inc.
P.O. Box 1338, Ellicott Station
Buffalo, New York 14205

Published in Canada by
Firefly Books Ltd.
50 Staples Avenue, Unit 1
Richmond Hill, Ontario L4B 0A7

Project manager: Donald Sommerville
Design: Danny Gillespie Greene Media
Artwork: Mark Franklin

Printed in China

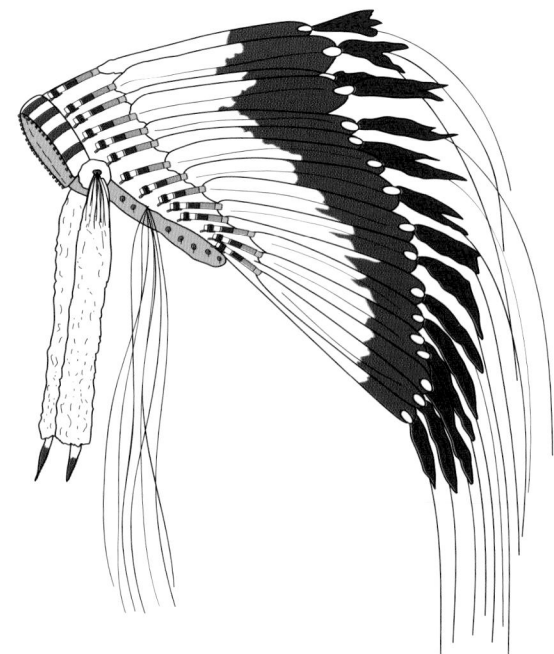

Acknowledgments

Many people and institutions have helped the writer over the years. I would especially like to thank the following individuals who contributed their time and knowledge by mail and conversations through many years; they include from the U.S.A. Dr. James H. Howard, Norman Feder, John Painter, Arthur Einhorn, Ben Stone, Guy Wood, Samuel Cahoon, Frank Bergevin, Dr. William Sturtevant, Wes White (Taukchiray), Gerry Biron; in Canada Dr. Cath Oberholtzer, Dave Sager, John Hellson; from Germany Ute and Hermann Vonbank; and from the U.K. Dr. Colin Taylor, Ian West, Richard Hook, Jack Hayes, Richard Green, Mark Sykes, John Datlen, Leo Woods, Edward Blackmore, William Reid, and Albert "Dennis" Burdett. For reading my notes, Tim O'Sullivan. Some of these friends are unfortunately no longer with us but are fondly remembered. Finally to my family for their cheerful patience, wife Nancy and daughters Sarah and Pauline.

Cover photos: Front — A Umatilla woman wearing a beaded buckskin dress, shell bead necklaces, shell disk earrings, and a woven grass hat, c. 1910. LoC

Page 1: Hopi basket weaver, c. 1908 (Frederick I. Monsen photo).

Page 2: Blackfoot man's skin shirt, leggings, and moccasins. RAMM

Page 4: Plains Cree bonnet.

ARTS & CRAFTS
OF THE NATIVE
AMERICAN TRIBES

MICHAEL JOHNSON

& BILL YENNE

FIREFLY BOOKS